DUTCH LANDSCAPE PAINTING
OF THE SEVENTEENTH CENTURY

NATIONAL GALLERY OF ART : KRESS FOUNDATION
STUDIES IN THE HISTORY OF EUROPEAN ART

DUTCH LANDSCAPE PAINTING

OF THE SEVENTEENTH CENTURY

BY WOLFGANG STECHOW

Cornell / Phaidon Books

Cornell University Press
ITHACA, NEW YORK

© 1966 by Phaidon Press Limited, Oxford

All rights reserved. Except for brief quotations in a review,
this book, or parts thereof, must not be reproduced in any form
without permission in writing from the publisher. For information
address Cornell University Press, 124 Roberts Place, Ithaca,
New York 14850.

First published by Phaidon Press Ltd. 1966
First published, Cornell Paperbacks, 1981

International Standard Book Number 0-8014-9228-9
Library of Congress Catalog Card Number 81-66148

Printed in the United States of America

CONTENTS

PUBLISHER'S NOTE

The first edition of this book was published by Phaidon Press in 1966 as one of the National Gallery of Art Kress Foundation Studies in the History of European Art. It was reprinted with corrections in 1968, and this paperback edition has been photographically reprinted from the 1968 edition.

FOREWORD

THE reasons for the lack of a comprehensive book on Dutch landscape painting of the seventeenth century became very clear to me in the course of writing this one. Among them, two are of special importance.

First, our knowledge of this field is still scanty. This statement may sound strange and even preposterous to some but I think it is correct, and I shall try to justify it in my Introduction. On this ground, then, this book must be considered as being *ante tempus*, quite apart from its other shortcomings.

Secondly, the difficulties of finding an adequate system of organizing the wealth of material involved in the present topic are wellnigh insuperable.

Should one proceed by individual artists? This method would be most satisfactory in some respects, but it is easy to see its disadvantages as well. While the art of Jan van Goyen lends itself to tracing the development of a main trend of Dutch landscape painting through three significant stages, other important artists stand apart, either as individuals or as representatives of a chronologically or aesthetically restricted group. Monographic treatment has produced excellent chapters in books such as Wilhelm Bode's, but it cannot answer many questions concerning the general nature, scope and development of Dutch seventeenth-century landscape painting.

Should one proceed entirely by phases, generations or decades? This could easily lead to an excessive slighting of individual contributions and, in particular, to an overdose of formalistic constructions of the kind that has already wrought havoc in art-historical literature.

Should one proceed by 'schools'? There were practically no significant distances between the main centres of production – and certainly no barricades. Artists moved freely about, and while there is no doubt about the predominance of such centres as Haarlem and Amsterdam, it is as impossible to make a neat distinction between the landscape painting of these two cities as it is between either and the best that was painted in Leiden, The Hague, Utrecht, and even Kampen and Zwolle. Does Jacob van Ruisdael belong to Haarlem or to Amsterdam?

In view of these difficulties I decided on an organization which is certain to suffer from some of the disadvantages inherent in all other approaches. Still it seemed to me worth trying, partly because it might help to avoid some other drawbacks, partly – and frankly – because it is a new approach. To call it iconographical would be somewhat misleading, but in any case, it is an approach by subject within the general framework of 'landscape'. The discussion of the contributions and even of the development and interrelationship of individual masters will by no means be eliminated but it will be subordinated to that of the subject.

The chapter titles give the necessary initial information about this organization; suffice it to add that the inclusion of 'seascapes' and 'townscapes' was not decided upon without qualms but finally considered necessary in order to round off the

presentation of the Dutch artists' visual conquest of nature. There is certainly no danger here of neat packaging; overlapping abounds; repetition is unavoidable. But there may be some justification for pleading attenuating circumstances.

As landscape artists moved from one subject to another – and fortunately most Dutch landscape painters did just this, with the result that some of them will appear in many chapters of this book – their works appear closely linked to the effort which other artists, of their time and before their time, had spent or were spending on that particular subject, and sometimes also to the effort that they themselves had spent on it at an earlier phase of their career. In concentrating on this spectacle, one might hope to trace significant elements of continuity or change within the development of each subject which other methods of presentation would not easily reveal, even though this must be done at the cost of slighting some other problems concerning the development of each individual artist as well as of losing the opportunity to study his 'total image'.

Such a method could be employed even with regard to the art of more recent times when artists were much more anxious than their seventeenth-century forebears to show originality in each of their works or at least in their approach to each subject. But it is of course more valid with regard to a period in which even the greatest masters never hesitated to appropriate a good way of viewing and interpreting a subject when they saw it, without much respect for anybody else's artistic 'copyright', and without fear of self-repetition. Granting the existence of individual and 'school' competition (about which we know next to nothing), Dutch seventeenth-century art was by and large a family project.

The necessity, concomitant to the chosen method, to observe stylistic changes primarily restricted to comparable subjects, may perhaps provide a welcome protection against what Erwin Panofsky has so aptly called the 'boa constructor'. If we investigate Ruisdael's winter landscapes in their relationship to the winter landscapes of other masters rather than to his own forest landscapes, the family bond will become more apparent without necessarily endangering an insight into his unique contribution to the history of winter landscape painting; at the same time, the temptation to compare incomparables within Ruisdael's art, and from such comparisons to deduce dubious theories about his 'entelechy', will be withstood. While the writer of a monograph on an individual artist will investigate these bonds carefully – and Jakob Rosenberg's book on Jacob van Ruisdael is an outstanding example of how this ought to be done – he will do so only in so far as his hero is affected by them; here it is proposed to offer a brief monograph on each of these subjects. Needless to say, neither this short book nor even a much longer and better one could ever replace careful monographic work; in fact, it will suffer from serious gaps and errors wherever the ground for it has not been prepared by the latter.

I cannot hope to have accomplished the best possible equilibrium in presenting individual achievements, trends of development and the exigencies of the subjects themselves. Furthermore, my views on the relative importance of a number of artists

of the second rank will be open to criticism, even though there can be little cause for disagreement on the selection of artists of the first rank and the advisability to eliminate those of the third rank, at least from the main stream of discussion. The discarding of the great landscape draughtsmen was a sad necessity; an exception was made for a pioneer group, the discussion of whom seemed indispensable to an understanding of the history of landscape painting early in the century. No attempts have been made to cover the vast field of 'Nachleben' and 'Nachruhm' of the Dutch landscape painters; this would require another book.

During the over-long period of preparation of this volume, I have enjoyed the support of many faithful helpers, to whom I wish to express my warmest thanks. I am greatly indebted to the Philosophical Society of America and to Oberlin College for financial help on study trips, and to the Institute for Advanced Study in Princeton for a semester of quiet research. The method employed in the book was tested in public lectures on the invitation of the Frick Collection in New York and the Cleveland Museum of Art.

Among the host of individuals who have provided valuable information and photographs whenever requested I should like to single out, first of all, Dr. H. Gerson and Dr. S. J. Gudlaugsson in The Hague, and Prof. Jakob Rosenberg in Cambridge, Mass. Furthermore: Dr. Ernst Brochhagen in Munich, Mr. J. Carter Brown in Washington, Mr. J. C. Ebbinge Wubben in Rotterdam, Dr. Susanne Heiland in Leipzig, Dr. Ernst Holzinger in Frankfurt, Dr. U. I. Kuznetsow in Leningrad, Mr. F. Lugt in Paris, Dr. Cornelius Müller Hofstede in Berlin, Dr. Lisa Oehler in Kassel, Prof. Seymour Slive in Cambridge, Mass., Dr. Charlotte Steland-Stief in Göttingen, Dr. Eduard Trautscholdt in Düsseldorf, Mrs. Susanne Schiller Udell in New York, Prof. H. van de Waal in Leiden, and Dr. Gustav Wilhelm in Vaduz.

The Rijksbureau voor kunsthistorische documentatie in The Hague, the Frick Art Reference Library in New York, and the Platt Collection of the Princeton Department of Art and Archaeology have put their vast treasures at my disposal with the greatest generosity.

I am deeply grateful to the Trustees of the National Gallery of Art, Washington, and to the Samuel H. Kress Foundation, for accepting this book for publication in the series of Kress Foundation Studies in the History of European Art. To the Phaidon Press I wish to express my sincere thanks for the care they have devoted to the appearance of the book.

I have not hesitated to reproduce pictures of world renown whenever I found them essential in their present context, but I hope to have balanced them with an adequate number of less known but significant ones. To the owners – in some cases, by necessity, former owners – of the works reproduced in this book go my thanks for permission to publish them; to those not identified, my apologies.

Oberlin, Ohio, July 1965 WOLFGANG STECHOW

FOREWORD TO THE SECOND EDITION

As no detailed critical reviews of the first edition have yet appeared I am specially beholden to all who have privately communicated corrections, additions, and suggestions. I wish to thank, besides those already listed on page ix: Dr. Fredo Bachmann in Nürnberg, Dr. Hans Ulrich Beck in Augsburg, Prof. J. G. van Gelder in Utrecht, Prof. E. Haverkamp Begemann in New Haven, Dr. Anneliese Mayer-Meintschel in Dresden, Dr. Kurt Schwarzweller in Frankfurt, Miss Joaneath Spicer in New Haven, and Dr. Horst Vey in Cologne.

The text has undergone no fundamental revisions but I hope that a number of passages have gained in precision. Three plates have been replaced for the sake of more accurate presentation. The bibliography has been brought up-to-date.

Only after the publication of the first edition did I happen to learn that in an unpublished lecture given in Basel on November 18, 1873, Jacob Burckhardt organized the material of Dutch landscape painting of the seventeenth century in the following fashion: Patronage, sky and horizon, times of the year and day, countryside, dunes and meadows, the forest, the sea, and the nocturne. His lecture ended with a repudiation of mere 'realism' (Burckhardt also had a marked predilection for the Italianate masters), and a late addendum to the manuscript reads: 'Das Minimum wirkt als ein Infinitum'.[1]

WOLFGANG STECHOW

Oberlin, Ohio, December 1967

1. Werner Kaegi, *Europäische Horizonte im Denken Jacob Burckhardts*, Basel-Stuttgart, 1962, pp. 150 ff.

DUTCH LANDSCAPE PAINTING
OF THE SEVENTEENTH CENTURY

'Ruralium Picturae . . . tam immensa in Belgio nostro ac praeclara seges est, ut qui singulos commemorare curet libellum impleat.'

Constantijn Huygens, *ca.* 1630

INTRODUCTION

WORKERS in the field of seventeenth-century Dutch painting have often been envied the wealth of their material and, even more, the relative wealth of their authenticated material. Yet their position is not really quite as favourable as it looks at first sight; and this is as true of the special category of Dutch landscape painting as it is of Dutch painting in general.

Undoubtedly there is a wealth of reliably documented works; even if one takes the view that John Smith and Cornelis Hofstede de Groot accepted too many, say, Cuyps or Wijnants's, the consensus of scholars on the number of genuine Cuyps and Wijnants's still supports the view that there is an unprecedented number of acceptable pictures of this kind. But it would be foolish to be too optimistic about the margin of error, particularly with regard to signatures.

First of all, there are many forged signatures, designed to make purchasers accept a copy or a forgery as an original work, and there is no question but that even excellent connoisseurs have occasionally been trapped by them. Secondly – and this is perhaps more dangerous – there are the missing signatures, i.e. the cases in which the genuine signatures of minor artists have been removed in order to make the picture pass as the work of a greater master.

While the absence of any signature on a painting attributed to van Goyen or Jacob van Ruisdael should in itself be taken as a warning, since these masters undoubtedly signed their works in the vast majority of cases, it is nevertheless clear that not only may they occasionally have neglected to put it there but that the present absence of it is also quite frequently due to abrasion or fragmentation[1] of the picture; furthermore it is certain that some Dutch landscape painters were much less careful in signing their works than the masters just mentioned. On the other hand, simple mathematics are sufficient to prove that the deletion of the genuine signatures of smaller masters has produced a vast number of apocrypha of the greater ones. Even admitting the fact that the works of smaller artists, in a natural process of selection, are apt to be more easily discarded or hidden from view than the works of the greater masters, no theories of the 'survival of the fittest' can account for the fact that the signed paintings of artists like Jan Coelenbier, François Knibbergen and Johannes Schoeff, all of them quite gifted imitators of Jan van Goyen, now number no more than a few dozen. In fact, there is very good reason to assume that the majority of the unsigned van Goyens were originally provided with the name of artists of this kind and that the process of the 'survival of the fittest' has not nearly been so unkind to the little masters as is often assumed, for the simple reason that a goodly number of their works was of amazingly respectable quality and could pass as paintings by van Goyen even before excellently trained eyes.

There hangs in the Rijksbureau voor kunsthistorische documentatie – as a grim warning to its personnel, one is tempted to think – the one and only known signed

3

painting by a Haarlem artist of van Goyen's time by the name of Joost de Volder.[2] It is reproduced here (fig. 2) in order to fortify the point just suggested in a more abstract fashion. It is clearly the obligation of everyone working in this field to ponder how many pictures attributed to van Goyen or Salomon van Ruysdael in the trade and in private or even public collections, may have been painted by this almost unknown, considerably talented artist.

The question of forgeries and copies is sufficiently familiar to be recalled here only very briefly. Everybody remembers van Meegeren, many are familiar with the works, and even the names, of some main forgers of paintings that have passed as works by Frans Hals and Meindert Hobbema. Here exposure is taking place at a swift rate, thanks to our vastly increased knowledge both in the field of technical research and of the material which forgers were, and are, forced to use in their pastiches – material in the sense of the use of actual old paintings and of their compositions. A spectacular and enlightening example of the former is the falsification of a G. C. Bleeker into a Hercules Seghers, recently published by Gudlaugsson (figs. 8, 9).[3] Similarly, copies are now much more easily recognized as our photographic material is increased in such research institutions as the Rijksbureau voor kunsthistorische documentatie in The Hague and the Frick Art Reference Library in New York; but it is necessary to remember that even this vast material is still very far from being complete, particularly with regard to masters whose works were neglected in comparatively recent times, such as the Italianate landscape painters. It is still pertinent to ask what has happened to the innumerable copies after seventeenth-century Dutch masters painted by Josef van Bredael for the art dealer Jacob de Witte in 1706,[4] and by the industrious Cornelis Vermeulen (1732–1813), sold by auction in Dordrecht after his death.[5]

Another problem that turns out to be much more troublesome than might be expected is that of reliable dates.[6] It is true that some artists, among them van Goyen and Potter, put a date on the vast majority of their paintings. Others were less generous in this respect but still provided us with a reliable framework of dates (Salomon van Ruysdael, Adriaen van de Velde, Jan Wijnants). But there are some who, after giving us a considerable number of dates on their early paintings, ceased to do so more or less entirely in their later years (Aert van der Neer, Jacob van Ruisdael, Hobbema for the middle period), and still others for whose œuvre we have to rely on a pitifully small number of casual dates (Avercamp, Cuyp, Pijnacker, Hackaert), or who have left us practically without any such help (Both).

In addition, wrong reading based on poor preservation of the date, excessive dirt covering it or even insufficient knowledge of the way in which the Dutch shaped – and still shape – their figures, have caused difficulties and misunderstandings, the enumeration of which would fill a small book. The changes in the spelling or the shape of a master's signature may occasionally help in assigning his undated paintings to more or less well-defined and restricted periods (van Goyen, Salomon van Ruysdael,

Hobbema, Berchem and some others),[7] but in other cases this attempt may well be doomed to failure. There are a few cases in which the more or less accurate dating of a picture is possible on the basis of topography, costume of staffage figures and similar considerations. But here a word of warning must be given. A topographical *terminus post quem* may sometimes be conclusive; a topographical *terminus ante quem* seldom is because the painting may be based on an older drawing and the artist may simply not have been interested in bringing the matter up to date.[8] And staffage figures, while occasionally useful for general dating purposes, have so often been altered or even added later on that special care must be taken before they can be proffered as reliable material in this respect – and here, too, as *terminus post quem* only.[9]

What makes us look for dates? We may first of all want to understand the development of the art of a given master, we search for the logic of his growth (or decline or just change), we wish to gauge the range of his mind, his imagination, his knowledge, at a given period, not only during his career as a whole. But we may also want to understand the development of the art of a given period of shorter or greater length; again, we search for the logic of its growth (or decline or just change); again, we wish to gauge the range of its intrinsic possibilities of expres.·)n in contrast to the preceding or following period. Maybe we are apt to place too much emphasis on this matter, possibly as a result of nineteenth-century fascination with biological problems; still none of us can wholly escape from being drawn into discussions of this kind. But the question of what is possible at a certain moment of the development of an artist or during an entire period must be asked again and again if we want to escape dangers of formula more restrictive and destructive here than in most other fields.[10]

How much of our equipment in tracing such a development without complete chronological documentation is defective, and in what sense? What defines the range of a master at a certain moment or of a whole period? Is the 'classical' demonstration of the beginning of tonality in the works of Jan van Goyen, which can be documented year by year, quite as convincing and compulsory as it looks at first sight? And even if this does apply to van Goyen, does it necessarily apply to the others? Have we selected our examples too well? Have we sufficiently considered additional influences on stylistic progress and processes, such as inspired and uninspired days or hours, the wishes and idiosyncrasies of patrons, the vagaries of fashion (as opposed to style), the specific problems of price as determining artistic effort? Have we learned enough from the late Guercino's willingness to paint a companion piece to a Rembrandt in his 'prima maniera' in order to please his patron and to conform to Rembrandt's style;[11] from Poussin's differentiation between the major and the minor mode as applicable to different subjects at the same time;[12] from the incredible diversity of styles employed, within a few years or even within one and the same year, by perfectly respectable masters like Herman Saftleven, Jan Lievens, not to mention such minor protean figures as Anthonie van Borssom or the Camphuysens? Can we correctly gauge the possible extent of the decline, in their last years, of artists like Hobbema or

Jacob van Ruisdael – even in the light of what we know about Pieter de Hooch? We shall return to some of these problems as they arise in the course of our specific investigations. It is unnecessary to state that while we can ask these questions and perhaps shed occasional light on them we cannot pretend to offer anything like a solution for any of them.

The question of the patron's wishes forms part of a relationship about which we know next to nothing. We do know that people very rarely chose to write about it in Holland, either in terms of critical books and essays or even in a practical fashion, and the works of art themselves are almost equally silent about it. Were there expensive and inexpensive landscape paintings depending on the use of expensive and inexpensive pigments, differences of size and painting ground, collaboration of different specialists in staffage? We do not know, and the prices mentioned in early inventories and sales speak no clear language. How many Dutch landscape paintings were made on commission and how many for the free market? We know of only a few cases of the former with certainty. Some bear all the earmarks of commercial speculation, such as the amazing contract made in 1615 between Jan Porcellis and a certain Adriaen Delen (forty seascapes in twenty weeks, assistant provided!);[13] others are concerned with dignified tasks such as van Goyen's large *View of the Hague* for which he received 650 guilders from the City Fathers in 1651 (HdG 109).[14] Did he submit a *modello* of it before painting it? Are there any *modellos* for Dutch landscape paintings in existence? Are there any oil sketches properly speaking? We are not sure, although there are a few cases in which an artist seems to have prepared a larger version by making a smaller, sketchier one.[15] Even preparatory drawings properly speaking are of conspicuous rarity.[16]

The number of landscape paintings done for the free market must in any case have been large. They conformed to certain standard sizes and to certain favourite shapes (next to the normal oblong: upright, round and oval ones). The innumerable landscapes depicted in Dutch interiors of the seventeenth century are rarely identifiable with the work of a known master; they range from forest views to panoramas, dune and river landscapes and marines. They are exhibited in simple black (fig. 4)[17] or (mostly after 1650) in gold frames (fig. 5, close to Wouwerman),[18] and certainly do not appear to have been painted on commission. Most of them cannot possibly have been very expensive, and the life story of van Goyen vividly illustrates the economic precariousness of a prolific landscape painter, a condition which he and others anxiously attempted to ameliorate by either looking for additional income of various sorts or even by more or less abandoning painting for a different job, with a ' Sunday Painter's' production (Hobbema after *ca.* 1669) or possibly complete cessation (Cuyp) as a result. Beginning in the 1620's, people everywhere bought landscapes, just as they bought *genre* pieces and still lifes; it was the new fashion, such things aroused interest and made money everywhere, although *genre* scenes were on the whole even more popular. The miracle lies not in the quantity but in the quality of what was painted

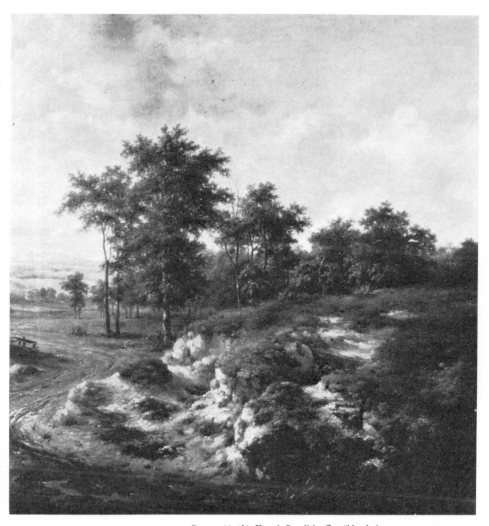

1. JAN WIJNANTS: *Dunes.* 1667 (?). Kassel, Staatliche Gemäldegalerie

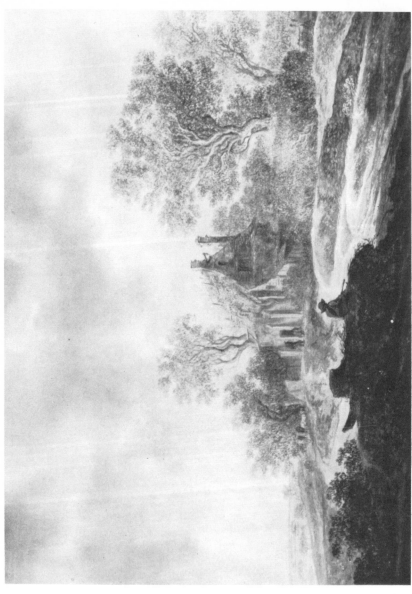

2. JOOST DE VOLDER: *Cottage and Trees.* The Hague, Dienst voor 's Rijks Verspreide Kunstvoorwerpen, on loan to the Rijksbureau voor kunsthistorische documentatie

3. JACOB VAN RUISDAEL: *Waterfall*. Toledo, Ohio, Museum of Art

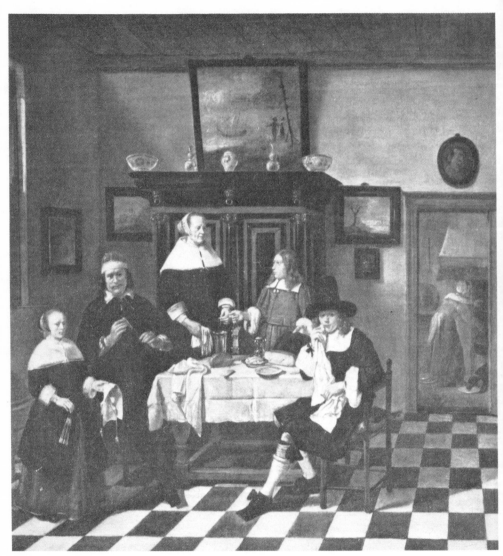

4. CORNELIS DE MAN: *Family Dinner*. Detail. Malibu, California, J. Paul Getty Museum

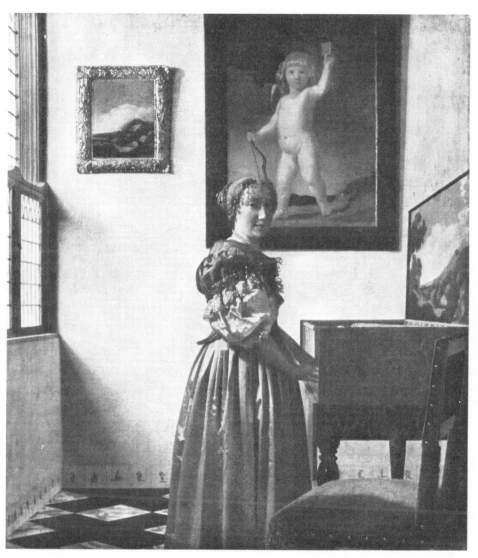

5. JAN VERMEER VAN DELFT: *A Young Woman Standing at a Virginal.* London, National Gallery

6. SALOMON VAN RUYSDAEL: *Winter near Utrecht.* Enschede, Coll. Mrs. van Heek-van Hoorn

7. SALOMON VAN RUYSDAEL: *Pelkus-Poort*. The Hague, Dienst voor 's Rijks Verspreide Kunstvoorwerpen

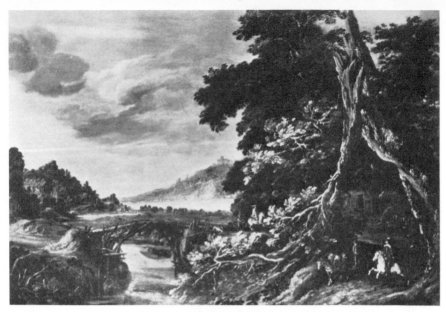

8. GERRIT C. BLEEKER: *The Wooden Bridge*. Formerly Art Market, Holland

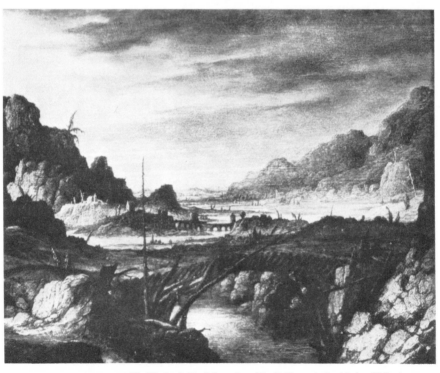

9. SEGHERS FORGERY: *The Wooden Bridge* (left section of fig.8). Formerly Art Market, Holland

and purchased – but again, we know little about the exact relationship between the pictures known to us today and the overall production of that era.

The painting of staffage figures was done by many of the landscape painters themselves; only in a few exceptional cases do we find another hand collaborating in the works of van Goyen and Jan Both, and none in those of Salomon van Ruysdael, Aert van der Neer, Aelbert Cuyp, Adriaen van de Velde or any of the marine painters. At the other extreme stand painters such as Jan Wijnants, who seems to have employed other artists for all but his tiniest figures. The middle line is held by Jan van der Heyden, Jacob van Ruisdael and Hobbema who sometimes did and sometimes did not paint their own figures – according to rules (if any) of which we know nothing. We are far from knowing all the answers as to the executants of these little figures. Needless to say, what we do know or pretend to know is based almost entirely on stylistic criteria; there are very few double signatures in existence,[19] and most of the early reports on this matter are either spurious or have been misinterpreted, as is so drastically illustrated by the case of Jan and Andries Both.[20]

The favourites must have been Adriaen van de Velde and Johannes Lingelbach, but their names, too, have often been used in vain. Since van de Velde died as early as 1672 he cannot have painted the staffage in any of Jan van der Heyden's later paintings; in these, however, the figures are so much like his that we must think of van der Heyden as deliberately imitating them[21] – which, of course, he may have done just as well before 1672. While Lingelbach seldom if ever achieved the subtlety and integrative skill of van de Velde he was still one of the best specialists in this difficult field. In some landscapes, the hand of Poelenburgh (fig. 305), Berchem (fig. 139) and a few others can be distinguished without too much difficulty.

Our research is not infrequently handicapped by the wilful manipulations of later generations. Indecent figures or animals were overpainted, missing ones supplied (fig. 3, right group), others eliminated or altered. It is on record that deterioration and unscrupulous treatment of pictures presented problems at an early date; in a document dated 1661, no less a person than Jacob van Ruisdael declared before a notary that a painting which was perhaps begun by Jan Porcellis must not be sold as a work by that master in its present condition.[22]

There are also cases in which landscape painters did the landscape background for professional figure painters;[23] these are of little concern to us, but it is worth pointing out that in this field, as in the corresponding one of Flemish painting, we cannot hope for any conclusive support from documentary evidence at all.

The question of staffage naturally brings up the problem of the whole relationship between man and nature in seventeenth-century Holland in painting as well as in general. A Dutch landscape painting of that period without any figures is a phenomenon of great rarity. In some cases it is simply the result of unfinished business; in spite of the presence of Wijnants's signature, his painting in Kassel (no. 881, HdG 674; fig. 1)[24] was certainly not intended to remain without figures of the usual

type. But even in the most 'romantic' examples – works by Seghers, Rembrandt, Everdingen, Ruisdael – complete lack of staffage is an exception.[25] What does this signify?

First of all it means that man does not lose himself in nature, that there is no attempt at a glorification or deification of nature as something beyond man's scope or control. A herdsman with cattle, a hunter of rabbits, a traveller on horseback talking to a man on foot, and, in marines, the crews of sailing and rowing boats – these are the figures that animate the typical Dutch seventeenth-century landscape of the mature period, i.e. after biblical, mythological and allegorical staffage had ceded its prominent place to the 'everyday' conception of landscape. It is an animation which rarely involves a story; if the story is important the figures are apt to predominate over the landscape as they often do in depictions of folk festivals, battle engagements, robberies and so on. But it is an animation which provides a human scale; it prevents the widest panorama, tallest trees and wildest sea from growing beyond man's compass and comprehension. This art appealed to people who were characterized by 'that intense enjoyment of things in their external appearance, by that undisturbed belief in the reality and importance of all earthly matter which, untouched by any philosophical realism, was experienced by all Dutch seventeenth-century minds simply as *joie de vivre* and interest in the objects [as such]'.[26] A Dutch landscape is as far removed from one by Caspar David Friedrich as it is from one by Cézanne. In a Friedrich landscape, man is indissolubly linked to an elevated state of nature which is the reflection of the artist's state of mind; in a Cézanne landscape, man, if at all present, means little or nothing. Dutch landscape painting represents a phase which lies before, or in any case outside, the 'sin' or 'tragedy' of making nature into either the superior or the hand-maiden of man; even the conscious wish to 'réaliser le motif' would have been alien to a Dutch artist of that period. Here, nature and man were still completely apart – and still balanced in perfect harmony.

Nature, then, was a nature everybody was able to grasp and to recognize. This of course does not mean that nature was rendered with topographic exactness. Although most landscape painters made numerous drawings directly from nature (as is testified by writers and the frequent appearance of draughtsmen within paintings, see fig. 304),[27] it seems certain that paintings were only very rarely done out of doors.[28] Even then, re-arrangements would have been inevitable. Characteristic of the basic freedom of the painters is the way in which they availed themselves of the motifs offered them by their towns. While there exist some topographically correct city views (mostly views within a city), the majority of these subjects were used with freedom and even caprice, as for instance in some very startling combinations of motifs from different towns in one picture (fig. 6).[29] Certain buildings which were used over and over again changed their appearance depending on requirements of composition or simply from a desire for variation; this applies to whole town silhouettes as well as to church spires and other buildings such as the Pelkuspoort near Utrecht, which was never mentioned as

such in early descriptions but can be clearly identified in spite of all the variations to which it was subjected (figs. 7, 103).[30]

A similar freedom prevailed with regard to the indication of the seasons. After the actual representation of seasons as an allegorical subject had become rare (it was never completely dropped), painters did not endeavour to differentiate sharply between them, with the exception of winter. There are many pictures in which some of the foliage is turning brown while the rest is still a fresh green but, as far as I can see, there was never an effort to characterize autumn in the manner of nineteenth-century painters like Courbet (Americans will think of Cropsey) nor to differentiate between spring and summer with similar precision. Why this should be is not really easy to explain; but a clue is provided by the fact that winter is quite clearly and unequivocally characterized: here it is man and man's occupation that wrought a change which, at least at the beginning, would not have been granted to nature alone. In this sense, then, Dutch landscape painting is, with some exceptions, closely akin to *genre* painting.

We may stop here for a moment to ask whether the new vision of the landscape painters found an equivalent (or, for that matter, non-equivalent) expression in contemporary Dutch literature.

Artist-writers appear to have given little more than technical advice, bringing van Mander's recommendations with regard to design and colour somewhat more up-to-date,[31] or to have made desultory observations on a few main elements of landscape painting (Hoogstraten);[32] connoisseurs listed a few outstanding artists and works (van Buchel[33] and others). With a few exceptions,[34] it is difficult to discover in these scarce writings anything of the spirit of the painters themselves. Strangely enough, the latter is more clearly reflected in some of van Mander's poetical efforts such as his *Boereklacht*, posthumously published in 1610 in *Den Nederduytschen Helicon*, where one finds passages such as this:[35]

> 'Over my fertile green land I looked early and late in the day,
> And how the westerly winds delved into it with abandon
> And often caused the corn to move in waves like the sea.'

Van Mander was part-mannerist, part-realist, both as writer and as painter; in lines like these he turns out to be the immediate forerunner of the magnificent Bredero, who was trained as a painter and whose writings form the most convincing parallel to what Esajas van de Velde, Buytewech and Seghers were just then beginning to do in their prints and drawings. In a famous sonnet, Bredero depicted his sweetheart as 'early at daybreak loosening her gold-blonde, lemon tresses, sitting in the open air nigh behind the backdoor', and, with a characteristic mannerist conceit, envied her comb and ribbon their part in her coiffure; but he quickly returned to the praise of her untamed locks because 'the naturally beautiful surpasses all art'.[36] On nature in its untrammelled form, specifically on landscape, Bredero wrote some of his most inspired lines – straightforward and as unstilted as any painting or etching by

Esajas van de Velde; overlooking the Amsteldijk and fixing his gaze on the Zuider-
kerk, he marvelled how 'the sun scintillates with reflective shimmer on that tiled roof
and that fresh-hewn timmer'.[37]
 There were but few among the Dutch poets of this or any later phase of the seven-
teenth century who could vie with him in this field (perhaps a few lines from Hooft's
Granida or from poems by Jacob van Zevecote come to mind), least of all Holland's
greatest poet, Joost van den Vondel, for whom the naturally beautiful had indeed
ceased to 'surpass all art'.
 The liberties which the Dutch masters took with regard to topographic accuracy
are conclusive proof – if this be needed – that the truly novel 'realism' of the young
landscape painters owes its existence as little to wide-eyed innocence and narrow-
minded neglect of artistic tradition as do Bredero's lines. To see the emergence of the
ars nova of the Dutch seventeenth century in such uncomplicated terms was the almost
enviable privilege of most late nineteenth- and early twentieth-century writers. To
them, it was obvious that the mannerists had walked through the Dutch countryside
with their eyes closed, and that the new generation had only to open theirs to paint
realistic pictures of their homeland. To us, alas, this process looks a great deal more
involved. We can now see that some of the mannerists saw the new things just as
vividly as the generation with the new eyes but that these new vistas were as private
an affair with them as they had once been with Dürer, and were not entrusted to
panels and canvases. We see more clearly that it was only when the artists of the
new generation started to paint rather than to draw landscapes, that they needed
compositional crutches provided by the older generation of painters. We can see that
even the fully developed pictorial production of the new generation oscillated between
a more casual, and in that sense more realistic yielding to nature and a more deliberate,
and in that sense more unrealistic re-structuring of nature, even before the latter
procedure became a more generally accepted stylistic principle towards the middle of
the century. We can see that the Italianate Dutch landscape painters, characteristically
neglected by those writers, do not fit into the realistic pattern at all.
 All this proves the indestructible power of historical continuity and diversity, as
well as of certain principles of picture-making, which cannot be said to have given way
to a new visual realism any more than poetic tradition and the exigencies of metre and
rhyme in Bredero's works can be said to have given way to a new literary realism.
 On the other hand, it seems to me that there is no need or even justification for
minimizing the new freedom of the Dutch artist, so dear to the older writers. By the
same token one could deny the fresh vision of the Impressionist landscape painters
because we have learnt to see that they were good composers as well, even before
Cézanne. Of course they were, just as van Goyen, in the 1630's and 1640's was a good
composer, i.e. before he himself in his later years, or Jacob van Ruisdael, re-empha-
sized structure more deliberately. But the Impressionists and the van Goyen of that
middle period were indeed the discoverers of many new facets of nature and made

decisive contributions to the breaking up of traditional formulae of composition as well as of colour. There simply is no denying this, and it does not seem profitable to me to let – or make – the pendulum of interpretation swing too far to the other side.

This discovery of 'untrammelled nature' also meant that nature was now for the first time represented entirely for its own sake and became a subject of painting in its own right. This fact, too, should not be underrated, the less so as landscape differs significantly from other new subjects of seventeenth-century Dutch art.

It is perfectly true that still life painting of that period retains much more symbolism than Bode or Hofstede de Groot would ever have admitted; that *genre* continued to carry more allegorical significance than they suspected; that plants, flowers, pictures on the wall contain more or less subtle, and more or less plausible, allusions that are only today in the process of being rediscovered; that the analysis of group portraits is confronted with problems of occasion, commission, tradition and composition never dreamt of by Riegl. But little of this applies to landscape after it had been established as a province of painting rather than of drawing or printing. As I said before, it remained to a degree allied to *genre*; but once it had shed – with what after all are few exceptions – its bonds with religion, mythology and allegory, it was landscape and little else. It varied from decoration to cabinet piece, from stateliness to intimacy, from sociability to reticence, from gaiety to melancholy; but, again with few exceptions, it did not display – and hardly hid – symbolic elements, either by tradition or for any special effects, and where it remained tied to historical or contemporary events, it immediately seemed to lose something of its real identity.[38] 'What music is in the categories of art, landscape is in the categories of painting' (M. J. Friedländer).[39] In front of a Dutch seventeenth-century landscape one might add the qualification 'chamber music'; no-one should look to them for the message of vocal music or, for that matter, the dimensions of a symphony.

The synthesis of new discoveries in nature and the exigencies of tradition and craft which characterize Dutch landscape painting of this era has never been better formulated[40] than by Samuel van Hoogstraeten's term 'keurlijke natuurlijkheid', with which he credited the art of 'that great Raphael of marine painting', Jan Porcellis. 'Selective naturalness'! The landscape etchers of the early century had aimed only to please their customers with the views of 'amoenae regiunculae', but even they had gone far beyond topographical amenities. Hoogstraeten's characterization of the art of Porcellis (who died in 1632) is certainly as appropriate for all great painters of that earlier generation as it would be for his contemporary, Jacob van Ruisdael, although we would put the accent on 'natuurlijkheid' for the former, on 'keurlijk' for the latter. They all selected from nature; but what counts in their selection is nature.

PART ONE

THE DUTCH SCENE

The Countryside

A. *Pioneers in Drawings and Prints*

I F there is any period in the development of Dutch seventeenth-century landscape painting which would remain obscure without considering drawing and print-making it is the very first one, which covers approximately the first quarter of the century. It has often been observed that in many periods the art of black and white anticipated discoveries made later in painting. It is no wonder that this should have happened at a time when so many new subjects were being looked at with a fresh vision and with the prospect of representing them for a public that, although eager to explore new worlds with the artists, definitely expected to pay little for the results at the start.

In addition, there existed a graphic rather than a pictorial tradition on which to build, and that tradition had grown up in Flanders. In many respects, it harks back to the great Pieter Bruegel the Elder. It is not easy for us, in the twentieth century, to imagine that in Flanders and Holland in the late sixteenth and early seventeenth centuries very few people could have been familiar with Bruegel's paintings. These have become accessible to all of us by an abundance of reproductions and to many of us in public museums, but at that time were hidden away in a small number of private collections. Very few of them were known through prints. However, owing to the efforts of publishers like Jerome Cock, people at that time were well acquainted with a large number of prints after Bruegel's drawings which had been made by a host of engravers and brought out in quantities to satisfy a great demand. While Bruegel himself probably did no more than a single etching and no engravings, the number of engravings after his designs made during the second half of the sixteenth century is very large. Among them were at least fifteen landscape prints, specifically a series of twelve which Cock published about 1555.[1] These prints were copied repeatedly in order to meet increasing demands and, as time went on and people became more and more aware of Bruegel's prime reputation as a landscape artist, his name was occasionally attached to engravings which were made after designs by other artists. Two such series of prints the designs of which were wrongly attributed to Bruegel play a very important role in the making of Dutch landscape art of the seventeenth century.

But Bruegel's art was of paramount significance for only one trend of Dutch landscape painting: the imaginary one. As van Mander relates, people used to say of Bruegel that on his journey to Italy he had swallowed up the Alps and regurgitated them on panels and canvases upon his return home. His Alpine views turned into fantasies and were similarly understood – or misunderstood – by innumerable

successors in Flanders, soon to be joined by equally eager imitators in Holland. We shall trace this development at a later opportunity (p. 131). Here we must realize that although the native scenery was no less dear to Bruegel and was no less poignantly represented by him in some paintings and drawings than the foreign one, the compositions known through prints, primarily the *Large Landscapes* series, are almost all of the kind in which Southern mountains, though blending with the dunes, villages and fields of Flanders, do not yield to simple, exclusively native surroundings. Thirty years ago, this statement would have been disputed with reference to the two series with *Small Landscapes* (then considered to be Bruegel's own work). But this attribution to Bruegel had to be abandoned.

These series, first published by Jerome Cock in 1559 and 1561, and re-edited by Th. Galle in 1601,[2] were partly copied in etching by Claes Jansz. Visscher at Amsterdam in 1612 under the title 'Regiunculae et villae aliquot ducatus Brabantiae', with the remark 'a P. Brugelio delineatae'.[3] However, as early as 1912, Ludwig Burchard[4] pointed out that, while the first edition mentions no designer, Th. Galle's of 1601 expressly states that these 'Regiones et villae rusticae ducatus potissimum Brabantiae' were 'a Cornelio Curtio . . . artificiose depictae', and in the following edition several prints are marked: 'C. Coert Inventor in Brabantia'. This has made it imperative to eliminate these two series from Bruegel's œuvre, a decision facilitated by the fact that several preparatory drawings have been preserved which clearly show a hand different from that of Bruegel. J. C. J. Bierens de Haan[5] has recently summarized and fortified the reasons for accepting the authorship of Cornelis Cort for these drawings. It may be useful to remember that this artist, who lived from 1533 until 1578, was not only a native of the Northern Netherlands (Hoorn), where he lived until the age of about twenty, but also that he would have made the drawings for these two series soon after settling in Antwerp. This was many years before he moved to Italy and into the orbit of Titian and Muziano, whose landscapes may well have influenced his later drawings so different from those made before 1559.

Even those who consider the attribution to Cort insufficiently supported agree that Bruegel cannot be the author of these designs. If one compares the fine and characteristic drawing in New York (fig. 10),[6] of which the left half was used for one of the prints in question, with one of the relatively few (and somewhat later) Bruegel drawings with a similar motif (fig. 11) the other master (let us call him 'Cort') emerges as a person of inferior imagination, less poetic, less subtle, but a supreme realist in the sense in which his early Dutch seventeenth-century successors are realists. Individual things are seen as individual things skilfully united in a well-balanced composition, whereas Bruegel subordinates them to a 'total' structure. While Bruegel, even in his drawings with strictly native motifs, always lets his wonderful trees engulf man's dwelling places 'Cort' admits nature only as an orderly accompaniment of houses and roads. Bruegel permeates the entire composition with light; 'Cort' distributes light carefully so that it models each individual item in pleasant alternation with

shaded parts. Bruegel's foliage and buildings are pictorial, fluffy, 'pointillé'; 'Cort's foliage is mostly linear and crisp, his buildings have clear outlines and are defined in detail. Bruegel evokes; 'Cort' describes. Even apart from qualitative criteria, these are two different worlds. One might say that Bruegel's was the world of the past – and of a more remote future – while 'Cort's was the world of the leaders of a generation born forty to fifty years later.

From these drawings and prints, whether they be anonymous or by Cort, a straight road leads to the two most decisively progressive artists in Holland at the end of the old century and the beginning of the new: Hendrick Goltzius in Haarlem and Claes Jansz. Visscher in Amsterdam.

The extraordinary importance of Goltzius in the history of Dutch seventeenth-century landscape art was rather consistently overlooked until about two decades ago, when J. G. van Gelder and J. Q. van Regteren Altena drew attention to it in their works on Jan van de Velde and Jacques de Gheyn, respectively.[7] The versatility of this artist is phenomenal and, although we are still inclined to view his activity as a painter and even as an engraver with certain misgivings, there is no gainsaying his technical virtuosity and his boldness of interpretation in both these media. Among his numerous drawings, which have now been fully and admirably presented and analysed by E. K. J. Reznicek,[8] there are many that are intimately connected with his engravings, particularly those with mythological and allegorical subjects; they also include a considerable number of fascinating and highly accomplished portraits. The number of landscape drawings is indeed comparatively small but their significance can hardly be overrated. Some are of the mountainous-fantastic type, and these will occupy us later; others, even less numerous, represent his native surroundings; there are also a few excellent studies of individual trees.[9]

The 'realistic' group includes a few which reflect a topographical interest such as the coloured view of the ruins of Bredero of 1600, now in Amsterdam (fig. 12).[10] This work is also remarkable for its brilliant light effects, produced by various shades of green washes contrasted with paper-white, and for its broad pen work, which differs from the comparatively meticulous portrayal of foliage, stems, ground, etc. in most earlier drawings. In addition, the motif of the ruin is seen in a comprehensive manner not only as to technique but also as to composition; the eye does not have time to dwell on details before it has encompassed the entire surface of the sheet and perceived the building in its totality, related to its surroundings; yet, contrary to Bruegel but similar to Cort, this building is sharply and concisely modelled in light and dark. As one turns to Goltzius's most amazingly precocious drawings, the panoramic views made in and around 1603 (figs. 52-54), something of the older multiplicity of execution is again in evidence; here the resemblance with Cort both in technique and detail is quite striking. But in composition, these works anticipate the stylistic features of that branch of seventeenth-century landscape painting characterized by the mature works of Philips Koninck: a panoramic view of a typical Dutch dune landscape, seen from

above so that the horizon clearly terminates the ground area, leaving the top part of the drawing, up to three-fifths of the entire surface, almost entirely to sky. We shall return to these works later.

Few draughtsmen[11] followed Goltzius on this path until several decades later when they and the painters had found a number of other prerequisites for the development of landscape painting.

The second rediscovery of recent scholarship was the activity of Claes Jansz. Visscher as a draughtsman.[12] He had always been known as a maker and publisher of prints, and in 1612 he brought out the copies after the series of landscape prints now tentatively given to Cort but attributed to Bruegel by Visscher. It was the first of a long series of other 'Regiunculae', whose very existence proves the new popularity of such representations of the everyday surroundings of artists and public alike. Visscher's own drawings of a comparable kind, those done between ca. 1606 and 1608, were made with a similar view; and while they were more readily identifiable as representing certain well-known places near Amsterdam and Haarlem, they are certainly more than mere topographical studies; like Goltzius's *Bredero* drawing, they aim at the whole of the motif without getting lost in details.

One of them, used by Visscher for one of the etchings in a series of twelve landscapes representing the surroundings of Haarlem (published in 1608?), is inscribed: 'Outside Haarlem on the road to Leyden, 1607' (fig. 13).[13] In a most suggestive manner, the foreground has here been left empty, giving the onlooker the impression of complete casualness, of yielding to nature without 'compositional interference'; and there is not a single human being to be seen. This is an amazing anticipation of Rembrandt's landscape sketches. It is the epitome of landscape 'naer het leven'; the time when the rendering of landscape had to provide a justification by way of biblical, mythological or allegorical meanings seems a matter of an irrevocable past. The optical truth is now 'plaisant' in itself, and Visscher said that much on the title-page of this very series of prints: 'Here you may have a quick look at pleasant places, you art lovers who have no time to travel far. . .'.[14] But it is also clear that Visscher's new attitude and style had a firm foundation in those series of prints after drawings by 'Cort' which Cock had first published in 1559/61 and which Visscher himself copied in etchings and was to bring out in 1612 under the name of Bruegel. 'Cort's drawings, such as the one illustrated and discussed above (fig. 10), are characterized by much the same freedom of setting, including the empty foreground; and Visscher's rendering of foliage and houses shows, besides some reminiscences of Bruegel, a strong resemblance with 'Cort's. On the other hand, Visscher's own style is appreciably more sketchy and vivid; and the feeling of wide space encompassing middle and background has been enhanced. Across a span of almost fifty years, 'Cort's revolutionary attitude toward nature, which had hardly been understood in their time, reasserted itself in intensified form; and now it came to conquer. The time was ripe, and the work of a comparatively minor artist set a great tide in motion. As mentioned before, printed series of such

pleasant 'Regiunculae' followed each other in rapid succession; but more important, their increasing popularity in prints fired the imagination of the painters.

B. *The Painters*

DUNES AND COUNTRY ROADS

This first section on painting will deal with the subject matter which one might consider the most logical continuation of the *Amoenae Regiunculae* of the 'Cort'-Visscher tradition: the 'plaisante' countryside around the Dutch towns, characterized primarily by simple roads, gentle dune elevations, occasional farm or village buildings, a clump of trees or a row of them lining a road. From this will be excluded panoramic views proper, river and forest scenes, because they pose special problems and encourage special patterns of composition. These, as well as views of all types of Dutch scenery in winter time, will be discussed later.

The crucial transfer of the new landscape vision from drawing and print-making to painting is indissolubly connected with the personality of Esajas van de Velde, the oldest member of an illustrious family of artists.[1] He was born in Amsterdam late in 1590 or early in 1591 (a cousin of the etcher Jan van de Velde, whose art depended to a large degree on his) but moved to Haarlem in 1610 and became a member of the Haarlem guild of painters in 1612, in the same year as Willem Buytewech and Hercules Seghers. Today we can say with a good deal of confidence that the older view that Frans Hals's reputation caused so many promising artists to settle in Haarlem cannot be upheld; instead, the centre of attraction may well have been Hendrick Goltzius, whose leadership in landscape drawing was discussed in the preceding section.

The first authentic date for any landscape drawings and etchings by Esajas van de Velde is 1614. An undated but obviously very early series of sixteen small landscape etchings is closely connected with the style of Visscher's drawings of *ca.* 1607-8. But it is the etched landscape series of 1614 (Burchard 34) and the slightly later one with the views from the vicinity of Haarlem (Burchard 8-17), as well as the preparatory drawings for them, which must be considered the very foundation of all subsequent Dutch landscapes, painted as well as black and white. They betray a more progressive spirit than even Visscher's work – a spirit so progressive that van de Velde's own paintings did not dare express it for some time.

The drawing of the village of Spaerwou (fig. 14),[2] the preliminary study for an etching datable *ca.* 1615-16 (Burchard 10; fig. 15), may serve as an example of what van de Velde achieved at that early date. From the point of view of composition, it is not markedly different from some of Visscher's most advanced works; it even recalls some of 'Cort's designs of 1559-61. But its overall effect has been clarified and unified to an extent not found in Visscher's, let alone 'Cort's works. Esajas uses quick pen strokes throughout whereas Visscher had strongly differentiated between a few rapid

and many more meticulous touches, even in his most sketchy drawings of 1607. Over
these fast pen lines, Esajas applied a quick but judicious wash which holds everything
together with supreme skill and produces a balance of spontaneity and pictorial order
which is quite amazing at this early moment and goes considerably beyond the more
meticulous effect of the finished etching, admirable though it is (fig. 15).

Despite all this, the drawing has not lost the basic 'naer het leven' approach: the
topographical interest has not been abandoned and, even more important, the
directness of the relationship between the onlooker and the motif as a whole has been
preserved intact. We are not taken by the hand and led around to admire things in
succession, nor is there the slightest flavour of allegorical meaning such as we find in
the rendering of the *Four Seasons*, then still popular with many draughtsmen and
engravers. We are face to face with 'a' Dutch landscape: specifically, the surroundings
of Spaerwou but, far beyond this, with a synthesis of nature, buildings, people and
animals which transcends all that is merely topographical.

Not all of van de Velde's drawings were done in the same technique as that of
Spaerwou. Some show the application of a more descriptive pen line, with no wash
added to it; here the connection with the 'Cort'-Visscher tradition is often more evident.
Others exhibit a kind of combination of the two techniques just described, and others
again are of a rapid execution which recalls the most daring sketches of Adam Els-
heimer, whose work became known to Dutch artists around 1608–13 through Goudt's
engravings and whose drawings may also occasionally have been available in the
Netherlands.[3] The versatility of van de Velde the draughtsman is matched by van de
Velde the painter.

Esajas van de Velde's early activity as a painter belongs to his Haarlem years which
lasted from 1610 until 1618; in this year he moved to The Hague where he was to die
as early as 1630. From the very outset we must not assume that this activity closely
paralleled in style his drawings and etchings. In these, his inspiration came from
an entirely different and much more progressive source, presumably directly from
Visscher back in his Amsterdam years, perhaps modified by recent Haarlem impres-
sions in which Goltzius and the Elsheimer tradition seem to have played major roles.[4]
His background as a painter was considerably more conservative. Early drawings of
genre scenes show unmistakably that he took his departure from the works of the
Flemish émigré and Amsterdam resident, David Vinckboons; and *genre* paintings, the
first of which is dated 1614,[5] amply corroborate that impression. The influence of
Vinckboons lasted much longer in paintings than it did in drawings, stylistically as
well as with regard to subjects.

But even in his early landscapes more traditional Amsterdam elements persist. He
then painted a few imaginary, mountainous landscapes, which will occupy us later
(p. 134). Even in his 'Dutch' views, such as the undated *Summer* of the Oberlin
Museum (fig. 16),[6] which may have been done about 1612, the compositional scheme
goes back to Gillis van Coninxloo, another Flemish emigrant and teacher of Hercules

Seghers; witness the feature of lateral 'wings' and the placing of a cluster of trees in the centre of the middle-ground, which are found almost identically in works by Coninxloo.[7] Another typically conservative feature of this painting is the fact that, together with a *Winter* (fig. 168), it formed a pair of landscapes with allegorical meaning, and that both contain biblical stories as 'staffage': the *Summer* the *Journey to Emmaus*, and the *Winter*, the *Flight into Egypt*. On the other hand, this picture is done with a quick, even brilliant brushstroke which is equally far removed from any tonal effect as it is from the system of sharply differentiated planes characteristic of the Flemish tradition. While the figures are painted in vivid local colours,[8] the treatment of the landscape is surprisingly precocious, not in the sense of tonality[9] of the thirties and forties but rather of the age of Jacob van Ruisdael and Philips Koninck, when there was a return to crisp colour accents reminiscent of the brown-rose-green touches in which the Oberlin picture glories.

It is significant that the most progressive paintings van de Velde did after his conservative beginnings were winter landscapes in which Netherlandish artists appear to have felt more at liberty to discard traditional features than they did with regard to 'normal' landscapes. In any case, it did not take the painter van de Velde very long to catch up with the stylistically advanced status of his own drawings although in some paintings more traditional features subsisted. The most spectacularly 'modern' paintings were done before 1618; and as early as 1614, Esajas van de Velde painted, in addition to the very progressive Winter Landscape in Raleigh (fig. 169), a work whose freedom of composition is comparable to that of the contemporary drawings and etchings, the *Landscape with Two Horsemen* in the Rijksmuseum at Enschede (fig. 17). The heavy Flemish touch of some other early works is lacking and, although there are still traces of the crisp, multifarious elements in design which characterize the Oberlin picture, the more casual distribution of the trees, the greater openness of the vista, the more unifying quality of the winding road assign to this picture a very important role in the evolution leading to complete freedom.

Esajas van de Velde's development was somewhat desultory after these landmarks had been erected. He was a born experimentalist; it is also probable that his patrons at The Hague preferred a more old-fashioned type of painting in which larger *genre* scenes often play an important role, and that he yielded to such demands more readily after he moved to that city in 1618.[10] His most 'modern' pictures, some of which we shall discuss in our chapters on river and winter landscapes, are usually of very small size and executed with speed and in a sketchy technique; a few tiny panels, some of them in round format, belong with his most intimate and charming works. In these works he tended to do away with the traditional multiplicity of colours and to arrive at a more nearly tonal result. This aim was once more powerfully furthered in the incomparable *Dune Landscape* of 1629 in the Rijksmuseum in Amsterdam (fig. 18). While this picture still retains distinct traces of the traditional (Flemish) stratification into brown, green and blue planes – one is here reminded of Seghers as well – the

unifying elements clearly prevail. The work is steeped in a golden brown with which the main figure and the dog blend; it marks a decisive step in the direction of tonality. To this corresponds its structure which shows an amazing freedom. The balance is again a precarious one, in great contrast to the elaborate equilibrium of the *Ferry* of 1622 (fig. 91) and some other paintings of the twenties; it depends on the appreciation of such small features as the birds, whose flying direction helps the rising ground and the clouds to counterbalance the left bend of the windswept tree, or the light left foreground with prominent 'staffage' which is counterbalanced by the brilliant light area in the right middle distance. Here again some of the subtlety of such balancing is slighted by black-and-white reproductions, with much worse results than where the means of equilibrium are of a sturdier nature. The picture is one of the high points of Dutch landscape painting in the third decade of the new century. It is direct in its approach to nature, a climax of the development which started with 'Cort', was taken up by Goltzius and Visscher and perfected by Esajas van de Velde himself. It has overcome the earlier tendency to proceed on an additive basis in structure as well as in colours and has achieved a unity of composition which, short of employing traditional crutches, was formerly attained in drawings and etchings only, and a unity between a relatively small number of hues which foreshadows the finest achievements of the next two decades of Dutch landscape painting.

Esajas van de Velde was not the only one among the main masters of the Dutch scene whose drawings were stylistically ahead of his paintings. The same can certainly be said of his greatest successor, Jan van Goyen,[11] who was born in Leiden in 1596, but after absolving several rather insignificant apprenticeships, must have received his most decisive inspiration about 1616/17 from Esajas van de Velde, who was then still in Haarlem. Pen drawings by van Goyen from several sketch-books which can be dated around 1620/25[12] are far more advanced in the direction of freedom, comprehensive vision and unity of space and light than were his paintings of that period. Some of these early drawings already show van Goyen ahead of most of Esajas van de Velde's landscape sketches; on the other hand, paintings by van Goyen in 1625 are considerably more old-fashioned than van de Velde's *Dune Landscape* of 1614. If one compares such a pen drawing from van Goyen's 'Sketch Book A' (fig. 90) with his painting of 1625 in Bremen (fig. 20), the contrast is almost shocking; the drawing directly foreshadows the compositional freedom and, to an extent, the tonal quality of his works of the later thirties, while the painting is filled with a plethora of details which must be read one by one, and is multi-coloured to a degree only rarely found even in Esajas van de Velde's less progressive works.

Van Goyen has obliged us by putting a date on practically all of his paintings. After the earliest group (with dates from 1621 to 1625), which is indebted throughout to Esajas van de Velde if in various degrees, one can distinguish clear signs of a loosening up of the multiplicity in composition as well as in colours. A picture, now in the Leiden Museum, signed and dated 1626 (HdG 306, fig. 19),[13] represents a village

view which is still crowded in parts and in which the greens, browns and reds are still spread evenly over the surface as before. But in comparison with the earlier works, there is a noticeable reduction of figures (none on the right side!); there is the beginning of a unifying diagonal movement; and the colours have become much lighter than before, indicating that they will soon be capable of adjusting themselves to a more unified tonality, towards which the background, in grey green and pink, is already distinctly tending. A similar development had taken place between van de Velde's earliest works and the lighter gamut of some later ones. It may suffice to give this brief sketch of van Goyen's early development, which has been more fully treated in earlier publications.

It is perhaps more important to pause here a moment and inquire about the contemporary works of the two other main masters of early Dutch landscape painting: Pieter Molijn and Salomon van Ruysdael. We shall not be surprised to find their development during this period to correspond very closely to van Goyen's. Both of them were residents of Haarlem where Esajas van de Velde had taken the first steps towards the new goal and later inspired van Goyen's efforts. As regards priority, Molijn[14] – who remains on the whole a somewhat enigmatic master, being in the forefront of the new movement in his early years and then falling behind considerably – seems to have exerted some influence on both van Goyen and Ruysdael. The crucial year is 1626. Molijn's earliest works show only restricted landscape aspects; his pictures of 1625 in Dublin and Brussels are basically *genre* scenes (the latter a nocturnal one)[15] and closely related to Esajas van de Velde, whose influence is still felt in the *Kermis* of 1626 in Dessau.[16] Of Molijn's four etchings of 1626,[17] three have rather predominant figures, and their unmistakable source is Abraham Bloemaert's mannerist fusion of *genre* figures and decorative landscape elements; however, the fourth, while not free from these features, is much more definitely a *landscape*, with small figures and a free vista on the left, and comes somewhat closer to the master's epoch-making painting of the same year in Braunschweig.

This oft-discussed work (fig. 24) remains one of the corner-stones of Dutch landscape painting. Compared with van Goyen's of the same year (fig. 19) it looks like fulfilment compared with promise. The small picture – upon re-visiting it one is quite surprised at how small it is – combines a gem-like preciousness with a certain grandeur. Local colour is almost entirely restricted to the figures in the light (there is some red and blue in the dress of the woman); the men in the shadow farther away to the left are already subordinated to the grey-green overall tonality under dark grey clouds. The road is painted in alternating broad stripes of white, brown and greenish; the latter is also the colour of the fence in front of the dark foil of tree and distant hill-line. The brilliant effect of the light road enclosed between a dark foreground strip on the left and the rising diagonal of the dark middle distance, with the blue sky and a white cloud (above the grey ones) providing a light counterbalance above, indicates a stage prior to full tonality. Yet this constitutes a powerful unifying element which has

usually been considered to be without precedent and was indeed destined to dominate Dutch landscape painting of the subsequent period in many ways.

The qualification about precedents inserted in the last sentence refers to a picture which, although published in 1928, has not received the attention it deserves. It is Pieter van Santvoort's landscape in Berlin (fig. 23),[18] which bears the clear date 1625 next to the master's signature. This rugged picture was thus painted in a year which saw van Goyen paint the crowded, old-fashioned landscape in Bremen (fig. 20); it precedes any known painting by Salomon van Ruysdael; it directly anticipates Molijn's picture of 1626 in Braunschweig and goes way beyond this master's works of 1625. Santvoort – who was one of the few affluent Dutch painters of the seventeenth century – may have painted little, some of his works may go under wrong names, and there is also a chance that several of his early pictures have remained unidentified because he signed them with initials corresponding to his alternate name Pieter Bontepaart (the signature 'Bontepaart' does appear on drawings of 1623).[19] In the Berlin picture, the sweeping encounter of the diagonals formed by the road and by the trees and cottage is very similar to the corresponding effect in the Braunschweig Molijn (fig. 24), although more sharply emphasized (notice also the way in which the clouds repeat the upper diagonal), and the road leads to a higher middle distance. Details of design such as the treatment of foliage and fence are closely akin and, above all, the thoroughly novel handling of strong contrasts of light and shade, which none the less involves a considerable reduction of colour variety and prepares the way for a more unified tonality, is almost as pronounced as it will be a year later with Molijn, and is far ahead of any work by van Goyen of the year 1625. There is no question but that this somewhat crude but magnificently daring painting occupies a decisive place in the evolution of Dutch landscape painting.

Much has been written about the provenance of the diagonal elements which are already important in these pioneer works and were to become even more characteristic of their successors. It is undeniable that the landscapes of Adam Elsheimer,[20] done in Rome between 1600 and 1610 and accessible in the Netherlands by 1608/13 through the reproductive engravings of Hendrick Goudt, contributed to the popularity of this type of composition, even though some writers, notably Rolph Grosse,[21] seem to have exaggerated the role played by Elsheimer in this process. The situation was recently summarized in a most judicious manner by E. Haverkamp Begemann.[22] In addition to Goudt, Moses van Uyttenbroeck may occasionally have contributed to the popularity of the Elsheimer scheme among the group of Haarlem artists during the crucial years from ca. 1612 to 1616.[23] But here again original etchings and drawings were far in advance of the paintings. As is well known, Willem Buytewech, for whose sake Haverkamp Begemann reconsidered the role of Elsheimer, never did any landscape paintings, Jan van de Velde's paintings are negligible, and Moses van Uyttenbroeck's are rarely landscapes proper (and all later than his most important etchings). The diagonal-triangular scheme, which is here under consideration, actually did not

enter painting in earnest before Pieter van Santvoort's and Molijn's pictures of 1625 and 1626 respectively; but it appears fully developed in a drawing by Esajas van de Velde of 1616 in Frankfurt (fig. 22),[24] in which the upper diagonal is formed by a succession of trees from the upper right corner to the lower left, and the lower one, which joins the upper in the left distance, by a road leading into depth from the lower right corner. In river landscapes we shall find Esajas van de Velde working in a similar vein even a few years earlier. In any case, no Elsheimer influence could have been absorbed where the ground was not prepared for it by the activities of Goltzius and Claes Visscher as draughtsmen and, one might add, Hans Bol as etcher. The most decisive – and the most fortunate – point is that the diagonal pattern, even when based on Elsheimer's (fig. 345), permitted a well-nigh inexhaustible number of variations in the course of its translation into the Dutch vernacular, and that the Dutch artists made the best of that opportunity. Among the leading artists, Molijn, van Goyen, Salomon van Ruysdael and Cuyp gave us a plethora of beautiful solutions; paradoxically, Esajas van de Velde, who fully mastered the design in the Frankfurt and some other drawings, did not employ it even in his most mature paintings (which in a sense point *beyond* the era of its popularity).

This is perhaps the best moment for a brief discussion of the role which Abraham Bloemaert (1564–1651) played in the development of Dutch landscape painting during the century, which he entered at the age of thirty-six. Rolph Grosse[25] has assigned him a considerable part in it, particularly as a draughtsman, but our now appreciably extended knowledge of this artist's output[26] does not seem to warrant that author's high estimate of the Utrecht master as a driving force in this chapter of Dutch art. His innumerable drawings of landscape details (mostly trees, farm houses and the like) usually remain just that, so far as they can be dated early; only his later drawings represent unified landscape vistas, and they are surely dependent on artists of the younger generation such as Esajas van de Velde, Molijn and van Goyen. His early landscape paintings are mannerist fantasies in which mountainous motifs and old-fashioned panoramic vistas predominate; they do not substantially proceed beyond the comparable works of Gillis van Coninxloo and Karel van Mander, although they skilfully adopt more modern elements. A more fully Netherlandish landscape interpretation does not emerge before the twenties but remains a matter of deliberate composition of picturesque buildings, compact groups of peasants (an additional biblical subject may appear in tiny background figures, true to mannerist tradition), farm utensils and trees, now placed more directly and intimately before the spectator and set off against flat landscape vistas. Colours make only occasional concessions to a Molijn and van Goyen-like tonality; on the whole, a great variety of brilliant hues in which red and green play a large role persists and even increases in the forties, although with a new bright luminosity. Mythological figures gain foreground prominence at the same time: Latona appears in 1646 (Utrecht Museum), and Argus and Mercury in a brilliant picture of 1645 in the Liechtenstein Collection. The Berlin painting of

1650 (fig. 21)[27] exhibits all the flaws and merits of Bloemaert as a landscape painter: the continued restriction to single motifs, however brilliantly handled; the blocking of spatial unity; the lack of a true feeling for atmospheric effects. Yet there is a remarkable understanding of the *decorative* qualities of picturesque farm buildings, elegant trees, cleverly posed figures and the beauty of all-pervading swaying curves which transform the mannerist heritage into bolder premonitions of the Rococo. At the same time, this work of 1650 still adheres to the basically diagonal pattern which the more progressive painters had established in the late twenties.

Molijn's ascendancy was short. The *Evening* of 1628 in Berlin[28] paraphrases the Braunschweig picture of 1626 in the reverse and with a sharper accent upon the depth-producing quality of the light road but with a less convincing, rather mottled overall effect. The *Landscape with Cottage* of 1629 in New York (fig. 25) – one of the rare seventeenth-century landscapes with only the slightest intimation of human figures – is distinguished by a much more unified sweep than the Berlin picture; powerful curves and diagonals are most effectively interlaced, and while the middle distance is still bathed in a strong light which contrasts with a dark foreground, a tendency toward greater tonality is unmistakable. After 1630, most of Molijn's works can be said to fall in line with the works of van Goyen and Ruysdael rather than leading the way; others are decidedly old-fashioned.[29]

The epoch-making importance of Molijn's landscape of 1626 in Braunschweig is clearly reflected in the early works of Salomon van Ruysdael, who in that same year painted his earliest dated work as a *genre* piece in the manner of Esajas van de Velde.[30] His *Dune Landscape* of 1628 (St. 227) is indebted to that of Molijn in colour and composition, and even in significant details. Some works by Ruysdael of the years 1630 and 1631 establish a diagonal composition of an almost planned clarity and of a certain monumentality that are quite extraordinary. The most important pictures of this group are all based on the diagonal road leading into the left middle distance or background from the right foreground, with a dark frontal strip on the left serving as a *repoussoir*; the 'answering' diagonal however, which leads from upper right to lower left, shows lively variations. In the Berlin picture (St. 232) it is most 'orthodoxically' displayed; in Budapest (St. 181; fig. 30) and Warsaw[31] in a more loosely varied fashion, which leaves room for a little dip at the right. The colours, mostly brown and green, and the sharp light on the road are still reminiscent of Molijn and conceived more in terms of contrast than of tone; it is in this field that van Goyen, rather than Ruysdael, was leading the way, although Ruysdael's *river* scenes of the same period keep pace with those of the Leiden master.

Van Goyen's paintings of the late twenties have repeatedly been analysed with respect to their steady development from multiplicity of design and colour to tonality and more unified structure of composition.[32] It is sufficient to cast comparative glances at the Leiden picture of 1626, the Frankfurt *Country Road* of 1628 (HdG 312), the Berlin *Dune Landscape* of 1629 (HdG 280) and the Braunschweig *Fence* of 1631 (HdG

294), to grasp the essence of this evolution. In spite of some intimations of restraint mentioned above, the picture of 1626 (fig. 19) still shows crisp contrasting colour specks and a plethora of charming details of design; unity of composition is achieved almost exclusively by judicious counterbalancing of details both in design and colour. In the picture of 1628 (fig. 26), the *matériel* has been significantly reduced, and so have the number of colour nuances, although there are still reminiscences of Esajas van de Velde; the composition is still basically bilateral, in spite of the spatial thrust of the road and the houses in the centre. In the Berlin picture of 1629 (fig. 27),[33] the 'classic' diagonal composition has been approximated in the road and the descending line of the dunes, trees and houses above. But it is not until 1631 (fig. 28)[34] that this system is permeated with that characteristic 'allegro' sweep which affects every detail and subordinates it to a brilliantly unified silhouette; and only here has the tonal quality reached the stage in which local colours are more fully integrated into the lemon-yellow and grey harmony of the whole.

Minor masters took up the diagonal scheme with amazing alacrity. We find it at a very early date in works by Pieter de Neyn,[35] who depended on van de Velde, Molijn, Ruysdael and, most strongly, van Goyen, but employed diagonal compositions as early as 1629, almost contemporaneously with van Goyen. Among the more important artists, the young Aelbert Cuyp occasionally embarked on a similar path. One of the two early landscapes of his which were formerly in Berlin (HdG 682) employs the motif of the road leading straight into depth in the middle of the picture, with farm buildings arranged on either side under a surprisingly high sky (a composition reminiscent of van Goyen's work of 1628 and of Bloemaert); the other (destroyed in 1945; HdG 683; fig. 29) shows a basically diagonal pattern, with the road leading from the middle of the foreground to the left background and an answering diagonal (however freely interpreted) coming down from the upper right.

These early works by Cuyp also share with van Goyen's comparable paintings the tonal quality, mostly in a strong yellow-brown combination with some grey-green nuances; none of them is dated but it is quite certain that they belong in the late thirties and early forties.[36] Parallels are found in van Goyen's work between *ca.* 1633 and 1644, when this master's tonal period reached a climax – a climax we shall discuss more fully in connection with his important river landscapes of the same phase.

The diagonal scheme remained very much alive in works of that period by van Goyen and Ruysdael but it is more frequently rivalled by other tendencies, with which it occasionally combines to produce pleasing effects. A very typical example of the latter group is Ruysdael's *Halt at the Inn* of 1643 (St. 147; fig. 31), in which the old diagonal pattern is somewhat altered by introducing a continuous dark repoussoir zone, which extends calmly throughout the foreground, and by activating a more pronounced counter-movement from the left side of the picture towards the centre; in a similar picture of 1644 this is achieved by means of a man leading four horses in Indian file![37] In this way a more strongly bilateral element is introduced; this had

already gained strength in some earlier works of the same master, including some in upright format, in which prominent trees are assuming a more important role.

This tendency is less noticeable in van Goyen's production of the 1640's, but it is important to point out (if only as an antidote to easy generalizations) that some of his works done in the early thirties anticipate this trend, though with a decidedly old-fashioned flavour. Some of these will be discussed in the next section, since they are at least 'half-panoramic'; but the sturdy, colourful, compact, still somewhat Molijn-and even Bloemaert-like painting of 1634 in the Hermitage (no. 806; fig. 32) may represent this particular and peculiar field of van Goyen's restless experimentation.[38]

Thus, both Ruysdael and van Goyen heralded the new style of the late forties and early fifties, in which tonality recedes in favour of stronger contrasts of light and dark and more pronounced areas of colour, and in which the 'gliding' diagonals with vague structural accents make way for a re-emphasis on more compact forms.

Large tree groups are a characteristic means of achieving this new effect but there are also other possibilities, including those in which the diagonal remains important. Van Goyen's landscape of 1647 in Oberlin (fig. 34)[39] still emphasizes the double diagonal from right to left but the effect is altered by the stronger contrast of light and dark, the more massive treatment of the clouds, the greater emphasis on central motifs (church spire and dark figures in the foreground). Well-known pictures of 1653 and 1654 by van Goyen (HdG 275 and 276)[40] are joined by works of Salomon van Ruysdael (1655; St. 155) and were actually preceded by the more genre-minded Isaak van Ostade (HdG 79; fig. 33).[41] He still employs the basic diagonal motif but now its descent from the upper right, with its complex of cottages and trees, is interrupted by a high tree before it is continued to the left by draw-well, cart and stooping figures. The colouristic appearance of all these pictures conforms to this 'synthetic' conception, with its new emphasis on local colours and stronger light-dark contrasts, in opposition to Ruysdael's paintings of 1643 (fig. 31), similar in composition, but still quite tonal.

More vigorous colour nuances, though much less detailed than in Ostade's somewhat chatty works, are also the hallmark of Rembrandt's brilliant, brown-rose sketch of 1654 in Montreal (Br. 453; fig. 36). Here the traditional diagonal pattern is still very much in evidence but miraculously encompasses a wholly novel feature – a spacious, shaded court on the right, giving this entire section a polyphonic structure comparable to the vista on the left. In the meantime, the new structural effect was often achieved by more emphatically bilateral compositions or other devices which can do without diagonal elements altogether; it is in the same period that the tonal panoramic view with its tendency to dissolve the composition changes smoothly to a panorama with renewed emphases on structure and colour (p. 41).

But diagonal elements survive even in the early work of the main master of the new generation, Jacob van Ruisdael. We shall trace other facets of this great artist in the chapters on panoramas, forest and winter scenes, sea and beach scenes, imaginary and

Scandinavian scenes; but quite a number of works from his early period (*ca.* 1646–49) find their logical place here. They are characteristic dune landscapes in which trees are inserted more sparsely, not as in a forest view proper. The composition of the painting of 1646 in Hamburg (HdG 806, Ros. 503, fig. 35) still uses the falling diagonal (and even reminiscences of the rising one), together with an open vista on the left. The more sweepingly unified falling diagonal of the dune picture of 1648 formerly in Hannover[42] ends in the agitated waters of the sea. Several other pictures which belong to this period of Ruisdael's activity preserve the falling diagonal very clearly, although the rising one is abandoned in favour of a road winding directly into the distance on the same side of the picture;[43] in others, more complicated compositions, with central and bilateral motifs and only traces of the diagonal one, prepare the way for the greater freedom of Ruisdael's later pictures.[44]

About 1650, Ruisdael's work became increasingly independent of all traditional patterns and at the same time more closely tied to the forest scene, the river view or the panorama. Yet there is a rather large group from the early fifties, in which dunes still play a predominant role;[45] and even in the sixties a few famous pictures combine the old dune view with such motifs as cornfields and windmills, now in the wonderful openness and stateliness of the master's most mature landscape vision. That in some of these the old 'double diagonal' still survives is exemplified by the *Grainfields* in New York (HdG 141; fig. 37). Comparing this with a picture of 1649 in Antwerp (HdG 790; fig. 39), one is struck by a change of mood which intimately parallels the change from a closed to an open spatial organization. The massing of trees in the earlier one (fig. 39), their gnarled form, the dramatic contrast between live and dead branches, the filling of one side of the picture plane almost to the upper margin, the sharper contrast of light and shade throughout, the closeness of the spectator to the main elements of the composition – all this is a far cry from the fluffiness of the scattered trees in the later work (fig. 37), their simple light growth, the high sky forming a vault over the entire ground area, the even distribution of mellow light and shade, the distance of the onlooker from it all. Compact tension has given way to relaxed serenity but there is (as yet) no lack of dignity, no boredom, no emptiness in this serenity; it is like a moment of supreme harmony between the 'baroque' drama of Ruisdael's youthful work and the exhaustion that makes itself felt in his late works.

The dune landscape remained a favourite subject for a number of excellent masters of the middle of the century, including Philips Wouwerman, Jan Wijnants and Adriaen van de Velde.

To think of Wouwerman primarily as a painter of *genre* scenes, mostly with horses and horsemen (cavalry battles, camps, hunting parties, stables, smithies, riding schools and so on) is justified in terms of quantity rather than quality. Hofstede de Groot listed far more than a thousand pictures of this kind against about two hundred landscapes proper (of which three dozen or so are winter landscapes) – but these are *non multa sed multum.*[46]

The master's beginnings can be linked with Pieter van Laer[47] and Pieter Verbeecq; they belong with the history of *genre* rather than landscape painting except for the little gem of 1646 in the Leipzig Museum (HdG 219; fig. 38), in which the crystal-clear landscape is not to be ignored. It shows large plants, a thick willow trunk and a sparsely foliaged, slender tree in the foreground, painted in a manner which is strongly reminiscent of Ruisdael's very first pictures of 1645–46 (p. 71). Contrary to common opinion, it also clearly anticipates similar forms in Wijnants's pictures by a consider-able margin of time; the traditional dune diagonal is still very much in evidence. In a recently discovered, fresh and colourful painting of 1652 (fig. 41)[48] and in works of about 1660, which can be grouped with a dune landscape in Rotterdam, dated to that year,[49] the somewhat ostentatious details of the picture of 1646 have been eliminated and the landscape much more emphasized. Likewise in a painting in Leipzig (HdG 1068: fig. 40), the silvery harmony of dunes, vegetation and sky, and the seemingly fortuitous but carefully calculated distribution of inconspicuous figures betray full maturity; the composition, in a slightly upright format, has outgrown all clichés. In such works Wouwerman emerges as a master of surprising originality. The gracefully gregarious tone of the Leipzig picture and others of its kind is replaced by an un-expectedly romantic note struck by the lonely horseman making his way into the remote distance of the extraordinary little panel in Frankfurt (HdG 1057; fig. 42). It is steeped in a very light terracotta hue, on to which the blue-green and brown of the horseman, the white of the dog, the very light shades of yellow-green and grey-green in dune and tree, the lightest grey in the water and a breath of grey-blue in the sky have been dabbed with consummate skill. Its open spaciousness is a telling parallel to Ruisdael's mature style. A good look at a picture like this explains better than scores of written pages why Wouwerman became the declared darling of the Rococo.

The typical dune landscapes of Jan Wijnants do not seem to antedate the late fifties and therefore cannot have influenced Wouwerman in 1646; earlier works by this little-studied master, whose date of birth is still a matter of speculation but may actually be as late as 1630 or even later,[50] are of a very different type. They are mostly rather close views of farm-houses under high trees, reminiscent of Emanuel Murant, and often enlivened by conspicuous fowl, usually painted by Dirk Wijntrack. Reliable dates do not become plentiful before 1659 – that is, one year before Wijnants left Haarlem and moved to Amsterdam. The influence of Ruisdael's dune landscapes on his work may not have been marked until Wijnants joined that other ex-Haarlemer in Amsterdam. The large, gnarled trees which are characteristic of many pictures by Wijnants have their origin in works of the later forties by Ruisdael and Wouwerman, but forest landscapes proper by Wijnants are comparatively rare, more so than paintings of Italian scenes (p. 163). His dune pictures are sometimes large, stately, and somewhat overcrowded; he is by far at his best in small, intimate landscapes such as the one of 1659 in Hamburg (HdG 355) and the upright picture in Rotterdam (HdG 523a),

whose figures, as in the majority of Wijnants's landscapes, were painted by Jo Lingelbach. Others are graced with figures by Adriaen van de Velde; in the fir these, mostly of the 1660's such as the small gem in London (HdG 138 and 38c 43), one can enjoy a spontaneity, an economy of means and clarity of atmosphere which are most gratifying; they are still sometimes based on the double diagonal pattern (road and sloping dune) but with many variations often provided by tree groups (figs. 1 and 331). Large dune pictures are more frequently conceived in deliberately contrasting masses, often arranged on either side of a road leading into the picture in or near the centre. No clear evolution can be observed in Wijnants's well-documented later production, which is sometimes marred by a certain harshness of touch.

Adriaen van de Velde's[51] connection with Wijnants could be supposed to offer few problems because we know that he, although born in Amsterdam (1636), was a pupil of Wijnants, probably in Haarlem in the early fifties; van de Velde married in Amsterdam in 1656. Yet here again, the lack of early dates on comparable paintings by Wijnants complicates the situation.

The first indisputable date on any of van de Velde's pictures seems to be 1654 (HdG 215). This is a small gem of crystalline clarity and lucidity, a harbinger of that Mozartian serenity, harmony and composure which was to become the hallmark of the finest works of this lovable artist (who died at the same age as Mozart). However, in this painting, the landscape is very much subordinated to human figures and animals. His further output is fully documented between 1656 and 1672. His contributions to the realms of winter, beach, river and forest landscape will be considered later; his animal pictures properly speaking do not concern us here but there are a number of works in which the dune landscape predominates, and it is here that he joins Wouwerman and Wijnants – both of whom have been mentioned as his teachers although only the latter seems to have a legitimate claim. The connection with Wijnants is indeed close; not only did Adriaen paint his inimitably fine and tasteful figures in a number of his teacher's paintings throughout the years, as he did for so many others, but his *landscape* style is so akin to that of Wijnants's finest that there are cases in which doubts about the attribution have arisen. One example is the charming picture of 1663 in Amsterdam (HdG van de Velde 176; fig. 44) which is signed by the younger master alone but whose landscape seemed to de Groot to be the work of the older. However, this was in 1663, when Wijnants's own style was fully developed. In 1656 when van de Velde painted his rather unusual *Ferry*, in the Strasbourg Museum (HdG 345), the structure and style of the landscape is indeed (as was remarked by Zoege von Manteuffel[52]) reminiscent of Wijnants – but the latter's style was by no means fully developed by 1656. Thus it may actually have been early works by Wouwerman which inspired the young Adriaen van de Velde, and the similarity of his landscapes with those of Wijnants in the early sixties may be due to his mature collaboration with him rather than to an early pupil-teacher relationship.

Dune and pasture landscapes in which animals and *genre* figures do not play the main role can be found throughout van de Velde's career; witness the *Little Farm* of 1661 in London (no. 2572, HdG 81; fig. 45),[53] which shows extraordinary originality of composition and rivals the *Summer* panorama of the same year (fig. 62) in airiness and technical perfection. Like Ruisdael's *Grainfield* (fig. 37), it admits us to vast spaces that are magnificently controlled; it represents a moment of unsurpassed grace and harmony, just before the decline which is barely perceptible in some 'late' works of the master.

The farther we proceed towards the end of the century the oftener do we encounter representations of the countryside in which tall trees play an important role without evoking the image of forest scenes proper. This increase in the importance of trees is of course the logical corollary of the 'return to structure' which is noticeable in all Dutch painting after the middle of the century and which finds its characteristic counterpart in the 'return to colour' after a period of often extreme tonality. The works of Jacob van Ruisdael discussed above are early examples of this trend; his uncle Salomon van Ruysdael had even preceded him in a few cases and, in the fifties and sixties,[54] concentrated quite heavily on this new element of stateliness in contrast to van Goyen, who at that time hardly contributed anything to it. Salomon van Ruysdael was joined at an early date by some excellent artists such as the young Aert van der Neer[55] and the early Berchem (fig. 308),[56] and somewhat later by lesser lights such as I. van Moscher[57] and a host of imitators of his own and his nephew's style such as Dubois, van Borssom, Claes Molenaer,[58] Cornelis Decker, the Rombouts and many others. The landscape of Adriaen van de Velde's *Family Portrait* of 1667 (Amsterdam; HdG 29) and a few fine works by Hobbema[59] belong to the same group. In many of these the traditional diagonal structure is still noticeable, however modified.

It may seem almost facetious to end this section with a reference to Hobbema's *Avenue of Middelharnis* of 1689 in London (HdG 13; fig. 47), but it might well be argued that the *tour de force* of its perpendicular road is in fact but a kind of transposition of the traditional structure and that the projection of the tree tops in an acute angle on the picture plane and their exquisitely calculated relationship to the roadsides on the left and right 'wings' of this 'triptych' is a sophisticated variation on the old diagonal pattern. This was not entirely Hobbema's own idea; he was preceded by a curious and rather crude early seventeenth-century composition of uncertain attribution (fig. 48)[60] and an exceptional, daring but hardly successful experiment by Aelbert Cuyp in the Wallace Collection in London (HdG 168; late but certainly before 1689; fig. 46). But both of these pictures (topographically inspired as was that of Hobbema) show the avenue considerably off-centre,[61] and Rosenberg's reference[62] to Ruisdael's famous *Grainfield* of the Altman Collection in the Metropolitan Museum in New York (HdG 119) as a source of Hobbema's symmetrical alley-field structure remains valuable. However this may be, Hobbema's refined use of the various angles, the subtle rhythm of his slender poplars, his emphasis on spaciousness in order to counter-

balance the 'obvious' main motif, his judicious restraint with regard to staffage hardly need the foil of the earlier works to shine; for the year 1689, this picture, painted by a near-pensioner, remains a stunning miracle.

PANORAMAS

The panoramic view has often been considered the most outstanding contribution of Dutch painters to the history of landscape painting. It is Dutch through and through: the vast plain seeming to stretch out endlessly, the small towns barely rising above the level fields, the low horizon which often leaves up to four-fifths of the picture plane to the moist sky, the rich alternations of clear lights and transparent shadows in the shifting clouds. Here is the quiet glorification of a phenomenon which casts its spell over all those who have a more than nodding acquaintance with the country. How long did it take the Dutch painters to discover this great spectacle, and along what roads did they approach its representation?

The term 'panoramic landscape' is as ambiguous as most other art-historical terms. It is being widely used for the kind of landscape which abounds in the circle of Pieter Bruegel and his successors. There it designates a type of composite scenery viewed from above which is not based on a more or less spontaneous and momentary vision but on a large collection of single visual memories, however vivid. One may call this a 'world panorama', and it is something that, in the hands of a great master like Bruegel, can reach loftier heights than were ever attained by many of the humbler painters of the 'modern' panoramas we are about to study.

The two types are far apart. The older one worked with a rather different landscape material: the combination of mountain scenery and Netherlandish vistas such as is found in most of Bruegel's works of this kind (fig. 50),[1] usually with the main emphasis on the mountains; in contrast, the new type only very occasionally goes beyond (or above) the flat plains of Holland. Furthermore, the older type used a high horizon – as well as the mountains – primarily as a device to accommodate as many landscape facets (and details) as possible, with great concern for *universality* but regardless of the *optical* exigencies of *unified vision*; in fact, one does not get the impression that the artists were aware of the rules of perspective which govern the relationship between the spectator's eye-level and the picture's horizon. It is therefore no surprise to find that the 'modern' panorama sprang, not from the older one but from a different root, a more purely Dutch one; and again we have to concentrate on *drawings* in order to discover it. This is true in spite of the *View of Antwerp* by Hans Bol, painted as early as 1575,[2] and a similar town panorama of 1578 (Los Angeles, fig. 49);[3] these works are either pictorial maps or composite fantasies with highly anecdotal staffage, rather than landscape paintings of the kind with which we are here concerned, however progressive they may appear when compared with the panoramic type produced by

early sixteenth-century masters like Joachim Patenier or even the fantasies of Bruegel and his circle.[4]

We first reach firm ground with the very same master whose work has proved to be of such extraordinary importance for the entire 'realistic' trend. We know at least three panoramic drawings by Goltzius's hand[5] which are no less startlingly 'modern' than his works studied in connection with the advent of Esajas van de Velde's art. Two of them are dated 1603: one in Rotterdam (fig. 53) and one in the Lugt Collection (fig. 52); the third, provided with an apocryphal signature of Lucas van Uden and the (surely no less apocryphal) date 1615, is also in Rotterdam (fig. 54). While the technical features of these drawings resemble those of earlier works by Goltzius, such as the one in Dresden (dated 1595),[6] particularly with regard to the fine differentiation of the grounds by means of a delicate handling of the pen, they constitute a completely new departure in terms of subject: the view, from a slightly elevated standpoint, of a typical Dutch countryside (near Haarlem) with fertile fields, farm buildings, clusters of trees and perhaps a faint line of dunes on the horizon, rendered in richly varied stratification yet with a fine feeling for unity and with an impeccable skill in suggesting aerial perspective. It may also be noted that only a small suggestion of a diagonal movement into depth is found in all three works. But at the same time, they differ from each other quite considerably, and their differences clearly indicate three of the main trends in which Dutch panoramic painting was to develop a few decades later.

The drawing in the Lugt Collection, with signature and date 1603 (R. 400; fig. 52), is seen from an only slightly elevated standpoint and at a moderate distance. The result of the former – now clearly recognized as a consequence of the laws of perspective – is an occasional overlapping of the horizon by tree group, house and haystack placed in the middle distance. The result of the moderate distance of the observer from the foreground is a fairly 'normal' size – considering the vastness of the total area – of foreground forms and figures.

The Rotterdam drawing with the signature and date 1603 (R. 404; fig. 53) is seen from a considerably higher elevation and – partly as a result of that fact – at a much greater distance. Consequently, almost no objects overlap the horizon line, and even the small piece of rising territory which is actually represented in the lower right corner shows small forms, not to mention the minuteness of figures and objects farther 'down' in the foreground.

In the other Rotterdam drawing (R. 405; fig. 54), the standpoint and distance are approximately between those of the two preceding ones; the new feature here is the introduction of a hilly background which replaces the almost strictly level horizon 'line' of the two other drawings.

All three of these extraordinarily precocious and prophetic works are characterized by two more important features. First, they have a very oblong format, their height-to-width proportion varying from 1 to 2·5 to 1 to 1·9; the sky does not play nearly as large a part in any of them as it will several decades later, and in none of them does it

occupy more than about one half of the sheet. Secondly, they lack all traces of a 'side wing' framing construction. This feature, which painters were slow to accept, had indeed occurred in drawings of other types as is shown in examples by 'Cornelis Cort' studied above (fig. 10). But in them, the desire for some 'completeness' of composition could more easily be satisfied by a judicious pattern of houses, trees and other somewhat more conspicuous items which would occupy a comparatively large part of the surface area. In panoramas seen from an elevated standpoint it is precisely the lack of such larger compositional elements which make the problem of balance a difficult one: as everything is being subordinated to the feeling of a quasi-amorphous stretch of flat land extending endlessly toward the distance and a larger area of sky extending above it, how can one maintain the minimum substance of composition or 'backbone' normally required of a finished product?

In other types of composition, the device of 'stage wings', usually of groups of trees on both sides of the picture was traditional; it had been made even more familiar in the Northern Provinces by the Flemish emigrants;[7] and it was sure to provide the necessary stabilizing quality. But as applied to the panorama it would have destroyed the feeling of vast extension so important to this entire concept, not of course with regard to extension in *depth* (which could have been emphasized to any desirable degree even if enclosed between such stage wings) but certainly with regard to *lateral* extension which, though less vital, still could not be completely sacrificed with immunity. It is therefore hardly surprising to find that the compromise of *one* lateral group of trees (or a corresponding device) was occasionally employed, prior to arriving at a more sophisticated solution of the problem which required no such crutches at all. A one-sided motif of this kind was of course in itself a precarious thing because it offered its own problem, namely how to balance it without employing a similarly substantial object on the other side. But attempts were repeatedly made to solve it; there may even have been a special fascination to it, a challenge that draughtsmen and painters took up eagerly.[8]

The early masters in Haarlem, inspired by Goltzius, never lost sight of the new possibilities; but again, it took them a considerable time to probe into them in paintings and also to dare to omit lateral foreground support. In one of Esajas van de Velde's etchings of the series of *ca.* 1614 (Burchard 16, fig. 51), the right side is reserved for a hillock on which a torture-wheel and gallows rise; counterbalance on the open side is achieved by a combination of larger expanses of dark tones, a dune and a cloud formation (to which a prominent signature was added later on). There is a wide vista in the centre and on the right in one of Jan van de Velde's etchings of the year 1615 (Fr. 234)[9] in which clusters of trees and darker clouds accumulate on the right side in order to balance a prominent left 'wing', consisting of a large figure, a conspicuous draw-well, birds, house and tree.

It is at this point, speaking chronologically as well as systematically, that Hercules Seghers[10] enters the picture.

The problems of his activity, and particularly of the chronology of his etched and painted œuvre, are manifold and have not been brought much nearer complete solution in recent years. We do not even know for certain whether his activity as an etcher paralleled his activity as a painter; his apprenticeship, until the age of about seventeen, with Gillis van Coninxloo in Amsterdam proves that he started as a painter but we have no documentary evidence as to when he began to make etchings. On the other hand, the circumstances of his appearance in the guild of Haarlem in 1612, together with Esajas van de Velde and Willem Buytewech, suggest that he became interested in etching, specifically landscape etching, at that time. Not only is it difficult to believe that the former's precocious achievements in this field should have failed to stimulate his own production but it is also hardly doubtful that he was deeply impressed by the work of Goltzius, some of whose chiaroscuro woodcuts must be considered important forerunners of Seghers's coloured etchings of mountain vistas, and whose drawings of 1603 may have directly inspired the younger master's etched panoramas. Apart from this, the priority of etching over painting which we have observed in Esajas van de Velde and van Goyen would have to be expected in the case of Seghers as well, unless strong evidence to the contrary is made available. Back in Amsterdam (1614–31) he can logically be assumed to have concentrated on painting; as a painter he was famous enough to see one of his works offered to the King of Denmark as early as 1621; he was now back at a place where the Coninxloo tradition was still esteemed and Vinckboons still working successfully; his return to that tradition, however individually altered, must be expected. We do not know when he commenced his attempts to 'imitate' painting in his etchings; it is of no decisive importance to our present inquiry.

One realizes with a slight shock that only three Dutch panoramic etchings can be attributed to Seghers with any degree of certainty. Springer's group of 'Flat Landscapes' contains six numbers (31–36) but the first three of these, known also in later states worked over by Anthonie Waterloo, are most probably works by Johann Ruyscher, the 'Young Hercules', as is no. 36.[11] This leaves only the *View of Amersfoort* (Spr. 34 and pl. XXXIV; our fig. 56) and the *Two Windmills* (Spr. 35 and pl. XVII) as undisputed etchings by Seghers himself, but to these may be added *The Oak* (Spr. 40 and pl. XV), which shows a splendid panorama in its right-hand section. Since the palace built in 1630–31 by the 'Winter King' is lacking in the *View of Amersfoort*[12] it can be dated before 1630 with some (although by no means complete)[13] confidence. Both it and the *Two Windmills* are oblong in shape (86 × 303 and 88 × 313 mm. respectively); in this they go beyond Goltzius's drawings and are reminiscent of such works as Jan van de Velde's landscape series of 1615.

With regard to composition, the *View of Amersfoort* (fig. 56), while significantly more daring than any work by the van de Veldes and also more so than the *Two Windmills* (which has a wing-like left side), is really not too far away from Goltzius's drawing of 1603 in the Lugt Collection, the most oblong of that group (fig. 52).

The motif of the road winding its way into the picture, which is so conspicuous in the *Two Windmills* and was a hallmark of so many other Seghers etchings, is lacking; the etching uses only a slight intimation of a diagonal direction in the foreground and relies almost entirely on subtle differentiations of values, not unlike Goltzius's drawing. Neither has a lateral 'wing'. Seghers uses even less sky than his predecessor. As in the latter's drawing in the Lugt Collection (fig. 52), elevation and distance are moderate but the overlapping of the horizon by buildings is restricted to a minimum, with the one exception of the Cunera Church, which Seghers also used most ingeniously as an important structural factor (Goltzius relied on many more elements for this purpose), counterbalancing it primarily through a predominance of darker values in the left foreground. In spite of this resemblance to Goltzius it is not probable that this master-piece is an early work; it rather looks as though Seghers, perhaps shortly before 1630, had rediscovered the greatness of Goltzius's vision of 1603, after having made his own excursions into the land of fantasy.[14]

However this may be, Seghers's *painting* of the *View of Rhenen*, now in Berlin (fig. 58), may also have been done prior to 1630, since it, too, fails to show the characteristic building of the Winter King's palace. It is one – and probably the last – of Seghers's three universally accepted paintings of Dutch panoramas, the other two being the *Landscape with Two Windmills*, now in the collection of Mrs. Borthwick-Norton (fig. 57), and *Village near a River* in Berlin. In one of the strangest manipulations known to art history, all three of these paintings were posthumously altered by the addition, on top of the original panels, of boards with a high sky painted in; Jan van Gelder, who discovered this fact,[15] assumes that this was done when the three pictures were together in the hands of Johannes de Renialme (*ca.* 1640), with a view to making them more saleable since by that time panoramas with such high skies had become fashionable. The composition of the *Landscape with Two Windmills* (fig. 57) is almost identical with that of the etching Spr. 35, although the high mills seen in the background of the latter are missing here. In terms of colour, the picture is closely related to the Berlin paintings; but as indicated in the comparison between the corresponding etchings the motif of the winding road may suggest a somewhat earlier date.

All three paintings must be reconstructed in our minds with the same extremely oblong format which occurred in the etchings, rather than accepted in their van Goyen-like present form; still, these works reflect an astonishing precocity in their economy of means, subtlety of light effect and refinement of equilibrium. In the *Two Wind-mills* (fig. 57) the resemblance with the Goltzius drawing of 1603 in the Lugt Collection (fig. 52) is again surprising, in spite of the winding road motif; yet there is here a trace of a somewhat artificial wing motif in the right and left foreground. The *Village* in Berlin is freer in this respect, and the *View of Rhenen* (fig. 58) perhaps freer still. In both of them, the overlapping of the horizon is less conspicuous: although it is *de facto* somewhat more pronounced, it occurs in three widely separated areas and with needle-like accuracy rather than in bulk. Altogether one can hardly escape the feeling

that these three paintings reflect a serenity attained only after the turmoil of Seghers's fantastic views, rather than represent the germ of the latter; their greatness seems to rest on a synthesis of visionary power and visual straightforwardness rather than on a threatening eruption of that vision. If this is true, the *View of Brussels* and the other painting (fig. 267) in the Rotterdam Museum, both containing panoramic elements but in strong competition with mountains, form the transition from the austere mountain scenes in Amsterdam (fig. 265) and Florence (fig. 266) to the three panoramas proper: a transition from violence to composure, and at the same time from mountain to plain. We would thus arrive at the same chronological order which E. Haverkamp Begemann proposed in his admirable catalogue of the Seghers Exhibition held in Rotterdam in the summer of 1954.

It is by no means certain that Seghers's etched and painted panoramas were as instrumental in making this type of composition popular as is usually assumed. When he produced them he was living in Amsterdam; but it was in Haarlem that the panoramic motif had first been developed (Goltzius); there Seghers himself may have adopted it (1612–14), there it was kept alive by the van de Veldes around 1615–16 and there it was further developed in the thirties, now supplemented by the high sky which was but posthumously added to Seghers's own panoramas. One can make an excellent case for a straightforward native Haarlem development of this intrinsically Dutch type of painting.

An early example – characteristically a drawing – is Cornelis Vroom's view of a wooded terrain, dated 1631, in Berlin (fig. 55).[16] It is an exceptionally precocious work which foreshadows the panoramas of Ruisdael and Koninck and tries to manage without any lateral crutches whatsoever. It is true that the effect is a somewhat precarious equilibrium achieved by means of opposing diagonals in the middle distance, with the foreground left in a somewhat unstable condition. One can easily understand that painters did not yet dare to rush in where such draughtsmen still feared to tread. A new feature of this drawing, which from now on is found rather frequently, concerns the choice of terrain. The spectator is on the level of the foreground but the terrain slopes downward towards the middle distance, thus shifting the 'elevated' standpoint of the spectator into the picture, as it were, rather than suggesting it in front of the picture.

Painters followed Vroom's daring exploit at some distance and with reservations; the one-sided 'wing' takes first place in their works. Vroom himself did a beautiful picture of this kind;[17] other examples, some as early as 1631, are by Pieter Post.[18] Salomon van Ruysdael's *View of Amersfoort* of 1634 (St. 236; fig. 59) may here represent this stage;[19] it is also perhaps the foremost candidate if we seek proof of some modest Seghers influence upon this group. The town, in a daring colour combination of light red and blue-green, occupies the right middle distance and background; with the church spire slightly left of centre and somewhat lower than the foreground, a group of high trees forms a 'wing' on the left which is counterbalanced

by means of a dark foreground strip and prominent staffage in the right foreground, as well as by a cloud formation which answers the trees with a diagonal in the other direction. Most important: the sky is now very high indeed in relation to the horizon; it is the ratio later superimposed on Seghers's painted panoramas. Ruysdael was a sky painter of the first order; it is entirely conceivable that he should have been the first to use this device, which was to culminate in the art of his great nephew, and that he should have found his way to it with the help of the huge tree, which he did not see fit to sacrifice to an 'overall' sky. This 'one-winged' solution, already known to us from etchings by Esajas and Jan van de Velde as well as by Seghers, was almost at once taken up by Jan van Goyen; but it was he, too, who was to replace it with the 'wing-less' solution prepared by Goltzius and Seghers, and was to blend this tradition with Ruysdael's idea of the huge sky.

The 'one wing' pattern occurs in an embryonic form with van Goyen as early as 1632, when in a painting at Moscow[20] he adapted the composition of what may be an early Seghers etching (Spr. 40 and pl. xv) but minimized the effect of the distant view by introducing a large and prominent figure group in front of it. His two tree trunks are, if anything, more fanciful than Seghers's combination of a single tree and wooded hill. Van Goyen remained fond of this motif of 'romantic' trees juxtaposed with a panoramic view; witness the famous painting of 1641 in Amsterdam (HdG 267; fig. 60) with its much more fully unified composition and tonality. It is interesting to observe that, while these trees and panorama as such foreshadow Jacob van Ruisdael, van Goyen's combination of the trees with a panorama occurs only once with Ruisdael, and this in an early painting which is not a paraphrase of van Goyen but of Rembrandt's equally unusual etching of the *Three Trees* of 1643; this painting by Ruisdael, dated 1648, is now in the Museum of Springfield, Mass. (fig. 61). It is quite possible that Rembrandt's etching – which is as famous as it is uncharacteristic of the main trend of Rembrandt's etched landscapes – was inspired by works by van Goyen and Seghers.

The 'one wing' pattern is of comparatively small importance in the later history of the panorama but is found in a number of individually delightful forms. An early example is Isaak van Ostade's surprising painting of 1641 in Basel (no. 1350; fig. 63), conspicuous for its direct dependence upon landscapes of the late thirties by Rembrandt and Adriaen van Ostade (p. 211) with regard to brushstroke, temperament and treatment of light, yet quite original in its more intense colour gamut in middle distance and background (pink, yellow-green, blue-green). Works of this kind by Philips Koninck (late paintings which stress the contrast between plain and tree groups very pointedly),[21] Joris van der Haagen[22] and others followed. One of the loveliest of all, though not completely 'Dutch', is the small *Summer* of 1661 by Adriaen van de Velde (HdG 67), once in the collection of Catherine of Russia, and until recently owned by the late J. C. H. Heldring in Oosterbeek (fig. 62).[23] The somewhat stormy mood of Rembrandtesque pictures by Ruisdael and Ostade, the

more heroic stature of van Goyen's trees and the somewhat prosaic touch of those of Salomon van Ruysdael have here been replaced by a serene translucency which evokes the memory of great chamber music.[24]

It stands to reason that there exist many intermediate stages between the fully developed 'one wing' pattern and the completely wingless panoramic view initiated by Seghers's etchings and paintings.[25] In Aelbert Cuyp's *View of Amersfoort* in Elberfeld (fig. 65),[26] the role of the Ruysdael and van Goyen trees is taken over by a hillock with sheep and shepherds directing our attention to the panorama of the town bathed in warm sunlight; in other works by Cuyp, this role of the shepherds is even more pointedly taken over by a draughtsman sketching the view 'for us'.[27] These rudiments of a 'wing' tend to become increasingly lower and to yield to the high sky even on their side of the picture. There are many such compositions in the œuvre of van Goyen; a windswept tree may struggle half-heartedly upward, halfway or less; a group of cattle standing on a low dune may only slightly overlap the horizon on one side (1642, Rotterdam no. 2496); a windmill may occupy that position but, in spite of its being placed on a dune, may be almost dwarfed by a magnificent sky as in the great picture of 1642 in the National Gallery in London (no. 2578; HdG 835; fig. 64). Counterbalance is here provided by two dark figures, sharply silhouetted against the water that appears in the low middle distance, and a diagonal movement of dark clouds. While some of the slightly earlier pictures by van Goyen still show a good deal of stratification in brown-yellow-green zones reminiscent of the Flemish tradition and of Seghers, this work is colouristically more unified in that these few hues are distributed more evenly across the picture surface in a wonderfully rich array of subtly chosen values. The exciting quality of the wavy ground and dominating mill on the right is tempered by the composure of the distant plain and the simple everyday-life accent provided by the figures.

In some other works, van Goyen suggests a slight elevation on both sides, a 'two wing' reminiscence as it were but in such a way that one feels he is well on his way to the 'unaided' panoramic view which Goltzius's drawings had dared to open up as early as 1603. An excellent example is a picture of 1641 (HdG 497; fig. 67) in which the left elevation is included in a dark foreground strip (a few figures on a dune) while the right one is furnished by a slight, bright hillock, a figure and a hut; yet even this precocious picture seems to have been preceded by as much as thirteen years in a painting by Salomon van Ruysdael which – admittedly in a less brilliant manner – anticipated the same compositional device.[28] It is interesting to compare these subtle intimations of a bowl-like framing device with the obviousness which somewhat mars a similar attempt in a painting by Cuyp in Frankfurt (HdG 193; fig. 68); here the panorama is framed by the large figures of a shepherd and his dog on the left, and by a prominent cottage and other figures on the right. This picture must have been painted about seven years later than the van Goyen, that is, around 1645, and actually marks the beginning of the new 'structural' style of the middle of the century, although the same artist had

painted works of a more panoramic nature before, witness the characteristically straw-yellow paintings in Washington (Corcoran Gallery, Clark Coll.; HdG 701)[29] and in Munich (HdG 700; fig. 69). In the latter, painted about 1640, practically everything is kept below a very low horizon line and a sky that occupies three-quarters of the picture area. If, however, one compares this picture with van Goyen's admirable *View of Leiden* of 1647 at Smith College (HdG 1136?; fig. 70),[30] which shows a similar relationship between land and sky area, one notices two important differences. First, the Smith picture is seen from a considerable distance and from a higher standpoint with the result that it has no foreground, thus closely conforming to the Goltzius drawing of 1603 in the Lugt Collection (fig. 52), except that the sky is much higher (4 to 1 for 2 to 1); secondly, instead of the yellow-brown, dark-light contrasts of the Cuyp it exhibits a basically unified grey-green-brown tonality, which already showed itself in van Goyen's panorama of 1641 in Schwerin[31] (a picture compositionally more comparable to the Cuyp under discussion) and was fully developed in the London picture of 1642 (fig. 64). In a few places in the Smith picture of 1647, the beginnings of the new, 'post-tonal' re-emphasis on colour and light contrasts can already be discerned (exactly as in the Oberlin picture of the same year, fig. 34); and the same is true of the very similarly composed *Haarlemer Meer* of 1646 in New York (HdG 579), a gem of the greatest intimacy and rhythmic refinement.

Fully comparable with this masterpiece is the *View of Rhenen* of 1646 in the Corcoran Gallery in Washington (HdG 210; fig. 71).[32] It lends itself for contrast with a view of the same town painted in exactly the same size in 1636 (New York, HdG 209; fig. 72), which is important as one of van Goyen's earliest attempts at a 'wingless' panorama, although the rather compact massing of spire and town on the right recalls the 'wing' device of Salomon van Ruysdael's *View of Amersfoort* of 1634 (fig. 59). The relative multiplicity of the earlier work in design and colour has been conquered in the Corcoran picture. The town is farther removed from us and blends more smoothly with its surroundings; the sharply defined and individualized figures and animals in the foreground of the New York picture have been replaced by two groups (boats, carriages etc.) which are more casually placed and more fully absorbed by their environment; contrasts of light and colour have been toned down and have made room for a basic grey-green-brown tonality; the silvery, meandering river leads more convincingly into a distance radiant with atmospheric delights; in short, the daring promise of the earlier work has only now been splendidly fulfilled. Here, too, a certain crispness of forms (the spire), the formation of the clouds in the luminous sky and some more colourful touches distributed throughout the picture foreshadow the new tendencies of the middle of the century when compared with the 'total' tonality of some works painted about 1640, particularly of some of the river landscapes proper. Many panoramic views of the town of Arnhem fall into the same category, with the town in the middle distance sometimes entirely 'submerged' under the horizon line; the majority of these are dated in the mid-forties.

There exist some fine works of this type by minor masters such as Guilliam Dubois;[33] Molijn, too, contributed to it in his middle years.[34] We have already mentioned the Rembrandtesque painting of 1648 by Jacob van Ruisdael in Springfield (fig. 61). Another extraordinary work of his, painted as early as 1647, is the *View of Naarden* in the Castle Rohoncz Collection (fig. 66)[34a], in which reminiscences of Seghers and Rembrandt (sharp, dramatic, yellow light effects) are blended with a compositional pattern which is basically identical with that of van Goyen in the same period; its dark colours (brown-blue-green; there is no red here at all), while akin to van Goyen's, have a deep sonority of their own. Everywhere the sky occupies a large majority of the picture surface; the popularity of this motif must have been very great, and we remember that it was this period which saw Seghers's oblong formats literally raised to the height they now exhibit. And it was this period which saw the first panoramic paintings by the greatest specialist in this field, Philips Koninck. But before turning to him, we must cast a glance in the direction of another artist fascinated by the panoramic theme, even though in a somewhat desultory fashion: Rembrandt.

The story of Rembrandt's contribution to panorama is not a long one but neither is it devoid of excitement and of complexities. Most of the master's painted landscapes belong in the category of fantastic scenery, usually mixed with motifs taken from the Dutch countryside. Several of these introduce a panorama-like view as a subsidiary element in one way or another (notably the *Stormy Landscape* in Berlin, Br. 445), and one of them (Wallace Collection, Br. 451) even concentrates on it more fully; but they hardly belong in our present group. There actually exists no painted panorama universally attributed to Rembrandt.[35]

It is well known that Rembrandt's first intensive study of the countryside around him does not antedate the years shortly after 1640. True, the occasional flashes of Dutch scenes which appear embedded in most of his painted mountain views, as well as in some etched and painted religious subjects of the 1630's, are more than ingenious fillers, and paintings such as the Amsterdam *Bridge* (fig. 108) indicate an even more intimate understanding of important facets of his surroundings. But even the latter is landscape adapted to a personal mood rather than landscape for its own sake. It was not until Rembrandt forgot all about painting landscapes and concentrated entirely upon drawing and etching landscapes that he yielded to landscape, sat before it in unceasing wonderment and indefatigable studiousness and in doing so, opened a new chapter in the history of landscape interpretation in black and white. On the whole, this history falls outside the scope of this book. Its course is tied to compositional patterns which show certain parallels to the paths pursued by van Goyen and Salomon van Ruysdael at the same time; but Rembrandt's prints and drawings neither served as models for those masters nor does their main claim to greatness lie in their indubitable originality with regard to structure. Their essence is the unexcelled subtlety with which they capture light, open air and atmosphere with purely graphic means, and it is in this respect that they revolutionized all subsequent efforts in that field. However,

at least one of his etchings turned out to be very influential in the development of landscape painting.

As far as the panoramic view is concerned, Rembrandt made contributions to both the 'oblong' type familiar to us from Seghers's etchings and paintings (in their original form) and the 'high sky' type. Strangely enough the latter precedes the former in Rembrandt's work. It is the etching of the *View of Amsterdam*, probably done around 1643 (B. 210, H. 176, M. 150; fig. 73), which was of decisive importance for the development of panoramic painting connected with the name of Jacob van Ruisdael: it established the new type in which a city, located in the background, forms a clear silhouette against the sky. The difference between this and earlier views of towns is very significant; whereas in them, only an occasional spire or tree was seen cutting into the predominantly unbroken horizon, the latter now sparkles with the towers, houses, mills, shipmasts etc. that are placed upon it and whose upper parts actually suggest the idea of a light curve vaulting over the horizon (corresponding to an 'answering' curve in the foreground), rather than a strictly horizontal ending as was customary before. We shall reconsider this point in connection with Ruisdael later in this chapter.

I can see no influence of Seghers in this epoch-making print. First of all, its format occurs nowhere in Seghers's own work; in this respect, it is much more closely related to the similar endeavours of van Goyen and Salomon van Ruysdael around 1640. Secondly, the specific treatment of the horizon, which has just been discussed, is likewise not found in Seghers's works, except for slight intimations. It is an interesting, and at first puzzling, fact that the etching of *Saxenburg*, done in 1651 (fig. 74), is much more closely related to the enigmatic older master. On the other hand, we know that Seghers's art never ceased to fascinate Rembrandt as it had already done in the thirties when Rembrandt's painted landscapes were deeply influenced by him. It has often been assumed that Rembrandt used a discarded Seghers plate in the *Three Trees* of 1643, an etching which monumentalizes the type of composition known to us from van Goyen's Amsterdam painting of 1641 (fig. 60): a combination of a ponderous lateral foreground object with a far vista opening on the other side; and we know for certain that Rembrandt created a second state of a Seghers plate at an even later date.[36]

The so-called *Goldweigher's Field* (fig. 74), dated 1651, has turned out to be a view of the country house of Saxenburg which at that time belonged to Christoffel Thijsz, one of Rembrandt's unsatisfied creditors.[37] Here Rembrandt reverted to Seghers's favourite extremely oblong format (which also appears in what is perhaps Rembrandt's greatest landscape of them all, the *Landscape with the Tower* of approximately the same period).[38] The print is an unexcelled masterpiece of composition under spectacularly difficult circumstances, superior in this respect to Seghers's anticipating works in painting as well as in etching. There is now a manifold counterpoint (notice the relationships between the two dark burr flecks in the foreground and the two church spires in the background and their interconnecting auxiliaries in the middle distance)

working together with the harmonious inward curves on the two sides which bars any thought of an arbitrary lateral continuation, yet grants the observer a feeling of open vistas more vast than he had ever enjoyed before.

It was in this very year, 1651, that Philips Koninck painted his most Rembrandt-esque work, the view of an imaginary city in the Reinhart Collection in Winterthur (G. 60). By the same token, Rembrandt's own work of 1651 bespeaks the influence of the younger master, who had anticipated many of its essential features in works dated 1647 (Victoria and Albert Museum, G. 34, fig. 75), 1648 (E. Assheton Burnett Collection, G. 13) and 1649 (New York, G. 46, fig. 76). In spite of its many short-comings, the painting of 1647 anticipates some features of Rembrandt's *Saxenburg* etching (fig. 74), including even the overlapping of the horizon by some buildings which was to disappear from Koninck's works later on.[39] Yet much of Koninck's landscape conception, and particularly his colour gamut, was deeply indebted to Rembrandt's work of the late thirties and early forties, as Gerson has convincingly shown,[40] even though it changed resolutely from the imaginary to the realistic scenery With Rembrandt, the latter does not appear in its own right until 1641 (in etchings).

H. Gerson's excellent monograph on Koninck traces the master's development as a painter of panoramas fully and convincingly. The time span from 1647 to 1676 encompasses changes from groping to maturity, from reminiscences of tonality to more outspoken colour composition, from a somewhat schematic arrangement of parallel strata to a more comprehensive fusion of all-important spatial elements, and there are also many minor anticipations and regressions. But, on the whole, the stylistic framework remains rather steady. The horizon is basically a straight line or rather an intimation of a line in thin brushstrokes appropriate to the hazy distance; it divides the picture into roughly two halves: earth and sky. Overlappings of the horizon hardly ever occur; the standpoint of the spectator is high enough to prevent that. In this respect, Koninck's panoramas closely correspond to Goltzius's Rotterdam drawing of 1603 (fig. 53), though the distance of the spectator from the scene is less extreme. Sometimes the spectator is led to the middle distance by a winding road or a winding river; in other cases gently undulating forms (dunes, bushes) accompany him to the same region; farther back, parallel strata take over (naturally in more rapid succession and therefore in the shape of long horizontal stripes). All these movements evoke the feeling of calm and peace since they are completely subordinated to the restful horizon line. Some drama is provided by the wonderfully rich alternation of luminous lights and transparent shades, by the dynamic counterpoint of the terrain waves, and by some of the finest clouds ever painted; but where the drama is heightened by imaginary elements such as higher mountains or fancy buildings, the artist is apt to slip or even to fail. It is the reality of his familiar surroundings, enhanced by subtleties of atmosphere and colour only, which inspired Koninck to his finest achievements, such as the picture of 1664 in Rotterdam (G. 52; fig. 77). A comparison with its fore-runner of 1649 in New York (G. 46; fig. 76) does reveal, within the same composi-

tional pattern, a process of maturing which can be compared with that of Mozart's symphonies from 1770 to 1788 (except that Koninck was already thirty when he painted the former). It seems unnecessary to demonstrate this in detail as far as the design is concerned; in addition to what reproductions tell, the gigantic size of the earlier work puts it at one more disadvantage. The sharp yellow-pink light in the centre, the somewhat monotonous quality of the colours, the way in which the foreground is 'covered' by a deep shadow and the exaggerated smallness of the figures (comparable to Goltzius's drawing, fig. 53) was replaced in 1664 by a strong but magnificently varied sand-yellow in the centre, deeply resonant reds and browns and greens, luminous shadows in the foreground and a small but coherent group of plausible figures. The poetry of this picture is the poetry of Dutch reality seen through the eyes of an artist who, like the great masters of the first half of the century, still remains basically the servant of nature, even though he is about to develop a note of tasteful selection which is somewhat more consciously subjective, and borders on a somewhat more deliberate stylization, than is found with his predecessors.

Could the same be said of Jacob van Ruisdael's celebrated panoramas of his native Haarlem and its surroundings? One could consider an affirmative answer to this question for an early work such as the *Rabbit Hunt* in the Haarlem Museum (HdG 885, Ros. 545; fig. 78), which has been doubted without sufficient reason (probably because it differs so much from the familiar type of Ruisdael's later panoramas).[41] The foreground still recalls the late forties with its strong alternation of light and dark; under the broad grey sky, the white dunes with deep blue-green invading them from the left, the grey mill (with one pink and one light grey sail) and the red horseman bespeak the early fifties, as do the crystal-clear air and the palpable plasticity of all forms. The horizon, a slightly curving line of dunes, shows no overlappings; in a sense, we have here a continuation of van Goyen's type of panorama, with some Koninck features woven in; the Seghers-Rembrandt-inspired dramatic quality of Ruisdael's pictures of 1647 (fig. 66) and 1648 (fig. 61) is altogether absent.

But the characteristic Ruisdael panorama, as we think of it, is a different phenomenon again. It is a rather late creation of the master. That it existed before 1669 is proved by an inventory drawn up in January of that year, in which 'een Haarlempje van Ruysdael' is specifically mentioned,[42] with a 'brand-name' casualness which bespeaks the familiarity of the user of the inventory with that type. We shall represent it here by the magnificent picture once in the Vieweg Collection in Brunswick and now in the Ruzicka Foundation in Zürich (HdG 59 and 92, Ros. 44; fig. 79).[43] Like many of the 'Haarlempjes', it is painted on an upright canvas.[44] The whole problem of the choice and use of this format in Dutch seventeenth-century painting deserves a special investigation. Undoubtedly it is much more frequent in the second half of the century, when a certain erect stateliness was desired not only in the compositional arrangement within the picture itself but also in its appearance on the wall;[45] but it does appear in a considerable number of paintings done in the thirties and forties as

well, in which tall buildings and tall trees – or even tall sailing-boats – were important elements. It is of course these very objects that became greater favourites with painters of the second half of the century, and we shall find the upright format frequently employed in the wooded landscapes of Ruisdael (all the way from 1645 to his late period) and Hobbema (mostly late). But what would prompt a painter to choose this format for panoramas, in direct, startling contrast to its beginnings with Seghers and the other Haarlemers? The ready answer that it was done simply for the sake of introducing as high a sky as possible bears no conviction; in the Ruzicka picture, the sky occupies but a little more than two-thirds of the area – the same (or less!) as in some oblong pictures by Ruisdael – while in many van Goyen panoramas the ratio was 4 to 1. That the concept of a view through a window should have played a role here, as it did with Monet in the 1860's, is hardly to be expected. It is more reasonable to think of a desire to match the vista of the ground, which is taken from an extremely high standpoint and seems to extend endlessly, by a sky that would answer that inward movement from the top of the picture down and backwards in an equally all-embracing, counterpoint-like movement. It is in this way that Ruisdael achieved the 'Urbild der Weltweite und der Erhabenheit des Himmels über der Erde', which Jakob Rosenberg has so eloquently praised as the very essence of these late pictures.[46]

Rosenberg rightly calls Ruisdael independent of Koninck in this endeavour. One is immediately struck by the manifestation of a mind which does not, like van Goyen's, rest content with a poetry that, however enchanting, is mainly derived from listening to, or, more correctly put, transmuting the natural motif itself, or, like Koninck's, restricts itself to a somewhat more personal selection. The dunes near Haarlem, the city itself, the church spires and castles and ruins, the corn and bleaching fields, the woods, the great clouds, the sharp lights and deep shadows had to be re-united in a process which may be defined as the result of the artist's deliberate choice from the storehouse of nature under the impact of a specific mood. 'Natuurlijkheid' is not forgotten, but the 'keurlijk' aspect is more strongly emphasized.

It is no accident either that the conception of the Ruzicka *View of Haarlem* (fig. 79) is so much closer to Goltzius's Rotterdam drawing of 1603 (fig. 53) than to the one of the Lugt Collection. The latter (fig. 52) is a van Goyen *in statu nascendi*, the former is immediately prophetic of Ruisdael in the way in which the spectator is placed extraordinarily high above the scene so that the forms appear tiny even on the tri-angular piece of a much lower dune on the right and then tinier still in the rest of the foreground, next to the groundline of the picture area; also directly akin to Goltzius is the distribution of fields, trees and houses in the broad strata of the plains moving faster toward the horizon in rich alternation of light and shaded areas. But the simi-larity stops here – not only because of Ruisdael's huge sky and dramatic clouds but also because of the treatment of the horizon itself. It no longer fuses with the sky (as it also did in Koninck's paintings). Instead, the lower part of the sky serves as a foil for the proud (and vastly enhanced)[47] form of Haarlem's *Groote Kerk* and other

churches. They stand in awe-inspiring immutability where the great tracts of land (from below) and clouds (from above) meet; they provide the main vertical accent – relatively small but all-important because only they stand out; in their position relative to the centre and sides of the picture area they counterbalance the prominent piece of dune in the right foreground; they provide an accent of strong, light reds in a canvas otherwise dedicated to browns, greens, greys (water) and yellows.

Nothing like this powerful focusing on forms placed directly upon the horizon line had ever been attempted before in painting; but it has its clear antecedent in Rembrandt's etching of the *View of Amsterdam* (fig. 73). It is true that the effect is now quite different in many ways, even apart from the difference between painting and print. The Rembrandt vista is not taken from above but from the ground; the connection between foreground and city silhouette is achieved by a slight overlapping of forms on the left and a small body of water leading inward on the right; there is no drama in the sky, no sharp contrast of light and dark throughout. Ruisdael glories in expressing the result of a very high standpoint, a complex variety of directions in the area between foreground and the culminating city view without strong indications of direct connecting links but – in contrast to Hans Bol's map-like panorama of 1578 (fig. 49) – through a sophisticated network of subtle correspondences. Rembrandt's work now looks simple, easy to survey and to grasp, with foreground and background arranged in two flat curves that join in an oval; that of Ruisdael is complex, with a composition appealing to the eyes of the connoisseur, arranged in a variety of directions, tensions and intensities, whose final harmonization is as little obvious as possible; the upright format underlines all these refinements. And yet there is no doubt that the basic idea behind this high point of panoramic painting is deeply indebted to Rembrandt's pioneer work.

The same motif recurs in an imposing group of other 'Haarlempjes' of the years before and around 1670, some upright, some oblong: paintings in Amsterdam (HdG 55, Ros. 38), Berlin (HdG 56, Ros. 39), The Hague (HdG 65, Ros. 48) and the former Huldschinsky picture, now with Étienne Nicolas in Paris (HdG 58, Ros. 41), to mention only the best known examples. In some other cases, the focus is directed upon an outstanding building – a castle, a ruin – in the middle distance, but the effect is quite similar. Such a building may be surrounded by dark trees and have a light-flooded background as a foil, or it may be exposed to a superbly dramatic spotlight as in the painting at the Musée Jacquemart-André in Paris (HdG 43 and 76, Ros. 60; fig. 80).[48] This is a late work of exactly square proportions, very thinly painted (the canvas shows on the lower left) in fusing browns and greens, with the light pink ruins rising behind a yellow wheat field, a brittle, somewhat meticulously painted tree on the left, a pigeon-grey body of water forming a foil for two tiny specks of figures in red[49] and blue – a picture which shows the artist in an unmistakable decline but which is still ennobled by a magnificent sky and a rhythmic tension powerful even in its moribund state.

In several paintings by Ruisdael of this (and a slightly earlier) period the spectator views the land from a less elevated position, and the effect is less strikingly dramatic – but at times perhaps more poetic. In such a case a building (usually a village church) in the middle distance or background may appear less remote and even more commanding in its relationship to the horizon line. The quiet, pastoral picture in Munich (no. 10818; HdG 37, Ros. 27; fig. 82) with the wonderfully needle-like, resilient spire of a village church is a magnificent example, in which the rhythmic refinement in the placing of the main vertical accent a little to the right of centre, a secondary one near the left margin (mill) and a tiny but clearly important one on the right (roof turret) deserves admiration. Others are conceived in a more romantic mood, with ruins near shaded waters in the foreground, a large area of strong light farther back, and a church in front of more threatening clouds in the distance.[50] Then again, there are rather late panoramic paintings by Ruisdael[51] in which the straight horizon line is nearly unimpaired as in most of Koninck's pictures and in Ruisdael's own, much earlier work in Haarlem (fig. 78), but the mood is characteristically sombre, the selection from nature more arbitrary; the spectator is not invited to enter the picture; the importance of the figures is minimized to the extreme.

Ruisdael's panoramas were emulated and profusely imitated by several artists. We can be brief with regard to these and completely eliminate the more slavish imitators, such as Jan van Kessel.[52] Perhaps the most noteworthy and most independent of the former were Jan Vermeer van Haarlem (1628–91) and Joris van der Haagen (ca. 1615–69).

Dated works by Jan Vermeer (van der Meer) van Haarlem[53] range from 1648 to 1676,[54] but include few panoramic paintings Two reliable dates are 1675 (*Dunes near Haarlem*, Louvre, Donation de Croij)[55] and 1676 (*View of Noordwijk*, Rotterdam); both pictures are rather dry and hard, and the latter is indeed but an inferior variant of a fine picture, in a private collection in Cologne, which was certainly painted a good deal earlier.[56] There is reason to assume that the finest and freshest of Vermeer's panoramas belong in the 1660's, with some tending compositionally more toward Philips Koninck (Strasbourg 168; Hannover 400), others more definitely toward Ruisdael. One of the very finest of the latter group is the painting in the Dresden Museum (no. 1388A; fig. 81);[57] it represents the familiar view of a village from the dunes, is painted with crisp, quick, sure brushstrokes and is distinguished by its crystal-clear, breezy atmosphere. The distribution of forms in all strata of the picture, the shape of the trees, the sparse use of small figures (which Vermeer rarely omits) and the treatment of the grass are all immediately reminiscent of Ruisdael but the mood is not his; there is nothing of the deliberate *mise en scène*, no dramatic light-dark contrast, and the clouds are more natural; we are back to a van Goyen-Molijn-like directness of interpretation of nature which has even less grandeur than in Koninck's works. Vermeer's colours are simpler also; they are usually restricted to brown, yellow and blueish green. If the unsigned *View of Haarlem* in Munich (no. 9562) is indeed by Vermeer we must assume that after the drying up of his style in the 1670's he took a

'second wind'. The picture (fig. 84) is painted in a fat, quick *pointillé* in very light grey-green, pinkish and blueish tints which give it a decidedly rococo-like appearance, reminiscent of certain properties found in Hobbema's works of the 1680's but blending less successfully with the main ingredients of his style than in the case of Hobbema. As Vermeer lived until 1691, such an ending does not seem impossible.[58]

The main excuse for mentioning in this context the often rather weak eclectic, Joris van der Haagen,[59] is that extraordinary 'hit', the *View of Ilpendam* in Paris (no. 2382; fig. 83),[60] a jewel worthy of the company of Adriaen van de Velde. It has the additional distinction of outdoing all other panoramas by showing a relationship of seven to one between sky and land, although we are now firmly back on the level of the figures in the foreground. The picture derives its beguiling charm primarily from its Potter-like neatness and the almost miniature-like refinement of the buildings on the horizon which bespeak the meticulousness of a topographer without giving the picture a pedantic touch. Nowhere else is one reminded more forcefully – or rather more gently – of the winsome double meaning of the Dutch word 'schoon': 'clean' and 'beautiful'. It is difficult to assign this work to its correct place because of the dearth of dates on the artist's pictures[61] and of their protean diversity; and it must be admitted that the attribution of the unsigned picture is not absolutely certain.

Postponing to a later chapter the mountain panoramas of the Italianate masters (p. 158), I should like to conclude this survey with another extraordinary, unmistakably Dutch vista, Hendrick ten Oever's[62] *Canal with Bathers* of 1675 in the Gallery in Edinburgh (no. 22; fig. 85). The silhouette which is delicately yet clearly placed on the horizon against the sun-drenched evening sky is that of the town of Zwolle, where the artist seems to have spent most of his life. He was active between *ca.* 1659 (when he was a pupil of Cornelis de Bie in Amsterdam) and *ca.* 1705 (last dated work), but next to nothing is known about his personality and his artistic career. His rare pictures, which include all manner of subjects, are of very uneven merit; none of them can touch the brilliant Edinburgh picture.[63] It was once attributed to Cuyp, with whose works it shares the golden glow and the light-line reflections on the contours of the figures and the cattle. But the main attraction of this canvas is something quite different from anything found in Cuyp's work: a mixture of naïveté and sophistication, small-town talk and cosmopolitan accent, crystal-clear literalness and elegant touch of poetry, insouciant forgetfulness of the nude bathers and eloquent *ad spectatorem* of the cattle – all under the protection of a magnificent sky which foreshadows visions of Caspar David Friedrich and Wilhelm Kobell.

RIVERS AND CANALS

Some of the towns that appeared in 'dune' and 'panoramic' views (Rhenen, Arnhem,
Dordrecht) are actually situated on the banks of those great arteries, Rhine and Maas,
and owed their prosperity to them; others, like Nijmegen, will be met with in this
chapter. In addition, there are innumerable smaller rivers and lakes all over the
country which were altered over and over again by canalization. Many of these pro-
jects were finished, or at least started, during the sixteenth and seventeenth centuries;
nor should it be forgotten that the typical Dutch windmills – a feature fondly remem-
bered by all travellers in Holland and trustingly accepted as characteristically Dutch
even by those who know it from advertisements only – have always been part and
parcel of a vast water-control system. Shipping on the rivers and canals has been of
decisive importance to Dutch commerce; most of it is conducted on the Rhine, and
much on the Amsterdam-Rotterdam canal system, both of paramount importance
already in the seventeenth century. Several painters, including Philips Koninck,[1]
aspired to, and obtained, more or less lucrative jobs in canal and river shipping.

 The frequent representation of motifs from the Dutch waterways – rivers and
canals – will therefore not come as a surprise to anyone; and whoever has taken the
trouble to walk, or travel at something like seventeenth-century speed, along one of
them, will have been struck by the wonders of the water flowing gently on or above
his own level, with boats floating on it as on air, with magnificent skies vaulting over
the flat pastures, and with those tender reflections of trees, farm buildings, boats and
the sky on the calm surface of the water.

 These phenomena alone may not perhaps justify our taking up painting of this
kind as a special group, separate from the countryside at large. But there are some
compositional problems involved in this intimate synthesis of land and water which
may indicate that such a division is not entirely arbitrary. The interpretation of the
countryside poses problems of structure which range from a strong emphasis on
individual buildings or trees to a complete neglect of everything except wide vistas,
with the panoramic view proper as its extreme. This development led – as indicated
in the previous chapters – from a multiplicity of objects and strata, as well as of
colours, to a sparsity of objects and a unification of planes and colours, and eventually
back to a greater emphasis on structural contrasts and stronger local colours in massed
areas. As a river or canal enters the repertory of objects – and I am speaking here of
considerable waterways of this sort, not of occasional ponds or other very small water
areas, nor of large water areas which together with their sailing boats are predominant
to the extent of producing a marine painting[2] – it produces some additional problems
of its own. In the former realm the problem concerns only land and sky. In a river
view the relationship between three different elements presents a special challenge.
How is the artist to divide the available area between the three? How is he to blend
them together again if this is desired? What position does he take with regard to a

body of water? This, too, is less easy to decide than 'on land'. Does he meet, or invite the spectator to meet, the river head-on by viewing it from a bridge or a boat, or sideways from its bank in full horizontal extension, or diagonally from a more precarious foothold? Actually, all of these possibilities have been tried, and it may be worth while to see how – and on the basis of what traditions – this was done, even though the resulting compositions do not always differ radically from those discussed before.

Rivers had formed parts of landscapes before, and some artists of the fifteenth and sixteenth centuries had been confronted with compositional problems of the kind just indicated. But it stands to reason that all those rivers fulfilled a specific task in a religious, mythological or topographic context and that therefore the solutions of the older artists were apt to differ rather radically from those now sought, even when a fine sensitivity to the beauty of a body of water was already demonstrated. Jan van Eyck's miraculous *Baptism of Christ in the Jordan* (*Heures de Milan*), Dirk Bouts's *St. Christopher* (Munich), Patenier's *Baptism of Christ* (Vienna) and *Styx* (Madrid) come readily to mind and at the same time illustrate the variety of early ways of meeting the problem. 'World panorama' views of the water were the almost universal rule with the sixteenth-century masters, including Pieter Bruegel (*Icarus, Autumn*), even though some of his drawings are, in spite of their topographic *raison d'être*, important forerunners of seventeenth-century intimate views.

The more recent Italian development, as represented by Annibale Carracci's *River Landscape* in Berlin, never aimed at the effect which was about to attract the Dutch masters. It was concerned with a structural arrangement of basic natural phenomena in which the river appears – if I may be pardoned the hyperbole – as 'the' river rather than 'a' river, as something embodying one of nature's timeless ideas; this is the concept which Poussin was to embrace and from which even Claude, the draughtsman of the Tiber, hardly deviated in his paintings. Even those Dutch river landscapes in which the element of deliberate structure vies most strongly with that of a 'find' in nature never aspire to the same amount and type of idealization that characterizes the Italian-French group. This is true even of the Dutch painters of the *Italian* scene;[3] nobody will be surprised to find the difference more conspicuous still with regard to those of the *Dutch* scene.

Again it is Esajas van de Velde who ranks supreme in the early Dutch development, and again it is the draughtsman and etcher van de Velde who conquers all difficulties before the painter van de Velde – or any other painter, for that matter – catches up with him.

A primitive solution of the head-on device was offered by Claes Jansz. Visscher in a somewhat overworked drawing (of 1614?) in Copenhagen (fig. 86), which on the basis of a later inscription was wrongly attributed to Esajas van de Velde[4] until Haverkamp Begemann pointed out its true author.[5] It shows a wooden drawbridge leading across the water parallel to the picture plane, a piece of the river bank on the left and right, each with high trees on it, and a sailing-boat approaching behind the

bridge at an angle of almost ninety degrees, seen against a distant bank (possibly the bank of a river or canal from which the one in front branches out at right angles). The effect is completely static, with the water, in spite of some effects of reflection, smothered by accessories, and with the entire structure made over-symmetrical in an effort to avoid 'tearing a hole' into it. An early painting by Salomon van Ruysdael at The Hague (St. 481) shows the artist encountering similar difficulties, even though he tried to overcome them by deflecting the direction of the river in the foreground. Even where greater variety of the lateral treatment and greater distance from the spectator brings more freedom into such a composition, the effect is not entirely satisfactory; a good example of this is a drawing of the Tolsteegpoort in Utrecht by Andries Both (fig. 87), an interesting early work of the *genre* painter.[6]

Esajas van de Velde certainly realized this problem right from the beginning. In the etching of the Ter-Tolen Bastion (Burchard 13; *ca.* 1615–16),[7] where the river already slants backwards to the right, the one-sided weight of the left bank, with large buildings, is quite insufficiently balanced by a rowing-boat on the right; but another etching, done as early as *ca.* 1612–14 (Burchard 23; fig. 88), foreshadows the most mature solutions of this problem of organization with the same amazing precocity that the master exhibited in his countryside drawings of the same period (see fig. 14).[8] In this tiny masterpiece, the wooded left bank of the river recedes and descends from the left foreground to the right middle distance; as it does so, the objects arranged on the bank are subtly reflected in the water in such a way as to help balance the distribution of light and dark forms; in the far distance on the right, there is a suggestion of the river making a turn to the left, with a tiny part of the right bank showing at the back. This is the pattern which was to be reached and exploited in the paintings of Jan van Goyen and Salomon van Ruysdael in the thirties – and not before. It was not used in van de Velde's own paintings at all!

It is immediately apparent that this is basically the same double diagonal conception which we encountered in the dune landscapes of that same critical period, and the origin of which has usually been traced back to Elsheimer. Esajas van de Velde's Frankfurt drawing of 1616 (fig. 22) follows the same principle, and in fact contains, however inconspicuously, a small body of water which can easily be imagined assuming a more important role without alterations to the basic compositional pattern. We need not reiterate here the main points of the question of derivation; suffice it to say that this type of river view seems to have developed perhaps even more spontaneously in the Haarlem of the second decade than the dune landscape, even though we need not deny some inspiration from the Elsheimer-Goudt tradition. Here again, it is the flexibility of the basic pattern which matters.

The number of landscape paintings by Esajas van de Velde in which water plays a prominent role is actually surprisingly small. There is no parallel in the rest of his work to the *Ferry* of 1622 in Amsterdam (no. 2452; fig. 91), in which the painter came to grips with the problem that Visscher had faced in the Copenhagen drawing (fig. 86).

To be sure, the river is not met head-on quite in the same sense as in that drawing; it curves to the left and then to the right gently enough to avoid a static symmetry. A tree and an inn rising in the left foreground are balanced by a group of trees and houses farther back on the right; church spire and windmill with their reflection in the water are carefully added to the inventory on the left, as is the ferry which, being parallel to the picture plane, keeps our attention on the foreground and prevents the river from flowing away from us too fast. It is in many respects an astonishingly conservative picture, with a great multiplicity of small, carefully rendered objects (note the ducks and storks), a very rich accumulation of trees and figures, and, of course, a great wealth of local colour, which is all the more conspicuous as the distance of the spectator from the scene is very considerable. And yet, the contrast with any late sixteenth-century work is great, as is clearly shown by a comparison with Hans Bol's generally quite similar print with the *Ganstrekken* game (H. 19; fig. 89).[9] Not only is the horizon of van de Velde's painting lower but there is, in spite of all the details, a much greater spaciousness, a feeling of greater subordination of man to nature. This is caused partly by the smallness of the figures; but even more important are the skilful pattern of recession, the judicious differentiation in the treatment of the details in foreground and middle distance and, last but not least, the wonderful subtlety in the rendering of reflections in the water. In addition, the appearance of the motif of the ferry in a painting was a happy novelty[10] which was to serve generations of great and mediocre painters alike.

But this is not all. Four years before painting the *Ferry*, Esajas van de Velde had created a work which was much more precocious and, in many respects, more immediately appealing. This is the *View of Zierikzee* (Zeeland) in the Berlin Museum (no. 1952), dated 1618 (fig. 93).[11] The *Ferry* is a piece for full orchestra; this is chamber music at its best – and I am not comparing physical sizes alone. This painting of 1618 is also an amazing experiment in that the river is now flowing almost entirely parallel to the picture plane, with a subtle deviation, which is also found in a drawing by Buytewech of approximately the same date.[12] This deviation makes the appearance of a small section of the spectator's bank plausible and serviceable for a refined *repoussoir* effect, which is heightened by the presence of some fishermen, their boat and some fishing tackle. This section, with its crisp and rather strong local colours, is most ingeniously counterbalanced by greater emphasis on the right middle distance (where the other bank advances and a pier juts out) and also by the treatment of the sky which, with its ascending light streaks, most successfully counteracts the falling diagonal of the town silhouette. This wonderful picture, whose main points van de Velde varied in a few other works of the same period,[13] not only prepares the way for a number of works by masters of the following generation but even foreshadows the composition of the greatest of all Dutch city views, Vermeer's *View of Delft*, painted more than forty years later (p. 125, fig. 254).

The quiet horizontality of this work by Esajas van de Velde finds a parallel in Arent

Arentsz's[14] river landscapes, for example the one in London (no. 3533; fig. 92). However, in these, a strip of land extends across the entire front of the picture and is framed by conspicuous figures; the river flows towards the background but the horizontal emphasis predominates. Much more in the spirit of van de Velde's Berlin picture are some works by Arentsz's greatly superior model, Hendrick Avercamp. In the painting in the van Heek Collection, Enschede (fig. 94),[15] the river also extends towards the centre of the background; however, the foreground is treated, not as a sharp barrier against the water as in Arentsz's pictures, but with the gentle touch and the daring sophistication of van de Velde. Nevertheless, a subtle 'tree-wing' was placed on the left in order to counterbalance on the right the large sailing-boat on the piece of land, ingeniously prolonged by an unrigged fishing vessel. The softness of atmosphere and the fusion of the grounds indicate a late date for this masterpiece (*ca.* 1630).

We should not leave Esajas van de Velde without mentioning a panel in the East Berlin Museum (no. 730A), the tiny tondo with a bastion on a river and a sailing-boat (fig. 95). As the river curves around the bank it echoes the round form of the picture as does the circular shape of the solid fort; and the sailing-boat with its softly curved body and high mast forms a subtle contrast to the massive bastion to which it is related in height in a rhythm of impeccable taste. The brushstroke is of an enchanting freedom and weightlessness, and the whole a happy improvisation unsurpassed by any of the master's emulators, including Jan van Goyen.

As we have seen before, the draughtsman van Goyen, too, was ahead of the painter. A ferry appears in one of his early pen drawings (*ca.* 1620)[16] remarkable for its freedom of treatment and ahead of van de Velde's decisive painting. In others (fig. 90)[17] we find the young van Goyen boldly, if sometimes clumsily, tackling the entire inventory and the free distribution of objects familiar from his paintings of the thirties. Asymmetrical tendencies of the same kind are further pursued in later drawings of the twenties, even though a strong *genre* content, with large figures, frequently overshadows the landscape effect. As to paintings, a *Village near a River* of 1623 and a *Ferry* of 1625[18] are basically *genre* scenes, with very little emphasis on the water and a multiplicity of form and colour that shows little if any progress beyond van de Velde. It was not before the beginning of the thirties that van Goyen, together with Salomon van Ruysdael, achieved full maturity in this field: at the same time, and naturally so, as he mastered the problem of interlocking planes and tonal unity in his countryside landscapes. In a picture of 1630 (HdG 718)[19] he still stressed the horizontal layers in a way which prevented full realization of spatial freedom and he sinned by introducing a vertical element in the exact centre of the composition; in 1631 (Glasgow, HdG 542) the movement towards the background became more fluid, and the opposite side was free; in 1632[20] almost complete maturity was reached and the painter caught up with the draughtsman. Out of a welter of little masterpieces of this sort we may choose for analysis the painting of 1636 in Munich (no. 4893, HdG 509; fig. 96).

That this picture is compositionally closely akin to Esajas van de Velde's early etching (fig. 88) needs no further demonstration; it is also the immediate successor of van Goyen's own picture of 1632 just mentioned and of several others painted by him and by Salomon van Ruysdael during the early thirties. The most important point to be made here is the great advance it marks in the direction of dissolving local colours for the sake of greater tonality. Not that it marks the climax of this development, which, in fact, was reached somewhat earlier by Ruysdael. There is still a strong orange-red in the central roof which is echoed in a somewhat milder intensity in the roofs on the left and right and there is some blue in the sky. But the yellow-green trees, the grey water, sky and dovecot, and the advanced fusion of grey, yellow and pink in the figures make this a key picture on the road to the full tonality of van Goyen's river landscapes of the forties.

Salomon van Ruysdael's river views[21] started in 1631, thus a little later than van Goyen's, which may indeed have influenced them; the works of the two masters are sometimes difficult to separate in this period. After Ruysdael had thrown away some crutches[22] he attained full freedom as early as 1632 (Hamburg, St. 498; fig. 97), in views seen either from a considerable distance or close to as in van Goyen's; the fusion of grey-green, grey, and a little blue in some of them bespeaks a further advance toward complete tonality than is found with van Goyen. The motif of a ferry plying the calm waters, first found with Esajas van de Velde in 1622 (fig. 91), was timidly taken up by Ruysdael in 1631, made more prominent by him after ca. 1634, and was to lead to some of his finest achievements in the late forties and the fifties. Towards the middle of the thirties a yellow-green and generally somewhat warmer nuances predominate; it is here that confusion with van Goyen most frequently occurs.

Early in the forties, the yellow-green and grey-green of Ruysdael's river views often turn to yellow-brown permeating all parts of the picture; at the same time, the earlier, more strictly diagonal structure is handled more freely by more deliberately placed and spatially more diversified groups of trees and buildings; obvious counterbalancing moves become more common on the opposite side. The picture of 1642 in Munich (no. 2718, formerly Bamberg, St. 447; fig. 98) is one of the finest examples displaying both of these qualities. The picture of 1632 (fig. 97) looks almost monotonous in comparison; there is now a feeling for colouristic and compositional differentiation within the tonal-diagonal patterns which heralds new aims of stateliness (see below, p. 56). Similar high points occur in some of van Goyen's works of the middle forties such as the overall brown-golden *River Bastion* of 1644 in Boston (no. 47.235). Both van Goyen and Ruysdael now become fond of using more prominent buildings in their river views. It is these that facilitate the modification of the earlier – and still basically preserved – diagonal structure; an amazingly precocious example is a (treeless!) *River View* by van Goyen, dated as early as 1636, in the Warburg Collection (fig. 99), a large stately work, which may serve as an appropriate warning agaisnt constructing chronological strait jackets.

Nevertheless, if one considers both structural and colouristic aspects, a clear line of development can be traced. Primary examples are the many views of Nijmegen, almost all of them done in the forties. By looking at this series in chronological sequence,[23] one can easily follow the gradual increase in stateliness, the diminution of tone for the sake of greater light-shade and colour contrasts, the greater terracing of the diagonal structure, until finally, in immediately related views of the same scenery painted by Aelbert Cuyp in the early fifties, a climax of new structural aims and effects has been achieved – but still without complete abandonment of the time-honoured diagonal. Van Goyen's picture of 1643 in the Walters Art Gallery in Balti-more (no. 37.375; fig. 101) still has the tonal unity extending along the whole town silhouette; in Ruysdael's view of the same motif of 1648 in the De Young Museum in San Francisco (St. 354; fig. 100) colour and mass have gained over the tone, and the individual sections of the town silhouette, marking contrasting planes in a more linear design, have gathered new strength; finally, in Cuyp's picture in Indianapolis (fig. 102), the more or less tonal procedures of the two older masters have been replaced by a new luminosity based on fresh colouristic exploits which we shall discuss later.

Other great town views by van Goyen represent Arnhem and Rhenen,[24] the latter known to us from panoramas by Seghers and van Goyen himself; they range from the early forties to the fifties, while the most striking example by Ruysdael belongs to the sixties.[25] This series would permit a review of the development from the typical tonality of the early forties to the new stateliness of the fifties and sixties which was to come to a climax in Jacob van Ruisdael's *Mill at Wijk bij Duurstede* (fig. 115).

Prominent individual buildings are often employed for the dual purpose of modi-fying and compartmentalizing the diagonal effect. The Pelkuspoort near Utrecht was often used in this fashion, either in its actual surroundings or boldly transferred to other shores.[26] The enchanting picture of 1646 (not 1643) by van Goyen in New York (no. 45.146.3, HdG 789?; fig. 103) is one of many examples painted by him in the forties, and by Ruysdael in the fifties and sixties (fig. 7). Here the diagonal is started by the old gateway at the left and supported near the centre by a church spire before merging with the horizoñ near some sailing-boats; the counterbalancing and horizontalizing rowing-boat is on the right; the magic of a wonderfully crisp and free brushstroke conjures up a miracle of grey and brown overall tonality.

The diagonal river views of van Goyen and Ruysdael were joined in the early forties by a small number of beautifully intimate, yellow or grey-green ones by Aelbert Cuyp, such as the one in London (no. 2545, HdG 638 = 667 = 677; fig. 107).[27] Minor masters such as the ubiquitous Herman Saftleven[28] and a host of van Goyen and Ruysdael imitators[29] followed suit. It is interesting to find that some masters best known for an entirely different type of picture were occasionally partial to this trend; the lovely early picture by Aert van der Neer in Frankfurt (no. 1090, HdG 32; fig. 105), the date of which must probably be read 1642,[30] is still reminiscent of Esajas van de Velde and the pre-tonal diagonal river view, while Simon de Vlieger's painting of

1647 in Mainz (no. 140; fig. 106) heralds the early river landscapes by Ruisdael but clings to a strictly diagonal pattern.

The breaking up of that pattern took other forms, more radical than those studied in connection with the views of Nijmegen and of individual buildings. Large, dominating tree groups or even a powerful single tree[31] provided one particularly important means. Here Salomon van Ruysdael is the leading master. Occasionally as early as 1642 (fig. 98), then more frequently after 1645, powerful clumps of trees begin to detach themselves from the traditional diagonal pattern. They rise either in the centre or on one side, in which case the equilibrium is often maintained rather precariously (but in a manner characteristic of the new compositional tendencies) by a strong contrast between one basically vertical and one basically horizontal half of the picture; the course of the river is often adapted to this new pattern by making it less straightforwardly diagonal than before. The new type is fully developed in Ruysdael's *Ferry* of 1647 in Brussels (St. 351) and the motif of the long, flat ferryboat was ingeniously used by Ruysdael in dozens of variations in order to counterbalance the verticality of the trees. The fine picture of 1650 (Amsterdam, Coll. A. Schwarz, St. 363; fig. 104) is characteristic of the way in which such a powerful tree group plays its role. It is placed at the right of centre and in front of the trees and buildings on the bank rather than initiating the traditional diagonal by keeping to the right margin and in line with the other trees, as in the paintings of the thirties. It is true that this new pattern had already been prepared in a picture of 1642 (fig. 98) but a comparison between these two paintings reveals significant differences. In the earlier one, the tree group is not as dominating as it is now; it is seen from a greater distance and, most important, it blends colouristically with its surroundings, whereas in the one of 1650 it is quite sharply set off against its more differentiated environment: the other trees, the sky, and in particular the red roofs of the houses. The large ferry on the left draws everything to the foreground even more pointedly; no such unified massive element occurs anywhere in the earlier work. Many of Ruysdael's finest pictures belong in this new category, less brilliant examples of which occur in van Goyen's work from the middle of the forties onwards[32] and in Ruysdael's own work of the sixties.[33]

Other river views by both van Goyen and Ruysdael renounce the trees as supports of compositional structure and rely on an open river; this frequently results in a marine appearance, with large expanses of water and sailing-boats in a conspicuous role. Transitional cases of this kind occur in views of more distant towns;[34] in many of these a strip of the river bank with fishermen or cows reappears in the foreground as a gentle *repoussoir*. Such patterns are also found in Herman Saftleven[35] and many followers of van Goyen and Ruysdael.

Among Rembrandt's painted landscapes only one, so far as I can see, can be classified as a Dutch river scene. This is the superb *Stone Bridge* in Amsterdam, which was presumably painted around 1637/38[36] (Br. 440; fig. 108). The picture stands alone not only within Rembrandt's own work but also within the whole of Dutch landscape

painting, except for a few imitations. In addition, it is not so much its composition
which is unique but its mood as expressed in its treatment of light and dark. Its
structure is quite comparable to some works by van Goyen and Ruysdael. But the
mere thought of them is enough to reveal its originality. The tree group near the
centre is struck by a violent light which makes its yellow-green hue – in itself anything
but extraordinary at that time – look explosive, as it were, and stand out sharply
against the sonorous darkness of the rest of the picture. But in the shaded part of the
foliage, brown is introduced – a brown greyish in the deeper shade, reddish in the
lighter, and it is exactly the same nuances of brown which pervade all their surround-
ings, supplemented only by the steel-grey of the water, the duller grey of the sky and
a somewhat more pronounced light red in the roofs of the houses near the centre.
Thus there is no part of the picture, not even the one most violently contrasted with
the rest, that is not directly related to the whole in terms of colour; the sharp light on
the road across the bridge similarly merges with the overall brown wherever it loses
some of its intensity. This is a far cry from the tonality of other masters in the same
period; theirs, though no less rich in value differentiation, lacks the drama of Rem-
brandt's contrasts; and although van Goyen and Ruysdael tone down the local colour
of their figures in pictures of this kind they offer nothing that is comparable with the
way in which Rembrandt binds together his figures, along with his boats, carriage,
houses and trees, in a chiaroscuro that lends to the simple motif the mysterious air of
his biblical works of the same period. There is little in nature itself that corresponds
to this phenomenon. It is surely not accidental that during this time of his artistic
career Rembrandt preferred a landscape of his own making to the Dutch reality.
The picture before us, realistic with regard to its inventory, is imaginary with regard
to colour and light; no actual atmospheric conditions can make a Dutch landscape
look like that. In other words, what Rembrandt painted here was within himself, not
without; he looked at landscape with the same preconception with which he looked at
his mirror. Not until a few years later did he take the great step from introspection to
extrospection with regard to landscape – and he did not use colours when he did.

 The role of river landscapes in the art of the great tree and forest painters of the
middle and second half of the century is comparatively small but not negligible.

 Cornelis Vroom started out with works that lead us back all the way to the time and
style of Elsheimer, Uyttenbroeck and their immediate followers; witness the 'oriental'
scene in Haarlem[37] which cannot have been painted much later than 1620. The more
boldly painted landscape in the former Bakker Collection in Amsterdam (fig. 109)[38]
with its Esaias van de Velde-like figures, the sharp blue-green of its trees, and the
river flowing parallel to the foreground across the entire picture, can be but little later.
The first date on any of the master's paintings is that of 1626 on the London landscape
(no. 3475; fig. 138) in which the small body of water is all but dwarfed by a magnificent
forest as it is in several other works by him;[39] the river landscape of 1630 in Schwerin
and some others in which water is prominent represent foreign or imaginary scenes,

but the Elsheimer pattern was revived most successfully and with a more distinctly Northern flavour in the poetic scenery of a panel recently acquired by the Museum in Karlsruhe (no. 2228, fig. 110).[40]

Jacob van Ruisdael's river landscapes with Dutch motifs likewise constitute but a small portion of his output.[41] There are a few rather early pictures with prominent sluices in which the river plays a minor role.[42] More important are some paintings with the river seen from a somewhat elevated standpoint, enlivened with boats winding their course backwards along wooded banks with bridges and houses from a broad foreground extension. These too, are early works; one is dated 1647,[43] another 1649.[44] In others the river, less broad in front, and still seen from above in various degrees, is itself spanned by a bridge connecting hilly banks on which tree groups are strongly emphasized. One, very panorama-like, is in Edinburgh (HdG 703, Ros. 431) and has just been found to be dated 1649;[45] another, of 1652,[46] in the Frick Collection (fig. 142), will occupy us later. The kind of river landscape that suggests the very breeze and smell of flowing water is rare with Ruisdael, but this painter of magnificent marines and beaches did not entirely neglect it. Most of the pictures in this group are small. One is in the National Gallery in London (no. 2565; HdG 704, Ros. 434); the other, representing exactly the same spot but seen at a somewhat greater distance, is in Detroit (no. 712; fig. 113).[47] While the London picture presents a calm, rather even surface with only moderate light effects, the one in Detroit fills its spacious vista with dramatic light-and-dark contrasts in sonorous browns and greens, reds and greys; sky and water are more agitated, and the picture is painted with brilliant brushstrokes and thick highlights. It shares this technical aspect with a picture in Berlin (no. 885H; HdG 680, Ros. 425), a work also comparable in its composition which is still clearly reminiscent of Salomon van Ruysdael's 'variations on the diagonal theme'.

In some other works by Ruisdael a large windmill takes over the role of the tree groups as the climax of the old diagonal; the colouristic treatment of these pictures – as of the *Haystack* in Detroit – often suggests the early Hobbema.[48] In a well-known picture now also in Detroit (HdG 181 and probably 190; Ros. 110; fig. 111),[49] the huge mill has been shifted nearer the centre, and the diagonal element has been all but eliminated; the date 1657 or 1667, formerly read on it, has come off, together with a false signature, in a recent cleaning, but the earlier of these two dates may well be accepted.

About ten years later, Ruisdael returned to a variation on this theme in the incomparable *Mill at Wijk bij Duurstede* in Amsterdam (no. 2074; HdG 105 and probably 183, Ros. 70; fig. 115). This picture is a good deal larger than those discussed above but it is characteristic of its intrinsic monumentality that, re-visiting the original, one is invariably surprised by the comparative modesty of its actual dimensions. Looking back at the three versions of the *View of Nijmegen* by van Goyen, Salomon van Ruysdael and Cuyp (figs. 100-102) or at Ruisdael's own *Mill* at Berlin (HdG 179, Ros. 109), one realizes that the basic composition has undergone little change; the upper

diagonal is clearly marked by the mill and the three masts, and the sailing-boat on the left forms the vertex of this and the lower diagonal, which is carried along the pales of the river bank to the right foreground. However, the turn that the bank takes here towards the centre of the frontal plane is more than a graceful flourish. As it forms a bay, it imparts to the body of water a powerful volume which water flowing by would never have suggested; its roundness is echoed in the majestic body of the mill (the actual size of which was vastly enhanced), and this in turn is echoed by almost palpably three-dimensional cloud formations; everywhere, diffuse and transitory qualities have been replaced by sturdy, compact, lasting ones. Needless to say, there is no tonal fusion of parts here; strong browns, greys and greens hold their own in magnificent equilibrium. This was Ruisdael's last, and greatest, contribution to the river landscape theme.

Almost all of Hobbema's river scenes are rather early works,[50] which means that they lag no more than a decade behind the earliest efforts of this kind by Ruisdael. He started in 1658 (Detroit) with pictures which actually show little influence of the older master, as far as their composition and details, such as trees, are concerned; these may hark back to Salomon van Ruysdael. However, the quick brushstroke, the fresh combination of green, brown, grey and red, the strong light contrasts, and the thick highlights of fine pictures in Amsterdam (HdG 253; fig. 114) and in the former Argenti Collection in London (HdG 254 and 283)[51] are indeed indebted to such paintings as Ruisdael's *Haystack* in Detroit (fig. 113). Both of them, still free variations of the double-diagonal system, must have been painted about 1660 – the very year in which Ruisdael testified that Hobbema had 'served and learned with him during several years'; this is true even though the main impact of Ruisdael's work on the younger master – complete with copies and closest emulation of his compositions – did not make itself felt until 1662 (and mostly in forest scenes proper).

River landscapes abound among Ruisdael's innumerable imitators, particularly Cornelis Decker but also Roelof van Vries, Claes Molenaer,[52] Thomas Heeremans and others. Most of these continue to paint variants to the old diagonal scheme right to the end of the century.

Adriaen van de Velde's river landscapes proper can be counted on the fingers of one hand but they include some veritable gems. In the *Ferry* of 1656 in Strasbourg (no. 182, HdG 345),[53] one of his earliest works, he places little emphasis on the water – as he does, in a different fashion, in the 'classical' *Ferry* of 1667 in Munich (HdG 344);[54] furthermore, both are inspired by Southern motifs. But the famous picture in Berlin (no. 922B, HdG 348) and the much less popular one of 1658 in Leipzig (no. 1068, HdG 350) are Dutch through and through and have few peers among landscape paintings of their decade. The painting in Berlin (fig. 116) places the observer at a considerable distance from the scene; water occupies the entire foreground, and beyond it, every object appears small in size but with a crystalline clarity such as we find in the master's beachscapes (see fig. 213): brown and white horses and sheep on

a fresh green meadow, distant houses, trees and church in a vast plain and under a vast sky of an almost Elsheimer-like blue with soft white clouds – and all these treasures mirrored to perfection in the still water. The composition is entirely independent of all traditional patterns, free but of perfect – again, one is tempted to say, Mozartian – harmony. The Leipzig picture of 1658 (fig. 112) has an entirely different structure. Here we stand quite close to the scene, so that the horse and the goat loom large against the light area where river and sky blend in a soft haze, while the two sailing-boats and their subtle reflections gently overlap the lightly wooded bank on the left –ꞏ unforgettable like the Berlin picture, and equally original in structure and subtlety of pictorial language. The last of such completely and enchantingly pure Dutch land-scapes by Adriaen van de Velde in which water plays any role is the one of 1661 in London (no. 2572; HdG 81).[55]

The importance of the animals in van de Velde's picture in Leipzig is matched and often exceedeed by those in most of Cuyp's mature river landscapes. Even the *View of Nijmegen* (fig. 102) contains an important group of cattle with their herdsmen; in the larger version of the same view in the Duke of Bedford's Collection (HdG 175)[56] they have become even more conspicuous and are joined by two elegant horsemen in the centre of the foreground. Still, it would be absurd to classify such work under animal painting. Cuyp's amazing ability to represent the moist atmosphere of the river, particularly at eventide when it is drenched in gold, is the decisive quality at least in some of his paintings. It is their greatest artistic asset, compared with which the wonderful rendering of the animals counts much less. There are a number of river views by Cuyp which belong with marine painting proper since in them it is the majestic appearance of sailing-boats which is most important; these will occupy our attention later (p. 119), as will his nocturnal river views (p. 181).

The Indianapolis *View of Nijmegen* (fig. 102) has already been briefly compared with representations of the same motif by van Goyen and Salomon van Ruysdael (figs. 100, 101). The old diagonal scheme can still be felt. But not only has it been significantly altered by the long strip of foreground which, continued in the boat, runs parallel to the picture plane, but it has also lost the continuity of design which had been imparted to it by the older masters' method of uniting all sections of the diagonal either by kin-ship of tone or of brushstroke or both. The entirely novel golden luminosity of Cuyp's picture was achieved by radically new means. Every detail is made to appear bathed in light by a specific method which is altogether beyond the scope of lines and strokes as such. All architectural details are produced by a mixture of dull-coloured glazes and flecks of light which give them a semblance of constant fluctuation and a glistening quality reminiscent of the sheen of living mineral. A few strong colours in the fore-ground – the vivid red of the standing shepherd, the bluish grey of the seated one, the black and brown of the cows – provide the necessary contrast with the extreme refinement of the liquid gold above the water and its reflection in the water. Contrast is also provided by the extraordinary grey clouds which, characteristically different

from Salomon van Ruysdael's diagonal, multicoloured, compositionally devised streaks, are here felt to be related to the composition as a careful supplement only, a re-evocation, as it were, of the moisture permeating the entire atmosphere as well as every detail of the architecture and staffage. But with all these refinements the composition shows absolutely no lack of convincing balance. Furthermore, the higher level on the right has been achieved in a soft, slow, terrace-like movement from the left; and significantly, the change from the softest vapour in the golden distance on the left to relative clarity on the right follows a similar terrace-like stratification of planes rather than the continuous 'graphic' method of unification employed in the diagonal sweeps of van Goyen and Ruysdael. Everything is much calmer and more deliberate here than in the pictures of the older masters; there is a hint, as often with Cuyp, of a Claude-like classicism, suggested to him by the art of Jan Both, whose golden atmosphere Cuyp must have studied most carefully (Both's career had already ended when this picture was painted) but which he restated on the basis of a deeper understanding of classical restraint than Both ever achieved (or aimed at).

This method of interpreting colour and handling the brush is as different from that of Jacob van Ruisdael and Hobbema as it is from the works of van Goyen and Salomon van Ruysdael and from the early works of Cuyp himself. True, those contemporaries of Cuyp share his return to structure and greater wealth of hues, as compared with the older masters of the thirties and forties. But the specific luminosity of Cuyp's palette rests on an increase in subtle optical observations made in a moist atmosphere and which are therefore not accidentally first discussed in this chapter; they were fully matched only by Holland's greatest marine painter, Jan van de Cappelle (and to a lesser extent in the winter and night scenes of Aert van der Neer). These achievements will occupy us later;[57] here we shall illustrate Cuyp's contribution with one more great river painting, which must stand for quite a number of others, even if we exclude those of unmistakably Italianate character.

That I am choosing for this purpose a landscape in an English collection is not an accident; the early love of British collectors for Cuyp's art has persisted tenaciously through many decades and many vicissitudes, and England is still richer in great Cuyps than any other country, including Holland. The picture in the National Gallery in London which I have in mind (no. 823, HdG 391; fig. 117) was probably painted in the middle fifties; it is of modest size and magnificently preserved.[58] This is a far cry from the van Goyen-like picture which Cuyp painted only a dozen or so years earlier (fig. 107) and this in spite of the fact that the arrangement and expanse of the river are practically identical in both pictures. Then, only a small *repoussoir* appeared in the left foreground which was otherwise left empty; the boats and fishermen, trees and house, were relegated to what practically amounts to middle distance size. Now, the *repoussoir* at the left has grown into a large boat with two sizeable figures; in the centre and on the right, five large cows are directly in front of us, together with their herdsman, and the steep bank is but a summarily indicated

backdrop for them. Instead of viewing the scene from a distance we are intimately drawn towards it (I studiously avoid the term 'involved in it' because it is always wrong) and indeed placed so close to it that we could hardly take it all in at one glance – a process which had been shunned by the masters of the thirties and forties but could hardly have seemed objectionable at a time when a deliberate construction of the picture area triumphed again.

Correspondingly, local colours were not drowned in an overall haze but recognized as 'building blocks' in a new ensemble – yet they are totally different not only from the multiple hues of the 1620's but also from those of Jacob van Ruisdael's contemporaneous pictures. Again every detail is made to appear bathed in moist atmosphere by a system of flecks and thin lines of white highlights strewn over darkish, sonorous hues in the foreground, set against dull-coloured glazes farther back and sometimes permeating the grey clouds as well; as in the *View of Nijmegen*, the result is an effect of constant fluctuation unobtainable by any more strictly graphic means, and of glistening moisture bound into the gold of the evening sun.

The impeccable use of this technique in the service of the Dutch landscape and Dutch animals is Cuyp's own secret; but the technique itself is not without precedent. As was already suggested, Cuyp was here deeply indebted to Jan Both, a fact that has always seemed obvious to me; indeed, it goes considerably beyond the golden tone and includes details like the specific form and colouristic treatment of the dune in the London picture and of the reeds and rushes in many other pictures as well. Willem Martin, who has written some fine pages on Cuyp, has gone so far as to suggest that Cuyp made a prolonged stay in Utrecht, where his father had been Bloemaert's pupil and where Jan Both lived from about 1642 until his untimely death in 1652;[59] one could strengthen this hypothesis by pointing to connections between Cuyp's style of the middle forties and that of older Utrecht artists[60] and the conversion of Cuyp to the Both-like trend, which apparently followed immediately afterwards.

Both's Italianate motifs were likewise often employed by Cuyp – as in the mountains of the famous river landscape of the Rotterdam Museum (no. 1133; HdG 397) – although Cuyp even then invariably looks more Dutch than Both. Nevertheless it is apparent that the classical language had already undergone a translation into a Northern idiom in Both's art; upon this Cuyp, who never went to Italy, was able to build his even more specifically Dutch – one is almost tempted to say, provincial Dutch – style in relatively remote Dordrecht. Nobody will connect the undeniable poetry of Cuyp's London *River* with the poetry of Claude, which is steeped in nostalgia for the classical past; nor is Both's poetry – that of an entranced traveller in Italy rather than of a resident – fully comparable. What binds the three together is the poetry of the golden sunlight itself; and Cuyp's pictures show loving observation of its essential qualities at every turn. However, it is probable that this poetic inspiration withered quickly – not so much because of insufficient optical nourishment but because of Cuyp's sudden affluence (1658). No dates exist after 1655; no costumes on

any of his pictures seem to post-date *ca.* 1665; those which indicate the latter date occur on pictures which show undeniable weaknesses; it is entirely possible that Cuyp did not paint at all, or – like Hobbema – only very occasionally during the last twenty-five years of his life. There is nothing to suggest that the great tenderness and poetry of the London *River* or the Indianapolis *View of Nijmegen* outlived the 1650's.[61]

WOODS

The painting of trees has a longer history than the painting of landscapes; the painting of woods has not. It is of the essence of a landscape artist that he should be able to see the woods rather than the trees. In Schongauer's *Flight into Egypt* the trees are admirable as such; in Dürer's woodcut of the same subject, greatly indebted though it is to Schongauer's engraving, it is the forest that counts.

In the genesis and development of the forest landscape Italy occupies a more important place than she does in other provinces of landscape painting; yet the climax was not to be hers. It is comparatively rare to find in any Italian representation of a forest the spontaneous effect of intimacy or awe which so many Northern painters have embodied in theirs. That this has nothing to do with the topography of either country is easy to see; the ridiculousness of Paolo Pino's ingenious explanation of the Northerners' special aptitude for landscape painting on similar grounds stands as a monumental warning.[1] The difference can probably not be explained without taking into account the sociological, and – in the case of the greatest forest painter, Jacob van Ruisdael – the personal factors that governed the output of works of this kind in Holland; and it would certainly be impossible to account for it by speculating on racial characteristics.

However that may be, 'landscape' for an Italian artist of the sixteenth century included woods perhaps even more compellingly than mountains. But needless to say, these woods were populated by gods or by privileged mortals of considerable religious or mythological significance; Italian wood landscapes of that period were predominantly the stages for Arcadian or heroic events (the fact that they were sometimes executed by Netherlanders should not be over-emphasized). They are not everyday landscapes; they belong neither in the realm of *genre* nor in the realm of personal moods. There is nothing in Italian landscape painting of the sixteenth century that can be compared with Gerard David's two amazing panels in The Hague (no. 843; fig. 118)[2] with their combination of rustic simplicity and shadowed seclusion.

Nevertheless, the forest landscapes of Titian and Muziano in particular exerted a very strong fascination and influence upon the Northerners, not only upon those from the Southern but also on those from the Northern Netherlands. But it is characteristic that Dutch artists such as Cornelis Cort and Hendrick Goltzius, who were deeply impressed by these Italian achievements, reproduced them in or adapted them

for works which were completely different in nature from those which represent their most incisive contributions to Northern landscape painting of the following century. Even in Flanders, the most strikingly novel features of landscape painting show little or no Italian background; witness the work of Rubens, with the characteristic exception of his mythological landscapes. Generally speaking, Italian influence on Dutch landscape painting was limited to the Mannerists; but whenever Dutch landscape artists emerged from their Mannerist chrysalis to take on their true imago, the last vestiges of Italy were soon left behind. On the other hand, their Flemish inheritance was of decisive importance.

This is not the place to dwell in detail on the problem of the exact origin of the art of those Flemish painters who contributed most to Dutch forest painting of the seventeenth century. Some of them are indeed inseparable from the Italian orbit, among them Paolo Fiammingo (Pauwel Franck; fig. 121) and Lodewijck Toeput (Pozzoserrato); others developed their art in close contact with the Italian and Italo-Flemish output, and this group includes several representatives of a younger generation such as Frederick van Valckenborch and Kerstiaen de Keuninck. But the master who became most important for Dutch painting, Gillis van Coninxloo, never saw Italy; and although he was certainly not unacquainted with works by Titian and Muziano (from prints) he was sufficiently independent not to become completely enthralled by them, and to arrive at a style significantly his own towards the end of his life. The result was that Karel van Mander, himself deeply influenced as a landscape painter by Coninxloo, could write towards the end of his own career that 'his style begins to find many emulators in Holland, and the trees, which were a bit arid in these parts, are starting to grow in the manner of *his* trees as best they can'.[3] Whether Hendrick Goltzius was in accord with this judgment we do not know; his landscape drawings before 1600 are perhaps more indebted to Italian than to Flemish sources; but his magnificent wood and tree studies, done in Haarlem while Coninxloo was painting his revolutionary forest landscapes in Amsterdam, are at least witness of a similar spirit[4] – the same as that which moved van Mander to write his hymns on Haarlem's woods about the same time.

We do not have to concern ourselves with Coninxloo's earlier works, in which the trees generally play a minor role (comparable with what we find in many compositions by his contemporaries in Flanders) and in which his landscape interpretation in general conforms with much of the older Flemish tradition of the Patenier-van Gassel type, even though he was already striving after greater unity of composition and colour. It was not until the end of the period of his comparative isolation at Frankenthal in the Palatinate (1587–95) that he shed many of the traditional schemes and became absorbed in a more intimate study of nature and particularly of trees – a study that laid the foundations for a truly new stylistic departure which culminated in the great forest scenes of his late years and also decisively affected the young Elsheimer. The old patterns had to be abandoned and nature consulted anew; he had to steep

himself in a new study of details before a new integration became possible. True, this was probably not accomplished without some help from outside; for instance, one may assume a renewed study of Cornelis Cort's engravings after Muziano and of such precocious graphic examples of Netherlandish forest scenes as Jerome Cock's etching of the *Temptation of Christ* after a drawing by Pieter Bruegel (fig. 119).[4a] But even this is relegated to a minor position when compared with Coninxloo's amazing *Forest* of 1598 in the Liechtenstein Gallery (fig. 122).

It has been pointed out that the composition of this painting – a cluster of trees near the centre enclosed by two recesses and counterbalanced by two lateral tree groups – shows a resemblance to paintings by Paolo Fiammingo such as the one in Berlin (fig. 121);[5] but the juxtaposition of the two works also reveals their basic differences with particular clarity. That of Paolo Fiammingo is a 'composition' in the narrower sense of the word, which was so repugnant to Goethe: an arrangement of details to fit a preconceived pattern; Coninxloo's is ostensibly a 'find' in nature, pulsating with the excitement of a new discovery. With Paolo Fiammingo, the (mythological) figures are prominently displayed in front of the landscape; with Coninxloo, the few tiny figures are submerged in nature. Fiammingo's trees conform; those of Coninxloo rebel. Fiammingo's distribution of light and shade is dictated by compositional convenience; that of Coninxloo seems to obey the laws of natural lighting, is less symmetrical and serves to bring out the individual qualities of the foliage without overemphasizing the details. Fiammingo's differentiation of foreground, middle distance and background is rather mechanical; that of Coninxloo is based on a free, lively interweaving of design, light and colour; enough to convey the feeling of natural variety and of interrelationship between the various strata of pictorial space, yet restricted in such a way as to guarantee the re-assertion of the picture plane and the equilibrium of the basic pictorial elements. Thus, the 'meaning' of the two landscapes emerges as belonging to two entirely different worlds. Paolo Fiammingo's canvas is essentially decorative, and in it nature is twice removed from independence because it echoes the figure groups and forms a pattern of conventionally conceived objects; in Coninxloo's panel, nature has been recognized as the main source of inspiration by giving it command over man and by abandoning most elements of traditional stylization. With this, the road was prepared for the advent of the art of Jacob van Ruisdael; and Coninxloo's landscape of 1604, likewise in the Liechtenstein Collection, those of 1600 and 1605 in Graz and Speyer, and others in Vienna and Strasbourg, fully corroborate his position as a great artist in his own right and as the greatest harbinger of seventeenth-century Dutch forest painting.[6]

It is occasionally suggested that there is something like a vacuum between Coninxloo and Jacob van Ruisdael as far as the depiction of Dutch woods is concerned, but this is true only in that no paintings of comparable depth of feeling and vision were produced during that stretch of nearly five decades. We would hardly be justified here to pass over this period in silence. While the host of minor imitators of Coninxloo can

be eliminated without many regrets and while the art of David Vinckboons, though of considerable quality, is somewhat rarely concerned with the rendering of the forest properly speaking,[7] a few words must be said about masters to whom the forest scene did mean a great deal and who – however different from each other – achieved considerable distinction in their work of this kind. They were evidently well acquainted with the works of Coninxloo and of other masters of Flemish extraction, at least in graphic reproductions (which were plentiful); in Utrecht and Amsterdam they had before their eyes the stately and powerful fir trees which appear in the pictures of Roelandt Savery in Tyrolean and other mountainous settings (fig. 282). But they are primarily important to us because they translated these experiences and influences into the Dutch idiom.

This is why the art of Gillis d'Hondecoeter (died 1638)[8] must hold our attention for a while. This little-known master appears to have moved to Amsterdam from Utrecht around 1610. He began under the spell of Coninxloo, witness his first known work, a pair of small upright landscapes of 1603,[9] and even the intimate little *Entrance to a Forest* of 1609 in the Lugt Collection in Paris (fig. 123), as well as a picture of the same year in Karlsruhe (no. 2125).[10] However, in these two paintings, in which, incidentally, the highlights on the foliage are much like those in contemporaneous works by Roelandt Savery,[11] the horizon is lower than before, and the treatment of the trees more delicate, with the colour contrasts considerably toned down. The important 'break-through' comes in works like the *Landscape with Elijah and the Widow of Sarephat* of 1613 in Antwerp (no. 828) and the *Landscape with the Healing of the Blind* of 1615 in Leipzig (no. 937, fig. 120). Here the 'romantic' tree trunks in the left foreground, their foliage, the shape of the reeds are still close to Coninxloo; also in evidence are Coninxloo's later compositional principles of interrelationship between massed foreground trees on one side and a somewhat lighter treatment of trees on the other. But it is evident that d'Hondecoeter has greatly reduced the firmness of this pattern and, in particular, opened up a much more spacious and sun-lit vista in the centre, even suggesting that this area is just as important as the foreground. We can follow the master's development after 1615 quite well since dated examples are not rare; a comparison of some of them with earlier works is highly instructive. Inevitably, the new freedom is also expressed in a less marked contrast of colours, even more so than in the pictures of 1609. While the foreground remains mostly a darker zone, the general tendency is now towards a blending rather than a contrasting of browns and greens, preparing the way for the tonal experiments just then being conducted by Esajas van de Velde and Seghers and later taken up by Molijn, van Goyen and others. A fine, greyish-brown tonality was achieved as early as 1618 in a picture in Kassel (no. 176) and continued into the twenties, when d'Hondecoeter, apparently stimulated by the success of Roelandt Savery, turned to painting many works in which animals were more important (Paradise, Orpheus etc.) and the landscape was often restricted to a more subsidiary role. But others are landscapes proper,

including a small one of 1627 (fig. 125)[12] in which a tall tree, standing on a rock in the centre, bends over gracefully to the right in such a way as to encompass, as in a window-frame, a light road leading along cliffs from the middle distance to the foreground. Monochrome tendencies, restrained by a predilection for warm orange-browns and subtle grey-greens, characterize the best of this later production.[13]

Like Coninxloo and Vinckboons, Alexander Keirincx (1600–52)[14] was born in Flanders (Antwerp) and moved to the Northern Netherlands later on; but he did so neither as a child (like Vinckboons) nor in his forties (like Coninxloo) but most probably at the age of about twenty-eight, when he seems to have become a resident of Utrecht;[15] by 1636 he had settled in Amsterdam. His picture of 1621 in Braunschweig (no. 182; fig. 124) proves that he began entirely in the style of Abraham Govaerts – who was his senior by eleven years – a style strongly dependent on Jan Brueghel and the earlier Coninxloo, though slightly more unified in terms of colour (light green). It was not until 1630 that he began to paint impressive forest scenes, in which he reached a stage somewhere between the true 'nature poetry' of the late Coninxloo and the more Mannerist, fantastic-decorative trend which the Flemings Frederick van Valkenborch and Kerstiaen de Keuninck had developed with the help of Italianate masters such as Paolo Fiammingo, Paul Bril and the earlier Coninxloo himself. Keirincx's *Forest* of 1630 in the Antwerp Museum (no. 902; fig. 127) with its wildly spiralling and contorted trees, shows a strong resemblance to landscapes by Frederick van Valkenborch and Kerstiaen de Keuninck, but instead of the Flemish-Italianate colour gamut of his predecessors (glowing, dark and multi-coloured) he tends increasingly to restrict his palette to a few predominant hues, mostly brown or green, and the characterization of his majestic trees betrays a more detailed study of the trunks and foliage which recalls the late Coninxloo's loving care for them. In landscapes of this period he consciously emphasized the difference of size between his huge oak trees and tiny, sometimes hardly perceptible figures.

Five years later, in his *Wood Landscape with the Temptation of Christ* of 1635 at Munich (no. 2059, fig. 128), the restriction in the colour gamut has been increased to produce a very light brown tonality which recalls contemporaneous efforts by van Goyen and Salomon van Ruysdael; the forest is less impenetrable, revealing wider spaces of ground which encompass much of the front and middle distance, but the trees are still powerful and of a dignified individuality, even though much less agitated and primordial. Finally, in 1640 (Braunschweig no. 183; fig. 126), the landscape becomes more open, the forest recedes to one side, and the light brown tone of ground and foliage blends with the soft rose of an evening sky, against which the fantastic shapes of the trees on the left stand out in a crisp, lace-like, almost 'surrealistic' pattern. The latest dated painting on record (1648) is an extremely fluffy landscape in Hamburg (no. 287) in which Flemish reminiscences have been reduced to a minimum, the trees are less gnarled, and the entire mood is more intimate.

The somewhat fantastic shape of gnarled, spiralling trees common to Keirincx's

paintings of about 1630 and perhaps most vividly illustrated by the picture of that year in Rotterdam recurs in most wooded landscapes by Jacob van Geel[16] – one is tempted to say 'with a vengeance'. His painting of 1637 in Braunschweig (no. 777; fig. 130) clearly shows his dependence on Keirincx, coupled with a slight influence from Hercules Seghers, and exemplifies well the grotesque vein and rather unharmonious and clumsy method of composition invariably employed by this artist, for whom authenticated dates exist only after 1634. His sharp greens and browns, with a blue-green distance, prove a strong Flemish affiliation. It is little known that the beginnings of Aert van der Neer belong in this group. His first dated landscape, once in the Wilstach Museum in Philadelphia (HdG 74; sold in 1954; fig. 134), was painted in 1635 and shows unmistakably that he was trained in the Keirincx tradition; its monochrome tendencies and relative openness point to Keirincx's output of the same period and perhaps also to some connection with Gillis d'Hondecoeter.[17]

The very protean Herman Saftleven[18] also deserves mention in this connection. He had been fascinated by tree motifs as early as 1627 when he did his Buytewech-like landscape etchings but in the thirties, when he had moved from Rotterdam to Utrecht, he turned to a trend inspired by Seghers and van Goyen. In the early forties he entered the field of forest painting, partly in conjunction with the 'Arcadian' Italianate trend, partly in purely Dutch terms. All these works show the distinct influence of Keirincx as is immediately evident from a landscape of 1643 in Braunschweig (no. 343), to which Poelenburgh contributed the figures, as he had done for Keirincx during the thirties. However, Saftleven did not turn to a really Dutch landscape conception until he had sought new inspiration from working with the etching needle. His *Forest* of 1644 (B. 27; fig. 129), in which the vigorous trunks, fresh foliage and clear sylvan atmosphere are accentuated by the upright format, has no Italian flavour at all and is one of the most important contributions to strictly Dutch forest scenes prior to Jacob van Ruisdael; it is rustic rather than Arcadian, and its trees, though still somewhat indebted to those of Keirincx, are sturdy and genuine samples from the Dutch countryside, a far cry from the twisted fantasies of a van Geel. Saftleven the painter followed suit with a few paintings of the same type, some of which betray the influence of Jan Both in their colour scheme; the most striking among them is the *Interior of a Forest* in the Brediushuis at The Hague (fig. 131), dated 1647, which is entirely given over to huge trees: only small fragments of sky filter through the dense foliage, and gigantic tree trunks, placed close to the foreground, dwarf the few figures.[19]

Closely related to Saftleven's forest landscapes are those by Simon de Vlieger (*ca.* 1600/5–1653), the great painter of seascapes (p. 115) and beach scenes (p. 102), and like Saftleven a native of Rotterdam. His stately *Entrance to a Forest* in Rotterdam (no. 1924; fig. 133) betrays the proximity not only of Saftleven but also of Cornelis Vroom, as do other works in Budapest (no. 387) and Stockholm (no. 682), as well as some of his beautiful etchings in which the great dignity of trees, trees of a less dramatic and more sober type, is combined with calm rivers and quite small figures

(B. 6; fig. 132). The dates are missing on these works[20] but we know that de Vlieger died as early as 1653. We are here confronted with those tree groups which, beginning in the middle forties, were again appearing in pictures by Salomon van Ruysdael, I. van Moscher and others to form a decisive element of composition in river landscapes and flat vistas.

In general one would have to admit that Gillis d'Hondecoeter, Keirincx and Jacob van Geel may be likened to a dead branch rather than a live shoot, while Saftleven's and de Vlieger's few works in this field remained an exception. In the case of Keirincx one might even say that his very 'progressiveness' – in the sense of his attempt to join van Goyen and Ruysdael in what was surely their most progressive contribution in the thirties, namely their tonality – militated against his excelling in his chosen field. Such light tonality simply does not mix with forest poetry or mystery. Coninxloo in his late years had given a magnificent 'preview' of what was possible in this field; to continue what he had started required a finer sensibility, a finer ear for darker harmonies than Keirincx possessed. Once more, the challenge was taken up by a man who was not to bring it to full fruition but who did hand it down in direct succession to its main champion. This man was the Haarlemer, Cornelis Vroom (ca. 1590/1–1661).[21]

Vroom started his pictorial career, so far as we know, in the early twenties; his first dated work is of 1626 (London no. 3475; fig. 138). It contains a wood as subsidiary to a river view as do other works attributable to this decade. But even here, a feeling for the compactness of a forest or grove, the feeling that it is more than a sequence of tree groups is clearly apparent as comparison with any of Salomon van Ruysdael's river landscapes will at once demonstrate (see figs. 97-98). It is noteworthy that the composition of this picture is quite similar to certain etchings and drawings by Buyte-wech[22] which, however, lack the characteristic density of Vroom's wood. In this one finds a kind of glossy darkness, a thickness of undergrowth which prevents the light from intruding into its shelter, contrasts vividly with finely lighted skies behind and by means of subtle highlights along the edges of stems produces a deep luminosity quite its own. All these elements appear in their full glory in pictures that must have been painted between 1630 and 1650. They were well characterized in Rosenberg's pioneering article on the master, whose catalogue of only twenty paintings indicates the extent to which he had been neglected by previous research. Among the new-comers is the beautiful *Forest View with Two Cows* in the Rotterdam Museum (no. 2141; fig. 137), undoubtedly a rather late work, not too far removed from the only fully authenticated and dated picture of the fifties (Copenhagen no. 224; dated 1651). A reflection of the art of Jacob van Ruisdael can be detected in such works but hardly ever with the effect of mere imitation, let alone a deterioration in technique. The majesty of the forest is magnificently visualized and conveyed in the Rotterdam picture; but in contrast to Ruisdael, the main impression remains one of serenity rather than drama or deep solitude; characteristic of this gentler, less heavy mood is

the very blue sky, which often appears in Vroom's finest works. In this respect, and in some details of brushstroke and treatment of light, Vroom is occasionally more reminiscent of the late Salomon van Ruysdael and his son, Jacob Salomonsz. van Ruysdael.[23]

The sapling that Cornelis Vroom had planted grew to glorious stature in the art of Jacob van Ruisdael. Rosenberg lists as many as 140 wooded landscapes by him. Although this amounts to less than a quarter of his entire output it remains true that, according to the same author, 'with the exception of the few and somewhat meagre efforts of the older Haarlem masters, Vroom and Dubois,[24] Ruisdael was the only one among the Dutch landscape painters of the seventeenth century who had a fully developed feeling for the beauty and the unique qualities of the forest', and that it is Ruisdael who has 'earned for all time to come the title of the painter of the forest'.[25]

Ruisdael's contributions to this theme begin in the 1640's, that is, very early in his career. In fact, it can be assumed that his very first serious attempts at painting, at the age of seventeen, led him first to the edge of the forest and afterwards into the thicket itself. A picture which Ruisdael can have painted only about 1645 (HdG 644 c; fig. 135)[25a] and which measures only 10 by 7¼ inches, is indeed a somewhat abstruse effort – as abstruse as some very early Rembrandts and equally pregnant of things to come. In the foreground, we are pulled rather violently into a short section of a road which in the middle distance leads to brightly lit open country, and the road is flanked by three gigantic, grotesquely over-characterized willow trees on the right and a group of oak trees, preceded by a thick diagonal trunk, on the left; a peasant leaning over a fence and an isolated dog form the very inconspicuous staffage. The format of the panel shows an exaggerated predominance of height over width; it is as though the youthful artist could not have imagined expressing the powerful growth of these trees in any other way. Obviously, man is very small in comparison with such giants; and it seems that at this time Ruisdael even experimented with making comparatively small forms of nature appear gigantic beyond reason, for a painting of 1646, now in Hartford (fig. 140),[26] shows a thistle and another solitary plant growing with such vigour before the eyes of the (supposedly Lilliputian) spectator that they cover up to four-fifths of the picture plane. The brown and grey-green colour gamut is still reminiscent of Molijn's tonality. The strange picture in Budapest (no. 263; Ros. 279a and pl. VIII), with its 'portrait' of a huge bare tree at the right and its unique emphasis on various birds painted by D. Wijntrack (they, too, look like portraits) may very well mark his next approach to the theme: still an awkward one, full of flaws in the setting but already full of tension and power, and intimating, in the tree groups of the middle distance, 'that characteristic density of growth which was from the beginning a hallmark of his style'. Over and over again in these early years we find paintings in which Ruisdael concentrated on huge and grotesque single trees, in the study of which he undoubtedly made use not only of nature itself but also of such magnificent examples as Esajas van de Velde's etching of a large oak tree (Burchard 5), Roelandt

Savery's forest giants such as appear in the famous etching Wzb. 1 (fig. 136) and
Lievens's brilliant woodcut (Rov. 63), the result of a renewed contact with Flanders
(*ca.* 1640–45).[27] After all, Ruisdael started as an etcher himself as early as 1645 (or
in 1646 at the latest) and was doubtless familiar with these works. Characteristic
examples of such primordial vigour in depicting a single tree are found in paintings at
Leningrad,[28] Nancy, Montpellier and Manchester, New Hampshire (fig. 209). Occa-
sionally he expanded the motif to form a group of such giants, and we have already
observed (p. 39) that in the process of doing so he encountered, admired and
emulated Rembrandt's etching of the *Three Trees* which he copied freely in his
painting of 1648 in the Museum in Springfield, Mass. (fig. 61).

As to matters of composition, the trouble which Ruisdael encountered in these bold
efforts seems to have thrown him back upon a careful study of Cornelis Vroom's
achievements, which he watched being accomplished in his native Haarlem. Some
works of 1646 are as closely related and as deeply indebted to Vroom as work of genius
can ever be to work of talent. In the picture of that year which was once in the L.
Janssen Collection in Brussels,[29] and in the undated but very similar and certainly
contemporaneous one in the Vienna Academy (no. 1368; fig. 141), the glossy darkness
of the trees and undergrowth, with the characteristic greyish-white highlights along
the edges of the tree trunks and the fine differentiation between the structure of solid
and light boughs, dense and lacy foliage; the ochre-brown and dark green hues; the
shrunken staffage are all features which were prefigured in the works of Vroom's
middle period. But more important, these works by Vroom taught the young Ruisdael
a good deal about sound methods of composition (so obviously neglected in the Buda-
pest picture mentioned above, and others) and also instilled in him a deeper under-
standing for that 'romantic animation of the landscape which had no place in the
everyday mood and the sober pictorial objectivity of van Goyen's circle but which
Vroom, in his solitary light-dark forest and hill landscapes, had expressed in a refined
and personal way'.[30] However, these paintings by Vroom still show a certain strictness
and sharpness of detail and a fine, somewhat prudish delicacy. Those of Ruisdael's
forest landscapes which show the young master profiting from Vroom's works
immediately show him to be the superior artist. The ground area (usually dominated
by rather straight horizontals and diagonals in works of this period by Vroom) is
beginning to assume an intensely diversified life of its own, with little ups and downs,
and studded with brilliant suggestions of rough texture in the soil, highlighted grass
or weeds; the trunks are more supple, bending more freely and related to each other
more naturally; in the treatment of their crowns one observes a host of brilliant
impasto flecks imposed upon the glaze which suggests the deeper recesses of the
foliage, as well as a most subtle blending of their extreme points with the surrounding
atmosphere, in strong contrast to the crisp precision with which Vroom's foliage
stands out against the sky. It has already been pointed out (p. 70) that late landscapes
by Vroom reflect his deep appreciation of Ruisdael's new discoveries.

The influence of Vroom upon Ruisdael did not altogether disappear after the younger artist, while remaining a resident of Haarlem, embarked upon his many wanderings through the Netherlandish provinces and the neighbouring German territories. But the obsession with the single tree as an organism with its own character, growth, dignity and awe-inspiring majesty (which had occupied him before in some almost grotesque attempts) reasserted itself to the point where he abandoned Vroom's and his own forest approach, only to return to it on a higher level. In a painting of 1651 (HdG 702a, Ros. 276) two great oaks again became the real heroes. Such powerful trees, alone or in groups, now appear more frequently in commanding positions, surrounded by smaller trees, undergrowth and fallen trunks massed on one side of the picture plane and counter-balanced on the other by a combination of motifs such as other tree groups, rivers, farms, towns, dunes or larger hills.[31] A beautiful example is the picture of 1652 in the Frick Collection in New York (HdG 525, Ros. 393; fig. 142),[32] in which the massive oak on the left combines with the dunes to which its roots cling precariously, other trees and the shaded recess of the road, to form a powerful niche-like structure, which contrasts with the more airy treatment of the other parts of the picture, including its staffage. In other paintings of this phase, the main tree itself, or a subsidiary group, may reach over to the other side of the picture in order to soften the sharpness of division.[33] It is here that Ruisdael's monumentalization of the Castle at Bentheim fits in: the motif, rather unimpressive in itself,[34] was blown up into a majestic, almost fairy-tale structure, situated on a high wooded mountainside, its imposing mass enhanced by smaller elevations or trees on both sides of the foreground. Such is the case in the magnificent, often illustrated example of 1653 in the Beit Collection (HdG 25, Ros. 18); it significantly followed by two years the version in Sir Hickman Bacon's Collection (HdG 24, Ros. 15)[35] in which the same castle had been but a subsidiary and in fact rather negligible background motif.

The point at which intense study of the individual tree led Ruisdael back again to the representation of the forest proper can be rather accurately fixed and illustrated by the painting in the Fogg Art Museum (HdG 538, Ros. 275, fig. 143).[36] Here, a giant tree to the left of centre still dominates its surroundings but at the same time the silent grouping of other heavy oaks in the stagnant water foreshadows the awesome mood of a later stage of development. This picture (which still betrays a few reminiscences of Vroom) must have been done shortly before 1653 when the artist painted the beautiful *Forest Entrance* in Amsterdam (HdG 440, Ros. 256, fig. 139), to which Nicolaes Berchem contributed the staffage. Here none of the tall trees dominates the picture plane; there is an amazing variety of growth and of texture; it is as though a veritable host of new pictorial ideas had precipitated themselves upon the artist and been fixed on the panel in a wonderful equilibrium of richness and restraint. The lively play of light in the middle distance penetrating into the foreground along the deeper tones of the tree group on the right, the crispness of the plants in the left foreground

in contrast with the fine observation of aerial perspective in the distance, the tender afternoon light in the sky and its reflection in the water – all combine to make this one of the most successful masterpieces of Ruisdael's middle period; no wonder that Berchem surpassed himself in the figure of the shepherd, the cows and the wondering and wonderful black pig in the foreground. A look back from here to the early forest scenes of *ca.* 1646 reveals a striking growth in originality, mastery of the problems of form, and unity in diversity.

It is a matter of personal opinion whether one prefers to such intimate scenes the more monumental, more majestic works which immediately follow and form a close parallel to the Bentheim pictures of this phase and to the new emphasis on mass and contrast which characterizes the fifties in general. It is the development well described by Rosenberg, who says that 'Ruisdael, by pushing back the clusters of trees, discovers the possibility of defining clear contours, accentuating the effects of mass and contrast, and eventually of achieving greater freedom in rendering space'.[37] Famous landscapes in Mulhouse (HdG 492, Ros. 349) and, particularly, in Worcester College, Oxford (HdG 121, Ros. 89) and Vienna (HdG 521, Ros. 384, fig. 145) exemplify this trend. The forests represented in them are now seen from a 'safe' distance, not in intimate proximity as before. The giant oaks are bound together in stillness and form the backbone of a solid, in some cases austere structure in which the incisiveness of a unifying outline against the sky plays an overpowering role. The colours are likewise conceived in terms of more strongly contrasting masses, mostly dark brown and dark green, with rather substantial grey-white highlights providing well-planned relief. But with this structural severity, which in the hands of a minor artist could easily have degenerated into pompous rhetoric, Ruisdael combined a dignity and poetry, a never-wavering sense of pictorial truth and artistic honesty which make the best of these works outstanding masterpieces of landscape painting of all time – midway, one is tempted to say, between the 'Dutch' and the 'universal'. We have here reached the realm of the two versions of the *Jewish Cemetery* (fig. 280), to which this group is most clearly related; to them we shall return in the chapter on imaginary scenes – since that is what these truly exceptional pictures really are. Ruisdael had by now settled down in Amsterdam; the more rarefied atmosphere of the metropolis corresponded well with the stately character of this phase, which approximately parallels that of Rembrandt's 'classical' landscape in Kassel (fig. 276) and the Washington *Mill* (fig. 277).

During the next decade or so we observe how the relatively compact wall of trees is again invaded by space and how the spectator again steps closer to the grandeur and vastness of the oak forest. Paintings like that in the Earl of Crawford's Collection (HdG 488, Ros. 336) prepare the way: a road winds into (rather than toward or along) the thicket, allowing a glimpse of background territory to emerge in the light (this motif was soon to be exploited by Hobbema), and space begins to envelop and vault the trees, which become less wall-like and less remote – again an older idea taken up on a new level. At first, this loosening up, characteristically tying in with some new

ventures into the open country, is incorporated in pictures with the somewhat more every-day, serene motifs of a watermill and roads with busy people, lighted by brilliant sunshine (Amsterdam no. 2077, dated 1661,[38] HdG 145, Ros. 93; fig. 144). But soon, more austere views predominate again, frequently combined with the waterfalls which he loved to depict at that time; and presently we are confronted with some of the most celebrated works by Ruisdael, the representation of giant oaks skirting, or emerging from quiet swamps or ponds in deep forest solitude. Rosenberg speaks here of the 'revival of the heroic style',[39] and we remember that similar motifs had indeed occurred in fine pictures of the early fifties (fig. 142); but looking back at them now, one cannot help feeling that they were but the germ of what blossomed into full glory in the middle and late sixties. 'He now attempted to synthetize the opposites: to combine powerful forms seen from close by with open spaces', and the tremendous challenge was answered with a glorification not only of open spaces such as the great *Mill at Wijk bij Duurstede* (fig. 115) but also of the deep recesses in which oaks cover the picture plane almost to the upper border and yet enclose great volumes of dark areas, at the same time suggesting other worlds of sunlit space beyond. The essentially decorative and somewhat grandiloquent busyness of Savery[40] and Keirincx is here replaced by a calm grandeur which rests primarily on economy of material, firm structure and impeccable planning but lacks all artificiality, and bespeaks sustained incorruptible observation of nature. In the Berlin *Swamp* (HdG 444, Ros. 264) we are still at some distance from the forest which nonetheless, in comparison with that of the superficially similar work of the early fifties in Oxford, permits the lighted middle distance and background spaces to permeate it instead of sealing us off from them. But the famous painting with the same motif in Leningrad (HdG 508, Ros. 313) and the somewhat calmer, and perhaps even more striking *Pool* in London (no. 854, HdG 481, Ros. 320; fig. 146) allow us to advance very close to the ground plane, to face nature as intimately as we wish and dare, and yet belong to a realm in which nature has been cleansed of all fortuitous matter.[41] The colour gamut of these and similar works is in keeping with their profoundly elevated mood; the deep browns and greens with silvery highlights are now increasingly supplemented by the yellow nuance of an approaching sunset which is occasionally contrasted with a stronger blue.

In the early seventies, a kind of intimate Rococo followed upon this magnificent Baroque; with its scintillating brushstrokes, the landscape in Hannover (no. 341, HdG 592, Ros. 303; fig. 147), which is also more open in its spatial setting, is a fine example of this new phase, and I wonder whether the quiet *Pool* in London (fig. 146) does not mediate between the 'baroque' and the 'rococo' group rather than precede the former.[42] It was a short epilogue. I agree with Rosenberg's interpretation of Ruisdael's last style as a decline.[43] The one dated example of 1678 (Dublin no. 37, HdG 456, Ros. 404; fig. 148) with its thinning trees, rather lifeless mountains, pretty swans, profusion and confusion of directions, does not admit of any other explanation;

and the same is true of the pictures with alleys and country vistas, in which sapless orderly trees, meticulously painted brush-wood and elegant mansions provide appropriate surroundings for fashionably dressed, rather lifeless figures.[44] It is almost impossible to say how much Ruisdael painted during the last fifteen years or so before his death in 1682; the number of works attributable to that period is not large but may have been decimated by neglect. Be that as it may, it remains an unhappy fact that the great master outlived himself as did some other artists of that era.

The only master whose wood landscapes bear comparison with those of Ruisdael[45] is Meindert Hobbema (1638–1709),[46] although it must at once be added that this great painter never really vied with Ruisdael as an interpreter of forest solitude and mystery.

There are almost no Hobbemas without trees, and only a handful of his pictures in which trees with rich foliage do not play a predominant role. This is in utter contrast with his teacher, Ruisdael, whose panoramic views, winter landscapes, beaches and seascapes constitute a very important section of his total output. Hobbema was a specialist, with all the virtues and flaws which that term implies; only a few of his river landscapes and his *Avenue of Middelharnis* appear in other chapters of this book. His versatility within this restricted field is nevertheless worthy of admiration. He can be formal and intimate, brilliant and simple, gay and subdued; and in the midst of what sometimes looks like routine production he can surprise by a stroke of genius. The old myth that he abandoned painting at the age of thirty – that is after procuring for himself through his young wife the position of wine gauger for the city of Amsterdam – has at long last been exploded but it is true that with one spectacular exception (the *Avenue of Middelharnis* of 1689, fig. 47), his greatest works were all painted in the 1660's. Hobbema died as late as 1709; whether during the last twenty years of his life his artistic faculties declined in the same general way as those of Ruisdael and de Hooch we may never know, since we cannot attribute one single painting to the period after 1689 with any degree of certainty.

Hobbema's earliest paintings are river landscapes (p. 60). Trees already play an important part in these works, and they significantly increase in stature from 1658 (HdG 255, Detroit) to 1660.[47] The same metamorphosis can be observed in wood andscapes proper, from slender trees reminiscent of Salomon van Ruysdael in the very early landscape of the Corcoran Gallery in Washington (HdG 139) to the more robust ones of the picture of *ca.* 1660/1 in Munich (HdG 40) and the already very typical *Wooded Road* of 1662 in Philadelphia (HdG 46), which was done at the end of a short but intense period of outright imitation of Ruisdael by Hobbema.[48] As Rosenberg pointed out,[49] Hobbema's *Swamp*, once in the Liechtenstein Collection, now in the Castle Rohoncz Gallery (HdG 264; the same composition, dated 1662, HdG 132, now in the Melbourne Gallery), is an outright copy after a Ruisdael etching (B. 4) and a whole series of *Watermills* by Hobbema take their direct origin from Ruisdael's painting of 1661 in Amsterdam (fig. 144). Some of these are dated

1662; I am reproducing here the less well known but very characteristic painting in Toledo (fig. 150),[50] undated but undoubtedly of 1662 also, as is evident from its dark brown, somewhat glossy appearance which is characteristic of this short phrase only. Rosenberg has also shown[51] that Hobbema's famous *Watermill* in Amsterdam (HdG 66) makes more assiduous use of a drawing by Ruisdael than of his own study of the motif.

With these pictures Hobbema ventured into larger sizes and more ambitious compositions, soon without support from Ruisdael. The beginning of the glorious 'opening up' which was to become a hallmark of Hobbema's art came in the year 1663 and is well documented by dated pictures in Washington (HdG 171), Brussels (HdG 127) and the Beit Collection (HdG 136), as well as by the undated masterpiece in Rotterdam (HdG 138) which is certainly of the same year. The Washington Landscape (fig. 151) is a far cry from the lightness of the earliest works and the heavy stateliness of 1662; its open freshness and greenness is almost closer to the former than to the latter but shows a very superior diversity in the organization of space. The road, starting in the centre of the foreground, winds inwards to the pond in the centre and to the forest entrance on the left; but this in turn finds a gentle, curving response in a smaller group of trees on the right which grow on the slope of a higher path leading back and out to the right foreground and opening up a vista of distant fields. Everything here sways to and fro in soft rhythms and, at the same time, there is an almost breath-taking diversity of greens in the crisp, yet quickly and brilliantly painted foliage, ranging from a very light grey-green (with a bluish shimmer) and yellow-green to darker greens of all descriptions, together with brown glazes.

In 1664, the crispness of the foliage is still noticeable but well on its way to even greater freedom in the magnificent *Watermill* of the ten Cate Collection (HdG 86; fig. 152).[52] When one thinks of watermills one thinks of the mature works of Hobbema rather than of Ruisdael, from whom Hobbema derived the use of the motif. Nobody has equalled him in the way in which he combined its gentle busyness with commanding clusters of trees and a sunlit vista of roads, distant fields and the yellows and light greens of the background. The few human figures, mostly from his own hand, blend well in design and colour scheme. In the picture of 1664, the bluish grey-green of the year 1663, which was still very noticeable in the famous version of the same motif in Amsterdam (no. 1187; HdG 66), has gone from the highlights of the foliage but a certain crispness is still present and separates it from the later watermills in Chicago (HdG 71), Indianapolis (HdG 87, 1667) and elsewhere. The Chicago picture (HdG 71; fig. 153)[53] shows the watermill at a greater distance: not as the main subject as in the famous Amsterdam paintings, nor with the falling water conspicuously framed by houses and a larger cluster of trees in the centre as in the ten Cate picture, but merging with the landscape of the middle distance in a brilliant light which extends to the background in the centre and on the left, and filters forward even through the large tree group. This new arrangement, which appears in almost identical form but with

perhaps even greater freedom in a picture of the Wallace Collection (no. 99; HdG 85), goes hand in hand with an even greater brilliancy of brushstroke which renounces the crisp, relatively concise foliage of the earlier sixties and replaces it with more quickly applied forms of a decidedly less descriptive, more generalized nature; at the same time, trunks and branches take on a more wavy appearance, are more brilliantly highlighted and seem to be interlaced in a more spacious pattern.

We can observe the same change of technique, combined with an opening up of composition, in Hobbema's other works between 1663 and 1667–68. In the Washington painting of 1663 (fig. 151) we witnessed the very beginning of an 'opening up' but this was still mainly restricted to the foreground and a small fraction of the distance on the right. A painting of 1665 in the same gallery (HdG 121) and the picture with the same motif in the Frick Collection, also dated 1665 (no. 744, HdG 42; fig. 154), seems to expand into space with much greater ease; it does not so much open up the foreground as it does the middle distance and background where the main light centres on road, hut and trees and whence it radiates back to the house on the left. The colour gamut now consists of a very lively yellow-green, a warm brown, soft greys and dull reds. The brushstroke of these works is of an extraordinary freedom; one is here reminded of both Hals and Rembrandt because of the skilful blending of glazes, impasto and *alla prima* technique which contributes so much to the total effect of spaciousness, transparency and a near-impressionistic sparkle.

Among the many masterpieces of the late sixties the *Forest Pond* in Oberlin (HdG 218; fig. 156)[54] deserves a special mention. Apart from the painting at Buckingham Palace which has exactly the same dimensions (HdG 78), it is the only work dated 1668, the year of Hobbema's portentous marriage. In character it differs somewhat from most other paintings of this period in that it suggests a greater intimacy and restraint. In a sense there is a little more here of Ruisdael's solitude, yet in forms which are distinctly Hobbema's own. The sunlit field in the middle distance, the light radiating softly from there towards the foreground, the brilliant abbreviation of twigs and foliage, the wavy trunks and branches, the mellow browns and greys are all typical of Hobbema; but in comparison with the watermills and other motifs of this period, including the picture at Buckingham Palace, there is here a composure and a cloistered stillness which are intimately connected with the distribution of less spectacular trees, the calm pond with the subtle reflection of trees and sky, and the inconspicuous road and figures, and which can be called 'classical' in a sense rarely applicable to Hobbema's works.

When Rosenberg wrote his excellent article on Hobbema thirty-six years ago, the gap between the dates of 1668 and 1689 was still undocumented. Realizing that to assume a complete suspension of Hobbema's artistic activity between these two dates was not to be recommended he suggested a date 'around or after 1670' for a number of pictures, including all of Hobbema's works in upright format such as the de Ridder painting (now in Washington, HdG 28). In this painting he observed 'a degree of

transparency also in the upper parts of the trees, an exaggeration of specific Hobbema effects and a reduction of the corporeality of the landscape which are difficult to imagine in the same year as that in which the Buckingham Palace picture was painted' (1668).[55] Recently discovered dates corroborate his statement. While the date 1670 (or 1672) which appeared on the (upright!) *Water Mill* once in the Weber Collection must, together with the authenticity of the picture, remain debatable until its re-appearance,[56] we now have an unquestionable date of 1671 for the *Castle of Brederode* in the London National Gallery (no. 831; HdG 6, as dated 1667; fig. 155) and a probable date of either 1681 or 1689[57] in the *Landscape near Deventer* in the Bridge-water Gallery (HdG 77, without date). The former, while still a brilliant performance, contains some undeniable elements of decline. The happy equilibrium between fidelity to natural form and pictorial brevity which characterized the work of the late sixties has been disturbed: the trees are beginning to look somewhat schematic, the twigs and foliage too sketchy and yet somewhat dry, the trunks less pulsating with growth. The landscape is almost too open now, and the distribution of darker and lighter areas lacks the variety and originality of the sixties. The ducks in the foreground are too conspicuous. It is not difficult to find similar features in the upright *Watermill* in Washington (no. 60, HdG 28, ex de Ridder Coll.) adduced by Rosenberg; some other works can be placed in the same group, including the undated *Forest* in New York (no. 50.145.22; HdG 119) with its strong red and pink accents, its greys and very cursory treatment of the foliage and its blue distance.[58] If I illustrate here the *Water-mill* in Cincinnati (once in the Oppenheimer Coll., HdG 75; fig. 149),[59] a small sketchy canvas in upright format, it is because I feel that the violent contrast between the huge size of the trees (cut by the upper edge of the picture) and the mill seems to suggest something of the same sophistication of design that characterizes the *Avenue of Middelharnis* (fig. 47); the picture might well be dated to the eighties rather than the seventies. The painting of 1681 or 1689 in the Bridgewater Collection is a somewhat topographic town view with hardly any trees; it would be precarious to draw con-clusions from it with regard to the date of typical Hobbema compositions.

In contrast to Ruisdael, Hobbema had but few followers, among whom Balthasar van Veen and Isaak Koene[60] seem to have made a special effort at close imitation; his real progeny arrived in England in the eighteenth and nineteenth centuries. The many artists who settled down to a comfortable and possibly even profitable activity in the shadow of Ruisdael did most of their work during the late fifties, the sixties and early seventies, still a period of considerable demand for landscapes with Dutch motifs. This roughly corresponds to the period of Hobbema's own greatest productivity. Around 1675, when his work had attained a wider reputation – how wide, we really do not know – the situation was quite different. A list of dated Dutch landscape paintings after 1675 clearly indicates a rapid decline, in quantity as well as quality, with regard to landscapes with typically Dutch motifs.

But here we have run ahead of a few fine, if desultory, examples of that section of

Dutch painting with which we are concerned in this chapter. They belong primarily
to the sixties and seventies and are works of artists who did not specialize in this field
nearly as much as did Hobbema or even Ruisdael. On the other hand, they are more
independent and therefore more interesting than are the works of typical Ruisdael
imitators.

We have encountered Philips Koninck before as a painter of trees: they occur in
his 'one wing' panoramas, sometimes in solo roles (G. 10) or in small groups (G. 21),
and occasionally also with a more elaborate forest effect (G. 3). Forest paintings
proper, in which the painter's favourite panoramic theme is completely overshadowed
by massive tree groups, are relatively rare and are found in his late period only, in the
sixties and seventies.[61] I am illustrating here the very large picture in the de Young
Memorial Museum in San Francisco which had remained unknown to Gerson (but is
identical with his no. 99; fig. 157); its motif is entirely Dutch and more closely related
to the spirit of Jacob van Ruisdael and his immediate circle (particularly Jan van
Looten) than most other works of this group.[62] Still a little later seems to be the *Forest
Glade* in the Loyd Collection at Lockinge House (G. 30 and pl. 13), a thoroughly idyllic
work, entirely different from the mood of the San Francisco picture and quite obvi-
ously the result of a strong influence from similar works by Paulus Potter and Adriaen
van de Velde. There are only few paintings by Paulus Potter (1625–54) which can be
called landscapes proper and in which animals do not at once 'steal the show'. This
does not mean that landscape was neglected in his finest paintings; the freshness of a
crisp afternoon light flooding a green pasture or striking a willow tree was captured
by him with loving care and admirable results. But from the point of view of a true
predominance of landscape, the *Departure for the Hunt* of 1652 in Berlin (no. 872A,
HdG 161; fig. 158) is rather exceptional. Potter's trees are calm, their growth straight
without being schematic or overly thin, even though one can sense something of the
lack of complete co-ordination which characterizes so many of this artist's pictures.
The general effect is that of a peaceful idyll, of a wood (apparently the Bosch near The
Hague) viewed as a work of pure, pristine perfection, untouched by any suggestion of
being the sounding board of human moods or passions – as utterly different from
Ruisdael's woods as one could imagine.[63]

From here it is only a small step to Adriaen van de Velde's few forest glades such as
the incomparable panel of 1658 in Frankfurt (HdG 337; fig. 159; a very similar
picture in London, no. 982, HdG 207, also of 1658). Undoubtedly inspired by Potter,
van de Velde far surpasses him with regard to compositional skill and colouristic
refinement. The idyllic touch of this marvel of tender and slender verticality has been
enhanced by the spectator's distance from the trees seen across the little creek, by the
peaceful group of grazing, drinking and resting deer, and by the utter absence of any
allusion to a hunt. The fresh green of the trees turns into a most delicate grey-green
in the highlights, similar to the dominating tint of the strips of grass in foreground and
middle distance with which the subtle yellow-brown of the deer blends to perfection;

and the morning sky is of a blue-white combination which evokes the memory of Elsheimer and the late Bril at their very finest.[64]

Some perfectly genuine northern trees are found in the paintings of southern scenes by artists such as Berchem, Wijnants and others; they do not add anything of great importance to the present inquiry. However, there is one painter of Italianate landscapes who gave us a small number of strictly Dutch scenes in which trees play a predominant role. I am thinking of Jan Hackaert (1628–after 1685).[65] Some of his works, such as the rightly celebrated *Alley* in Amsterdam (HdG 32; fig. 160) are views of roads in which tall, slender but stately aspens, ashes and beeches reach up to the upper edge of the picture plane, which cannot contain the wealth of their crowns; they often skirt along the gentle curve of a body of water and line roads on which gay parties of gentlefolk return from the hunt or ride in elegant carriages. These works were consistently done in upright format, which brings out the slenderness of the stems to perfection, and are drenched in the golden light of an evening sun. No less impressive are some pictures in a second group which represents stag hunts in the thick of a forest. In the example belonging to the Detroit Institute of Arts (HdG 28, fig. 161)[66] the picture plane is completely filled with trees; as in some of Herman Saftleven's works (fig. 131), only a suggestion of sky penetrates into the dark of the wood which admits additional light only in a section of the foreground where the stag is being overwhelmed by dogs near a pond. The trees (ashes?) are of imposing size; those in the foreground show only the very beginning of their crowns near the upper edge, above the glistening trunks; they show the unmistakable influence of the late Jan Both (see fig. 306). While little or none of Ruisdael's forest mystery is captured – or rather, aimed at – in these pictures, they are nevertheless fine examples of the representation of the very innermost recesses of the forest and, as such, perhaps unexcelled until the advent of Gustave Courbet.

CHAPTER II

Winter

I N many ways, the Winter Landscape is the Dutch seventeenth-century landscape *par excellence*. There is here no competition from Italy or France, and little from Flanders, although Flemish *sixteenth*-century antecedents were of decisive importance in its genesis. There is not even much competition in later centuries, with the exception of some works by Caspar David Friedrich, Claude Monet and a few others. The number of those who, when asked to name the finest in winter landscape painting, will mention artists other than Avercamp, van Goyen, van der Neer, van de Cappelle or Jacob van Ruisdael must be small – unless it be Pieter Bruegel, of whom the seventeenth-century masters could indeed have said what Mozart is reported to have said of Philipp Emanuel Bach: 'He is the father, we are the boys.' But the boys were a pretty independent lot.

Fortunately the seasonal restriction does not entail a dearth in variety of moods or even narrative features; the range of Dutch winter landscapes extends from serenity to gloom, from enjoying a game in brisk sunshine to being swept into loneliness by a fierce gale.

The scenery is almost exclusively Dutch; there is only an occasional example of an Italianate or a strictly imaginary view. But with regard to the Dutch scene, the output was of surprisingly large proportions. To the present writer, who once lived through an entire Dutch winter without having a single chance to put on his skates, it might seem that seventeenth-century winters were more severe than of late, or else that its painters were eager to represent winter pleasures – which by far outweigh other winter aspects – because they were comparatively rare. However that may be, since there are still many hundreds, perhaps some thousands, of such pictures in existence, their number must have been very imposing in relation to Holland's seventeenth-century population. It is another example of an extraordinarily high patronage by a large section of the people – even though they did not have to pay high prices for their treasures. It stands to reason that here, too, our survey must be restricted to the leading masters and their most accomplished followers, to the exclusion of many whose works still partake in the high average excellence characteristic of Dutch seventeenth-century art as a whole.

Winter landscape painting[1] began in the workshop of the Limburg Brothers some time around 1415. The *Chantilly Hours* calendar is one of those works of art that open a new epoch, and its *February* is no exception. While the traditional 'labour of the month' motif (people warming themselves at the fire) has not been slighted (but rather revelled in with an acute sense of sympathy and good humour), it is already the winter landscape itself which matters most: the sheep huddling together in the fold, the peasant driving his mule to market, the distant village and, above all, the snow on the

ground and on the roofs set off against the leaden winter sky. Even a little earlier, probably about 1405, we find the first renderings of games played at winter time; a snowball fight is represented in the *January* fresco of the Torre dell' Aquila at Trent. The allegorical quality of these and a few other examples was never abandoned until the middle of the sixteenth century, and was to subsist long into the seventeenth, even though on a small scale. Pieter Bruegel's greatest winter landscape, the unforgettable one in Vienna, is either 'a Season' or, more probably, 'a Month' (or 'Two Months'). It corresponds closely to the master's other 'World Panoramic Landscapes' in that it combines the unfamiliar with the familiar, the grandeur of Alpine mountains with the quiet charm of a Flemish skating rink, the sweep of wide spaces with the sharply observed foreground detail, the traditional allegory of the preparation of the feast with the insouciant everyday activity of hunting and skating – all of this united in one of the greatest masterpieces of composition the sixteenth century has left us. In other winter landscapes, it is the biblical story that fitted into – or gave rise to, nobody could safely say which – the seasonal aspects that make these works of Bruegel dear to us. And in the process of shedding the vestiges of traditional limitations, of concentrating exclusively on the everyday aspects of winter activity and winter scenery, it is again Bruegel who assumed the decisive role. Even though the evidence is not completely unambiguous with regard to some existing works there is little doubt that such paintings were done by him. The *Skating at Porte St. Georges at Antwerp*, known through an engraving of 1553 (or 1559),[2] was done after a drawing rather than a painting; but the *Skaters and Birdtrap* in the Delporte Collection in Brussels, said to be signed and dated 1565, is either an original by Bruegel or goes back to a Bruegel painting rather than a drawing; and although this is still a 'world picture' *qua* subject matter, it prepares the ground for the complete secularization and de-allegorization of the winter landscape which was achieved by Bruegel's successors.

Among these, Lucas van Valckenborgh, Jacob and Abel Grimmer, and Bruegel's sons, Pieter and Jan, are most important; but there were many others who participated in this development, which cannot be related here in detail. Suffice it to say that there is a continuous pictorial trend leading directly towards two early seventeenth-century Dutch masters who were in close touch with the Flemish scene: Hendrick Avercamp and Adriaen van de Venne. Their dates are not particularly early, yet they remain indebted to the Flemish tradition and represent but a secondary trend in Dutch seventeenth-century winter landscape, in spite of the fact that one of them, Hendrick Avercamp, was the first – and the only important! – near-exclusive specialist in this field. They never quite abandoned a conception likewise adhered to by their Flemish forerunners and, in the last analysis, still inherited from Pieter Bruegel: namely that such a picture is not so much a unified transcription of an aspect of nature as a pictorial arrangement which allows for the accumulation of many interesting details. True, these details are no more connected with religious or allegorical subject matter; but they are still brought together in such a way as to 'make up' the concept of

winter in terms of bare trees, snow-covered roofs, skaters, golfers, noblemen, peasants: in short, in terms of a composite affair which still needed a high horizon to accommodate all and sundry. It is a trend which outlived even that relatively late group of 'Flamisants'; minor artists such as Hendrick Avercamp's son, Barent, continued it decades after a more progressive group had established itself in full glory. In this group, Esajas van de Velde, Jan van Goyen and Salomon van Ruysdael again played a decisive role.

Strangely enough, the large number of winter landscapes painted in Flanders towards the end of the sixteenth century finds no equivalent in the Northern Netherlands of the same period. No Dutch winter landscapes were painted until the first decade of the new century and even the relatively scarce prints from the period before 1600 are, with few exceptions, of strictly Flemish provenance. The beginnings of Dutch winter landscape painting still offer some difficult problems of chronology, particularly with regard to Hendrick Avercamp (1585–1634), by far the most significant and fertile master of the 'Flamisant' trend in Holland. Only a few dated pictures by Avercamp survive, and no fully documented example is known before 1608.[3] Two of the rare winter landscapes by Adriaen van de Venne (1589–1662) bear the dates 1614 and 1615.

The works of Avercamp which can be assembled around the one dated 1608 are much dependent on Flemish models available in prints and in occasional paintings, including works by Flemish emigrants active in Amsterdam. Among the latter, Hans Bol and David Vinckboons seem to have played a major role in the genesis of Avercamp's art. The close connection between his earlier style (fig. 163) and engravings after Vinckboons such as the 'Winter' (Castle Zuylen) of the series engraved by Hessel Gerritsz (Hollstein 20) has already been commented upon by Miss Welcker;[4] the number of similar cases could easily be increased. Here we have the same profusion of figures on the ice, of buildings and trees, the same gay hustle amid the richly costumed personages:

'. . . where the Rhine
Branch'd out in many a long canal extends,
From every province swarming, void of care,
Batavia rushes forth. . . .'[5]

The great variety of local colours which characterizes these paintings is anticipated in the crisp precision of the engraved detail; but it is also prefigured in the colour gamut of Lucas van Valckenborgh and the early Jan Brueghel, some of whose works were probably known to Avercamp. It is this 'additive' quality and multicoloured gaiety which has found its perfect expression in Bredero's *Boeren Gezelschap* of 1622:[6]

'Maer Mieuwes, en Lientjen, en Jaapje, Klaes en Kloen,
Die waren ekliedt noch op het ouwt fitsoen,
In't root, in't wit, in't groen,
In't grijs, in't grauw, in't paers, in't blaeuw,
Gelijck de Huysluy doen.'

The high horizon, a legacy of the Bruegel tradition as exemplified by Valckenborgh, Jan Brueghel and still by the earlier works of Coninxloo and Vinckboons, is another feature typical of most pictures of Avercamp's first phase. At least as Flemish is the appearance of his round pictures such as the famous one in London (no. 1346; fig. 163). The format here is particularly reminiscent of the extremely popular round etchings by Hans Bol, whose *Skaters,* from a series of six plates (Hollstein 22; fig. 162), looks like a true kin of Avercamp's painting; for the compositional role of the large tree in the latter, Bol's etched œuvre and other Flemish prints of the late sixteenth century offer many close parallels.

Such prominent trees occur over and over again in Avercamp's paintings, usually employed as a *repoussoir* on one side only, and counterbalanced by a group of houses and opposing trees in the middle distance on the other side, or by some similar device. In other cases the counterbalance is provided by combinations of boats, tents or by special arrangements of figure groups. Frequently the horizon is barred from view by a great accumulation of details in the middle distance although there is a tendency to let the observer's glance continue toward the distance and to help it on its way through skilful use of linear and aerial perspective – but still without sacrifice of detail and variety.

However, it would be altogether wrong to think that one could build a strict chronology of Avercamp's works on such 'progressive' elements as greater sparseness of figures and low horizons.[7] This is proved by the existence of a panel with the date 1609 (fig. 166), which seems to be far in advance of the stylistic character of the painting of 1608 inasmuch as it is less crowded with details of design as well as of colour, has a lower horizon line and altogether a much more unified composition than the picture of 1608 and its direct relatives such as the roundel in London (fig. 163). That these two stylistic possibilities existed side by side, is a sobering fact; it can be corroborated by the existence of a winter painting by Jacob Grimmer, which was done as early as 1575 (Budapest) and already shows the basic 'progressive' features of Avercamp's painting of 1609, and of a work by a rather weak imitator of Avercamp, Adam van Breen, which is dated as early as 1611.[8] The same features in a considerably purer form were to appear a few years later with Esajas van de Velde.

Another road towards a more strictly Dutch interpretation of the winter scene is pursued in Adriaen van de Venne's paintings of 1614 (Berlin)[9] and 1615 (Worcester, Mass.; fig. 167). True, the high horizon, the handling of elegant figures on the ice, the sharply outlined lateral trees with numerous birds perched on them are strongly reminiscent of Avercamp's more traditional trend. But the impression of deep space has been enhanced by two important devices. First, the spectator is farther removed from the scene so that his view becomes more comprehensive; and secondly, there is an increased use of aerial perspective and, in spite of the retention of many bright hues in the foreground, a strong hint of a new tonality such as that stressed by Esajas van de Velde at exactly the same time. Van de Venne himself never followed

this up but the Berlin and Worcester pictures mark an important step in the direction in which the finest winter landscape paintings of the era developed.

Such progressive features were not entirely lost on Avercamp. His later output may be grouped around one of the rare dated paintings, the panel of 1620 once in a private collection in Amsterdam (fig. 164).[10] Here the lateral tree *repoussoir* is gone, together with the concomitant counterbalancing element, and Avercamp's main method of achieving a satisfactorily 'rounded' composition is precisely by rounding it off in such a way as to intimate a more or less elliptical arrangement: the projection on the picture plane of a circle of people standing, kneeling, skating, playing, riding on the huge expanse of ice. The horizon is lower than before (even lower than on the panel of 1609), the aerial perspective is more subtle, a faint intimation of two towns gives a slight emphasis to the lateral areas of the background vista. The figures are less prominent in design and colour, they have become part of the landscape to a greater degree. In other paintings of this phase figures remain more sharply defined and the horizon relatively high; we have already been warned against jumping to the conclusion that these must precede the picture of 1620. Others show by their greater independence of composition and advanced tonality that they must indeed belong to the late twenties or early thirties; one of the finest of these is the unusually reserved and poetic picture in the Collection of Baronesse van Wijnbergen-Dommer in Utrecht;[11] it is the convincing corollary of the *River Landscape* of the van Heek Collection discussed above (fig. 94). And we ought not to forget that some of Avercamp's finest work is represented by his many watercolours, dated examples of which seem to range (as far as winter scenes are concerned) from 1620 to 1630.[12] Although most of these are more remarkable for their figures than for their landscape effects, there are some which for freedom of touch and successful abbreviation of material, for the 'unified vision' of figures and atmosphere, are in advance of his paintings and link up directly with the work of Esajas van de Velde and van Goyen.[13]

The compositional scheme of Esajas van de Velde's earliest winter landscape, once in the Mansi Collection in Lucca (fig. 168),[14] depends to some degree on the Flemish tradition as represented by an engraving after Paulus Bril, in which the shape and place of the groups of trees in the centre and on one side appear in a very similar form. But apart from this, van de Velde's painting marks an entirely new departure in the history of winter landscape painting, in spite of the fact that it is linked to the past in two other respects: first, by being one of a pair of *Summer-Winter* representations (the 'allegory of the seasons' tradition) and secondly, by containing biblical staffage, the *Flight into Egypt* (corresponding to the *Road to Emmaus* scene of the *Summer* panel, our fig. 16).[15] The decisively modern features of the Mansi panel are these: first, the traditional elements in the composition have been replaced by a much greater freedom of structure; secondly, its technique shows a corresponding freedom, in fact to such a degree as to suggest at first glance a much later date. In comparing the picture with any work by Avercamp of the same period, and even with A. van de Venne's Berlin

and Worcester (fig. 167) paintings of exactly the same period, the main impression is one of the most gratifying natural simplicity. There is no accumulation of details, either in landscape elements or in figures; the personages of the biblical story, wearily trudging through the snow, do not detract from the landscape elements, and these do not detract from the landscape as a whole, which is characteristic of a Dutch winter in terms of mood rather than of mere activities. This really feels like winter rather than 'adding up' to winter; we face it without much delay, we can survey everything with a quick glance. And this impression has been vastly enhanced by the free, almost 'impressionistic' brushstrokes as well as by the great economy in the colouristic structure: against a leaden sky, the picture stands out mainly in brown and white, with the blue and red nuances of the figures retained in a strictly secondary role. We are very close to Rembrandt's masterpiece of 1646 (fig. 178).

Since this picture by van de Velde cannot be dated later than about 1612–14, we have neither need nor opportunity to look for drawings and etchings of his which might have prepared the way for it. On the other hand, ample corroboration from the realm of graphic works of its decisive role in the 'freeing of the winter' is not lacking; witness the drawing in the van Regteren Altena Collection[16] and the corresponding etching of 1614 (Burchard 34 e), in which the same wonderful economy of means has been applied to the everyday scene of a frozen canal bordered by an old watch tower, a few houses and trees, a boat and a small number of people on and near the ice. The panel of the same year in Raleigh (no. 72; fig. 169)[17] shows somewhat less parsimonious scenery, with a frozen canal leading more pointedly into the distance, more prominent houses and trees; the horizon lies a little higher than in the drawing. My suspicion that the high sky of this picture was added later, as in the case of Seghers's oblong panorama paintings (figs. 57, 58), has been borne out.[18] In the Leipzig painting of 1615[19] the prominence of houses is even more marked and the horizon rather high, while in the dazzlingly bright Munich picture of 1618 (no. 2884; fig. 165) the number of gay skaters and golfers, duplicated as it were by their cast shadows, has increased to such a degree that Avercamp's emphasis on figures comes inevitably to mind. But even in these panels, the brilliant spontaneity of movement in the figures, the crisp and vigorous abbreviation in the rendering of houses, trees and distance, the greater refinement in harmonizing the rose-brown and grey-green tints in middle distance and background bespeak a style that is less 'Flamisant', and more typically 'Dutch' in the sense of the later development than any of Avercamp's paintings. And in some later works such as the pictures of 1624 in The Hague (fig. 172) and of 1629 in Cologne (no. 2623) and Kassel (no. 384), there appears, in spite of the continuing crispness of atmosphere and clarity of detail eminently appropriate to any winter scene, a tendency toward greater tonality which foreshadows even more the endeavours of the next generation, although houses and trees have been given greater emphasis in relation to the picture plane.

In the art of Jan van Goyen, winter landscapes play an important role during two

distinct periods: the very earliest, and the 1640's. It is of course during the former that Esajas van de Velde's example exerted a decisive influence on the younger master; there has even been talk of collaboration between the two.[20]

It will be remembered that van Goyen, after having gone through apprenticeships with some rather obscure painters and having fended for himself during several years of residence in Leiden and travel through France, spent a year with Esajas van de Velde in Haarlem, probably in 1617. Around and before that time, the latter painted a number of 'Summer-Winter' companion panels. The pair we have discussed (figs. 16 and 168) is in oblong format, but there also exist some roundels of this subject by van de Velde; one such pair, dated 1618, was once in the Habich Collection in Kassel[21] and rivals such little masterpieces of intimate vision as the Berlin *Bastion* (fig. 95) with regard to freedom of brushstroke and economy of means. It is this little group of works which apparently made the deepest impression on van Goyen, for he began, in 1620 at the latest, to produce a very considerable number of such small roundels with the representation of the two seasons. The very smallest of these, only four inches in diameter, is in Berlin; it is dated 1621 (no. 865 B, HdG 1153; fig. 170). It shows that van Goyen, though most clearly dependent on van de Velde with regard to content, format and details, harks back to an even earlier tradition; in some measure his panels are less indicative of the new freedom and spontaneity of touch than van de Velde's, they are more crowded with details, more multicoloured and show less feeling for wide spaces and the subtleties of aerial perspective. It was a healthy new start; van Goyen's subsequent important contributions might easily have been vitiated by an easy juggling of the older master's achievements. It took him almost ten years to reach the stylistic level of van de Velde's mature works – but by that time he was ready to surpass them.

The Berlin *Winter* of 1621 (fig. 170)[22] is indeed vividly reminiscent of Hans Bol's etching with skaters (fig. 162), the diagonal composition of which is even more clearly approximated in another van Goyen roundel of the same year (HdG 1192), while one of 1620 (HdG 1193) has a still more strictly bilateral structure, with the figures drawn out in front of a central alley. In the Berlin panel, too, the contrast of red, green, brown and blue represents a notably earlier stylistic phase than van de Velde's comparable works which were actually done some years before.

Contemporary with these roundels (the production of which seems to have ceased in 1625)[23] are a number of winter landscapes in rectangular format, some of them of larger size. Their style corresponds fully to that of the summer landscapes of the same period, such as those in Braunschweig (1623) and Bremen (1625; fig. 20), as well as of the round winter panels.[24]

Van Goyen seems to have ceased painting winter landscapes almost completely from about 1627 until about 1640,[25] but between 1641 and 1645 his activity in this field reached a sudden climax, and this output is of admirable variety despite the fact that all the pictures partake in the fine, spray-like tonality so characteristic of

the artist's dune and river landscapes of that period. Some of them are small, sketch-like panels exhibiting the greatest freedom of brushstroke and composition; a good example is the splendid picture of 1645 in London (HdG 1166; fig. 171),[26] which forms an enlightening contrast to the multicoloured *tondi* of the 1620's (fig. 170). Others vary in size from small cabinet pieces to very large canvases.[27] Many of them show the characteristic form of the Great Church in Dordrecht and its surroundings as a foil for gay activities on large expanses of ice. Two of these are illustrated here in order to demonstrate the diversity at van Goyen's command in such a simple and unpre-tentious subject. The somewhat larger panel of 1644 in Rotterdam (no. 1245; fig. 173) shows the town silhouette in the right middle distance and indulges in a broad horizontality which is emphasized by an almost uninterrupted line running – strictly parallel to the groundline – across the picture, forming the horizon on the left, ramparts and bridge on the right. Through the grey-brown tonality, a variety of lively, partly opalescent hues draw attention to a host of enchantingly diversified but supremely well ordered details. In the smaller picture of 1643 in the City Museum in St. Louis (HdG 48; fig. 174), the scene is encompassed within an upright format not frequent at this time. The town silhouette is relegated to the left background, en-veloped in a haze and completely subdued by a magnificent sky which occupies more than two-thirds of the panel. The foreground figures, however, are nearer the spec-tator than in the Rotterdam picture, larger, more pronounced, in greater contrast to the rest of the staffage; the horizon is less clearly marked, the clouds more unified in greyness; the general effect is more casual (as in the very small panels), less stratified, and tending somewhat less towards the kind of 'classicality' which shows itself in the painting in Rotterdam. It would surely be wrong to explain this difference by pointing to the fact that the picture in St. Louis was painted a year earlier than the one in Rotterdam. Variety of size, format and mood is at least as important a factor here as any developmental tendency.

After 1645 winter landscapes by van Goyen become rarer; and by the end of the decade the few extant examples show a tendency – already well known to us – to emerge from tonality and, at the same time, to re-introduce stronger structural con-trasts. As early as 1645 the tall, majestic Pelkus-Poort, which appears on other works of that period (figs. 7 and 103), shows its wintry face in a painting now at Lille (HdG 1165);[28] in 1648 the Groote Kerk of Dordrecht, so inconspicuous in the St. Louis picture (fig. 174), nearly overpowers the skating rink but is matched by more sharply emphasized figures and heavier clouds.[29] Of the few later paintings,[30] one of 1650 in Berlin (no. 865 C; HdG 1154; fig. 176) deserves special attention. Although at first sight reminiscent of earlier works it reveals several significant indications of its actual place in the master's development. One is the much more compact composition which avails itself of the consistent diagonal line along the tree tops, a device perfected by van Goyen in his other landscapes during the 1640's, now slowly going out of fashion but occasionally continued, as we have seen before. Another is the almost square

format of the panel which adds to its calm and stateliness; and finally there is a new equilibrium of colours with a reinforced local base, which is totally different from the tonality of the forties and hardly less different from the mottled scheme of the twenties in that van Goyen retained from the preceding experience the ability to blend the individual nuances with landscape and atmosphere without sacrificing their greater distinctness.

I can be very brief with regard to the early winter landscapes of Salomon van Ruysdael. Only three are known (St. 1-3) and they all seem to be dated 1627 – a period in which the master's individuality was not yet fully developed. One of them, probably a little later than the other two (its date has also been read 1629; St. 3; fig. 175), recalls Esajas van de Velde, particularly his picture of 1624 at The Hague (fig. 172); yet there is a distinctly freer breath in the younger master's picture, a quicker tempo and a more daring openness toward the distance, and it leaves van Goyen's contemporaneous efforts far behind. Other paintings of this phase of Ruysdael's development are deeply indebted to Molijn; but of this artist's rare winter scenes only one seems to antedate Ruysdael's (Venice no. 194; 1626?) and that does not seem to anticipate much of its style. Instead, one is tempted to refer back once more to the extraordinarily precocious Pieter van Santvoort (see fig. 23); in 1625 he signed and dated a winter landscape which unfortunately is known only from a poor reproduction but seems to be more nearly comparable with Ruysdael's than are Molijn's.[31] The colours in Ruysdael's picture are sonorous and of great originality: there are still strong local hues in the figures (red, pinkish-brown, olive-yellow) but together with the blue-green distance and the grey of the ice they blend into a warm overall brown; only a few late works by van de Velde are comparable on this score. We shall return to Ruysdael once more in connection with the winter scenes of his late period.

Reliable dates for the winter landscapes of Isaak van Ostade exist for the years between 1642 (HdG 262b)[32] and 1647,[33] and there is no reason to assume his activity in this field for any other year, earlier or later. Some of these are rather elaborate, large compositions, usually with a diagonal scheme with trees, inns and travellers arranged on an elevated river bank on the right and a large expanse of ice stretching into the background on the other side; the foreground is filled with dark figures set off against the ice. In contrast to these formal arrangements, which are echoed in an exceptional early work by Jan Steen,[34] some very small panels, painted with a quick brush in sketchy style, are much more freely composed. One of these is in Berlin (no. 1709; not in HdG; fig. 177); the broad, huddled figures, the sonorous brown tone, the cold breeze brilliantly suggested by tree and boat and clouds, place this tiny panel in the immediate vicinity of Rembrandt's masterpiece in Kassel.

This picture (Br. 452; fig. 178) is exceptional not only within its master's œuvre – even more so than that of Isaak van Ostade – but also within the history of winter landscape in general. It was jotted down on a very small panel in 1646; its spontaneity is dazzling, and one has the impression that it was made on the spot in a sense other-

wise applicable only to the master's drawings and an exceptional etching such as *Six's Bridge*. There exist a few winter landscape drawings by Rembrandt which are to some extent comparable with the Kassel picture but none of them can be considered a preliminary sketch for it. The composition in broad parallel strata, however, is found in many of Rembrandt's landscape drawings; among the paintings of this period, only the *Landscape with the Flight into Egypt* of 1647 in Dublin (fig. 353) offers a somewhat similar structure (in spite of its totally different nature). In the winter landscape the three figures in the foreground, left and right, together with a shadow on the ice, form a dark zone which serves as a strong *repoussoir*; there follow, first a light stratum, joined by dog, woman and seated skater, and then the comparatively dark zone at the back (really middle distance and background in one) with other figures, farm buildings, tree and mill. Above, the sky appears to be divided horizontally into a lighter and a darker stratum. The economy of material in this picture surpasses anything seen before in winter scenes; there are now one person on a hand sled, one fastening his skates, one resting, one standing, one walking – and one dog. Their movements are interrelated in a rich rhythm but in complete tranquillity; they are colouristically interwoven by means of deep grey-browns and, in the case of the three figures on the right, also of strong reds. The flooding of the second zone with light creates the impression of enormous space with the help of the *repoussoir* character of the figures, but the three figures that are closer to that light zone are tied to it by means of strong impasto highlights. A similar impasto is used for the clouds where it is applied over brown flecks strewn across the deep steel-blue of the sky, with a whitish-pink light on the right; the middle distance is held in warm browns and greys. This is Rembrandt's greatest contribution to the Dutch scene in painting; all the incomparable intimacy of his most cherished drawings and etchings has been enshrined in it.

At this point it is necessary to speak briefly of winter landscapes by two of the normally 'Italianate' masters, Nicolaes Berchem and Jan Asselijn.

Berchem's winter scenes fall into three groups,[35] painted in the late forties, the fifties and (probably) the sixties. The picture of 1647 in the Haarlem Museum (on loan from the Rijksmuseum, no. 464; HdG 802; fig. 179) uses the familiar double diagonal but in a form in which re-emphasis on more massive structure is already very apparent, just as it is in river landscapes of the same period by van Goyen (fig. 101) and Salomon van Ruysdael (fig. 100). The *genre* scene, while not exactly predominant in itself, receives significant support from the detailed design of its architectural foil, with the result that nature and winter are relegated to second place. A painting probably of 1650 (HdG 815),[36] with a more intimate motif and done with a bolder brush reminiscent of Wouwerman's finer winter scenes (fig. 193), still uses the diagonal pattern, while the late works (e.g., HdG 804) are showy *genre* pieces which recall a similar group of inferior works by Wouwerman (p. 98).

Jan Asselijn's somewhat earlier little panel (*ca.* 1645) in the Lugt Collection (fig.

180), an almost unique[37] example of a winter scene painted by this master, defies the kind of classification Berchem encourages. It is highly original, witty and absolutely enchanting. Its unusual, very upright proportions underline the groping bareness of the snow-covered trees which rise from elevated ground and are cut off by the upper margin; the silky curtain of background and sky hangs near them in a marvellous, almost Chinese contrast. But any thought of pathos or melancholy is cheerfully contradicted by the comfortable curve of the bridge and the crisp, humorous shapes of the hunting party. The picture suggests the scherzo of a string quartet of which Rembrandt's winter scene in Kassel forms the first movement (and perhaps van de Cappelle's finest – fig. 187 – the second).

The 1640's, to which all of Ostade's winter scenes, the unique one by Rembrandt, Berchem's early works and Asselijn's masterpiece belong, also saw the emergence of the mature style of Aert van der Neer, and with this, the opening of a decisive chapter in the history of colour which until now we have touched upon only in the discussion of works by Aelbert Cuyp. As van der Neer, whose earliest works are still a complete mystery to us, left behind the realm of grey-brown(-green) tonality, to which he had adhered through the late thirties (see figs. 134, 105) down to about 1641 (fig. 205), and began to concentrate on problems of a new luminosity, he found his ideal subjects not only in landscapes illuminated by the setting sun, the moon and the flames of burning cities (see below, p. 177), but also in winter scenes in which fresh snow on the ground, on houses, boats and trees reflects a cold afternoon sunlight already widely dissipated and partly refracted by light clouds. It is opportune to remember here that snow had played a rather negligible role after Esajas van de Velde. With the advent of tonality – in its very beginnings with some of van de Velde's late paintings and van Goyen's earlier ones – snow had ceased to be an interesting element; the grey sky of those paintings fused with its reflection on the ice much better than with snow, the subdued hues of the figures did not demand a fresh white as a foil but the moist air tinged with the grey of the clouds. The local colours of the early pictures of Esajas van de Velde had the brilliant white of snow added to them almost as another local colour; the tonal period was to have none of it.

Snow now returns to the scene – but not as a local colour. It now glistens and glitters with a new brilliance throughout the picture. As the sunlight is not only reflected on, but also refracted by thin clouds, it floods the entire landscape space and imparts its own coloured luminosity to the objects it illuminates; at the same time these objects are interpreted mainly as carriers and distributors of such all-pervading light phenomena. Instead of displaying local colours they are now incandescent with a light which, however, has many more hues than were shown in the immediately preceding tonal group. But it is important to realize that, although this new light effect was based on subtler observation of optical phenomena than ever before, the artists still enjoyed a greater freedom of choice than their elders – just as did those who used the camera obscura with regard to space. In this process of employing a great new variety of

luminous effects, the snow not only became one of the most important carriers of coloured light but also served to deepen the contrast between light and dark which was regaining strength after the period of preferred tonality. It stands to reason that the tendency to sharpen this contrast belonged primarily to van der Neer's later works whereas his earlier winter landscapes (in the forties) still show some tonal effects, albeit of a more silvery nature.

The chronology of van der Neer's œuvre is far from easy to determine. There are as few reliable dates for his winter landscapes as there are for his other works; the first one is of 1642 (HdG 499), the last can clearly be read 1665 (HdG 575). That of 1642 (Hamburg, Private Collection; fig. 181)[38] is still closely related to Esajas van de Velde, more than to van Goyen or Ruysdael, particularly in the sharply graphic trees and houses which almost convey the impression of a coloured drawing. It differs from all earlier masters in the great distance of the spectator from the scene, a situation which led to a miniature-like scale of objects; and van der Neer was reluctant to abandon this feature although he did not continue it with the same degree of exaggeration as is found here. The prominent bare trees of the picture of 1642 which in their gnarled form recall the artist's Keirincx-like beginnings (see fig. 134) recur in a more slender form on the similar winter scene of 1643 in the Earl of Crawford's Collection (HdG 510), together with the very small and loosely distributed figures. The painting of 1645 in the Corcoran Gallery in Washington (no. 26.148, HdG 568; fig. 182)[39] indicates a considerable change of style. The figures have become more numerous; they appear larger because the scene is viewed more closely; we now look at the river in such a way as to encompass both banks leading into the background even though one of them is still predominant and introduced by tall trees; the figures are very multicoloured and somewhat awkwardly arranged. Still, the picture is an important link between van der Neer's early and mature style. The two-bank pattern is found in most later works, and although some of these retain the more distant viewpoint and the smaller figures of the early group, they almost invariably establish a firm foreground zone with some significant horizontal elements consisting of boats, logs, the ground itself or figure groups which serve as a compositional guide and as a necessary supplement to the depth-producing tendencies of the river and its two banks. At the same time, the linear qualities of the early works are replaced by a new vision based upon new optical discoveries, some of which can already be observed in the Corcoran painting of 1645 but which do not fully mature until about a decade later. During this phase, dates are lacking;[40] we do not encounter a fully reliable one until 1665 (HdG 575, now with Alfred Brod in London).

The *Frozen River* in Amsterdam (HdG 479; fig. 183), which was probably painted about 1655, illustrates the new discoveries quite clearly. Although it is still a colourful picture, its colours have practically nothing of the multiple quality of the Corcoran painting of 1645 (fig. 182). The reason for this is that the entire picture plane is dominated by a warm, rose-brown tint which binds houses, sky, trees and figures

together in what one perceives as an all-enveloping moist atmosphere. The technical
means employed to produce this effect are not easy to define. One of them is the superb
observation of aerial perspective which resulted in an unusually careful and compre-
hensive reduction of the graphic and colouristic definition of forms as they recede into
depth. There is no lack of such distinction in earlier paintings but it was either
applied in parallel strata, that is, in an additive (or subtractive) process of diminution
of clarity or on a smaller scale; only here is one tempted to connect it with the
principles of differential calculus. However, this is not all. As already indicated, the
very close colour relationship between sky and ground is based upon new observations
concerning reflection and refraction, and their adaptation to the landscape painter's
craft. The dispersion of the afternoon sunlight by the moist clouds adds rose-brown
tints to their greys and whites; a patch of blue sky appears in the lower centre. In
itself, this is not a new discovery, since the red-orange-yellow effect of refracted light
occurs in some earlier works, particularly by Salomon van Ruysdael; but there it is
rendered by basically graphic means, without the moist luminosity here achieved by
softer blending. And this colour ensemble is now subtly reflected in the lower part of
the picture; the houses throw back the clouds in a somewhat lighter nuance (orange-
brown – grey-brown – white), while the two churches in the far distance reflect the
blue section of the sky in a distinctly bluish tint. At the same time, the ice reflects all
the greyish, brownish and bluish tones. All this serves to unify the colouristic appear-
ance of the canvas far beyond the early possibilities of the master. In its sonorous
gamut strong contrasts of individual colour are by no means avoided but they are
subordinated to an all-pervading atmospheric effect. If, confronted with van der
Neer's early pictures (see also figs. 134, 105) one could hardly imagine that they were
painted by the master best known for his moonlight effects, this is now by no means
difficult to understand.

The painting in Amsterdam is one of a large group in which there is a considerable
number of figures, and a certain formality of setting; many of these are quite large.
It is not accidental that the enchanting picture in London (no. 969; HdG 502; fig.
184) is hardly half as large. That which was somewhat consciously arranged in the
former seems spontaneously jotted down in the latter; there is much greater intimacy
and economy of means in the small panel than in the larger canvas. Its tone is more
silvery, more reminiscent of earlier works, but the relationship of the pink and grey
tints in the sky to the grey, white and red nuances on the ground and the compositional
clarity of the panel place it in the period of van der Neer's full maturity;[41] in fact, it
does not seem to be too far removed in style from the picture dated 1665.

Unfortunately, all dates are lacking for van der Neer's last period; whether the date
1675, given for a winter scene preserved in an engraving of 1753 only (HdG 538), is
reliable cannot be ascertained. It is equally unfortunate that there is a considerable
group of winter landscapes in existence which are undoubtedly by van der Neer but
are hard, awkward and almost crude, and must be assumed to have been done in his

later years. They contain all the characteristics of the mature group but in an exagger-
ated, indeed in a distorted form. Just prior to this late phase (van der Neer did not die
until 1677, after living in great poverty for many years) he must have painted a group
of pictures in which the coarsening of his style is already quite noticeable but which
are interesting for one or another daring exploit; foremost among these is a small
number of works in which he revived the idea of representing snow actually falling.
This had not been attempted since the time of Lucas van Valckenborgh,[42] who in turn
had taken his cue from Pieter Bruegel.[43] In the painting at Vienna (HdG 534; fig. 185),
van der Neer filled almost the entire picture plane with the tiny white flakes as they
fell on houses, frozen river, agitated bare trees and heavily muffled figures;[44] but while
the effect is moderately amusing one cannot overlook a certain clumsiness which
makes other late pictures appear like a sorry epilogue to the brilliant career of a gifted
and highly intelligent painter. To this period also belong the larger part of the
rare paintings in which the artist sought to exploit the double feature of winter
and nocturnal effects.[45]

Among those who were inspired by Aert van der Neer's winter landscapes was one –
and only one – whose few contributions to this realm all but overshadow the older
master's works: Jan van de Cappelle. No more than about two dozen of these are
known;[46] only about half a dozen bear dates, and these are restricted to the years 1652
and 1653 as far as available works are concerned. This indicates a priority of van
der Neer, not only in tackling the subject as such in paintings but also in the new
luminosity introduced by him into that subject; in order to confirm the latter point,
however, one would have to refer to van der Neer's achievements in the realm of
moonlight scenes reliably dated in the late forties (below, p. 177). It is in any case
probable that van de Cappelle, who was van der Neer's junior by twenty years and
self-taught, was impressed by the winter landscapes of the older master; and indeed,
when we compare van de Cappelle's two earliest winter scenes, in the Beit Collection
(dated 1652, HdG 151) and in Enschede (HdG 154; fig. 187), with van der Neer's
work of the forties (figs. 181, 182) the connection becomes evident in the design of
the trees, the houses, the sky and even to some extent in the figures. But it is also
apparent that van de Cappelle outdid his model, not so much in effects of luminosity
as in subtlety and harmoniousness of composition and colour combination, and most
conspicuously in his capacity for reticence and poetical understatement. The empty
foreground in the Beit picture alone is a marvel of refinement; and so is the entire
structure of the picture in Enschede (fig. 187):[47] it is done on a moderately sized
upright panel, with slender trees between houses in the middle distance comple-
mented by a few vertical accents in the right foreground; the left foreground is empty
except for a wonderfully delicate expanse of ice in which the winter sky is reflected;
there are no figures at all on the ice, and the few that are present merge with the bank
of the frozen canal in the middle distance. The merry skaters are gone, as is all mere
statement of fact; one is tempted to say that this is the first interpretation of winter in

terms of a sublimated personal experience: here, winter was an inspiration for a lyrical monologue rather than a fact described in narrative terms.

The paintings in the Lugt Collection (HdG 155; fig. 186) and in the former Widener Collection (HdG 157 and 168) are both dated 1653, one year later than the Enschede and Beit pictures, and represent an identical motif with slight but artistically not insignificant variations. Here the mood is somewhat less introspective than in the panel in Enschede, the connection with van der Neer more evident, particularly with his most intimate works such as the London picture (fig. 184); still, even here there is greater restraint, greater originality of structure, subtler balance and a more glorious sky, the reflection of which on the ice is less obvious and more delicate than that of van der Neer.

The painting of the same year at The Hague (HdG 148; fig. 188) is somewhat larger than the other works and painted more broadly; its composition, with prominent buildings and figures, contains a central group of trees which reach to the upper edge of the canvas. The new tendency toward increased structural emphasis and stateliness is much more evident here, although an intimation of it had already been present in the upright picture of 1652 (fig. 187). A painting which seems to stand midway between the Lugt and the Mauritshuis pictures has just entered the Rijksmuseum with the de Bruyn Bequest (HdG 160).[48] These pictures parallel the glorious first phase of van de Cappelle's documented career as a marine painter.

It is as though greatness in the interpretation of winter as a drama had been reserved for one single artist: Jacob van Ruisdael.

There exists not a single dated winter landscape by Ruisdael, and the chronology proposed by Jakob Rosenberg[49] must remain as tentative as it was offered by him. His suggestion that Ruisdael experimented at an early stage, soon after 1655, with such unusual compositions as one finds in the picture until recently owned by the late J. C. H. Heldring in Oosterbeek (Ros. 614; fig. 189),[50] is supported by the fact that Jan Beerstraten painted in a very similar manner as early as 1658.[51] Here the curves formed by the wooden bridge vaulting over a canal in the middle distance is continued sideways in two snowy hillocks so as to complete a full sweep across the width of the picture, while houses behind it crouch under a deep grey winter sky and a few figures are dwarfed by a pile of snow and vast shadows. Again, as with van de Cappelle, this is winter not as a fact but as an experience, albeit in a hesitant, somewhat half-hearted interpretation; however, the emphasis is already shifting from the lyrical to the dramatic. Some inspiration for this change may have come from Allaert van Everdingen, to whom Ruisdael owed a great deal in other respects (see below, p. 121 and p. 145) – not from his amiable *Winter* in the Six Collection[52] but from earlier works such as the fierce *Snowstorm at Sea* in Chantilly (fig. 246).

The climax of this development toward dramatic greatness is marked by a group of paintings by Ruisdael which can be assumed to date from the early sixties. Among the somewhat more formal but by no means large compositions, the famous canvas

in Amsterdam (HdG 985, Ros. 602; fig. 191) remains unexcelled. Here there is no trace left of the traditional gaiety of the scenes painted by Avercamp or even van Goyen and van der Neer nor of the lyrical elegance of those by van de Cappelle. It would be altogether absurd to think of skaters when looking at this picture; the real topic is the forlorn mood of a winter day, of nature in shackles. It is this tragic implication and a certain grandeur which places the picture much nearer to northern literary trends of the eighteenth century, when James Thomson was to write of the season in which 'the sun scarce spreads through ether the dejected day'; it is curious that van Mander should have already envisaged paintings showing 'melancholy (*swaermoedighe*) winter days', on which one could not see the familiar objects 'farther away than a stone's throw'[53] – a vision evidently far ahead of Lucas van Valckenborgh's amusing rather than oppressive snow-flurry scenes.

But the mood is without any grandiloquence, more profound, and wonderfully intimate in the even smaller panels such as the one in Munich (HdG 999, Ros. 618; fig. 190), painted on an upright canvas as were several other works of this group. The 'dejected day' is now silenced by a deep, desolate grey from which some patches of sharply lit snow stand out threateningly rather than soothingly. An old man, accompanied by a boy, pulls a flimsy tree trunk on a rope slung over his shoulder towards the dark recesses of the background. There is nothing comparable with this in Dutch seventeenth-century landscapes; and outside of landscapes, only the deep gloom that spreads over a religious tragedy through the magic of Rembrandt's chiaroscuro comes to mind. I do not doubt that in spite of all technical and colouristic discrepancies, Rembrandt's 'synthesis of the visible and the invisible'[54] here inspired Ruisdael: the very fact that all outward, imitative features of such an 'influence' are missing, is eloquent, for this can be expected of the fruitful relationship between two very great artists.

Presumably painted during the second half of the sixties, closely corresponding in style to such panoramic views as the one in the Musée Jacquemart-André (fig. 80), some winter landscapes by Ruisdael open up vast spaces, seen from a considerable distance and stretching endlessly beneath all-encompassing skies. Beautiful examples can be found in the Johnson Collection at the Philadelphia Museum (HdG 1005, Ros. 625) and in the Lugt Collection in Paris (HdG 1002, Ros. 622; fig. 192). Here the familiar diagonal scheme reappears once more but in a form which differs significantly from that of the *Mill at Wijk bij Duurstede* (fig. 115). The motif has been de-dramatized, the contrast of light and dark mellowed, the individual forms made to appear tender, subtle, delicate, all in the service of a harmony of distinctly classical flavour. It was a happy state just prior to a distressing decline, comparable with what we found in Ruisdael's forest landscapes of that late period. There is a fussiness in some of his last winter scenes, an emptiness in others, that are as disappointing as the poor quality of their figures (HdG 994, Ros. 611; HdG 1004, Ros. 624; HdG 1027).

It is worth mentioning that the specific optical problems pursued in the winter landscapes of van der Neer and van de Cappelle were ignored by Ruisdael, as they were by the painters that follow. It is the same situation that prevailed in the development of the River Landscape with regard to Ruisdael and Cuyp (p. 62).

Philips Wouwerman's rather rare winter landscapes are little known today. Nobody can be expected to wax very enthusiastic over his busy scenes with tents, ornate sleighs, elegant couples, peasants and playing children – works somewhat in the style of late winter scenes by Ostade and Berchem.[55] But there exist a number of beautifully intimate, spontaneously conceived and executed small panels which are closer in mood and quality to those of Ruisdael than are any others. No dates occur on any of them but there is little doubt that the majority belong to the early and middle sixties[56] – which would make them exact contemporaries of those of Ruisdael. A little jewel of this kind is in the Museum of the Historical Society in New York (possibly HdG 1140 b; fig. 193); others, of somewhat less startling originality, are in the Johnson Collection at the Philadelphia Museum (HdG 1148; in upright format, like several of them), in Berlin (HdG 1133) and elsewhere (HdG 1131 and 1137, both recently with P. de Boer in Amsterdam). One might argue that the composition of the New York picture is lop-sided, with its windswept pull to the right which carries along with it not only the tree, the smoke and the figures but even the road and the houses; but it is amazing to see how successfully the storm clouds on the left counterbalance this sharp movement, thus providing a remarkable example of an equilibrium kept precarious in the service of expression. There are no light colours anywhere in this picture except for the highlights; the lively figures, the brilliant effect of the fire and smoke, the freedom of brushstroke contribute further to making it a worthy companion of Wouwerman's finest achievements in the painting of dunes (figs. 38, 40-42).

And as in that realm, Wouwerman found a congenial competitor in the person of Adriaen van de Velde. The younger master painted only a handful of winter landscapes, and probably all of them in 1668 and 1669 – thus rather late in his short life – but they fall into two distinct groups. In one of them, the spectator has moved close to the scene; the figures are large and give the picture the appearance of a *genre* scene with landscape in a somewhat subsidiary role though still full of fresh light effects and rich, somewhat enamel-like colours, including a blue-pink sky (Dresden, HdG 369;[57] London no. 869, HdG 370). In contrast, in the two paintings in Paris (HdG 371; dated 1668) and in the Johnson Collection in Philadelphia (HdG 373; fig. 194) the landscape is of decisive importance; the horizon is very low and unencumbered by large figures, the filigree of bare trees displayed against the sky with consummate tact and delicacy. The picture in Philadelphia (worn but still splendid) is painted in rose-brown tints; the red and blue in the woman's dress is subtly echoed all over the panel; the mood, beautifully sustained throughout, is harmonious and of a subdued gaiety – characteristic of van de Velde at his very best. No stronger contrast can be imagined than Ruisdael's winter scenes of the very same decade; and it is not an

accident that a composition in which van de Velde included a somewhat threatening aspect of winter (stormy weather, rushing figures; HdG 374 and an identical picture in Berlin, no. 1999) remains far below the level of his other works in the field.

In the year in which van Goyen painted his late winter landscape in Berlin (fig. 176), that is, in 1650, Salomon van Ruysdael returned to this theme after a pause of more than twenty years.[58] The resulting picture in New York (St. 5) is basically a *genre* scene (representing the popular game of *Drawing the Eel*) with a large crowd in front of an inn and a few winter accessories. A much exhibited and often reproduced picture of 1653 (St. 6; now in the Ruzicka Foundation, Zürich),[59] with a tent and many figures on a large expanse of ice and a view of Dordrecht in the background, is reminiscent of winter scenes of the forties by van Goyen and Isaak van Ostade. However, it has an entirely different colour gamut in which, not unexpectedly, a greater variety of hues replaces the tonality of the preceding phase and adds greatly to a successful characterization of the crispness of a fine winter day. Among the paintings of the 1660's, the magnificent panel of 1661 (St. 14; now Collection de Geus van den Heuvel in Nieuwersluis; fig. 195)[60] is – unfortunately – an exception with its composition lacking obvious pictorial devices but entirely convincing and harmonious, its sustained horizontality and its superb co-ordination of ground and sky. All other winter paintings from this late period of Ruysdael's activity make use of large architectural motifs which betray a strong revival of topographical interests, even though some of them are significant examples of that free combination of correct details in an imaginary whole which was discussed in our introductory chapter. The picture there referred to (St. 13, dated 165(8?), now Collection van Heek in Enschede; fig. 6) is easily the finest of that group, still composed in the diagonal pattern of earlier river landscapes (see figs. 97, 98) and with a judicious balance of atmospheric subtlety and vivid local colours; works of this type dated to the sixties suffer from somewhat crude and loud effects, particularly in their prominent figures.

The predilection for stately buildings, usually with a topographical interest as an important factor, characterizes a very large part of the production of winter landscapes in the decades from *ca.* 1660 to the end of the century. One single example must suffice to illustrate the competent, somewhat pedantic but dignified and stately character of a large number of such works: the *View of Nieukoop* by Jan Beerstraten in Hamburg (no. 9; fig. 196), which was probably painted shortly before the artist's early death in 1666. That the dark grey and pink tints of this artist (the sky is purplish-grey and light blue) and his thin, delicate trees with the snow indicated by tiny crisp brushstrokes are likely to reflect the influence of Ruisdael has already been mentioned;[61] but there is also a hint, more outspoken in other works of this phase, of a revival of Flemish characteristics found in the circle of Jan Brueghel and Joos de Momper – a revival which is also indicated by the contemporaneous works of Herman Saftleven and others in the field of imaginary landscape painting.[62] Together with the predilection for significant architectural motifs goes a renewed emphasis upon narrative

features; and it is amusing to see that Beerstraten's picture introduces, in the middle distance, a motif which was to find a glorious climax in Caspar David Friedrich's great winter landscapes one hundred and fifty years later: a funeral cortège, here emerging from behind the church and approaching the frozen canal – only to find it occupied by insouciant skaters.[63]

CHAPTER III

The Beach

I T stands to reason that the depiction of the Dutch coast for its own sake originated
at a later date than that of the countryside, the woods, the rivers and canals.
Familiar though the beach must have been to the painters and their patrons, its
representation may not have meant much to them at a time when the rendering of the
more immediate environments of their towns and the occupations and pastimes with
which they were enlivened was only slowly being appreciated in paintings. Thus it is
not surprising to find that when the interest of the public was first attracted to this
new field it was done by means of some special event taking place on the beach, such
as a prominent embarkation or landing. Again, the painters were preceded by draughts-
men and engravers, but even these needed a special catalyst to become involved in the
representation of the beach; here the most popular event was the stranding of a whale,
that inexhaustible subject of chroniclers and a great attraction for huge crowds who
loved to keep a black-and-white souvenir of it. The appreciation of the coast as the
scene of everyday activities represents an advanced stage of interest – not to mention
its appreciation as a vehicle of sheer beauty or of a particular mood.

As an auxiliary motif, the coast appears in many paintings and drawings by Pieter
Bruegel and his circle; even before that, Patenier had shown some interest in it, and
earlier still, the author of the greatest of the *Heures de Turin* miniatures, most probably
Jan van Eyck, had given an astonishing anticipation of some of the most striking
phenomena later developed in this trend: the subtle rendering of moist atmosphere,
of the white-caps dancing on the water, and of the white softness of the sand.[1] But
none of this was ever done with the idea of concentrating on the beach motif for its
own sake, of stepping close enough to the scene to dwell exclusively upon its restricted
area. Perhaps if Dürer's *Konterfey* of the stranded whale, made on that memorable
trip to the coast of Zeeland which may have hastened or even caused the ruin of his
health,[2] had been preserved, we would be able to cast a glance at the first modern
representation of the beach. As it is we have to wait for other whales and artists, all
draughtsmen, etchers and engravers. The drawing made by Hendrick Goltzius of a
sperm-whale stranded between Scheveningen and Katwijk in 1598 (fig. 197) was
engraved in the same year by Jacob Matham; it has the distinction of offering the first
example of a coast receding into the picture (perpendicular to the groundline) and
thus anticipates an important feature of much later paintings.[3] Another whale put in
a final appearance on the coast of Noordwijk in 1614 and drew the attention of Willem
Buytewech, Esajas van de Velde and another excellent etcher; he was preceded and
followed by several others, duly preserved for posterity, and considered portentous
omens by some.[4] While these crowded scenes – usually showing the fish parallel to

101

shore and groundline in contrast to Goltzius's drawing of 1598 – do betray a sensitive observation of the dunes showing behind the hero and his admirers, they must cede priority and superiority as a harbinger of beach painting proper to a magnificent drawing of 1602 by Jacques de Gheyn in Frankfurt (fig. 198).[5] This represents only a few fishermen at work on the beach and some boats lying on the shore and sailing far away on the water but contains in this simple subject the main elements of a large group of subsequent beach paintings: the beach extending horizontally across the foreground, and the sea behind under the straight (though still rather high) horizon, which is overlapped only by a few sails and the riggings of boats in the foreground. It is not at all surprising that this drawing was once attributed to Jan Porcellis[6] – even by such a great connoisseur as Hofstede de Groot.

While these important and liberating experiments were made in drawings and in prints, Dutch painters slowly began to tackle the problem in their own ways, which were probably closely linked to special commissions they received. Thus Adam Willaerts, in a painting of 1613 (?) in the Maritime Museum in Amsterdam (fig. 199),[7] depicted the Embarkation of Prince Frederick of the Palatinate in England which eventually led to his ill-fated ventures on the continent. The English shore line, with carefully delineated houses and trees rising on steep rocks in the middle distance and background, and numerous people gathered on the low ground in front, occupies the right side of the composition while the fully manned ships and a large rowing-boat throng the left; the horizon is fairly high. The colouristic appearance is similarly multifarious and sharply defined within three different strata, reminiscent of other landscapes of that period; the middle distance brings to mind Gillis d'Hondecoeter, Willaerts's Utrecht colleague, in the way in which light greens are inserted into the rose-brown nuances of the tower and cliffs; the cliffs and even the castle in the background are rendered in bluish-green. This is still the representation of an historical event which 'happened' to take place on the coast, depicted by a chronicler in order to commemorate that event – a far cry from what 'beachscape' was destined to become within a few decades.

Even in a very early work, Jan van Goyen went a little beyond Willaerts's conservative ways (which continued into the forties and led to the threshold of a revival of the narrative and representational trend with which he had started). Van Goyen was not aided and inspired by any paintings of Esajas van de Velde in this field although his teacher made a few drawings of beaches. A picture of 1623 (HdG 1118c, fig. 200)[8] shows a coast scene which is quite as varied in design (and presumably also in colour) as the Willaerts of 1613 and may in fact be indebted to some such picture, what with its inordinately steep dunes, fantastic beacon and bewildering multitude of other motifs and people. But there is no historical or state event depicted here; instead, this is pure *genre*, an everyday scene, with fishermen, peasants, amorous cavaliers, thievish fortune-tellers moving and standing about the hilly shore with its queer Toonerville-like buildings and signal posts. The sea occupies but a very small fraction of the

picture plane on the right. Nine years later (1632), in the picture at Leipzig (no. 1010, HdG 235; fig. 201) the same lateral view of the sea appears – but the effect is already quite different. Although the *genre* aspect is still of paramount interest to the artist and little of the sea is shown, the mottled appearance of the older work, in design as well as in colour, is gone. The diagonal formed by the mast of a sailing-boat on the left, the spire of the Scheveningen church, the roofs, the elevated figures in the centre and the sailing-boat on the right, has been consistently carried through rather than sporadically intimated as before; the human groups are coherent instead of being scattered all over the surface; one is able to survey the whole field at a glance, instead of having to read the details one by one; we are 'in' the scene instead of looking down and across in the manner of the sixteenth-century 'world panorama'; local colours are making way for a strongly unified olive-brown tone. In 1634 (Leningrad, no. 2820, HdG 240) the 'artistic' intent of the painting is nicely illuminated by the introduction of a draughtsman sitting in the centre and sketching the sea under the eyes of a few curious onlookers; here again the scene is clearly localized by the characteristic small church of Scheveningen (which alternates with that of Egmond aan Zee in many similar paintings). It comes as no surprise that these views of the coast can be found in drawings by van Goyen long before they appear in paintings, beginning in 1624,[9] although in the early examples the *genre* scene predominates over beach and water.

In this respect, van Goyen was actually preceded by Salomon van Ruysdael, who in a very Molijn-like but almost entirely brown-grey beach scene (also with little water) reached a very advanced stage of tonality and depicted a very simple diagonal structure as early as 1629.[10] Another early work by this master, probably dated 1635 (fig. 202),[11] is even more advanced than van Goyen's works of this period and vies in precociousness with Simon de Vlieger's paintings of the 1630's and 1640's. The diagonal shore line, softly fusing with that of the now much more prominent sea, is interrupted only by two sailing-boats lying on the beach; an immense sky covers from two-thirds to four-fifths of the picture plane.[12]

The type most beloved of van Goyen (until *ca.* 1650) and of several of his imitators during that decade is well represented by one of his views of Egmond aan Zee, dated 1646 (HdG 100; fig. 203)[13]. The low horizon is again formed by the sea on the right and is hidden from view on the left, but here the left foreground rises half-way up the picture plane, and church and people stand out crisply against a threatening sky. In other paintings, the sea is not actually hidden by the foreground rising on one side, but curves in such a way as to leave that side to an extended view of the coast in the middle distance;[14] however, in both cases the foreground remains fully occupied by the beach. As in Ruysdael's picture of 1635 (fig. 202), the sky sometimes occupies up to four-fifths of the picture above the horizon; on the free side there are only minor overlappings by sails or other objects. Imitators of van Goyen, such as the excellent van der Hulft and the less skilful Willem Koolen, painted many pictures of this sort,

mostly views of Scheveningen[15]. The same pattern appears in a very unusual early work by Aert van der Neer in 1641 (HdG 41; fig. 205);[16] here the sea is more agitated, the clouds very dramatic, the buildings of a more imaginary type, and the whole mood quite different from the rather placid one of van Goyen and his followers; Jacob van Ruisdael does not seem too far away.

Simon de Vlieger's contribution to the painting of beaches was quite as important as his contribution to marine painting proper. His first picture of this kind was painted as early as 1630 (fig. 204),[17] and, with its capricious waves and its grey sky, is characteristic of de Vlieger's general indebtedness to the great marine painter Jan Porcellis, whose dramatic picture of a *Shipwreck on a Coast* (1631; now Mauritshuis)[18] it even precedes. De Vlieger's beach consists of a very small strip which extends across the foreground and becomes solid and dark at the right, where frantic people are preparing a rowing-boat – a scene skilfully counterbalanced by the rescue scene on the left. While the beach occupies little room and attention here, most later renderings by de Vlieger conform much more fully to the van Goyen trend of the forties, as he lets us see the coast more fully spread across the foreground, with crowds attending to their business of selling and buying fish, carrying it to the shore or just looking on or resting, while the sea stretches across the middle distance, partly overlapped by sails and by people in the foreground. A famous example of this kind dates from 1643 (Mauritshuis, no. 558); it shows an elegant couple and their dog watching the sea from a dune and is a work full of silvery light and endearing charm; a very similar picture appears on the wall of an interior by Cornelis de Man (fig. 4). Others, much more crowded, can be placed in the later forties on the basis of a work dated 1646.[19] It must, however, be mentioned that a rather early painting by de Vlieger, of 1633 (Greenwich, fig. 206),[20] astonishingly, if somewhat clumsily, anticipates a type of composition usually connected with Jacob van Ruisdael and other later masters; here the coast (near Scheveningen) recedes into the picture, with the sea curving back as in Goltzius's *Whale* (fig. 197) and in many of van Goyen's works of the forties, but now in such a way that the entire left half of the picture is given over to the sea. In this early work, the foremost waves still form a distinct dark stripe which continues the dark front strip of the entire foreground. De Vlieger's extraordinarily beautiful *Beach Scene* in Cologne, (no. 2563; fig. 207), however shows this type of composition in its fully mature form and directly anticipates Ruisdael's late works. It must have been painted *ca.* 1646–48 and still recalls the basic tonality of van Goyen's works of that period in the fine relationship between the grey water and the light yellow-brown dunes, the grey-brown of the land in front, and the grey-white and lightest blue of the sky. But there is a somewhat stronger emphasis on colour in the figures: red-brown, golden green and bluish-grey, for example, presaging the fifties in general and perhaps even the new luminosity of Jan van de Cappelle, together with a new subtlety in expressing the serenity of late afternoon.[21]

At this time, Jacob van Ruisdael was entering the same field with some significant

contributions of a very different nature. In his early renderings of Egmond aan Zee the sea plays a very minor part as compared with the village itself, the dunes and their vegetation; in one of them, dated 1648, now in the Museum of Manchester, N.H. (HdG 49; fig. 209),[22] the far-distant strip of greyish-blue water with two sailing-boats on it, is so inconspicuous that it hardly shows on reproductions, and in one of the two views of Egmond in the Philips Collection in Eindhoven (Ros. 28) it is altogether suppressed. The other large painting of the same motif, dated as early as 1646 (Ros. 29; fig. 208),[23] is a brilliant preview of his later panoramas rather than of his beach scenes properly speaking; though still tonal in the sense of van Goyen's and Salomon van Ruysdael's[24] of the forties, it is steeped in deeper tints (grey and red are important) and in a heavier mood as well. When Ruisdael returned to the same motif somewhat later in the Glasgow picture (HdG 47 with wrong date 1655, Ros. 31), this aspect was intensified, the spatial coherence enhanced, the sea more powerfully contrasted with the land and the church more 'organically' conceived as a head growing out of, and towering above, the body.

Ruisdael's beach scenes proper are of quite a different nature and carry no dates but undoubtedly belong in the sixties, and perhaps seventies. At least one of them partakes of the dramatic tension, the symphony in grey characteristic of an important group of his winter landscapes and seascapes; this is the magnificent small painting now in the Ruzicka Foundation in Zürich (HdG 922 and 937, Ros. 573; fig. 210),[25] whose composition reverts to the type introduced by van Goyen and de Vlieger in the forties: the two strata of beach and water one behind the other, with one side of the foreground rising and overlapping the sea horizon with dunes, a few men, houses and a signal post. It is the first 'beachscape' – and one of the few in existence – which fully conveys the excitement of a brewing gale and impending roar; its diagonals, far from being only a conventional pattern, take on the character of foreboding and drama; its clouds are racing menacingly toward us as the people and even the signal post seem to lean over to meet their fury. The white area in the centre is of an amazing luminosity; it fuses with golden and grey browns towards the right; figures and houses are painted in grey throughout, the dominating tint of the picture, which is interrupted only in the sky by a light touch of blue.

Next to such a masterpiece, Ruisdael's calmer beach scenes – probably painted *ca.* 1670 – have a difficult stand; yet they contain much that is delicate and pleasing, including beautiful skies. Their compositional pattern may be called a synthesis of the two main previous trends, and at the same time it revives that of the extraordinary de Vlieger of 1633 (fig. 206); the coast recedes towards the distance with roughly one-half of the picture given over to the sea and the other to the beach (even though this may intrude upon the other section in the foreground); but at the same time, a strong accent is placed upon the low horizon of the sea itself, extending over one half or so of the width of the picture as it did in the van Goyen type of the forties and in Ruisdael's own picture in the Ruzicka Collection (fig. 210). Quite different from the latter is

the standpoint sometimes taken by the artist: not close to the scene but at a consider-
able distance so that figures in and near the foreground appear almost unreasonably
small and accentuate the tendency, so frequent in Ruisdael's late paintings, to stress
great spaciousness of the scenery to the point of dwarfing and – because of their
distinctness – somewhat isolating the figures within the wide expanse of land and
water. The most famous example of this group is the composition preserved in three
versions: one in the former Neeld Collection (HdG 923, Ros. 566), another in the
Mauritshuis (HdG 924, according to Rosenberg p. 119, note 3, probably by Jan van
Kessel), and a third in the S. and F. Clark Institute in Williamstown, Mass. (HdG
929, Ros. 572).[26] It is closely related to the *View of Egmond* in London (no. 1390,
HdG 927, Ros. 570; fig. 211), which in turn is rightly considered a companion piece
of the *View of Muiden* now in the Greville Collection (Polesden Lacy) of the National
Trust (HdG 102, Ros. 572a). In the London picture the sea occupies the left half, and
the beach meanders back into the centre towards the distant horizon line, while a dune
and the spire of the church of Egmond rise in the right middle distance; a high sky
vaults over the scene which is enlivened by elegantly dressed people walking along the
beach or standing around in groups. The composition is somewhat similar to that of
de Vlieger's picture in Cologne (fig. 207) but the older master's serene calm has been
replaced by a lively breeze, his clearly defined spatial compartments by a more diffused
spaciousness, and his combination of grey-brown tonality and darkish local colours
by a greater emphasis upon light, silvery, grey-blue tints. There is a certain thinness
to it all but in both of the companion pieces the figures, though not by Ruisdael
himself,[27] are more successfully integrated into the landscape than in many other late
works of the master, the prevailing coolness is pleasing and refined, and the sky is a
masterly combination of subtle grey clouds with rose and yellow lights – an effect of
'old-fashioned' refraction reminiscent of certain works by Jacob's uncle Salomon van
Ruysdael (see above p. 94) – and the light blue breaking through in several places.
The somewhat precarious tendency towards wide, open, rather empty spaces, which
seemed somewhat incongruous in Ruisdael's late forest scenes, appears – not un-
expectedly – to fit the subject of the 'beachscape' much better, creating a group of
works which, though certainly not constituting the main glory of the master's career,
are anything but negligible.

The contrast between a work of this kind and the few beach scenes proper painted
by Jan van de Cappelle is striking in terms of their composition, and even more so,
of their attitude to colour. In the great marine painter's wonderful picture in the
Mauritshuis (no. 820, HdG 133; fig. 212)[28] the beach appropriately yields a little more
ground to the sea but extends – in a diagonal slant reminiscent of the van Goyen
group of the forties – over a considerable section of the foreground, where some
prominent figures are placed quite close to the spectator as they watch their belong-
ings being carried to them from a sailing-boat. Thus, there is here less emphasis on
spaciousness and remoteness than in Ruisdael's late work, and more interest in con-

trast of scale and in concisely determined relationships between land, sea, sky, boats and figures. But even more significant is the colouristic difference between Ruisdael and van de Cappelle.

Ruisdael's picture with its cool, bluish and pinkish-greys, its crisp details in the depiction of dunes, water and figures, and its clearly distinguished colour nuances in the clouds, is essentially conceived in terms of local colour subjected to slight tonal revisions. Van de Cappelle's picture is based on 'luminous tonality' of a kind related to, yet different from what we have observed in Cuyp's river landscapes and in van der Neer's Amsterdam *Winter* (fig. 183). The picture is essentially restricted to a gamut extending from grey to brown (with some related reds and blacks in the figures and some lemon-yellow in the dunes) but at the same time, this tonality, far from being of the more graphic and somewhat schematized type favoured by artists of the thirties and forties, exhibits a silky, all-pervading luminous sheen which results in the impression that the entire scene is steeped in moisture. This effect has been achieved by an extremely significant change from the essentially draughtsman-like approach to figures and objects in the art of van Goyen and his contemporaries to a more specifically pictorial one. The figures on the left are still set off against the dunes but they are less defined in detail, their outlines are blurred, their faces consist of flecks of colour; the man facing the spectator wears a light brown cloak which is actually encompassed by line-shaped lights so that it is not sharply separated from the water, which in turn shows a brown reflection at this spot. In fact, there is hardly any object in this picture which is circumscribed by normal outlines. The 'light lines' (edges) occur in the sailing-boats as well; there is a constant display of cognate colour nuances in neighbouring objects and an echoing of related tints, such as a series of subdued reds, all over the picture plane. Aerial perspective has been observed more carefully and rendered more subtly than ever before (very evident in the diminution of intensity in the red nuances toward the distance); extremely delicate reflections in the water such as the long soft shadow of the central boat add to the feeling of infinite tenderness of forms; compared with the ostensibly fortuitous shape of these moisture-laden clouds, most other seventeenth-century clouds look 'made'. It would be useless to search for anything more or even equally striking and perfect in other works by van de Cappelle or Willem van de Velde, let alone Bakhuyzen and other minor artists. Once more, Jan van de Cappelle emerges as one of the great representatives of a true *ars nova*; again his new achievement is based on new optical discoveries; again, it is not the discoveries that automatically result in a new style; again, it is not sight alone but sight coupled with insight that counts, and accounts for this miracle.

With the few beautiful beach scenes of Adriaen van de Velde we are returning to a style which is closer to the later Jacob van Ruisdael than to Jan van de Cappelle yet is of unmistakable originality; probably all of them antedate Ruisdael's work in this field. The most celebrated example is the *View of Scheveningen* in Kassel, dated 1658 (no. 374, HdG 355; fig. 213); it is his first and perhaps his finest, but there are almost

equally admirable masterpieces at Buckingham Palace (HdG 357), in the Louvre (HdG 360), at The Hague (HdG 356; fig. 214) and in a few private collections; they range in date from 1658 (Kassel) to 1670 (Collection de Geus van den Heuvel in Nieuwersluis).[29] Adriaen van de Velde is not interested in tonality, neither of the van Goyen nor of the van de Cappelle variety. His day on the beach is the one which so many people miss on Dutch beaches: the day when all forms stand out in unadulterated colours, bathed in a fresh, clean light which softens their contours without blurring them. In the painting in Kassel (fig. 213), the effect of the complete permeation of the picture surface with a glorious sunlight, which a thin film of clouds deprives only of its harshest glare, is entirely the master's own; so is the wonderful harmony of the low, dominating horizon line which descends in an admirable cadence from the slightly elevated church tower on the left via the softest of dunes to the straight but delicate surface of the sea on the right, with just a trace of overlapping occurring in a wagon most judiciously placed in the exact centre of the middle distance. Here our distance from the scene (which is viewed with the coast leading into depth, though with an extension of the beach into the right foreground) is enough to make all figures appear small and dispersed far and wide, and our standpoint is high enough to keep them all under the horizon. However, in the fine painting of 1665 in The Hague (fig. 214), in which beach and sea extend parallel to the groundline, we are moved closer to the scene and placed low enough to see the larger and more densely grouped figures and the hut on the left rise and overlap the horizon even more conspicuously than do boats and carriage on the right. The result is a greater emphasis on the *genre* scene at the expense of the landscape, exactly as in van de Velde's second group of winter scenes (p. 98), but here with a clearer implication of development from the former to the latter type. A comparison with similarly organized pictures by van Goyen in the forties (fig. 203) indicates a greater refinement in the way in which the sea atmosphere envelops van de Velde's figures and suggests greater expanses of sunlit water in the far distance.

It is not so easy to separate Adriaen van de Velde's beach scenes from those of his brother Willem van de Velde the Younger, who was his senior by three years. In the first place, it is possible that Adriaen painted the figures in some of Willem's pictures of this subject, notably the *Shore at Scheveningen* in London (no. 873; HdG 13 and 15) and the similar scene once in the James Simon and Buchenau Collections, dated 1659 (HdG 12).[30] These two works are very closely related to Adriaen's *Beach of Scheveningen* in Kassel (fig. 213) in composition as well, and with it, are prophetic of the composition of Ruisdael's late works. However, other beach scenes by Willem van de Velde, rather different in style, are more comparable with the justly famous *Beach near Zantvoort* of the former Six and Jurgens Collections (fig. 215),[31] which has been attributed consistently and probably correctly to Adriaen (HdG 353). Its monogram is not distinct ; its date has sometimes been given as 1667 (which would exclude an attribution to Adriaen for reasons of chronology) but is more likely to read 1658.

The panel is quite without parallel in Adriaen's work but its uniqueness can perhaps be explained by the assumption that it was painted directly from nature, as Hofstede de Groot suggested. Extraordinary in any case are the wonderful light effect with the long shadows; the breezy treatment of water and sky; and the highly original composition, seen from above, with prominent figures walking down the hollow centre towards the sea, with dunes rising on both sides but remaining entirely below the high horizon line, which is overlapped only slightly by the roof of a house on the left and the masts of some sailing-boats otherwise completely hidden by the dunes.

This same motif is encountered in a picture, fully signed by Willem, in Rotterdam (no. 2533)[32] but in a distinctly softened and weakened form which almost seems to confirm the attribution of the Six painting to his greater brother; it should also be noted that, judging from the costumes of the elegant couple in the foreground, the painting in Rotterdam must belong to the late sixties. Somewhere between the Six picture and the more typical beach scenes by Willem stands a small panel, signed with Willem's initials, in Indianapolis (fig. 216);[33] its composition is less startling, more conservative than that of the two pictures just discussed, but the general character of its design and execution preserves a good deal of the spontaneity of Adriaen's panel. It surely preceded the Rotterdam picture and also the *Beach* of the van der Vorm Collection in Rotterdam (HdG 333),[34] which may be called characteristic of Willem van de Velde's mature works of this kind, more closely related to his calm marine paintings and probably dating from the early sixties.

Most beach scenes by minor masters of the second half of the century have a tendency to emphasize prominent figure groups, together with the characteristic new preference for local colours instead of tonal effects and for clearly defined structural elements instead of subordination to sweeping diagonals and the like. Depending upon the painter's artistic bent, these pictures vary from the overcrowded though amusing and brilliantly clear pieces by Salomon Rombouts,[35] the large, often hasty and rather indifferent production of Egbert van der Poel,[36] and Ruisdael-inspired works by Claes Molenaer and others, to the much more original output of Jacob Esselens. This very protean master (he als) painted wooded river views, landscapes of the classical type and others in the style of van Everdingen) painted a number of shore views which combine prominent, colourful figure groups on one side of the foreground with well unified, broad vistas of beach and sea, seen either panoramically from an elevated foreground or close to in a more intimate fashion (fig. 217).[37] In works by Cornelis Beelt and others, the familiar scenery of Scheveningen became merely the framework for elaborate and very crowded state and society affairs, and the history of 'beachscape' ends on a note reminiscent of its beginnings, with regard to subject as well as to an accumulation of multifarious details and colours.[38]

CHAPTER IV

The Sea

THE term 'landscape' seems to exclude 'seascapes'. Yet general surveys of land-scape painting are apt to include at least a brief word on marine painting and, for obvious reasons, this appears to be particularly unavoidable when speaking of seventeenth-century Dutch art.

There exist two monographs on this special subject, both dealing with Flemish as well as Dutch marine painting of our period. One is a scholarly book of considerable substance,[1] the other was written by an enthusiastic amateur,[2] but both are eminently useful and quite well illustrated. The present chapter might serve as a recapitulation of some main points discussed in these books and at the same time of some phenomena touched upon in other chapters of this volume. Beyond that, the author simply wishes to present some of the greatest achievements in this field and to raise a few questions which do not seem to have been accorded the attention they deserve.

The fact that both Willis and Preston included the 'beachscape' in their books illustrates but one difficulty in differentiating between seascapes proper and the realm of 'land'-scape. The same dilemma obtains within the category of 'sea, lake and river'. Here my basic criterion in defining a seascape proper has been not so much the expanse of water as such (although this is important too) as the prominence of sailing-boats in the composition of the picture. Wherever this feature is of paramount signifi-cance I speak of seascapes; in other words, a decisive point of the picture, in addition to a strong emphasis on the calm or agitated surface of the water, will be the relation-ship between the sailing-boats as the only truly commanding vertical or diagonal object, the water and the sky. It stands to reason that this relationship is likely to parallel in many ways that between land, sky and trees or buildings, as observed in landscapes proper.

It is also clear from what has just been stated as a criterion for seascapes that there do not exist, in seventeenth-century Dutch painting, any representations of the sea without vessels; and vessels mean men. The sea without man was as much a discovery of the nineteenth century as was landscape without man. And as with regard to land-scape, one could maintain that most marine painting of that period is to some extent *genre* painting because no marine painter ever lost sight completely of the daily life of his fellow-countrymen, for whom the sea meant both blessing and peril, livelihood and ruin, and of the events that took place on the seas and vitally affected the welfare of the young republic. Only rarely does one find a ship in which man is not actively involved in keeping everything shipshape, be it in a storm or in a calm, be it his business simply to keep the vessel afloat or to perform acts of ceremony on it; and in the few cases where man seems to abdicate before nature we are in the presence of

the same *rara avis* among Dutch seventeenth-century painters who by minimizing the role of man in a dune or forest landscape sometimes achieved a similarly near-romantic effect: Jacob van Ruisdael.[3] No wonder that only he seems to have paid scant attention to the type of vessel that he shows being swept into the solitude of the vast seas; most of the other Dutch painters of seascapes (the term covers both the sea proper and the inland *meeren*) were thorough connoisseurs of ships as well as of the water.

The re-emergence of stylistic elements of works of the first generation in those of the third – the grandchild-grandfather affinity so often observed before – is particularly striking in marine painting. It is here often tied to a specific subject; but a word of warning against overrating this element is in order. If, in thinking of the first and the third generation of marine painters, representations of sea battles and princely embarkations or landings with all their crowding and to-do come first to mind, it is not because no such pictures were painted during the second generation[4] but because the other two phases have a less illustrious record in subjects which – with us – count more than battles, embarkations and landings. I think one might aver that marine painting had a shorter period of outright greatness than landscape painting proper: no seascape of the time shortly before 1630 is great in the sense in which some of Esajas van de Velde's landscapes of *ca.* 1615–30 are great, and none after *ca.* 1665 are great in the sense in which Ruisdael's late 'Haerlempjes' or Hobbema's *Avenue of Middelharnis* is great. But it was a marine painter, Jan Porcellis, who led the field in the development of all tonal painting; in a sense, it was only through this development that marine painting pure and simple could come into its own and, to a degree, all great marine painting was bound to remain tonal more than any branch of landscape painting proper. Not before atmosphere, both in the literal and figurative sense, became a main concern of the Dutch painters, did the seascape come into its own, and it was bound to run out when the main impetus in that direction had been spent. Both before and after this great development, marine painting was basically the painting of events happening on water.

In contrast to landscape painting, marine painting was not decisively prepared and stimulated by a precocious group of draughtsmen and etchers; among the few exceptions we again find the young van Goyen, whose sketch-books of the early 1620's contain such astonishing premonitions of the mature phase of marine painting as the little sketch in Frankfurt reproduced here (fig. 218).[5] The antecedents of the Dutch seascape lie in Flemish painting rather than in Dutch graphic art. There is less of a gap between Pieter Bruegel's great *Harbour of Naples* and early Dutch seascapes than between Bruegel's landscapes and early Dutch ones. Some of Jan Brueghel's river landscapes with prominent sailing-boats anticipate an even more advanced stage of Dutch marine painting with their calm, non-narrative motifs; their influence is reflected in late works by Hendrick Avercamp, one of which we discussed among the river landscapes (p. 54, fig. 94). The meticulous study of individual ships, which became a

passion of some Dutch artists of the seventeenth century, such as Willem van de Velde
the Elder, had a long history in Flanders, reaching back all the way via Pieter
Bruegel to engravers of the late fifteenth century such as the Master W.✧. In
view of distinguished contributions of this kind it is all the more striking that in
the further course of the seventeenth century Flanders never produced a group of
marine paintings that even remotely approached the Dutch achievements in this field.[6]

The discussion of the first Dutch phase can conveniently be restricted to a few
works by Hendrick Cornelisz Vroom (1566–1640),[7] who was born and died in Haarlem
but travelled widely and wildly, mostly painting tiles until he settled in his native town
about 1590. His early production may not have included any seascapes at all. Tapes-
tries made after his design for the Abbey of Middelburg in 1597 precede his earliest
known marine painting, done at the age of forty-one (1607).[8] A picture of 1614 shows
an Eastern rock-enclosed bay, crowded with ships, from a bird's-eye view, entirely in
the Bruegel tradition.[9] Later he concentrated on exact renderings of specific sea battles
and maritime festivities, panels of emphatically topographical interest, and a few less
elaborate subjects such as 'portraits' of individual ships, or a stormy sea, in which,
however, narrative and dramatic details, including the spouting whales of the Bruegel
tradition, are still of paramount importance. The picture in Amsterdam (no. 2604A;
fig. 222), which commemorates a Dutch victory over the Spanish fleet won in 1607,
but may have been painted a good deal later, conveys a good idea of this type of marine
painting: full of lively and reliable details of rigging, manœuvring, fighting and
drowning; the picture plane quite fully dominated by men-of-war, even to the detri-
ment of the expanse of water; a still relatively high horizon; the colours multifarious
in the innumerable figures and flags, crisp and sharply detailed even in the rendering
of the waves.

Transferred to a calmer scene of predominantly topographical interest, we find
many of the same ingredients in the *View of Haarlem from the Spaarne* in the Haarlem
Museum (no. 302; fig. 223). The very oblong format does not increase the impression
of spatial freedom as it does in similarly proportioned (if smaller) works by Seghers
and others, although there are no artificial lateral 'wings' in this (relatively late)
picture; in spite of its fine rhythmic structure, our attention is still riveted on specific
objects which must be 'read' in succession. The freshness and crispness of the indivi-
dual forms are nevertheless a delight, enhanced by the crystal-clear green-blue-grey-
red hues, and make the picture look like a polished apple in comparison with the grape,
plum and peach tones of the next generations.

Almost the only similarity between Vroom and Jan Porcellis can be found in the
restlessness of their lives. Born in Ghent about 1584, Porcellis lived and worked in
Rotterdam (1605), Antwerp (1617 master in the guild), Haarlem (1622/23), Amster-
dam (1624/25), Voorburg (1626) and finally in Soeterwoude near Leiden, where he
died prematurely in 1632.[10] Porcellis is the earliest master of the tonal style, and
although it is in my opinion wrong to maintain that masters like van Goyen and

Salomon van Ruysdael would never have developed their own tonal style without him, they were undoubtedly fascinated by his works; and in marine painting proper he was indeed the teacher of an entire generation.

Setting aside a somewhat problematic 'beachscape' of 1622 which has vanished from sight,[11] the first secure date on any known work of the master is 1624 – the time when he had just moved from Haarlem to Amsterdam. The picture of that year in Dessau[12] represents a group of whaling vessels in heavy sea and places considerable emphasis on the narrative and dramatic aspects of that enterprise, although some compositional features (not the colours) seem to point forward to the year 1629 in which Porcellis painted two decisive works. The year before, he had already been praised by Ampzing as 'the greatest artist in ships'.[13]

The very small picture of 1629 in Munich (no. 5742, fig. 219) is a unique synthesis of Mannerist iconographic sophistication and epoch-making stylistic progressiveness. The wood-work painted around the seascape proper is a window frame, on which the sheet of paper with signature and date seems to have been casually deposited; this is prominent enough to sustain the effect of the window trompe l'œil, although one also receives the impression of a painted picture frame of the kind that, together with the painted curtain, became fashionable only after Rembrandt had introduced it in his *Carpenter's Family* of 1646, seventeen years later.[14] The agitated sea, painted entirely in an olive-grey tone under a grey sky with a few light pink patches, is enclosed within the yellow-brown of the window – a remote vision far away and yet of incredible intimacy. The few ships now battle the waves instead of each other; they are small, almost insignificant in comparison with the stormy waves and clouds; they are part and parcel of the universal greyness, without individuality or local colour, atoms in the universe called 'sea'.

The seascape of the same year, 1629, in Leiden (fig. 221)[15] differs considerably from the Munich picture and is even more prophetic of the achievements of the 1630's and 1640's; it fully anticipates the mature (though not the latest) style of Jan van Goyen as well as of Simon de Vlieger. The still somewhat precious quality of the Munich picture is gone. So is the latter's relatively sharp demarcation of a *repoussoir* of foreground waves, which has been replaced by a casual-looking system of alternating slightly diagonal zones of greyish and brownish-grey, in which the blending is actually more important than separation; to these zones, the diagonals of the sails and masts are clearly yet most unobtrusively related. A wonderfully light touch pervades everything: light in the sense of a fresh clarity and breeze as well as in the sense of ease and effortlessness. In the tiny upright picture in Berlin (no. 832A;[16] fig. 220) everything has become even more subtle and delicate; the choppy sea has here been replaced by a calm, the struggling diagonal boats by serenely stately ones, and although tone is still all-pervasive, there is even – miraculously – an intimation of that renewal of contrasts in colour and structure which became the hallmark of the second half of the century. The picture's upright format – the first instance in seascapes of this

novelty – points in the same direction, and specifically to the very similar seascapes of this type painted in the 1650's by Salomon van Ruysdael (fig. 229).

I shall be brief concerning the other masters of the tonal period, whose works are in fact better known than those of Porcellis. A comparison between one of van Goyen's earliest painted seascapes (dated 1636; HdG 81a; fig. 224)[17] and Porcellis's picture of 1629 in Leiden (fig. 221) will at once reveal resemblances so close that no words need be wasted on them, and even the reproductions provide a clear enough hint of their similarity in tone. Van Goyen's little masterpiece of 1638 in London (no. 2580, HdG 1043; fig. 228) adopts the upright format and tall sky of Porcellis's Berlin picture (fig. 220) but preserves the closer view of the scene which the master preferred at that time; it is a perfect jewel with its undisturbed serenity and its all-pervasive light grey tone, which nevertheless leaves room for a warm accent of brownish-red and blue in the standing fisherman.[18]

Between the late thirties and the year of his death (1656), van Goyen may have painted close on one hundred seascapes, more or less equally divided between agitated and calm seas, but with a proportionate increase of the latter with advancing age. There are examples from almost every year but a sudden crescendo occurred one year before the end, in 1655.[19] And then, there is one more supreme masterpiece from his last year (Frankfurt, no. 1071, HdG 1028: fig. 225). It is the most eloquent testimony we have to van Goyen's 'Altersstil'.

Compared with the early calm marines, the only significant new feature in general setting had been introduced around 1650: the spectator now often – by no means always – stands somewhat farther removed from the scene and at the same time a little farther above, so that the horizon lies a little higher, with no overlapping by foreground figures (cf. figs. 224 and 228). This serves to accommodate a greater expanse of water and boats under the horizon line, with the additional result that quieter parallel strata seem deliberately to retard our journey into the distance. Thus was created a greater feeling of 'recollection in tranquillity' in the spectator; there is greater reserve, a touch of greater classicality. But an even more decisive difference from the earlier works lies in the increase of contrasts of mass and hue. In the Frankfurt picture, the boats and even the distant river bank are more on their own than before; they are set off against the light sky and water more firmly; they do not blend into their surroundings, they assert themselves more boldly. And this goes together with a new emphasis upon colour – hues which likewise assert themselves more proudly rather than submitting to a general tonality. The picture, which even a sensitive observer has called 'merkwürdigerweise ganz bunt',[20] seems indeed to inaugurate a new colour style – a few months before the master's death. The rowing-boats and the intimation of the shore on the left and the hull of the sailing-boats on the right are of a deep but luminous brown (with red and brown nuances in the figures), richly contrasting with the liquid silver of water and sky; but the most amazing colour effect is provided by the sails and the distant shore: a succession of grey, pink, and then a

mixture of green, buff pink and grey in well-defined strata, which foreshadows some of Jacob van Ruisdael's most daring experiments. The colour exploits in van Goyen's painting of 1623 (fig. 200) have not been forgotten; but the experience of the tonal period has provided the artistic basis for their highest sublimation. In this way, and with such authority, one master spoke for three generations.

The marine pictures of Salomon van Ruysdael were painted roughly a decade later than those of van Goyen. The earliest dated example is of 1642, the latest of 1663. Many are undated but there is no reason to assume that any of them are to be placed beyond either of those limits.[21]

The tonal works of the forties are indebted to van Goyen, and perhaps even more to Porcellis and de Vlieger; but characteristically, there are no stormy seas. Ruysdael's calmer temperament, his 'sober poetry' (Schmidt-Degener), made him concentrate on placid river or lake scenes in which the sailing-boats, though predominant, often do not outshine the banks and shores (with their buildings and occasionally their animals) as fully as is the rule in most of the seascapes by van Goyen and de Vlieger. By the same token, the grey tonality is usually tempered by somewhat more varied, though very subtle hues. The most perfect example of this phase remains the undated picture in Frankfurt (no. 1112, St. 313; fig. 226). As may be expected, the grey tones diminish in the fifties, the soft hues become more vivid, a soft blue appears in the skies, horizontals and verticals predominate more clearly. There are many beautiful examples of this kind in the traditional oblong shape, but significantly, some of the finest are intimate chamber-music pieces in upright format which look like translations of Porcellis's precocious Berlin picture (fig. 220) into a somewhat more modern idiom (*View of Alkmaar*, St. 48; fig. 229). Most works of the sixties continue the trend of the more fully orchestrated paintings of the fifties in a somewhat more sombre, slightly more romantic key; in the finest of these, such as the *View of Rhenen* in the Barnes Collection (St. 309), some features of the seascapes by Salomon's great nephew Jacob van Ruisdael are foreshadowed.

How much Simon de Vlieger[22] owed to Porcellis can be instantly seen from his early beach scenes (figs. 204, 206) and his painting of 1631 in Berlin (no. 934), which is closely related to Porcellis's picture of 1629 in Leiden (fig. 221); in Rotterdam, where de Vlieger was born (*ca.* 1600–05) and resided until 1633, paintings by the older master, who had worked there for a while in his earlier years, were certainly not difficult to come by. The same relationship is evident from the wild 'Stormy Sea' pictures of the 1630's and 1640's, such as the fine, early one in the Fogg Art Museum of Harvard University (fig. 227),[23] which recall similar scenes by Porcellis in their refined, grey-brown-pink-blue colour combinations as well.

De Vlieger's river, forest, beach and night scenes are briefly discussed elsewhere in this book. The group of seascapes proper is on the whole his most significant achievement. But within it, our attention must be directed not so much towards his Porcellis-like works or towards his occasional borrowings from elsewhere, such as his early

variations on Rembrandt's *Christ and the Disciples in the Storm*, now in the Gardner Museum in Boston;[24] it is rather the production of his very last years that really matters.

These were the few years (1649–53) de Vlieger still had to live after having moved from Amsterdam, his residence from 1638 to 1648 (though with many interruptions), to Weesp, about ten miles to the east. It is as though the calm of this provincial town, a peaceful haven after a life nearly as hectic as that of Vroom or Porcellis, had been needed to inspire in him the marvellous serenity expressed in his last works. The *Beach* in Cologne (fig. 207) announced this late phase, which comes into full glory in works securely placed by a few dated examples between 1649 and (strangely) 1654 (Schwerin, no. 1086).[25] Not that he had never painted scenes of quiet composure before;[26] but now they show a stateliness and, at the same time, convey a sense of poetry which exceed all earlier efforts, and this is even true of the 'parade' or 'traffic' type of seascape (Vienna, no. 1339, of 1649;[27] Cambridge, no. 105, of 1651; Budapest, no. 314). The less 'representative' type includes the famous, closely interrelated works in Schwerin, in the Vienna Academy (no. 867), and in Rotterdam (no. 1923; fig. 230).

It is evident that in such a work we face a fundamental change highly reminiscent of van Goyen's last development: a new stately calm; quietly horizontal strata with sparing vertical counterparts ('classicality'); a revival of significant structural aspects and even some local colour, as opposed to diagonals, spatial complexity and strictly tonal atmosphere. Yet at least one difference between van Goyen and de Vlieger is very important. Van Goyen's colours are based on deep browns and greys, and his brushstrokes are spontaneous, relatively open, and invariably betray the natural draughtsman. De Vlieger's colours are based on silvery-greys and lighter hues throughout (the first boat on the left in fig. 230 is painted in a characteristic soft rose-brown), and his brushstrokes are smooth and lose their identity in careful glazes. A clear gauge of this difference is provided by the respective effects of reflection in the water: a hazy suggestion with van Goyen – and also in Salomon van Ruysdael – and a great discovery brilliantly exploited by de Vlieger in the service of greater overall luminosity and balanced design within each section of the picture surface. Was this discovery de Vlieger's very own? The answer to this question depends on our interpretation of his relationship to the man whom I do not hesitate to call the greatest Dutch marine painter, Jan van de Cappelle.[28]

This great artist, rich industrialist and amateur collector extraordinary (Amsterdam, *ca.* 1624–79) painted perhaps less than two hundred pictures during his lifetime. These include about fifty (at the most) winter landscapes; all the rest are seascapes, invariably with calm water. The first absolutely certain date is 1649 (Stockholm, no. 562), the last probably 1665. Since dates are rare, it may be helpful to state that all paintings genuinely signed in the form 'Capel' or 'Capelle' were most probably painted before or in 1651, all those signed 'Cappelle' in or after that year.[29] Unfortunately the most

crucial date cannot be verified at this time; it is that of the splendid picture in the John Robarts Collection (HdG 50), which has been read 1645.[30] This is a 'parade' composition entirely in the style of de Vlieger's last years (Budapest; Vienna of 1649). Nothing of this kind was painted by de Vlieger in 1645 but, while van de Cappelle's next dated picture of 1649 in Stockholm, with a view of the sea between pier and shore, is clearly in the style of de Vlieger's works of the forties, his 'parade' marines of 1650 in London (no. 965, HdG 34) and Amsterdam (no. 681, HdG 17) are again entirely of the type and style of the Robarts picture.

It has invariably been assumed that de Vlieger was the source of van de Cappelle's inspiration, and in this connection it has been pointed out that the younger master owned nine paintings and no less than one thousand three hundred drawings by the older. The question is whether this fact means what it is supposed to mean. Van de Cappelle was a collector in the grand style; he also owned sixteen paintings by Porcellis (whom he copied), ten by van Goyen, landscapes by Esajas van de Velde, Seghers and Molijn, and any number of Rembrandt drawings; and many of the artists whose works he collected were as 'recent' as was de Vlieger, whose works may thus have been but another *desideratum* for van de Cappelle's collection. If the Robarts picture is in fact dated 1645, van de Cappelle's priority with regard to composition would certainly be established.

It is true that from the point of view of softness of brushstroke and overall luminosity, de Vlieger's latest style seems to have been further advanced than van de Cappelle's by 1650. The Robarts picture is crisp, cool and silvery, and although a golden tone is beginning to tell in 1650 (Amsterdam, London), details do not seem to be as much subordinated to the general effect as in de Vlieger's works of that period.

Yet the specific luminous treatment of the figures which we discussed as a basic discovery of van de Cappelle in connection with his *Beach* at The Hague (fig. 212) does not really occur in de Vlieger's paintings save for a few suggestions of the kind that we found in his *Beach* in Cologne (fig. 207).[31] On the other hand, this effect is rather fully developed in van de Cappelle's three seascapes of 1651 in Chicago (no. 33. 1068, HdG 110: fig. 231), in the Lonsdale (HdG 69)[32] and in the Spencer Churchill (HdG 108)[33] collections. There is 'tonality' here of the new kind: an all-embracing silky atmosphere, with red-brown, grey-brown, greyish-blue, red, white nuances in the figures fully subordinated and painted in the suggestive rather than descriptive technique which gives an impression of all-permeating moisture and sunlight. In this connection it may be worth stating that these three paintings (as well as all large ones of later years) were painted on canvas, while the earlier ones are all painted on wood.

The style of 1651 eventually gave rise to the enchantment which emanates from works datable between 1654 (HdG 52)[34] and 166(5?) (HdG 35, London no. 966). Among these is the large painting in Rotterdam (no. St. 5; fig. 234), which dominates its surroundings not so much by virtue of its size or the splendour of its subject but

by its magnificent luminosity. Again brown, grey, some red (flags and some costumes) and some blue (sky and water) are held together by an atmosphere of an almost palpable moisture such as had never been painted before; all details are steeped in it, blurred by it; even the reflections in the water of the figures in the 1650 paintings now look over-detailed and almost picayune in comparison. The wonder of these reflections now outshines de Vlieger's (fig. 230). Another high point, this time from the group of paintings with more intimate subjects (which we have neglected so far), is the greatly daring picture in Cologne (no. 2535, HdG 54; fig. 235) with the dazzling sunset in the very centre which links it with similar but lesser exploits of van Goyen and Aert van der Neer.[35] It is characteristic of this great artist – and to a degree typically Dutch – that the glory of this sunset should embrace a humble fisherman at work, rather than a majestic frigate.

It must be emphasized that all the mature works of Jan van de Cappelle are not of the 'golden' or the 'brown' type. The cooler, more silvery sheen of the Robarts picture (1645?) was continued in a few paintings which belong to the fifties. Actually, the picture of 1651 in Chicago (fig. 231) is more silvery than golden, but its grey has a warm sheen. Cooler is the painting in the Ruzicka Collection of the Zürich Kunsthaus (HdG 21, dated 165–, most probably 1650); another, very closely related to it in composition (green river banks are visible on both sides in the middle distance), is in the Toledo Museum (ex Arenberg Collection, HdG 24; fig. 232) and is probably somewhat later because of the greater perfection of its atmospheric treatment. This masterpiece would defy description by a poet as much as by a painter; a detail (fig. 233) will show better than any words how the objects in this picture are rendered by what one is tempted to call the spirit of the brush itself – not of a slashing brushstroke like that of Frans Hals but of a calm, noble and subtle brushstroke of equal timelessness.

Perhaps this is the moment to consider briefly the oft-repeated theory that Jan van de Cappelle (and the late de Vlieger) developed their 'Lichtmalerei' under the influence of Rembrandt. Here again we ought to resist the temptation to confuse the collector van de Cappelle with the artist van de Cappelle and to overrate the fact that he and the late de Vlieger – who earlier had borrowed from Rembrandt, as did Jacob van Ruisdael and many others – resided in Amsterdam. How much of van de Cappelle's 'Lichtmalerei' can actually be linked with Rembrandt? There is surely next to nothing in Rembrandt's landscape paintings that is comparable, not even in the few late ones (which in fact are a little later than van de Cappelle's fully developed seascapes); but I cannot detect any parallel even in other Rembrandt paintings. It is another question whether Rembrandt's wonderful, light-saturated landscape etchings and drawings – of the latter van de Cappelle owned no less than 277,[36] – did not inspire the marine painter. But if such an influence existed, it must have been a very subtle one, and it must be said that van de Cappelle's wonderful etching of a seascape proper[37] does not favour the assumption of a very strong Rembrandt influence.

A similar question has occasionally been raised with regard to Aelbert Cuyp, whose

seascapes, related to those of van de Cappelle in spirit and style, find their logical place here. Again, I must consider the possibility of a bond with Rembrandt very remote. In any case, Cuyp owed a much greater debt to Jan Both; his particular type of golden luminosity also differs from van de Cappelle's softer, browner or greyer haze and is more closely linked to Jan Both; it has little or nothing to do with Rembrandt.

As may be expected, dates on Cuyp's seascapes are almost non-existent.[38] His van Goyen-like early river landscapes seem to have made room for Utrecht-inspired works around 1646, reminiscent first of older Utrecht artists, then increasingly of Jan Both. To judge from their style, some of his seascapes must have been painted shortly before 1650, prior to the development of full luminosity and still reminiscent of the yellow overall haze of his own and van Goyen's river scenes of about 1644–45. Such a work is the large canvas in Toledo (fig. 236) with a motif from the river Maas near Dordrecht. It certainly goes beyond the earlier works by virtue not only of its increased admixture of golden haze but also of its enhanced composure, noble stateliness and 'classicality', which closely parallels works by de Vlieger of the late 1640's and early 1650's (see fig. 230). Cuyp's moonlit seascapes of this period will be considered later.[39]

The clearer, more crystalline golden luminosity which we already know from Cuyp's *View of Nijmegen* (fig. 102) must have been the fruit of his intensified study of Jan Both and possibly Jan van de Cappelle. It culminated in the celebrated *View of Dordrecht* at Kenwood (HdG 165=631) and in the imposing embarkation scene taking place at the same spot (Washington no. 501, HdG 28; fig. 237). With regard to the crisp, colourful design of the figures and other details in the foreground, a comparison with de Vlieger and with the van de Cappelle of 1650 shows a good deal of similarity (more so than with the van de Cappelle of the later period); but the 'liquid gold' of middle distance and background, achieved with the same means as in the *View of Nijmegen* (fig. 102), remains without parallel outside the master's own work. As so often in Cuyp's pictures, the figures, very prominent here, are somewhat awkward, the foreground heavy; but further back and upwards, all prose is submerged in poetry.

The art of Willem van de Velde the Younger (1633–1707)[40] has always been praised, and often damned with faint praise. A fresh study of this artist is needed; recent literature has paid more attention to his father, Willem van de Velde the Elder, than to him, at least as far as his paintings are concerned. Only a brief sketch can be offered here.

The precocity of this artist becomes very evident from some of the paintings he did at the age of twenty to twenty-two. The *Calm* in Kassel (no. 420, HdG 186; fig. 238) is a beautiful, though rhythmically rather awkward piece in the soft, atmospheric style of the late de Vlieger, who was van de Velde's teacher and died in that very same year, 1653. Its artistic economy is particularly striking when compared with other

works of 1653, such as are found in Budapest (no. 216, HdG 83) and Leningrad (no. 1021, HdG 92; fig. 239); these clearly originate in the 'representative' type of de Vlieger's and van de Cappelle's output around 1650 and at the same time foreshadow later developments but are distinguished by a charming naïveté lacking in the artist's late style. The fine, reticent touch of the late de Vlieger is still remembered in 1657 (London no. 870, HdG 195) but its combination with a more outspoken clarity of atmosphere, in which fuller emphasis is given to structural elements and more individual recognition to hues, indicates the full maturity of van de Velde's own style.

Large sunny skies with powerful masses of clouds are increasingly favoured in near-square and upright formats. Patterns of composition in which depth is emphasized in a great variety of ways still seem to be inexhaustible throughout the fifties; there often remains a remarkably beautiful balance between the subtle observation of the many moods of the sea and an increasing interest in human activities. Such a work is the *Evening* in Leipzig (from Lützschena, HdG 328; fig. 240), a picture probably painted in the late fifties, in which the calm of water, sails and sky is admirably wedded to the mood of the early evening, the termination of a day's work in the striking of the sail by a man silhouetted against the sky in the centre of the picture; comparison with the painting in Kassel (fig. 238) reveals a much refined sense of rhythm. The agitated sea is recognized in its own right at least as early as 1658 (London no. 2573, HdG 485; fig. 241); the grey tone, which is here part and parcel of the subject as is the prominent participation of diagonals in the compositional pattern, still vies in restraint and subtlety with that of de Vlieger, even though it already tends to become a little more dramatic through contrasting light effects.

It is not before the sixties that a sometimes disturbing over-emphasis on human bustle and activity occurs in both the calm and the rough seascapes of van de Velde. Somewhat grandiloquent compositions of 1661 in London (no. 871, HdG 196)[41] and elsewhere (HdG 205[42] and HdG 312[43]) still have their very great merits with regard to atmospheric and compositional refinement. However, they reveal that, when it comes to a more representative style, van de Velde cannot compete with van de Cappelle and descends slightly to the (still very respectable) level of an artist like Hendrick Dubbels, whose rarely dated works, occasionally quite close to van de Cappelle's, run parallel to those of van de Velde rather than being dependent on them.[44] The placing of figures in silhouette (not just one but several) against sky and water now often becomes mannered and tiresome, the accumulation of activities becomes distracting, unity of thought and structure precarious, except perhaps in small panels; colour effects begin to assume a certain sweetness, in which light blue and a vaporous pink combine with red and white (1666: Berlin, no. 1679, HdG 81).[45] Huge canvases with embarkations, views of primarily topographic interest, and sea battles become more and more frequent.

As is well known, the high tide of this development began at about the time when van de Velde, together with or shortly before his father, moved to England (1672) and

soon set out to concentrate on English rather than Dutch naval victories. It would be entirely unfair to judge all of his later activity by the works of both paternal and atavistic character such as the huge *View of Het IJ* of 1686 in Amsterdam (no. 2469, HdG 2), the many representations of the *Battle of Solebay* in 1672 (an example dated 1673 in Hannover, no. 394, HdG 37), and similar canvases; it is not accidental that some of these have posed problems of attribution involving the name of Ludolf Bakhuyzen, a master who on the whole was certainly much inferior to van de Velde.[46] Some of the works with less spectacular subjects painted in the 1670's are still highly effective, both in the 'rough sea' and the 'calm sea' category (E. H. Fisher Gallery, University of Southern California, 1674, HdG 257; fig. 242).[47] But the last phase shows a conspicuous decline of taste, as can be gauged from a comparison of the shallow romanticism of the *Evening* of 1690 in the Vienna Academy (no. 792, HdG 338) with the refreshing straightforwardness of our fig. 241; often the design of the water appears mannered, its texture over-glossy, contrasts of light and dark overdone. It is no wonder that the best pictures of this period, such as the one in the Johnson Collection of the Museum in Philadelphia (no. 591, HdG 538; fig. 243),[48] represent a rough sea, not a calm; when it comes to the lesser things, a Presto is always more palatable than an Adagio.

The wonderful *Harbour at Sunset* in Amsterdam (no. 2698A 2; fig. 244), a work by Emanuel de Witte, may perhaps be likened to a synthesis between van de Cappelle's luminosity of about 1660 (fig. 234) and the cooler evening light of van de Velde's picture in Leipzig (fig. 240); indeed I am not sure that '*ca.* 1678–80'[49] is its correct date and that it should not be placed in the vicinity of the *Loggia* of 1664 in the Bremmer Collection,[50] rather than of the late *Fishmarkets*. But in contrast to the works by the other masters, the boats on the left and the corner of the building on the right have been anchored on the picture plane and connected with each other horizontally. The result is a more systematic stratification, in which middle distance, horizon and the sky participate; nevertheless diagonal directions in the sailing-boat on the left and the large frigate inject very subtle elements of diversity and contrast. These refinements confer upon the picture a peculiar sense of enigma which is congruous with its uniqueness in de Witte's output; we are familiar with the same subtleties of composition from his church interiors, but as they are applied out of doors and – more than in the *Fishmarket* pictures – to an unencumbered vista, they strike us as a great discovery which for some strange reason the master never followed up.

In the seascapes of Jacob van Ruisdael,[51] as in his Scandinavian scenes, one can recognize a strong debt to Allaert van Everdingen, whose earliest known painting is actually a *Rough Sea* of 1640, much in the trend of Jan Porcellis and the early de Vlieger.[52] The particular type of frothy wave crests which characterizes many of Ruisdael's rough seas, is foreshadowed here, and Everdingen's extraordinary, olive-grey *Snowstorm at Sea* in Chantilly (no. 136; fig. 246)[53] anticipates with its almost ghostly terror and forlornness much of Ruisdael's heavy mood; in fact, it somewhat

overdoes it, as a comparison with the latter's *Beach* of the Ruzicka Collection (fig. 210) will perhaps most convincingly demonstrate. While the Chantilly picture shows a few figures battling the storm in a rowing-boat, the sombre *Swedish Coast* of 1648 in Stockholm (no. 421) contains no figures at all. From a work like this, Ruisdael must also have derived the Nordic motifs which occur in some of his seascapes. All these paintings by Everdingen antedate those of Ruisdael by a considerable margin.

Ruisdael may have painted about forty to fifty seascapes properly speaking, of which about thirty are known today.[54] Needless to say, there are no calms among them. Not a single one carries a date but there can be little doubt that none was painted before 1660. It may be assumed that the *View of Het IJ* in Worcester (no. 1940.52, ex Northbrook Coll., HdG 959, Ros. 594; fig. 245) belongs in the mid-sixties and with Ruisdael's relatively early paintings of this kind; it preserves a great deal of the Porcellis–de Vlieger tradition.[55] Its mood could almost be called mellow, the view of Amsterdam in the distance gives it a somewhat familiar touch, light–dark contrasts are kept to a minimum, the sailing-boats close to the horizon, the foreground transparent. The celebrated *Rough Sea* in Boston (no. 57.4, ex Beit Collection, HdG 957, Ros. 591; fig. 247) was dated *ca.* 1660 by de Groot but as late as *ca.* 1670 by Rosenberg.[56] It was certainly painted later than the picture in Worcester; contrasts of light and dark have become more marked in the water, the sky and also in the sails; individual colours are more sharply defined everywhere, almost to the extent of opposing the concept of atmosphere as a primarily unifying agent; this is quite comparable with what Ruisdael was doing in his views of Haarlem of the same period, certainly not much before 1670. A still later group may be represented here by a picture in Philadelphia (Elkins Collection, HdG 963, Ros. 599; fig. 248). The drama has been heightened by placing a heavy, dark foreground with bigger waves in front of a sharply lit background strip and placing the dark sails, figures and hulks of the two main boats against a light sky which is about to be overwhelmed by threatening clouds. The emphasis on massive boat shapes, already greater in the Boston picture than in the one in Worcester, has been heightened further. Dark grey is still a powerful force but red and brown hues in the sails and figures are now even more important than in the Boston picture. It cannot be denied that some pictures of this late group[57] indicate a decline reminiscent of that noticed in other Ruisdael paintings of this period, and occasionally even invite unfortunate comparisons with minor artists such as Ludolf Bakhuyzen.

It may not be quite fair to the often excellent Reynier Nooms, called Zeeman (*ca.* 1623–before 1667), to represent him by his *Battle of Leghorn* only (Amsterdam, no. 1753; fig. 249), a huge canvas, in which he commemorated a Dutch naval victory of 1653. His less ambitious seascapes with Dutch (1658: Bremen, no. 100) and Mediterranean motifs (1659: Braunschweig, no. 342)[58] are more pleasing, although they are stylistically inconsistent and oscillate between Verschuier-like softness (cf. figs. 367-368) and Bakhuyzen-like glossiness. But the *Battle of Leghorn* is too good to miss in an

attempt to show the recrudescence of so many characteristic features of the typical works of the early decades; basically, it is a modernized H. Vroom (fig. 222), and as a special *tour de force* it contains a careful description of the event, written on a painted piece of paper seemingly stuck into the frame, a variation upon the (still Mannerist) 'gimmick' found in Porcellis's Munich picture of 1629 (fig. 219). The wealth of detail in this work immediately brings to mind the paintings by the late Willem van de Velde, Abraham Storck, J. Beerstraeten and other lesser lights of the late seventeenth century. However, it precedes them sufficiently to warrant the assumption of a direct contact with Willem van de Velde the Elder, and thus to emphasize again the fact that this kind of historic-topographic painting actually forms a continuous current, albeit with stages of greater importance at both ends of the development. It is significant that in addition to this type of reportage, 'dramatic' scenes involving (once more) whales[59] and other adventures in Arctic waters[60] became favourites with late seventeenth-century marine painters and their patrons.

CHAPTER V

The Town

WHEN does a picture which contains the view of a town cease to be a 'landscape' and become a 'cityscape' or town view proper? There is naturally no answer to this question which would satisfy everyone's taste, and I shall not attempt to give one here. Considering the general aim of this book, I may perhaps be permitted to exclude from this discussion not only all works that are of wholly or even primarily topographic interest but also those in which nature yields to architecture or to *genre* (or both) to such a degree as to minimize the paramount importance of landscape environment. Therefore one will find here, Vermeer's *View of Delft* but not his *Straatje*, and Fabritius's *View in Delft*, but not his *Sentry*. The latter example also indicates that we shall not restrict ourselves to towns seen from the outside; the presence of an important element of landscape seemed to be a more valid criterion than a mechanical distinction, but street views are indeed apt to play a minor role in this context. The views of Rhenen, Arnhem and Nijmegen by van Goyen, Salomon van Ruysdael, Cuyp and others, discussed in earlier chapters, are landscapes with a town view as an important foil; the paintings discussed in this chapter are town views with landscape as an important foil.

In his dissertation (which covers more than the area just delineated) Rolf Fritz[1] has pointed out that the town view proper does not appear before about 1650. It is not difficult to see that it presupposes the renewed emphasis on structure and colour which has so consistently turned out to be the hallmark of those crucial years. The thought of a town view proper in the tonal style of the thirties and forties is almost an absurdity, much more so than for a master of the preceding style; in fact, it almost stands to reason that the prototype of Vermeer's *View of Delft* should have been a work by Esajas van de Velde rather than by van Goyen, although even then, the difference is great.[2]

It is significant that the shiny and wonderfully delicate views of the outsides of Utrecht churches by Pieter Saenredam (1579–1665)[3] should have followed his drawings of the same motifs by a considerable margin of time. The drawings of the façade and the choir of the *Mariakerk* were done in 1636; of the corresponding pictures, one is dated 1659, the other 1662.[4] However, it must not be overlooked that these drawings are often elaborated by means of water colour,[5] and that works of this kind are indeed of amazing precocity and boldly anticipate Jan van der Heyden's paintings. Even these works are preceded by a few Roman vistas which Saenredam, who never travelled outside Holland, painted between 1629 and 1633 after drawings by Maerten van Heemskerck but miraculously raised to a level of colouristic refinement which leaves behind veteran residents of Rome like Poelenburgh and Breenbergh.[6] But of the painted Dutch town views, none – and there are only a handful of them – was done before 1657. In this year he took out of his portfolio a water colour of 1641 with a view of the

Old Town Hall in Amsterdam which in the meantime (1651) had been destroyed by fire; he especially noted on the painting (which the City Fathers bought from him in 1658) that he had drawn the building 'with all its colours' sixteen years earlier. In its rosy beauty, the picture (Amsterdam, no. 2099A; fig. 250) is a double triumph: of complete subordination to facts, and yet of an extremely subtle adaptation of the earlier drawing to the stricter demands of pictorial composition in general setting, shading, colours, and distribution of figures.[7] One is vividly reminded of the (artistic) miracle of Konrad Witz's *Lake Geneva* of 1444.

On the whole, then, town view painting was the result of the stylistic change around 1650. Its origins lay, not in Haarlem, where Saenredam was working, but in Delft. Carel Fabritius's famous *View in Delft* of 1652 in London (no. 3714; fig. 253) is a *genre* and street scene with a 'cityscape' as a background only – but what a background! There is here more feeling for sunlight and for a great building's reaction to it than in most other Delft views, let alone Egbert van der Poel's endlessly and relentlessly repeated representations of the town's funeral pyre of 1654, in which Fabritius perished.[8] Of the finest that Pieter de Hooch, active in Delft from *ca.* 1653/54 to *ca.* 1660/63,[9] accomplished in this field, the early picture in Toledo (HdG 287; fig. 252) can convey a good idea; the quiet idyll of the foreground is here admirably supported by a sensitive rendering of the unforgettable tower of Delft's *Oude Kerk*, the same tower which in Jan Steen's *Mayor of Delft and his Daughter*[10] is nearly obliterated by the obtrusive sentimentality of the beggar woman in the foreground.

It is a moot question whether Jan Vermeer van Delft remembered Esajas van de Velde's *View of Zierikzee* (fig. 93) when he conceived his incomparable *View of Delft* in the Mauritshuis (fig. 254). The pictures are more than forty years apart but their general structure is amazingly similar:[11] the diagonal section of the river bank with a few figures in the left foreground, the broad band of the river traversing the picture horizontally, the buildings on the other bank with their fine rhythmic relationships and their reflection in the calm water. Here the similarities end. Vermeer's standpoint is higher (maybe he did conceive this scene from a second floor window),[12] the river less prominent, his figures are smaller, the reflections of the buildings brought up to the very foreground. The town is in the middle distance rather than in the background. The execution is *legato*, not *détaché*. The town's silhouette forms a light, melodious curve instead of a diagonal. The clouds occupy a higher sky; far from being used to counterbalance the diagonal in the foreground in a linear pattern, they 'vault' in space from the middle distance, back to the foreground, comparable with Ruisdael's 'Haerlempjes' (p. 46) and the result is a mellow unification in space as well as on the picture plane; they seem to be made of the same moist stuff as the river (as in fact they are); they are the French horns in this great score, and they are certainly among the most wonderful clouds ever painted. The colours in the figures are cool (blue-yellow), without the strong red found in Esajas van de Velde's; the reds and pinks and rose-browns, in their incomparable, scintillating 'pointillé' application, are reserved for the buildings

(which had been painted in a combination of light brown and grey by the older master) and thus give added emphasis to Vermeer's hometown as the real protagonist of the picture. That this miraculous performance by Vermeer should have remained his only one in the province of landscape painting is one of the great enigmas of art history.

In spite of Hofstede de Groot's qualms[13] it seems rather evident that Jan van der Heyden (1637–1712) must have received inspiration from Delft in his early years, particularly from Pieter de Hooch. Van der Heyden's earliest town views proper do not antedate 1666 (HdG 95);[14] at that time he began to paint a large series of them in which he seems to have availed himself of drawings made, probably before 1661, during journeys to Brussels, the German Rhine, and possibly a good deal farther south.[15] With few exceptions (HdG 87),[16] this series seems to terminate in 1678 (HdG 44, 158); by that time van der Heyden had made his way to wealth through his invention of improvements in street lighting and fire fighting.[17]

Although van der Heyden's technique was, from the beginning, more meticulous than de Hooch's, the two artists share a delight in a bright, all-pervading sunshine which brings out local colours with remarkable intensity. But while de Hooch's art moved away from this procedure, clarity of atmosphere, for van der Heyden, became increasingly synonymous with counting brick after brick. Nevertheless, the variety of approach to his motifs, his compositional skill and his sense of colouristic equilibrium raise the level of most of his paintings above the ordinary and provided a solid basis for many enjoyable (and increasingly esteemed) eighteenth- and even nineteenth-century emulations. Besides topographically accurate vistas, van der Heyden, like so many other Dutch artists, painted composite views, which were evidently just as much appreciated by his patrons; a characteristic example is a picture in London (no. 994; HdG 157), in which the castle of Nijenrode is ingeniously combined with the sacristy of Utrecht Cathedral, about seven miles away.[18]

Van der Heyden's most famous pictures are street scenes of the kind I decided to eliminate from this survey; views of the Dam in Amsterdam with the elegant New Town Hall, of many other sections of inner Amsterdam, of outstanding squares and churches in Haarlem, Veere, the German Rhinelands (Cologne, Düsseldorf, Emmerich, Xanten) and elsewhere. On the other hand, he painted a considerable number of landscapes proper (p. 163, fig. 330). The finest synthesis of the two trends is embodied in some unidentifiable views of town canals (*grachten*) such as the intimate, seemingly unambitious and casual but in reality quite sophisticated painting in Karlsruhe (no. 339; HdG 204; fig. 255)[19] with its surprising revival of the old 'double diagonal' structure, in which sculpture, chimneys, trees, gables and embankment ingeniously share. The climax of compositional refinement, however, is reached in his views of the park in the 'Old Residence' at Brussels (HdG 42-51). The version in the F. Markus Collection (HdG 50; fig. 256)[20] is a good example: the park is seen from a high rampart, in 'diamond' perspective like a floor in a Vermeer interior; pieces of architecture are 'arbitrarily' chopped off by the frame, others arranged in complex positions or

obscured – and supplemented – by trees. Such a picture might well be called the Middelharnis Avenue of town painting, unless one wants to reserve this title for the extraordinary *tour de force* which is Daniel Vosmaer's *View of Delft* of 1665 (fig. 251).[21]

The light effects of the town views of the Haarlem brothers Berckheyde, Job (1630–1693) and Gerrit (1638–98), must likewise have been inspired from Delft, although some connection with Saenredam is also noticeable.

Job's charming, well-known *Oude Gracht in Haarlem* (Mauritshuis, no. 746; fig. 257) is his earliest work of this kind (1666); the daring frontality of its main motif and its rather broad execution remain somewhat exceptional. Some similarity with van der Heyden, who started painting his own town views in the very same year, is evident. Also in the manner of van der Heyden, but invariably warmer in the shadows and painted in more opalescent colours (somewhat reminiscent of de Witte) are the later works of this many-sided artist. His brother Gerrit was much more prolific as a painter of town views (particularly Haarlem and Amsterdam scenes); dates are available from the late sixties to 1697.[21a] His paintings are more sober, often also cooler and crisper than those of his brother, although still less sharply detailed and less brightly lit than van der Heyden's; he is the 'sober poet' of the town view as Salomon van Ruysdael is of the landscape proper. The intriguing *Sachlichkeit* of his pictures has put him in the limelight in recent years.[22] Most of his pictures are street scenes proper, others are landscapes proper, but, as in the case of van der Heyden, some hold a middle position. The *Flower Market in Amsterdam* (no. 483; fig. 261) is one of the finest of this type. The new Town Hall is not, as in other paintings by the same artist and by Jan van der Heyden, the protagonist; it is seen sideways at a more modest angle, partly hidden by a row of picturesque houses which in turn are overlapped by silvery trees. In contrast to van der Heyden's pointed precision, a somewhat broader brushstroke in the sky and in the architecture is again reminiscent of Emanuel de Witte; the foliage, with the highlights scintillating above a shaded core, is utterly different from that of van der Heyden (fig. 255). In composition, there is less refinement and originality, more plain common sense; but it is still very good painting.

Next to this group of meticulous, impeccable, somewhat 'Kleinmeister'-like town views there existed, in the same city of Amsterdam, an entirely different one which, in comparison, tends to elicit epithets like breadth, grandeur, and even drama, without necessarily being less faithful to topographic facts. Representative of this trend are three artists who belong together in more than one respect: Allaert van Everdingen, Jacob van Ruisdael and Meindert Hobbema. To these must now be added Jan Wijnants, who quite unexpectedly has turned out to be a pioneer in this field with a *View of the Heerengracht in Amsterdam*, painted as early as 1660-62 (fig. 254A).[22a]

Hobbema has left us only one generally accepted work of this kind but it is a major one: the *View of the Haarlem Lock and the Herring-Packers' Tower* in London (no. 6138; HdG Hobbema 3 and Ruisdael 14; fig. 262). Although it has been proved that this picture faithfully represents the architectural ensemble prior to some alterations

being made in 1662,[23] the date of the painting itself (not, of course, of a hypo-
thetical preparatory drawing) cannot, for stylistic reasons, be earlier than *ca.* 1666/68 –
but also not later than that. One can only regret that Hobbema did not paint more
pictures of this type during that finest period of his career. The compositional equilib-
rium of the London picture is superb, with the most harmonious relationship between
tower, houses, lock, bridge, masts and trees, a wonderfully cool shade, a perfect sky,
luminous greys, and bluish-green foliage which goes well with the brick-red. The well-
placed, unobtrusive figures are by Hobbema's own hand.

Everdingen's *View of Alkmaar* (fig. 258) is one of the many surprises and delights of
the Lugt Collection in Paris. A large canvas, this panorama of the artist's native town
with the active but calm boats in the partly shaded foreground and middle distance,
the brightly lighted silhouette of the city behind, and the rather dramatic sky above,
cannot, to judge from the costumes, have been done much before 1670 and seems to
reflect the closely related style of Ruisdael's 'Haerlempjes' rather than anticipate it.

However, Ruisdael's own city views, hardly more than half a dozen, undoubtedly
belong to his very last period, presumably later than Everdingen's work.[24] This is true
even of those pictures which share a panoramic character with those of Everdingen and
are, in fact, seen from an even more elevated standpoint. The most extraordinary of
these is the *Panorama of Amsterdam* in an English collection (HdG 9, Ros. 2;
fig. 260), which is based upon a drawing done on the unfinished roof of the New Town
Hall (state of *ca.* 1665)[25] but, to judge from its style, was hardly painted before the late
(upright) 'Haerlempjes', to which it is in a sense more closely related than to town
views proper. Two clearly interrelated versions of a *View of the Amstel*, in Cambridge
(no. 74, HdG 10, Ros. 4) and in the Philips Collection in Eindhoven (Ros. 5), must
for unambiguous topographic reasons be dated after 1675.[26]

There are three architecturally almost identical views of the *Damrak in Amsterdam*:
in Rotterdam (HdG 13, Ros. 8; no. 1744), in the Mauritshuis (no. 803, HdG 18),[27] and
in the Frick Collection in New York (no. 110, HdG 12, Ros. 7); a picture in Berlin
(no. 885 D, HdG 8, Ros. 1) includes the Dam Square with the Old Weigh-House in
the foreground and middle distance, thus pushing the Damrak itself far into the back-
ground. In the Frick picture (fig. 259) diagonal rows of well identifiable houses – Ruis-
dael's own, in the Kalverstraat, is just around the corner – accompany the canal basin,
which is seen head-on, into the distance, where the Oude Kerk appears in strong light
on the right; the composition as such is a modernized version of a pattern often used
by much earlier artists who employed town views for their historical and *genre* scenes
(e.g., Paulus van Hillegaert).[28] In Ruisdael's work, however, sailing-boats in brilliantly
varied array, painted with the supreme skill displayed in his contemporary sea and
beach scenes, vie in busyness with the rich staffage of vendors, buyers and flâneurs. The
colours are darkly sonorous, the shadows have deepened, a sombre tone pervades the at-
mosphere, but – as in some of the late beach and winter landscapes – the elegant figures
do not permit the dark mood to unfold. It is Ruisdael in decline – yet still Ruisdael.

PART TWO

FOREIGN LANDS

FROM the late nineteenth century until not so long ago, it was customary to identify Dutch seventeenth-century landscape painting with seventeenth-century painting of the Dutch scene, the only conspicuous exceptions being the imaginary vistas of Seghers and Rembrandt. The paintings by other masters who followed a similar trend found little acclaim; the Scandinavian scenes by Allaert van Everdingen and Jacob van Ruisdael aroused only desultory interest; the Brazilian views of Frans Post were considered a mere curiosity; and finally, but most important, the large production of three generations of Italianate artists, from Poelenburgh to Both and Glauber, were often treated with little more than outright contempt.

There has been a considerable change in this attitude during the last few decades, particularly with regard to the Italianate artists and the works of Frans Post, and I shall return to this phenomenon later on. But it is safe to say that that change has as yet been little reflected in more general accounts of Dutch landscape painting. This I shall attempt to rectify in the following chapters – *sine ira et studio,* as far as possible.

It must be admitted at once that it would be impossible to put every important work belonging to this vast 'non-Dutch' group into its correct pigeon-hole. There are 'imaginary' vistas that are somewhat Italianate but not quite, and vice versa; the same relationship often exists between Scandinavian and Dutch motifs, and Italian and Dutch ones, combined in one and the same picture. Compromises are inevitable.

It is proposed to begin with the more strictly imaginary trend and hence to pass on, first to the Tyrolean and Scandinavian groups which are perhaps most closely related to the former. The Italianates will follow, and after that, a mixed group containing works representing the German Rhinelands and the non-European scene.

CHAPTER VI

Imaginary Scenes

THE 'world panoramas' of Pieter Bruegel are neither real nor possible though they are artistically convincing. His mountains, 'swallowed up in Italy and regurgitated after his return',[1] had changed considerably during this process and were in fact remade somewhat in the image of the crags and cliffs of Patenier and Herri met de Bles; and even where they look more natural, they were combined with Northern motifs in such a way as to put the whole pictorial arrangement beyond considerations of strict fidelity to nature. These methods persisted in the works of many of Bruegel's Flemish followers and were to have an aftermath of great artistic import in Holland. The fantastic mountain-river-scenes of Lucas van Valckenborgh, though content with a less sweeping vista and occasionally quite progressive in colour, even in the direction of tonality,[2] are surely not topographic even when they contain a few elements of fact gleaned from the Rhine, the Danube or other regions; their staffage is apt to remain biblical, a feature revived in some of Rembrandt's landscape fantasies. The works of Kerstiaen de Keuninck continue this trend and sometimes lend it a weird note which foreshadows Seghers (Antwerp, no. 876; fig. 264)[3]; the early works of Coninxloo indulge in it and may have passed it on directly to Seghers, who was his pupil; and as late as ca. 1620 Joos de Momper was still fascinated by gigantic mountains rising over plains and coasts which are as unreal as is the brown-green-blue division of the ground.

Some Dutch artists around 1600 were quite impressed by all this fantasy; and again, the draughtsmen and printmakers were in the forefront. And as we look for the finest contributions to this field we encounter some of the same artists who had played a decisive part in furthering the emergence of the Dutch scene: Hendrick Goltzius and Jacques de Gheyn. In Goltzius's astonishingly precocious chiaroscuro woodcuts of landscape we find a highly ingenious and personal blend of many ingredients. In the *Arcadian Landscape* (B. 241, H. 377), here reproduced from a purely black and white impression (New York; fig. 263), the cloud-capped peak reminds one of Bruegel, the temple of Bril, the trees of Coninxloo; yet there is something intensely individual in it – and the town embedded in the valley on the right clearly presages Seghers.[4] This print, made shortly before 1600 – thus certainly before any of Elsheimer's mature works – closely corresponds in style to a number of independent drawings dated or datable between 1594 and 1598; magnificent examples are the alpine view in Dresden (1595, R. 395) and the somewhat later, utterly romantic one in Stockholm (R. 406), so carefully analysed, together with others, in E. K. J. Reznicek's recent monograph.[5] Reminiscences from Bruegel, Bril and Coninxloo blend here with others from Titian and Muziano in a style of unmistakable originality, which is echoed in several exquisite drawings by Jacques de Gheyn such as the mountain-castle fantasy of 1603.[6] It

was at about this time that both masters became more and more absorbed in their daily environment and gradually abandoned those fantasies for the strict discipline of factual observation as exemplified by Goltzius's great panoramic views of 1603 (figs. 52-54) and de Gheyn's *Beach* (fig. 198). But by this time, the painters, too, had taken notice.

Amsterdam, already a great melting-pot, harboured the masters who were of importance in this respect, although their own works remained outside the strictly imaginary sphere. Coninxloo had moved there in 1595; David Vinckboons was only fifteen when his father went to live there (1591); Roelandt Savery appeared there sporadically before and during his stay with the Emperor (1604-19); Pieter Lastman returned from Italy in 1607. The mixture of Flemish, Italo-Flemish and more strictly Italian forms which underlies Goltzius's work in this field characterizes much of the Amsterdam production of those years, and it is important to realize that the style of Coninxloo's late (forest) paintings was only slowly appreciated and emulated, as van Mander states;[7] his pupils – Coninxloo died in 1607 – may have been trained more fully in the type of landscape painting exemplified by his earlier works, which were still being greatly admired at that time. It would be futile to make an attempt to separate specific trends in this vast and multifarious group, the more so as landscape plays a subordinate role in so much of that output; very conservative elements often occur alongside more progressive ones, even in the works of important masters such as Pieter Lastman and the brothers Pynas.

It was from such a milieu that the strange and great art of Hercules Seghers emerged. In the chapter on panoramic painting (p. 36) an attempt has been made to sketch hypothetically the history of his development as an etcher and a painter so far as the lack of reliable documents and dates allows. His apprenticeship with Coninxloo makes it reasonably certain that he began as a painter; but he was only about seventeen years old when his teacher died, and nothing is known about his early output, not even after his appearance in Haarlem (1612), when he can be assumed to have concentrated on etching. He was back in Amsterdam for the period from 1614 to 1631, and we have adduced reasons for believing that he then started with the kind of painting we may expect of a Coninxloo pupil, and that a development from mountainous scenes via a combination of mountainous and flat vistas to pure panoramas, such as was assumed by Haverkamp Begemann, becomes highly probable in the dim light of our present knowledge.

Along this line of reasoning, the *River Valley* in Amsterdam (no. 2198B; fig. 265) is easily accepted as the earliest painting. Although its composition is more reminiscent of Joos de Momper than of Coninxloo, its colours preserve many memories of the latter, and it is certainly the most 'Flamisant' of all his known works. However, I believe that its Haarlem ingredients are anything but negligible. The way in which the dark shape of its foreground is used as a *repoussoir* and, above all, the way in which a single dark form in the centre (here a dead tree trunk) is set against a very light stream of water is as unlike anything in Coninxloo's works as it is like a drawing once

attributed to Goltzius but now tentatively attributed to C. C. van Wieringen (*ca.* 1600), in the van Regteren Altena Collection, in which one also finds the steep mountain in the left middle distance.[8] The Italianate square village tower down in the valley occurs in Goltzius's chiaroscuro woodcuts (see fig. 263); the flame-like cypress trees occur on the drawing mentioned above. A drawing by Goltzius once in the Lanckoronski Collection (R. 408) and the one in Dresden (R. 395) stand midway between Pieter Bruegel and Seghers. None the less, the Seghers landscape in Amsterdam and the very similar one in the Kessler Collection[9] herald simultaneously that deepening and darkening of mood and that enhancement of spatial grandeur which find their first climax in the large panel in the Uffizi (fig. 266).[10]

Before this great picture was extensively overpainted by Rembrandt – who created a 'second state' of it just as he was to do later with one of Seghers's etchings – its colour must have been even more like that of the Amsterdam picture; the farther middle distance and the background show this most clearly, whereas much of the foreground was considerably altered by the brown to red-brown glazes added by Rembrandt (we shall presently return to these changes). The specific nuance of light green in the background is still reminiscent of Coninxloo, and its more intimate combination with red foreshadows later works by Seghers such as the van Beuningen picture. The vastness and solitude of this masterpiece, its emphasis on foreboding and even decay in nature may not have been quite so commanding before Rembrandt took over but it was certainly there; before Rembrandt accentuated drama and tension, particularly by enhancing the contrast of light and dark, the poetry of the dead tree-trunks, barren cliffs and windswept trees must have been of a considerably different nature and prepared the way for Seghers's greatest etchings of this kind. The staffage of the picture is now that of Rembrandt, but the Amsterdam painting had a figure of a pedlar in the same corner; there is less human presence in the Kessler picture, and it is interesting to see that even here Goltzius had anticipated Seghers not only in private drawings but even in published prints.[11]

Seghers's *Valley* in Rotterdam (no. 2383), that more recently discovered marvel (fig. 267),[12] and the colouristically related *River Valley* of the van Beuningen Collection, now also in Rotterdam (no. 2525), stand between his 'fantastic' and 'realistic' works and may have been painted about 1625. They foreshadow his final truce with the Dutch scene; in fact, the latter work even uses the vista from Seghers's Amsterdam window almost verbatim but places it in front of a vast valley, with steep rocks added not only in the background but also in the right foreground. The new *Valley* is not only more Dutch than the previous works but also more serene; there is an Italianate building in the middle distance which, but for the still dramatic contrasts of dark and light and the agitated trees, would produce an almost Arcadian mood; in the distance appears a low horizon, whose flatness is undisturbed for a long stretch. In the van Beuningen picture, the panoramic character is even more pronounced, even though the steep rocks and pointed trees still provide vertical interest. We are close to the final

step: the yielding to the plains; the *View of Rhenen* (fig. 58) and the other panoramic
pictures were therefore most probably done after Seghers had moved out of Amster-
dam and settled down – however briefly – in Utrecht (*ca.* 1631).[13]

Seghers's mountain landscapes, like his panoramas, made no overwhelming impres-
sion on his contemporaries and the younger generation. In a number of cases, simila-
rities in works by other artists must – or can – be explained by the fact that they go
back to the sources that were tapped by Seghers himself, usually Flemish or at least
'Flamisant'. One of the few painters who seem to have been directly inspired by
Seghers in a relatively small number of his works was Frans de Momper (1603–60).[14]
This modestly gifted and rather protean artist, who was born in Antwerp but lived in
Holland during the forties (and probably before) and imitated van Goyen in many of
his 'Dutch' scenes, often painted in a style clearly related to that of Joos de Momper
but added a distinct Seghers flavour on occasion. The signed landscape in the Henry
McIlhenny Collection illustrated here (fig. 268) shows this Joos de Momper-Seghers
mixture quite well; others are even more Seghers-like, and it is small wonder that some
of the paintings wrongly attributed to the greater master can be given to Frans de
Momper with good reasons.[15] A direct stylistic connection with Seghers is also prob-
able in the case of Pieter Molijn's extraordinary *River Valley* in Berlin (no. 1933; fig.
269), which is dated as late as 1659.[16] The treatment of the middle distance, and the
thin, quick brushstroke with which the valley and mountains are painted (with the
curvilinear design shining through) connects this work with Seghers, while the thick
impastos in the foreground may go back to Rembrandt.

On the other hand, it is probable that the 'Flamisant' landscapes of Esajas van de
Velde must be traced not to Seghers but to van de Velde's Flemish ancestry and his
early training in Amsterdam, quite possibly under Vinckboons, even though his most
strikingly Flemish-looking pictures seem to date considerably later and were evidently
done alongside his most important contributions to the Dutch scene. The *Rocky Land-
scape* in Bonn (no. 36.551; fig. 270) was attributed to Joos de Momper until H. Gerson
restored it, together with some other works of a similar bent, to its real author.[17] If
such a picture was painted in Haarlem it is even smaller wonder that others of the same
kind were painted during the master's later years at the Hague, where his patrons are
likely to have shown an even stronger interest in paintings with Flemish associations.

The rare cases in which Aert van der Neer introduced mountains in his paintings
present some special problems. They seem to have been painted at a considerable
interval. The admirable landscape in Mr. Lugt's Collection (fig. 271),[18] which com-
bines features of a panorama with those of a fantastic mountain-lake scene somewhat
reminiscent of Switzerland, seen from a great distance and enveloped in a tender rose-
brown evening light, recalls Seghers in its general structure but is totally different
from him in colour and mood. It can be dated around 1645 since it forms a rather
convincing parallel to the early evening seascapes (fig. 354). The mountainous scene in
the van der Vorm Collection in Rotterdam (fig. 272)[19] was painted considerably later,

probably around 1660, and with its broad brushstroke – so utterly at variance with the refined detail work of the Lugt picture – its deep, warm luminosity and shimmering dark-light effects, its colourful figures, is more reminiscent of Rubens than any other work by the master.

But here we must return to Seghers once more in order to face a phenomenon which is as controversial as it is important: the bond between him and Rembrandt.

The few exceptional cases in which Rembrandt decided to represent his Dutch environment in painting have already been discussed above. It is well known that the majority of his pictures in the field of landscape painting are of a quite different type – one which in turn is almost never encountered in his etchings and drawings. Most of these paintings belong in the final phase of his 'dramatic' period – the late thirties and around 1640;[20] only a few may be dated later.

It has always been emphasized that these works are closely related to comparable works by Seghers. But when it comes to pinpointing exact similarities one is bound to run into trouble. The affinity lies more in the general mood of drama and tension, so rare in other Dutch artists; but even there, differences are evident. When Rembrandt acquired Seghers's Uffizi landscape (fig. 266) and altered it according to his own vision he cut deeply into the older master's individual characteristics, as has already been indicated. A comparison with Seghers's Amsterdam landscape (fig. 265) clearly demonstrates other discrepancies as well. The foreground of the latter is technically not very different from the background; it shows the same quick but grainy, dry and open brushstroke, and even the Rotterdam landscape (fig. 267) shows a homogeneous treatment although it is somewhat softer all around. In the Florence landscape, the typical Seghers background and the middle foreground are untouched; but on the left, Rembrandt covered Seghers's grainy brushstrokes with a profusion of complex glazes in a very un-Seghers-like deep red-brown and deep grey-brown; and on the right, similar retouching is visible in the darker (counterbalancing) nuances in the second stratum. It is this colouristic and technical treatment which appears in Rembrandt's own landscapes from the very outset. The *Landscape with the Baptism of the Eunuch* of 1636 in Hannover (Br. 439; fig. 274) is the first signed and dated example. It hardly reminds one of Seghers at all. There is deep grey-brown in the foreground which brings to mind the Uffizi picture – but not Seghers's part in it. A surprisingly large amount of grey-green appears in the middle distance and background; in the central tree, this blends weirdly with the light rose-brown of the lighted rocks. The figures derive from the Pynas-Lastman tradition; the sharp highlights, applied in small lines and dots on the figures, in heavier impasto on trees and rocks, carry most of the dramatic impact.

There is no denying the fact that Seghers's early landscapes – which are still indebted to the romantic trend of Coninxloo – tend towards a certain dramatization of nature: windswept trees, desolate tree-trunks, hostile rocks; but compared with the early Rembrandt, these elements appear subordinated to an orderly, almost conservative

organization. Large, sweeping diagonals are found once or twice; the *River Valley with Four Trees* of the Kessler-Stoop Collection,[21] in which the diagonal rises steeply toward one side, foreshadows the structure of Rembrandt's work of 1636, without however anticipating its greater plastic strength and its wilder accumulation of masses. The violent light-dark, that is, light yellow-dark brown contrasts, which were to remain characteristic of Rembrandt's early landscapes, are altogether missing from Seghers's works, as are the deep glazes; and even the buildings and trees, though Seghers-like to a degree, are painted in sharper contrasts throughout. The skies are more threatening; it is probable that in this area, too, the Uffizi landscape shows retouching by Rembrandt, for there is no convincing analogy for it in Seghers's output.

On the whole, Rembrandt's figures are more significant than are those of Seghers, who occasionally did away with them entirely and never developed them to any point of importance. Once in a while, Rembrandt introduced a biblical story: the *Baptism of the Eunuch* in 1636 (fig. 274), the *Good Samaritan* in the Cracow picture (Br. 442). But it would be futile to look for a subtle relationship between such stories and their landscape environment. The *Landscape with the Obelisk* of 1638 in the Gardner Museum in Boston (Br. 443; fig. 275) exhibits the same drama in nature as does the one in Cracow but all Rembrandt introduces as staffage is a man on foot, one on horseback, and a dog. The vitality of the landscape depends on the magnificent tension between the obelisk, the distant mountain and the wild cluster of trees whose branches on the left, like the arms of a ghost, grope toward the centre and weirdly adjust themselves to the shape of the mountain; the sky is reminiscent of the waves of rough sea, and rapid brushstrokes create movement on the ground. The scene is viewed from a slightly elevated standpoint as is the somewhat less violent landscape in the Wallace Collection (Br. 451), which still has a highly dramatic sky and strong contrast between a dark foreground and a brightly lit middle distance but represents an almost idyllic countryside with farms, wheatfields, a river, and a moated castle, with no windswept trees, no romantic ruins or obelisks, and not even any steep mountains. The tendency to approach the native environment more willingly and sympathetically is unmistakable and it led within a very short time to such almost entirely 'Dutch' motifs as the Amsterdam *Bridge* (fig. 108).

It has always been realized that the superb composure and impeccable rhythmic order which reigns over Rembrandt's *Landscape with Ruins* in the Kassel Gallery (Br. 454; fig. 276) suggests that its origin lies in the same stylistic phase which produced such etchings as *Landscape with the Square Tower* (1650) and others of the same group; the similarity is indeed convincing.[22] The recent cleaning of the picture has removed some of the golden sheen – which once made it look somewhat Claude-like – and restored its original tendency towards an overall grey-brown tonality, which is a far cry from the violent light-dark contrasts of the late thirties and links this work to some paintings by van Goyen and Salomon van Ruysdael of exactly the same period. Nor is this the only element that connects these works; the return to firmer structure and

more powerful massing of forms was found before to be characteristic of the middle of the century. It is true that in those cases it was tied to a resumption of stronger colour contrasts as against the preceding tendency to dissolve them in an all-embracing light tonality; with Rembrandt this phase was never realized in landscape painting and, for this reason, the present picture appears to be relatively more tonal than its predecessors of the late thirties with their sharp light-dark contrasts. The painting now represents a peaceful dream world. The drama and tension are gone; the sky and the trees are calm; there are no windswept forms, no sharp light contrasts, no dagger-like diagonals. The ruins, standing in quiet dignity and bathed in a subdued atmosphere, are not submerged in seething hills but are nobly outlined against the serene sky; straight-growing trees and solid mountain forms are arranged in stately counterpoint. The foreground is flanked by a sedate horseman turning his back to the spectator and riding alone towards the middle distance (a magnificent development of the somewhat ostentatious figure in the Wallace Collection picture) and a beautiful windmill; a bridge vaults low and gently, a cluster of trees shelters a farm-house, a pleasure boat glides quietly by, a fisherman sits on the bank near two swans. The middle distance is spacious, undisturbed, inviting, and stretches back to the mountain range and, on the left, to more distant plains and hills. A fine afternoon light permeates the picture and adds to the wonderful unity achieved by rhythms of the subtlest order, such as the horizontal strata of the bridge, grove and mountain line stretched tent-like between the posts of horseman, tower and mill.

In spite of doubts uttered by some greatly respected connoisseurs, I can still sense the same supreme sense of order and counterpoint in the (admittedly less well preserved) Widener *Mill* in Washington (fig. 277).[23] The picture is from a different mould, steeped in a different mood; it concentrates on the grandeur of a single object which is presented with greater eloquence, elevated to a more commanding role, and this lends to the composition a note of greater intensity, a new sense of drama, which is also indicated by the stronger contrast between the dark bastion, the pink blades and the deeper sky. All this, and the stronger accent of red and yellow may indeed indicate a somewhat later date for this work, say around 1653/55.[24] But its visionary power and superb rhythmic order seems to have grown from the same roots as the Kassel *Ruins*, to which it is closely linked by the terrace-like treatment of the horizon, by the way in which the foreground forms (boat-bridge) are related to the former, and by a close general resemblance in details and brushstroke.

We may be brief concerning the history of landscape painting in Rembrandt's intimate circle, under his direct influence. That the very romantic *Town in a Valley* of 1651 by Philips Koninck in the Reinhart Collection at Winterthur (G. 60) forms an exception in the work of the master, being a free paraphrase of Rembrandt's landscape in Kassel (fig. 276), has been demonstrated by Gerson.[25] Another well-known but more controversial Rembrandtesque landscape of considerable quality is the *Mountain Landscape with a Watermill* in Dresden (no. 1575), which has been attributed to

Koninck, Aert de Gelder and Roeland Roghman, with the odds in favour of the last-named artist.[26] We can represent this whole group fairly well by one of the few works by Aert de Gelder in which landscape plays a decisive role, his *Boaz and Ruth*, formerly in Berlin (no. 806A; Lilienfeld 20; fig. 273), presumably painted toward the end of the century. The picture once bore a false signature of Rembrandt and the date 1641; its attribution to Rembrandt was still zealously defended as late as the 1870's.[27] The colours of the landscape, the design of which combines features of the works of Rembrandt and Koninck, share the somewhat 'perfumed' qualities of the figure group and contain light rose and green nuances which foreshadow the eighteenth century; in this respect they form a convincing parallel to some other very late seventeenth-century landscapes such as Jan Vermeer's (?) Munich panorama (fig. 84).

Just as Rembrandt's 'Dutch' landscape paintings convey an impression of the imaginary to such an extent that it becomes most difficult to separate them strictly from his pure landscape fantasies (see fig. 108), a vast number of landscapes by Jacob van Ruisdael must be considered as borderline cases between the real and the imaginary, and all compartmentalization is open to doubt and attack. A painting like the *Coup de Soleil* in the Louvre[28] (once very highly regarded, now widely neglected) is a rare example of total imagination, in the sense – and undoubtedly under the direct influence – of paintings of this kind by Rembrandt (and perhaps Koninck). But even in other cases, motifs from Scandinavia, the German border territory and sometimes even Holland, take on the appearance of imaginary scenery as they are romanticized in various degrees. A few examples will give some idea of the wealth of effects produced in this way.

The large number of *Waterfalls* painted by Ruisdael in the sixties will find a more logical place in a chapter on the Scandinavian Scene – their connection with Allaert van Everdingen is a decisive point here. Other mountainous scenes, however, with trees precariously balancing on high cliffs above deep river valleys and fantastic castles silhouetted against distant summits and the sky, such as we find in a majestic (if somewhat oversized) painting in Cincinnati (no. 1946.98, HdG 772; fig. 278), are more purely imaginary. The present title of this picture is *A Scene in Westphalia*; but if Ruisdael was indeed inspired by such a view – as Hofstede de Groot was inclined to believe – it was surely romanticized beyond recognition; and as far as the pictorial tradition is concerned, the Cincinnati picture shows a close connection with a small group of paintings by Cornelis Vroom such as the *River View* once at Ward's in London, to which Rosenberg called attention in his Ruisdael monograph.[29] The classical example of aggrandizement of a motif is found in Ruisdael's treatment of the Castle of Bentheim which has been touched upon in a previous chapter (p. 73) and which was studied in detail by Rosenberg and Simon.[30] The way in which one of Ruisdael's favourite solitary oaks is joined by a massive mountain on one side and a distant coast on the other in order to produce what one is almost tempted to call a seventeenth-century 'Erdlebenbild' is beautifully illustrated by a painting of *ca.* 1665

(fig. 279),[31] in which the light green and reddish-brown foliage is dramatically con-
trasted with the dark bluish-grey mountain. This picture and the one in Cincinnati
may give an intimation of the extraordinary variety of approach to the imaginary
scene Ruisdael took at that time; some of these works are large, others comparatively
small, some present comprehensive vistas, others present almost intimate ones (in
which case the process of monumentalization is even more striking). Occasionally the
mood, at least in the background, becomes reminiscent of Poussin and his circle; in a
large, extremely fantastic scene (HdG 34=763, Ros. 410), a soaring alpine summit,
half-shrouded by clouds, is strongly reminiscent of the French master's late landscape
vision. Is it an accident that Ruisdael's stay in France (1676, Caen) might well ante-
date such pictures?

I believe that a recapitulation of the long controversy about the date and the
relative chronology of the two versions of Ruisdael's *Jewish Cemetery* (Dresden, HdG
219, Ros. 154; Detroit, *ad* HdG 219, Ros. 153; fig. 280) would be as much out of
place here as a detailed attempt to propose a new – and necessarily equally contro-
versial – solution. However, I do not hesitate to state my firm conviction that neither
version can be placed far from 1660.[32] The motif of the two works, the Jewish burial-
ground at Ouderkerk near Amsterdam, is well known to us from various drawings,
two of which are attributed to Ruisdael himself; they furnish incontrovertible proof
that the two paintings are not topographically accurate, even though some of the
tombstones are identifiable. There are no hills, let alone mountains, in the original
setting; the trees are of modest size; instead of Ruisdael's powerful ruins, reality
offered him a simple country church. Ruins abound in Ruisdael's paintings during
the fifties; none of them can be identified without difficulty, and the ruins in the two
versions of the *Jewish Cemetery* are not even identical. Everything points to a styliza-
tion of the real situation, to monumentalization and exaltation, just as in the treatment
of the Castle of Bentheim; but there is something more – something found only this
once in Ruisdael's work – and that is the use of a landscape motif for the purpose of
allegory.

At this point in the development of Dutch landscape painting, the old type of
allegory – the one from which independent landscape painting originated in the first
place – was not entirely forgotten but it was almost without importance. None of the
greater masters would have thought of representing summer and winter in terms of
the old 'Labours of the Month' or 'Seasons' context; the difference between van der
Neer's *Evening* and *Morning* (figs. 358, 359) was expressed in terms of the behaviour,
not of people but of the light. The ineradicable passion for allegories of the futility of
human life, the visual *memento mori*, was mainly channelled into still life painting –
where it remained very popular throughout the seventeenth century – and not
infrequently into *genre* painting, but hardly ever into landscape painting.[33] To think
of nature as a realm reflecting the inconstancy of human life and endeavour was
utterly outside the scope of Dutch thought; there is no reason to believe that the early

interpretation of landscape as something pleasant and joyful was ever abandoned in the course of the century except in the works of Seghers (which were rare and clearly not popular), those of Rembrandt (which were equally rare and form a desultory group within his œuvre) and those of Ruisdael (which we have every reason to suspect of similar unpopularity). But the *Jewish Cemetery* goes beyond this in two respects. First of all, it co-ordinates tombs, ruins, heavy clouds and broken trees in a comprehensive, carefully thought-out allegory of decay and futility; and secondly, it complements and relieves that allegory by the addition of the rainbow as a sign of promise and resurrection, and on the other side, by the addition of trees in full foliage about to triumph over the bare, dead trunk in front.

Goethe, writing on 'Ruysdael als Dichter',[34] analysed the Dresden version of the *Jewish Cemetery* as the last of a carefully chosen triad. It is the Goethe of 1813, and his essay deliberately avoids all semblance of an agreement with the melancholy interpretation of the Romanticists. He not only stresses the fact that 'light (is) about to conquer the rain squall' but also that the decay of the tombs themselves 'has been executed with great taste and admirable artistic restraint'; he considers the picture an outstanding example of how a 'pure-feeling, clear-thinking artist, proving himself a poet, achieves perfect symbolism and, through the wholesomeness of his outer and inner mind, delights, instructs, refreshes and animates us at the same time'. This interpretation of Ruisdael as a 'health-giving' artist was restated even more strongly in 1825, when a visitor whipped up the courage to defend what Goethe had disapprovingly called the 'negation of life' in Karl Friedrich Lessing's youthful *Monastery in Winter* by pointing to the 'elegiac' mood of Ruisdael's *Cemetery*; then the poet went so far as to say that 'the trees with their green foliage, grass and flowers make us forget that we are on a burial-ground'.[35]

I think it may be stated that, only if measured by the overwhelmingly optimistic tone of Dutch seventeenth-century landscape painting, the mood of the *Cemeteries* could be called melancholic. As usual, Goethe was right when he insisted on the fact that this was essentially a glorification of nature, not an attempt to project into it anything like *Weltschmerz*. But a glorification of nature is in itself a rarity in Dutch painting; one could defend the thesis that it is a phenomenon restricted to Rembrandt and Ruisdael, and that only here did Ruisdael support this interpretation – but by a conscious use of allegory. And this in turn has led to the fact that the *Cemeteries* are so controversial and that it is so difficult to define a common denominator of the reactions of various spectators to them. Some will remain unalterably opposed to this kind of treatment of nature; others will make every effort to go 'in Künstlers Lande' and grant to Ruisdael's nature what he willingly grants to the mythology of Rubens. It is a case of 'chacun à son goût'; and the same is true of the comparative esteem in which one will hold the two versions, which have unfortunately never been – and have little chance of ever being – confronted. But whatever one's reaction, one will feel that one has been addressed by a very great artist.

It is impossible to avoid an anticlimax in this, as in other chapters of this survey. The latest phase of the more popular type of imaginary painting in the seventeenth century reverts perhaps more blatantly than that of any other group to phenomena of the early part of the century. Confronted with a picture such as Herman Saftleven's *Christ Teaching on Lake Gennesaret* of 1667 in London (no. 2062; fig. 281), one might be pardoned for first thinking of Jan Brueghel rather than of a Dutch landscape of the time of Ruisdael. The 'world panorama' view is again with us, though not quite in the manner of Pieter Bruegel the Elder but made to look more 'logical' in imitation of Jan. The biblical subject is used to justify a completely imaginary vista – quite different from Saftleven's own Rhineland views[36] – with mountains, crags, trees, fortifications and towns adapted liberally from the Flemish tradition and even the people in the foreground looking more like those of Lucas van Valckenborgh (on the left) and Breenbergh than any 'biblical' figures in contemporary works. This is archaism of a kind rarely found in such a pronounced form anywhere in seventeenth-century art; and although we have observed certain retrogressive tendencies before, and shall find more later, none of them appears quite so spectacular. Even the colours share this quality; although the hues are not the same as in the paintings of Jan Brueghel and his successors, they are the same in their multiplicity. Paintings by Jan Griffier follow the same trend. This trend became tremendously popular in England at the end of the century and was to dominate an important section of eighteenth-century landscape painting all over Europe.

Tyrol and Scandinavia

THE main fascination Roelandt Savery (1576?–1639)[1] has held for the general public arises from his representations of animals and flowers, but his contribution to landscape painting proper is not negligible. One of the many Flemish émigrés (he was born in Courtrai), he settled in Amsterdam at an early age, probably in 1591. However, by 1604 he was in Prague in the service of the Emperor Rudolf II who commissioned him to make sketches during extensive travels in the Tyrol. After Rudolf's death Savery worked for his successor Matthias in Vienna (1614) but by 1616 he seems to have been back in the Netherlands. In 1619 he settled in Utrecht, where he occupied a high rank among his fellow-painters until his death in 1639.

Although his art retained a strong Flemish flavour, perhaps more so than that of the late Gillis van Coninxloo and certainly more so than that of Alexander Keirincx, its influence on Dutch art was considerable. Savery's Tyrolean drawings are on the whole superior to his paintings of similar motifs, and there can be no question at all that his early work is vastly superior to his later output, regardless of subject. It may therefore be sufficient to concentrate on one single landscape of 1609 (Collection of Countess Margit Batthyány, Castagnola; fig. 282).[2] While smaller works of this phase, such as the charming pair in Hannover (nos. 345/6), preserve a good deal of the intimacy of his drawings and found their more typically Dutch following in the early works of Gillis d'Hondecoeter (fig. 123), this more ambitious panel leans towards the more formal qualities of compositions by Coninxloo, whose dense forests from the turn of the century onwards (fig. 122) are likewise clearly reflected in paintings of the same period by Savery.[3]

There is no doubt that such works, though done in Prague, soon became known in Holland and impressed many painters and patrons. Although they represent rather stunning foreign scenery – and also take some liberties with the Tyrolean truth – Savery's vistas never indulged in the purely fantastic. Even the picture before us, although more 'romantic' than some others of the same period (and all later ones), and noteworthy for the minimizing of human activities in the face of nature's grandeur, retains in the design of the trees, the structure of the castle and even the massing of the mountains, an element of accurate observation and honest reportage which the Dutch patrons understood and appreciated as they did Coninxloo's forests. The very sobriety that distinguishes such a work from those of Pieter Bruegel, Frederick van Valckenborch, Kerstiaen Keuninck and much of the output of Joos de Momper, must have endeared it to his new fellow-citizens. It is also the reason for my presenting it, not with the landscape fantasies of Seghers – who has more of Keuninck and de Momper than of Coninxloo and Savery, in spirit though not in colour – but as an example of

142

Dutch views of a 'real' foreign scene. Echoes of Savery's work appear in drawings and possibly even in a few paintings by Esajas van de Velde[4] and in some pictures by Allaert van Everdingen, who is even reported to have been a pupil of Savery. And in this memorable way, the Tyrol is linked to Scandinavia.

Among the non-Italian sceneries that held a fascination for the Dutch painters of the seventeenth century and their patrons, those of the Scandinavian countries stand out. It is not always easy to identify them indisputably; since they are most frequently classified as Scandinavian simply because of their profusion of rocks and fir trees it must be recalled that similar features are often found in the Tyrolean views of Roelandt Savery which we have just discussed.[5]

The documentary topographic basis of this trend is provided by a few works of Allaert van Everdingen,[6] who was born in Alkmaar in 1621 and died in Amsterdam in 1675. It is Houbraken who says that he was a pupil of Savery in Utrecht and of Pieter Molijn in Haarlem, but there is no proof of this; we do know that he became a master of the Haarlem guild in 1645. Actually there are traces of the influence of both artists, as well as of Cornelis Vroom,[7] to be found in Everdingen's works after 1645; however, the earliest dates we have on any of his paintings are attached to seascapes in the Porcellis-de Vlieger style (1640, 1643).[8] The one of 1643, and a *Village near a Lake* of 1644,[9] indicate that the visit he made to Sweden and Norway falls within the latter year, and this is corroborated by the fact that he continuously resided in Haarlem between 1645 and 1651, during which years he painted several landscapes which clearly presuppose a journey to Scandinavia.

I am stressing this circumstantial evidence because the famous *View of Julitabroeck in Södermanland* in the Rijksmuseum (no. 906; fig. 283) and the drawing of *Mölndal Waterfall near Gothenburg*[10] are not dated. The former represents a cannon foundry and seems to have been commissioned by its owners, the Trip Family in Amsterdam; there is reason to believe that the picture does not antedate 1646. It is a huge, none too skilful topographic painting, with a map-like bird's-eye view. In dated works of 1647 (there are none of 1645–46) Everdingen developed a beautiful pattern for Scandinavian scenes with mountains, sheer steep rocks and stately fir trees brought together in pleasant unison, and with clearly defined details which are indeed somewhat reminiscent of Savery, his presumed teacher. These pictures display a significant feature rare in seventeenth-century Dutch painting and, although prefigured in some of the works of Savery and Seghers, quite evidently based on Everdingen's own vivid experience on foreign soil: man has become completely insignificant in the face of nature's grandeur. A lonely and lovely group of deer may stand out crisply silhouetted against the sky while only a few extremely small figures of travellers are embedded in the vast rocky ground (Braunschweig, no. 364, dated 1647; fig. 284).

In the following year, Everdingen partly abandoned the distant viewpoint which he had favoured before and approached the rocky soil more closely and boldly in the foreground. The mighty boulders which dominate the almost treeless pictures of

1648 in Berlin (no. 835B) and Copenhagen (no. 211) appear in a somewhat more mellowed and idyllic form in other works of the same and the following two years (1649: Dresden, no. 1835; 1650: Hamburg, no. 312; 1656?[11]: Cambridge, no. 66). At the same time, Everdingen's brushstroke became softer, his rendering of moist atmosphere more refined, his colours more sonorous, with deeper greens and warmer browns.

After 1650, dates are scarce, and it becomes difficult to establish a convincing chronology of Everdingen's works. The oft-repeated assertion that he moved to Amsterdam in 1651 is not corroborated by documents although it may be correct; he did not become a citizen of Amsterdam until 1657.[12] Scandinavian motifs were continued, often in a very idyllic, totally undramatic spirit and with many typically Dutch admixtures, quite comparable to his many distinguished drawings (a few dated in the 1650's) and etchings (all undated). These pictures are less well known than his Waterfalls but by no means negligible, as a glance at the painting of 1655 in Amsterdam (no. 908; fig. 286) shows; here, the figures in the foreground seem to betray the hand of Lingelbach.[13]

The first examples of a typically Scandinavian waterfall playing a prominent role in Everdingen's work appears as early as 1647 in paintings in Copenhagen (no. 210), Hannover (no. 96) and Leningrad (no. 1901); the latter, a large canvas, already contains all the features characteristic of the main group: a powerful cascade sweeping large boulders and dead trees to the foreground in a violent current, stately fir trees, some decrepit houses clinging to rocks in the middle distance, a small watermill. This pattern remained comparatively unchanged in Everdingen's later pictures; these, however, can be distinguished from the one in Leningrad by the same increase in softness and breadth of the brush as was found in other subjects of the later period. The painting in Munich (no. 387; fig. 287) is one of the few dated representatives of this group; it is dated 1650,[14] and in contrast to the examples of 1647, it already has the upright format which is most fitting for the combination of waterfall, rocks, mills or precariously perched huts, proudly erect trees, and (sometimes) high mountains in the distance. These motifs are handled with considerable skill and a good deal of 'local colour', geographically speaking; they would undoubtedly be more highly appreciated if they were not outshone so relentlessly by the comparable works of Jacob van Ruisdael.

I shall be brief concerning the latter, although their number is large. Their own reputation has suffered considerably during the last century or so, during which the paramount importance and abiding beauty of Ruisdael's contributions to the typically Dutch scene – dunes, panorama, rivers, forest, winter, beach – was rediscovered. It does not seem likely that there will be a reversal in this appreciation – not because the scenery here is less Dutch but because this particular trend was less directly grounded on Ruisdael's own vision of nature. Nevertheless, it is to be expected that the study of outstanding representatives of this group – and the elimination of imitations –

will eventually restore to them some of the prestige they enjoyed in the era of Goethe.

Jakob Rosenberg has convincingly shown that Everdingen's Scandinavian paintings were not only the catalyst that brought those of Ruisdael into being but that they directly influenced them in many ways.[15] Undoubtedly those by the younger master look somewhat less Scandinavian and have taken on some features of the Dutch-German border territory with which Ruisdael was so familiar; but no mere romantic overstatement of the latter, not even of the situation of Bentheim Castle (HdG 21), could have produced the elements which his pictures and those of Everdingen have in common. The priority of the older artist, who moved to Amsterdam a few years before Ruisdael but had painted Scandinavian scenes with waterfalls as early as 1647, is absolutely certain; none of Ruisdael's paintings of this type known to me antedates the 1660's.[16]

Celebrated examples of the finest of Ruisdael's paintings in this field are to be found in the museums at Amsterdam, Antwerp, Braunschweig, Kassel and London. Rosenberg has demonstrated that another excellent painting of this kind, once with the Steengracht family, is closely allied with an Everdingen from the same collection.[17] The splendid, immaculately preserved picture in the Fogg Art Museum of Harvard University (fig. 288)[18] represents this facet of Ruisdael's art at its best. It belongs to a well-defined group in upright format (and of a certain standard size) which was almost certainly painted in the mid-1660's. Even the finest Everdingen (fig. 287) suffers strangely when compared with such a work. It is as though, all of a sudden, every single element in the older master's picture appeared to be sliding around insufficiently directed; planes meet at indeterminate angles; the relationship between light and shade lacks equilibrium; resting and moving forces collide haphazardly. Looking at what Ruisdael wrought here, one is reminded of the way in which Raphael reacted to Perugino or Rubens to Otto van Veen. At once there is order within as well as above variety, a process of subtle but decisive crystallization and clarification. Profound re-appraisal of natural forms has led to more clearly differentiated textures in the rendering of water, foam, boulders, tree trunks, rocks, firs, oaks, house and castle; but as they interlock in powerful polyphony they are firmly consolidated within a carefully unified, easily surveyed visual field, whose borderlines allow for no fortuitous elements to form within it or escape from it. There is great economy of means; this is an art without pleonasm. At the same time, the mood is clearly defined, primarily through a most judicious treatment of light-and-dark relationships. While the Scandinavian flavour has by no means evaporated, it is of a less topographic quality than with Everdingen.

I cannot see here a really dark mood; romantic and grand, yes, but not depressed. What Ruisdael did to the (actual) mill at Wijk (fig. 115) he did here to Everdingen's Scandinavian 'reports', as it were; but this involved neither melancholy nor depths of allegory (as in the *Jewish Cemetery*). While the staffage in many of these pictures

continues Everdingen's theme of human insignificance in the face of nature's grandeur, others leave more room for *genre*-like activities; and in his description of such a Ruisdael in Dresden (no. 1495, HdG 214), Goethe was entirely justified – as usual – in stressing 'allbelebende Elemente'; 'die Bewegung, Klarheit, Haltung dieser Massen beleben köstlich das übrige Ruhende'.[19] This group is here represented by the splendid picture in London (no. 855, HdG 242, Ros. 184; fig. 285), in which the Scandinavian features, though unmistakable, blend with native ones in a completely convincing manner. In its organization the old double diagonal is revived (or has survived) but in a spirit totally different from that of both the tonal and the structural examples of the older masters (figs. 100, 101) and even of Cuyp (fig. 102); the terracing of the upper diagonal is immeasurably more varied in depth and contrast of values; the lower one is involved in a dramatic encounter between rocks, foam and shrubs, whose wealth of light-dark contrasts and tremendous three-dimensional strength are even enhanced by the counterpoint of the equally powerful clouds.

The tendency to incorporate vast spaces which is so characteristic of Ruisdael's late forest scenes finds its expression in many of his waterfalls as well. This does not necessarily entail a change from the upright to the oblong format, nor the use of larger canvases; nevertheless we are justified, or so it seems to me, to look for these phenomena in the majority of the master's very late output in this field (*ca.* 1670–80), although there are no dates to support us. The large picture in Toledo, which previously drew our attention because of its eighteenth-century staffage (fig. 3), is a case in point; here the middle distance has expanded into a large lake with shipping, the distance has been pushed back into a misty zone in which mountains blend with clouds – and the danger point of exhaustion and decay in Ruisdael's great art has been closely approached.[20]

CHAPTER VIII
The Italian Scene

I T has already been pointed out that scattered Italianate motifs are not infrequently included in imaginary landscapes of the Seghers-Rembrandt type without forming an essential element of them. However, there is a large number of Dutch seventeenth-century landscape paintings in which the Italian scenery is indeed of paramount importance.

The neglect of works of this trend by collectors and art historians in the late nineteenth and early twentieth centuries contrasts strikingly with the supreme role they played in the appreciation of eighteenth- and early nineteenth-century connoisseurs the world over.[1] It would take a small book to even sketch the extent of the esteem in which painters like Poelenburgh and Both (to name only one main representative of each of the two most important groups of this trend) were held, and of the influence which they exerted during that period. Suffice it to recall that no history of eighteenth-century German or British landscape painting could be written without mentioning some of those masters on almost every page, that some of the most enthusiastic pages ever written on landscape painting, including some by Goethe, were inspired by them, and that as late as 1875, a picture by Jan Both fetched 4725 pounds, more than ten times as much as the splendid Jan van de Cappelle in the same auction. Eighteen years later, the same picture was sold for 1134 pounds; nobody seems to know where it is today.

Late nineteenth- and early twentieth-century scholars everywhere, but particularly in Holland, showed an almost complete lack of interest in these Italianate masters. At a time when the most modest followers of van Goyen or Ruisdael were rescued from oblivion, the best Italianate artists fell into it; whenever they were talked about – often with the expression of regret that they turned their backs on the native scene – a note of apology prevailed, and in the lists of their works, discrimination between originals on the one hand, copies, imitations and forgeries on the other, rarely betrayed more than a fraction of the acumen bestowed on the national masters and their humblest emulators. But while, until 1952,[2] even recent exhibitions of Dutch art had included none or only few (and then not the best) works by these 'outsiders', a certain revival of interest in them is unmistakable; originals are being separated from imitations; a feeling for the finest specimens within the œuvre of each individual master is developing, research is increasing.

Is this simply the result of the scarcity of the works of the national painters and a lack of topics for dissertations? Or is there a less mercantile (or strictly academic) reason for this change of attitude? One is encouraged to believe the latter, and not only because of what one might call the advent of a somewhat more cosmopolitan

147

outlook on Dutch seventeenth-century art. It is the special imaginary element in the best works of the Italianate masters that stimulates many modern observers. In other words, what appeals to them is not an attempt to depict the Italian scene realistically – which Dutch masters, and for that matter, Italian masters hardly ever did – but an attempt to paint a Dutch variation on an Italian theme, a variation which inevitably entails very considerable transformations of the Italian scenery. This happened even when the Dutch artist was still in Italy; naturally, it happened to a greater degree after his return to Holland, and there is very little reason to condemn this increasingly imaginary treatment of Italian motifs as an inevitable ossification of foreign motifs, as has been done so often and so indiscriminately; after all, the heritage of art is replete with great works in which artists 'only remembered' experiences of their distant past. And then, there are the cases of Cuyp and Adriaen van de Velde – and possibly others – who painted Italianate scenes without ever having been to Italy at all.

It had originally been intended to arrange this chapter in a more strictly monographic fashion because, until very recently, little research on the individual masters of this trend had been done. However, during the last few years, dissertations on Berchem, Dujardin, Asselijn and Pijnacker have been undertaken in European universities, and although we still lack a monographic treatment of so important a master as Jan Both, it may now be possible to present the pertinent material arranged according to some main categories of subject matter as applied in the other chapters of this book – at least for the artists of the most important group, those of the second generation.

It seems indeed possible to distinguish between three generations of Italianate Dutch landscape painters, and although there are the usual overlappings and exceptions, it is hoped that this distinction will make art-historical sense. The oldest group, led by Poelenburgh, consists of artists born between ca. 1595 and 1600; their view of the Italian scene is basically 'Arcadian'. The artists of the second and most important generation – masters like Asselijn, Both, Berchem, Hackaert, Dujardin, Pijnacker – were born around 1615–30 and treated Italian motifs in an increasingly less antique way, with shepherds of the Campagna replacing Diana and her nymphs; high trees vying with ancient ruins; the golden evening light outshining silvery tints; nostalgia for Italy replacing Italian presence; and with a distinct increase in the imaginary handling of the Italian motifs and a frequent blending with native ones. They were joined by some artists who divided their interest between the national and the Italianate scene (Cuyp, Adriaen van de Velde, van der Heyden, Wijnants). The painters of the third generation, born between ca. 1645 and 1655, and including Glauber, Meyering and Jacob de Heusch, shed the warm, full, more independent manner of the previous one for the sake of a cool classicism, clearly nurtured by the study of Poussin, Dughet and the late Claude. A somewhat more monographic treatment of the first and third generations seems justified; for the former primarily

because of the outstanding role played in it by one artist; for the latter primarily because of the lack of even a modicum of previous research.

A. *The First Generation*

There are clear indications that we must consider Cornelis Poelenburgh[3] (*ca.* 1595?–1667) as both the fountain-head and the main representative of the style of the first Italianate group, although dated works are rare. We do know that Poelenburgh, born in Utrecht, was in Rome as early as 1617,[4] stayed there for about five years, and became co-founder of the Netherlandish *Schildersbent,* whose pronouncedly national characteristics, complete with nicknames, festivities, drinking bouts and occasional conflicts with their Italian confrères, have received a good deal of attention. In 1621,[5] he worked for the Grand Duke of Tuscany in Florence but was back in Utrecht by 1627 at the latest,[6] when he received a visit from Peter Paul Rubens.

Poelenburgh's early chronology has recently been surveyed successfully by E. Schaar,[7] and his style from 1620 to 1625 can now be traced by means of some reliably dated works. An *Orpheus* landscape in the Louvre and some other paintings have reasonably been considered to antedate 1620; they are reminiscent of Poelenburgh's Utrecht teacher, Abraham Bloemaert, and of the prints by Willem Nieulandt, and betray the strong influences of Adam Elsheimer, Paul Bril and Agostino Tassi. Much of this fabric persists in his mature style. It is also significant that looking at his pictures with larger figures – which remain important throughout the artist's career – Annibale Carracci comes to mind. His characteristic style emerges around 1620–22 with dated pictures in Paris, Madrid and Florence. A painting in Toledo, Ohio (fig. 289),[8] corresponds closely to those in Paris in its two-wing structure, strong emphasis on classical architecture and Arcadian touch in the people and animals, its somewhat enamel-like, bright local colours which nevertheless are subtly related to the browns, ochres, red-browns and greys of architecture and ground, and to the blue of the sky. The composition of these early works is by no means monotonous; there are many variations on the two-wing type of the Toledo picture but there are also freer patterns with vast distances counterbalancing one-wing elevations. In the Utrecht picture of the *Flight into Egypt,* which is dated 1625 or 1626 (fig. 290),[9] the very brightly coloured staffage is set off against the sky on top of a long diagonal slope which reaches across the entire picture; all details are subordinated to a long unifying shadow while the green hills and pink ruins on the right side stand in a brilliant light under the azure sky – a fairy-tale of distinctly Mannerist sophistication whose structure is precarious, to say the least, and may indicate the effect of Poelenburgh's renewed residence in Bloemaert's city. Dates on later paintings are extremely scarce.[10] His contribution to the *Pastor Fido* series (1635; Berlin, no. 956) shows behind the lively foreground scene a landscape of great fluffiness and delicacy, still with high

ancient ruins but significantly less stratified than in earlier works; and a picture of 1659 in Copenhagen (no. 549) with *Diana and Nymphs* (fig. 291) is still painted in practically the same style, except that the figures are piled up more ostentatiously in the foreground and the contrasts between light and dark further toned down.

Poelenburgh's art must have expressed to perfection the Arcadian aspect of landscape painting for people in Italy as well as in Utrecht and in England, where he worked for a while (from 1637).[11] He evidently had a considerable clientèle in Rome as well as in Florence, where a huge number of his works are still found together; with his usually small, gem-like paintings on panels and copper plates, his bright colours, his picturesque ruins, his lively scenes from everyday life, mythology and the Bible (with or without benefit of landscape), he must have been considered an admirable cross between a first-rate craftsman and a jack-of-all-trades, and perhaps something like the logical successor of Elsheimer. In Holland he was successful as the man who skilfully combined Bloemaert's more distinctly Mannerist interpretation of Arcadian standard scenes from Ovid, Boccaccio and Guarini with a more Theocritean and more authentically Roman landscape mood; in addition, he found many patrons for his distinctly ecclesiastical religious paintings and his (sometimes excellent) portraits.[12] He was furthermore much sought after as a staffage painter; his nimble, well-drawn, enamel-like figures are found not only in the landscapes of painters working more or less in his own style such as Herman Saftleven (p. 69), but also of representatives of the new Italianate trend such as Jan Both (fig. 305); in exceptional cases, staffage was painted by others into Poelenburgh's landscapes, witness Berchem's admirable cattle in a picture in Kassel.[13]

It is therefore not astonishing that the number of his imitators properly speaking is very large, but it is hardly worth defining the rather minimal (and rarely successful) individual deviations from Poelenburgh's style in the works of Vertangen, Haensbergen and many others.[14] The cycle of four scenes from Guarini's *Pastor Fido*, painted for Castle Honsholredijk in 1635 by Poelenburgh, Herman Saftleven, Abraham Bloemaert and Dirck van der Lisse (now in the Berlin Museum and Castle Grunewald),[15] affords an excellent opportunity to compare Poelenburgh's art with that of his ageing teacher and that of two younger artists who were strongly under his influence; one (van der Lisse) to the point of outright imitation, the other (Saftleven) without losing his identity. We shall return to the latter artist after a short discussion of Poelenburgh's Roman companion, Bartholomeus Breenbergh.

As for Breenbergh (1599/1600–1657), recent investigations by E. Schaar[16] have likewise brought welcome clarification. The development of the artist – who hailed from Deventer, was very little younger than Poelenburgh, came to Rome in 1619 and stayed there for ten years – ran parallel to that of the Utrecht master, but with even stronger dependence on Elsheimer. If the famous little panel with *Mercury and Battus* in the Uffizi is actually by him, as Schaar maintains, his earliest style is indeed unexpectedly close to that of Elsheimer; but even fully authenticated works of 1622[17]

and 1623[18] are unmistakable imitations of the Germano-Roman's art with some reminiscences of Paul Bril and Agostino Tassi. The affinity with Poelenburgh is only felt somewhat later, beginning with such works as *St. Peter among the Heathens* in Kassel (no. 205), but continuing for some time after his return to Amsterdam, even though their colours are less bright than those of Poelenburgh; a characteristic example is the 'Egyptian' landscape of 1631 in the J. Paul Getty Museum (fig. 292).[19] Other landscapes painted by him in Amsterdam show the most diverse influences. Some have a strong Flemish flavour; others are somewhat indebted to Rembrandt. Still others aim at a synthesis of the Roman classicism of his early works and the new Italianate style, to which Breenbergh's own, beautifully delicate etchings of these very years made such important contributions; in some paintings of this kind he even anticipated some effects of the art of Jan Both (*Cimon and Ifigenia* of 1640, Berlin, no. 924; fig. 293).[20] Most of Breenbergh's later works do not belong in a history of landscape painting.

We have encountered the very protean Herman Saftleven as a painter of early, Molijn- and van Goyen-like dune and river landscapes, of forest scenes, winter landscapes and imaginary views; his later output, which consists mainly of vast panoramas inspired by his travels along the Rhine and Moselle, will attract our attention later (p. 167). Here we ought to mention some works of the earlier forties which show a strong connection with the *Flamisant* forest scenes of Alexander Keirincx but which combine these Netherlandish features with Italianate backgrounds of the Breenbergh-Poelenburgh type. Pictures of 1641 (Vienna and Munich) and 1643 (Braunschweig, with mythological figures by Poelenburgh) come to mind; the one in Munich (fig. 294), less elegant and intimate than the Braunschweig picture, more formal and epic (and with biblical staffage not accidentally painted by his brother Cornelis), nevertheless has the yellow-brown tonality of a Keirincx, and mountains in which Utrecht elements of the Savery, Poelenburgh and Breenbergh type seem to merge. A small and very delicate picture in Utrecht (no. 241; fig. 295) indicates a first admixture of the style of Jan Both which grows much stronger in 1645 (Vienna, no. 1228) and also affects Saftleven's Dutch forests of the same year and of 1647, which were discussed above (p. 69 and fig. 131).[21]

We can be almost equally brief with regard to Herman van Swanevelt,[22] a very uneven painter, who can be said only with some reservations to belong in a history of Dutch painting. Born about 1600 in Woerden near Utrecht – thus an almost exact contemporary of Breenbergh and Claude Lorrain – he appeared in Paris as early as 1623 and stayed in Rome from *ca.* 1627 until *ca.* 1641–43; he revisited Woerden in 1645, 1647, 1648 (?) and 1649, but from 1644 had his main residence in Paris, where he died in 1655. In his paintings as well as in his drawings, he is most closely allied with Claude Lorrain. His earliest known painting is dated 1630 (Brediushuis, The Hague; fig. 296), that is, earlier than any generally accepted painting by Claude, and everything points to a reciprocal relationship between the Frenchman and the Nether-

lander. In other works he harks back to Paul Bril, or partakes to some modest degree in the Northern characteristics then being developed by Jan Both – such as a greater penchant toward naturalistic detail and light effects – but he never achieved Both's rhythmic finesse and golden luminosity. It is amusing to see that in a landscape painted in Woerden in 1643 or 1648[23] (Amsterdam, no. 2280 a; fig. 301) he not only inscribed the fact that he did this work in his hometown but also painted in a deliberate imitation of Jan Both – just as in 1646, in Paris, he painted a landscape with a *Storm* which is strongly reminiscent (or prophetic?) of Dughet (fig. 302).[24] His most enjoyable works are modest, Claude-like landscapes with biblical staffage, such as the two paintings in Cambridge (nos. 202 and 206, *ca.* 1640), for which, exceptionally, preparatory drawings still exist.[25] To establish a convincing chronology in the work of such an artist seems as difficult as it is of limited interest; how far removed we are from such a goal is shown by the fact that the *Arch of Constantine* in Dulwich (no. 11), which is actually signed 'Paris 1645', has been dated shortly after 1631;[26] the date of one of his most ambitious drawings has been read 1636, 1646 and 1655.[27] Among his drawings, some made in preparation for etchings (one set of which is datable 1653) and now preserved in the Uffizi excel everything he did in his more elaborate efforts and in any of his paintings; in them, his imitation of Claude's brilliant wash effects occasionally reaches a surprisingly high level.[28]

B. *The Second Generation*

With some of the paintings of Saftleven and Swanevelt we have anticipated features of the second generation of Italianate landscape painters. It is now necessary to justify the brief characterization given above by presenting some major aspects of the Italian scenery as these artists visualized and organized them: The Campagna landscape, scenes in the high mountains, harbour and coast scenes. This will be supplemented by a few paragraphs on some masters whose Italianate works form only a relatively minor part of their artistic output. Works by painters who concentrated on *genre* and animal scenes will be discussed only when landscape played an exceptionally important role in them.

In spite of considerable diversity, the landscapes with motifs from the country around Rome, here for brevity's sake called Campagna landscapes, have many elements in common: the relatively level paths winding their way between ruins, trees, rocks and hills with bluish mountains in the background; the quiet, subdued mood; a morning, afternoon or evening sky permeating the entire picture with a golden or silvery haze; idyllic figures of normal size in relationship to their surroundings, usually shepherds and their flocks resting or moving leisurely along the roads, replacing the mythological staffage of the older generation and forming, in their subordination to the landscape, the legitimate northern corollary of the literary idyll of

the classical tradition.[29] Some of these features, and in particular the 'liquid gold', do point to Claude Lorrain as one source of inspiration for the earlier masters of this group such as Jan Both and Jan Asselijn; but there can be no question of imitation proper, and I do not believe that the slightly younger artists of this group, such as Berchem, Hackaert, Moucheron and Pijnacker, had any significant contact with Claude's work.

The architectural remains of Roman antiquity which play such an important role in the works of Poelenburgh and Breenbergh were by no means entirely neglected by the masters of this trend; but they were apt to lose a great deal of their topographical (or at least topical) significance and to undergo important changes in their compositional treatment. In most cases, this process corresponds to the increasing alienation of the artists from the Roman scene; in fact, it is also quite noticeable in the works of Poelenburgh and Breenbergh themselves soon after their departure from Italy. But even in early works by Asselijn and Both, the treatment of the architecture is likely to differ considerably from that practised by the older masters.

A comparison of Poelenburgh's picture in Toledo (fig. 289) with Jan Both's early representation of Roman folk life in front of an imaginary combination of the Faustina Temple, Arch of Titus and Coliseum (HdG 26; fig. 297) is revealing. The stage-wing-like character of the architecture in the earlier work has been replaced by a continuous diagonal sweep leading from the right foreground to vast distances on the left side; the brisk overall clarity of the architecture has given way to a refined crescendo of haze; additive placing of figures and animals to an integrated if more complex grouping; even lighting to a picturesque combination of richly varied shades and brilliant highlights; cooler to warmer hues. Poelenburgh's Arcadian shepherds have been replaced with strongly active, somewhat caricatured peasant types[30] based on those found in the very influential *genre* paintings of Pieter de Laer and of Jan Both's brother Andries. This prominence of *genre* features is much more frequent in the works of some of Both's fellow-artists, including Jan Asselijn (*ca.* 1615–52),[31] who, though probably a little older than Both, arrived in Italy later than he (*ca.* 1641) and whose entirely different pre-Italian output (battle scenes) does not concern us here. However, there are a considerable number of paintings by Asselijn in which landscape is of paramount importance. The picture illustrated in fig. 298 belongs to his later, Amsterdam years, shortly before his premature death in 1652; its diagonal ruins follow the pattern established by Both, its reduced staffage parallels the same master's later habit as does its warm light effect, even if it is less reminiscent of Claude's gold than is that of Both. In contrast, a very late picture by Nicolaes Berchem (*ca.* 1670; HdG 149; fig. 303)[32] is characterized by a distinct showiness both in its architectural motif and in its staffage: the former by way of exaggerated picturesqueness and isolation, the latter through showy elegance in movement and recrudescence of local colour. This is by no means true of all of Berchem's works showing ancient ruins but it does provide a significant example of the latest phase of this second generation as

well as of the style of many imitators of Berchem. Of the stylistic sequence intimated
in these four pictures (figs. 289, 297, 298, 303) we shall repeatedly be reminded in the
following paragraphs, though not necessarily with the same qualitative connotations.

As Jan Both is undoubtedly the leading master in Campagna landscape painting, a
somewhat more extended discussion of his art and its Roman background will be in
order.

Jan Both[33] was born in Utrecht, probably about 1615–18, stayed in Rome from
1638 (at the latest) to 1641, was presumably back in Utrecht in the same year and died
there as early as 1652. Contrary to a seemingly ineradicable belief, not one single
painting by Both is known for certain in which the figures were painted by his brother,
the moderately gifted *genre* painter Andries (see fig. 87 for an unusual drawing of his),
although such pictures must have existed according to Sandrart's reliable testimony.
Since Andries died in Venice in 1641, he could not have painted any figures in pictures
of Jan's mature period. No painting certain to have been done by Jan during his
Italian period has yet been found; and even if the *Roman Folk-Life* (fig. 297) and some
other *genre* scenes with Roman buildings were painted during that phase of Jan
Both's life (which is probable) they do not fall in Sandrart's category since their
figures are certainly not by Andries but by Jan himself.[34]

The vast majority of his known works must in any case belong to the ten years (at
most) before his premature death, and for this period, hardly any reliable dates are
available either.[35] It is this group of works which has so often been taken to be but
little more than variations on a theme by Claude. This view is subject to considerable
qualifications

For the relationship of Jan Both to Claude Lorrain, our main source is once again
Sandrart. He observed that, while in small paintings the brothers adopted the manner
of Pieter van Laer,[36] in their landscapes they were closer to the style of Claude; and
he added that owing to their diligence and skill in peopling their landscapes with good
figures, they provided a wholesome competition for the French master, who was 'more
versed in landscape than he was in figures'. Now, personal contact between Jan Both
and Claude must have been limited to the few years between 1638 and 1641 when the
former was in Rome. Claude's work up to these years is really not very well known.
The two historical scenes of 1631 in the Louvre reflect in their silvery tints the influ-
ence of Elsheimer and Bril, of which there is no trace in Both's authenticated works.
Claude's *Mill* in Boston (fig. 299), however, is less dependent on these Roman
sources, and the *Mill*, whose date has been read as 1631 as well as 1637,[37] furnishes the
first tangible example of a more immediate stylistic connection between Both and
Claude, with the latter's priority rather firmly established. Here we have one of the
earliest instances of that golden atmosphere which was to become the hallmark of
Claude's seaports and some of his other canvases for nearly fifty years – and of the art
of his imitators for centuries. Such elements in the *Mill* as the bare-branched trees on
the left, the type and lighting of the buildings on the right or the treatment of distant

mountains, foreshadow features which occur repeatedly in the works of Both. In other respects, however, Both's paintings differ considerably from these earlier works of Claude, while to Claude's later, more pronouncedly classical style they show hardly any resemblance whatever. The very early date of Swanevelt's picture in the Brediushuis (fig. 296), namely 1630, and the appearance of golden atmosphere in it, speaks for a close contact between Swanevelt and Both; the former was still in Rome when Both arrived.[38]

As Sandrart pointed out, the brothers, working hard in Rome, 'endeavoured to approach nature as closely as possible'; they succeeded in this so well that in their paintings, 'one can recognize almost every specific hour of the day, together with all other appropriate characteristics of the fields, mountains and trees'. Realism of this sort, relatively rare in Claude's early works and almost non-existent in his later ones, is surely a Netherlandish emphasis. Looking afresh at a well-preserved, genuine and fully characteristic work of Jan Both's (HdG 155; fig. 300), we are struck by his love for the individual qualities of tree trunks, branches, foliage, shrubs, rocks and pebbles, all utterly unlike any part of Claude's idealized world. Such loving attention to detail could easily spell confusion instead of order but, in genuine works by Both, this is not the case. The details have been subordinated to the whole, and unity achieved primarily in three ways: first, by intensification of the all-pervading quality of the sunlight (akin to Claude's golden atmosphere); secondly, by the interweaving of planes through multiple roads and streams, refined spacing of groups of trees and subtle differentiation of values; and thirdly, by the masterly fashion in which figures are blended into this network of compositional directions.

Even in the unusually large *Landscape with the Draughtsman* in Amsterdam (no. 591, HdG 87; fig. 304), which de Groot called the artist's main work, these compositional and colouristic qualities shine forth brilliantly and provide a convincing yardstick for comparisons between Both's own works and the host of imitations and copies after them. The fine equilibrium between figures and landscape was not likely to be disturbed even when the staffage was painted by other masters. This seems to be invariably the case in the small group of mythological subjects, probably because Both hesitated to paint nudes; witness the *Judgment of Paris* in London (no. 209, HdG 23; fig. 305) where the scene, painted in by Poelenburgh with characteristic refinement, was deliberately echoed in the utter delicacy of trees and mountain vista; and the *Mercury and Argus* in Munich (HdG 14, fig. 306), a painting done in 1650 in which the much broader brushstroke and more sonorous colours of the landscape match the soft flesh-tones and blue-purple drapery of Nicolaes Knupfer's figures.[39]

There is no question but that the greatest debt of the Campagna landscapes by Nicolaes Berchem (1620–83)[40] is to Jan Both. This is particularly evident in the 1650's. In 1657 he painted the *Itinerant Musician* (in a private collection in Indianapolis; HdG 270; fig. 307), which was once considered to be a joint work by Berchem and Both;[41] here Berchem certainly vied with Both as a painter of soaring trees set off against steep rocks and a Claude-like sky (a very similar example of 1658 is in

London).⁴² In early works one finds combinations of Campagna and Dutch motifs; Italianate features of the Moeyaert, Both and J. B. Weenix type join Dutch features reminiscent of Cornelis Vroom, as is proved by the excellent picture of *ca.* 1647 in Hannover (no. 15; HdG 487; fig. 308),⁴³ with the brown-green foliage of its Haarlem-like trees, Italian mountains and rocks, and the red-blue-green-yellow-lilac harmony of its Italian staffage. Many paintings of the 1640's already contain more pronouncedly Italianate landscape elements (mostly derived from Weenix and Both), but animals and figures, whether biblical, mythological or *genre*, tend to predominate.

The best Campagna scenes by Jan Hackaert (1628–after 1685)⁴⁴ excel in the representation of fine, slender trees with light foliage and elegantly highlighted barks; they vary from intimate to more formal settings, from freshly animated to somewhat stilted, more classical-minded constructions; although they are considerably more numerous than his paintings with Dutch motifs (see p. 81) they are rarely of the same calibre. A picture in Berlin with lovely staffage by Adriaen van de Velde (and therefore datable before 1672)⁴⁵ is a good example of the more classical type (HdG 73; fig. 309). The more spontaneous type is perhaps best illustrated by a picture in Amsterdam (no. 1024; HdG 70; fig. 310), with its slender central tree curving gracefully against the falling diagonal of the distant mountains, its delicate grey-green, purple, light blue and yellow hues and a few discreetly handled red and blue figures. Dates on his pictures are almost entirely lacking,⁴⁶ and although we are well informed about the artist's sojourn in Switzerland (1653–58), the circumstances of his Italian visit or visits – whose existence is suggested by his extraordinary *Lake Trasimene*, fig. 321 – are obscure. The paintings reproduced here can only approximately be dated around 1670, considerably later than the Italian impressions. There is good reason to believe that his late paintings show a distressing decline.

I am here adding a few words on Frederick de Moucheron (1633–86),⁴⁷ whose Campagna scenes recall Both, Hackaert and Dujardin, but are occasionally not without originality. It is not quite certain that he was ever in Italy although we do know that he visited France after an apprenticeship with Jan Asselijn in Amsterdam which left strong marks on Moucheron's later style. His paintings are very rarely dated, and his development is still rather obscure. A fine painting dated 1668 (fig. 315) was in the Dutch trade in 1953; its only staffage consists of deer; its feathery, silvery trees and clouds are a hallmark of this artist although they are evidently related to certain works by Hackaert. A particularly attractive small canvas in Amsterdam (no. 1678; fig. 311), with figures by Adriaen van de Velde and therefore datable before 1672, contains a suggestion of that liking for the park – rather than for untrammelled nature – which is found on the increase in paintings of the native scene at the same time (e.g., by Jacob van Ruisdael, see p. 76); this is even more obvious in other works by Moucheron (London, no. 842, is a striking example) and was to be continued to the point of exhaustion in the paintings by his son, Isaac de Moucheron (p. 165). Late works by Frederick point to a serious decline of artistic faculties.⁴⁸

It is rather evident that the primary inspiration of the mature works of Adam Pijnacker (1621–73)[49] came from Jan Both, not only in what can be considered a relatively early phase but also much later, long after Both's death in 1652. One of his finest pictures, the *White Cow* in Munich (no. 868; HdG 91; fig. 312) is a free adaptation of a painting by Both in London (no. 957; HdG 229; fig. 313). One is strongly tempted to call the younger master's work superior; the contours of the landscape and trees (roughly the reverse of Both's) are more harmoniously related to the sky; the cow, though more of a 'portrait' than that of Both, is by no means too isolated but most successfully linked with the landscape: it forms the frontal end of an arch which comprises strongly coloured figures and animals and points upward to the sunny middle distance where it is absorbed by the curve swinging from lower left to upper right – a masterly achievement. Such highpoints are not frequent in Pijnacker's other pictures of the Campagna type. The scenery easily looks rather too grandiose, and the figures too isolated, even as early as 1654 (Berlin, no. 897, HdG 52);[50] dramatic scenes, such as a bridge collapsing under a herd, painted in somewhat garish figures protruding from the landscape, make an occasional appearance after 1659 (Munich; HdG 27);[51] the silvery sheen of the trees often becomes irritating, and even the finest, most reticent and most harmonious paintings – those retaining a Both-like golden glow and intimacy which include a few dated examples[52] – can only rarely vie with Both himself or with other masters to whose influence he bowed on occasion (e.g., Asselijn).[53] Some paintings exhibit a startlingly near-surrealist quality in the way in which extremely closely observed and meticulously rendered details of shiny, glossy, often wildly contorted trees and plants are blown up and matched against more purely decorative, hazily painted foils (Bonn, no. 35.241; fig. 314).[54] Here Pijnacker reached the same stage of sophistication and over-refinement as did Berchem in his late *Ruins* (fig. 303). Most of his huge decorative wall hangings (probably late works, although we have no dates for them) are now forgotten and inaccessible.

In the following section a few pictures will be chosen to represent a somewhat more dramatic aspect of Italian mountain scenery as interpreted by the same group of artists: either a deep penetration of the very core of higher mountains, or a vaster, more panorama-like view of valleys and distant summits as afforded by vistas opening up from higher levels. One is tempted to think here of impressions received in the Alps or the Apennines rather than in the Alban Hills.[55]

Jan Both's picture in Detroit (no. 89.31; HdG 162; fig. 316), called 'A Pass in the Apennines', is rather exceptional within this artist's œuvre. A tall, slender fir tree rises with marvellous freedom in front of a wooden bridge and a precarious path in the high mountain territory. The painting is not only bathed in gold but composed throughout of luminous browns, with a few deep, warm hues in the two small figures on the right, dwarfed by the majesty of the scenery.

Again, the step from Both to Berchem, even a relatively early Berchem of 1656 (HdG 282; fig. 317), is one from a higher to a lower level of inspiration, from a work

of great originality to one that does not entirely avoid banality. Yet, the view upwards from the comfortable shepherd group in the foreground towards the higher level of stream, rock and tower, and again up towards mist-enshrouded mountains, is not without considerable merits of composition and aerial perspective, quite superior to the later scenes with ruins (fig. 303).

The Italian panoramic view, with the onlooker placed on an elevated level, looking down on to a vast expanse of plains and lakes, and again up to high summits, seems to have originated with the many-sided, highly gifted Jan Asselijn, whose Campagna pictures tend on the whole more towards *genre* than towards landscape. His first picture of this kind, once in the Steengracht Collection, has been lost sight of after 1940;[56] it may have been painted as early as 1647. Three or four years later he painted his masterpiece, today in the Vienna Akademie (no. 836; fig. 318), a composition of amazing boldness and without clear precedence (except, perhaps, in Lanfranco's extraordinary early *Egyptian Mary* in Naples)[57] but presaging elements of nineteenth-century romanticism while yet retaining a typically Dutch sobriety in its shepherd staffage. As in the most mature representations of the Dutch panorama proper there are here no lateral boundaries, and the equilibrium of the picture depends on the judicious balance between masses, colours and values; the motif of the level foreground dipping down towards the middle distance, here beautifully underlined by the procession of figures and animals, also occurred in Dutch panoramic views (p. 38). But the real glory of this picture, covering two-thirds of the picture plane, are the stately mountains and the brilliantly lighted clouds and open sky towards which they are rising.

There is perhaps only one Italian panorama that can match this splendour, and that is Jan Hackaert's amazing canvas with the *View of Lake Trasimene*,[58] probably painted in the early sixties, shortly after the artist's return from the South (HdG 8; fig. 321). This can be assumed to have been based on a drawing made on the spot; yet Asselijn's Vienna picture – or one very similar to it – may well have inspired Hackaert to transpose his sketch into a painting of such great daring. It is an all-embracing panorama of the imposing site. In contrast to Asselijn's picture, it is seen from a height and distance which are great enough to dwarf completely the few figures on the left; also its proportions are more oblong, almost reminiscent of Seghers, thus increasing the difficulties of obtaining a convincing equilibrium of composition. Its colouristic treatment, particularly that of the distant mountains, is unthinkable without strong inspiration from Jan Both as well as from Asselijn; this is immediately revealed by a glance at Both's great *Landscape with the Draughtsman* (fig. 304), which hangs a few yards away from the *Lake Trasimene* in the Rijksmuseum.[59] But Both never painted a panorama of this kind – nor did Hackaert himself venture to paint another. This picture is the result of a profound experience and an exceptionally enlightened moment of perception; and its evening glow, harmoniously blending with cooler bluish nuances, is not easily forgotten.

The great panoramic sweep of these works is found in a somewhat reduced form though clearly based on them (as well as on fresh inspiration from nature) in a group of late works by Karel Dujardin (1622–78),[60] who returned to Italy in 1675 for a second visit, which ended three years later with his death in Venice. This period of the artist's activity was carefully reconstructed by E. Brochhagen; it produced some works which without being in the least purely derivative, clearly point back to Asselijn's achievements,[61] as do a number of comparable works by Berchem.[62] But as early as about fifteen years prior to the artist's final sojourn in Italy he painted the very small picture in Cambridge which was lovingly christened *Le Diamant* by the connoisseurs of the eighteenth century (no. 1099; HdG 137=235; fig. 320). Prepared for by a few pure landscape studies in etching and drawing,[63] this veritable jewel is as far removed from Asselijn's romanticism as it is from Hackaert's Umbrian fantasy; it is idyllic without being specifically Arcadian, unpretentious to the point of glorying in understatements, wonderfully luminous without sacrificing the dew-like freshness of its local hues. The late works continue this trend, and they do so with fine variations; of even greater originality, however, is Dujardin's small landscape in the Lugt Collection (HdG 211=221; fig. 319),[64] which is related to the previously discussed works not by a comprehensive panoramic view but by its massive mountains, which rise in the distance towards a high sky, and by its small figures. The animals cross the river in an Indian file of impeccable rhythm, the darkish grey-brown-green tints are profoundly silent and peaceful under the blue-orange evening sky. It is as though the master had envisaged a synthesis of the Italian South and the American West.

Our survey of Italian Harbour and Coast Scenes can be very brief in spite of a large group of paintings of this subject. The reason for this is that many, perhaps most, such works belong in the realm either of *genre* painting or of architectural painting rather than of landscape painting proper. The most celebrated harbour scenes by Berchem[65] belong in the former category, as do those by Jan Baptist Weenix,[66] Thomas Wijck,[67] Johannes Lingelbach and many others; among the latter one might mention works by Emanuel de Witte[68] and several lesser artists.

A characteristic feature of the *genre* type is its strong Levantine flavour. Although it is difficult to identify any specific places, some such paintings seem to be based on drawings by artists who visited the towns on the Asiatic and African coast as well as Malta.[69] Others are purely imaginary. In most of them, the main accent is on the picturesque costumes of oriental merchants and servants, and on their mercantile activities; occasionally, a subject from some unidentified contemporary play or novel seems to have been pressed into service.[70] This exotic flavour is rare with the group here discussed but it does occur in Asselijn's late composition (fig. 324). It can also be found in a few paintings by the widely travelled Reinier Nooms, called Zeeman, which have an authentic ring and in which the landscape aspect has not been sacrificed to the *genre* one.[71]

As mentioned above, most of the harbour scenes of the excellent Jan Baptist

Weenix belong to the *genre* type, often with significant architectural motifs, and in some of them the Levantine accent is clearly discernible. The most landscape-like picture of our group in which Weenix's hand can be recognized is the one in the Vienna Akademie (no. 761; fig. 322), which he signed jointly with Jan Asselijn;[72] and here the composition of the work must evidently be attributed to the latter, while Weenix seems to be primarily responsible for parts of the right side and of the background. The highly sophisticated composition, which is only remotely related to Claude's contemporary, epoch-making representations of the subject, was preceded by a few other paintings by Asselijn,[73] and from these there is only one short step to Berchem's very unusual and charming little picture in Leipzig (no. 987, HdG 791 and probably 94; fig. 327), which is not dated but whose signature ('Berrighem') proves that it was painted between 1645 and 1650;[74] the spontaneity of its brushstroke is happily matched by its seemingly casual structure and fine economy of means – a far cry from the artist's elaborate seaports of the fifties and sixties. About 1650–52, Asselijn composed an intimate harbour scene in upright format, of which two nearly equally fine versions are known: in the Ruzicka Collection of the Zürich Kunsthaus[75] and in Amsterdam (no. 385A1; fig. 324). Near a round coastal tower rises a fountain on a magnificently painted stone terrace; a manacled man is quenching his thirst; a group of two Chinese and a Negro converse on the right; two European merchants are standing near their boat. The story – if there is one – is told with an airiness and a fairy tale charm that are rare even with Asselijn. The basic colour harmony is of a reddish-brown and grey in the architecture, enlivened by ochre and blue in the figures.

The Coast Scenes of Adam Pijnacker have recently come into their own in an almost spectacular fashion. There are probably only two dozen or so of this kind known but they include some masterpieces. It seems that the subject first appeared as an auxiliary motif (Amsterdam, no. 1926; HdG 18), coupled with one of those partly dramatic, partly 'surrealist' foreground scenes. But the same museum (no. 1929A1, HdG 19) owns one of the finest examples of the mature group, which must belong to the fifties. The well-known upright picture in Leningrad (HdG 29)[76] and the similar one in the Vienna Academy (HdG 36; fig. 325) are distinguished by an extraordinary calm, which is the result of an equally extraordinary predominance of parallel horizontal strata formed by barges, the water and the distant bank (with nearly flat-roofed buildings in the Leningrad painting), and favoured by the elevated standpoint of the spectator. The picture in Hartford (no. 1952.51; fig. 328)[77] brings the spectator closer to the scene, places the barges in a half-shaded shelter between a strip of land in the foreground and a hill rising diagonally in the middle distance and closes this section with high sails in the centre and high distant mountains on the left, while on the right a fisherman and a stately frigate provide counterbalancing vertical accents. Behind the sharply highlighted plants on the left and the clearly but delicately outlined, brownish-red figure on the right (which reminds one of Adriaen van de Velde), forms and

colours are more vaguely defined: a bluish-green tint pervades the middle distance, in which the figures and objects are unified in luminous brown, grey and purple shades, and the light-blue distance merges with the pink, yellow and grey nuances in the sky.

Although these pictures seem to be indebted to Asselijn, they are Pijnacker's very own domain; within the realm of Italian coast and harbour scenes, they occupy a most honourable place by virtue of their originality and diversity of setting, their colouristic finesse and their genuine feeling for the calm, dreamy and nostalgic mood of an evening hour at the Mediterranean coast. This is romanticism of a kind perhaps more directly appealing to the modern eye than the works of other Italianate Dutch painters because of the intimate union of sharply realistic details and a fairy-tale-like haze – the combination which Pijnacker employed in many of his Campagna pictures without achieving quite the same effect of artistic unity.

Finally, a word on four masters of this second 'generation' whose Italianate works are of rather lesser importance in comparison with their representations of the Dutch scene: Aelbert Cuyp, Adriaen van de Velde, Jan van der Heyden and Jan Wijnants.

Campagna scenes appear in a considerable number of Cuyp's mature works, and in some of them the feeling for southern atmosphere, countryside, trees and staffage seems at first sight so genuine that one wonders how a painter leading a sedate life in relatively provincial Dordrecht could possibly have acquired it without having travelled southward as did most other Italianate painters. However, that first impression soon vanishes, particularly if one compares Cuyp's works with those from which he seems to have derived most of his notions about Italian golden hazes, ruins, mountains, trees and peasants: namely the paintings of Jan Both.

Early Italianate scenes by Cuyp point to older Utrecht masters such as Gillis d'Hondecoeter and Poelenburgh, rather than to Jan Both as a source; this was in 1646 and shortly later,[78] thus after an already distinguished career as a painter of van Goyen-like Dutch scenes (figs. 29, 107). But the full emergence of the new luminous style, described in our chapter on River Landscapes, particularly in connection with the *View of Nijmegen* (fig. 102), presupposes a careful and comprehensive study of Jan Both's fully matured Italianate style, although Cuyp was to go far beyond Both in the discovery of new optical effects and their pictorial equivalents. Also in contrast to Both, who painted only a handful of Dutch motifs, Cuyp immediately turned to the native scene and transferred to it his new vision.

It therefore does not matter much whether the new luminosity lends its magic to a *View of Nijmegen* (fig. 102) or to a strictly Italian view such as the radiant picture in Cleveland (HdG 465; fig. 326),[79] or, for that matter, to scenes with Dutch cows near a river with steep southern banks. The sky over Nijmegen and over the mountains and lake of the Cleveland picture is the same miraculous combination of light impastos over dull glazes; the contourless figures and trees magically produced by the little dabs of warm colour and brilliant highlights, the hazy glow of the distance, the little flecks of light intimating shrubs over the dark-glazed ground in the foreground, are

the same in his Dutch and Italian scenes; and it is enlightening to compare the last-named procedure with that in paintings by Both (fig. 304), where the undergrowth, though also done with highlights, clearly shows the individual form of each detail. But Both's work does look more genuinely Italian, particularly with regard to the figures (which he did himself, as did Cuyp). While the landscape is fully Italianate, Cuyp's Cleveland shepherd would be certain to reply to you in Dutch, and so would the husky girl and the three gentlemen on horseback in the great painting in a private collection (HdG 415; fig. 323). One of the glories of this picture – as of some others of this kind – is the gradual warming up of its tone from the cool, though sunny, pearl-grey background (with a 'Mediterranean' city) to the warmer olive-golden tints in the right foreground; a wonderful clarity permeates every corner of the picture, with a dominating light blue in the sky, crisp foliage in silhouette, and red, blue and gold-brown nuances holding their own in the figures. In the fine picture recently acquired by the Toledo Museum (HdG 615) all these southern features are naïvely yet quite convincingly combined with a variation on Utrecht's *Mariakerk*.[80]

The Italianate works of Adriaen van de Velde – who does not seem to have visited Italy either – are spread over the entire short span of his activity, from 1656 (at the latest) to 1672; and after *ca.* 1667 they seem to have completely crowded out the renderings of the Dutch scene proper,[81] with the exception of winter landscapes. But even the writer, certainly a staunch advocate of Dutch Italianate painting, would hesitate to suggest that van de Velde's Italian scenes equal his Dutch ones in quality. True, there are some gems among them, but they are less diversified, less original, less enchanting than his dunes, rivers, woods, winters and beaches. Some of them contain religious staffage and are fine examples of the serenity and devoutness of this Catholic artist, whose activity as a painter of altarpieces has recently drawn some attention;[82] his representations of the *Flight into Egypt* 'en bateau' are sensitive Dutch translations from the French (rather than the Flemish) pattern.[83] They precede the late Italianate pictures of the artist, which usually emphasize animals and often also large figures of shepherds and are likewise quite Dutch in cast and mood, in spite of their Italian landscape motifs. The picture once in the Cook Collection (HdG 129; fig. 329)[84] is a typical example of this trend, probably painted towards 1670. The shepherd washing his feet in the stream, clearly based upon the antique *Spinario*, is nevertheless as Dutch in substance as are his animals; both immediately bring to mind van de Velde's superb etchings and drawings of these motifs. While the distant ruins are painted in the tradition of Asselijn and even Poelenburgh, the trees, with their somewhat cursory, feathery technique, betray their origin in his rather late period. Freed from the crust of varnish and dirt, which disfigure so many of van de Velde's late paintings, the colours of this one are again clear and display a fine harmony of brown, green and white against the blue, grey-white, light gold and rose-brown of sky and ruins. Imitations and copies of such pictures are legion.

Italianate landscapes by Jan van der Heyden are rare, and the buildings in them are

usually even less Italian than in those of his confrères. Yet in spite of the long time that must have elapsed between the artist's Italian journey (if indeed it ever took place) and the execution of these pictures, some of them are distinguished by a southern atmosphere remarkable for its sunny luminosity and serenity. As dates on them are extremely scarce it will be well to reproduce the *Hilly Landscape* of 1666 (HdG 323; fig. 330),[85] the more so as it represents what Houbraken already considered van der Heyden's 'best period'. Its pleasant intimacy contrasts vividly with the ambitious vistas of other, presumably later pictures of this kind[86] with which it does share the traditional – and by now again increasingly popular – upper diagonal of Elsheimerian provenance.

Jan Wijnants's Dutch dune landscapes were accompanied by a number of Italianate paintings. Our knowledge of the artist's development is so scanty that we cannot tell when his first pictures of this type were painted; but none of them seems to be dated before the mid-sixties.[87] In any case, the most characteristic and most enjoyable works of this group were painted about that time, and the pair once in the Collection of the Duke of Bedford, dated 1665,[88] represents this facet of Wijnants's art at its best (fig. 331). As in the Dutch scenes of this period, his style is now tempered and enriched by a more personal observation of nature. Here, as almost invariably, Wijnants blends native motifs (more pronounced in the companion piece) with Italian ones, which do seem to be based on autopsy. But the specific stateliness of this composition distinguishes it not only from that of the considerably earlier works of Asselijn and Both but also from those of Berchem and most other contemporaries; it is more static, more consciously contrived. Hackaert's more formal paintings of the same decade are its closest parallels (fig. 309), except that Wijnants's light and colour effects are apt to be simpler, cooler and crisper. In his later Italianate pictures, Wijnants was frequently in danger of either excessive hardening or excessive softening of his brushstroke; correspondingly, similarities with the style (or styles) of Frederick de Moucheron became more marked. Altogether, his classical tendencies make him a logical link between the second and the third generation of Italianate Dutch landscape painters.

Before we turn to the third group, a word may be in order on an issue pertaining to the second group as a whole. The question has been raised – and repeatedly answered in the affirmative[89] – whether the decidedly structural elements which characterize so many works of the second generation of Italianate painters contributed to the rise of the 'structural' phase of the national trend around the middle of the century. High trees, massive rocks and mountains, large towers and other buildings have been cited in this connection. It is difficult for me to see any convincing evidence for this assumption. The emphasis on trees as a compositional 'building block' never disappeared from the national group during the thirties and around 1640, thus before a possible influence of Jan Both, let alone other Italianate painters; witness Jan van Goyen (fig. 32), Salomon van Ruysdael (fig. 30), Aert van der Neer (fig. 105), and, above all, the

early masters of the forest view such as Gillis d'Hondecoeter, Keirincx and Cornelis Vroom (figs. 120, 123 ff.); even the tinge of Both's influence noticeable in Saftleven's *Forest* of 1647 (fig. 131) did not affect the basic elements of this picture's style. The same is true of towers and other buildings (fig. 99). Even the structural effect of massive rocks and mountains was not forgotten among the earlier masters, particularly those of the imaginary scene (fig. 265 ff.). We have here a case of converging interests rather than an influence, and a new appreciation of the Italianate masters would gain nothing by claiming a role for them which they did not play. Naturally, this denial does not in the least imply that Italianate painters exerted no influence whatever on members of the national group; the extent to which Cuyp reflects the light effects of Jan Both even in representations of the Dutch scene is a case in point. It is quite certain that the 'clear and light' palette of the Italianate painters was highly appreciated at home; but here again it must be doubted that it actually influenced painters of the national scene to any considerable extent, as has been suggested.[89a]

c. *The Third Generation*

This group includes Eglon van der Neer (1634–1703), Johann Glauber (1646–ca. 1726), Aelbert Meyering (1645–1714), Jacob de Heusch (1657–1701) and a number of lesser artists; their style was continued well into the eighteenth century by Jan van Huysum (1682–1749). Research on these artists is in its infancy, as the following brief remarks will show only too clearly. It is now difficult – but also essential – to realize that de Lairesse's favourite landscape painters were 'Albaan Genouilje [Genoels], Gaspar Poussyn, den Duitschen Polidoor [Glauber]'.[89b]

The distinguishing characteristics of the landscapes of Eglon van der Neer,[90] none of which seems to date before 1690, is their evidently deliberate return to Elsheimer. We have noticed reminiscences of Elsheimer in works by Adriaen van de Velde (p. 81) and Jan van der Heyden; the more conscious return to him which we find here is a phenomenon which parallels the 'Bruegel-Renaissance' of Herman Saftleven and others, and in a sense recalls the van Eyck and Campin-Renaissance of the late fifteenth century. The *Tobias with the Angel* in Berlin (no. 846A; HdG 7) is a figure piece with an insignificant landscape setting; the influence of Elsheimer is here perhaps more apparent in subject matter and figure style than in the landscape background. But in the landscape paintings proper which contain the same subject only as staffage (HdG 6 of 1690, HdG 8 and 9), the mood, design and colour of the entire picture is affected. These are small, even tiny paintings of jewel-like refinement; the one in Munich (no. 2862, HdG 9; fig. 334) is inspired by the Germano-Roman master (fig. 333) in every respect, conspicuously so in the sonorous green and blue harmony of the trees and sky but also in the yellow-blue-red of the figures. Yet all of van der Neer's works do not show the same derivation; some are painted in a brown-grey-blue colour gamut more reminiscent of Herman Saftleven, even though of a more decidedly classical com-

position. Memories of Poussin, Dughet and Claude partly merge, partly compete with more realistic Dutch tendencies occasionally recalling Breenbergh rather than Elsheimer (Munich, no. 5239, HdG 167; fig. 332).[91]

Johann Glauber, [92] a pupil of Berchem and one of the most widely travelled of all Dutch painters, received his most vivid impressions in France (1671–75) and Italy (from 1675). His pictures are rarely dated, and it is at present impossible to tell with certainty what his earlier works of the sixties and seventies might have looked like, although an unsigned and undated landscape in Madrid (no. 2082) suggests a relatively early date by virtue of its rustic staffage and Hackaert-like composition – if its attribution is correct.[93] The works of his mature period – there is a very large one dated 1686 in Paris – show the overwhelming impact of Nicolas and Gaspar Poussin in composition[94] but differ considerably in their colouristic appearance; in a picture in Braunschweig (no. 399; fig. 335), the trees are feathery (reminiscent of Moucheron), the blues greyish, and the entire effect much softer than in typical Poussin imitations.

On the other hand, Glauber's friend, Aelbert Meyering, shows in his Braunschweig landscape of 1686 (no. 397, fig. 336) a much cooler and glossier colour gamut, in which clearer blues and shiny lights predominate; there are livelier contrasts here, the details are more sharply drawn, the figures stand out in lighter hues, and one is reminded of the very late Claude Lorrain – and at the same time, almost of Salomon Gessner and his circle. An undated painting in Hamburg (no. 467) is much softer; its date must remain uncertain, although the same composition was etched by the artist himself (B. 8) during his stay in Amsterdam, thus probably after 1688.[95]

Easily the strongest Dughet influence in any Dutch works of the seventeenth century is to be found in some paintings by Jacob de Heusch,[96] but it is blended with an equally strong dose of the style of Salvator Rosa. The fact that the artist's nickname in the Netherlandish *Schildersbent* was 'Afdruk' has perpetuated the wrong impression that his style was hardly distinguishable from that of his uncle, Willem de Heusch (both signed some of their paintings with the initial 'G', which can stand for 'Giacomo' as well as for 'Guglielmo'!); in reality, such confusion could possibly arise with regard to Jacob's somewhat hypothetical early period but not to his works of the 1690's. In the painting of 1693 in Utrecht (fig. 339) the far distance is reminiscent of Poussin, the foliage like that of Dughet, and the figures like those of Rosa. In contrast, the pictures by Willem de Heusch are unadulterated emulations of the works of Jan Both.[97]

It is the style of this group which was adopted by some good artists of the following generation and preserved throughout the eighteenth century. An amusing and enlightening return to stylistic features of the first generation of Italianate painters is noticeable in some works by Jan Griffier (1645?–1718); the Arcadian Landscape attributed to him in Cambridge (no. 393; fig. 337) was once quite understandably given to Poelenburgh, whose figure style was also the obvious source for the bathing nymphs added to the landscape by Willem van Mieris.[98]

Isaac de Moucheron (1667–1744) appears as a stricter adherent to the French

classical trend in most of his works. One of his specialties was views of parks, a subject which, needless to say, became dear to the eighteenth century; it has already been pointed out (p. 156) that some paintings by his father, Frederick de Moucheron, had prepared the way for this. Of superior quality are the relatively rare landscapes of the famous flower painter, Jan van Huysum (1682–1749).[99] Again, Poussin, Rosa and particularly Dughet come to mind when contemplating his best works, such as those in Amsterdam (no. 1279, HdG 19A; fig. 338)[100] and in Braunschweig (no. 447, HdG 6).[101] But surely there is more to such a work than is indicated by the listing of influences of that kind?

Even though nobody will argue that the last generation of Dutch seventeenth-century Italianate painters and their immediate successors such as van Huysum rivalled the splendour and wealth of ideas which characterized the best efforts of the second generation, it should not be viewed, I believe, as the merely eclectic, insignificant ancestor of a now little known and appreciated progeny. Its adoption of the French classical mould was not unqualified; and it was not only blended with colouristic influences from Elsheimer, Rosa and Saftleven but it also involved the translation of the heroic idiom into an idyllic, more intimate one, particularly in works of small, 'cabinet' size which in this very fact suggest another affinity with Elsheimer. In the best of these paintings one can detect and enjoy a typically Dutch 'verzorgdheid' (a loving meticulousness) of detail and composition; their browns and greens, blues and purples are fresh and pleasing, not merely derivative, and their Arcadian, non-heroic mood is convincing, setting the pace for the typical eighteenth-century idyll. A comparison of van Huysum's painting (fig. 338) with one (of approximately the same size!) by Dughet (London, no. 98; fig. 340) will reveal this contrast between idyllic and heroic classicism very clearly; and even Jacob de Heusch's (larger) canvas (fig. 339) falls in line with the Dutch group, not only because of its greater differentiation of natural forms (particularly obvious in the treatment of the foliage) but also because it lacks the pathos or the sublimity that are never entirely absent from the pictures of the Franco-Roman style.

Hofstede de Groot's judgment that Jan van Huysum's 'heroic landscapes have ceased to impress anybody today and are hardly worth stopping for'[102] is apt to be revised along with many similar pronouncements on this phase of Dutch art. At that time, the painters of the native scene showed an almost universal decline of their faculties; but I submit that the appearance of the group here under consideration suggests something more than a mere filling of a vacuum. One may think of it as a wholesome retrenchment which, even though one cannot call it a 'reculer pour mieux sauter', efficiently prepared the ground for a century without giants.

CHAPTER IX

Other Foreign Scenes

<p style="text-indent: 2em">
THE Rhine is one of Holland's great arteries and appears in works of almost all the great land and river painters. The views of Arnhem and Rhenen (figs. 58, 71, 72) show it flowing through flat territory; it is only near the eastern border of Holland that the one steep bank of the river at Nijmegen introduces a different note (figs. 100-102); further east and south the plains once more prevail, with only slight elevations at a few points.
</p>

A really 'foreign' scenery, to Dutch eyes, is provided by the Rhine in its north-south extension only, roughly between Bonn and Mainz, the Siebengebirge and the Rheingaugebirge.[1] Here are mountains, not hills; yet, they are 'plaisant', of neither Alpine nor Apennine grandeur.

The number of Dutch painters who were fascinated by these vistas is not large, and none is of the highest rank. However it would be wrong to pass them over in complete silence; at least one of them, Herman Saftleven, created a pattern for such views which retained its validity far into the eighteenth and even nineteenth centuries.

We have encountered this protean artist as a painter of panoramas (p. 195), river views (p. 56), forest (p. 69), winter (p. 205) and imaginary scenes (p. 141). Most of these activities were dropped after the late forties in favour of pictures more or less clearly based on a large number of drawings which he made during travels undertaken from Utrecht and during a period of residence at Elberfeld (1667).[2] These and other drawings, praised by van den Vondel (which by itself is not a recommendation), are as a rule topographically correct, while the paintings are almost invariably composites of such motifs. Nevertheless, each of these motifs is faithful enough to be clearly identifiable; in other words, Saftleven's pictures granted the German scene as much or as little reality as those of a large number of his fellow landscape painters granted the Dutch scene.

Thus, Saftleven's picture of 1653 in Mainz (no. 99; fig. 341)[3] is a clearly 'impossible' composite of the *Zollburg* at Bonn, the *Round Tower* of Andernach, the *Godesberg* and the *Drachenfels* – but each one defined unmistakably and the whole treated in such a way as to preserve an unmistakably Germano-Rhenish character. In this respect, Saftleven's art differs fundamentally from the composite views of Bruegel and his circle, which are much more thoroughly imaginary, and aligns itself with the more sober spirit of Savery, who had lived and worked in Utrecht until 1639 and whose deep valley and mountain vistas had clearly impressed Saftleven (fig. 281). On the other hand, Saftleven's art is indeed not unrelated to the Bruegel tradition, though more to that represented by Jan than by Pieter Bruegel. This is evident in the multiplicity of details on a wide variety of planes and levels within a basically homogeneous

167

landscape pattern, and no less in the multifarious colour scheme which began to dominate Saftleven's production around 1660.[4] His crisp combinations of red-blue-green-brown, often of a miniature-like brilliance and reminiscent not only of Jan Brueghel the Elder but also of his successors such as his son Jan the Younger, Pieter Gysels and the Bout-Boudewijns team, did make a strong impression on late seventeenth-century painters in Holland and particularly on eighteenth-century artists in Germany such as Christian Georg Schütz and many others.

Jan Vermeer van Haarlem the Younger (1656–1705) painted such Rhenish motifs occasionally,[5] and Jan Griffier the Elder (1645 or 1652–1718) actually specialized in them although he spent a larger part of his life in England.[6] A brief glance at his characteristic painting in Bonn (no. 54.17; fig. 342)[7] tells the story of the completed circle of seventeenth-century painting 'by generations' more vividly than words; it may be added that in the figures, boats and houses, an orgy of reds, blues, purples and browns is arrayed against a green-blue gradation in the landscape which brings to mind Lucas van Valckenborgh and his Flemish successors more than anything Dutch. It may be considered symbolic that as early as 1630, Saftleven had finished or re-touched a painting done by Lucas van Valckenborgh in 1582 (Venice, no. 369).

I shall not accompany Dutch painters to any of the other European countries because it seems to me that in their interpretations of these foreign scenes they did not add significantly to what has already been surveyed in the previous paragraphs. The British vistas by Claude de Jongh, Hendrick Danckerts, Thomas and Jan Wijck, Jan Griffier, Jan Vorsterman and others are topographically and artistically competent but of scant originality; they have been adequately if not exhaustively studied in recent publications.[8] French scenery was usually seen with Italianate eyes by Italianate artists;[9] Spain was hardly ever visited; Jan Hackaert's many Swiss drawings[10] were not matched by any paintings which would convey characteristics of the Swiss scene; and even the Southern Netherlandish scene was very rarely repre-sented by Dutch artists.[11] Oriental views, including a kind of *chinoiserie*,[12] occur sporadically but, except for topographically interesting drawings, all that the artists were anxious to achieve was an oriental flavour added to otherwise fully Italianate harbour scenes.[13] Cornelis Vroom's early painting with a mixture of Roman ruins, orientalizing figures and Dutch trees is an amusing oddity.[14]

The situation is different with regard to Frans Post's celebrated views from Brazil.[15] The brother of the remarkable architect-painter Pieter Post (see p. 38), Frans was born in Leiden about 1612, accompanied Prince Maurits of Nassau to Brazil (1637–44) and upon his return settled in Haarlem, where he flourished greatly and died in 1680. North-eastern Brazil had been taken from the Portuguese by the Dutch in 1630 but had to be returned to its former owners in 1654; the comprehensive exploration of the territory by Prince Maurits's scientific staff during the short Dutch tenure was a magnificent achievement.

Frans Post must have made a large number of drawings on the spot, of which only

a pitifully small part seems to have been preserved;[16] of the paintings, which he continued to produce after those drawings for a long time after his return, the fine piece of 1649 in Munich (no. 1560; fig. 343) may be singled out to advantage because it combines a compositional pattern characteristic of much of Post's production with that particular sharpness and shininess of detail which has reminded several observers of Henri Rousseau, and which was carried to fascinating extremes in some of his more unusual works.[17] Other, more intimate paintings strangely anticipate the North-American romanticism of George Caleb Bingham.[18]

The stylistic background of the picture in Munich, which was painted five years after Post's return from Brazil, must be looked for in the early works of his brother Pieter, which were mentioned in our chapter on the Panorama.[19] Some of these, painted as early as 1631, show quite the same type of 'one wing panorama' as that which we have before us. But the old bottle has indeed been filled with new wine; there are the exciting tropical trees, plants and flowers, rendered with a precision worthy of Post's travel companion Albert Eckhout,[20] and the wonderfully painted ant-eater in the foreground (the companion piece has a no less engaging armadillo in its place), the natives carrying their loads in the middle distance, houses and fortifications in the background hills. The ground is still – or again –[21] stratified into green, blue-green and blue zones, in continuation – or revival – of the old Flemish pattern, but infinitely more subtle in execution and more cleverly utilized in the service of creating an impression of vast, 'real' distances. Few of Post's many later variations on this and similar themes can vie with the two Munich pictures in freshness, precision and elegance.

It is interesting to watch other familiar patterns of composition appear in Post's painted adaptations of Brazilian scenes. The structure of a painting of 1652 in Mainz (no. 193; fig. 344) emulates the type encountered in Cornelis Vroom's *River Landscape* in Karlsruhe (fig. 110); in fact, there exists a kinship between Post and Vroom in their predilection for clear, sparkling, precise pictorial language as well. The same picture furnishes a good example of the free treatment of topographic details which was found to be so characteristic of many views of Dutch scenery; exactly the same hacienda is depicted on a painting in Schwerin,[22] undoubtedly from the same drawing, but the landscape setting is entirely different, and to conform with it, the structure of the mansion has been significantly altered in one, if not both, of the two paintings.

PART THREE

NOCTURNES

CHAPTER X

Nocturnes

P AINTINGS of nocturnal landscapes were a good deal more frequent in the seventeenth century than most observers have realized. It is true that Aert van der Neer was the only specialist in this field and that the poetry of a moonlit landscape has never been more sincerely felt, more acutely observed and more beautifully expressed in painting than in some of his works, with the exception of isolated examples by Rembrandt, Rubens, Brouwer and perhaps a few artists of the Romantic period. But I hope to show in this chapter that some of van der Neer's Dutch elders and contemporaries made contributions to this field which are worthy of our attention, the more so as several of them differ significantly from his in content and style.

That the early history of this province of painting is indissolubly connected with subjects from the Bible will surprise no one. The greatest anticipations of what the seventeenth century was to accomplish are found – and this was again to be expected, judging from what happened in winter landscape painting – in fifteenth-century book illumination. In one of Jan van Eyck's lost Turin miniatures the occasion was the *Betrayal of Christ*; the result was an evening sky and a glistening reflection of the torchlights on the soldiers' armour which are peerless – the first 'nocturne positive'.[1] Compared with this, the earlier achievements of Taddeo Gaddi (*Annunciation to the Shepherds*, Baroncelli Chapel of Santa Croce, Florence), of the Limburg Brothers (*Gethsemane*, Heures de Chantilly), and even the slightly later one of Gentile da Fabriano (*Nativity* predella of the Uffizi Altarpiece) look somewhat timid and tentative. During the later fifteenth century, one work stands out because of its intense interpretation of early morning *Stimmung* as well as its iconographical originality: the representation of *Cuer reading the text on the magic well at sunrise* in King René's *Livre du Cuer d'Amour Espris* (ca. 1460–70, Vienna) with its wonderful, spacious forest glade; yet one must not forget to mention the background in Geertgen's London *Nativity*, in which Gaddi's promise was gloriously fulfilled.

There is very little in sixteenth-century nocturnal painting that demands closer attention in the context of landscape painting. There are, of course, the extraordinary achievements of Albrecht Altdorfer; but these stand outside all main currents. Moonlight fills the background of some biblical paintings of the century with magic light, beginning with Gossaert's amazing *Christ on the Mount of Olives* (Berlin). On the other hand, the moonlit landscape by Cornelis Massys (1543, Berlin), which serves as scenery for the (unexplained) amorous antics of the women escaping from a peasant cart in the foreground, is not much more than a daylight landscape plus a nice nocturnal sky; and the setting sun in Bruegel's *Census in Bethlehem* (1566, Brussels) could be overlooked with equal impunity. More impressive is the weird evening

173

atmosphere permeating the catastrophe-filled background of Bruegel's *Triumph of Death* in Madrid; the road from here to Rubens and Brouwer is not so very long.

The importance of freshly interpreted nocturnal subject matter for late sixteenth- and early seventeenth-century landscape painting can be illustrated by a number of Flemish representations of the *Burning of Troy* (Schoubroeck, Gillis and Frederick van Valckenborgh, Kerstiaen de Keuninck), and of the *Rape of Helen* (Gillis van Valckenborch). Greater originality characterizes the persuasive and pervasive romanti- cism of a landscape by de Keuninck[2] – in which a rising moon, partly hidden by trees, is brilliantly reflected in a pond and sheds a glittering light on the sky and on nearby castle, church and trees – and Ambrose Dubois's moonlit *Aethiopica* scenes in Fon- tainebleau.[3] Both of these artists were entirely independent of Elsheimer.

There can be little doubt that essentially the origins of the Dutch Night-Landscape can be traced back to Adam Elsheimer. Although the other facets of Elsheimer's influence on Dutch landscape painting seem to have been somewhat over-empha- sized, the originality of the master from Frankfurt and Rome in this particular field stands recognized by the greatest artists of the mature phases of the Baroque, including Rubens and Rembrandt. But here as elsewhere, Dutch masters quickly adapted pre- vious achievements to serve their new purposes, and ten years after Elsheimer's disciple, Hendrick Goudt, had made his master's work known to all Netherlandish artists through his devoted labour as a reproductive engraver, Dutch masters pursued their own paths in this area in a robust, rather unromantic and certainly un-Els- heimerian fashion. It took the poetical imagination of Rembrandt, Aert van der Neer and Aelbert Cuyp (all in the 1640's and after) to create works comparable in poetic content with those by Elsheimer.

Between 1610 and 1613, Goudt engraved some of Elsheimer's indoor and outdoor night scenes: *Philemon and Baucis* (1612), *The Derision of Ceres* (1610) and *The Flight into Egypt* (1613; fig. 345); in the latter alone the landscape is of decisive importance. To this stroke of genius Rubens responded in 1614 with a magnificent variation (Kassel), in which the reflection of the moonlight in the water was significantly preserved.[4] It was this work of Elsheimer, too, that Rembrandt was to remember so vividly in 1647 (Dublin; fig. 353). True, it would be wrong to hold Goudt solely responsible for introducing nocturnal features into Dutch landscape art; late Mannerist prints yield many examples of it, and the strong influence of the Bassani produced painted representations of the *Nativity* as night scenes even before the main wave of Caravaggism reached the Dutch shores.[5] But the idea of turning to night, and particu- larly to moonlight, without predominant emphasis on religious or mythological sub- jects, but as an inspiration primarily derived from nature as an important realm of its own, certainly originated with Elsheimer.

As indicated, a true continuation of Elsheimer's poetic trend was not immediately attempted. Rather, the Dutch artists started with a characteristic mixture of allegory and *genre*. Jan van de Velde's etching after Willem Buytewech's *Ignis* (fig. 346) is part

of a series of compositions representing the *Four Elements*; Buytewech's drawing shows the subject in broad daylight but was transformed into a night scene by van de Velde by blending it with the nocturnal landscape of Elsheimer's *Flight into Egypt* (fig. 345).[6] Jan van de Velde's own, equally diverting *Sorceress* of 1626 (v.d.K. 114) produces a variety of somewhat Bosch-like, but on the whole rather amiable, monsters (including one smoking a pipe) out of a fire burning in a peaceful neighbourhood, in a scene more *genre*-like than mythological in mood. But by this time, two painters had already availed themselves of the new and exciting light-effects which they had eagerly culled from Goudt's Elsheimer pieces; and they are painters familiar to us from their precocious exploits in other fields: Esajas van de Velde and Pieter Molijn.

As early as 1620, Esajas van de Velde painted a *Plundering of a Village* (a subject represented by him with such distressing frequency) as a night scene (Copenhagen, no. 735; fig. 347), in which the light is provided by a burning house, some candle or lamp light shining through windows, and a half moon (not a full moon half hidden as often used later but a regular half moon, a *rara avis* in Dutch painting).[7] The light of the burning house is sharply reflected on some people, particularly a horseman in armour, but one must confess that this effect is a rather auxiliary one, and the modelling of most of the figures has been carried out entirely according to a day-light pattern. However, this has changed noticeably in the *Battle Scene* of 1623 in Rotterdam (no. 1890; fig. 348). In this picture, in which a burning tent has become the only source of light, the entire group of attacking armoured cavalry on the right is rendered as a dark mass differentiated only by sharp highlights intimating the visored heads of soldiers and the furious aggressiveness of the horses; even the forms of the foot soldiers on the left are more strongly affected by the artificial light than in the picture of 1620. The splendidly highlighted tree on the right is a very precocious harbinger of effects not utilized more fully until several decades later.

In sharpest contrast to the lugubrious subjects of Esajas van de Velde's night scenes stand those of Pieter Molijn. To him, nocturnal scenes are scenes of fun. Already Gillis Coignet, a Flemish emigrant to Holland, whose nightpieces van Mander expressly extolled,[8] had represented a highly amusing scene in a drawing for a lottery in favour of the rebuilding of the 'Dolhuis' in 1592;[9] Vinckboons did a similar piece in 1603.[10] Some time in the twenties, Jan van de Velde etched after Molijn's drawings representations of children making the round of the town with the Christmas Star, and begging and dancing to the music of the *rommelpot* at night.[11] These, too, are city scenes, with the Christmas Star and lanterns providing the main illumination, but a fine moonlit or starlit sky above the houses adds considerably to their charm. The same may be said of Molijn's painting of 1625 in Brussels (no. 314; fig. 349),[12] a crowded *genre* scene with lots of children and a complex display of two main light sources, but with a very suggestive landscape touch in the distant houses and the night sky above them – after all, Molijn was to become one of Holland's most progressive landscape painters a year or so after he finished this painting (fig. 24). Some other

important landscape painters made an occasional contribution to the nocturnal scene at this early phase, including Simon de Vlieger, who painted a *Burning of Carthage* as early as 1631;[13] his composition can at once be distinguished from the many Flemish pictures of the *Burning of Troy* by its low horizon, the lack of foreground figures (in this it also differs strongly from Elsheimer's representation of that story) and subtler effects of reflection.

The combination of *genre* and landscape which is characteristic of most of these early works was continued for a considerable period. In a general way, one can sense an Elsheimer background in a fascinating representation of *Crab Fishing by Moonlight*, dated 1645, by Berchem (fig. 352),[14] but it is almost as far removed from Elsheimer's idyllic mood as it is from that of Rembrandt and van der Neer, and was doubtless directly inspired by a similar nocturnal scene painted by Pieter van Laer (Palazzo Spada, Rome);[15] iconographically, it may well hark back to calendar illustrations in which night fishing occasionally occurs as a typical *March* occupation.[16] As the blinding torchlight is reflected in the water and lights up the fishermen and the party of onlookers, a carefully composed foreground group is established; this is set off against a fine foil of rocks and trees submerged in deep shadows, and in turn closed off against a steel-grey sky with a full moon illuminating some light clouds and a small section of the distant landscape. The dark vivid colours of the figures (a great variety of warm and cool browns and some blue, green and red touches) clearly point back to van Laer. In Jan Asselijn's picture in Copenhagen (no. 9; fig. 351), which is a little later than Berchem's, the meticulous modelling of the figures has disappeared together with the solid composition of the foreground; the story has been subordinated to the landscape; everything looks freer, lighter, ostensibly more casual in grouping and brushstroke; the reflections are entered with a sparse touch; the clouds, lighted from below, have the fluffiness of Elsheimer's finest. The mature phase of night painting has begun; it is the phase of painted poetry, with nature, 'seen through a temperament', predominating over all specific subject matter.

The first climax of this new poetic trend was reached in 1647 – two years after the work by Berchem, and possibly in the same year as that by Asselijn. I am speaking of Rembrandt's incomparable *Rest on the Flight into Egypt* in Dublin (Br. 576; fig. 353). It has the same twofold uniqueness as the master's winter landscape of the previous year (fig. 178): it is unique within his own œuvre and unique in the history of all painting. True, it has always rightly been assumed that Elsheimer's *Flight into Egypt*, which had inspired Rubens in 1614 and which was undoubtedly known to Rembrandt, though probably through Goudt's engraving only (fig. 345), moved him to paint this picture; but the mysterious way in which trees, rocks, ruins, moonlight and sky are miraculously woven together, and the deeply touching and highly original synthesis of a *Rest on the Flight* and what really amounts to a reminiscence of the *Adoration of the Shepherds* have only a slight precedent in Elsheimer's work. The twofold light source does occur with him, and with Berchem and Asselijn as well (figs. 352, 351),

but none of these made more than a tentative step in the direction of Rembrandt's colouristic unity, in which the dark browns, grey, and dull greens of the landscape blend to perfection with the warm orange of the fire and the muted red-brown and grey in the figures. It may be appropriate to point out at once that the colouristic structure of this picture has nothing whatever to do with the 'coloured light' of Aert van der Neer's mature works; it belongs to a fairy-tale world which is just as far removed from optical realities as the content of the picture is from everyday life.

Night effects in Dutch landscape painting are invariably linked with the name of Aert van der Neer, and this is undoubtedly justified, not only in terms of quantity but also, to a considerable extent, of quality. The master's beginnings, which have been touched upon in previous chapters, foreshadow this development in some respects; but it is interesting to see that when he painted his first night picture properly speaking, van der Neer was already forty years old and had contributed to several other provinces of landscape painting.

Van der Neer's earliest moonlight scene is dated 1643; I shall return to it in a moment. Even the picture of the 1630's in Frankfurt, however (fig. 105), has a suggestion of evening atmosphere, and the wonderful *Mountain Lake* in the Lugt Collection (fig. 271) has a pearly evening sky which points to the mature achievements of the late forties and early fifties. But this is of lesser importance here in comparison with the extraordinary group of harbour paintings in upright format which van der Neer painted between 1644 and 1646. Whether these were inspired by some unusually precocious marine paintings with a rising moon such as the lovely, still basically tonal (brown – light grey) panel of 1643 by van Goyen in Strasbourg (HdG 1068; fig. 350),[17] is hard to tell, but it is noteworthy that van der Neer did begin exploring evening and night effects in pictures with a distinct accent on sailing-boats. The earliest, of 1644 (HdG 589), highly praised by Bode,[18] is known to me from a lithograph only. Its general aspect is less nocturnal than in the painting of the former Hölscher-Stumpf Collection (HdG 165), dated 1645, in which the rising moon, half hidden behind clouds, fully illumines the high sky; and in the amazing *Marine* of 1646 in the collection of the late N. Argenti (HdG 595?; fig. 354), a new peak of luminosity has been reached which, coupled with the device of the road-like reflection of the moon on the water, closely approaches the ultimate of what van der Neer was to accomplish in this field.[19]

His series of river landscapes with wooded banks and moonlight effects is a long one; it is the type of picture which comes first to mind when the name of van der Neer is mentioned. The earliest date occurring on any of these is 1643 (Gotha Museum, HdG 36; fig. 356).[20] The large picture contains all the characteristic ingredients of the group but the trees are still reminiscent of the early Frankfurt picture (fig. 105) and, with that, of van der Neer's indebtedness to Keirincx (see fig. 134), and there is a certain 'additiveness' in this picture which was soon to make way for a greater comprehensiveness of vision and a more unified composition. This is already noticeable in 1645 (HdG 382) and even more so in 1646, the year of the Argenti *Marine* (fig. 354); witness a

beautiful painting once in Mr. Mensing's Collection (HdG 175) of which a very close variation exists in Schwerin (HdG 296), also dated 1646. This is the last year in which van der Neer frequently dated his pictures; only a very occasional one is found later on. But by that time his art had reached full maturity (fig. 357).

The extraordinary importance of his style during its apogee – from *ca.* 1646 to *ca.* 1658 – has been well elucidated in a short essay by Hans Kauffmann.[21] In so far as the essence of the new concept is 'coloured light', van der Neer's nocturnes represent but another aspect of a development already found to be characteristic of other works of the middle of the century, particularly in paintings by Aelbert Cuyp, Jan van de Cappelle and in winter scenes by van der Neer himself. However, the case of the nocturnal setting is unique to the extent that local colours are minimized by near-darkness and that the light of the setting sun or the moon is used to emphasize distribution of reflected and dispersed light over a basically monochrome (brown-grey) area. In this respect, van der Neer's mature style allowed for a continuation of elements from his previous tonal period rather than necessitating a break with them, as was the case with Cuyp.

But the contrast between his early and mature works is nevertheless considerable. The monochrome element in the latter is but one phenomenon, not the phenomenon; in fact, it is a minor one. First of all, the light effect which gives them distinction (setting sun, moon) does form a conspicuous contrast with the monochrome area; it commands our attention at once and focuses it at the same time upon an adjacent area of the sky and of the ground surface, usually a body of water. The all-pervading quality of light is, however, not slighted. This was achieved partly by reflections on the bodies of men and animals as well as on buildings and trees. In relatively earlier works in the fully developed style, such as the beautiful picture in Amsterdam (from the Six Collection, HdG 155; fig. 357) these reflections are partly rendered by a system of 'light-lines' taking the place of the traditional contours, comparable with what we have observed in van de Cappelle's beach scene (fig. 212);[22] later they are usually applied in a more casual, spotty impasto fashion, as in the superb upright picture in London (HdG 47; fig. 355).

The dispersive treatment of the light – which plays only a minor role in other seventeenth-century landscapes, except perhaps in some of van der Neer's own winter landscapes – is of course concentrated on the areas near the source of light itself. Very enlightening is the deliberate – and certainly somewhat arbitrary – contrast between warm and cool light and their behaviour under conditions of dispersion in the pair of *Evening* and *Morning* (a rare subject with van der Neer; probably late 1640's) in the Mauritshuis (HdG 53, 54; figs. 358-359). The clouds, and their reflection in the water near a sunset (fig. 358) glory in the red and orange and only 'admit' the yellow, blue and purple; those near the moon (fig. 359) glory in the yellow, blue and purple and only 'admit' the red and orange.[23] But even beyond these glowing areas the coloured quality of the light remains effective; it spreads over the entire picture, vying with the

reflective touches and the basic monochromatic tendencies, and imparting some colour nuances to objects of different local colour. The all-pervading quality of van der Neer's light is thus firmly supported by its dispersive as well as its reflective properties.

As Kauffmann has pointed out, 'coloured light' had already been discovered and utilized in Rubens's landscapes of the 1630's.[24] He has also suggested that van der Neer must have been influenced by Rubens either directly or by way of Jan Lievens. Mention of the latter makes it imperative to consider, however briefly, the role of Adriaen Brouwer in this hypothetical interplay between Flemish and Dutch masters.

All of Rubens's decisive works in this field were done in the thirties. Adriaen Brouwer, who had witnessed the emergence of Molijn as a painter of night scenes (fig. 349) when a resident of Haarlem in the twenties, can be assumed to have painted his between *ca.* 1633 and 1637, and it is reasonable to think of the relationship between him and Rubens as one of give and take.[25] Rubens owned a Brouwer 'landschap bij maneschijn'; it appears in his estate. Their works have even been confused.[26] Both of them probed deeply into the possibilities of expressing the poetic mood of a moonlit landscape; and while Rubens went much farther in eliminating the human interest – at least three of his nocturnal landscapes have no human figures in them at all[27] – even Brouwer's *genre* leanings were here largely subordinated to nature's magic.

This is not the place to discuss in detail the differences between the night landscapes of Rubens and Brouwer. One brief juxtaposition must suffice. It is immediately apparent that Brouwer's *Dunes in Moonlight* in Berlin (fig. 360; possibly the very piece Rubens owned) is based on a less profound observation of optical phenomena than Rubens's *Landscape by Moonlight* in Count Seilern's Collection (fig. 361).[28] With all its stunning spontaneity of brushstroke, Brouwer's work makes the impression that its well-defined local colours in the figures and its essentially graphic treatment of the trees are in the last analysis independent of the phenomenon in the sky. In Rubens's work, the dispersed moonlight penetrates into the most remote corners of the landscape and changes the appearance of every tree trunk, every leaf, and every drop of water by impregnating them with unexpected colours; and this also lends an impression of much greater spaciousness to the entire scene. Kauffmann has emphasized that Rubens did not go so far as did the Dutch artists in eliminating the local colours of objects;[29] this does apply to some of Rubens's landscapes but is much more true of those of Brouwer.

It is true that Jan Lievens is the logical candidate for the role of a mediator between this Flemish achievement of the thirties and Holland. That he is the author of some of the most celebrated 'Brouwer' nocturnes has been firmly established by Hans Schneider.[30] He became a member of the Antwerp guild in 1635 and a citizen of the Scheldt city in 1640; these are the years of the high tide of the activities of Rubens and Brouwer as painters of night landscapes. By 1644 Lievens was back in Amsterdam. His knowledge and experience of the new type of nocturne painting, which is amply

demonstrated by the imposing picture in the Collection of the Duke of Westminster (Sch. 301) and the more intimate ones in Berlin (Sch. 300) and in the Lugt Collection (Sch. 308; fig. 362) may indeed have served as a catalyst for Dutch works of this kind; although there are no moonlight scenes among them they do represent the new poetic trend toward painting nature 'going to rest' which became so important in Holland during the forties. On the other hand, Lievens's works show almost the same limitations with regard to the observation of 'coloured light' as do those of Brouwer, and for this reason I find it hard to believe that van der Neer's specific interest and accomplishment in that field could have been inspired by him.

Moreover, van der Neer's first night pieces, painted in Amsterdam almost exactly at the time of Lievens's return to that city, do not show a strong Flemish touch; we recall that they are either seascapes (fig. 354), to which van Goyen may have contributed more than Rubens, or are still strongly connected with van der Neer's style of the thirties (fig. 356). But beginning in 1646, with the characteristic van der Neer compositions of that year, the memory of Rubens's work is inevitably evoked. Rubens's picture in Count Seilern's Collection (fig. 361), while of greater imaginative power and profundity of mood than anything van der Neer ever accomplished, leads us much closer to some of the latter's finest works than any Dutch pictures of the preceding generation or any painting by Lievens. In some works of van der Neer, not only the interpretation of the sky and atmosphere but even the style of the figures and animals seem to be based on Rubens, clearly more so than on Brouwer or Lievens; a very good example of this is the fine *Sunset* in the van der Vorm Collection in Rotterdam, in which van der Neer utilized a rare mountainous panoramic effect and which we have discussed in connection with the Imaginary Scene (fig. 272). Even some of his winter landscapes seem to show signs of the impact of this new vision.

That van der Neer's output after his financial debacle and a probable period of inactivity (1658–1662) shows a pronounced decline has already been demonstrated with regard to his winter landscapes. Although not a single dated night scene is available for the entire period between 1662 and 1677,[31] marked differences between the works dated in the late forties (and datable in the early fifties) and a group with harsher and clumsier effects again suggests that the latter belongs in the terminal phase of the artist's career, the more so as details of costume sometimes point to the same conclusion (Louvre, no. 2484; HdG 250). A strong Flemish touch continues into this late period as is evident from a large picture in Buckingham Palace (HdG 51), which in addition to a classical gateway contains figures which are reminiscent of Jan Brueghel almost as much as of Rubens. In other works of the late period one can find a distinct leaning toward the work of some of the Italianate painters such as Both and Pijnacker;[32] old-fashioned two-wing compositions are occasionally revived.

It will have been noticed that none of van der Neer's once famous nocturnes with burning towns have so far been mentioned; Hofstede de Groot lists about fifty of these,[33] roughly one-half of which were known to him, including two which show

such conflagrations in winter time. None of these works is dated. In some of them, the burning houses look almost like an afterthought, and the moonlight is really in full command (HdG 472); in others the bright flames are almost the only sources of light, heavy smoke having obscured the sky (HdG 474, 476). It is fairly safe to assume that the latter, including the winter scenes of this kind, belong to the artist's late period and that none of the entire group antedates the early fifties. With few exceptions, among which the brilliant sketch in Brussels (HdG 452; fig. 363) deserves special mention, they add little to van der Neer's stature. Finer (and possibly earlier) is the combination of moonlight and artificial light in the rather unique *Caulking of a Ship* in Schwerin,[34] which foreshadows effects exploited by Turner. The ancestry of this group can be sought among the paintings depicting the *Burning of Troy* in the tradition of Elsheimer and Schoubroeck; their progeny consists of some paintings by Rafael Camphuysen,[35] Anthonie van Borssom,[36] Frans de Momper[37] and a group of rather uninspired works by Egbert van der Poel. The latter range in date from 1658 to 1663,[38] and some of them recall Esajas van de Velde's *Battle* of 1623 (fig. 348), the more so as, in contrast to van der Neer, the conflagrations are here usually represented close to the picture plane, and emphasis is also placed on the reflection they throw on large crowds. Van der Poel's earliest dated picture with a night effect, the one of 1654 in Bonn (no. 38.2; fig. 364), differs from the rest in that it represents a fireworks display in a Delft street – a charming painting in upright format which clearly derives from Molijn's nocturnal *genre* scenes (fig. 349).[39] Fate favoured some of the late-comers in this field by offering them the spectacle and the lucrative reportage of the *London Fire* of 1666.[40]

A handful of nocturnal seascapes by Aelbert Cuyp form a group which is hardly comparable with anything we have considered so far, with the possible exception of the van Goyen of 1643 in Strasbourg (fig. 350) and the earliest van der Neers of 1644–1646 (fig. 354). They seem to have been painted at various phases of Cuyp's career and are in urgent need of more careful investigation than they have been accorded (and can be accorded here, partly for lack of personal inspection). It is clear that the three most famous large paintings of this kind, those in Leningrad (HdG 725), in Cologne (HdG 720) and in the Six Collection in Amsterdam (HdG 719), cannot have been painted at the same time. The signed picture in Leningrad (fig. 365) must be relatively early (*ca.* 1648?); it is not so far removed from van Goyen's seascape in Strasbourg (fig. 350). Even the painting in Cologne (fig. 366), which one is tempted to date later on account of its considerably firmer structure and stronger contours, can hardly have been done after 1650; it is practically all grey over a vibrating brown, with silvery highlights in various degrees of impasto, and grey-brown figures. The utterly romantic picture once at Goudstikker's (HdG 728) is quite similar and may not date much later. But the celebrated and often reproduced picture in the Six Collection differs decisively from these two. If the traditional attribution of this unsigned work, first recorded in 1785, is correct, Cuyp must here have been deeply influenced by

painters of the Italianate trend; but this work is disturbingly different from his well-known paintings which lean toward this trend.

How far removed are we here from Cuyp's *Evening Landscape* in the Brediushuis in The Hague (HdG 690; fig. 369)! There is nothing pointedly romantic, nothing deliberately structured here; instead, this canvas – which may have been done as early as the late forties – illustrates one of the most intimate facets of the history of nocturnes. The motif, with the round buildings in front of distant hills, is somewhat Italianate; it recalls Claude Lorrain, and also Jan Both, to whom the undergrowth in the foreground points in particular. But the trees, the shepherds and the cow are Dutch – in fact, the solitary group of trees leads us back to Rembrandt's etching of 1643 and Ruisdael's paraphrase of it (fig. 61). However, the mood is idyllic the sunset peaceful, and the symphony of olive-green, brown, some grey and light ochre is ennobled by a fine luminosity which was achieved with methods reminiscent of the artist's own *View of Nijmegen* (fig. 102): dull-coloured glazes with thin impasto highlights in forms of lines and little flecks, together with suggestions of all-pervading 'coloured light'.[41]

The final burst of fireworks is provided by the best virtuoso effort of a minor master, Lieve Verschuier of Rotterdam (*ca.* 1630–86),[42] whose Dutch marines are hardly very distinguished (though easily distinguishable by their cardiogram-like waves). His two small panels in Rotterdam (nos. 1903-1904; figs. 367-368) are all the more surprising. They show little kinship with his average output, except for the strong red nuance which now takes over more boldly. Both show an Italian coast scene, one at dawn, the other at nightfall; in the latter respect, they are in the tradition of van der Neer's pair in the Mauritshuis (figs. 358-359). Their compositions are entirely eclectic: the *Morning* is a variation on Zeeman, the *Evening* on Claude. Even the effect of the sun bursting forth is clearly derived from van der Neer (fig. 354). Yet with their spontaneous brushstroke and daring juxtaposition of red, brown, yellow and grey flecks, and in their bold but sensitive differentiation between quiet, slow forms for evening composure, and alert, quick forms for morning activity, these two brilliant sketches form a more satisfactory coda to this chapter than that available for some others.[43]

EPILOGUE

I HAVE called this last (and short) chapter an epilogue because I feel that it would be presumptuous to attempt a conclusion or even a summary; both would require more abstracting than I am competent and willing to do. If one of the tentative justifications for the organization of this book was that it might help to avoid the semblance of a straitjacket there would be no use in applying that garment now. 'History tempts reason with a lure of order';[1] the crux of that lure is of course that it is impossible to define the borderline between discovering and constructing that order. It is bad enough that as we try to cover a field as large as this we have to cover up so much in order to discover something worth while at all.

In justifying my profound scepticism with regard to attempts to see the development of Dutch landscape painting as a kind of self-realization of certain highly comprehensive concepts, and in particular the concept of space, I cannot rely entirely on the complete silence of contemporary sources; it is obvious that one cannot refute such theories by pointing to the fact that the carriers of a development were not aware of their role. Rather, I should have to prove that such speculation is simply not compatible with the facts. This obligation I cannot discharge here in full, but a few suggestions may be in order.

That which has been shown to be a tendency of many masters throughout the century:[2] their participation in a development starting with multifarious elements in composition, proceeding to unifying elements in composition and ending with a new emphasis on more complex but characteristically firm structure, is not a development of space – as a three-dimensional phenomenon – but of picture plane organization. Now it is obvious that every painting of the seventeenth century is a compromise between picture plane organization and ostensible space as it is represented in the painting. Freedom and ability to suggest great open spaces was of course an important goal of the Dutch landscape painters. But it seems to me that attempts to make the conception of space the criterion of a personal style or the style of an entire generation or period have greatly suffered from the failure to co-ordinate the investigation of this special problem with that of the paramount one of two-dimensional organization, that is, the criterion that alone decides the rhythmic structure and therefore the artistic essence of a painting.[3] Three-dimensional space, in other words, is much more clearly related to subject matter than to organization; it therefore has an iconography of its own which, while it has a strong bearing on form, must not be confused with it.

If I am not entirely mistaken, the conquest of space was an accomplished fact in Goltzius's drawings of 1603 and in the paintings of Seghers and van Goyen in 1630–1640; thus it cannot possibly be considered the main object of a stylistic development throughout the century. As to the elements which have been adduced over and over again as steps toward the accomplishment of that goal, such as roads winding their way into the picture, parallel strata, depth-producing diagonals etc., these are mainly

important as means of organizing the picture plane rather than producing ostensible depth; although they are of course derived from visual experience in space, they have been translated into two-dimensional pictorial organization from the very outset. For the artist they never existed outside the flat paper or the flat panel; and the scientist had no part in this transformation. It has been shown that perspective in seventeenth-century landscape painting is a complex affair,[4] but the complexity is not due to different theories; it is a complexity of empirical approaches undertaken with complete freedom from any rules, and during all phases of the century.

What may occasionally look like a gradual development of unlimited space throughout the seventeenth century is in reality a development of ever more sophisticated pictorial means, colouristic as well as compositional, which were used by the artist in order to render more convincing – or simply more interesting – what had been seen and experienced for a long time. But this was not done according to a fixed plan aiming at producing more and more complete expansion of space. During the period of tonality, unlimited space was intimated through a particularly subtle observation of aerial perspective, thus by minimizing forms on the horizon; later, in Ruisdael's 'Haerlempjes', unlimited space was achieved by a method of focusing attention on the horizon, together with a special emphasis on the spectator's distance and elevated standpoint, on mighty cloud formations echoing the layout on the ground, and so on; both may or may not employ roads leading into depth, diagonals or parallel strata.

In Ruisdael's forest scenes, a complex fluctuation of now more, now less spacious vistas has been observed (and where it has been denied, the 'boa constructor' seems to have been at work); comparing these works with his winter scenes and beaches, his seascapes and waterfalls, one would be extremely hard put to it to demonstrate a logical development of the artist's handling of space in all of these subjects. But it is hoped that within each subject group, his struggle with basic problems of composition has emerged as a decisive feature of his art.

The various pictorial means which had to be combined in many complex ways in order to produce the general development from the multiple via the tonal to the structural phase, can result in exceptional phenomena if the mixing is itself exceptional. Normally, the new structural phase employed recrudescent local colours; but occasionally, a more tonal treatment occurs in such a work, and the result is an 'exception'. Subject matter has a good deal to do with this; it is primarily in seascapes that this kind of exception occurs, and the reason for this is obvious. By the same token, the tonal phase normally eliminated local hues in the figures as well as in the landscape itself; but occasionally, more sharply defined local hues occur in such a work, and the result is an 'exception'; that this happens mostly in winter scenes is equally understandable. It is important to state that these cases are by no means restricted to *retardataires*. They are exceptions within the main stream, and they prove that subject matter is indeed of paramount importance here. Tonal forest scenes are rare;[5] there are no tonal night scenes proper and no tonal Italianate scenes to speak of.

Among the pictorial means we do find some completely new ones, and these were the result of new optical discoveries actually unavailable to artists before about 1645 or so. Efforts to connect these new observations with the scientific discoveries made during that period have so far led to no palpable results, at least with regard to documentary proof. But the discoveries themselves were of decisive importance, and I have tried to emphasize this in my presentation of the art of Cuyp, van de Cappelle and van der Neer. This had to be done in several chapters and may therefore have failed to emerge as clearly as it deserves. But the chapters in which these demonstrations occur were not selected at random. The new optical discoveries have to do with light[6] and its relationship to colour. It is therefore not accidental that they shone in all their glory in subjects in which light appears in unusual circumstances which encourage experimentation with a brush directed by a new sensitivity to optical effects: sunlight affected by moisture near the river (Cuyp) or the sea (van de Cappelle), by wintry sky and snowy ground (van der Neer, van de Cappelle), by southern evening skies (Both, Cuyp), and moonlight contrasted with nocturnal darkness (van der Neer, Cuyp). Here, the middle of the century marks the beginning of a new era, a change of much greater significance than were variations in spatial conception. No wonder the early Cuyp hardly presaged the mature Cuyp; no wonder a seascape by van de Cappelle seems to come from a mould which differs radically from that of the contemporary works by van Goyen and Salomon van Ruysdael.

If, then, diversity and wealth of individual solutions count more than any abstract pattern of development (and that includes the three phases I did recognize as a genuine development!) can we still afford to indulge in the old game of tracing a sequence of youth, maturity and decline in Dutch landscape painting of the Golden Age? Strangely enough, this question is not so easy to answer as one would by now be inclined to think.

I believe that it would be foolish to close one's eyes to the relative validity of at least one facet of this comparison, that of decline. As to youth, this will remain a matter of vague metaphorical usage. It is true that an early van Goyen looks exuberantly and even awkwardly youthful when compared with his mature work; but this applies to a work of his actual, individual youth. To call Esajas van de Velde's *Summer* (*ca.* 1612; fig. 16) or *View of Zierikzee* (1618; fig. 93), let alone Goltzius's panoramic drawings of 1603 (figs. 52-54), youthful in the stylistic sense is of no value whatever. Maturity may sound like a good name for the great period from the 1640's to the 1660's but this was also a period of the fresh, daring, youthful investigations and discoveries we have just recapitulated. However, when it comes to the end of the century we are faced with a dilemma. With all due respect to objectivity, who will maintain that the late works of Ruisdael, van der Neer, van der Heyden, even the Italianate painters (although I tried to break a lance for them), in other words: the works painted after *ca.* 1670, equal those from the beginning and the middle of the century in quality – *pace* Hobbema's *Avenue of Middelharnis*? The word that came

to mind again and again in contemplating most of these paintings was exhaustion; and exhaustion is decline of vital faculties, even if (and there is an if here) it turns out to be a temporary decline. There is no denying the fact that a great era was at an end.

The afterglow of this great era came in various stages. While in the eighteenth century the reputation of several masters of the middle of the seventeenth (particularly those of the second generation of Italianate painters, but also others like Ruisdael, Hobbema, Wouwerman, Wijnants) held its own beside that of the representatives of the last decades, it was left to the later nineteenth century to rediscover realistic painters such as van Goyen, Molijn and Salomon van Ruysdael, as well as Hercules Seghers, all of whom had been omitted from John Smith's great *Catalogue raisonné* of 1829–37. Lately, there has been a renewed interest in the Dutch painters of foreign lands (see above, p. 147). Is this the usual game of ups and downs which the strict relativists keep calling an inevitable result of the perennial fickleness of taste? I challenge this view. True, there will always be vacillations and fashions here as elsewhere, but the history of Western Art has by now arrived at a certain frontier; even the former 'Shangri-Las' have been investigated and put on the map, and discoveries of the kind that in the past made possible substantial revisions of the general picture cannot be expected to continue in the future. Whoever has worked his way through the photographic material assembled at the Rijksbureau voor kunsthistorische documentatie, the Frick Art Reference Library, the Courtauld Institute and the Platt Collection, must have realized that Hercules Seghers was the last and final summit discovered in this area. A certain consensus on what is great in such a territory has now been achieved. It takes a perverted view to make summits look like valleys or hills, and it takes a similarly perverted view to make hills and valleys look like summits; there is really little danger that this will happen in serious literature.

Is this situation – which now seems to be in sight even for our younger sister discipline, the History of Music – deplorable? I do not think so; in fact, it contains a great challenge. Only after an area has been mapped out more or less completely can full attention be concentrated on the summits – those that have now been proved to be permanent and unrivalled. And concentrating on the summits is a formidable but indispensable task of the future. We need monographs on Esajas van de Velde, Jan van Goyen, Jan Porcellis, Hercules Seghers, Aelbert Cuyp, Jan van de Cappelle, Aert van der Neer, Jan Both and Philips Wouwerman (a new, English edition of Jakob Rosenberg's admirable book on Jacob van Ruisdael is fortunately being prepared). The kind of bird's-eye view employed in the present book will not help here; you cannot really explore in a helicopter. There will be danger from chasms, storms and avalanches in each of these ascents; but the work must be done.

NOTES

The full titles of books cited in abbreviated form
will be found in the Bibliography on pp. 223-236.

NOTES

INTRODUCTION

1. See, e.g., van Goyen, HdG 364, and Salomon van Ruysdael, St. 70.
2. On this painter see now B. J. A. Renckens in *Oud-Holland*, LXXXI, 1966, pp. 58 f. and 269. The picture, on loan from the 'Dienst voor 's Rijks Verspreide Kunstvoorwerpen', is signed 'J. d Volder 16—'. The prominent colours are brown, lemon-yellow and yellow-green, which points to a date around 1635–40. See also below, p. 201 on B. van Veen. Another aspect of this problem is illustrated by Bredius's remarks on the disappearance of all works by the marine painter Barent C. Kleeneknecht (K. I., p. 348; see also Th-B, 1927) and Sir Lionel Preston's publication of one of these paintings, made without any further reference (*Sea and River Painters of the Netherlands*, London, 1937, fig. 96).
3. S. Gudlaugsson in *Oud Holland*, LXVIII, 1953, p. 182 ff.
4. W. Martin in *Burlington Magazine*, XI, 1907–8, p. 363.
5. H. Gerson in *Oud Holland*, LXIX, 1954, p. 247 ff.
6. W. Stechow in *Oud Holland*, LXXV, 1960, p. 79 ff.
7. W. Stechow in *Festschrift Dr. h.c. Eduard Trautscholdt*, p. 111 ff.
8. A well-known, crucial example of this is the attempt to date Seghers's *View of Rhenen* in Berlin before 1630–31 because it lacks the palace of the 'Winter King', built during those years; see below, p. 36.
9. Just as some older people will prefer old-fashioned clothing in their portraits, conservative painters may put staffage figures clad in antiquated costumes in their pictures. I submit that this is the case in late works by Jan van der Heyden (see below, p. 126), and not only there.
10. How a great art historian can be spectacularly misled by such a formula is demonstrated by Alois Riegl's article on Jacob van Ruisdael (1902; reprinted in *Gesammelte Aufsätze*, Augsburg-Vienna, 1929, p. 133 ff.).
11. Jakob Rosenberg, *Rembrandt*, 1948, p. 166; revised edition, 1964, pp. 280 ff.
12. Jan Bialostocki in *Zeitschrift für Kunstgeschichte*, XXIV, 1961, p. 128 ff.
13. W. Martin, *op. cit.*, p. 363.
14. H. van de Waal, *Jan van Goyen*, p. 56-57.
15. H. Gerson in *Kunsthistorische Mededelingen*, II, 1947, p. 43 ff.
16. See below on Swanevelt (p. 152).
17. The beach scene is remarkably similar to that of Simon de Vlieger of 1643 in the Mauritshuis (no. 558).
18. W. Stechow in *Nederlands Kunsthistorisch Jaarboek*, XI, 1960, p. 165 ff. I take this occasion to correct a grievous error which I committed in that article. The 'Ruisdael' landscape in the *Interior* by Eglon van der Neer in the Boston Museum, discussed there on p. 183, has turned out to be a product of the nineteenth century, painted over a mantelpiece with a nude Venus, Cupid and two amorous doves. (Information kindly provided by Mr. Thomas H. Maytham.)
19. Of the more than 350 known cases of collaboration mentioned from documents by Hanns Floerke, *Studien zur niederländischen Kunst- und Kulturgeschichte*, p. 145, few can be authenticated today from genuine signatures. Examples are: Asselijn and J. B. Weenix (below, p. 160); Keirincx and Poelenburgh (below, p. 199). See also note 24.
20. W. Stechow in *Magazine of Art*, XLVI, 1953, p. 131 ff. (also in *Actes du XVIe congrès international d'histoire de l'art*, The Hague, 1955, p. 425 ff.).
21. C. Hofstede de Groot, *Cat. rais.*, VIII, p. 328.
22. A. Bredius in *Oud Holland*, VI, 1888, p. 21, and in K. I., p. 348. Allaert van Everdingen took an even dimmer view of Porcellis's part in this picture.
23. A fascinating paragraph in this unwritten chapter would be dedicated to Frans Hals; see Seymour Slive, Catalogue of the Frans Hals Exhibition in Haarlem, 1962, passim.
24. G. Gronau in *Berliner Museen*, XLIV, 1923, p. 63; dated 1667 (?). A similar case in the same museum: J. van der Haagen, no. 404 (in which figures had been added later; removed in 1921). The sale catalogue Lord Leigh a.o. in London, April 5, 1963, no. 6, lists a landscape signed by Wijnants in 1661 and by Lingelbach in 1664.
25. It is therefore a vast exaggeration to say that 'for Jacob van Ruisdael the presence of

human beings is a profanation' (M. J. Friedländer, *Landscape, Portrait, Still-Life*. p. 99); for Goethe's opinion on this matter see below, p. 146.

26. Translated from a passage in J. Huizinga's fundamental essay 'Nederland's Beschaving in de Zeventiende Eeuw', *Verzamelde Werken*, Haarlem, 1948, II, p. 480. See also W. Martin in *Monatshefte für Kunstwissenschaft*, I, 2, 1908, p. 752 f.

27. Two other excellent examples (by J. van der Haagen and A. Cuyp) are reproduced in H. E. van Gelder, *Holland by Dutch Artists*, Amsterdam, 1959, figs. 82 and 83. See also W. Martin in *Burlington Magazine*, X, 1906–1907, p. 363 ff., with the valuable proof that the outdoor work included wash drawings.

28. For a possible exception see below, p. 109.

29. Salomon van Ruysdael, St. 13. The church on the right and the house in the foreground are from Utrecht (Cathedral and Huis Groenewoude); the two-tower church in the distance is very similar to St. Walburgis in Arnhem. The same combination occurs on St. 13A. Both Arnhem churches are combined with a close variation on the Bijlhouders Tower in Utrecht in St. 12. Other examples are not hard to find; a variation on the St. Mary Church in Utrecht was even put in an *Italian* landscape by Cuyp (below, p. 162).

30. W. Stechow in *Oud Holland*, LV, 1938, p. 202 ff. See also Hans-Ulrich Beck in *Oud Holland*, LXXII, 1957, p. 241 ff., J. W. Niemeijer in *Oud Holland*, LXXIV, 1959, p. 51 ff., and H. J. J. Scholtens in *Oud Holland*, LXXVII, 1962, p. 1 ff.

31. L. de Pauw-de Veen in *Revue belge de philologie et d'histoire*, XXXIV, 1956, p. 365 ff.

32. Samuel van Hoogstraten, *Inleyding tot de Hooge Schoole der Schilderkonst*, Rotterdam, 1678, p. 123 ff. and 135 ff.

33. Arnoldus Buchelius, '*Res pictoriae*', ed. Hoogewerff and van Regteren Altena, The Hague, 1928.

34. This applies primarily to the occasional remarks of the magnificent Constantijn Huygens; cf. J. A. Worp in *Oud Holland*, IX, 1891, p. 106 ff.; *idem*, 'Fragment eener autobiographie van Constantijn Huygens', *Bijdragen en Mededelingen van het Historisch Genootschap Utrecht*, XVIII, 1897; *idem*, *De Briefwisseling van Constantijn Huygens*, The Hague, 1911–13; A. H. Kan, *De jeugd van Constantijn Huygens door hemzelf beschreven*, Rotterdam-Antwerp, 1946.

35. R. Jacobsen, *Carel van Mander, dichter en prozaschrijver*, Rotterdam, 1906, p. 246. See also the passage quoted by Reznicek, *Die Zeichnungen von Hendrick Goltzius*, p. 213 f. Some passages in the chapter on landscape (VIII) of van Mander's *Grondt der edel vrij Schilderkonst* (Hoecker, *Das Lehrgedicht des Karel van Mander*, p. 196 ff.) also betray a significant departure from Mannerist patterns. See also below, p. 65.

36. Sonnet 'Natuur en Const'; J. A. Alberdingk Thijm, *Gedichten uit de verschillende tijdperken der noord- en zuid-nederlandsche literatuur*, II, Amsterdam, 1852, p. 53.

37. From the *Klucht van de Koe*, written in 1612; quoted by J. G. van Gelder, *Jan van de Velde*, p. 45: 'Hoe flickert de Son met weerlichtend geschimmer / Op die verglaasde daken en op dat nuw getimmer'. See also below p. 84 on Bredero's depiction of winter scenes. Bredero's specific mention of his preference for 'painters who come closest to life' over (brilliantly characterized!) Mannerists has been repeatedly quoted, f.i. by G. Knuttel, *De Nederlandsche Schilderkunst*, p. 204 f. On the other hand, Buytewech's illustration for the first edition of Bredero's *Lucelle* has added allegorical overtones of a more traditional character, see E. Haverkamp Begemann, *Willem Buytewech*, p. 24 f., fig. 23. The mixture of new landscape feeling with conservative attachment to the 'Four Seasons' concept, which we find with some early landscape painters, is paralleled in the song of Grusella in Samuel Coster's Ovidian drama *Itys* (1615; reprinted in J. A. Alberdingk Thijm, *op. cit.*, p. 105), except that winter is not yet the season for skating but of the bad-weather and be-glad-*you*-have-to-eat variety. On H. L. Spieghel (1549–1612) contrasted with Bredero see van Gelder, *op. cit.*, p. 44; but even he has his more 'progressive' moments, as Willem Martin, *De Hollandsche Schilderkunst in de Zeventiende Eeuw*, I, p. 236, and Reznicek, *op. cit.*, p. 212, have emphasized.

38. On this aspect see A. Dohmann in *Revue d'histoire moderne et contemporaine*, V, 1958, p. 265 ff.

39. *Landscape, Portrait, Still-Life*, p. 143; already August Wilhelm von Schlegel had called landscape painting 'den musikalischen Teil der Malerei'.

40. This has already been emphasized by H. van de Waal, *Jan van Goyen*, p. 27.

CHAPTER I

PIONEERS IN DRAWINGS AND PRINTS

1. René van Bastelaer, *Les Estampes de Peter Bruegel l'Ancien*, Brussels, 1908, nos. 3-17.
2. *Ibid.*, nos. 19-69.
3. *Ibid.*, nos. 70-93.
4. Th-B (1912) and *Amtliche Berichte aus den Preussischen Kunstsammlungen*, XXXIV, 1912–1913, p. 223.
5. C. J. C. Bierens de Haan, *L'Œuvre gravé de Cornelis Cort*, The Hague, 1948, p. 217 ff. For dissenting opinions see E. Haverkamp Begemann, *Willem Buytewech*, p. 38 and note 192.
6. Charles de Tolnay, *The Drawings of Pieter Bruegel the Elder*, London, 1952, p. 90, no. A.18.7. I do not think one can speak of this as 'two landscapes by the same hand . . . pasted together'; the composition is well balanced, and the *adjustment* of the left half to the average format of the print is as carefully made as in the case of the halving of the equally convincing unit of the Chatsworth drawing, Tolnay, p. 90, nos. A. 18, 5-6 (*sic*; his no. 5 should read 9).
7. J. G. van Gelder, *Jan van de Velde*; J. Q. van Regteren Altena, *The Drawings of Jacques de Gheyn*, I (vol. II has never been published).
8. *Die Zeichnungen von Hendrick Goltzius*, Utrecht, 1961.
9. Reznicek, *op. cit.*, nos. 397, 402, 410.
10. *Ibid.*, no. 391; first published by J. G. van Gelder, *op. cit.*, fig. 5.
11. The *View of Leiden*, by P. Bast, engraved in 1601 (*Oud Holland*, LXVI, 1951, p. 31) is still basically a topographical affair, related to map-making, although it is a remarkable achievement. In spite of van Mander's enthusiasm, Abraham Bloemaert's early studies are but of 'motifs usable in landscapes'. His landscape drawings proper must be dated rather late (see also Reznicek, *op. cit.*, p. 131); they never abandoned their basically Mannerist attitude.
12. Maria Simon, *Claes Jansz Visscher*, Diss., Freiburg i. B., 1958 (unpublished).
13. First published by I. Blok in *Oude Kunst*, IV, 1918–19, p. 107 ff., together with the etching; also by M. D. Henkel, *Le Dessin hollandais*, pl. XXX b.
14. On this aspect see also J. G. van Gelder, *op. cit.*, and K. Bauch, *Der frühe Rembrandt*, p. 13 ff.

DUNES AND COUNTRY ROADS

1. It is worth emphasizing that as early as *ca.* 1630, Constantijn Huygens designated Esajas van de Velde as 'omnium instar' among the landscape painters (together with Jan Wildens!); see *Oud Holland*, IX, 1891, p. 117. Main literature on Esajas van de Velde: L. Burchard, *Die holländischen Radierer vor Rembrandt*, p. 60 ff. and 151 ff.; Rolph Grosse, *Die holländische Landschaftskunst*, *1600–1650*, p. 44 ff.; K. Zoege von Manteuffel, *Die Künstlerfamilie van de Velde*, p. 6 ff.; J. G. van Gelder, *Jan van de Velde*, passim; W. Stechow in *Nederlandsch Kunsthistorisch Jaarboek*, I, 1947, p. 83 ff.; Ake Bengtsson, *Studies on the Rise of Realistic Landscape Painting in Holland*, *1610–1625*, p. 23 ff.; H. Gerson in *Oud Holland*, LXX, 1955, p. 131 ff.; E. Haverkamp Begemann, *Willem Buytewech*, passim.
2. First published by J. G. van Gelder, *op. cit.*, p. 40 and fig. 19.
3. On these see *ibid.*, p. 40 ff.
4. Haverkamp Begemann, *op. cit.*, p. 39 ff.
5. Mauritshuis, no. 199; see also Kurt Bauch, *Der frühe Rembrandt und seine Zeit*, p. 30, and J. R. Judson in the Brussels *Bulletin*, XI, 1962, p. 105.
6. W. Stechow, *op. cit.*; Exh. 'The Young Rembrandt and his Times', Indianapolis and San Diego, 1958, no. 34.
7. See the drawing in the J. Q. van Regteren Altena Collection, reproduced in W. Stechow, *op. cit.*, fig. 1. Buchelius ('*Res pictoriae*', ed. G. J. Hoogewerff and J. Q. van Regteren Altena, p. 50) mentioned in 1621 a landscape by Coninxloo with figures by Esajas van de Velde (who was about seventeen years old when Coninxloo died in 1607).
8. I shall use this term throughout in the rather generally accepted sense of 'factual' or 'objective' hues of objects, undisturbed by atmospheric and reflective alterations.
9. This term, although distressingly ambigu-

ous, still seems to fit best a pictorial pheno-
menon familiar to all. The usual alternative
to 'tonal' is 'monochrome' but it is not
preferable to it (and has no suitable corres-
ponding noun). Most 'tonal' paintings are
in fact 'bichrome' or even 'trichrome',
rather than 'monochrome'; brown and
grey, brown and yellow, grey and green are
some of the most frequent tonal combina-
tions. The decisive point here is the *down-
grading* of local ('objective') *hues* for the
sake of emphasis upon many *values* of a
few hues, as a result of closer observation of
the effect of atmosphere on local hues. Need-
less to say, this may become a matter of
routine or deliberate exaggeration as well.

10. Bengtsson, *op. cit.*, p. 67 ff.
11. Main literature on van Goyen: Hofstede de
Groot, *Cat. rais.*, VIII; H. Volhard, *Die
Grundtypen der Landschaftsbilder Jan van
Goyens und ihre Entwicklung*; H. van de
Waal, *Jan van Goyen*; J. G. van Gelder in
Kunstmuseets Aarsskrift, XXIV, 1937, p. 31
ff.; B. J. A. Renckens in *Oud Holland*,
LXVI, 1951, p. 23 ff.; H.-U. Beck in *Oud
Holland*, LXXII, 1957, p. 241 ff., and in
Apollo, LXXI, 1960, p. 176 ff.; J. Carter
Brown, *Jan van Goyen, a Study of his Early
Development*, unpublished M.A. Thesis,
New York University, 1961.
12. J. G. van Gelder, *op. cit.*
13. First published by van de Waal, *op. cit.*, p.
13; Exh. Warsaw, 1958, no. 34.
14. Little has been written on Molijn since
Granberg (1884): T. H. Fokker, Th-B
(1931); R. Grosse, *op. cit.*, p. 55.
15. Below, p. 175 and fig. 349.
16. Cat. 1929, no. 99 (Amalienstift, no. 202), ill.
Bernt 546. The date on the picture in
Prague, which has been read 1624 (Nostitz
Cat.) and 1627 (Gerson, I, fig. 133), has
turned out to be 1628 (I owe this informa-
tion, verified by a microphotograph, to Mr.
J. Carter Brown in Washington).
17. Burchard, *op. cit.*, p. 84
18. C. Müller in *Berliner Museen*, XLIX, 1928,
p. 64 ff.; W. Stechow in Th-B (1935). The
painting exhibited in Ghent, 1961, no. 54,
as being dated 1619 bears in fact no date at
all (kind comm. from Dr. H. Gerson, The
Hague); it is probably later than the one in
Berlin.
19. Their style recalls the 'imaginary' works of
E. van de Velde, on which see below, p.
134. A list in J. G. van Gelder, *Jan van de
Velde*, p. 75.

20. H. Weizsäcker, *Adam Elsheimer, der Maler
von Frankfurt*, Berlin, 1936–52.
21. *Op. cit.*, p. 35 ff.
22. *Op. cit.*, p. 35 ff.
23. *Ibid.*, p. 36. On Uyttenbroeck's paintings
see now Ulrich Weisner in *Oud Holland*,
LXXIX, 1964, p. 189 ff.
24. *Handzeichnungen alter Meister im Städel-
schen Kunstinstitut*, V, 1910, no. 10; already
very similar to the etching of the *Road to
Hillegom*, Burchard, no. 9 (shortly after
1614), reproduced by K. Bauch, *op. cit.*,
fig. 5.
25. *Op. cit.*, p. 12 ff.
26. Gustav Delbanco, *Abraham Bloemaert*,
Strasbourg, 1928; C. Müller in *Oud Holland*,
XLIV, 1927, p. 193 ff.; *idem* in *Berliner
Museen*, XLVIII, 1927, p. 138 ff.; T. Bodkin
in *Oud Holland*, XLVI, 1929, p. 101 ff.;
J. W. Niemeijer in *Oud Holland*, LXXV,
1960, p. 240 ff. Early pictures seem to be
signed 'A. Blommaert' (Amsterdam, no.
545, A 2; also the picture formerly in the
Matsvansky Collection in Vienna, 1606(?),
see Müller in *Oud Holland*, 1927, fig. 4). W.
Stechow in *Festschrift Trautscholdt*, p. 116.
27. C. Müller, *Oud Holland*, 1927, fig. 8, and
Berliner Museen, 1927, p. 139. Somewhat
more progressive is the style of the *Parable
of the Tares* in the D. Sutton Collection
(Exh. 'Vasari to Tiepolo', London, Hazlitt
Gall., 1952, no. 2).
28. Date misread as 1627 in the Berlin cat. of
1963. On the picture of 1628 in Prague see
note 16.
29. That he was privileged to paint the back-
ground in some of Frans Hals's portraits
has been suggested by Seymour Slive, Cat.
Exh. Frans Hals, Haarlem, 1962, nos. 13,
35, 57.
30. W. Stechow and A. Hoogendoorn in
Kunsthistorische Mededelingen, II, 1947, p.
36 ff. A landscape of 1626 in a Swedish
private collection is known to me from a
small reproduction only; its style is more
advanced than that of the other picture of
1626 but would fit well into the group
formed by the early Molijn, Pieter van
Santvoort and Ruysdael's own works of
1627–30.
31. Formerly attributed to Cuyp; the mono-
gram of Ruysdael and date 1631 recently
rediscovered: Exh. Warsaw, 1958, no. 89.
The picture of the same year in Leipzig (St.
180 and fig. 5) deviates from this group and
anticipates other developments.

32. Grosse, Volhard, van de Waal, *op. cit.*
33. A transitional stage, shortly prior to this work, is represented by a famous painting of the same year in Munich (HdG 344), in which a group of high trees in the centre seems to struggle with a more 'diagonal-minded' tendency of other parts.
34. The date definitely reads 1631, not 1635.
35. Now firmly identified with the Mono-grammist PN, long wrongly believed to be identical with Pieter Nolpe; see H. Gerson in *Nederlandsch Kunsthistorisch Jaarboek*, I, 1947, p. 95 ff.
36. W. Stechow in *Oud Holland*, LXXV, 1960, p. 86 ff.
37. W. Stechow, *Salomon van Ruysdael*, no. 139 and fig. 21.
38. Not in HdG; first published by N. I. Romanow in *Oud Holland*, LIII, 1936, p. 189. A similar effect in the same year is provided by a picture in the Dr. H. Wetzlar Collection in Amsterdam (Cat. 1952, no. 35; not in HdG).
39. Almost certainly identical with HdG 295, but monogrammed and dated 1647.
40. Reproduced by Grosse, *op. cit.*, pls. 52 and 53. Both pictures are in a poor state of preservation (the figures of HdG 275 do not seem to be by van Goyen at all) and were sold by the Alte Pinakothek before the second world war.
41. Exh. 'Die Sammlung Henle', Cologne, 1964, no. 27. The pattern is frequent in other works by Isaak van Ostade; see also his winter landscapes, below, p. 90.
42. HdG 925, Ros. 567, now in a private collection in Cologne, Exh. Cologne, 1954, no. 19, with reproduction in the cat. The same spot is represented in HdG 928, Ros. 571 (1647), which is quite similarly organized.
43. 1647: HdG 877, Ros. 531; 1649: HdG 790, Ros. 484, Antwerp (our fig. 39).
44. 1647: HdG 910, now in the Castle Rohoncz Collection, cat. 1952, no. 219; exactly the same spot as HdG 890, Ros. 557 (Louvre). Also of 1647: HdG 889, Ros. 556 (Munich).
45. 1652: Frick Collection, New York, hitherto wrongly dated 1654, HdG 525=719c, Ros. 393 (our fig. 142); of about the same time: Frankfurt, HdG 882, Ros. 542; *ca.* 1655: *The Barrow*, now in the Museum in Bonn, HdG 795, Ros. 487.
46. An exact study of Wouwerman's development is urgently needed. Hofstede de Groot, *Cat. rais.*, II (1909); Bode, 1921, p. 240 ff.; Th-B (1947).

47. This connection has now become clearly established through a picture of 1646, exhibited in London, 1952/53, no. 454, see H. Gerson in *Burlington Magazine*, XCV, 1953, p. 51 and fig. 20; see also Leipzig, HdG 1018.
48. HdG 1121 (without specified date). For a colour reproduction see *The Connoisseur*, Oct. 1961, p. lxxvii.
49. Exh. Rotterdam, 1955, no. 141 (not in HdG).
50. See HdG. *Cat. rais.*, VIII, p. 427 (*ca.* 1620–1625); H. W. in Th-B (1947; *ca.* 1630–35). The date of 1643 on a picture in Leningrad (no. 1713, HdG 18) is highly suspect and in any case connected with a (false?) signature by Wijntrack, not by Wijnants. The North-brook picture (HdG 485) is not dated 1643 but possibly 1673, to judge from a photograph; its style excludes the early date. HdG 150 is certainly not of 1645, the Lobmayr Cat. read the date 1651, and the style looks even more advanced; HdG 679, Mainz, is dated 1675, not 1645, see *Ein grosses Jahrhundert der Malerei, niederländische Gemälde des Mainzer Museums*, Speyer, 1957, no. 123. This leaves 1649 (HdG 457) as the first possibly reliable date on a work by Wijnants.
51. On Adriaen van de Velde see Hofstede de Groot, *Cat. rais.*, IV (1912); Bode, 1921, p. 227 ff.; Zoege von Manteuffel, *op. cit.*, p. 55 ff. The latter two are fine, sympathetic treatments of this great artist, who has since been unduly neglected.
52. *Ibid.*, p. 58 and fig. 56.
53. HdG misread the date as 1663. An excellent master of the Wijnants-van de Velde trend was the enigmatic Willem Buytewech the Younger (1625–70), whose pictures are extremely rare and whose landscape in London (no. 2731) was once attributed to Jan Wijnants.
54. W. Stechow, *Salomon van Ruysdael*, p. 22 ff.
55. HdG 18, 32, 74, 82; see below, *passim*.
56. A superb example is the (basically 'Dutch') picture of 1648 in Leipzig, no. 301, HdG 375.
57. J. Q. van Regteren Altena in *Oud Holland*, XLIII, 1926, p. 18 ff. See also the fine, rather unusual landscape by Jan Lievens in the Collection Mrs. S. Schneider-Christ in Basel (Sch. 303).
58. A surprisingly fine picture of 1647 (!) in Leipzig, no. 1042.

59. W. Stechow in *Art Quarterly*, XXII, 1959, p. 3 ff.

60. Two versions, in reverse, in Hamburg, no. 182 (as Adriaen van de Venne), and in Amsterdam, no. 2598 A1 (as Sebastian Vrancx; here reproduced).

61. Both of these precursors have recently been published and compared with Hobbema's picture by Max Imdahl in *Festschrift Kurt Badt zum 70. Geburtstage*, p. 173 ff. The *Alley*, by Jan van Kessel (died 1680) in Stuttgart (Plietzsch, 1960, fig. 172; once given to Hobbema on the basis of a forged signature) differs from the three pictures here illustrated by the fact that its two rows of trees extend over the entire picture plane, permitting glimpses of the middle- and background only *through* the foliage; this type had already been employed in an etching by Jacques Foucquier (*Gazette des Beaux-Arts*, XC, 1948, p. 432).

62. *Jahrbuch der Preussischen Kunstsammlungen*, XLVIII, 1927, p. 151 and fig. 21.

PANORAMAS

1. On this drawing see now also K. Arndt in *Pantheon*, XXV, 1967, pp. 97 and 104, note 4.

2. Brussels, no. 49; the version in Copenhagen, no. 870, may be only a copy.

3. Tempera on canvas; Cat. 1954, no. 8. Called 'View of the Scheldt', but there is no clear indication that this is the river which Bol had in mind. There exist gouache drawings of the same kind by Bol (*View of Antwerp*: Bremen, dated 1585?, Reznicek, *Die Zeichnungen von Hendrick Goltzius*, p. 108, note 33). Other comparable works are by Hendrick van Cleve (e.g., *View of Rome*, 1589, 1960 in the Winter Exh. at P. de Boer's in Amsterdam, *Burlington Magazine*, XCV, 1953, p. 306); they remained popular far into the seventeenth century (P. Segaer, *View of Copenhagen*, Exh. P. de Boer, Amsterdam, Summer, 1959).

4. An equally antiquated impression is conveyed by van Mander's (brilliantly painted) picture of 1577 in Utrecht (new acq., 1956) with the Pilgrims of Emmaus before a vast panorama with an 'ancient' city. Only Jerome Bosch had anticipated important aspects of the 'Dutch Panorama'.

5. Reznicek, *op. cit.*, nos. 400, 404, 405.

6. *Ibid.*, no. 395 and figs. 242-244. Its left section strongly foreshadows Seghers.

7. Employed by van Mander in his picture of 1577, see note 4.

8. A brilliant early example is Jacques de Gheyn's Munich drawing of 1603, a dramatic view with a dramatic story (a murder scene), which foreshadows the landscape style of Rubens (reproduction in Grosse, pl. 6).

9. Reproduced by K. Zoege von Manteuffel, *Die Künstlerfamilie van de Velde*, p. 25.

10. The basic literature on Seghers consists of E. Trautscholdt's articles in Th-B (1936), *Pantheon*, XXV, 1940, p. 81 ff., and *Imprimatur*, XII, 1954-55, p. 78 ff., and E. Haverkamp Begemann's catalogue of the exhibition held in Rotterdam in 1954; indispensable for the etchings is Jaro Springer's catalogue and three volumes of magnificent reproductions in the *Graphische Gesellschaft* series, XIII, XIV, XVI, Berlin, 1910-12. That the monograph by Leo C. Collins, Chicago, 1953, must be used with great caution I have tried to show in detail in *Art Bulletin*, XXXVI, 1954, p. 240 ff.

11. A. Welcker, 'Johannes Ruyscher alias Jonge Hercules', article series in *Oud Holland*, XLIX, 1932, L, 1933, LI, 1934, and LIII, 1936 (also as separate publication, 1936).

12. It is shown in Spr. 33, which is probably by Ruyscher. Spr. 34 is known in one impression only (Amsterdam; our fig. 56), and this is printed in one colour only (blue, on bluish paper). Of Spr. 35, four impressions are known, all provided with additional brush work, conservative in one case (Berlin, Spr. pl. XVII), more extensive in the others.

13. See above, p. 189 note 8.

14. On the other hand, Spr. 40 may have been done a good deal earlier.

15. *Oud Holland*, LXV, 1950, p. 216 ff. and LXVIII, 1953, p. 149 ff. The fact that this manipulation (see also E. van de Velde, below, p. 87) remained undiscovered for so long is very instructive. It is a forceful reminder of the futility of speculations about a 'logical' relationship between high standpoint and high sky. Obviously, Seghers as well as Goltzius felt that the very oblong

format was most characteristic of a panoramic view, regardless of the observer's standpoint.

16. Bock-Rosenberg, no. 8501 and pl. 214.
17. Collection D. Hannema, Castle Weldam (Exh. Rotterdam, 1955, no. 136, fig. 65).
18. S. J. Gudlaugsson in *Oud Holland*, LXIX, 1954, p. 59 ff. (on both Post and Vroom; the painting by the latter [see previous note] does not seem to me quite so early).
19. Another good example by Salomon van Ruysdael is St. 186 of 1641 (*View of Arnhem*).
20. N. I. Romanow in *Oud Holland*, LIII, 1936, p. 187 ff.
21. H. Gerson, *P. Koninck*, p. 36 ff. and plates 14, 17, 19.
22. E.g., Berlin, no. 916.
23. D. Hannema, *Catalogue raisonné of the Pictures in the Collection of J. C. H. Heldring*, Rotterdam, 1955, no. 32a. See also W. Stechow in *Bulletin of the Allen Memorial Art Museum, Oberlin College*, V, 1948, p. 7 f. Sold at Sotheby's in London, March 27, 1963, no. 23.
24. It is matched by some watercolours by the same master (Berlin, dated 1662, Bock-Rosenberg, no. 2424, pl. 204).
25. A very early example (*ca.* 1630) is the picture by H. Saftleven in Rotterdam, no. 1769 (reproduced by H. Gerson, II, fig. 123).
26. Städtisches Museum, Elberfeld, *Die Niederländer des XVII. Jahrhunderts*, n.d. (1922?), p. 12, no. 258. Not in HdG.
27. One is reproduced in H. E. van Gelder, *Holland by Dutch Artists*, fig. 83.
28. Collection A. Stahlberg in Hannover. I know only a photograph of this picture (dated 1628; on wood, 30 × 46.5 cm.); it suggests close resemblance with Ruysdael's *Haytime* of 1627 in the F. C. Butôt Collection in Amsterdam (Exh. Indianapolis-San Diego, 1958, no. 58).
29. James D. Breckenridge, *A Handbook of Dutch and Flemish Paintings in the William Andrews Clark Collection*, 1955, p. 10. The same village appears in HdG 473. W. Stechow in *Oud Holland*, LXXV, 1960, p. 87.
30. It is a view of *Leiden*. First published by A. P. A. Vorenkamp in *Bulletin of the Smith College Museum of Art*, no. 23, June 1942, p. 10 ff.
31. Not in HdG; reproduced by R. Grosse, *op. cit.*, pl. 45.
32. Breckenridge, *op. cit.*, p. 21, no. 26.95.

33. E.g., a picture of 1646 in sale Amsterdam, May 6, 1913, no. 10.
34. E.g., the picture attributed to Salomon van Ruysdael in sale L. Janssen, Amsterdam, April 26, 1927, no. 104, and the one in the Schloss sale, Paris, Dec. 5, 1951, no. 41.
34a. Cat. 1958, no. 364; Exh. London, 1961, no. 95.
35. I must defer judgment of the *View of Saxenburg* published by W. R. Valentiner in *Art Quarterly*, XIV, 1951, p. 341 ff., and J. Q. van Regteren Altena in *Oud Holland*, LXIX, 1954, p. 1 ff. The measurements of the panel, omitted in both publications, are 30 × 44 cm. Exh. Raleigh, 1956, no. 22. Present whereabouts unknown.
36. B. 56, H. 266, M. 216. Münz's early dating (*ca.* 1643/44) seems unacceptable to me.
37. See note 35.
38. B. 223, H. 244, M. 168.
39. The landscape in the Castle Rohoncz Collection (Cat. 1952, no. 205, Exh. London, 1961, no. 90: Bredius 447), which used to be attributed to Rembrandt, is now considered a very early work of Ph. Koninck by H. Gerson (*Burlington Magazine*, XCV, 1953, p. 48, note 12, and *Festschrift Dr. h.c. Eduard Trautscholdt*, p. 109 ff.).
40. Gerson, *P. Koninck*, p. 20 f.
41. K. E. Simon, *Jacob van Ruisdael*, p. 76 ('wohl aus späterer Zeit'); *idem* in Th-B as Jan van Kessel.
42. Bredius, K. I., p. 425.
43. *Gemälde der Ruzicka-Stiftung*, Kunsthaus Zürich, 1949-50, no. 32.
44. See HdG 55, 58, 59, 70, 77; others are exactly square (e.g., HdG 43 = 76; fig. 80).
45. W. Stechow in *Nederlands Kunsthistorisch Jaarboek*, XI, 1960, p. 165 ff.
46. Jakob Rosenberg, *Jacob van Ruisdael*, Berlin, 1928, p. 57; H. Beenken in *Neue Beiträge deutscher Forschung, W. Worringer zum 60. Geburtstag*, Königsberg, 1943, p. 1 ff.
47. Even more exaggerated in HdG 64, Ros. 47 and fig. 138.
48. Exh. New York (Wildenstein's), 1956, no. 21.
49. The only red nuance in the entire picture.
50. E.g., London, no. 990 (HdG 136 = 758 = 844d, Ros. 24) and no. 2561 (HdG 36 = 66a = 90, Ros. 25 = 26).
51. E.g., Berlin, no. 885E (HdG 57, Ros. 40).
52. However, it may be worth stating that there has been a recent tendency – particularly on the part of K. E. Simon – to attribute to this artist several paintings which may well

have been done by Ruisdael in less inspired moments, of which there were undoubtedly some. A careful comparison between such paintings by Ruisdael occasionally attributed to van Kessel (e.g., Castle Rohoncz Collection, Cat. 1958, no. 370, HdG 79, Ros. 66; Simon, p. 73: van Kessel, from reproduction) and signed works by the latter (or others now given to him in more universal agreement, such as HdG 61) will reveal some irreconcilable differences. Remarkably fine is a 'Haerlempje' by the rare Claes Hals (1628–86), reproduced by W. Martin, I, p. 383, fig. 229. For A. van der Neer see below, p. 134.

53. E. Trautscholdt in Th-B (1940) with important clarification of the still recurrent confusion between the artist and his father (who was probably not a painter at all).

54. The date 1646 on a Panorama once with van Diemen (RB Neg. G.K., no. 414) must have been misread; it cannot be earlier than the picture of 1648 in the Mauritshuis (no. 724). 1678: Rotterdam, no. 1502, reproduced by W. Martin, Dutch Painting of the Great Period, 1650–1697, pl. 96.

55. This picture seems to carry what may well be Lingelbach's (died 1674) last staffage figures.

56. Cicerone, IX, 1917, p. 401, fig. 22.

57. On the obsolete attribution of this picture to 'Jan Vermeer I' see note 53.

58. If the signature and the date 1689 (or 1686) on a picture 1936 at Stern's in Düsseldorf was correctly read, the 'finis' to Vermeer's activity would appear to have been less satisfactory. On the problematic attribution of the View of Amersfoort in Leipzig, no. 640, whose date has also been read 1689, see Trautscholdt, op. cit.

59. J. K. van der Haagen, De Schilders van der Haagen, Voorburg, 1932.

60. Van der Haagen, no. 109. Wrongly called 'La plaine de Harlem' in the Louvre.

61. Not even the date 1649 on the View near Arnhem in the Mauritshuis (no. 46, van der Haagen, no. 22) can be accepted without qualms because it is attached to a house in the picture rather than to a signature.

62. Th-B (1931); J. Verbeek and J. W. Schotman, Hendrick ten Oever . . ., Zwolle, 1957; Plietzsch, 1960, p. 106.

63. A 'semi-Italianate' panorama by ten Oever of great charm is in the Brediushuis in The Hague (reproduced by W. Martin, Dutch Painting of the Great Period, London . . ., 1951, pl. 84). A very unusual and very beautiful Dutch panorama by Jan Asselijn with hunters and a fisherman in the foreground, once in the Cook Collection (Cat. 1914, no. 203) shares with ten Oever's picture in Edinburgh the quiet composure and deep glow.

RIVERS AND CANALS

1. He was owner of the ferry service between Amsterdam and Rotterdam, and of the inn run by it ('Waerd op het Rotterdamer Veer'), see Gerson, Koninck, p. 11 f.

2. On these, see below, p. 110.

3. See the Coast Scenes, pp. 159ff.

4. Ake Bengtsson, Studies on the Rise of Realistic Landscape Painting in Holland, 1610–1625, p. 28 and repr. opp. p. 17.

5. Buytewech, p. 218, note 210.

6. Paleis Soestdijk, Atlas Munniks van Cleef, no. 93.

7. Reproduced by M. Sinajew in Musée Ermitage, I, 1940, fig. 13.

8. The epoch-making importance of this etching was already recognized by E. Haverkamp Begemann, Buytewech, p. 40.

9. This popular pastime is represented in

another etching by Hans Bol (van der Kellen 18), in a drawing of 1629 by Esajas van de Velde in Groningen (M. D. Henkel, Le Dessin hollandais, Paris, 1931, p. 48) and elsewhere; the related 'Catching the Eel' appears in a winter landscape by Salomon van Ruysdael of 1650 in New York (St. 5; reproduced in Art Quarterly, II, 1939, p. 256, fig. 6).

10. It appears somewhat earlier in a drawing by van Goyen, see note 16. An early imitator of the style of Esajas van de Velde's Ferry of 1622 was Roger Claesz called Suycker, whose monogrammed (RC) picture in Braunschweig, reproduced by Rolph Grosse, Die holländische Landschaftskunst, 1600–1650, pl. 20, as by Rafael Camphuysen, comes close to van de Velde in design but shows

bluish colour nuances more reminiscent of
Pieter de Neyn. Some of his pictures are
dated in the 1620's (see the *View of Haarlem*
of 1625, sale in London [Sotheby's], Nov.
11, 1959, no. 72, repr. in *Art and Auctions*,
Feb. 15, 1960, p. 637, and H. Gerson in
Kunsthistorische Mededelingen, I, 1946, pp.
52 ff.). For a comparable de Neyn of 1626
see H. Gerson in *Nederlandsch Kunst-
historisch Jaarboek*, I, 1947, p. 104, fig. 3
(Leiden, no. 77).

11. Colour reproduction in K. Zoege von
Manteuffel, *Die Künstlerfamilie van de
Velde*, fig. 1. Formerly called a view of
Wesel, but the identification with Zierikzee
(Gerson, I, p. 48) is, in spite of some
liberties taken, completely convincing; see
the engraving after C. Pronk, reproduced
in H. E. van Gelder, *Holland by Dutch
Artists*, fig. 110a. The Berlin Cat. of 1963
misreads the date as 1615.

12. E. Haverkamp Begemann, *op. cit.*, no. 112.
13. Notably the picture of the same year which
was exhibited in Arnhem, 1953, no. 67, with
repr. (colours very similar to the Berlin
picture).
14. The historical importance of this Amster-
dam painter, who was born in 1585/86 and
died there in or before 1635, was empha-
sized but also exaggerated by G. Poensgen,
who considered him a forerunner rather
than a successor of Avercamp (*Oud Holland*,
XLI, 1923-24, p. 116 ff.); see MacLaren in
the London Catalogue of 1960, p. 2. Works
like the one in London nevertheless amply
justify careful consideration of his rather
small œuvre.
15. Signed with the monogram; possibly the
only fully authenticated 'non-winter' panel
of the artist. Exh. Breda-Ghent, 1961, no.
6. Welcker S. 49.
16. First published by J. G. van Gelder, *Kunst-
museets Aarsskrift*, 1937, p. 35, fig. 4; from
'Sketchbook A'; Hamburg, Kunsthalle,
Inv. no. 21986; Exh. Leiden, 1960, no. 54.
17. Frankfurt, no. 3589; from 'Sketchbook A';
van Gelder, *op. cit.*, p. 43, no. 4.
18. Exh. Leiden, 1960, no. 2, fig. 1 (Collection
A. de Medeiros e Almeida, Lisbon); H. van
de Waal, *Jan van Goyen*, p. 11.
19. Van de Waal, p. 21.
20. *Ibid.*, p. 22. A preparatory drawing in
London (see H.-U. Beck in *Oud Holland*,
LXXII, 1957, p. 242 and notes 9-10).
21. W. Stechow, *Salomon van Ruysdael*, p. 19
f. and 41 f.

22. London, no. 1439; St. 435 and fig. 8.
23. W. Stechow in *Bulletin John Herron Art
Institute, Indianapolis*, XLVII, 1960, p. 4 ff.
It now seems that the Cuyp in Indianapolis
is identical with HdG 196, which was sold
from the Gotha Museum and subsequently
cleaned, and that the Hannover provenance
given for it was fictitious.
24. See the long lists in Hofstede de Groot, *Cat.
rais.*, VIII, s.v.
25. St. 309 and fig. 46; also *Art Quarterly*, II,
1939, p. 261 (Barnes Foundation, Merion,
Pa.).
26. W. Stechow in *Oud Holland*, LV, 1938, p.
202 ff., where the New York picture is not
mentioned.
27. On the question of date cf. W. Stechow in
Oud Holland, LXXV, 1960, p. 87.
28. Leipzig, no. 808.
29. C. Hofstede de Groot in *Burlington Maga-
zine*, XLII, 1923, p. 4 ff.
30. Dr. Kurt Schwarzweller of the Städelsche
Kunstinstitut kindly informs me that the
first, second and fourth digits of the date are
quite clear but the third entirely illegible.
31. Salomon van Ruysdael, St. 412 and fig. 30;
now in the Museum of São Paulo (*Habitat,
Revista das artes no Brasil*, no. 2, 1951, p.
39).
32. One of many examples: HdG 550 of 1652.
33. With cows in place of the ferry: our fig. 7.
34. Van Goyen: 1639 (HdG 10, 1957 at G.
Cramer's at The Hague); 1643: HdG 15 A
(not identified with this number in Exh.
Leiden, 1960, no. 31, fig. 16; a tondo, now
in the Museum in Arnhem); 1646: HdG
788; 1652: HdG 33 (not Delft but The
Hague; Exh. Leiden, 1960, no. 45, fig. 27;
Collection A. de Medeiros e Almeida.
Lisbon).
Salomon van Ruysdael: St. 54 (*ca.* 1663)
and St. 472 (probably dated 1660 rather
than 1668).
35. Leipzig, no. 592, dated 1644.
36. It is really not far removed in its colouristic
attitude from the *Baptism of the Eunuch* of
1636 (our fig. 274).
37. Jakob Rosenberg in *Jahrbuch der Preussi-
schen Kunstsammlungen*, XLIX, 1928, p. 102
ff. See below, p. 168.
38. *Ibid.*
39. E.g., Copenhagen, *ibid.*, fig. 5.
40. Some works by Guilliam Dubois come very
close to Vroom's of the 1640's and 1650's.
41. HdG nos. 656-729, including many which
one could hardly call river landscapes and

also some that are not genuine; on the other hand, some of the pictures listed under Windmills by HdG (no. 172 ff.) belong here. Jakob Rosenberg, *Jacob van Ruisdael*, p. 98 ff., nos. 421-458.

42. HdG 659, Ros. 444, dated 1647, now in the Rijksmuseum Twenthe in Enschede; HdG 663, Ros. 448, 1942 at Knoedler's (*ca.* 1649).

43. HdG 694, Ros. 449, Nivaagaard, no. 49.

44. HdG 687, Ros. 457, Harrach Gallery, no. 315. Cf. also HdG 679, Ros. 426.

45. I am indebted to Mr. Colin Thompson for this communication. The correct date had been anticipated by K. E. Simon, *Jacob van Ruisdael*, p. 20. Reproduced in J. Rosenberg, Ruisdael, fig. 34. I cannot see the hand of Wouwerman or Berchem in its figures as de Groot suggested.

46. Not 1654; see below, p. 73.

47. Not in HdG and Ros.; ex Collection Earl Howe, Gopsall; mentioned by N. MacLaren as a variant of the London picture (as with D. Katz, Dieren, before 1946).

48. Cf. HdG Ruisdael nos. 172-193. The style of Dulwich, no. 168, HdG 175, Ros. 115, conforms entirely with that of the Detroit picture, our fig. 111. It is certainly not of the eighteenth century, as Simon, *Ruisdael*, p. 74, suggested; both Hobbema and Anthonie van Borssom were inspired by works of this kind. See also Berlin, no. 885 J, HdG 179, Ros. 109.

49. Cat. of the Whitcomb Bequest, 1954, p. 31. Formerly in the L. Mandl Collection.

50. W. Stechow in *Art Quarterly*, XXII, 1959, p. 3 ff.; an exception is the picture illus-

trated in *Burlington Magazine*, XCV, 1953, p. 48 and fig. 18 (Exh. London, 1952-53, no. 381), which may have been painted around 1670.

51. Reproduced by W. Stechow, *op. cit.*, figs. 5 and 11.

52. His very charming river scene of upright format, certainly a rather early work (*ca.* 1650), is in the John G. Johnson Collection in Philadelphia (no. 576).

53. Reproduced in K. Zoege von Manteuffel, *Die Künstlerfamilie van de Velde*, fig. 56.

54. *Ibid.*, fig. 72.

55. Wrongly dated 1663 in HdG. A certain kinship with these works by Adriaen van de Velde can be detected in Jan van der Heyden's few Dutch river landscapes, among which that in Buckingham Palace (HdG 258, reproduced by Gerson, II, 163; see *Oud Holland*, LXXV, 1960, p. 121) is by far the finest.

56. Reproduced in the Indianapolis *Bulletin*, XLVII, 1960, p. 5.

57. Below, p. 106 f.

58. Closely related are HdG 390 and 393.

59. *De Hollandsche Schilderkunst in de Zeventiende Eeuw*, II, Amsterdam, 1936, p. 342.

60. W. Stechow in *Oud Holland*, LXXV, 1960, p. 88, and Exh. Cat. Utrecht, 1965, p. 172.

61. If H. Gerson's new chronology of Cuyp's activity which is based on topographical data (*Opus musivum*,) 1964, p. 257 ff.) is correct, the dates suggested in this book (as in all others) must be drastically revised. A debate on this point is urgently needed.

WOODS

1. E. Gombrich n *Gazette des Beaux-Arts*, ser. 6, XLI, 1953, p. 335 ff., particularly p. 349 ff.

2. On loan from the Rijksmuseum. The panels formed the outside wings of the triptych with the *Nativity*, now in New York (no. 49.7.20; Bache Collection).

3. Van Mander-Floerke, II, p. 126; R. Hoecker, *Das Lehrgedicht des Karel van Mander*, p. 340 ff. On Coninxloo see, in addition to E. Plietzsch, *Die Frankenthaler Maler*: J. A. Graf Raczyński, *Die flämische Landschaft vor Rubens*, p. 27 ff.; Arthur Laes in *Annuaire des Musées Royaux des Beaux Arts de Belgique*, II, 1939, p. 109 ff.;

Jan Bialostocki in *Biuletyn Historii Sztuki*, XII, 1950, p. 105 ff.; Ottheinz Münch in *Festschrift des Pfälzischen Museums*, Speyer, 1960, p. 275 ff. The article by Laes and the account on Coninxloo in the book by Yvonne Thiéry, *Le Paysage flamand au XVII*ᵉ *siècle*, p. 14 ff., must be used with caution; e.g., the *Landscape with Elijah fed by the Raven* in Brussels is certainly not by Coninxloo (see Bialostocki, *op. cit.*, p. 134, and H. Wellensiek in the Brussels *Bulletin*, 1954, p. 109 ff.), although it is still attributed to him by the catalogue of the exhibition 'Le siècle de Bruegel', Brussels, 1963, no. 80. The importance of Hans Bol for the late

phase of Coninxloo's art seems to me to have been overstated by H. G. Franz in *Bulletin Museum Boymans-van Beuningen*, Rotterdam, XIV, 1963, p. 66 ff.

4. For an influence by Barocci see E. K. J. Reznicek, *Die Zeichnungen von Hendrick Goltzius*, nos. 397, 402, 410.

4a. See K. Arndt in *Pantheon*, XXIV, 1966, p. 207 ff.

5. Raczynski, p. 49 f. and figs. 14, 15.

6. On van Mander's own paintings of this kind see E. Valentiner, *Karel van Mander als Maler*, p. 55 ff., 83 f.

7. David Vinckboons (1576–1632, since 1591 in Amsterdam) never strikes one as being a landscape painter at heart, a fact acknowledged by Korneel Goossens in his monograph on the master (Antwerp–The Hague, 1954, p. 11 ff.). His first fully 'integrated' landscape is the *Forest* of 1618 in Leningrad (Goossens, fig. 26); it is considerably later than the early works of Gillis d'Hondecoeter (see our fig. 123)! That Goossens underrated Coninxloo's influence on Vinckboons's early landscapes has been rightly stressed by S. Slive in *Art Bulletin*, XXXIX, 1957, p. 314. It is significant that Vinckboons's influence on such members of the following generation as Esajas van de Velde was in the field of *genre*, not of landscape proper. The finest he had to give in the field of landscape in his earlier years is found in some *drawings*.

8. H. Schneider in Th-B (1924).

9. Sale van Buren, The Hague, June 1, 1942, no. 28.

10. Reproduced in *Holländische Meister aus der Staatlichen Kunsthalle*, Karlsruhe, 1960, no. 2.

11. See below, p. 142 and fig. 282. In some of these early paintings, done in Antwerp, the signature reads: 'J (or G) de hondecoutre', as it still does in a document of 1638 (K. I., IV, p. 1221). Most paintings carry the monogram G DH (in ligature). The French spelling may be important in an attempt to avoid confusion between him and his son, Gijsbert d'Hondecoeter (W. Stechow in *Festschrift Trautscholdt*, p. 116).

12. Exh. Enschede, 1929, no. 21.

13. In his last year, 1638, he painted a landscape with a vast vista of a winding river, which almost foreshadows the late Herman Saftleven (Theodor von Frimmel, *Studien und Skizzen zur Gemäldekunde*, III, 1917–18, pl. IX). The attribution to Gillis d'Hondecoeter of a picture in Rotterdam (no. 2303) which

was formerly given to Rubens remains debatable.

14. H. S(chneider) in Th-B (1927). E. Greindl, 'La Conception du paysage chez Alexandre Keirincx', *Annuaire du Musée Royal des Beaux-Arts d'Anvers*, 1942–47, p. 115 ff.

15. C. Poelenburgh painted figures into pictures by Keirincx which are dated or datable between *ca.* 1628 (Braunschweig, no. 181; The Hague, no. 70, Bernt 441) and *ca.* 1636 (Düsseldorf, acq. 1936). A painting in Bremen, dated 1633 (no. 64), is signed by both artists. On Keirincx's stay in London (1625?, 1640–41) see Henry V. S. Ogden and Margaret S. Ogden, *English Taste in Landscape in the Seventeenth Century*, passim. The date on the picture in Dresden, no. 1145, which the catalogue reads 1620, is likely to be 1626, since the style of the picture is clearly further developed than that of the painting in Braunschweig, dated 1621 (fig. 124) and of Dresden, nos. 1143-44, which are evidently also of *ca.* 1621. Another picture dated 1621, representing a vegetable garden, was in Exh. Gallery Robert Finck, Brussels, 1963, no. 43.

16. L. J. Bol in *Oud Holland*, LXXII, 1957, p. 20 ff.

17. The charming pair of oval panels by van der Neer in the Toledo Museum (HdG 81-82) still show traces of this background and can be dated *ca.* 1637/38, between the picture in 1635 (fig. 134) and the one of 1639 of Amsterdam (no. 1718, HdG 18). The artist's earliest known work (1632) is a *genre* painting (H. Seifertova-Korecka in *Oud Holland*, LXXVII, 1962, p. 57 f.).

18. W. Stechow in Th-B (1935).

19. In paintings of 1644 (at Colnaghi's in London, Exh. June 1955, no. 4), 1645 (Vienna, no. 1228, Bernt 721; Czernin Collection, no. 126) and 1647 (Czernin, no. 189), the influence of Jan Both (who had recently returned to Utrecht from Italy) is also evident. In 1648 (Warsaw, no. 129052, exh. in Warsaw, 1958, no. 94) one can already detect the impact of C. Vroom and possibly of the young Jacob van Ruisdael.

20. The signature of de Vlieger and the date 1640 on a painting in the Liechtenstein Collection (no. 414) were, as Director Dr. Wilhelm kindly informs me, false and have been removed; the genuine date 1650 and illegible remains of a signature (of A. Verboom?) have appeared under it.

21. Jakob Rosenberg in *Jahrbuch der Preussi-*

schen Kunstsammlungen, XLIX, 1928, p. 102
ff.: Th-B (1940); J. G. van Gelder in *Oud
Holland*, LXXVII, 1962, p. 56 f.

22. E. Haverkamp Begemann, *Willem Buyte-
wech*, figs. 77, 78, 82.

23. The Rotterdam picture was formerly called
Berchem. A large picture in Detroit (no.
1048 as 'attributed to Berchem'), which was
once called Hobbema (HdG 144c, B. 145),
might well be a very late Vroom under the
influence of Ruisdael (Ros. fig. 39); Simon's
attribution to Dubois (*Zeitschrift für Kunst-
geschichte*, IX, 1940, p. 208) is unacceptable
before the original.

24. Guilliam Dubois started 1636 in an almost
Keirincx-like style (even with Coninxloo
reminiscences), as is proved by a picture
once at Dr. Schaeffer's, see J. Rosenberg
in *Zeitschrift für Kunstgeschichte*, II, 1933,
p. 238 (the article there announced has
not been published). After a Seghers-like
interval (1640: Amsterdam, no. 537h) he
seems to have submitted to the influence of
Vroom, as many forest scenes of the 1640's
show. In addition, he painted an occasional
panorama (in the trend of Molijn, see p.
42) and, in his later years, also beach
scenes (see p. 206). See K. E. Simon in
Berliner Museen, LIII, 1932, p. 61 ff., and
Zeitschrift für Kunstgeschichte, IX, 1940, p.
208.

25. J. Rosenberg, *Ruisdael*, p. 27.

25a. Once with T. H. Ward in London; sale in
London (Sotheby's), July 6, 1966, no. 37.

26. The picture has suffered through abrasion
but signature and date are unmistakably
genuine. Johns Hopkins University Exhibi-
tion 'Landscape Painting from Patinir to
Hubert Robert', 1941, no. 22 as by Roland
Roghman; as such still listed in the *Duits
Quarterly*, no. 5, 1964, p. 7. J. Rosenberg
drew my attention to this picture.

27. Reproduced in J. G. van Gelder, *Prenten en
Tekeningen*, p. 35. On a group of drawings
of 1642 by Govaert Flinck see Cat. Exh.
Leiden, 1956, no. 121 and pl. 31. The
chief Mannerist ancestors of these drawings
are works by A. Bloemaert and the truly
imposing *Old Oak* by Jacques de Gheyn in
Amsterdam (Exh. Brussels, 1961, no. 5, pl.
II).

28. Old no. 1140, not in the Cat. of 1958; HdG
893, Ros. 616. Hofstede de Groot's doubts
about its authenticity seem to me as un-
founded (from the photograph) as they did
to Rosenberg.

29. HdG 448a (without date), Ros. 261. Sale in
Amsterdam, April 26, 1927, no. 100.

30. Rosenberg, *Ruisdael*, p. 19.

31. *Ibid.*, figs. 34, 36, 42, 48, 49.

32. The date is clearly 1652, not 1654. Probably
identical with HdG 719c. The figures,
which HdG considered painted in later,
seem to me contemporary, but I cannot
identify their author, who probably also
painted the galloping horseman in the
picture of 1651 just adduced in the text
(HdG 702a, Ros. 276 and fig. 38).

33. Rosenberg, *Ruisdael*, figs. 38–39.

34. *Ibid.*, fig. 46.

35. The picture is dated 1651, see Exh. London,
1952–53, no. 318 (with repr.).

36. With F. Mont in New York in 1946.

37. Rosenberg, *Ruisdael*, p. 28.

38. Simon (*Ruisdael*, p. 41) reads 1663, Broulhiet
(*Hobbema*, no. 31) 1664 ('d'après une
vérification'). With Rosenberg (*Ruisdael*, p.
40, note 1) and the Amsterdam Catalogue I
prefer 1661.

39. *Ruisdael*, p. 45 ff.

40. This even applies to Egid Sadeler's famous
engraving after a Savery composition
(Rosenberg, *Ruisdael*, p. 48 f. and fig. 104).

41. A corroboration of the customary dating of
these works in the 1660's is provided by a
stylistically very closely related picture in
the Clowes sale, London, Feb. 17, 1950, no.
49, on which the date 166. is still visible
(HdG 548).

42. This was the opinion of Rosenberg, who
dated the picture in the early 1660's; Mac-
Laren (London Cat. of 1960) has already
suggested a date in the later 1660's on the
basis of the costumes.

43. *Ruisdael*, p. 63 ff.

44. E.g., Berlin, no. 885A, HdG 789, Ros. 485.

45. I do not think it profitable to dwell here on
forest scenes by Decker, the Rombouts, the
van Vries, Looten, Jacob Salomonsz van
Ruysdael, Waterloo and many others – not
even those of the late Molijn. All of these
artists painted some highly creditable works
but none of them added significantly to the
scope and depth of this trend of Dutch
landscape painting, nor did they 'fill gaps'
in the development of it as other minor
masters such as Keirincx had done.

46. Hofstede de Groot, *Cat. rais.* IV (1911) and
Th-B (1924); J. Rosenberg in *Jahrbuch der
Preussischen Kunstsammlungen*, XLVIII, 1927,
pp. 139 ff.; J. Broulhiet, *Meindert Hobbema*;
W. Stechow in *Art Quarterly*, XXII, 1959,

p. 3 ff.; MacLaren in London Catalogue 1960, s.v.

47. W. Stechow, *op. cit.*; HdG 163, which shows the 'early' signature and was listed as being inaccessible to me on p. 18, is indeed a work of this period, very similar to the one in Grenoble (in 1959 at Hirschl and Adler's in New York). The picture of 1660 (*ibid.*, fig. 14) is now in Collection Henle in Duisburg (Exh. Cologne, 1964, no. 16, erroneously identified with HdG 183).

48. *Ibid.*, pp. 10, 14 f. and fig. 8.

49. *Op. cit.*, p. 142.

50. Not in HdG and B.; W. H(utton), *Toledo Museum News*, Fall 1957, p. 10, and W. Stechow, *op. cit.*, p. 10.

51. *Op. cit.*, p. 140 f., following F. Lugt.

52. Exh. New York – Toledo – Toronto, 1954–1955, no. 41.

53. *Ibid.*, no. 42.

54. *Ibid.*, no. 43. The figures are by Hobbema himself. The date 1669, given by HdG and by W. R. Valentiner in *Art in America*, II, 1914, p. 165, is erroneous.

55. *Op. cit.*, p. 151.

56. Not in HdG; B. no. 447 (with some doubts).

57. Simon retracted his reading 1670 (Th-B XXIX, p. 192) in favour of 1689 as given by Broulhiet no. 53 ('vérification faite en janvier 1936'), see *Zeitschrift für Kunstgeschichte*, IX, 1940, p. 206; MacLaren, Cat. London, p. 167, calls the date 'pretty surely 1689'. My own impression, many years ago, was that the date read 1681.

58. Also the *Landscape with Ruins* in the Corcoran Gallery in Washington, no. 26.100 (J. Breckenridge, Cat. 1955, p. 26), which HdG (no. 19) erroneously listed as being in the Frick Collection.

59. After Oppenheim in Collections Chillingworth and Nemes, since 1946 in Cincinnati. Exh. Kleykamp, The Hague, 1926, no. 22. The well-known, somewhat empty *Watermill* now in Ottawa (ex Steengracht Collection and Mauritshuis, HdG 73) must also be quite late (see Rosenberg, *op. cit.*, p. 151 and fig. 20).

60. Simon's attempt at a reconstruction of Koene's earlier output (*Zeitschrift für Kunstgeschichte*, IX, 1940, p. 207) has, in my opinion, been unsuccessful (*Art Quarterly*,

XXII, 1959, p. 18, note 15). Works by Balthasar van der Veen, who was much older than Hobbema (born in 1596/97!) but seems to have died considerably after 1657 (when he was a member of the Haarlem Guild), have recently been promoted to Hobbemas in increasing quantities. His signed pictures are correspondingly rare. See A. Bredius in *Oud Holland*, XII, 1894, p. 57 ff., and XIII, 1895, p. 128. A fully signed picture, which carries a number of so-called Hobbemas with it, was in 1955 at Alfred Brod's in London.

61. H. Gerson, *Koninck*, p. 35 ff. Only one (G. 29) is dated (1668).

62. The forest landscapes by Jan Vermeer van Haarlem are closely related to this group; excellent examples are in Munich (Bernt 917) and in the Czernin Collection, no. 131 (now Salzburg Residenz-Galerie, Cat. 1955, no. 135). It is interesting that a copy of Vermeer's picture in Aachen, no. 296 (not dated 1650; probably 1670), once passed as a Hobbema.

63. The landscape background of one of Potter's last pictures (1653, HdG 162; Duke of Bedford Collection, Exh. San Francisco, 1961, no. 16) is totally different; it recalls Dujardin (HdG) and van der Heyden. Potter's main landscape style is reflected in some works by the excellent Jan Lagoor, whose picture in London, no. 1008, bore a false Potter signature. His fine picture in Budapest (no. 261) is reproduced by Bernt (469).

64. An occasional woody landscape by Jan van der Heyden such as the (unsigned) *Farm among Trees* in London (no. 993; HdG 302) is somewhat comparable to van de Velde's by virtue of its light verticality and quiet stratification; more playful is the monogrammed *Landscape with Bathing Boys* of the Rijksmuseum in Enschede (J. B. Scholten Collection; Exh. Rotterdam, 1938, no. 87).

65. See below, p. 156

66. E. P. Richardson in *Bulletin of the Detroit Institute of Arts*, XXX, 1950–51, p. 66 f. The figures and animals are by A. van de Velde. The somewhat more 'open' *Forest Scene* in London (no. 829; HdG 18) is signed by Berchem, who painted the staffage.

CHAPTER II

WINTER

1. For the following see W. Stechow in *Criticism*, II, 1960, p. 175 ff.
2. René van Bastelaer, *Les Estampes de Peter Bruegel*, no. 205; the original drawing for this print, dated 1559, was published by L. Münz, *Bruegel, The Drawings*, no. 140, pl. 137.
3. Museum in Bergen, Norway, ill. in *Oud Holland*, LXXV, 1960, p. 81.
4. Clara J. Welcker, *Hendrick Avercamp*, p. 88.
5. James Thomson, *Seasons* (1730), *Winter*, vs. 765-768.
6. But Mieuwes, and Lientjen, and Jaapje, Klaes and Kloen [all boys]
 They were still dressed after the old fashion,
 In red, in white, in green,
 In grey, in dun, in purple, in blue,
 The way the peasants are.
 A. A. van Rijnbach, *Groot Lied-Boek van G. A. Brederode*, p. 35. Other examples from contemporary literature were given by J. G. van Gelder in the introduction to the catalogue of the exhibition 'Hollandsche winterlandschappen uit de zeventiende eeuw' at Goudstikker's, Amsterdam, 1932.
7. On the following see W. Stechow in *Oud Holland*, LXXV, 1960, p. 80 ff.
8. J. G. van Gelder and N. G. van Gelder-Schrijver in *Oudheidkundig Jaarboek*, I, 1932, p. 110 ff.
9. Good reproduction in Franz Roh, *Holländische Malerei*, fig. 119; Plietzsch 1960, fig. 151. This still has a *Summer* companion piece (Roh, fig. 118); see also van de Venne's *Four Seasons*, Amsterdam, nos. 2492-2495, dated 1625 (furniture panellings?).
10. Welcker, no. S5. Exhibited at Goudstikker's 1932, no. 6. A picture listed as being signed and dated 1629 in the Exh. Breda-Ghent, 1961, no. 7, does not seem to be by Avercamp.
11. Welcker, no. S28 and fig. XXIV.
12. Welcker, nos. T3 and T6, fig. 45; neither date (1620, 1630) is quite certain.
13. E.g., Edinburgh, Welcker, fig. 55. Avercamp's imitator and rival, Arent Arentsz (Cabel), of whom we have spoken before (p. 53), painted only a few winter landscapes, probably in the early twenties. The picture now in Toronto (Exh. Rotterdam,

1938, no. 50) is particularly fine; another is now in the Cologne Museum (no. 2835; Exh. Breda-Ghent, 1961, no. 3). In comparison, Barent Avercamp (1612/13-1679) and Anthonie Verstraelen (1593/94-1641) were both rather weak painters, although pictures by the former with dates after 1634 were often given to his father before the date of his death was known. Verstraelen's only claim to fame was founded on the misread (or mis-spelt) date 1603 of a picture in the Mauritshuis (no. 659; now usually read 1623).
14. W. Stechow in *Nederlandsch Kunsthistorisch Jaarboek*, I, 1947, p. 83 ff.; its present whereabouts is unknown; companion piece of our fig. 16.
15. My former contention that earlier representations of this scene had failed to connect it with a real winter landscape (*ibid.*, p. 86) was corrected by reference to Abel Grimmer by H. Gerson in *Oud Holland*, LXX, 1955, p. 134.
16. J. G. van Gelder, *Jan van de Velde*, p. 38 and fig. 15.
17. W. Stechow, *Nederl. Kunsth. Jaarboek, op. cit.*, p. 84, no. 2. Exh. 'The Young Rembrandt and his Times', Indianapolis–San Diego, 1958, no. 35.
18. 'The addition is just at the point of the abrupt ending of the tree on the left hand side' (kind communication from Mr. Ben F. Williams).
19. Reproduced in K. Zoege von Manteuffel, *Die Künstlerfamilie van de Velde*, p. 4.
20. See H. Volhard, *Die Grundtypen der Landschaftsbilder Jan van Goyens und ihre Entwicklung*, p. 51, concerning HdG 1156.
21. Sale in Kassel, May 9, 1892, no. 151; reproduced in E. Michel, *Les van de Velde* p. 17 (wrongly as in the Kassel Museum).
22. Its companion piece, HdG 740, is dated 1621.
23. HdG 1172; with its companion piece, HdG 357, since 1958 in the Rijksmuseum in Amsterdam; Exh. Leiden, 1960, no. 8; colour repr. in Exh. Cat. Hallsborough Galleries, summer 1958, no. 13. See note 26. The composition of this picture is still very closely related to that of Hans Bol's etching.

24. A notable small example of 1623 is in Col. F. G. Glyn's Collection (Exh. London, 1952–53, no. 236); its composition and colours still vividly recall the Berlin roundel of 1621.

25. I do not feel confident about any dates between 1627 (e.g., HdG 1182, now Foundation van der Vorm in Rotterdam, Cat. 1962, no. 31, unidentified) and 1641. HdG 1190 is dated 1627, not 1637 (see Cat. J. R. Bier in Haarlem, 1960, no. 8); HdG 1189 must be much later than 1630.

26. The picture is listed by Hofstede de Groot as no. 1666, but the description was made from the photograph of a different composition. The church in the background has been tentatively identified with Zaandvoort or Overschie (MacLaren, Cat. National Gallery 1960 and Exh. Leiden-Arnhem, 1960, no. 32).

27. E.g., London, no. 1327, HdG 46 (Dordrecht).

28. Reproduced in Oud Holland, LV, 1938, p. 205, and in van de Waal, Jan van Goyen, p. 35; strangely, HdG 1205 is entirely identical with 1165 in composition.

29. At B. Houthakker's in Amsterdam in 1936; not in HdG.

30. 1653: Exh. London, 1952–53, no. 232 (E. Assheton-Bennett Collection), a brilliant sketch, as is the picture of the same year in the Fentener van Vlissingen Collection in Worth Rheden, illustrated in Vier Generaties Nijstad, Lochem – The Hague, 1962; 1655: 1961 at H. Terry-Engell's in London, with a strongly emphasized tower on the right (Connoisseur, Oct. 1961, p. xxxix). All these not in HdG.

31. Sale R. H. Ward in Amsterdam, May 5, 1934, no. 145. His winter landscape in Haarlem (no. 260, reproduced by C. Müller in Berliner Museen, XLIX, 1928, p. 65) is evidently a 'late' work of his (i.e., shortly before 1635); it is of a surprisingly complete grey tonality and, like the one in the former Lanz Collection (Exh. Goudstikker, 1932, no. 84), stands somewhere between Esajas van de Velde and Aert van der Neer.

32. Date not given by HdG. Now Collection E. Bührle, Zürich (Exh. Schloss Jegenstorf, 1955, no. 13); Exh. Goudstikker, Amsterdam, 1932, no. 71.

33. No date given by HdG, no. 98. Appeared last in a sale at Paris, Dec. 15, 1958, no. 63.

34. HdG 881a; Collection Baron Rutger von Essen, Skokloster, Sweden; W. Stechow in Zeitschrift für bildende Kunst, LXII, 1928–29,

p. 174; Steen Exh., The Hague, 1958–59, no. 1. The picture was purchased for Marshall Wrangel at The Hague in 1651.

35. My chronology of the later works differs slightly from that of Eckhard Schaar, Studien zu Nicolaes Berchem, Diss. Cologne, 1958, p. 80 f., although I now agree with him on the late date of HdG 804 and the problematic nature of HdG 807 and HdG 812. But the date of HdG 815 is most probably 1650 (see next note), and its style differs from that of HdG 804, which seems to be of the sixties.

36. Now Collection E. Vromen, Forest Hills, L.I., New York. The picture is signed 'Berighem', a signature which does not occur on the artist's dated works after 1650, see W. Stechow in Festschrift Trautscholdt, p. 113. HdG read 1658, but the last digit is illegible, while the third is clear.

37. Of the same period as the picture of the Lugt Collection is the Summer-Winter pair in Leningrad, no. 1115, formerly wrongly attributed to Jan Both (HdG 70 and 315a); see the reproduction in H. Fekhner, Le Paysage hollandais . . ., pl. 84-85. The picture once in Schwerin (no. 2638; lost since 1945) and one in a private collection in England, which, as Ch. Steland has shown (Oud Holland, LXXIX, 1964, p. 99 ff.), served as a theme for two variations by Willem Schellinks (Amsterdam, no. 335, wrongly attributed to Asselijn but monogrammed W. S., and P. T. A. Swillens in Kunsthistorische Mededelingen, IV, 1949, p. 19 ff.) are dated ca. 1647 by Mrs. Steland, who feels that Berchem's Haarlem painting of that year (fig. 179) was already influenced by the Asselijn painting imitated by Schellinks. Whether the winter pictures attributed to Dujardin (HdG 369-369b) and Jan Hackaert (HdG 169) were really by these artists remains an open question.

38. On the sketchy treatment of the background of this painting see W. Martin in Burlington Magazine, X, 1906, p. 144. A similar E. van de Velde touch is still noticeable in a picture of 1644 (Apollo, LXXIX, April 1964, p. xxxviii).

39. J. Breckenridge, Dutch and Flemish Paintings in the William Andrews Clark Collection, p. 32.

40. The date '1655', read on the Mauritshuis picture HdG 494, must be abandoned (see Oud Holland, LXXV, 1960, p. 79 f.).

41. The date given in N. MacLaren's catalogue

of 1960 (mid-forties) seems too early to me.

42. Pictures of 1586 in Vienna (E. Heidrich, *Vlämische Malerei*, fig. 19) and of 1575 in sale Frankfurt, May 3, 1932, no. 112. A few examples from the fifteenth century exist.

43. *Adoration of the Magi*, Collection O. Reinhart, Winterthur.

44. Another example: Exh. San Francisco–Toledo–Boston, 1966/67, no. 52 (HdG 531). The Vienna picture has been doubted without sufficient cause.

45. E.g., HdG 583 and 584. HdG 579 (still in the Earl of Crawford's Collection) is much earlier but the nocturnal effect is almost negligible. Rafael Camphuysen's winter scenes are poor imitations, and certainly not anticipations, of van der Neer's (Leipzig, no. 996; Hoech sale, Munich, Sept. 19, 1892, no. 36). See below, p. 181. H. W. Schweickhardt (1746–97) painted some dangerous imitations after van der Neer.

46. See HdG, nos. 143-180, from which list several must be deleted (e.g., nos. 144, 174, and 177), while some others are doubtful; there are also some duplications: 149 = 171; 157 = 168; 147 = 163a = 178 ?).

47. Exh. Rotterdam, 1938, no. 61, and Eindhoven, 1948, no. 12. Dated 165-.

48. Reproduced in *Bulletin van het Rijksmuseum*, IX, 1961, p. 55. Another beautiful picture, perhaps a little later, is in the Liechtenstein Collection in Vaduz (no. 863; probably identical with HdG 147, 163a and 178). Jan van Kessel imitated this group of van de Cappelle paintings (Exh. Goudstikker, Amsterdam, 1932, nos. 39 and 40). Dated winter drawings by van de Cappelle exist from the years 1654 (Album Heyblocq, with Eeckhout's famous reference to van de Cappelle as being self-taught) and either 1652 or 1662 (Berlin, Bock-Rosenberg, no. 2425, pl. 79, as 1662, but the third digit is very different from the second).

49. Jakob Rosenberg, *Jacob van Ruisdael*, pp. 40, 55, 61.

50. D. Hannema, *Catalogue raisonné of the Pictures in the Collection of J. C. H. Heldring*, no. 26; from Collection van Valkenburg in Laren. Sold in London at Sotheby's, March 27, 1963, no. 14.

51. London, no. 1311, *The Castle of Muiden in Winter*. On this artist see also below, p. 99.

52. See note 63.

53. R. Hoecker, *Das Lehrgedicht des K. van Mander*, p. 202. For the literary and musical parallels see W. Stechow in *Criticism, op. cit.*, p. 183.

54. See Jakob Rosenberg in *Technical Studies* VIII, 1940, p. 193 ff.

55. E.g., HdG 1134 (Munich, no. 152).

56. HdG calls his nos. 1132 (Berlin, no. 900D) and 1137 (in 1959 at P. de Boer's in Amsterdam, repr. in cat.) early, but this remains debatable.

57. Colour reproduction in K. Zoege von Manteuffel, *Die Künstlerfamilie van de Velde*, p. 74.

58. W. Stechow, *Salomon van Ruysdael*, p. 25 f.

59. *Gemälde der Ruzicka-Stiftung*, Kunsthaus Zürich, 1949–50, no. 33, pl. XXXVIII.

60. Exh. Arnhem, 1960–61, no. 55 (erroneously as St. 27).

61. See above, p. 96. The problem of the several Beerstratens is still unsolved. The latest discussion in N. MacLaren's London catalogue of 1960, p. 12 ff., seems to have successfully settled the controversy about the 'two' *Jan* Beerstratens (there was only one). However, the Abraham – Anthonie question remains bothersome. If the picture in the Lanfranconi sale in Cologne, Oct. 21, 1895, no. 8, was actually signed by an 'A.' Beerstraten and dated 1671, it must have been done by a *third* (and very poor) artist of that name, since it does not go with either Abraham or Anthonie in style and date.

62. See below, p. 141. This includes a number of winter landscapes, e.g., by Jan Griffier (1645 or 1652–1718).

63. A few desultory winter landscapes by other masters may be briefly mentioned here:
 L. Bakhuyzen. HdG 478 (Copenhagen, no. 18) and 481 (reproduced in Cat. Exh. P. de Boer, summer, 1961, no. 4; a whaling party strongly reminiscent of works by *Abraham Hondius*, such as Cambridge, no. 355, on which see now A. Hentzen in *Jahrbuch der Hamburger Kunstsammlungen*, VIII, 1963, p. 45 and figs. 18, 19).
 A. Cuyp. The list in HdG, nos. 731-743a, has already shrunk and is in great need of further investigation. Nos. 734 (Dulwich, no. 181) and 735 (London, no. 3024) are now officially listed as by *Calraet*; nos. 737a-743a are either identical with others (733, 736, 737) or are untraceable. No. 732 was doubted by HdG himself, the title of no. 731 not capitalized by him. This leaves as undoubtedly genuine the admirable picture HdG 733 (Duke of Bedford Collection, reproduced in 'Paintings from

Woburn Abbey', The Arts Council of London, 1950, no. 20, pl. 11b; the almost identical picture from the L. de Rothschild Collection in London, HdG 736, now in the De Young Memorial Museum in San Francisco, is of doubtful authenticity), and the picture in the Yarborough Collection (HdG 737, Exh. London, 1952–53, no. 340; Bode 1921, p. 217).

H. Dubbels. A few works, see Willis, *Niederländische Marinemalerei*, p. 76, and Th-B (1913); one is dated 1655 (Exh. Goudstikker 1932, no. 29, strongly de Vliegerlike). Form of signature and style point to a different hand in the picture of the Summer Exhibition at P. de Boer's, Amsterdam, 1937, no. 19.

A. van Everdingen. Formerly Six Collection, Amsterdam (sale Oct. 16, 1928, no. 11). An amusing work of considerable originality, reminiscent of his finest drawings and etchings. See also above, p. 96.

J. van der Heyden. HdG 328-328c and another picture, dated 1700 or 1706, in sale Lachovski, New York, April 20, 1939, no. 17, and Hartveld, New York, Nov. 15, 1950, no. 19.

M. Hobbema. HdG 288. Collection Marquis of Bute. To judge from a photograph, this picture contains elements of Jacob van Ruisdael, Wouwerman, and van der Neer.

H. Saftleven. Kassel, no. 406, dated 1646,

with a pink-yellow evening sky, which shows the sudden influence of van der Neer's earliest experiments of this kind, see below, p. 177. A mountainous winter landscape done in 1648 (Herdringen Castle, see C. H. de Jonge in *Oudheidkundig Jaerboek*, I, 1932, p. 127 f. and fig. 7) belongs to a series of the *Four Seasons* and anticipates the artist's later style with its characteristic revival of Flemish tendencies of the early seventeenth century.

J. Steen. See above, p. 90 and note 34.

W. Schellinks. See above, note 37.

E. de Witte. It is understandable that a picture in the D. Hannema Collection, signed 'E. de Witte f.' (D. Hannema, *Kunst in de oude sfeer*, p. 81), should not have been fully accepted by Ilse Manke, *Emanuel de Witte*, no. 238 on p. 128 (title not capitalized) and text p. 55; it is somewhat reminiscent of Berchem. The picture attributed to de Witte in the Goudstikker Exh., Amsterdam, 1932, no. 95, was certainly not his. But an unfinished 'Winter' by de Witte did exist in 1669 (Bredius, K. I., p. 1839; I. Manke, *op. cit.*, p. 4 and p. 128, no. 237), and Miss Manke's attempt (*ibid.*, p. 55) to reconstruct its style on the basis of a signed winter landscape by *Hendrick van Streek* (illustrated in Bredius, K. I., p. 1342) has much to recommend it.

CHAPTER III

THE BEACH

1. E. Panofsky, *Early Netherlandish Painting*, p. 234 and fig. 297. Most probably this is part of the *Dutch* coast!

2. E. Panofsky, *Albrecht Dürer*, Princeton, 1943, p. 10.

3. J. Q. van Regteren Altena, *The Drawings of Jacques de Gheyn*, p. 56; H. van de Waal, *Drie eeuwen vaderlandsche geschied-uitbeelding*, I, p. 20; II, p. 8 f.; E. K. J. Reznicek, *Die Zeichnungen von Hendrick Goltzius*, p. 112, Cat. no. 419; E. F. van der Grinten in *Nederlands Kunsthistorisch Jaarboek*, XIII, 1962, p. 149 ff; W. Timm in *Staatliche Museen zu Berlin* [*East*], *Forschungen und Berichte*, III/IV, 1961, p. 76 ff.

4. E. Haverkamp Begemann, *Willem Buytewech*, p. 29 f.

5. Not signed but certainly by de Gheyn: *Handzeichnungen alter Meister im Städelschen Kunstinstitut*, 1911, no. 8. It is significant that this quick drawing was the happy by-product of elaborate studies which de Gheyn made at the beach near The Hague for Swanenburch's print with Prince Maurits' ultra-modern sailing coach (Hollstein, de Gheyn 63); see van Regteren Altena, *op. cit.*, p. 90. In contrast, a *Rocky Shore* of 1605 by Abraham Bloemaert in the Lugt Collection (Exh. London, 1929, no. 525, and Brussels, 1937, no. 28, pl. xx) is a

decidedly Mannerist work in the tradition of the earlier Goltzius and C. C. van Wieringen (see Exh. Collection P. van Eeghen, Amsterdam, 1958, no. 123, fig. 7).

6. The picture attributed to Porcellis by Eric C. Palmer in *The Connoisseur*, CXLV, June 1960, p. 11 f., fig. 5, now in the Maritime Museum in Greenwich, is not signed, its attribution debatable, and its date (which has been read 1622) retouched.

7. Exh. New York–Toledo–Toronto, 1954/55, no. 90. The arrival of the same expedition in Holland was represented in seascapes proper by Abraham de Verwer (Collection de Geus van den Heuvel, Exh. Arnhem, 1961, no. 77) and H. Vroom (Haarlem, no. 300); a beach by Vroom, comparable to that of Willaerts, was in the Weber and Coray-Stoop Collections (sale Lausanne, July 29, 1925, no. 31).

8. The picture was with W. E. Duits, Amsterdam, in 1923; H. van de Waal, *Jan van Goyen*, p. 9. It was preceded by a nearly square one of 1621, which is even more strictly *genre*-like, with figures reminiscent of the 'Pseudo-van de Venne' (not in HdG; Exh. in Villa Hügel, Essen, 1953, p. 11, no. 4).

9. Berlin; Bock-Rosenberg, no. 2736.

10. Not in St.; new acquisition of the Metropolitan Museum in New York, formerly Collection R. L. Joseph. Reproduced in *New Masters from Old Holland*, Exh. at the Mortimer Brandt Gallery, New York, 1941, no. 24.

11. St. 271 (wrongly dated 1662 on the basis of the sale cat. of 1879). The picture reappeared at F. Mont's in New York in 1948.

12. Some beach scenes by Hendrick Anthonissen belong in this group, see, e.g., Cambridge, Cat. 1960, no. 43, pl. 2 (the date suggested there, *ca.* 1628/30, seems too early to me), which was once attributed to Salomon van Ruysdael.

13. Before 1938 at G. Stein's in Paris; H. van de Waal, *op. cit.*, p. 47.

14. Van Goyen, HdG 239 (1646); Dubois, Haarlem, no. 25 (1647).

15. See C. Hofstede de Groot in *Burlington Magazine*, XLII, 1923, p. 16. On one of the (not infrequent) cases of confusion between van Goyen and van der Hulst see HdG, van Goyen, no. 233. Works by G. Dubois (1647: Haarlem, no. 25; 1649: Aachen, no. 125) follow similar patterns. On E. van der Poel see below, note 36. Salomon van Ruysdael

joined this trend in a few minor works of his late period (1662: St. 272; 1665: St. 275), but reverted to the view with the receding coast, with a small curving area of water appearing in one segment only, in others, mostly in upright format (1660: St. 31/32; 1663: St. 35/36).

16. In 1953, at P. de Boer's in Amsterdam; sale in London (Christie's), July 2, 1965, no. 134.

17. In 1942 on the Swiss art market.

18. Ex Collection Sir Bruce Ingram. Reproduced in Gerson, I, fig. 137; also *Burlington Magazine*, XCV, 1953, p. 49, fig. 17.

19. In 1952 at A. Brod's in London.

20. Eric C. Palmer, *op. cit.*, Exh. London, 1952/ 1953, no. 212.

21. Similar masterpieces in the former Kappel Collection (sale Berlin, Nov. 25, 1930, no. 24) and in the Collection P. van Leeuwen Boomkamp in Hilversum, Exh. Rotterdam, 1955, no. 134, fig. 25. But perhaps the greatest achievement of de Vlieger as interpreter of the Dutch coast is the incomparable late drawing in the Lugt Collection in Paris (Exh. Brussels, 1961, no. 45, pl. XXX), which, as its owner states in the catalogue, is a convincing example of the influence of painting upon drawing (although I suspect that we have here a reflection of Jan van de Cappelle's rather than de Vlieger's own paintings; see below p. 117).

22. Ex Cook Collection; Exh. Worcester, 1951, no. 24. Elizabeth Smith, 'An Early Landscape by Ruisdael' in *Art Quarterly*, XIV, 1951, p. 359 f.

23. Exh. London, 1929, no. 225, without date; the identification with HdG 52 there proposed is very uncertain.

24. I am not certain enough of the date of St. 268 to consider the picture prophetic of Jacob. St. 279, still similar in structure, already belongs to the early sixties and may have been 're-influenced' by Jacob van Ruisdael.

25. *Gemälde der Ruzicka-Stiftung*, Kunsthaus Zürich, 1949–50, no. 31. On Everdingen's somewhat comparable (probably earlier) seascape in Chantilly see below p. 121 and fg. 246.

26. Similar paintings in the von Pannwitz Collection (HdG 926, Ros. 568; Exh. Rotterdam, 1945–46, no. 40) and in the former Stroganoff Collection (HdG 931d?, sale Berlin, May 12, 1931, no. 75).

27. Rosenberg, *Ruisdael*, p. 60, has proposed Gerard van Battem as the author of the

figures in the von Pannwitz picture; on this difficulty problem see now MacLaren in Cat. London, 1960, p. 365.

28. Exh. Rotterdam, 1945–46, no. 14; New York–Toledo–Toronto, 1954–55, no. 18. Comparison with the scanty dates on Jan van de Cappelle's seascapes (below, p. 117) suggests the years around 1655/60.

29. Exh. Rotterdam, 1945–46, no. 48; Arnhem, 1961, no. 72.

30. Reproduced in H. P. Baard, *Willem van de Velde de Oude, Willem van de Velde de Jonge*, p. 43. Now Collection Henle in Duisburg (Exh. Cologne, 1964, no. 41).

31. Reproduced in F. C. Willis, *Die niederländische Marinemalerei*, p. XXII; Exh. London, 1929, no. 274.

32. Exh. Rotterdam, 1955, no. 130; also repr. in Baard, *op. cit.*, p. 46. The Rotterdam Cat. of 1962 suggests that the figures might be by Adriaen.

33. Probably identical with HdG A. van de Velde 362 and W. van de Velde 14.

34. Ex Cook Collection; Cat. Hannema 1950, no. 101, pl. 32; Exh. Rotterdam, 1955, no. 131. Cat. 1962, no. 81.

35. E.g., Leipzig, no. 348.

36. Kassel, no. 287; one of the rare dated examples (1660) was in the sale in Lucerne, July 26, 1926, no. 171.

37. Exh. Paris, 1950–51, no. 24. Other beach scenes in the same collection, in Amsterdam (no. 905 D 2), at Kleykamp's, The Hague, 1929, no. 12, at de Boer's in Amsterdam, 1932, etc.; see also S. J. Gudlaugsson in *Oud Holland*, LXVI, 1951, p. 62 f.

38. This trend is already noticeable in a picture of 1649 by van Goyen in the Marquis of Bute Collection (HdG 238). A characteristic *Embarkation at Scheveningen* by C. Beelt, signed and dated 1660, was in the Stuart sale, Amsterdam, Dec. 1930, no. 2.

CHAPTER IV

THE SEA

1. F. C. Willis, *Die niederländische Marinemalerei*.

2. Sir Lionel Preston, *Sea and River Painter of the Netherlands*. Cf. also W. Waetzoldt in *Neue Beiträge deutscher Forschung, Wilhelm Worringer zum 60. Geburtstag*, p. 224 ff.

3. A few seascapes by Allaert van Everdingen can be added to this – not by accident, as will be shown below, p. 121.

4. Although they are usually not discussed or tend to be dated too early or too late. Works of this kind were done by Jan Porcellis (Hampton Court, see Preston, fig. 17), Hendrick Anthonissen, Abraham Willaerts (1644: Exh. 'The Young Rembrandt and his Times', Indianapolis–San Diego, 1958, no. 90), and others, quite apart from the pen grisailles of Willem van de Velde the Elder and Experiens Sillemans.

5. J. G. van Gelder in *Kunstmuseets Aarsskrift*, XXIV, 1937, fig. 3.

6. See the short summary by H. Gerson in *Art and Architecture in Belgium, 1600 to 1800* p. 157 f.

7. Th-B (1940); H. van de Waal, *Drie eeuwen vaderlandsche geschied-uitbeelding*, I, p. 246.

8. On this, and the early designs for tapestries with the defeat of the Spanish Armada,

today known from eighteenth-century engravings only, see Willis, p. 17 ff.

9. Eric C. Palmer in *Connoisseur*, CXLV, June 1960, p. 11 f., fig. 1; exh. London, 1952/53, no. 604. Now in the Greenwich National Maritime Museum.

10. J. Held in Th-B (1933). A monograph on this great artist is urgently needed. Still indispensable: A. Bredius, 'Johannes Porcellis' in *Oud Holland*, XXIII, 1905, p. 69 ff., and XXIV, 1906, p. 129 ff., 248 ff.

11. See note 14.

12. Cat. 1929, no. 75; reproduced by Bernt 651. The picture was doubted, without sufficient foundation, by A. Bredius in *Oud Holland*, XXIV, 1906, p. 137.

13. Quoted in *Oud Holland*, XXIII, 1905, p. 69. C. Huygens called him 'much superior to Vroom' as early as 1631. For Samuel Hoogstraeten he was still 'dien grooten Raphel in 't Zeeschilderen' (*Oud Holland*, XXIV, 1906, p. 134). On his etchings of this early period see L. Burchard, *Die holländischen Radierer vor Rembrandt*, p. 82.

14. P. Reuterswärd, in *Konsthistorisk Tidskrift*, 1956, p. 97 ff. If the date 1622 on a picture by Porcellis (sale in Munich, Feb. 16, 1928, no. 463; see Held in Th-B, 1933) has been

read correctly, the main idea of the Munich picture of 1629 was developed seven years earlier; sailing-boats are here revealed through a window with an opened shutter.

15. New acquisition, 1951. Signed: I PORCEL 1629.

16. Willis, p. 38 (wrongly as no. 836).

17. With Thos. Agnew & Sons in 1960 (Summer Exh., no. 31). The town in the distance is not Dordrecht but possibly Leiden. The seascapes of Abraham van Beyeren, mostly undated but for a panel of 1641 and the curious votive tablet of 1649 in Maassluis (I. Bergström, *Dutch Still-Life Painting*, p. 312, note 4, and p. 229 f. with fig. 191), continued this stylistic trend.

18. A similar seascape of the same year, but in oblong format, in Chicago, no. 33.1078 (HdG 1079); the Cat. of 1961 erroneously gives the date 1633.

19. HdG lists thirteen such pictures from this one year. One of them even seems to betray a direct influence from the group around the late de Vlieger, van de Cappelle and W. van de Velde: the *Cannonshot* of the former de Ridder Collection (HdG 1026; sale Paris, June 2, 1924, no. 22).

20. Willis, p. 52 (wrongly dated 1655).

21. W. Stechow, *Salomon van Ruysdael*, p. 26 f.

22. H. V(ollmer) in Th-B (1940); Bode 1921, p. 252 ff.

23. J. Rosenberg in *Fogg Art Museum, Harvard University, Annual Report*, 1953/54, p. 8. See also Dresden, no. 1549, reproduced by Willis, pl. x. The monogram which appears before the date 1624 in the oval picture in Leningrad (no. 1026) cannot readily be identified with de Vlieger's; the attribution has been doubted by HdG and Willis (p. 46). The picture is reproduced in Bode, 1921, p. 248, and Bode-Plietzsch, 1951, p. 323, as by de Vlieger. A monograph on de Vlieger, an urgent desideratum, is being prepared by Jan Kelch, Berlin.

24. Göttingen, no. 188 (1637) and Kloster Melk (etched by Ossenbeeck, Hollstein 30).

25. The alternative '1634' (Bode-Plietzsch, 1951, p. 330, note) is out of the question.

26. A compositionally and colouristically unusual combination of river view and seascape, dated 1642, is in Detroit (no. 243; reproduced in *Art Quarterly*, IV, 1941, p. 280).

27. Reproduced *ibid.*, p. 283.

28. Hofstede de Groot, *Cat. rais.*, VII; W. R.

Valentiner in *Art Quarterly*, IV, 1941, p. 272 ff. Still indispensable: A. Bredius in *Oud Holland*, X, 1892, p. 27 ff. and 133 ff.; Bode 1921, p. 257 ff.

29. W. Stechow in *Festschrift Trautscholdt*, p. 115 f.

30. Exh. London, 1929, no. 262: 'Signed I. V. Capel 1645' (a reading with which I agreed at that time); the same in Exh. Paris, 1950/1951, no. 13; colour reproduction in *Apollo*, Sept. 1928, cover.

31. See also above, p. 206, with regard to de Vlieger's extraordinary drawing in the Lugt Collection, which may reflect van de Cappelle's paintings of *ca.* 1651.

32. Reproduced in the 'Souvenir' of the Exh. London, 1938, no. 193.

33. Reproduced in Preston, fig. 61.

34. Collection Marquis of Zetland. No date was given by de Groot, but see the Catalogue of the Exh. London, 1929, no. 295, and *The Connoisseur*, CLIII, January 1963, p. 37, with repr.

35. See below, p. 177. There exist only a few pictures by van de Cappelle in upright format, probably all rather late, e.g., HdG 129i (now Barber Institute of Fine Arts, Birmingham, Cat. 1952, p. 14) and 142b (now Kenwood, no. 45).

36. *Oud Holland*, X, 1892, p. 87 f.

37. Reproduced by Hollstein, IV, p. 87, no. 1, from the (unique?) impression in the British Museum. To my mind it refutes all other attributions of etchings to the master (*ibid.*, nos. 2-11. See also Cat. Exh. Rotterdam III, 1944, p. 13 ff.).

38. The false signature of Cuyp and date 1641 on Leningrad no. 6828 (Cat. 1958) were removed during a cleaning in 1959, and the picture is more probably by de Vlieger (kind communication from Dr. Kuznetsow).

39. See the marvellous characterization by Eugène Fromentin, *Les Maîtres d'autrefois*, 1875, p. 246.

40. Hofstede de Groot, *Cat. rais.*, VII (1918); Bode, 1921, p. 263 ff.; H. P. Baard, *Willem van de Velde de Oude, Willem van de Velde de Jonge*; K. Zoege von Manteuffel, *Die Künstlerfamilie van de Velde*, p. 40 ff.

41. Reproduced by Zoege von Manteuffel, *op. cit.*, p. 45.

42. Reproduced in the Cat. of the Exh. at Agnew's in London, 1957, no. 20.

43. Reproduced by Willis, pl. XXIII; now in the van Holthe Collection in Aerdenhout (Exh. Milan, 1954, no. 169).

44. On Dubbels (1621?–1676?) see the very sympathetic account of Willis, p. 72 ff., and N. MacLaren in the London Catalogue of 1960, where the picture no. 2587, formerly attributed to van de Cappelle (HdG 38), is given to him.

45. Colour reproduction in Zoege von Manteuffel, *op. cit.*, p. 55.

46. Hofstede de Groot, *Cat. rais.* VII. In spite of the fact that this fertile artist, a pupil of H. Dubbels, painted a number of excellent seascapes, particularly in his earlier years, I think it can be justifiably said that he made no significant contribution to the history of marine painting in the sense in which this is true of other masters discussed in this chapter.

47. *Handlist of Paintings*, 1949, no. 3.

48. HdG mentions a now unfindable but not impossible date 1692.

49. Ilse Manke, *Emanuel de Witte*, p. 55 f., Cat. no. 234, fig. 89.

50. *Ibid.*, Cat. no. 215, fig. 56.

51. Jakob Rosenberg, *Jacob van Ruisdael*, p. 44, 55, 59; K. E. Simon, *Jacob van Ruisdael*, p. 55 ff.

52. Sale Hoech, Munich, Sept. 19, 1892, no. 64; see also below, p. 143.

53. Reproduced by Willis, pl. XVII. A composition by Ruisdael which exists in two identical versions (HdG 945, Ros. 579, and HdG 960, Ros. 595, now in Dublin) seems especially indebted to this work.

54. Hofstede de Groot, *Cat. rais.* IV, nos. 938-984 f; Ros. nos. 574-601.

55. To this phase must belong the beautiful picture in the Collection of Sir Edward Bacon (HdG 948, Ros. 583), a rare case of (slightly) upright format among Ruisdael's seascapes. Hendrick Sorgh's fine *Storm on the Maas* of 1668 in Amsterdam (no. 2215) seems to provide a *terminus ante quem* for these works by Ruisdael.

56. *Bulletin, Museum of Fine Arts Boston*, LVI, 1958, p. 145 f., with colour reproduction.

57. Paris, no. 2558, HdG 961, Ros. 596 ; Berlin, no. 884, HdG 941, Ros. 576, destroyed in 1945.

58. Reproduced by Willis, pl. XXIX.

59. Bakhuyzen: Exh. Detroit, 1942, no. 45 and pl. 6; also HdG 480, and HdG 481 (1961 at P. de Boer's in Amsterdam, Summer Cat., no. 4).

60. Abraham Hondius, Cambridge, no. 355 (dated *ca.* 1677 with reference to Hondius's *Frozen Thames* of that year).

CHAPTER V

THE TOWN

1. Rolf Fritz, *Das Stadt- und Strassenbild in der holländischen Malerei des 17. Jahrhunderts*, Diss. Berlin, 1932.

2. See below, p. 125.

3. W. Stechow, Th-B (1935); P. T. A. Swillens, *Pieter Janszoon Saenredam*; Exh. 'Nederlandse Architectuurschilders', Utrecht, 1953; Plietzsch, 1960, p. 117 ff.; Exh. Pieter Jansz. Saenredam, Utrecht, 1961 (with complete *Catalogue raisonné*).

4. Exh. Utrecht, 1961, nos. 145 and 147 (paintings); nos. 146 and 148 (drawings).

5. An outstanding example is *St. Mary's Square* of 1636 (*ibid.*, no. 144).

6. J. Q. van Regteren Altena in *Oud Holland*, LXVIII, 1931, p. 1 ff.; Plietzsch, 1960, p. 123; Exh. Utrecht, 1961, nos. 111, 113, 114.

7. Drawing and painting are reproduced together in the Exh. Cat. Utrecht, 1961, figs. 13 and 14.

8. A characteristic example is reproduced in

P. T. A. Swillens *Johannes Vermeer*, pl. 41a.

9. N. MacLaren in the London Cat. of 1960, p. 183 f.

10. HdG 878, Exh. The Hague, 1958/59, no. 7.

11. First pointed out by R. Fritz, *op. cit.*, p. 71 ff.

12. Swillens, *Vermeer*, p. 90 ff.

13. *Cat. rais.* VIII, p. 326 f. and Th-B (1924). Further literature on Jan van der Heyden: Cat. Exh. van der Heyden, Amsterdam (Hist. Mus.), 1937; Cat. Exh. Utrecht 1953.

14. Special attention is drawn to HdG 153 of 1667, a perfect little jewel, prophetic of much of van der Heyden's eighteenth- and nineteenth-century progeny (reproduced in Exh. Cat. Utrecht 1953, no. 43).

15. No firm conclusion can be drawn from the antique motifs found in some of his late works (a spectacular example is HdG 290, which reminds one of Isaac Moucheron; at Goudstikker's in April 1930, no. 26). The

attribution of the figures in this painting to Adriaen van de Velde, who died in 1672, is as absurd as it is in many other cases; it is clear that the late van der Heyden imitated van de Velde's style very skilfully, as de Groot has pointed out (VIII, 1927, p. 328).

16. The picture, now in the E. Assheton-Bennett Collection, has turned out to be dated 1694 – an important help for a (still badly needed) van der Heyden chronology (see also preceding note).

17. On this aspect and the pertinent etchings see the Exh. Cat. Amsterdam, 1937.

18. Another painting in London (no. 992, HdG 279) is a complete fantasy incorporating a Corinthian gateway and a pseudo-Gothic brick palace. This picture, too, seems to me much later than the costumes would indicate (late 1660's); the figures are certainly not by A. van de Velde but by van der Heyden himself.

19. (Ernst Brochhagen), *Holländische Meister aus der Staatlichen Kunsthalle Karlsruhe*, 1960, no. 28. The figures are neither by Lingelbach (Cat. 1920) nor by A. van de Velde (W. Bode) but probably by van der Heyden himself.

20. Ex ten Cate Collection; Exh. Amsterdam, 1937, no. 19 (mistakenly reproduced as no. 18, which was also in the ten Cate Collection, now in Los Angeles, Cat. 1954, no. 75, HdG 42); Exh. New York-Toledo-Toronto 1954/55, no. 40.

21. Exhibition Rotterdam, 1934, no. 95; Utrecht 1953, no. 102. With its signature covered up, the picture had previously been attributed to P. de Hooch. The article on Vosmaer in Th-B (1940) is highly unsatisfactory, but see now Susan Donahue in *Vassar Journal of Undergraduate Studies*, XIX, 1964, p. 18 ff. He was already active in Delft in 1645 (Bredius, K. I. VII, p. 270). The *View of Den Briel*, now in Detroit, no. 963, is another remarkable work of his, and his renderings of the Delft catastrophe (Hartford, dated 1654, also Bernt 966; probably

also the background of the de Hooch, HdG 317, see C. Brière-Misme in *Gazette des Beaux-Arts*, 1927, II, p. 56) are superior to those of van der Poel.

21a. See next note and K. M. Birkmeyer in *Bulletin California Palace Legion of Honor*, XII, 1954.

22. His *View of the Dam* of 1697 was something of a sensation in the Dreesmann sale in Amsterdam, March 22, 1960.

22a. See now W. Stechow in the Cleveland *Bulletin*, LII, 1965, p. 164 ff., and I. H. v(an) E(eghen) in *Amstelodamum*, LIII, 1966, p. 52 ff. Another early city view is H. ten Oever's *Keizersgracht* in the Mauritshuis, mentioned as early as 1664.

23. I. H. van Eeghen in *Oud Holland*, LXVIII, 1953, p. 120 ff., who therefore dated the picture before 1662; but see N. MacLaren in the London cat. of 1960, p. 173, who dates *ca.* 1665. The second version, in a private collection in Amsterdam, is a copy; see also MacLaren, *ibid.*, p. 174 and note 13.

24. I am exempting from this the picture in Budapest, no. 4278 (Ros. 3 and fig. 80; HdG 15 and 692c?), which is surely earlier but not a town view proper.

25. K. E. Simon, *Jacob van Ruisdael*, p. 65 f. The drawing is now in Amsterdam (see *Verslagen der Rijksverzamelingen van Geschiedenis en Kunst*, 1962, p. 35 with reproduction).

26. See H. Gerson in the Cambridge Cat. of 1960, also with regard to the Philips painting (reproduced in *Oud Holland*, XLIX, 1932, p. 177).

27. This one is in upright format; reproduced by W. Martin, *Dutch Painting of the Great Period*, pl. 275.

28. One striking example: Utrecht, no. 1087. Van der Neer used the same kind of prospect, seen from the New Bridge and minus the sailing-boats, for a spectacular conflagration scene by night (HdG 9, Copenhagen no. 497; Exh. Amsterdam, 1925, no. 429 with repr. in the Cat.).

CHAPTER VI

IMAGINARY SCENES

1. Van Mander-Floerke, I, p. 254 f.
2. E.g., Antwerp, no. 30.
3. The well-known picture in Detroit, no. 729,

now labelled 'Manner of H. Seghers', contains elements in its background which relate it closely to the works of de Keuninck.

4. W. Stechow in *Art Bulletin*, XXXVI, 1954, p. 243.

5. *Die Zeichnungen von Hendrick Goltzius*, p. 107 ff.

6. K. G. Boon, *De schilders voor Rembrandt*, p. 21. A drawing by de Gheyn in Berlin (Bock-Rosenberg, no. 4177 and pl. 24) is closely related to Goltzius's chiaroscuro woodcut, H. 379.

7. Van Mander-Floerke, II, p. 126.

8. As Goltzius reproduced in J. G. van Gelder, *Jan van de Velde*, fig. 2; on this drawing see now: Exh. *Hercules Seghers en zijn voorlopers*, Amsterdam, 1967, no. V, 31.

9. Exh. Rotterdam, 1954, no. 2.

10. Exh. Rotterdam, 1954, no. 4, with the older literature and a detailed discussion of Rembrandt's share in the picture; Exh. Dutch Painting of the Golden Age, New York–Toledo–Toronto, 1954–55, no. 75.

11. Chiaroscuro woodcut H. 378 (ill. in O. Hirschmann, *Hendrick Goltzius* [Meister der Graphik, VII], Leipzig, 1919, fig. 72).

12. Exh. Rotterdam, 1954, no. 5.

13. I am excluding here the controversial landscapes attributed to Seghers in London (no. 4383; now as 'Style of H. Seghers') and in the Brediushuis in The Hague (with the remains of a signature containing the letters I (?), V; see MacLaren in the London Cat. of 1960 under no. 4383); they need further investigation but I cannot easily imagine their being vindicated as works by Seghers.

14. Our knowledge of this artist is scanty, and the article in Th-B (1931) is quite obsolete. Hofstede de Groot, *Oude Kunst*, I, 1915/16, p. 213 (see also *idem*, *Burlington Magazine*, XLII, 1923, p. 21) was mistaken in asserting that none of his works is of the Flemish type; many signed examples are now known, see Arthur Laes in *Bulletin*, *Musées Royaux des Beaux-Arts*, Brussels, I, 1954, p. 57 ff. (Frans is here called a nephew of Joos, for which there seems to be no documentary evidence.) Hofstede de Groot mentions a picture of 1634 which is already Dutch in character, but this does not mean that all of his 'Flemish' works must have been done before that date. Gerson, *Pelican History*, p. 151 and note 21.

15. A very Seghers-like painting was at P. de Boer's in Amsterdam in 1953. See also W. Stechow in *Art Bulletin*, XXXVI, 1954, p. 241.

16. Certainly not 1639. For this type see also Guilliam Dubois, Berlin East, no. 1038.

17. *Oud Holland*, LXX, 1955, p. 131 ff. A similar painting in Haarlem, no. 274b. A rather wild 'Southern Coast' of 1628 in Lübeck was once called Lucas van Valckenborgh! A signed mountain fantasy, 1928 at Dr. Benedict's in Berlin, is particularly reminiscent of Joos de Momper as well as of Seghers, with two solitary fir trees, a high bridge over a ravine, an old fort etc.

18. From sales Kneppelhout-van Braam (Amsterdam, Dec. 16, 1919, no. 73) and A. W. M. Mensing (Amsterdam, Nov. 15, 1938, no. 72).

19. D. Hannema, *Catalogue of the Pictures in the Collection of Willem van der Vorm*, Rotterdam, 1950, no. 67 and pl. 10 (measurements wrongly given as 26·5 × 59 cm; *recte* 62·5 × 59, see Cat. 1962, no. 55).

20. Br. 442 and 443 are dated 1638; a *terminus ante* for this type is further provided by Adriaen van Ostade's picture of 1639 in the van der Vorm Collection in Rotterdam (Cat. Hannema 1950, no. 69, pl. 24; Cat. 1962, no. 58).

21. Exh. Rotterdam, 1954, no. 2.

22. The *terminus ante* of 1651 is provided by Philips Koninck's picture in the Reinhart Collection in Winterthur (G. 60), which clearly depends on it; see p. 137.

23. HdG 952; the picture was not admitted to Bredius's corpus. Although it has been rarely doubted in print (W. von Seidlitz in *Kunst und Künstler*, X, 1912, p. 27; W. Martin, *Kunstwanderer*, Sept. 1921) it is no secret that it is being looked at askance by several outstanding Dutch authorities.

24. *Christ and the Samaritan Woman* of 1655 in New York (Br. 589), in spite of its totally different subject, seems to offer remarkable analogies in treatment of landscape and colour.

25. *Philips Koninck*, p. 17.

26. *Ibid.*, p. 133, no. XXXI.

27. K. Lilienfeld, *Arent de Gelder*, no. 20.

28. HdG 664 = 701; Ros. 413.

29. P. 19 and fig. 22. Now Collection Thurkow, The Hague, Exh. Dordrecht, 1963, no. 134, pl. 57.

30. Rosenberg, p. 26 f.; Simon, p. 29.

31. 1957 in the Amsterdam and London trade.

32. The basic literature consists of: J. Rosenberg, *Art in America*, XIV, 1926, p. 37 ff.; *idem*, *Jacob van Ruisdael*, p. 30 ff.; K. E. Simon, *Jacob van Ruisdael*, p. 31 f.; J. Zwarts, *Oudheidkundig Jaarboek*, VIII, 1928,

p. 232 ff.; H. Gerson, *Burlington Magazine*, LXV, 1934, p. 79; K. E. Simon, *Das siebente Jahrzehnt, Festschrift zum 70. Geburtstag von Adolph Goldschmidt*, p. 158 ff.; H. Rosenau, *Oud Holland*, LXXIII, 1958, p. 241 f. It seems to me that the style of the two pictures, regardless of their sequence, speaks with absolute clarity against the attempt (see most recently H. Rosenau, *op. cit.*) to date them after the destruction of the Ouderkerk church spire in 1674. Miss Rosenau's argument that it is characteristic of Ruisdael to transform a real event into a fantasy of this kind rather than imagining it outright is valid, but could be applied to this case only if we were sure that Ruisdael had *never* seen a building struck by lightning; there is no need to hold him to the catastrophe that befell that particular church since Ruisdael himself has not identified it clearly. If it be argued that the pictures should be placed late because their attitude differs from that of Ruisdael's other works of the fifties and sixties, one would have to stress the fact that Ruisdael's production during the seventies, though authenticated by one date only (1678; fig. 148), can now convincingly be

gauged from a considerable number of works that cannot possibly have been done at any other time and which are totally different in style and even, in most cases, in quality, from the *Jewish Cemetery*. Hobbema's *Avenue of Middelharnis* is 'typically late' as a *formal tour de force* (p. 32); there is nothing 'typically late' in these works by Ruisdael, neither from the formal nor from the 'inner' point of view.

33. On this subject see now Seymour Slive in *Daedalus*, Summer 1962, p. 469 ff.

34. Written in 1813, first published in 1816. *Goethes Werke*, Hamburg (C. Wegner), XII, 1953, text on p. 138 ff. and commentary by H. von Einem on p. 611 ff.

35. *Ibid.*, p. 612, and C. von Lorck in *Westdeutsches Jahrbuch für Kunstgeschichte (Wallraf-Richartz-Jahrbuch)*, IX, 1936, p. 205 ff. A preparatory drawing for Lessing's picture is in the Cincinnati Museum.

36. See below, p. 167 and fig. 341. It is also different from Saftleven's picture with the same subject in Edinburgh (no. 1508; dated 1642), which is decidedly less archaic in style; its landscape is more Italianate, somewhere between Breenbergh and Both.

CHAPTER VII

TYROL AND SCANDINAVIA

1. K. Erasmus, *Roelant Savery*, Diss. Halle, 1908; K. Zoege von Manteuffel in Th-B (1935); P. Eeckhout, *Cat. Exh. Roelandt Savery*, Ghent, 1954; W. Stechow in *Bulletin John Herron Art Institute, Indianapolis*, XLIV, 1957, p. 46 ff.: g. Bialostocki in *Bulletin, Musées Royaux des Beaux-Arts*, Brussels, 1958, p. 69 ff.

2. Exh. Sammlung Schloss Rohoncz, Munich, 1930, no. 294.

3. E.g., Munich, no. 271 of 1609 (replica of 1610 in Dresden, no. 929), Exh. Ghent, 1954, no. 12.

4. Drawings of 1624 in Stockholm and of 1626 in Berlin (Bock-Rosenberg, no. 5410, pl. 205); the latter, however, looks more Scandinavian than Tyrolean (influence of Goeteeris-Frisius prints of 1619?). For the paintings, see above, p. 134; their Alpine features are intermingled with influences from Seghers's fantastic vistas. For Savery reminiscences in works by Adriaen Bloe-

maert see W. Stechow in *Allen Memorial Art Museum Bulletin* XXII, 1964-65, p. 5 f. The Swiss studies of Hackaert and others in the second half of the century (S. Stelling-Michaud, *Unbekannte Schweizer Landschaften aus dem XVII. Jahrhundert*) do not seem to have left clearly recognizable traces in painting.

5. It is not without significance that a drawing by Savery in Amsterdam (Exh. Ghent, 1954, no. 120) bears a false Everdingen signature.

6. A monograph on Everdingen is greatly needed. For the older literature see E. Plietzsch in Th-B (1915); Jakob Rosenberg, *Jacob van Ruisdael*, p. 42 ff.; K. E. Simon, *Jacob van Ruisdael*, p. 60 ff.; K. E. Steneberg, *Kristinatidens Måleri*, pp. 118 ff.

7. See, e.g., the painting of *ca.* 1630 in Karlsruhe (no. 1850), reproduced in *Holländische Meister aus der Staatlichen Kunsthalle Karlsruhe*, 1960, no. 7; though somewhat Scan-

dinavian-looking, it is probably indebted to Savery's Alpine vistas.

8. 1640: Hoech sale, Munich, Sept. 19, 1892, no. 64, see above, p. 121; 1643: Art dealer Stern in Düsseldorf, 1934, no. 32.

9. Exh. London, 1952–53, no. 197 (Collection Eric C. Palmer).

10. J. S. Held in *Konsthistorisk Tidskrift*, VI, 1937, p. 41 ff. Belatedly I see that a drawing of Österrisör, Norway, is dated 1644 (Exh. Dutch and Flemish Drawings, Stockholm 1953, no. 232).

11. Last digit uncertain; read 1656 by the catalogue of 1960, but the alternative 1650 still looks attractive, also in view of the Munich picture of 1650, see fig. 287 and note 14.

12. He signed a document concerning the value of some paintings by J. M. Molenaer in Haarlem on April 26, 1655 (Bredius, K. I., p. 17 f.), but this does not prove that he still resided there. See also next note.

13. If this is true, Everdingen's residence in Amsterdam by 1655 becomes very probable. Lingelbach had returned from Italy in 1650, continued to live in Amsterdam until his death in 1674, and was widely employed as a *staffage* painter.

14. A photograph of the signature kindly provided by Dr. E. Brochhagen shows a clear o as the last digit (see Wurzbach's correct facsimile, I, p. 498), not a 6 as read by the Munich catalogues and by F. Roh, *Holländische Malerei*, fig. 152. The picture is at present on loan to Castle Leutstetten.

15. *Jacob van Ruisdael*, p. 42 ff. Simon's denial

of this relationship (*Jacob van Ruisdael*, p. 60 f.) seems to me unfounded.

16. MacLaren, Cat. London 1960, p. 354, mentions 1659 as the earliest date for a Ruisdael *Waterfall* but does not identify the picture.

17. *Op. cit.*, p. 43.

18. Jakob Rosenberg in *Fogg Art Museum, Harvard University, Annual Report, 1952–53*, p. 11. A very similar painting, unaccountably declared an eighteenth-century copy by Simon (p. 80), is in Cambridge, no. 63, pl. 56 of the Cat. of 1960 (HdG 210, Ros. 149).

19. 'Ruisdael als Dichter', 1816 (see above, p. 140 and note 34). See also the beautiful passage on Ruisdael's 'air de plénitude, de certitude, de paix profonde' in E. Fromentin, *Les Maîtres d'autrefois*, p. 231.

20. A closely related picture is Ros. 132 (his fig. 99), 1928, at Dr. Benedict's in Berlin. It seems that some of these late pictures have been doubted mainly because of their disappointing quality (e.g., the one in Schwerin, no. 910, HdG 289, Ros. 246, see Simon, p. 74). It is true that some works by Jan van Kessel are hardly inferior to these but his name has been too often substituted for Ruisdael's without sufficient evidence (e.g., in the case of Dulwich, no. 105, HdG 247, Ros. 190, see Simon, p. 74). More unanimity has been achieved in attributions to the more easily recognizable Jacob Salomonsz van Ruysdael (e.g., HdG 240, London, no. 628; see Ros. p. 116, note 11, and Simon, p. 74).

CHAPTER VIII

THE ITALIAN SCENE

1. For the documentation of this and the next paragraph see W. Stechow in *Magazine of Art*, XLVI, 1953, p. 131 ff. (reprinted with different illustrations in *Actes du XVIIᵉ Congrès International d'Histoire de l'Art*, The Hague, 1955, p. 430 ff.). The Jan van de Cappelle is HdG 108, now in the Spencer-Churchill Collection (see p. 117); the Both, HdG 2. The appreciation of these painters in the seventeenth century is in need of investigation. Sandrart was enthusiastic about the beginnings; Houbraken, writing in 1718, quotes him with regard to Jan Both (ed. of 1753, II, p. 114) and says of Asselijn:

'He was one of the first to bring to Holland the clear and light style of landscape painting, in the manner of Glands (sic) Lorain' (*ibid.*, I, p. 64).

2. See H. Gerson in *Burlington Magazine*, XCV, 1953, p. 51, who points to the neglect of Jan Both even then. Just before going to press, the Catalogue of the Exhibition 'Nederlandse 17e Eeuwse Italianiserende Landschapschilders', Utrecht, Centraal Museum, 1965, becomes available to me, and I am able to insert a few references to this important work with which I find myself in basic agreement on the more essential points

of this chapter as it had been written. I shall refrain from the harping on small differences of opinion which unfortunately is a specialty of that catalogue; for two exceptions (notes 52 and 59) I plead self-defence. The exhibition was severely criticized in the review it has just received in the *Burlington Magazine*, CVII, 1965, p. 271 ff. (J. Nieuwstraten).

3. Fokker in Th-B (1933) gives the birth date as 'ca. 1586'; G. J. Hoogewerff, *De Bentvueghels*, as '1586' on p. 45 and 'ca. 1595' on p. 151; on the greater probability of the latter see E. Schaar in *Mitteilungen des kunsthistorischen Institutes in Florenz*, IX, 1959, p. 27 ff. The unprinted dissertation (London, 1954) by Kirsten Aschengreen, *Dutch Italianate Landscape Painting in the first half of the Seventeenth Century*, has remained unknown to me; its main thesis has been summarized repeatedly, see now Cat. Exh. Utrecht, 1965, passim. See further Plietzsch, 1960, p. 133 ff.

4. Poem in Album de Geest, see Hoogewerff, *op. cit.*, p. 45 f.

5. This seems to follow from the fact that in Florence he met Callot, who left in that year. The 'Cornelio pittore', who was still in Rome in 1625 (Hoogewerff, *Nederlandsche Kunstenaars te Rome*, p. 95), may well have been somebody else.

6. Schaar (*op. cit.*, p. 42) suggests 1625; the picture in Utrecht (fig. 290) was probably painted after his return, see below.

7. See note 3.

8. The attribution of this picture to Breenbergh (*Toledo Museum News*, Fall 1957, p. 11) seemed to be supported by the picture in the Louvre, Villot 55, which I once erroneously attributed to this painter (*Jahrbuch der Preussischen Kunstsammlungen*, LI, 1930, p. 135); Schaar (p. 36 ff.) has correctly restored the latter work and similar ones of 1620 to Poelenburgh.

9. No. 216; the Catalogue reads (16) 26.

10. A painting with the date 1643 in Helsinki (*Katalog öfver Finska Konstföreningens Samlingar*, 1898, no. 242a, without date), is, to judge from a photograph, of doubtful authenticity.

11. Henry V. S. Ogden and Margaret S. Ogden, *English Taste in Landscape in the Seventeenth Century*, passim.

12. C. H. de Jonge in *Oudheidkundig Jaarboek*, I, 1932, p. 120 ff.

13. HdG (Berchem 365) considers the whole

picture to have been painted by Berchem, but the landscape is undoubtedly the work of Poelenburgh, as can be seen most clearly from a comparison with Berchem HdG 358 of 1656 (Amsterdam), in which the landscape is totally different, whereas, strangely enough, the animals are exactly the same (the human figure in the Kassel picture is certainly not by Berchem). For the collaboration of Poelenburgh with Keirincx see above, p. 199 above.

14. On the more independent style of the relatively few landscapes by M. Uyttenbroeck, who came from the early Dutch Elsheimer circle and showed distinct influences from Poelenburgh (and Breenbergh) only in his later works, see now Ulrich Weisner in *Oud Holland*, LXXIX, 1964, p. 189 ff.

15. Berlin, nos. 956 and 958; Castle Grunewald, Cat. 1964, nos. 22 and 118. Illa Budde, *Die Idylle im holländischen Barock* (reviewed by W. Stechow, *Kritische Berichte zur kunstgeschichtlichen Literatur*, 1928–29, p. 181 ff.).

16. See note 3.

17. Schaar, *op. cit.*, fig. 30.

18. *Ibid.*, fig. 31. On a (tenuous) connection between the early Breenbergh and Jan Pijnas see now R. Klessmann in *Berliner Museen*, XV, 1965, p. 7 ff.

19. *Moses and Aaron change the Water of the Rivers into Blood* (Exodus 7, 14 ff.), J. Paul Getty Museum, Malibu, Cal., identical with the picture mentioned by A. Pigler, *Barockthemen*, I, p. 96; E. Feinblatt in *Art Quarterly*, XII, 1949, p. 266 ff. See also Hannover, no. 31, and Karlsruhe, no. 228, both of 1637.

20. On these phases see W. Stechow (see note 8), p. 136 ff.

21. The Frisian painter Jacobus Mancadan (*ca.* 1602–80) shows in his (semi-) Italianate pictures a somewhat similar mixture of stylistic features of the first and second generations. See A. Heppner in *Oud Holland*, LI, 1934, p. 210 ff.; Plietzsch, 1960, p. 105 f.; Cat. Exh. Utrecht, 1965, nos. 42–43.

22. For the main literature until 1960 see M. Waddingham in *Paragone*, XI, no. 121, 1960, p. 37 ff. (with many new attributions), and W. Stechow, in *Oud Holland*, LXXV, 1960, p. 83 ff.; furthermore L. Salerno in *Burlington Magazine*, CII, 1960, p. 27 (Berlin, no. 432, datable before 1638); M. D. Henkel in *Zeitschrift für bildende Kunst*, LVIII, 1924–

1925, p. 153 ff.; M. Röthlisberger, *Claude Lorrain*, 1961, passim.

23. This reading of the date is suggested in Cat. Exh. Utrecht, 1965, under no. 41, and is indeed more plausible (see no. 39 of the same exhibition which is dated 1643 and was perhaps still painted in Rome, as its signature seems to suggest).

24. Signed with monogram and F. P. (fecit Paris) 1646. With G. Cramer at The Hague, 1957. A very similar *Thunderstorm* of 1649 is in Dresden (*Holländische und vlämische Meister des 17. Jahrhunderts, Fünfzig Neuerwerbungen*, 1962, no. 39, fig. 28). The oval painting of the Louvre (Villot, no. 507), which was exhibited at Nancy, 1957, no. 77, comes from the decoration of the Hôtel Lambert, on which Swanevelt and Asselijn were working about 1646, according to E. Brunetti, *Burlington Magazine*, C, 1958, p. 316 (Th-B gives the date 1644 for this activity of Swanevelt).

25. H. Gerson in *Oud Holland*, LXXI, 1956, p. 113 ff.

26. E. Brunetti in *Paragone*, VII, no. 79, 1956, p. 50; see also Exh. Cat. Utrecht, 1965, p. 101. Dulwich no. 136 has 'Paris 1644', and its companion piece, no. 219, 'Paris 164'. (not 1625 or 1655, see Th-B).

27. Sale Oppenheimer, London, July 10, 1936, no. 317, signed 'Roma' and therefore surely 1636; see also the drawing of the same date in the Dutuit Collection (F. Lugt, *Les Dessins des écoles du Nord de la Collection Dutuit*, Paris, 1927, no. 73, pl. XXXIX).

28. A similarly bold drawing is in the Lugt Collection (Exh. Brussels, 1937, no. 57 and pl. XXXVIII).

29. I have attempted to show this in *Kritische Berichte zur kunstgeschichtlichen Literatur*, 1928–29, p. 181 ff.

30. The attribution of these figures to Andries (Exh. at Wildenstein's, London, 1955, no. 11, after Hoogewerff) is in my opinion quite unjustified.

31. Charlotte Steland-Stief, *Jan Asselijn*, Diss. Freiburg i. B., 1963 (unpublished). I am much indebted to Mrs. Steland for making her text and photographic material accessible to me with the greatest liberality. She has also pointed out that the traditional birthdate 1610 lacks proof and credibility; Asselijn's first dated picture is of 1634.

32. C. Hofstede de Groot, *Beschr. u. krit. Verz.*, IX, 1926; Eckhard Schaar in *Oud Holland*, LXIX, 1954, p. 241 ff.; idem, *Studien zu*

Nicolaes Berchem, Diss. Cologne, 1958; Plietzsch, 1960, p. 147 ff.; U. I. Kuznetsov in *Festschrift V. Lazarev*, Moscow, 1960, p. 325 ff. The book by Ilse von Sick, *Nicolaes Berchem, ein Vorläufer des Rokoko*, is to be used with caution.

33. W. Stechow in *Magazine of Art* (see note 1; some passages of this article are here reprinted); Lia de Bruyn in *Oud Holland*, LXVII, 1952, p. 110 ff.; Plietzsch, 1960, p. 152 ff.; M. Waddingham, *op. cit.* (note 22); Eckhart Knab in *Bulletin Museum Boymans-van Beuningen*, Rotterdam XIII, 1962, p. 46 ff.; M. Waddingham in *Paragone*, XV, no. 171, 1964, p. 13 ff. The information given by M. Röthlisberger that Both stayed in Rome until 1649 (*Claude Lorrain*, I, pp. 97 and 196) is erroneous.

34. However, Waddingham's suggestion of Jan's and Andries' collaboration in a painting in Budapest (no. 296 as Pieter van Laer) has much to recommend it (*Paragone*, XV, no. 171, 1964, p. 21).

35. I have previously stated (see note 1) that the picture in New York, no. B 651 (HdG 62) is neither dated nor by Both; the *Hunting Party* once in Berlin (no. 863, destroyed in 1945; HdG 44) was by an imitator (already doubted by de Groot). But see below p. 155 and note 39.

36. The question of the influence of this important master (1599 – after 1642) on the *landscapes* of Both, Asselijn and others must remain open, because we know next to nothing about his landscapes proper. The one in Bremen (Exh. Utrecht, 1965, no. 35) remains debatable and may in any case post-date some painted by Both after his return to Holland.

37. M. Röthlisberger, *Claude Lorrain*, I, p. 141, dates 1637, rather than 1631 as I think I can read, but this question must remain open, as in the case of other dates from the thirties. On the relationship between Both and Claude see now also A. Knab, *op. cit.* (note 33) and the more radical view of the Catalogue of the Exhibition Utrecht, 1965, p. 30 ff.

38. On this see Waddingham in *Paragone*, XV, no. 171, 1964, p. 13 ff.

39. The excellent Pigage read the date 1651; first read 1650 by W. Schmidt in *Jahrbücher für Kunstwissenschaft*, V, 1873, p. 51, confirmed by Dr. E. Brochhagen. The attribution of the figures to Knupfer was first made by K. E. Simon in *Pantheon*, XXVI, 1940,

p. 162, note 3; see also HdG 15, 16 (repr. in Bernt 122) and C. Willnau in *Oud Holland*, LXVII, 1952, p. 210 ff. (who confuses HdG 14 with HdG 16 on p. 215). On the relationship between Jan Steen's earlier landscapes (if one can call them that) and the Both-Knupfer tradition see H. Gerson in *Kunsthistorische Mededelingen*, III, 1948, p. 51 ff.; later works by Steen point to a great variety of other influences upon his landscape vision.

40. See note 32.

41. Smith, Both, 14, but also Berchem, suppl. 33; Schaar, *op. cit.*, p. 62; Exh. Indianapolis, 1960, no. 14.

42. No. 1004, HdG 173 (without date); Plietzsch 1960, fig. 259.

43. Schaar, *op. cit.*, p. 26; the Hannover Catalogue of 1954 dates '*ca.* 1650-60', which is certainly too late. For the interpretation of Berchem's signatures in terms of chronology see W. Stechow in *Festschrift Trautscholdt*, p. 113 ff.

44. G. J. Hoogewerff in Th-B (1922); Hofstede de Groot, *Beschr. u. krit. Verz.*, IX, 1926; S. Stelling-Michaud, *Unbekannte Schweizer Landschaften aus dem XVII. Jahrhundert*; Exh. Cat. Utrecht, 1965, p. 217.

45. De Groot and the Berlin catalogue of 1906 (not that of 1837) say: 'dated 1668'; Dr. C. Müller Hofstede kindly informed me that there is not even a trace of a date to be found on it.

46. Paintings dated 1670, 1674 and 1685 are mentioned by de Groot (nos. 161, 169, 167A) but none of them is known to me. Judging by their difference from his main works and the hardening of their technique, pictures like the *Woody Landscape with a Horseman* in the Ascott Collection (photo Courtauld C 55/20) seem to belong to the end of his career.

47. Th-B (1931); Exh. Cat. Utrecht, 1965, p. 219 (with another dated picture of 1668, no. 139).

48. See two paintings dated 1681: Dijon (Magnin Cat., 1922, no. 142), and sale Berlin, April 1, 1930, pl. 25.

49. R. Juynboll in Th-B (1933); Hofstede de Groot, *Beschr. u. krit. Verz.*, IX, 1926; Plietzsch, 1960, p. 135 ff.; W. Stechow in *Oud Holland*, LXXV, 1960, p. 90 ff. – The 'Dutch' picture in Leipzig (no. 1053, HdG 100), which I accepted as an early work in my article (note 50), has a suspicious signature and must be eliminated from Pijnacker's œuvre; its photograph is filed under Jan Snellinck in the Rijksbureau.

50. Reproduced in *Oud Holland*, LXXV, 1960, p. 89. I wonder whether the date 1653 on the picture in the Collection Lord Farington at Buscot Park (photo Courtauld B 62/605) has been read correctly; the picture looks later.

51. Reproduced in *Oud Holland*, LXXV, 1960, p. 90.

52. 1661: HdG 128 (the picture of this year reproduced by me, *ibid.*, p. 91, is doubted by the Exh. Cat. Utrecht, 1965, p. 193); 1670: Collection Prince Liechtenstein, Vaduz (not in HdG). The latter is called 'schematic and uninspired' by the Exh. Cat. Utrecht, 1965, under no. 116; I submit that this is a matter of taste and that the implication, by the writers of the same catalogue (no. 113), that I had disparaged the Munich picture of 1659 because of its 'unrealistic' character is wholly unjustified.

53. HdG Pijnacker 76, which represents the bridge across the Tyeron at Francheville near Lyon (drawn by Asselijn, Moucheron and Jan Wils). Reproduced in the *Souvenir* of the London Exh. of 1938, no. 265; also Exh. London, 1952/53, no. 472, and Manchester, 1957, no. 111.

54. Another version, signed and dated 1661, is HdG 128.

55. For Lake Trasimene see note 58. On the other hand, Berchem HdG 286 (dated 1659) has just been identified as in the vicinity of Allumiere (Latium) by E. Schaar (*Zeitschrift für Kunstgeschichte*, XXVI, 1963, p. 61).

56. Steengracht sale, Paris, June 9, 1913, no. 1, with excellent plate; sale Goudstikker, Berlin, Dec. 3, 1940, no. 20.

57. Reproduced in Ellis Waterhouse, *Italian Baroque Painting*, London, 1962, p. 41. This (or a very similar) picture, in turn, must have been the inspiration of Poelenburgh's *Glorification of St. Catherine* in Utrecht (no. 13101), a late work of his (Exh. Utrecht, 1965, no. 22).

58. I am retaining the traditional title of this picture, but proof of it seems to be lacking. The preparatory drawing can be fairly well reconstructed after the *View of Rapperswil*, reproduced in Stelling-Michaud, *op. cit.* (note 44), pl. 5.

59. It is difficult to understand how the Exh. Cat. Utrecht, 1965, no. 138, can specifically deny this connection.

60. Hofstede de Groot, *Beschr. u. krit. Verz.*, IX, 1926; Ernst Brochhagen in *Bulletin*,

Musées Royaux des Beaux-Arts, Brussels, VI, 1957, p. 236 ff.; *idem, Karel Dujardin*, Diss. Cologne, 1958; Plietzsch, 1960, p. 155 ff.

61. There have even been cases of confusion between Dujardin and Asselijn; see Brochhagen, *Brussels Bulletin, op. cit.*, p. 249, and HdG Dujardin 317a (now Rotterdam, Bank voor Handel en Scheepvaart), which Mrs. Steland has attributed to Asselijn. A signed picture by Moucheron (ex Cook Collection, later with G. Cramer, The Hague) is so closely related to a Dujardin in the Vienna Akademie (Brochhagen, *ibid.*, fig. 6) that one must assume a contact between them; since the Cook picture seems to show figures by the hand of Lingelbach, who died in 1674, Moucheron must be granted priority over Dujardin if Brochhagen's dating (*ca.* 1676) is correct.

62. For example, HdG 494 of 1652 or (rather) 1655 (Exh. Cardiff, 1960, no. 8; Bernt 67), HdG 387 of 1658, and HdG 134.

63. Etching B.32 of 1652; drawing of 1657 (=HdG 212; see Brochhagen, *op. cit.* [Diss.] p. 50).

64. Brochhagen, *Brussels Bulletin, op. cit.*, p. 249 and fig. 17. I am eliminating with regret and some qualms Dujardin's enchanting *Young Shepherd* in the Mauritshuis (HdG 58), a widely known masterpiece with a great mountain massif in the background but basically a *genre* picture.

65. Most of HdG 71 – 108. E. Schaar, *op. cit.* (Diss.), passim. The landscape is increasingly subordinated to the *genre* scene, starting with the earliest examples of 1654 and ending with some that are datable as late as *ca.* 1670.

66. W. Stechow in *Art Quarterly*, XI, 1948, p. 186 ff.; Plietzsch, 1960, figs. 236-237.

67. However, there exist harbour scenes by this master in which nature predominates (e.g., Mainz, no. 107, Exh. Speyer, 1957, no. 119). The paintings of this little known, underrated artist are invariably undated. See now Exh. Cat. Utrecht, 1965, p. 144 ff.

68. I. Manke, *Emanuel de Witte*, Cat. nos. 212 and 215, figs. 56 and 58.

69. H. Gerson, *Ausbreitung*, p. 524 ff.; R. van Luttervelt in *Bulletin Rijksmuseum*, III, 1955, p. 9 ff.

70. Weenix; Paris no. 2609; Berchem, HdG 71 (now in Hartford, Conn.).

71. E.g., the picture of 1659 in Braunschweig, reproduced in Fred C. Willis, *Niederländische Marinemalerei*, pl. XXIX.

72. Cat. Eigenberger, 1927, no. 761. Mrs. Steland has pointed out that Weenix's *influence* on Asselijn was strongest during the last years of the latter's activity.

73. Schwerin, no. 2219, dated 1647; one of two small, early companion pieces in the Collection of the Duke of Buccleuch.

74. For this interpretation of the signature see W. Stechow in *Festschrift Trautscholdt*, p. 113 ff.; the dates of nos. 75 to 77 of the Exh. Cat. Utrecht, 1965, are too uncertain to affect the proposals made in that article. The spelling Berchem (with a c) does not occur on *certain* signatures before 1656.

75. Exh. Zürich, 1949/50, no. 1.

76. Reproduced in colour in H. Fekhner, *Le Paysage hollandais.*

77. Not in HdG (hardly identical with HdG 46); from Collection Lady Cosmo-Bevan. Published by C. C. C(unningham) in *Wadsworth Atheneum Bulletin*, March, 1952, p. 1. Dated as late as *ca.* 1670 in Exh. Cat. Utrecht, 1965, p. 186. The very similar painting from the Ashburnham Collection was sold in London (Sotheby) on June 24, 1953, no. 79.

78. *Oud Holland*, LXXV, 1960, p. 88.

79. John L. Severance Bequest, Cat. 1942, p. 21, no. 3. The description in HdG contains some errors, and the picture engraved in the Galerie Lebrun is the similar one recently acquired by the Mauritshuis (no. 963). The Cleveland picture must date *ca.* 1650 or little later.

80. W. Hutton, *Toledo Museum News*, Autumn, 1961, p. 79 ff. (with colour repr.).

81. E. Brochhagen, *op. cit.* (Diss.), p. 5, assumes that van de Velde's turning to the Italianate trend was due to the influence of Dujardin; his article on this subject (announced in his note 37) has not yet appeared.

82. Seymour Slive in *Art Quarterly*, XIX, 1956, p. 2 ff.

83. In the early version in Schwerin (1659; HdG 8) the classical French component is surprisingly strong for that date; it is distinctly less pronounced in the Munich version of 1667 (no 1853; HdG 344).

84. Cat. Doughty House, II, no. 371. In 1959 with G. Cramer at The Hague. Exh. Sheffield, 1956, no. 53.

85. In 1954 with Agnew's in London.

86. For instance, HdG 40=246=304. Collection Simon Morrison, Exh. London 1938, no. 208 (reproduced in the *Souvenir*).

218 NOTES TO PAGES 163–168

87. The date of the picture in sale A. E. H. Digby, London (Sotheby's), June 20, 1951, no. 41 (not in HdG) must have been misread as 1656.
88. Sir George Scharf, *Catalogue of the Pictures at Woburn Abbey*, 1875, no. 91. Not in HdG; in 1953 at D. Koetser's in New York.
89. Particularly by Ida Ledermann, *Beiträge* ..., as the very title of her thesis indicates. The Exh. Cat. Utrecht, 1965, likewise rejects this thesis (p. 34).
89a. This theory, likewise proposed by Ida Ledermann, is given considerable credence by the Exh. Cat. Utrecht, 1965, p. 35 f., partly on the basis of a remark by Houbraken (see above, note 1) the importance of which seems to have been overrated.
89b. See J. A. Emmens, *Rembrandt en de regels van de kunst*, 1964, p. 127.
90. De Groot, *Cat. Rais.* v, 1913; Th-B (1931).
91. If this picture is really the companion piece of Munich no. 5240 (HdG 166), the date of the latter (1702) would apply to it as well. A painting of 1700 (HdG 180) is reproduced in the Schwerin Cat. of 1962. The picture in Karlsruhe, no. 277, which HdG (no. 8) mistakenly called a 'copy after Elsheimer', is reproduced by Bernt (591); it, too, seems to be related to Breenbergh as well as to Elsheimer and Swanevelt. It was even once attributed to Elsheimer; see further Heinrich Weizsäcker, *Adam Elsheimer*, II, Berlin, 1952, p. 92, no. 99. On the use of Elsheimer elements in the art of Jan Vermeer van Haarlem the Younger (1656–1705) see E. Trautscholdt in Th-B (1940).
92. Dirksen in Th-B (1921). Houbraken (1753), III, p. 216 ff., was well informed about Glauber.

93. Reproduced by Kurt Gerstenberg, *Die ideale Landschaftsmalerei*, pl. XXXVII, 2. Together with three other pictures of the series (nos. 2083-2085) attributed to Bloemaert in 1746!
94. See also the pictures reproduced by Illa Budde, *Die Idylle im holländischen Barock*, fig. 26 (also by Gerstenberg, *op. cit.*, pl. XLIV, 2), and by Bernt (310), both in Munich (nos. 897 and 244, respectively); further, one in Kassel (no. 413; Gerstenberg, *op. cit.*, pl. XLII, 1), and the large mythological canvases from Soestdijk Palace in the Rijksmuseum (one reproduced in J. J. M. Timmers, *A History of Dutch Life and Art*, London, 1959, fig. 433) and in the Mauritshuis.
95. There exists a rare state of B.1 with the date 1695 (Weigel, Suppl. to Bartsch, p. 280). M. D. H(enkel) in Th-B (1930). Another painting formerly in Hamburg (no. 466) is reproduced by Gerstenberg (*op. cit.*, p. 137, pl. XXXVIII, 2), who stresses its soft, atmospheric effect.
96. G. J. Hoogewerff in Th-B (1924).
97. See, for instance, fig. 24 in Illa Budde, *op. cit.*, and Kassel no. 409. Gerstenberg, *op. cit.*, p. 134 f. and pl. XXXIV, 2.
98. Willem van Mieris's own landscapes belong for the most part in the Saftleven-Griffier tradition and in the eighteenth century. Hofstede de Groot, *Beschr. u. krit. Verz.*, x, 1928. HdG 428, dated 1729, was reproduced in *Weltkunst*, Oct 1, 1962, p. 25.
99. Hofstede de Groot in Th-B (1925) and *Beschr. u. krit. Verz.*, x, 1928.
100. Exh. Nancy, 1957, no. 38.
101. Reproduced in Illa Budde, *op. cit.*, fig. 28.
102. *Beschr. u. krit. Verz.*, x, 1928, p. 336.

CHAPTER IX
OTHER FOREIGN SCENES

1. Catalogues of: Exh. *Deutsche Landschaften und Städtebilder in der Niederländischen Kunst des 16. bis 18. Jahrhunderts*, Krefeld, 1938; Exh. *Niederrheinansichten holländischer Künstler des 17. Jahrhunderts*, Düsseldorf, 1953; Exh. *Rheinische Landschaften und Städtebilder 1600–1850*, Bonn, 1960/61. I am not including here the motifs from Rhenish *towns* painted by Jan van der Heyden, on which see above, p. 126.

2. W. Stechow, Th-B (1935); *De Werken van J. van den Vondel*, ed. J. van Lennep, p. 341.
3. Exh. Bonn, 1960/61, no. 119.
4. There may be some connection here with works by Joos Droochsloot of Utrecht.
5. Hamburg, no. 289, dated 1697; Exh. Bonn, 1960/61, no. 176.
6. Henry V. S. Ogden and Margaret S. Ogden, *English Taste in Landscape in the Seventeenth Century*, Ann Arbor, 1955, passim.

7. Exh. Bonn, 1960/61, no. 37 with good colour reproduction (detail).
8. On de Jongh see John Hayes in *Burlington Magazine*, XCVIII, 1956, p. 3 ff.; on the other artists, H. and M. Ogden, *op. cit.*, particularly p. 112 ff. No Dutch landscape painters of the seventeenth century were more highly appreciated in contemporary England than Herman Saftleven and Jan Griffier.
9. See, e.g., the view of the famous bridge near Francheville in representations by Asselijn, Moucheron, Jan Wils and Pijnacker, mentioned in note 53, above, p. 216, Gerson, *Ausbreitung*, p. 41 ff.
10. S. Stelling-Michaud, *op. cit.*; Gerson, *Ausbreitung*, p. 353 ff. – Hofstede de Groot's dream of a documented itinerary of Hercules Seghers through Switzerland has not been fulfilled (see E. Trautscholdt in *Pantheon*, XXV, 1940, p. 81 ff.).
11. For Seghers's *View of Brussels* see p. 38; for Jan van der Heyden's impressions from the same city, p. 126.
12. For Asselijn's picture in Amsterdam see above, p. 160.
13. See above, p. 159.
14. Haarlem, no. 499; Jakob Rosenberg in *Jahrbuch der Preussischen Kunstsammlungen*, XLIX, 1928, p. 102 ff., fig. 1.
15. R. C. Smith, Jr., in *Art Quarterly*, I, 1938, p. 239 ff.; J. de Sousa-Leão, *Frans Post*; Gerson, *Ausbreitung*, p. 553 ff.; E. Plietzsch, 1960, p. 112 ff.; E. Larsen, *Frans Post, interprète du Brésil* (reviewed by J. G. van Gelder, *Oud Holland*, LXXVIII, 1963, p. 77 ff.).
16. Even the drawings in the British Museum, Cat. Hind, IV, 1931, p. 25 f., are placed in the post-Brazilian period by van Gelder (*ibid.*).
17. E.g., the extraordinary picture in Amsterdam, no. 1906A3 (Plietzsch, 1960, fig. 199 and Smith, *op. cit.*, p. 238).
18. E.g., the two Louvre pictures reproduced by Plietzsch, *ibid.*, figs. 196 and 197; Smith, pp. 244 and 249.
19. Above, p. 38.
20. Th. Thomsen, *Albert Eckhout*; Gerson, *Ausbreitung*, p. 554; Plietzsch, 1960, p. 112 f.
21. Compare the similar phenomenon in Griffier's picture discussed above (p. 165).
22. Reproduced by Plietzsch 1960, fig. 195 and in *Holländische Maler des XVII. Jahrhunderts im Mecklenburgischen Landesmuseum*, Schwerin, 1951, no. 212, pl. XXIX.

CHAPTER X

NOCTURNES

1. E. Panofsky, *Early Netherlandish Painting*, p. 236 and fig. 298.
2. J. A. Graf Raczyński, *Die flämische Landschaft vor Rubens*, p. 64 f. and fig. 29, as 'The Magic Garden of Armida'. Called 'Pyramus and Thisbe' in Exh. Berlin, Schaeffer Galleries, 1927, no. 50. Both titles are wrong, but I do not know the correct one.
3. Dubois was born in Antwerp. For illustrations of his nocturnal *Aethiopica* scenes see L. Dimier, *Histoire de la peinture française des origines au retour de Vouet*, pl. LVIII, and W. Stechow in *Journal of the Warburg and Courtauld Institutes*, XVI, 1953, pl. 16b. Works by David Teniers (Hamburg, no. 176; identical with both HdG Brouwer 234 and van der Neer 201A!), Daniel Heil and others come readily to mind. However, Teniers's charming *Flight into Egypt by Night* (Bonn, no. 36.183, reproduced in *Pantheon*, XXII, 1938, p. 240; in the Cat. of 1959 as 'David Teniers the Elder?') is clearly indebted to Elsheimer.
4. The status of the more sketch-like picture of the Gulbenkian Collection, now in Lisbon (Cat. Washington, 1950, no. 91) remains to be re-assessed.
5. A characteristic work which reflects all these sources is A. Bloemaert's *Nativity* of 1604 in Göttingen, no. 12, on which see now J. Richard Judson, *Gerrit van Honthorst*, p. 4 ff. and fig. 52. On the importance of Jacopo Bassano in particular see *ibid.*, p. 8 ff., and A. Buchelius's *Res Pictoriae*, ed. Hoogewerff and van Regteren Altena, p. 82.
6. E. Haverkamp Begemann, *Willem Buytewech*, cat. nos. 23 and CP 35, figs. 137 and 139.
7. Above the trees, upper left. A moon crescent occurs in Jan Saenredam's *Judith*, after Goltzius (B. 44) and in Rembrandt's etching

B. 75, see Alfred G. Roth, *Die Gestirne in der Landschaftsmalerei des Abendlandes*, p. 301 ff.; see also W. Heimbach's *Return from the Flight into Egypt* in Budapest (A. Pigler in *Kunsthistorische Mededelingen*, II, 1947, p. 8 ff.).

8. Van Mander-Floerke, II, p. 70.

9. Amsterdam, de Waag (on loan from the Rijksmuseum, no. 705); C. A. L. Sander, 'Het Dulhuys of dolhuys aan de vesten of de Kloveniersburgwal', *Maandblad Amstelodamum*, XLV, 1958, p. 229 ff.

10. Not preserved; see Seymour Slive, *Art Bulletin*, XXXIX, 1957, p. 314. I do not know the print by Frisius after Vinckboons with a carnival at night near a frozen canal, Hollstein 232.

11. Van der Kellen 110 and 111; the latter reproduced in K. Zoege von Manteuffel, *Die Künstlerfamilie van de Velde*, p. 20. The moonlit landscape which hangs on the wall of a *Gay Party* of 1628 by Dirk Hals looks more like a fantasy on a Jan van de Velde etching than a real painting; W. Stechow in *Nederlands Kunsthistorisch Jaarboek*, XI, 1960, p. 168 f. and fig. 1.

12. Later nocturnal scenes by Molijn do not add to his stature in this field; see on these S. J. Gudlaugsson, *Katalog der Gemälde Gerard Ter Borchs*, p. 57. M. F. de Boer occasionally continued this trend (picture at P. de Boer's in Amsterdam, 1962).

13. Collection E. C. Palmer in London, Exh. London, 1952–53, no. 617.

14. 1957 at Kleinberger's in New York; sold in London (Sotheby's) on June 27, 1962. The description of HdG 168 is identical but the measurements differ. Similar, but evidently later nocturnes by Berchem are in Munich (no. 2168; despite its measurements, 93 × 121 cm., identical with HdG 361) and in Leningrad (U. I. Kuznetsov in *Festschrift Lazarev*, p. 342 with repr.). Crab fishing by night also occurs in a charming picture by Frans de Momper in Leipzig (Exh. Paris, 1936, no. 50; a signed replica was at P. de Boer's in Amsterdam, Exh. 1931, no. 68). Both Berchem (HdG 170, now at York) and Asselijn painted the same subject by daylight. Comparable nocturnes with the *Annunciation to the Shepherds* were painted by Berchem (HdG 14-22 and others; see also A. Heppner in *Het Gildeboek*, 1940) and Pijnacker (HdG 3-4 and San Francisco, De Young Memorial Museum, no. 52-14); for their antecedents (besides Rembrandt's

etching, B. 44) see Boris Lossky in *La Revue du Louvre et des Musées de France*, XII, 1962, p. 57 ff.

Claude Lorrain had already painted a *Temptation of St. Anthony* with moonlight effect *ca.* 1636–38 (M. Röthlisberger, *Claude Lorrain*, no. 32 and fig. 88), but it cannot be assumed to have influenced either Berchem or Asselijn.

15. Federico Zeri, *La Galleria Spada in Roma*, no. 302, pl. 113; also G. Briganti in *Proporzioni*, III, 1950, p. 197, pl. CCIX, and Cat. Exh. Bamboccianti, Rome, 1950, no. 8. See also P. van Laer's drawing of a nocturnal camp scene in the Teyler Museum in Haarlem (Exh. Brussels, 1961, no. 29, with reference to the painted night piece by van Laer stolen from Herman Swanevelt in 1636).

16. Breviarium Grimani, fol. 4v; see also M. Schapiro in *Art Bulletin*, XLI, 1959, p. 328.

17. Other evening scenes by van Goyen: HdG 1095 (identical with 545?) of 1646, and a very dramatic one of 1655 in sale X . . ., Paris, June 15, 1933, no. 40. Van Goyen does not seem to have painted night scenes proper; HdG 809 is not by him (now attributed to Frans de Momper). Sea *battles* by moonlight had already been painted by Jan Porcellis (Hampton Court, Cat. 1929, nos. 748 and 837).

18. Bode 1921, p. 199 f.

19. Another *Marine* of this kind, undated, is owned by the National Loan Collection Trust, London, Cat. 1930, no. 33 (not in HdG). Here again, a comparison with Claude's many 'Sunsets' reveals little more than profound contrasts. Although 'coloured light' is not alien to Claude, nature's command over man, buildings, ships and even trees remains restricted. There exists no painting by Claude in which the sky and the clouds 'take over' the way they do here.

20. Exh. 'Kunstschätze gerettet-bewahrt-übergeben', 1959, no. 44. Its style shows clearly that the supposedly identical date on HdG 431 must have been misread.

21. Hans Kauffmann in *Festschrift für Adolph Goldschmidt zum 60. Geburtstag*, p. 106 ff. – See also Wolfgang Schöne, *Über das Licht in der Malerei*, p. 149 ff. (I do not agree with Schöne's objection to Kauffmann, note 307.)

22. There are no indications of this particular procedure in earlier painted night scenes, in which the highlights are much more 'sub-

stantial' (see figs. 347-349), though there are some anticipations in Goudt's and Jan van de Velde's *prints*.

23. This conception of Evening (Sunset) and Morning (Dawn with Moon) again differs radically from Claude's, who contrasts the warm sunset fully with a *cool sunrise*.

24. *Op. cit.*, p. 110. That Rubens was interested in theoretical studies of this kind is highly probable; see now Ch. Parkhurst in *Nederlands Kunsthistorisch Jaarboek*, XII, 1961, p. 35 ff.

25. Günter Böhmer, *Der Landschafter Adriaen Brouwer*; G. Knuttel, *Adriaen Brouwer*, p. 162 ff.

26. E.g., the sketch in the Ashmolean Museum, Oxford, no. 386, now recognized as by Rubens, was once given to Brouwer by Bode, though he later became doubtful about this attribution (*Adriaen Brouwer*, p. 136).

27. The figures representing the *Rest on the Flight into Egypt* which Rubens had already inserted in fig. 361 were later removed by the master himself. There are no figures either in the two Sunset pictures of the Neuerburg Collection, Glück nos. 17 and 39.

28. (Count Antoine Seilern) *Flemish Paintings and Drawings at 56 Princes Gate*, p. 70, no. 41; Gustav Glück, *Die Landschaften von P. P. Rubens*, no. 38; Exh. London, 1953/54, no. 183. See also the preceding note.

29. *Op. cit.*, p. 110.

30. Hans Schneider, *Jan Lievens*, p. 57 ff. See also Samuel van Hoogstraten's praise of a Lievens 'Maneschijn', reprinted *ibid.*, p. 300.

31. Authenticity of signature and date 1677 on HdG 219 are more than dubious.

32. E.g., in the painting in the Taft Museum, Cincinnati, Cat. 1939, no. 129: HdG 140 and 618.

33. HdG 8 (painted in 1652?), 9 (see above, p. 210, note 28), 449-476a, and 584-585b. The date read on HdG 475a, when it was at Singer's in Prague in 1935 ('1643'), is impossible.

34. HdG 594; reproduced in *Holländische Maler des XVII. Jahrhunderts im Mecklenburgischen Landesmuseum*, Schwerin, 1951, no. 197, pl. XXVIII.

35. Here mentioned only because R. Grosse, p. 30, introduced him as the originator of the night-piece; his few weak pictures of this kind do not bear out this claim at all. There are no dates; he surely did not antici-

pate van der Neer's style, although he died in 1657.

36. Leipzig, no. 589; Strasbourg, no. 171.

37. See above, note 14, for a particularly attractive example.

38. 1658: among others, Warsaw (J. Bialostocki and M. Walicki, *Europäische Malerei in Polnischen Sammlungen*, no. 342, and Exh. Warsaw, 1958, no. 73); 1663: Kunstzaal Oud Holland, The Hague, 1943.

39. *Pantheon*, XXII, 1938, p. 241. Another *Street Festival* is in the Delft Museum.

40. E.g., L. Verschuier, Budapest, no. 345 (reproduced in Preston, fig. 90). A night scene with a burning ship was painted by Willem van de Velde (Kassel, no. 424; HdG 55).

41. See the related *Coucher de soleil* in Leningrad (H. Fekhner, *Le Paysage hollandais . . .*, pl. 29-30); apparently identical with HdG 220 (not 693, as assumed by G. Bazin, *Musée de l'Ermitage*, Paris, 1958, p. 249, note 285).

42. Th-B (1940). Willis, p. 105 ff.

43. A few other interesting nocturnes may be briefly mentioned here:

 Adriaen van Ostade, *Slaughtering the Pig by Night* (Frankfurt no. 205B, dated 1637, HdG 408; a similar picture in Düsseldorf, date illegible, reproduced in H. Peters, *Meisterwerke der Düsseldorfer Galerie*, Honnef, 1955, pl. 18); probably the source of the popular painting by C. van der Schalcke in the Mauritshuis (no. 800, dated 1644).

 Jacob van Ruisdael, Wallace Collection, no. 247, HdG 1033, Ros. 326, reproduced by K. Simon, *Jacob van Ruisdael*, pl. 13. A late, rather weak work with very broad foliage and a grey-blue mountain right below the sinking sun (not a night effect proper).

 C. J. van Willigen, *The Burning of Troy*, interesting as a very late example (1660's) of this old subject (H. Gerson in *Kunsthistorische Mededelingen*, I, 1946, p. 53 ff.).

 Willem Schellinks, *Eruption of Vesuvius*, Copenhagen, no. 11, as by Asselijn, but correctly given to Schellinks on a note attached to the back of the picture.

 Jan Steen, *Street Serenade*, Prague, HdG 424, Exh. The Hague, 1958/59, no. 57 (late work, and a late echo of the Molijn tradition, see fig. 349). I do not know the *Winter with Moonlight*, published as by Jan van de Cappelle on p. 43 of the article by A. Stheeman in *Maandblad voor Beeldende Kunsten*, XII, 1935, p. 11 ff. and 39 ff.

EPILOGUE

1. George Steiner in *The Reporter*, Jan. 17, 1963, p. 50.
2. My demonstration of this development is anything but new; see in particular Adolph Goldschmidt in *Art Quarterly*, II, 1939, p. 3 ff. It cannot be applied, however, to the majority of the Italianate painters nor to several other painters of the foreign scene; see also below, p. 184.
3. An extreme example of such misunderstanding: 'Er (sc., the painter of the "naiv realistische" landscape, such as van Goyen) komponiert nicht aus seinem subjektiven Schöpfergeist ein Bild auf die Fläche, sondern überlässt die vereinheitlichende Kraft dem unendlichen Raume, und der Rahmen bezeichnet nur die Grenzen des Ausschnitts' (W. Drost in *Zeitschrift für Ästhetik und allgemeine Kunstwissenschaft*, XV, 1921, p. 278). Max Imdahl in *Festschrift Martin Wackernagel*, p. 153 ff., quotes Günther Fiensch (*Die Anfänge des deutschen Landschaftsbildes*, Münster, 1955) as saying: 'Dingliche Geschlossenheit kann für ihn (sc., space in landscape) niemals aus der Gegenstandsform gebildet werden . . . es sei denn, die Gegenstandsformen würden einer Verwandlung unterworfen, durch die sie zu Teileinheiten einer Flächenordnung gemacht werden können.' Following a similar line, Imdahl gives a comparative

analysis of one landscape each by Claude, Domenichino and J. F. van Bloemen, and shows how only Claude synthesizes these two basic elements, and how he achieves this decisive result – an important point! – even without the help of his famous light, that is, with purely compositional means. However, I think that Imdahl errs when he interprets the difference between the three painters as indications of different stylistic tendencies, even going so far as to see Mannerist touches in Domenichino, Baroque ones in van Bloemen, and classical ones in Claude; I see here *primarily* differences of *quality*.
4. Max Imdahl in *Festschrift Kurt Badt zum 70. Geburtstag*, p. 173 ff., particularly p. 178 ff.
5. See above, p. 70.
6. With regard to the use of Claude's type of light in the seventeenth century ('"natürliches" Leuchtlicht'), Imdahl (*op. cit.* in note 3, p. 182 ff.) has stated correctly that Wolfgang Schöne (*Über das Licht in der Malerei*) has not fully investigated the relationship between such light *qua* subject matter and *qua* form ('Bildgestalt', i.e., the unique, individual way in which the subject matter has been adapted to, and is conditioned by, this particular configuration). This brings to mind the problem of 'space' as subject matter discussed above.

SELECTED BIBLIOGRAPHY

The following list contains the great majority of the items cited (in abbreviated form) in the notes, plus a few others which I found useful without having occasion to cite specific pages in them. The 'older' literature (generally speaking, before the pertinent entries in Wurzbach and Thieme-Becker) is cited only in those cases where more recent research is either altogether lacking or has failed to make significant progress. That this method has created a certain lack of balance is evident; if the present list were drawn up with regard to 'merit' the names of scholars like Bode, Bredius and Hofstede de Groot would obviously occur much more frequently – just as the text would mention them more frequently for their lasting contributions than by way of correction or opposition.

Abbreviated forms are used in the text and the notes for a number of books; these are indicated here in angular brackets. Thieme-Becker articles are not listed by author in this bibliography.

Museum catalogues are listed only in those cases in which the work of the individual author – under whose name they appear – has put them in a special category. Otherwise, the most recent editions have been consulted – a point important to remember because of the frequent shifting of numbers in some instances. Some important catalogues of exhibitions are listed under their authors' names; for others see below, p. 235.

Arndt, Karl, 'Unbekannte Zeichnungen von Pieter Bruegel d. Ä.', *Pantheon*, XXIV, 1966, p. 207 ff.
— 'Frühe Landschaftszeichnungen von Pieter Bruegel d. Ä.', *Pantheon*, XXV, 1967, p. 97 ff.
Aschengreen, Kirsten, *Dutch Italianate Painting in the First Half of the Seventeenth Century*, Diss. London, 1954 (unpublished).

Baard, H. P., *Willem van de Velde de Oude, Willem van de Velde de Jonge*, Amsterdam (Palet series), n.d.
Bachmann, Fredo, *Die Landschaften des Aert van der Neer*, Neustadt a. d. Aisch, 1966.
Bartsch, Adam von, *Le Peintre graveur*, new ed., Würzburg, 1920. [B.]
Bastelaer, René van, *Les Estampes de Peter Bruegel l'Ancien*, Brussels, 1908.
Bauch, Kurt, *Der frühe Rembrandt und seine Zeit, Studien zur geschichtlichen Bedeutung seines Frühstils*, Berlin, 1960.
Beck, Hans-Ulrich, 'Jan van Goyens Handzeichnungen als Vorzeichnungen', *Oud Holland*, LXXII, 1957, p. 241 ff.
— 'Jan van Goyen: the sketchy monochrome studies of 1651', *Apollo*, LXXI, 1960, p. 176 ff.
Beenken, Hermann, 'Die Landschaftsschau Jakob van Ruisdaels', *Neue Beiträge deutscher Forschung, Wilhelm Worringer zum 60. Geburtstag*, Königsberg, 1943, p. 1 ff.
Bengtsson, Ake, *Studies on the Rise of Realistic Landscape Painting in Holland (Figura, III)*, Stockholm, 1952.
Bergström, Ingvar, *Dutch Still-Life Painting*, New York, 1956.
Bernt, Walther, *Die niederländischen Maler des 17. Jahrhunderts*, 4 vols. (I-III, 2nd ed., 1960; IV, 1962). [Bernt]
Białostocki, Jan, 'Manieryzm i poczatki realizmu w pejzazu niderlandzkim', *Biuletyn Historii Sztuki*, XII, 1950, p. 105 ff.
— 'Les Bêtes et les humains de Roelant Savery', *Bulletin Musées Royaux des Beaux-Arts*, Brussels, VII, 1958, p. 69 ff.
— 'Das Modusproblem in den bildenden Künsten', *Zeitschrift für Kunstgeschichte*, XXIV, 1961, p. 128 ff.
— and Walicki, Michal, *Europäische Malerei in polnischen Sammlungen*, Warsaw, 1957.

Bierens de Haan, C. J. C., *L'Œuvre gravé de Cornelis Cort*, The Hague, 1948.

Birkmeyer, Karl M., 'Three Dutch Landscapes of the 17th Century', *Bulletin of the California Palace of the Legion of Honor*, XII, May–June, 1954 (no pagination).

Blok, Ima, 'Tentoonstelling van prenten door Claes Jansz Visscher in 's Rijks Prentenkabinet te Amsterdam', *Oude Kunst*, IV, 1918–19, p. 107 ff.

Bock, Elfried and Rosenberg, Jakob, *Die niederländischen Meister* (*Staatliche Museen zu Berlin: Die Zeichnungen alter Meister im Kupferstichkabinett*), Frankfurt, 1931. [Bock-Rosenberg]

Bode, Wilhelm von, *Die Meister der holländischen und vlämischen Malerschulen*, Leipzig, 1921. [Bode 1921]. New edition by Eduard Plietzsch, Leipzig, 1956. [Bode-Plietzsch]

Bodkin, Thomas, 'Two Unrecorded Landscapes by Abraham Bloemaert', *Oud Holland*, XLVI, 1929, p. 101 ff.

Böhmer, Günter, *Der Landschafter Adriaen Brouwer*, Munich, 1940.

Bol, L. J., 'Een Middelburgse Breughel-groop, VI: Jacob Jacobsz van Geel', *Oud Holland*, LXXII, 1957, p. 20 ff.

Boon, K. G., *De schilders voor Rembrandt*, Antwerp, 1942.

Boschma, C., 'Nieuwe gegevens omtrent J. S. Mancadan', *Oud Holland*, LXXXI, 1966, p. 84 ff.

Breckenridge, James D., *A Handbook of Dutch and Flemish Paintings in the William Andrews Clark Collection*, Washington, 1955.

Bredius, Abraham, 'Het geboortejaar van Jacob van Ruisdael', *Oud Holland*, VI, 1888, p. 21 ff.

— 'De schilder Johannes van de Cappelle', *Oud Holland*, X, 1892, p. 27 ff. and 133 ff.

— 'De schilder Balthasar van der Veen', *Oud Holland*, XII, 1894, p. 57 ff. and XIII, 1895, p. 128.

— 'Johannes Porcellis', *Oud Holland*, XXIII, 1905, p. 69 ff., and XXIV, 1906, p. 129 ff., 248 ff.

— *Künstler-Inventare, Urkunden zur Geschichte der holländischen Künstler des XVI., XVII. und XVIII. Jahrhunderts* (*Quellenstudien zur holländischen Kunstgeschichte*, V–VII, X–XIV), The Hague, 1915–22. [Bredius, K. I.]

— *The Paintings of Rembrandt*, London, 1937. [Br.]

Brière-Misme, Clotilde, 'Tableaux inédits ou peu connus de Pieter de Hooch', *Gazette des Beaux-Arts*, 5. per., XVI, 1927, II, p. 51 ff.

— see also Misme, C.

Briganti, Giuliano, 'Pieter van Laer e Michelangelo Cerquozzi', *Proporzioni*, III, 1950, p. 185 ff.

— *I Bamboccianti*, Exhibition Catalogue, Rome, 1950.

Brochhagen, Ernst, 'Karel Dujardins späte Landschaften', *Bulletin, Musées Royaux des Beaux-Arts*, Brussels, VI, 1957, p. 236 ff.

— *Karel Dujardin*, Diss. Cologne, 1958.

Broulhiet, Georges, *Meindert Hobbema*, Paris, 1938. [B.]

Brown, J. Carter, *Jan van Goyen, A Study of his Early Development*, M.A. Thesis, New York University, 1961 (unpublished).

Brunetti, Estella, 'Some Unpublished Works by Codazzi, Salucci, Lemaire and Patel', *Burlington Magazine*, C, 1958, p. 311 ff.

Bruyn, Lia de, 'Het geboortejaar van Jan Both', *Oud Holland*, LXVII, 1952, p. 110 ff.

Buchelius, Arnoldus, *Res pictoriae*, ed. G. J. Hoogewerff and J. Q. van Regteren Altena (*Quellenstudien zur holländischen Kunstgeschichte*, XV), The Hague, 1928.

Budde, Illa, *Die Idylle im holländischen Barock*, Cologne, 1929.

Burchard, Ludwig, *Die holländischen Radierer vor Rembrandt*, Halle, 1912.

Clark, Sir Kenneth, *Landscape into Art*, London, 1950 (as *Landscape Painting*, New York, 1950).

Collins, Leo C., *Hercules Seghers*, Chicago, 1953.

C(unningham), C. C., 'Adam Pynacker, Landscape with River Barges and Mountains', *Wadsworth Atheneum Bulletin*, March 1952, p. 1.

Czobor, Ágnes, *Dutch Landscapes*, Budapest, 1967.

Delbanco, Gustav, *Abraham Bloemaert*, Strasbourg, 1928.

Dobrzycka, Anna, '*Jan van Goyen, 1596–1656*, Poznań, 1966.

Dohmann, A., 'Les Événements contemporains dans la peinture hollandaise du XVIIᵉ siècle', *Revue de l'Histoire Moderne et Contemporaine*, v, 1958, p. 265 ff.

Donahue, Susan, 'Daniel Vosmaer', *Vassar Journal of Undergraduate Studies*, XIX, 1964, p. 18 ff.

Drost, Willy, 'Über Wesensdeutung von Landschaftsbildern, gezeigt an der holländischen Landschaftsmalerei des 17. Jahrhunderts', *Zeitschrift für Ästhetik und allgemeine Kunstwissenschaft*, XV, 1921, p. 272 ff.

Ebbinge Wubben, J. C., 'Het nieuw verworven landschap van Hercules Seghers', *Bulletin Museum Boymans-van Beuningen*, IV, 1953, p. 31 ff.

— Catalogue Exhibition *Het landschap in de nederlandsche prentkunst*, Rotterdam, Museum Boymans, 4 booklets, 1943/44.

Eeghen, I. H. van, 'Een stadsgezicht van Hobbema', *Oud Holland*, LXVIII, 1953, p. 120 ff.

— 'De vier huizen van Cromhout', *Amstelodamum*, LIII, 1966, p. 52 ff.

Eigenberger, Robert, *Die Gemäldegalerie der Akademie der bildenden Künste in Wien*, 2 vols., Vienna–Leipzig, 1927.

Eisler, Max, *Rembrandt als Landschafter*, Munich, 1918.

Emmens, J. A., Rembrandt en de regels van de kunst, Diss. Utrecht, 1964.

Erasmus, Kurt, *Roelant Savery*, Diss. Halle, 1908.

Feinblatt, Ebria, 'Note on Paintings by Bartholomeus Breenbergh', *Art Quarterly*, XII, 1949, p. 266 ff.

Fekhner, H., *Le Paysage hollandais du XVIIᵉ siècle à l'Ermitage* (in Russian), Leningrad, 1963.

Floerke, Hanns, *Studien zur niederländischen Kunst- und Kulturgeschichte*, Munich–Leipzig, 1905.

—— See also van Mander.

Franz, H. J., 'De boslandschappen van Gillis van Coninxloo en hun voorbeelden', *Bulletin Museum Boymaus-van Beuningen*, Rotterdam, XIV, 1963, p. 66 ff.

Friedländer, Max J., *Landscape, Portrait, Still-Life*, Oxford, New York, n.d. (1950).

Frimmel, Theodor von, *Studien und Skizzen zur Gemäldekunde*, III, 1917–18.

Fritz, Rolf, *Stadt- und Strassenbild in der holländischen Malerei des 17. Jahrhunderts*, Diss. Berlin, 1932.

Fromentin, Eugène, *Les Maîtres d'autrefois*, Paris, 1875.

Gelder, H. E. van, *Holland by Dutch Artists*, Amsterdam, 1959.

— *Rembrandt en het landschap* (Palet series), Amsterdam, n.d.

Gelder, J. G. van, *Jan van de Velde*, The Hague, 1933.

— 'Pennetegninger af Jan van Goyen', *Kunstmuseets Aarsskrift*, XXIV, 1937, p. 31 ff.

— 'Hercules Seghers erbij en eraf', *Oud Holland*, LXV, 1950, p. 216 ff.

— 'Hercules Seghers, Addenda', *Oud Holland*, LXVIII, 1953, p. 149 ff.

— *Prenten en Tekeningen* (series: De schoonheid van ons land), Amsterdam, 1958.

— 'Cornelis Vroom, een onbekend landschap', *Oud Holland*, LXXVII, 1962, p. 56 f.

— Review of Erik Larsen, *Frans Post*, *Oud Holland*, LXXVIII, 1963, p. 77 ff.

— and N. F. van Gelder-Schrijver, 'Adam van Breen, schilder', *Oudheidkundig Jaarboek*, n.s., I, 1932, p. 110 ff.

Gerson, H., 'The Development of Ruisdael', *Burlington Magazine*, LXV, 1934, p. 76 ff.

— *Philips Koninck*, Berlin, 1936. [G.]

— *Ausbreitung und Nachwirkung der holländischen Malerei des 17. Jahrhunderts*, Haarlem, 1942. [Gerson, Ausbreitung]

— 'Claes Jansz van Willigen', *Kunsthistorische Mededelingen*, I, 1946, p. 53 ff.
— 'Een Hobbema van 1665', *Kunsthistorische Mededelingen*, II, 1947, p. 43 ff.
— 'De Meester P. N.', *Nederlandsch Kunsthistorisch Jaarboek*, I, 1947, p. 95 ff.
— 'Landschappen van Jan Steen', *Kunsthistorische Mededelingen*, III, 1948, p. 51 ff.
— *De nederlandse schilderkunst, I: Van Geertgen tot Frans Hals; II: Het tijdperk van Rembrandt en Vermeer* (series: *De schoonheid van ons land*), Amsterdam, 1950–52. [Gerson]
— 'De Ripa Grande te Rome', *Oud Holland*, LXVI, 1951, p. 65 f.
— 'Dutch Landscape', *Burlington Magazine*, XCV, 1953, p. 47 ff.
— 'Cornelis Vermeulen (1732–1813)', *Oud Holland*, LXIX, 1954, p. 247 ff.
— 'Enkele vroege werken van Esajas van de Velde', *Oud Holland*, LXX, 1955, p. 131 ff.
— 'Twee tekeningen van Herman van Swanevelt', *Oud Holland*, LXXI, 1956, p. 113 ff.
— 'Dutch Landscapes at Dordrecht', *Burlington Magazine*, CV, 1963, p. 461 f.
— 'Albert Cuyps gezichten van het *Wachthuis in de Kil*', *Opus musivum, Feestbundel voor Prof. Dr. M. D. Ozinga*, Assen, 1964, p. 257 ff.
— 'Italy through Dutch Eyes', *Art Quarterly*, XXVII, 1964, p. 342 ff.
— 'Bredius 447', *Festschrift Dr. h.c. Eduard Trautscholdt*, Hamburg, 1965, p. 109 ff.
— and E. H. Ter Kuile, *Art and Architecture in Belgium, 1600–1800* (*The Pelican History of Art*, ed. N. Pevsner), Baltimore, 1960. [Gerson, Pelican History]
Gerstenberg, Kurt, *Die ideale Landschaftsmalerei*, Halle, 1923.
Glück, Gustav, *Die Landschaften von P. P. Rubens*, Vienna, 1945.
Goldschmidt, Adolph, 'The Style of Dutch Painting in the Seventeenth Century', *Art Quarterly*, II, 1939, p. 3 ff.
Gombrich, E. H., 'Renaissance Artistic Theory and the Development of Landscape Painting', *Gazette des Beaux-Arts*, 6. ser., XLI, 1953, p. 335 ff.
Goossens, Korneel, *David Vinckboons*, Antwerp–The Hague, 1954.
Granberg, Olof, *Allaert van Everdingen och hans 'Norska' landskap*, Stockholm, 1902.
Greindl, Edith, 'La Conception du paysage chez Alexandre Keirincx', *Annuaire du Musée Royal des Beaux-Arts d'Anvers*, 1942–47, p. 115 ff.
Grinten, E. F. van der, 'Le Cachalot et le mannequin', *Nederlands Kunsthistorisch Jaarboek*, XIII, 1962, p. 149 ff.
Gronau, Georg, 'Neuerwerbungen der Casseler Galerie, 1912–22', *Berliner Museen*, XLIV, 1923, p. 60 ff.
Grosse, Rolph, *Die holländische Landschaftskunst, 1600–1650*,-Berlin–Leipzig, 1925. [Grosse]
Gudlaugsson, S. J., 'Een figuurstudie van Jacob Esselens te Besançon', *Oud Holland*, LXVI, 1951, p. 62 f.
— 'Landschappen van Gerrit Claesz Bleeker en Jan Looten tot "Hercules Seghers" vervalst', *Oud Holland*, LXVIII, 1953, p. 182 ff.
— 'Aanvullingen omtrent Pieter Post's werkzaamheid als schilder', *Oud Holland*, LXIX, 1954, p. 59 ff.
— *Gerard Ter Borch*, 2 vols., The Hague, 1959–60.

Haagen, J. K. van der, *De schilders van der Haagen*, Voorburg, 1932.
Haak, B., 'Adriaen van Ostade, Landschap met een eik', *Bulletin van het Rijksmuseum*, XII, 1964, p. 5 ff.
Hall, H. van, *Repertorium voor de geschiedenis der nederlandsche schilder- en graveerkunst*, 2 vols., The Hague, 1936–49.
Hannema, D., *Catalogue of the Pictures in the Collection of Willem van der Vorm*, Rotterdam, 1950.
— *Kunst in de oude sfeer*, Rotterdam, 1952.
— *Catalogue raisonné of the Pictures in the Collection of J. C. H. Heldring*, Rotterdam, 1955.
Havelaar, J., *Hoogtepunten der Oud-Hollandsche landschapskunst*, Bilthoven, 1942.

Haverkamp Begemann, E., *Catalogue of the Exhibition Hercules Seghers*, Rotterdam, 1954.
— *Willem Buytewech*, Amsterdam, 1959.
— 'Cornelis Vroom aan het Meer van Como', *Oud Holland*, LXXXII, 1967, p. 65 ff.
Hayes, John, 'Claude de Jongh', *Burlington Magazine*, XCVIII, 1956, p. 3 ff.
Heidrich, Ernst, *Vlämische Malerei*, Jena, 1913.
Held, Julius S., 'Ett bidrag till kännedomen om Everdingens skandinaviska resa', *Konsthistorisk Tidskrift*, VI, 1937, p. 41 ff.
Henkel, M. D., 'Swaneveld und Piranesi in Goethescher Beleuchtung', *Zeitschrift für bildende Kunst*, LVIII, 1924–25, p. 153 ff.
— *Le Dessin hollandais*, Paris, 1931.
Hentzen, Alfred, 'Abraham Hondius', *Jahrbuch der Hamburger Kunstsammlungen*, VIII, 1963, p. 33 ff.
Heppner, A., 'J. S. Mancadan', *Oud Holland*, LI, 1934, p. 210 ff.
— 'Nicolaes Berchem als illustrator van het Nieuwe Testament', *Het Gildeboek*, XXIII, 1940, p. 81 ff.
Hind, Arthur M., *Rembrandt's Etchings*, London, 1912. [H.]
Hirschmann, Otto, *Verzeichnis des graphischen Werks von Hendrick Goltzius*, Leipzig, 1921. [H.]
Hoecker, R., *Das Lehrgedicht des Karel van Mander (Quellenstudien zur holländischen Kunstgeschichte*, VIII), The Hague, 1916.
Hofstede de Groot, Cornelis, *A Catalogue raisonné of the Works of the most Eminent Dutch Painters of the Seventeenth Century*, transl. Edward G. Hawke, vol. I–VIII, London, 1908–1927. [HdG] and [Cat. rais.]
— *Beschreibendes und kritisches Verzeichnis der hervorragendsten holländischen Maler des XVII. Jahrhunderts*, vol. IX–X, Esslingen (Stuttgart)–Paris, 1926–28. [HdG] and [Beschr. u. krit. Verz.]
— 'Inedita IX: François de Momper', *Oude Kunst*, I, 1915–16, p. 213 ff.
— 'Jan van Goyen and his Followers', *Burlington Magazine*, XLII, 1923, p. 4 ff.
Hollstein, F. W. H., *Dutch and Flemish Etchings, Engravings and Woodcuts*, Amsterdam, 1949 ff.
Holmes, Jerrold, 'The Cuyps in America', *Art in America*, XVIII, 1929–30, p. 165 ff.
Hoogewerff, G. J., 'Pieter van Laer en zijn vrienden', *Oud Holland*, XLIX, 1932, and L, 1933.
— *Nederlandsche Kunstenaars te Rome*, The Hague, 1942/43.
— *De Bentvueghels*, The Hague, 1952.
Hoogstraten, Samuel van, *Inleyding tot de Hooge Schole der Schilderkonst*, Rotterdam, 1678.
Houbraken, Arnold, *De groote schouburgh der Nederlantsche Konstschilders en schilderessen*, 2nd ed., The Hague, 1753.
Huizinga, J., *Nederlands Beschaving in de Zeventiende Eeuw*, in: *Verzamelde Werken*, Haarlem, 1948, II, p. 412 ff.
Hutton, William, 'Aelbert Cuyp: The Riding Lesson', *Toledo Museum News*, Autumn, 1961, p. 79 ff.
Huygens, Constantijn, see Worp, J. A.

Imdahl, Max, 'Baumstellung und Raumwirkung', *Festschrift Martin Wackernagel*, Cologne–Graz, 1958, p. 153 ff.
— 'Ein Beitrag zu Meindert Hobbemas Allee von Middelharnis', *Festschrift Kurt Badt zum 70. Geburtstag*, Berlin, 1961, p. 173 ff.

Jantzen, Hans, 'De ruimte in de hollandsche zeeschildering', *Onze Kunst*, XVIII, 1910, p. 105 ff.
Jonge, C. H. de, 'Utrechtsche schilders der XVII. eeuw in de verzameling van Willem Vincent, Baron van Wyttenhorst', *Oudheidkundig Jaarboek*, n.s., I, 1932, p. 120 ff.
Jongh, J. de, *Die holländische Landschaftsmalerei*, Berlin, 1905.
Judson, J. Richard, *Gerrit van Honthorst*, The Hague, 1959.

Kan, A. H., *De jeugd van Constantijn Huygens door hemself beschreven*, Rotterdam–Antwerp, 1946.

Kauffmann, Hans, 'Die Farbenkunst des Aert van der Neer', *Festschrift für Adolph Goldschmidt zum 60. Geburtstag*, Leipzig, 1923, p. 106 ff.

Kellen, J. Ph. van der, *Le Peintre-graveur hollandais et flamand*, Utrecht, 1866. [v.d.K.]

Klessmann, R., 'Die Landschaft mit der büssenden Magdalena von Jacob Pynas', *Berliner Museen*, XV, 1965, p. 7 ff.

Knab, Eckhart, 'Bij een landschap van Jan Both', *Bulletin Museum Boymans-van Beuningen*, Rotterdam, XIII, 1962, p. 46 ff.

Knuttel, G., *De nederlandsche schilderkunst van van Eyck tot van Gogh*, Amsterdam, 1938.

— *Hercules Seghers* (Palet series), Amsterdam, n.d. (1941).

— *Adriaen Brouwer*, The Hague, 1962.

Kuznetsov, U. I., 'Claes Berchem and his Works in the State Collection Hermitage' (in Russian), *Festschrift V. Lazarev*, Moscow, 1960, p. 325 ff.

Laes, Arthur, 'Gillis van Coninxloo, rénovateur du paysage flamand au XVIᵉ siècle', *Annuaire des Musées Royaux des Beaux-Arts*, Brussels, II, 1939, p. 109 ff.

— 'Paysages de Josse et Frans de Momper', *Bulletin, Musées Royaux des Beaux-Arts*, Brussels, I, 1954, p. 57 ff.

Larsen, E., *Frans Post, interprète du Brésil*, Amsterdam–Rio de Janeiro, 1962.

Ledermann, Ida, *Beiträge zur Geschichte des romanistischen Landschaftsbildes in Holland und seines Einflusses auf die nationale Schule um die Mitte des XVII. Jahrhunderts*, Diss. Berlin, 1920 (unpublished).

Leymarie, Jean, *Dutch Painting* (transl. by Stuart Gilbert), New York, 1956.

Lilienfeld, Karl, *Arent de Gelder* (*Quellenstudien zur holländischen Kunstgeschichte*, IV), The Hague, 1914. [Lilienfeld]

Lorck, C. von, 'Goethe und Lessings "Klosterhof im Schnee"', *Westdeutsches Jahrbuch für Kunstgeschichte (Wallraf-Richartz-Jahrbuch)*, IX, 1936, p. 205 ff.

Lossky, Boris, 'Une "Annonce aux bergers" de Willem II. van Nieulandt au Musée de Tours', *La Revue du Louvre et des Musées de France*, XII, 1962, p. 57 ff.

Lugt, F., *Les Dessins des écoles du Nord de la Collection Dutuit*, Paris, 1927.

Luttervelt, H. van, 'Een nieuwe aanwinst voor de Historische Afdeling van het Rijksmuseum: Een schilderij van J. B. Weenix', *Bulletin van het Rijksmuseum*, III, 1955, p. 9 ff.

Lützeler, Heinrich, 'Vom Wesen der Landschaftsmalerei', *Studium Generale*, III, 1950, p. 210 ff.

MacLaren, Neil, *National Gallery Catalogue: The Dutch School*, London, 1960.

Mander, Karel van, *Het Schilderboeck* . . . Haarlem, 1604. New edition with German translation by H. Floerke, 2 vols., Munich–Leipzig, 1906. [van Mander-Floerke]

Manke, Ilse, *Emanuel de Witte*, Amsterdam, 1963.

Martin, Willem, 'The Life of a Dutch Artist in the Seventeenth Century, V and VI', *Burlington Magazine*, X, 1906–07, p. 363 ff., and XI, 1907–08, p. 357 ff.

— 'Über den Geschmack des holländischen Publikums im XVII. Jahrhundert mit Bezug auf die damalige Malerei', *Monatshefte für Kunstwissenschaft*, I, 2, 1908, p. 727 ff.

— 'Rembrandt-Rätsel', *Der Kunstwanderer*, 1921–22, p. 6 ff.

— *De hollandsche schilderkunst in de zeventiende eeuw*, 2 vols., Amsterdam, 1935/36.

— *Dutch Painting of the Great Period, 1650–1697*, London, New York, Toronto, Sydney, 1951.

Michel, Édouard, *Les van de Velde*, Paris, 1892.

Misme, Clotilde, *La Peinture au Musée du Louvre, École hollandaise*, Paris, n.d. [Misme]

— See also Brière-Misme, Clotilde.

Müller, Cornelis, 'Abraham Bloemaert als Landschaftsmaler', *Oud Holland*, XLIV, 1927, p. 193 ff.

Müller Cornelis (*contd.*), 'Neuerworbene holländische Landschaften im Kaiser Friedrich Museum, I: Abraham Bloemaert', *Berliner Museen*, XLVIII, 1927, p. 138 ff.
— 'Neuerworbene holländische Landschaften im Kaiser Friedrich Museum, II: Pieter van Santvoort', *Berliner Museen*, XLIX, 1928, p. 64 ff.
Münch, Ottheinz, 'Ein Spätwerk des Gillis van Coninxloo', *Festschrift des Pfälzischen Museums*, Speyer, 1960, p. 275 ff.
Münz, Ludwig, *A Critical Catalogue of Rembrandt's Etchings*, London, 1952. [M.]
— *Bruegel, The Drawings*, London, 1961.

Niemeijer, J. W., 'Het topografisch element in enkele riviergezichten van S. van Ruysdael nader beschouwd', *Oud Holland*, LXXIV, 1959, p. 51 ff.
— 'Johannes op Patmos door Abraham Bloemaert', *Oud Holland*, LXXV, 1960, p. 240 ff.
Nieuwstraten, J., 'Dutch Landscapes at Dordrecht', *Apollo*, XIX, 1963, p. 226 f.
— 'De ontwikkeling van Herman Saftlevens kunst tot 1650', *Nederlands Kunsthistorisch Jaarboek*, XVI, 1965, p. 81 ff.
Novotny, Fritz, *Die Monatsbilder Pieter Bruegels des Älteren*, Vienna, 1948.

Ogden, Henry V. S. and Margaret S., *English Taste in Landscape in the Seventeenth Century*, Ann Arbor, 1955.

Palmer, Eric, 'My Collection of Marines', *Connoisseur*, CXLV, 1960, p. 11 f.
Panofsky, Erwin, *Early Netherlandish Painting*, 2 vols., Cambridge, Mass., 1953.
Parkhurst, Charles, 'Aguilonius' Optics and Rubens' Color', *Nederlands Kunsthistorisch Jaarboek*, XII, 1961, p. 35 ff.
Pauw-de Veen, L. de, '"Den grondt der edel vrij schilder-const" van Karel van Mander en "Den Leermeester der schilderkonst" van Wibrandus de Geest, een korte vergelijking', *Revue belge de philologie et d'histoire*, XXXIV, 1956, p. 365 ff.
Peltzer, Alfred, *Über Malweise und Stil in der holländischen Kunst*, Heidelberg, 1903.
Peltzer, Rudolf. See Sandrart, Joachim von.
Pigler, A., *Barockthemen*, 2 vols., Budapest–Berlin, 1956.
— 'Une Scène de légende de Wolfgang Heimbach', *Kunsthistorische Mededelingen*, II, 1947, p. 8ff.
Plietzsch, Eduard, *Die Frankenthaler Maler*, Leipzig, 1910.
— 'Hendrick ten Oever', *Pantheon*, XXIX, 1942, p. 132 ff.
— *Holländische und flämische Maler des XVII. Jahrhunderts*, Leipzig, 1960. [Plietzsch 1960]
— See also Bode, Wilhelm von.
Poensgen, Georg, 'Arent Arentsz (genannt Cabel) und sein Verhältnis zu Hendrick Avercamp', *Oud Holland*, XLI, 1923–24, p. 116 ff.
Poortenaar, Jan, *Schilders van het hollandsche Landschap*, Haarlem, n.d.
Preston, Sir Lionel, *Sea and River Painters of the Netherlands*, London, New York, Toronto, 1937.

Raczyński, J. A. Graf, *Die flämische Landschaft vor Rubens*, Frankfurt, 1937.
Regteren Altena, J. Q. van, 'I. van Moscher', *Oud Holland*, XLIII, 1926, p. 18 ff.
— 'Saenredam archaeoloog', *Oud Holland*, XLVIII, 1931, p. 1 ff.
— *The Drawings of Jacques de Gheyn, I.* Amsterdam, 1936 (II not published).
— 'Retouches aan ons Rembrandt-beeld, II: Het landschap van den Goudweger', *Oud Holland*, LXIX, 1954, p. 1 ff.
Renckens, B. J. A., 'Jan van Goyen en zijn Noordhollandse leermeester', *Oud Holland*, LXVI, 1951, p. 23 ff.
— 'Joost de Volder', *Oud Holland*, LXXXI, 1966, pp. 58 f. and 269.
Reuterswärd, P., 'Tavelförhänget', *Konsthistorisk Tidskrift*, 1956, p. 97 ff.
Reznicek, E. K. J., *Die Zeichnungen von Hendrick Goltzius*, Utrecht, 1961, [R.]
Richardson, E. P., 'The Romantic Prelude to Dutch Realism', *Art Quarterly*, III, 1940, p. 40 ff.
— Jan Hackaert's Landscape with a Stag Hunt', *Bulletin of the Detroit Institute of Arts*, XXX, 1950–51, p. 66 ff.

Riegl, Alois, 'Jacob van Ruisdael', *Graphische Künste*, XXV, 1902, p. 11 ff. (reprinted in *Gesammelte Aufsätze*, ed. Karl M. Swoboda, Augsburg–Vienna, 1929, p. 133 ff.).

Rijnbach, A. A. van, *Groot Lied-Boeck van G. A. Brederode*, Bilthoven–Antwerp, 1944.

Roh, Franz, *Holländische Malerei*, Jena, 1921.

— *Holländische Landschaftsmalerei des XVII. Jahrhunderts*, Leipzig, 1923.

Romanow, N. I., 'A Landscape with Oaks by Jan van Goyen', *Oud Holland*, LIII, 1936, p. 187 ff.

Rosenau, Helen, 'The Dates of Jacob van Ruisdael's "Jewish Cemeteries"', *Oud Holland*, LXXIII, 1958, p. 241 f.

Rosenberg, Jakob, '"The Jewish Cemetery" by Jacob van Ruisdael', *Art in America*, XIV, 1926, p. 37 ff.

— 'Hobbema', *Jahrbuch der Preussischen Kunstsammlungen*, XLVIII, 1927, p. 139 ff.

— *Jacob van Ruisdael*, Berlin, 1928. [Ros.]

— 'Cornelis Hendricksz Vroom', *Jahrbuch der Preussischen Kunstsammlungen*, XLIX, 1928, p. 102 ff.

— 'Notizen und Nachrichten: Jacob van Ruisdael', *Zeitschrift für Kunstgeschichte*, II, 1933, p. 237 f.

— 'Rembrandt's Technical Means and their Stylistic Significance', *Technical Studies in the Field of the Fine Arts*, VIII, 1940, p. 193 ff.

— *Rembrandt*, Cambridge, Mass., 1948; second edition, London, 1964.

— 'A Waterfall by Jacob van Ruisdael', *Fogg Art Museum, Harvard University, Annual Report*, 1952–53, p. 11.

— 'The Wreckers by Simon de Vlieger', *Fogg Art Museum, Harvard University, Annual Report*, 1953–54, p. 8.

— 'A Seascape by Jacob van Ruisdael', *Bulletin, Museum of Fine Arts, Boston*, LVI, 1958, p. 145 f.

— Slive, Seymour, and ter Kuile, E. H., *Dutch Art and Architecture, 1600–1800*, Harmondsworth–Baltimore–Ringwood, 1966.

— See also Bock, Elfried.

Roth, Alfred G., *Die Gestirne in der Landschaftsmalerei des Abendlandes*, Berne, 1945.

Röthlisberger, Marcel, *Claude Lorrain*, 2 vols., New Haven, 1961.

Salerno, Luigi, 'The Picture Gallery of Vincenzo Giustiniani, II: The Inventory, Part I', *Burlington Magazine*, CII, 1960, p. 93 ff.

Sander, C. A. L., 'Het Dulhuys of dolhuys aan de vesten of de Kloveniersburgwal', *Maandblad Amstelodamum*, XLV, 1958, p. 229 ff.

Sandrart, Joachim von, *Teutsche Academie der Edlen Bau-, Bild- und Malerey-Künste*, Nürnberg, 1675. New ed. by A. R. Peltzer, Munich, 1925.

Schaar, Eckhard, 'Berchem und Begeijn', *Oud Holland*, LXIX, 1954, p. 241 ff.

— *Studien zu Nicolaes Berchem*, Diss. Cologne, 1958.

— 'Poelenburgh und Breenbergh in Italien und ein Bild Elsheimers', *Mitteilungen des Kunsthistorischen Institutes in Florenz*, IX, 1959, p. 27 ff.

Schapiro, Meyer, 'A Note on the Mérode Altarpiece', *Art Bulletin*, XLI, 1959, p. 327 f.

Scharf, Sir George, *Catalogue of the Pictures at Woburn Abbey*, 1897.

Schmidt, W., 'Bemerkungen über verschiedene Bilder der Galerien zu München und Schleissheim', *Jahrbücher für Kunstwissenschaft*, hsg. von A. von Zahn, V, 1873, p. 46 ff.

Schneider, Hans, *Jan Lievens*, Haarlem, 1932. [Sch.]

Scholtens, H. J. J., 'Salomon van Ruysdael in de contreien van Holland's landengte', *Oud Holland*, LXXVII, 1962, p. 1 ff.

Schöne, Wolfgang, *Über das Licht in der Malerei*, Berlin, 1954.

Schotman, J. W., see Verbeek, J.

Seifertová-Korecká, Hana, 'Das Genrebild des Aert van der Neer in Liberec', *Oud Holland*, LXXVII, 1962, p. 57 f.

Seilern, Count Antoine, *Flemish Paintings and Drawings at 56 Princes Gate*, London, 1955.

Sick, Ilse von, *Nicolaes Berchem, ein Vorläufer des Rokoko*, Berlin, 1930.

Simon, Kurt Erich, *Jacob van Ruisdael*, Berlin, 1930.

— 'Wann hat Ruisdael die Bilder des Judenfriedhofs gemalt?', *Das siebente Jahrzehnt, Festschrift zum 70. Geburtstag von Adolph Goldschmidt*, Berlin, 1935, p. 158 ff.

— 'Georges Broulhiet, Meindert Hobbema', *Zeitschrift für Kunstgeschichte*, IX, 1940, p. 205 ff.

— 'Jan Steen und Utrecht', *Pantheon*, XXVI, 1940, p. 162 ff.

Simon, Maria, *Claes Jansz Visscher*, Diss. Freiburg i. B., 1958 (unpublished).

Sinajew, M., 'Esajas van de Velde als Schlachtenmaler', *Musée de l'Ermitage*, I, 1940, p. 67 ff. (German résumé, p. 76 f.).

Slive, Seymour, 'Notes on the Relationship of Protestantism to Seventeenth Century Dutch Painting', *Art Quarterly*, XIX, 1956, p. 2 ff.

— 'Korneel Goossens, David Vinckboons', *Art Bulletin*, XXXIX, 1957, p. 311 ff.

— 'Realism and Symbolism in Seventeenth-Century Dutch Painting', *Daedalus*, 1962, p. 469 ff.

— *Catalogue Exhibition Frans Hals*, Haarlem, 1962.

— *Dutch Art and Architecture*, see Rosenberg.

Smith, Elizabeth, 'An Early Landscape by Ruisdael', *Art Quarterly*, XIV, 1951, p. 359 f.

Smith, John, *A Catalogue raisonné of the works of the Most Eminent Dutch, Flemish and French Painters*, 9 vols., London, 1829–42. [Smith]

Smith, R. C., Jr., 'The Brazilian Landscapes of Frans Post', *Art Quarterly*, I, 1938, p. 239 ff.

Sousa-Leão, J. de, *Frans Post*, Rio de Janeiro, 1948.

Springer, Jaro, *Die Radierungen des Herkules Seghers*, 4 vols. (*Graphische Gesellschaft Berlin*, vols. XIII, XIV, XVI, XVIa), Berlin, 1910–12. [Spr.]

Staring, A., 'De ruiterportretgroep van Albert Cuyp in het Metropolitan Museum te New York', *Oud Holland*, LXVIII, 1953, p. 117.

Stechow, Wolfgang, 'Illa Budde, Die Idylle im holländischen Barock', *Kritische Berichte zur kunstgeschichtlichen Literatur*, 1928, p. 181 ff.

— 'Bartholomaeus Breenbergh, Landschafts- und Historienmaler', *Jahrbuch der Preussischen Kunstsammlungen*, LI, 1930, p. 133 ff.

— *Salomon van Ruysdael, eine Einführung in seine Kunst*, Berlin, 1938. [St.]

— 'Die "Pellekussenpoort" bei Utrecht auf Bildern von Jan van Goyen und Salomon van Ruysdael', *Oud Holland*, LV, 1938, p. 202 ff.

— 'Esajas van de Velde and the Beginnings of Dutch Landscape Painting', *Nederlandsch Kunsthistorisch Jaarboek*, I, 1947, p. 83 ff.

— 'Jan Baptist Weenix', *Art Quarterly*, XI, 1948, p. 181 ff.

— 'Jan Both and Dutch Italianate Landscape Painting', *Magazine of Art*, XLVI, 1953, p. 131 ff. (similarly in *Actes du XVIIᵉ Congrès International d'Histoire de l'Art*, The Hague, 1955, p. 425 ff.).

— 'A Painting by Roelandt Savery', *John Herron Art Institute Bulletin*, Indianapolis, XLIV, 1957, p. 46 ff.

— 'The Early Years of Hobbema', *Art Quarterly*, XXII, 1959, p. 3 ff.

— 'Cuyp's "Valkhof at Nijmegen"', *John Herron Art Institute Bulletin*, Indianapolis, XLVII, 1960, p. 4 ff.

— 'The Winter Landscape in the History of Art', *Criticism*, 1960, p. 175 ff.

— 'Landscape Paintings in Dutch Seventeenth Century Interiors', *Nederlands Kunsthistorisch Jaarboek*, XI, 1960, p. 79 ff.

— 'Significant Dates on some Seventeenth Century Dutch Landscape Paintings', *Oud Holland*, LXXV, 1960, p. 79 ff.

— 'Italianate Dutch Artists in the Allen Art Museum', *Allen Memorial Art Museum Bulletin*, XXII, 1964–65, p. 3 ff.

Stechow, Wolfgang (*contd.*), 'Jan Wijnants, View of the Heerengracht, Amsterdam', *Bulletin of the Cleveland Museum of Art*, LII, 1965, p. 164 ff.

— 'Über das Verhältnis zwischen Signatur und Chronologie bei einigen holländischen Künstlern des 17. Jahrhunderts', *Festschrift Dr. h.c. Eduard Trautscholdt*, Hamburg, 1965, p. 111 ff.

— 'A Painting and a Drawing by Adriaen van de Velde', *Bulletin of the Cleveland Museum of Art*, LIV, 1967, p. 30 ff.

— and Hoogendoorn, Annet, 'Het vroegst bekende werk van Salomon van Ruysdael', *Kunsthistorische Mededelingen*, II, 1947, p. 36 ff.

Steland-Stief, Charlotte, *Jan Asselijn*, Diss. Freiburg i. Br., 1963 (scheduled for publication).

— 'Jan Asselijn und Willem Schellinks', *Oud Holland*, LXXIX, 1964, p. 99 ff.

Stelling-Michaud, S., *Unbekannte Schweizer Landschaften aus dem XVII. Jahrhundert*, Zürich–Leipzig, 1937.

Steneberg, *Kristinatidens Måleri*, Malmö, 1955.

Stheeman, A., 'De evolutie van her vlaamsche en hollandsche landschap', *Maandblad voor Beeldende Kunsten*, XII, 1935, p. 11 ff., 39 ff.

Swillens, P. T. A., *Pieter Janszoon Saenredam*, Amsterdam, 1935.

— 'Een schilderij van Willem Schellinks', *Kunsthistorische Mededelingen*, IV, 1949, p. 19 ff.

— *Johannes Vermeer*, Utrecht–Brussels, 1950.

Thieme, Ulrich, and Becker, Felix, *Allgemeines Lexikon der bildenden Künstler von der Antike bis zur Gegenwart*, Leipzig, 1907–1950. [Th-B]

Thiéry, Yvonne, *Le Paysage flamand au XVIIᵉ siècle*, Paris–Brussels, 1953.

Thijm, J. A. Alberdingk, *Gedichten uit de verschillenden tijdperken der noord- en zuid-nederlandsche literatuur*, II, Amsterdam, 1852.

Thomsen, Th., *Albert Eckhout*, Copenhagen, 1930.

Timm, Werner, 'Der gestrandete Wal, eine motivkundliche Studie', *Staatliche Museen zu Berlin [East]*, *Forschungen und Berichte*, III/IV, 1961, p. 76 ff.

Timmers, J. J. M., *A History of Dutch Life and Art*, London, 1959.

Tolnay, Charles de, *The Drawings of Pieter Bruegel the Elder*, London, 1952.

Trautscholdt, Eduard, 'Der Maler Herkules Seghers', *Pantheon*, XXV, 1940, p. 81 ff.

— 'Neues Bemühen um Hercules Seghers', *Imprimatur*, XII, 1954–55, p. 78 ff.

Valentiner, Elisabeth, *Karel van Mander als Maler*, Strasbourg, 1930.

Valentiner, Wilhelm R., 'Jan van de Cappelle', *Art Quarterly*, IV, 1941, p. 272 ff.

— 'Rembrandt's Landscape with a Country House', *Art Quarterly*, XIV, 1951, p. 341 ff.

Verbeek, J., and Schotman, J. W., *Hendrick ten Oever . . .*, Zwolle, 1957.

Vipper, B. R., *The Origin of Realism in Dutch Painting of the Seventeenth Century* (in Russian), Moscow, 1957.

Vorenkamp, A. P. A., 'A View of Rynland by Jan van Goyen', *Bulletin Smith College Museum of Art*, no. 23, June, 1942, p. 10 ff.

Waal, H. van de, *Jan van Goyen* (Palet series), Amsterdam, n.d. (1941).

— *Drie eeuwen vaderlandsche geschied-uitbeelding*, 2 vols., The Hague, 1952.

Waddingham, Malcolm, 'Herman van Swanevelt in Rome', *Paragone*, XI, no. 121, 1960, p. 37 ff.

— 'Andries and Jan Both in France and Italy', *Paragone*, XV, no. 171, 1964, p. 13 ff.

Waetzoldt, Wilhelm, 'Okeanos, Bemerkungen zur Geschichte der Meeresmalerei', *Neue Beiträge deutscher Forschung, Wilhelm Worringer zum 60. Geburtstag*, Königsberg, 1943, p. 224 ff.

Walicki, M., see Bialostocki, J.

Weiner, P. P. von, *Meisterwerke der Gemäldesammlung in der Eremitage zu Petrograd*, Munich, 1923.

Weisner, Ulrich, *Moyses van Uyttenbroeck*, Diss. Kiel, 1963 (unpublished).
— 'Die Gemälde des Moyses van Uyttenbroeck', *Oud Holland*, LXXIX, 1964, p. 189 ff.
Weizsäcker, Heinrich, *Adam Elsheimer, der Maler von Frankfurt*, 2 vols., Berlin, 1936–52.
Welcker, A., 'Johannes Ruyscher alias Jonge Hercules', *Oud Holland*, XLIX, L, LI, LIII, 1932–36.
— 'Pieter Boddink alias Pieter van Laer', *Oud Holland*, LIX, 1942, and LXII, 1947.
Welcker, Clara J., *Hendrick Avercamp en Barent Avercamp . . .*, Zwolle, 1933. [Welcker].
Wellensieck, Hertha, 'Das Brüsseler "Elias-Bild", ein Werk des Gillis van Coninxloo?',
 Bulletin, Musées Royaux des Beaux-Arts, Brussels, III, 1954, p. 109 ff.
Wijnman, H. F., 'Het leven der Ruysdaels', *Oud Holland*, XLIX, 1932, p. 49 ff., 173 ff.,
 258 ff.
Willis, Fred C., *Die niederländische Marinemalerei*, Leipzig, n.d. (1911).
Willnau, C., 'Die Zusammenarbeit des Nikolaus Knupfer mit anderen Künstlern', *Oud
 Holland*, LXVII, 1952, p. 210 ff.
Worp, J. A., 'Constantijn Huygens over de schilders van zijn tijd', *Oud Holland*, IX, 1891,
 p. 106 ff.
— 'Fragment eener autobiographie van Constantijn Huygens', *Bijdragen en Mededelingen van
 het Historisch Genootschap Utrecht*, XVIII, 1897.
— *De Briefwisseling van Constantijn Huygens*, The Hague, 1911–13.
Wurzbach, Alfred von, *Niederländisches Künstler-Lexikon*, 3 vols., Vienna–Leipzig, 1906–11.
 [Wzb.]

Zeri, Federico, *La Galleria Spada in Roma*, Florence, 1954.
Zoege von Manteuffel, Kurt, *Die Künstlerfamilie van de Velde*, Bielefeld–Leipzig, 1927.
Zwarts, Jacob, 'Het motief van Jacob van Ruisdael's "Jodenkerkhof"', *Oudheidkundig Jaar-
 boek*, VIII, 1928, p. 232 ff.

SOME RECENT EXHIBITION CATALOGUES

Almelo: Oude Kunst uit Twents Particulier Bezit. 1953

Amsterdam: Historische Tentoonstelling, Rijksmuseum and Stedelijk Museum. 1925
— Hollandsche Winterlandschappen uit de Zeventiende Eeuw, at J. Goudstikker's. 1932
— Salomon van Ruysdael, at J. Goudstikker's. 1936
— Jan van der Heyden, Historisch Museum. 1937
— Hercules Seghers, Rijksmuseum (Rijksprentenkabinet). 1967
— Hercules Seghers en zijn voorlopers, Rijksmuseum (Rijksprentenkabinet). 1967

Ann Arbor: Italy through Dutch Eyes, Dutch 17th-Century Landscape Artists in Italy, Museum, University of Michigan. 1964

Arnhem: Zeventiende-Eeuwse Meesters uit Gelders Bezit, Gemeente Museum. 1953
— Collectie B. de Geus van den Heuvel, Gemeente Museum. 1961
— Het Nederlandse Landschap in de 17e Eeuw, Gemeente Museum. 1964
— See also Leiden.

Baltimore: Landscape Painting from Patinir to Hubert Robert, Johns Hopkins University. 1941

Basel: Meisterwerke holländischer Malerei des 16. bis 18. Jahrhunderts, Kunstmuseum. 1945

Bologna: L'ideale classico del Seicento in Italia e la pittura di paesaggio, Palazzo dell' Archiginnasio. 1962

Bonn: Rheinische Landschaften und Städtebilder, 1600–1850, Landesmuseum. 1960–61

Boston: See San Francisco.

Breda: Het Landschap in de Nederlanden, 1550–1630. 1961
Also shown in Ghent.

Brussels: Cinq Siècles d'Art, Exposition universelle. 1935

Cardiff: Ideal and Classical Landscape, National Museum of Wales, 1960

Cologne: Meisterwerke holländischer Landschaftsmalerei des 17. Jahrhunderts, Wallraf-Richartz-Museum. 1954

Detroit: Dutch Landscape Paintings, Detroit Institute of Arts. 1939
— Five Centuries of Marine Painting, Detroit Institute of Arts. 1942

Dordrecht: Nederlandse Landschappen uit de Zeventiende Eeuw, Dordrechts Museum. 1963
— Zee-, Rivier-, en Oevergezichten, Dordrechts Museum. 1964

Düsseldorf: Niederrheinansichten holländischer Künstler des 17. Jahrhunderts, Kunstmuseum. 1953

Eindhoven: Nederlandse Landschapskunst in de Zeventiende Eeuw, Stedelijk van Abbe Museum. 1948

Enschede: Nederlandsche 17.-Eeuwsche Schilderijen uit Particuliere Verzamelingen te Enschede, Rijksmuseum Twenthe. 1935

Frankfurt: Adam Elsheimer, Werk, künstlerische Herkunft und Nachfolge, Städelsches Kunstinstitut. 1966–67

Ghent: Roelandt Savery, Museum van Schone Kunsten. 1954
— See also Breda.

Haarlem: See p. 231 above, Slive, Seymour.

Indianapolis: The Young Rembrandt and His Times, John Herron Art Museum. 1958
Also shown in San Diego.

Krefeld: Deutsche Landschaften und Städtebilder in der Niederländischen Kunst des 16. bis 18. Jahrhunderts, Kaiser-Wilhelm-Museum. 1938

Leiden: Jan van Goyen, Lakenhal. 1960
 Also shown in Arnhem.
London: Dutch Art, 1450–1900, Royal Academy. 1929
— Seventeenth Century Art in Europe, Royal Academy. 1938
— Dutch Pictures, 1450–1750, Royal Academy. 1952–53
— Artists in Seventeenth Century Rome, at Wildenstein's. 1955
Milan: Pittura olandese del seicento, Palazzo Reale. 1954
Nancy: Autour de Claude Gelée, Musée des Beaux-Arts. 1957
New York: Dutch Painting of the Golden Age, Metropolitan Museum of Art. 1954–55
 Also shown in Toledo and Toronto.
Paris: Le Paysage hollandais au XVIIᵉ siècle, Orangerie. 1950–51
Prague: Holandské Krajinářství 17. Století, Národní Galerie. 1964
Rome: Capolavori della pittura olandese, Galleria Borghese. 1928
— See also Briganti, G.
Rotterdam: Meesterwerken uit Vier Eeuwen, 1400–1800, Museum Boymans. 1938
— Het Nederlandsche Zee- en Riviergezicht in de XVII. Eeuw, Museum Boymans. 1945–46
— Kunstschatten uit Nederlandse Verzamelingen. Museum Boymans. 1955
— See also Ebbinge Wubben, J. C., and Haverkamp Begemann, E.
San Diego: See Indianapolis.
San Francisco: The Age of Rembrandt, California Palace of the Legion of Honor. 1966–67
 Also shown in Boston and Toledo.
Solingen: Niederländische Landschaften und Seestücke des 17. Jahrhunderts, Deutsches
 Klingenmuseum. 1965–66
Southampton: Marine Painting of the Netherlands from Vroom to van de Velde, Art Gallery.
 1949
Speyer: Ein grosses Jahrhundert der Malerei, Niederländische Gemälde des Mainzer Museums,
 Historisches Museum. 1957
Toledo: See New York and San Francisco.
Toronto: See New York.
Utrecht: Nederlandse Architectuurschilders, 1600–1900, Centraal Museum. 1953
— Pieter Jansz. Saenredam, Centraal Museum. 1961
— Nederlandse 17e Eeuwse Italianiserende Landschapschilders, Centraal Museum. 1965
Vienna: Die römische Landschaft in der Malerei des 17. und frühen 18. Jahrhunderts,
 Akademie der bildenden Künste. 1963
Warsaw: Krajobraz Holenderski XVII. Wieku, Muzeum Narodowe. 1958
Zutphen: Stad en Landschap, De Nederlandse Landschapskunst in de Zeventiende Eeuw,
 Burgerzaal. 1957

ILLUSTRATIONS

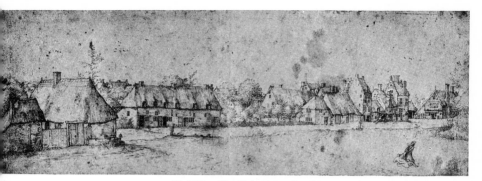

10. CORNELIS CORT (?): *Village*. New York, Metropolitan Museum of Art

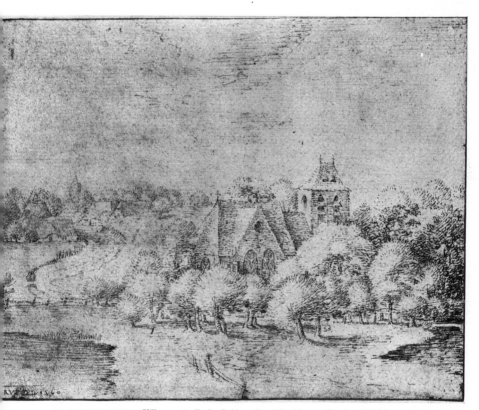

11. PIETER BRUEGEL: *Village*. 1560. Berlin-Dahlem, Staatliche Museen, Kupferstichkabinett

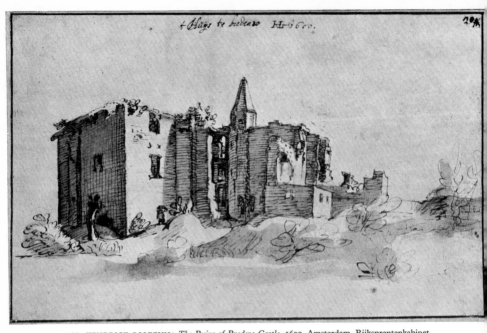

12. HENDRICK GOLTZIUS: *The Ruins of Bredero Castle*. 1600. Amsterdam, Rijksprentenkabinet

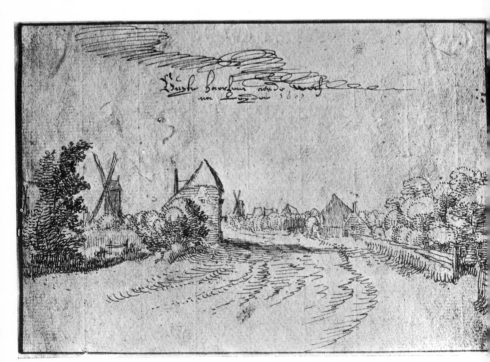

13. CLAES J. VISSCHER: *The Road to Leiden*. 1607. Amsterdam, Rijksprentenkabinet

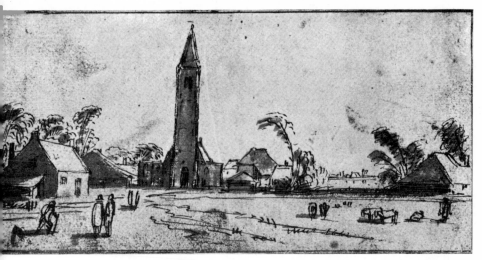

14. ESAJAS VAN DE VELDE: *Spaerwou*. Amsterdam, Rijksprentenkabinet

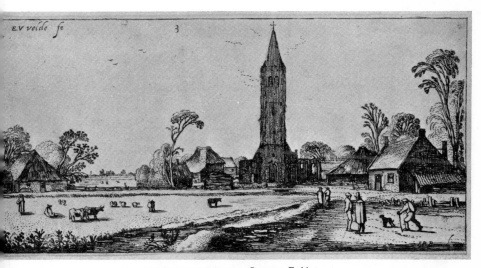

15. ESAJAS VAN DE VELDE: *Spaerwou*. Etching

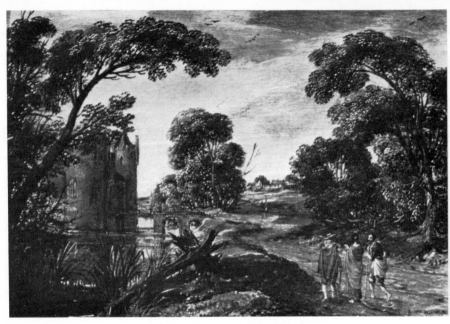

16. ESAJAS VAN DE VELDE: *Summer*. Oberlin, Ohio, Allen Memorial Art Museum, Oberlin College

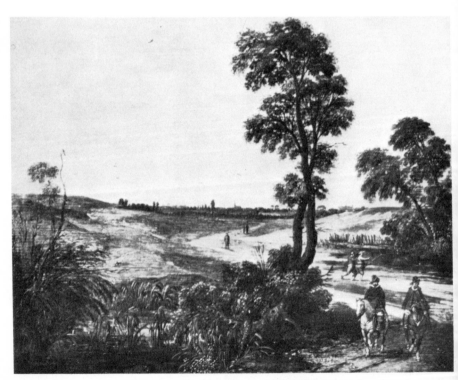

17. ESAJAS VAN DE VELDE: *Two Horsemen*. 1614. Enschede, Rijksmuseum Twenthe

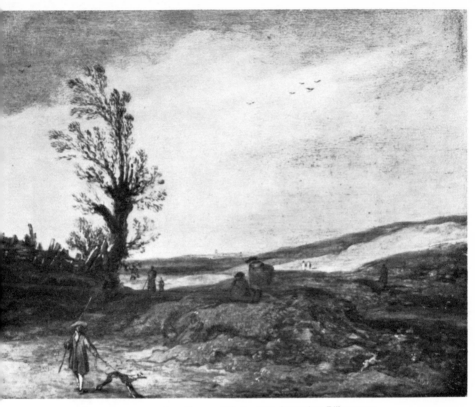

18. ESAJAS VAN DE VELDE: *Dunes and Hunter*. 1629. Amsterdam, Rijksmuseum

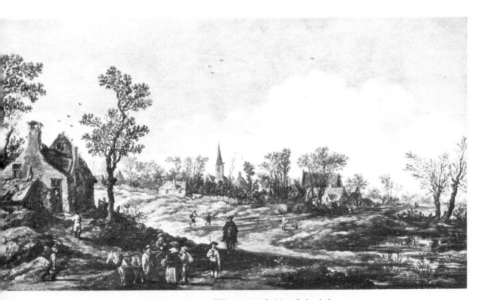

19. JAN VAN GOYEN: *Village*. 1626. Leiden, Lakenhal

20. JAN VAN GOYEN: *Village*. 1625. Bremen, Kunsthalle

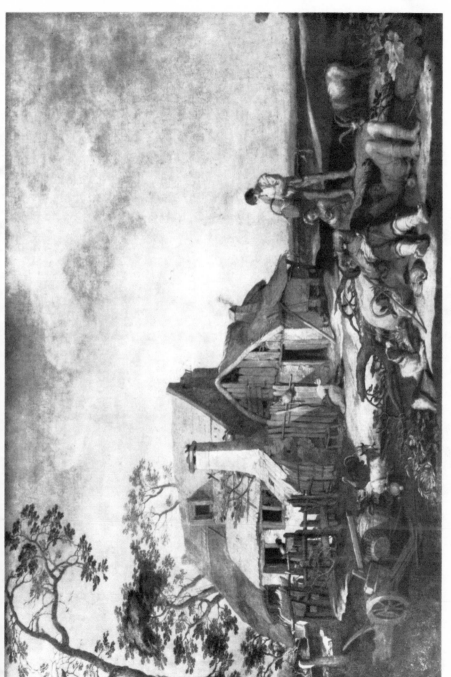

21. ABRAHAM BLOEMAERT: *The Farm.* 1650. Berlin-Dahlem, Staatliche Museen

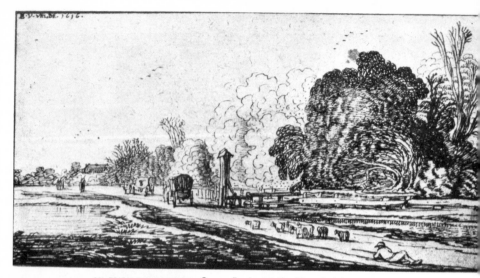

22. ESAJAS VAN DE VELDE: *Country Road.* 1616. Frankfurt, Städelsches Kunstinstitut

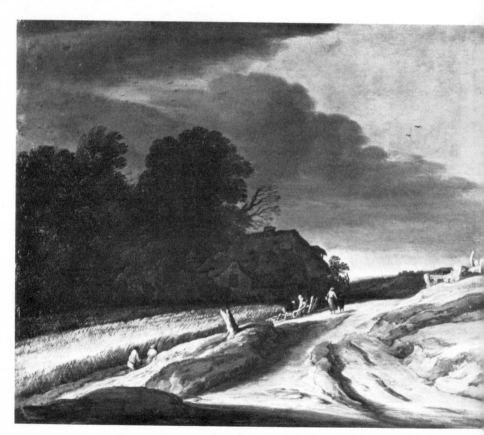

23. PIETER VAN SANTVOORT: *Sandy Road.* 1625. Berlin-Dahlem, Staatliche Museen

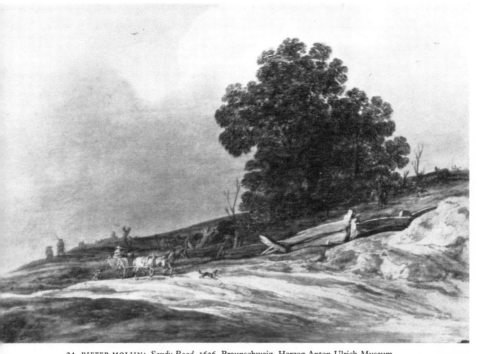

24. PIETER MOLIJN: *Sandy Road*. 1626. Braunschweig, Herzog Anton Ulrich Museum

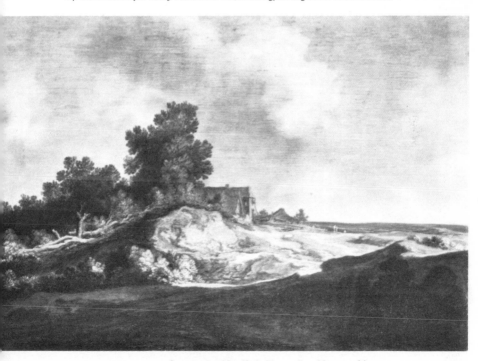

25. PIETER MOLIJN: *Cottage*. 1629. New York, Metropolitan Museum of Art

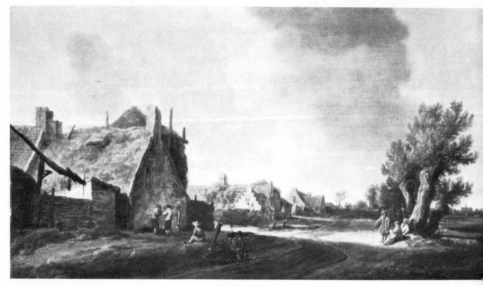

26. JAN VAN GOYEN: *Country Road.* 1628. Frankfurt, Städelsches Kunstinstitut

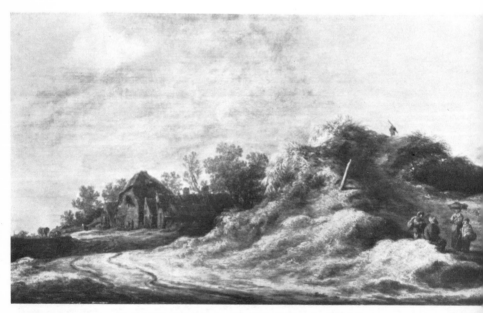

27. JAN VAN GOYEN: *Dunes.* 1629. Berlin-Dahlem, Staatliche Museen

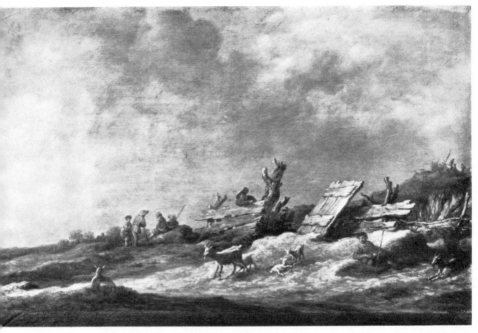

28. JAN VAN GOYEN: *Wooden Fence*. 1631. Braunschweig, Herzog Anton Ulrich Museum

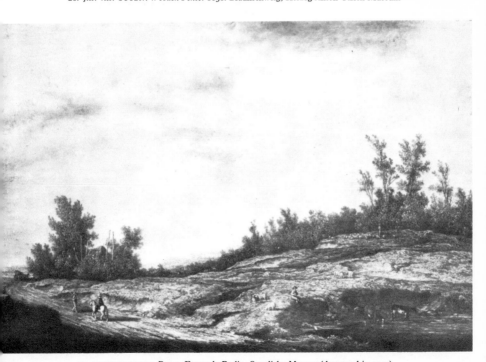

29. AELBERT CUYP: *Dunes*. Formerly Berlin, Staatliche Museen (destroyed in 1945)

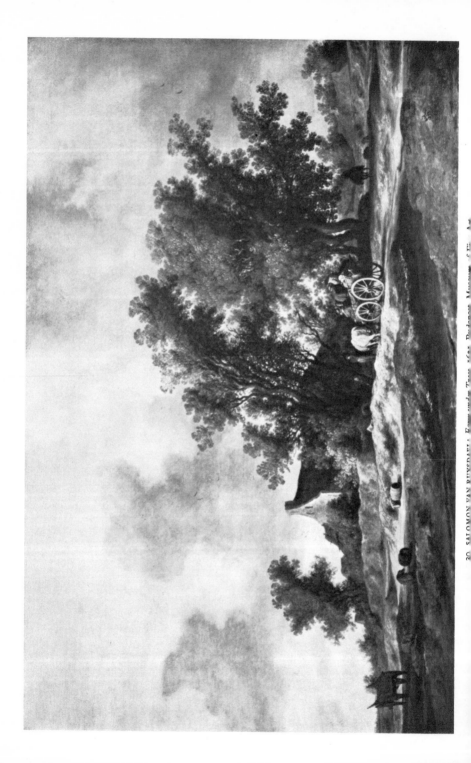

20. SALOMON VAN RUYSDAEL: *Ferry-boat Team. 1651.* Boymans Museum of Fine Art

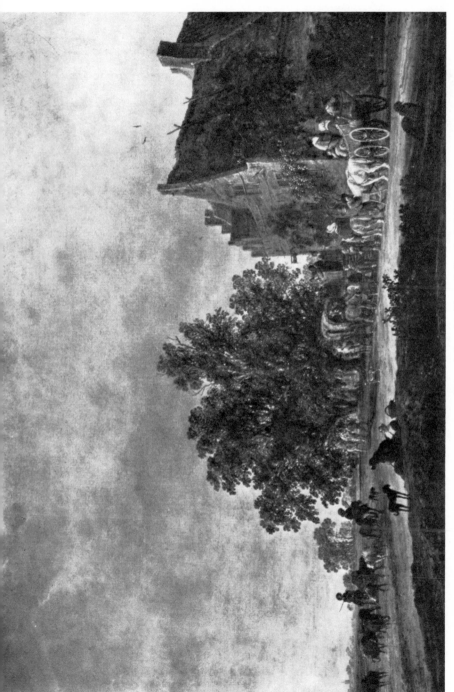

31. SALOMON VAN RUYSDAEL: *Halt at the Inn.* 1643. Montreal, Canada, Coll. J. Roos

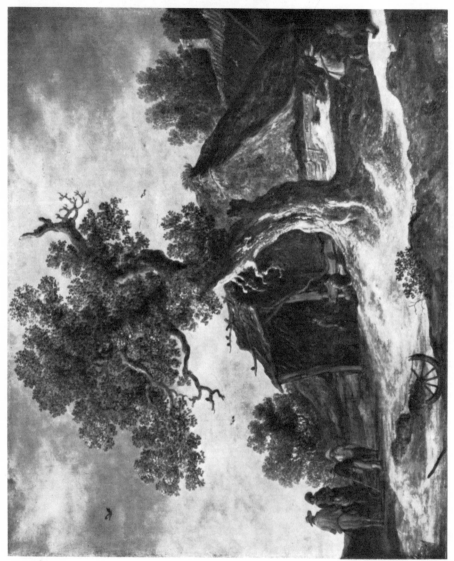

32. IAN VAN GOYEN: *The Oak*, 1634. Leningrad, Hermitage

33. ISAAK VAN OSTADE: *The Inn.* 1646. Duisburg, Coll. Henle

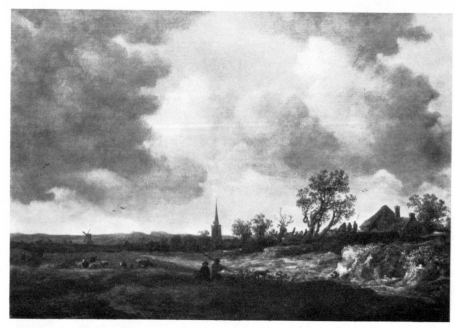

34. JAN VAN GOYEN: *Village and Dunes*. 1647. Oberlin, Ohio, Allen Memorial Art Museum, Oberlin College

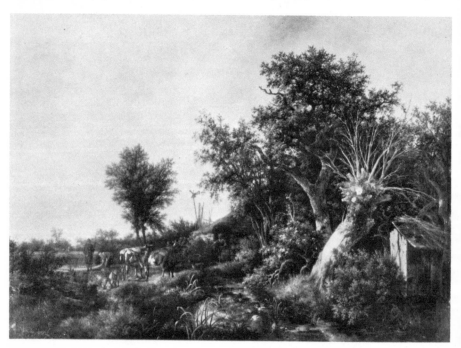

35. JACOB VAN RUISDAEL: *The Cottage*. 1646. Hamburg, Kunsthalle

36. REMBRANDT: *The Farm*. 1654. Montreal, Canada, Museum of Fine Arts

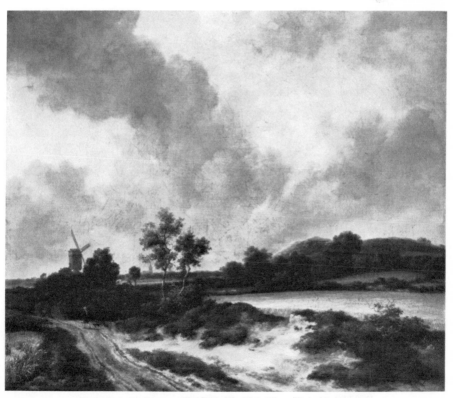

37. JACOB VAN RUISDAEL: *Grainfields*. New York, Metropolitan Museum of Art

38. PHILIPS WOUWERMAN: *The Rest*. 1646. Leipzig, Museum der bildenden Künste

39. JACOB VAN RUISDAEL: *Country Road*. 1649. Antwerp, Musée Royal des Beaux-Arts

40. PHILIPS WOUWERMAN: *Watering the Horse*. Leipzig,
Museum der bildenden Künste

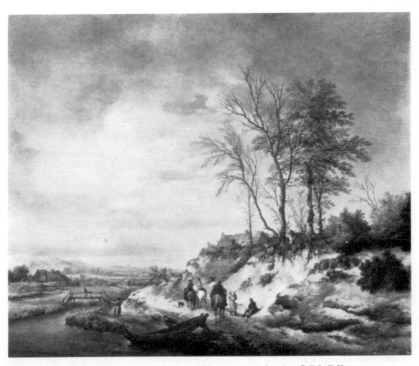

41. PHILIPS WOUWERMAN: *Dunes and Horsemen*. 1652. London, Coll. L. F. Koetser

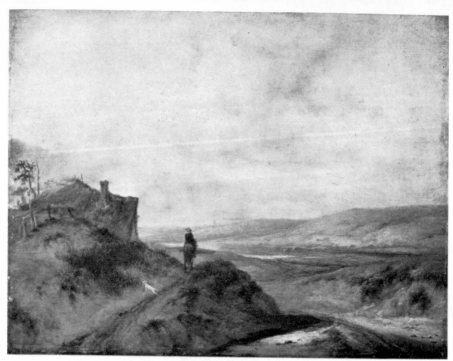

42. PHILIPS WOUWERMAN: *Dunes and Horseman*. Frankfurt, Städelsches Kunstinstitut

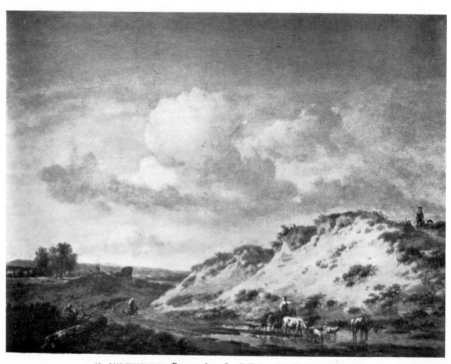

43. JAN WIJNANTS: *Peasants by a Sandhill*. London, National Gallery

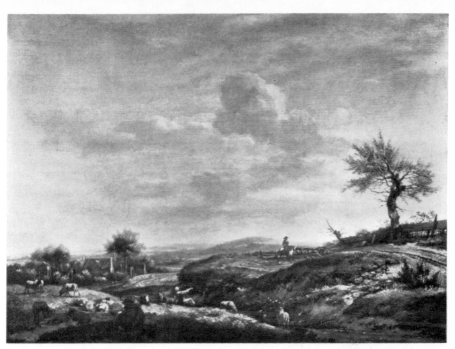

44. ADRIAEN VAN DE VELDE: *Dunes and Shepherds.* 1663. Amsterdam, Rijksmuseum

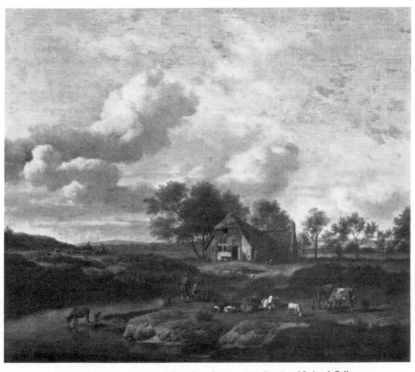

45. ADRIAEN VAN DE VELDE: *Farm by a Stream.* 1661. London, National Gallery

46. AELBERT CUYP: *Avenue at Meerdervoort*, London, Wallace Collection

47. MEINDERT HOBBEMA: *The Avenue of Middelharnis*. 1689. London, National Gallery

48. Flemish (?), early 17th century: *The Alley.* Amsterdam, Rijksmuseum

49. HANS BOL: *Town Panorama*. 1578. Los Angeles, California, County Museum of Art

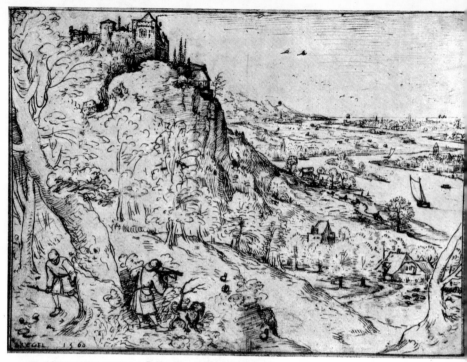

50. AFTER PIETER BRUEGEL: *Rabbit Hunt.* Copy after a lost preparatory drawing for the etching. Coll. F. Lugt, Institut Néerlandais, Paris

51. ESAJAS VAN DE VELDE: *The Gallows.* Etching

52

53

54

55. CORNELIS VROOM: *The Valley*. 1631. Berlin-Dahlem, Staatliche Museen, Kupferstichkabinett

56. HERCULES SEGHERS: *View of Amersfoort*. Amsterdam, Rijksprentenkabinet

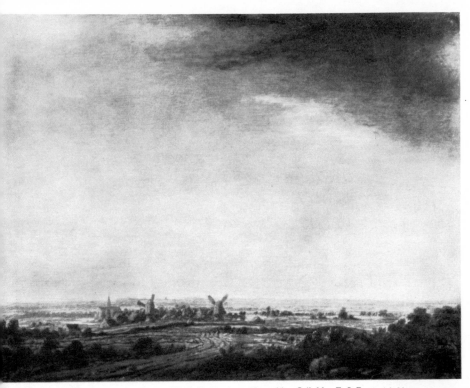

57. HERCULES SEGHERS: *The Two Windmills*. Fareham, Hampshire, Coll. Mrs. E. S. Borthwick-Norton

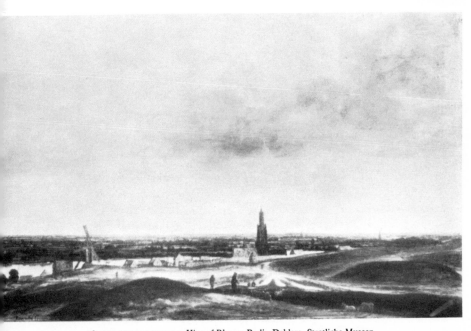

58. HERCULES SEGHERS: *View of Rhenen*. Berlin-Dahlem, Staatliche Museen

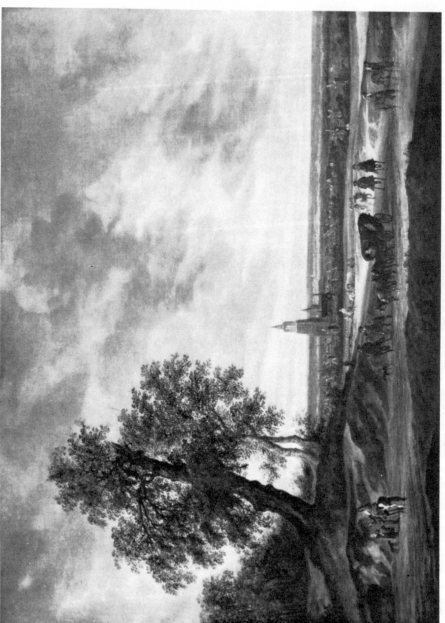

59. SALOMON VAN RUYSDAEL · *View of Amersfoort* 1634 Whereabouts unknown

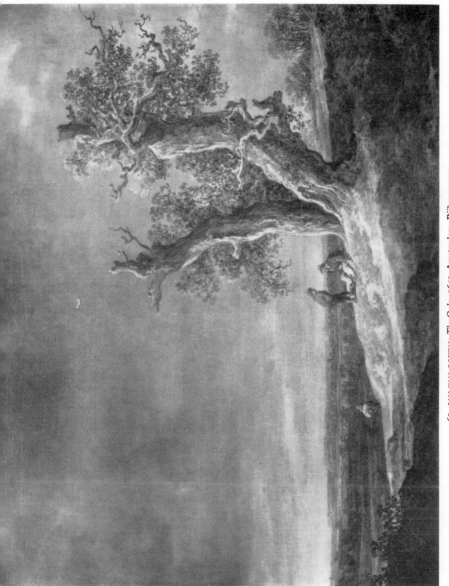

60. JAN VAN GOYEN: *The Oaks.* 1641. Amsterdam, Rijksmuseum

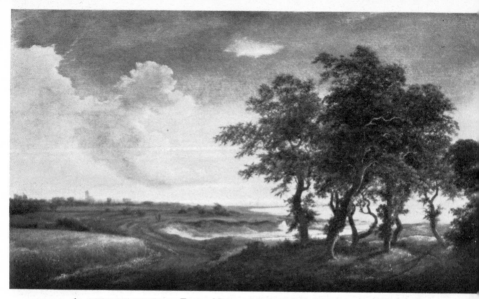

61. JACOB VAN RUISDAEL: *Trees and Dunes*. 1648. Springfield, Mass., Museum of Fine Arts

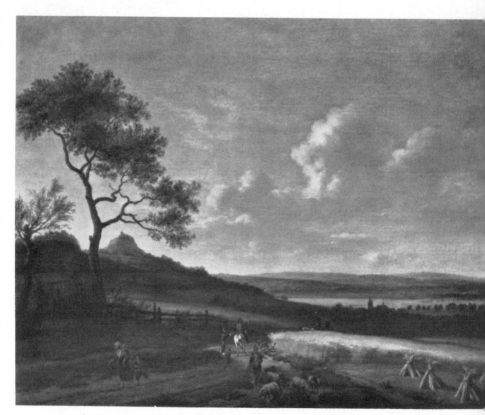

62. ADRIAEN VAN DE VELDE: *Summer*. 1661. Formerly Coll. J. C. H. Heldring, Oosterbeek

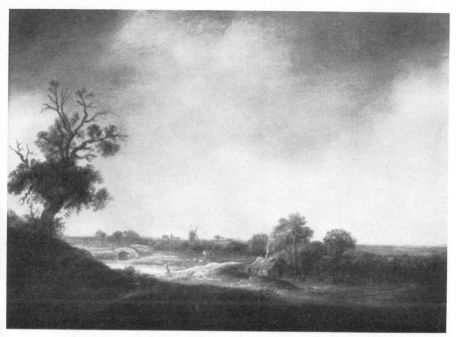

63. ISAAK VAN OSTADE: *Farm and Dunes*. 1641. Basel, Öffentliche Kunstsammlung

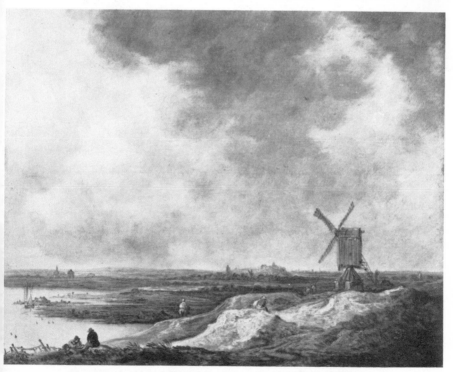

64. JAN VAN GOYEN: *A Windmill by a River*. 1642. London, National Gallery

65. AELBERT CUYP: *View of Amersfoort.* Wuppertal-Elberfeld, Museum

66. JACOB VAN RUISDAEL: *View of Naarden*. 1647. Lugano, Galleria Thyssen

67. JAN VAN GOYEN: *View of a Plain.* 1641. Amsterdam, Rijksmuseum

68. AELBERT CUYP: *The Shepherd.* Frankfurt, Städelsches Kunstinstitut

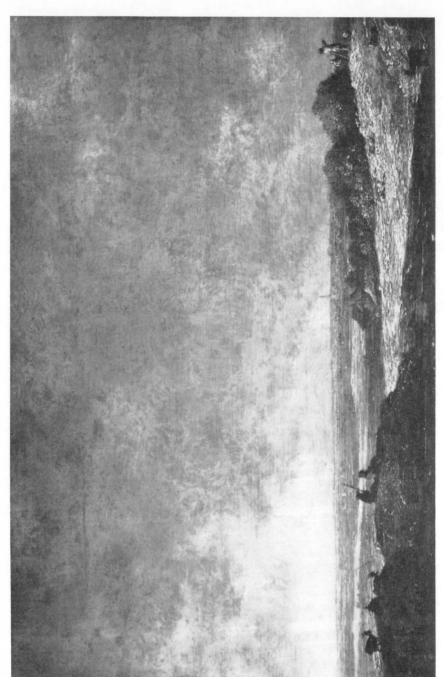

69. AELBERT CUYP: *Dunes and Shepherds.* Munich, Bayerische Staatsgemäldesammlungen

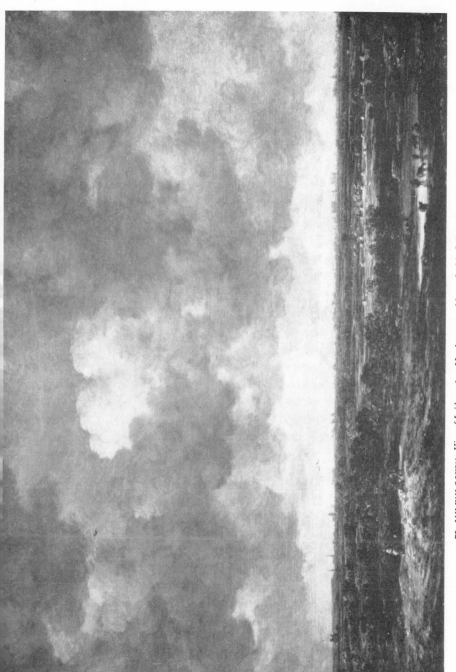

70. JAN VAN GOYEN: *View of Leiden.* 1647. Northampton, Mass., Smith College Museum of Art

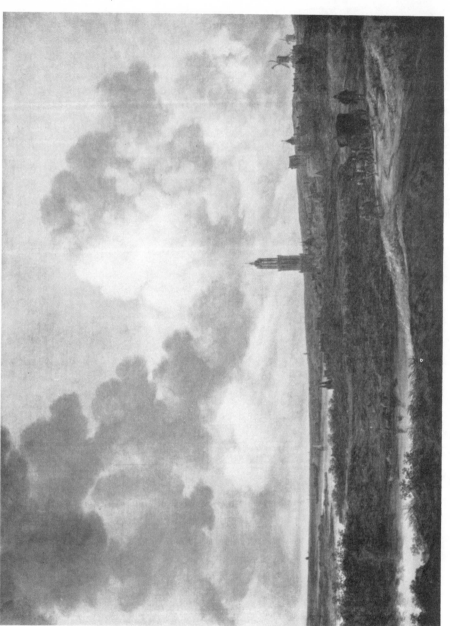

71. JAN VAN GOYEN: *View of Rhenen*. 1646. Washington, Corcoran Gallery of Art, W. A. Clark Collection

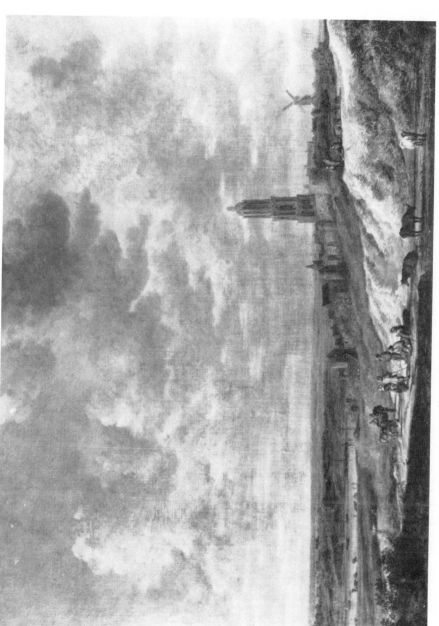

72. JAN VAN GOYEN: *View of Rhenen*. 1636. New York, Metropolitan Museum of Art

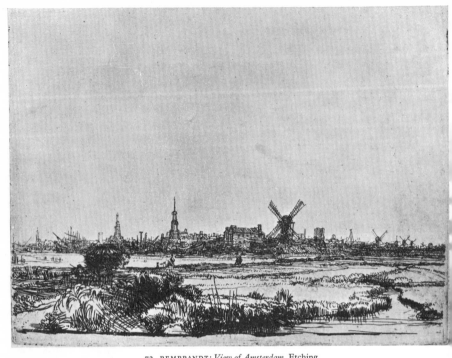

73. REMBRANDT: *View of Amsterdam.* Etching

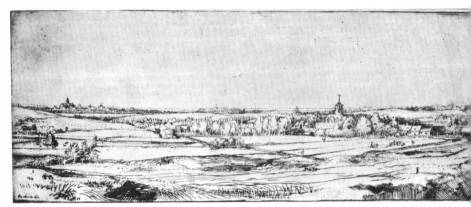

74. REMBRANDT: *View of Saxenburg.* 1651. Etching

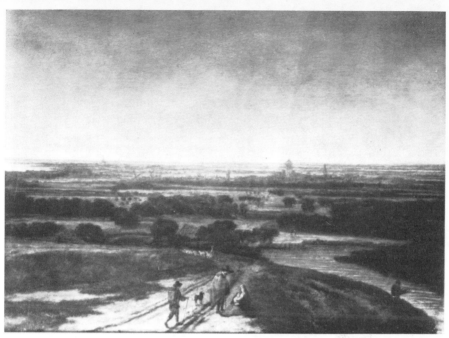

75. PHILIPS KONINCK: *Landscape*. 1647. London, Victoria & Albert Museum

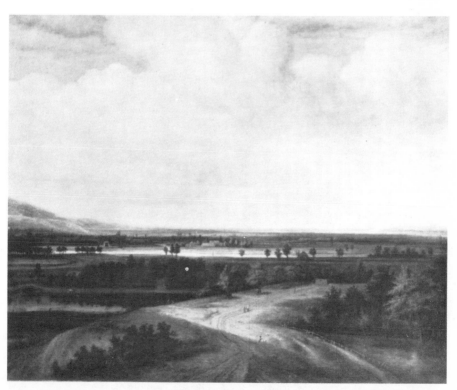

76. PHILIPS KONINCK: *The Dam*. 1649. New York, Metropolitan Museum of Art

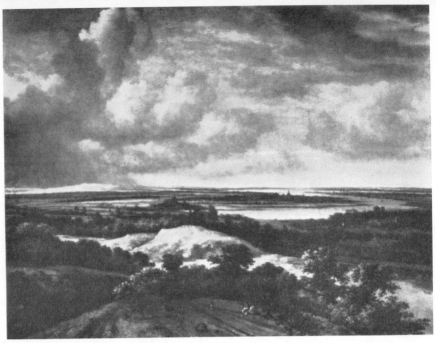

77. PHILIPS KONINCK: *Dunes and River*. 1664. Rotterdam, Museum Boymans-van Beuningen

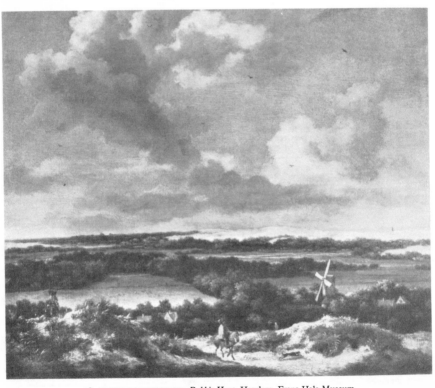

78. JACOB VAN RUISDAEL: *Rabbit Hunt*. Haarlem, Frans Hals Museum

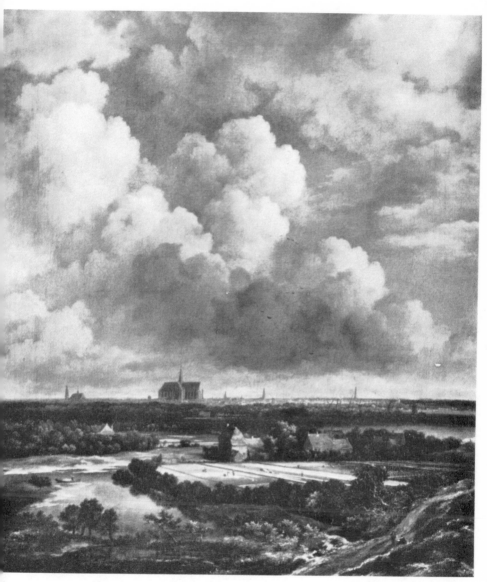

79. JACOB VAN RUISDAEL: *View of Haarlem*. Zürich, Kunsthaus, Ruzicka-Stiftung

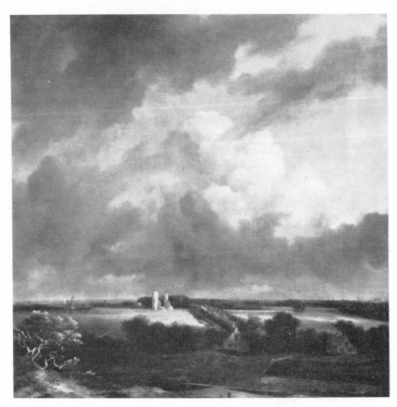

80. JACOB VAN RUISDAEL: *Bleaching Fields*. Paris, Musée Jacquemart-André

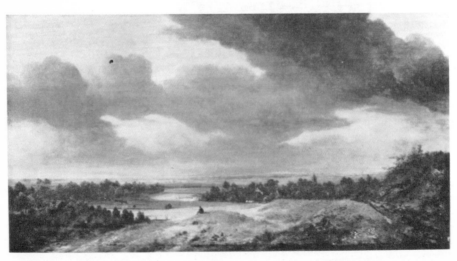

81. JAN VERMEER VAN HAARLEM: *View from the Dunes*. Dresden, Gemäldegalerie

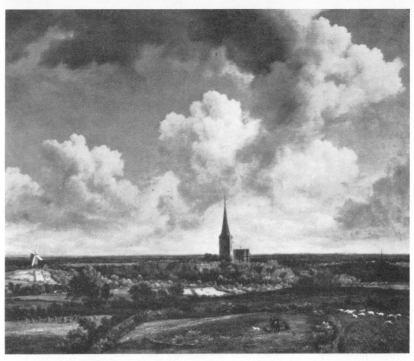

82. JACOB VAN RUISDAEL: *View of a Village*. Munich, Bayerische Staatsgemäldesammlungen

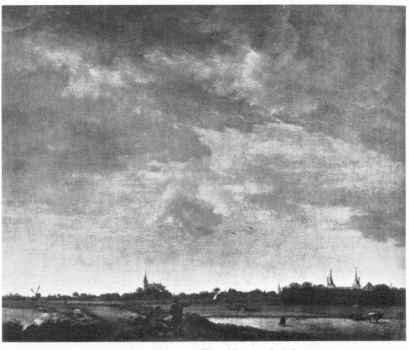

83. JORIS VAN DER HAAGEN: *View of Ilpendam*. Paris, Louvre

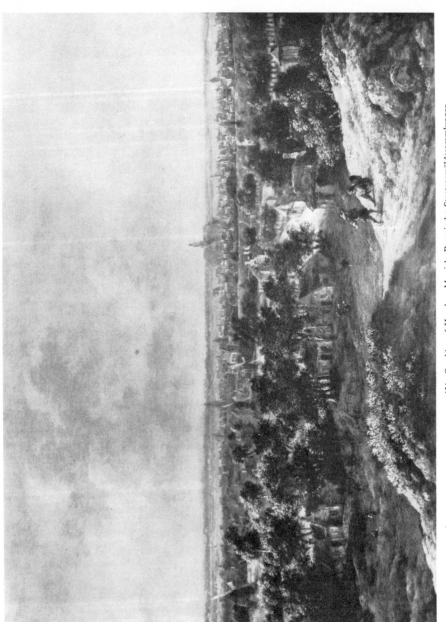

84. JAN VERMEER VAN HAARLEM (?): *Outskirts of Haarlem*. Munich, Bayerische Staatsgemäldesammlungen

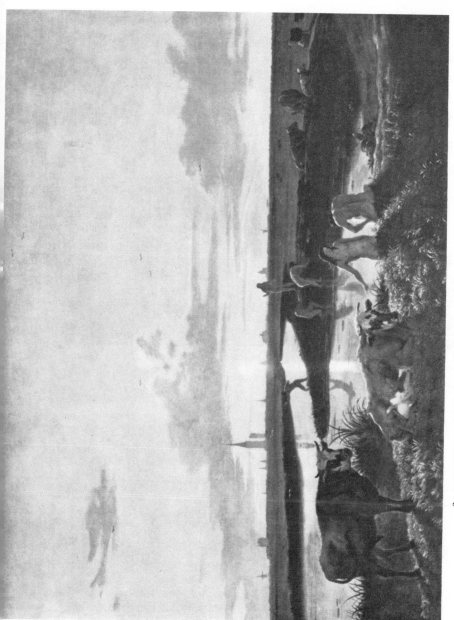

85. HENDRICK TEN OEVER: *Canal with Bathers*. 1675. Edinburgh, National Gallery of Scotland

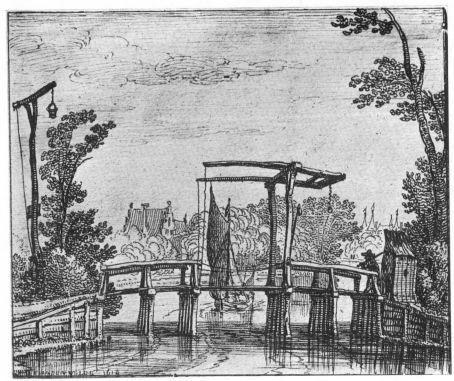

86. CLAES J. VISSCHER: *The Bridge*. Copenhagen, Statens Museum for Kunst, Print Room

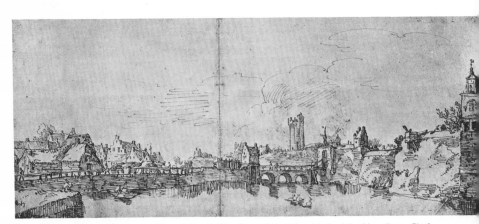

87. ANDRIES BOTH: *View of Utrecht*. The Hague, Paleis Noordeinde, Atlas Munnik van Cleef

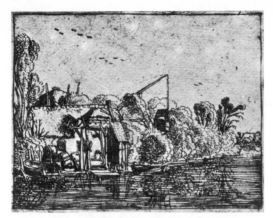

88. ESAJAS VAN DE VELDE: *The Brewery*. Etching

89. HANS BOL: *Ganstrekken*. Etching

90. JAN VAN GOYEN: *Canal and Castle*.
Frankfurt, Städelsches Kunstinstitut

91. ESAJAS VAN DE VELDE: *The Ferry Boat.* 1622. Amsterdam, Rijksmuseum

92. ARENT ARENTSZ: *Fishermen near Muiden Castle.* London, National Gallery

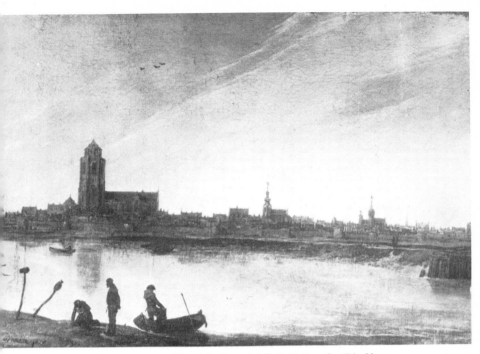

93. ESAJAS VAN DE VELDE: *View of Zierikzee.* 1618. Berlin-Dahlem, Staatliche Museen

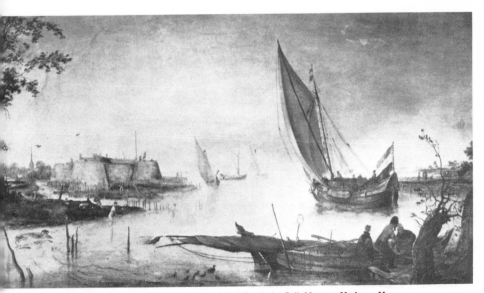

94. HENDRICK AVERCAMP: *Mouth of a River.* Enschede, Coll. Mrs. van Heek-van Hoorn

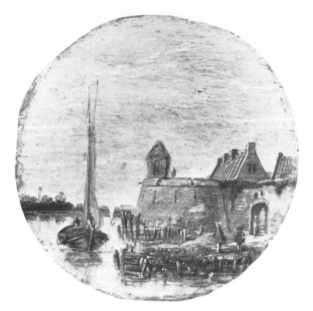

95. ESAJAS VAN DE VELDE: *The Bastion.*
Berlin (East), Staatliche Museen

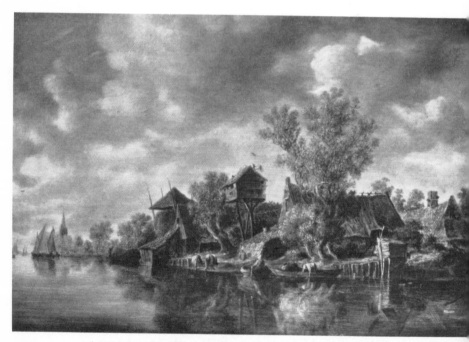

96. JAN VAN GOYEN: *Village.* 1636. Munich, Bayerische Staatsgemäldesammlungen

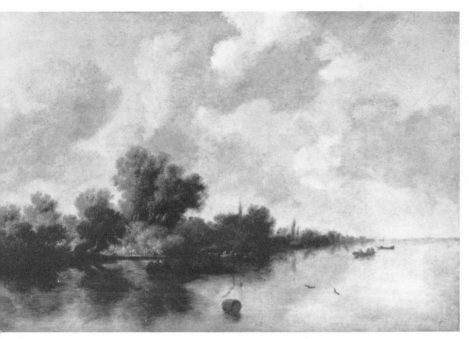

97. SALOMON VAN RUYSDAEL: *River Bank*. 1632. Hamburg, Kunsthalle

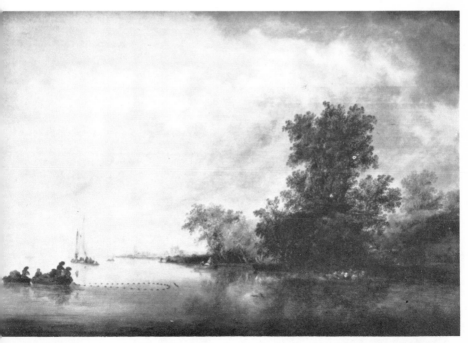

98. SALOMON VAN RUYSDAEL: *River Bank near Liesvelt*. 1642. Munich, Bayerische Staatsgemäldesammlungen

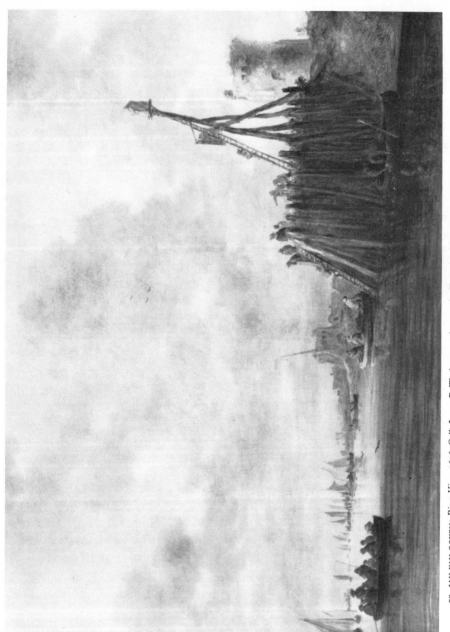

99. JAN VAN GOYEN: *River View.* 1636. Coll. James P. Warburg, on loan to the Fogg Art Museum. Harvard University. Cambridge. Mass.

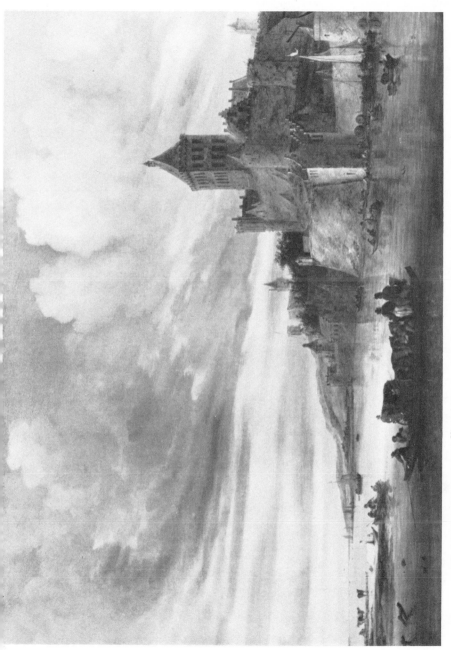

100. SALOMON VAN RUYSDAEL: *View of Nijmegen.* 1648. San Francisco, California, M. H. De Young Memorial Museum

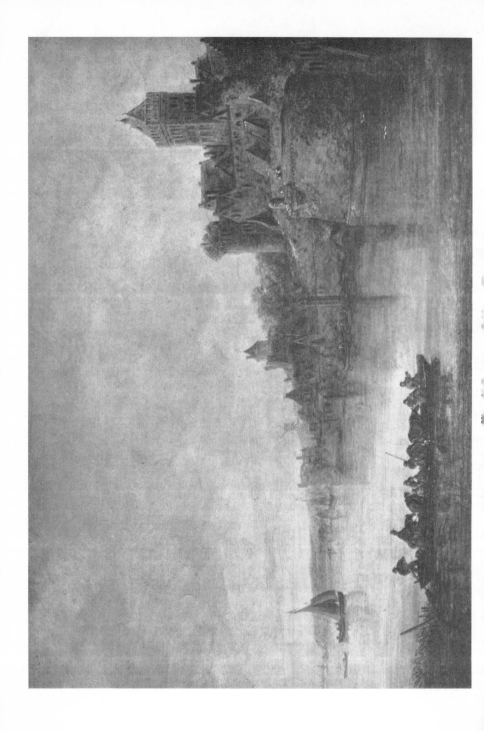

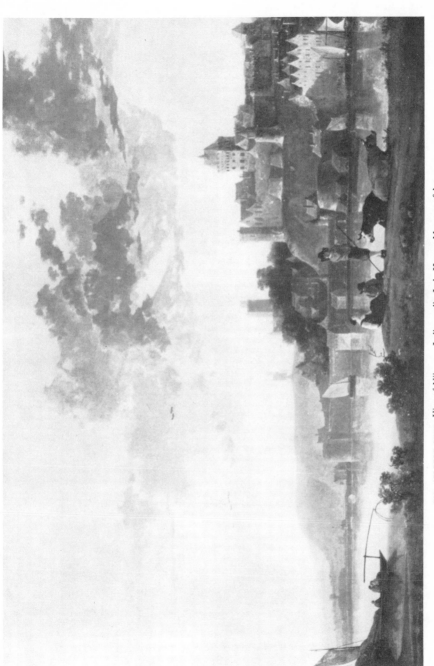

102. AELBERT CUYP: *View of Nijmegen.* Indianapolis, Ind., Herron Museum of Art

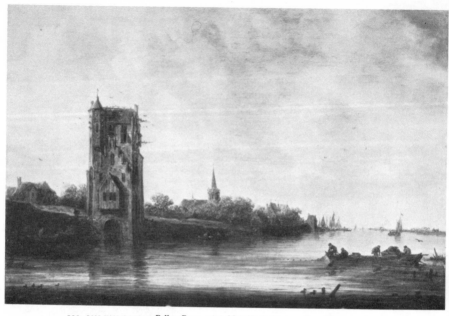

103. JAN VAN GOYEN: *Pelkus-Poort*. 1646. New York, Metropolitan Museum of Art

104. SALOMON VAN RUYSDAEL: *Ferry with Cattle*. 1650. Amsterdam, Coll. A. Schwarz

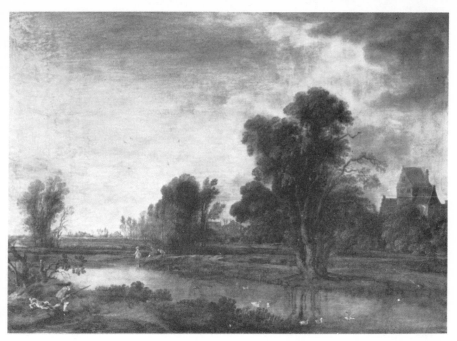

105. AERT VAN DER NEER: *Duck Hunting*. Frankfurt, Städelsches Kunstinstitut

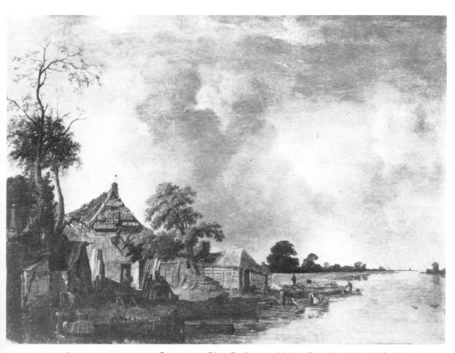

106. SIMON DE VLIEGER: *Cottage on a River Bank*. 1647. Mainz, Gemäldegalerie der Stadt

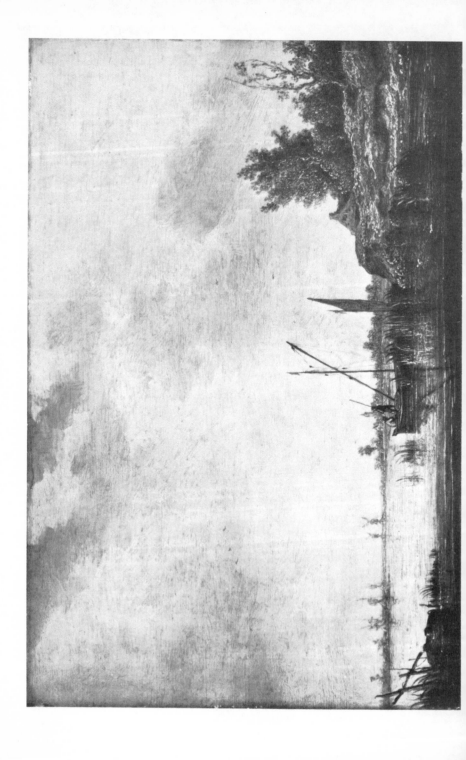

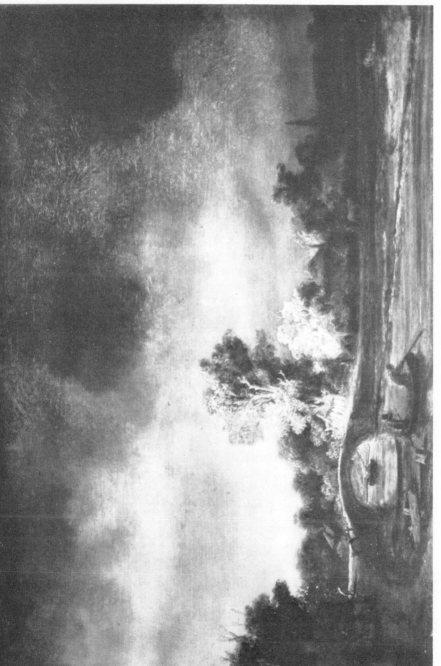

108. REMBRANDT: *The Stone Bridge.* Amsterdam, Rijksmuseum

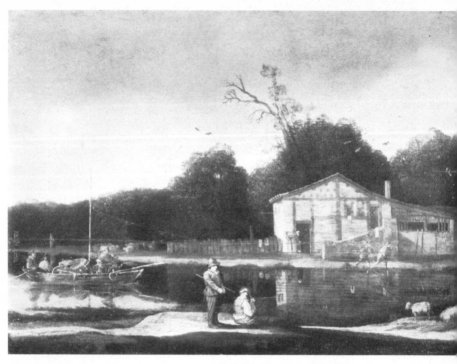

109. CORNELIS VROOM: *Trekschuit*. Whereabouts unknown

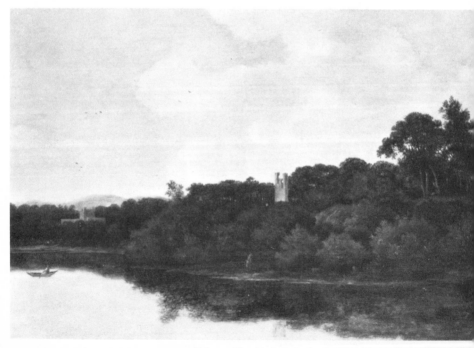

110. CORNELIS VROOM: *Ruin on a River Bank*. Karlsruhe, Staatliche Kunsthalle

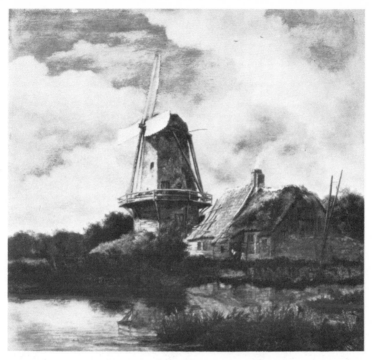

111. JACOB VAN RUISDAEL: *The Windmill*. The Detroit Institute of Arts

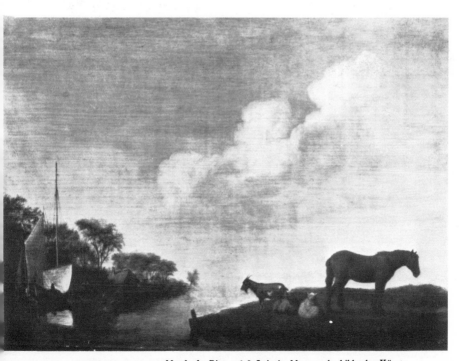

112. ADRIAEN VAN DE VELDE: *Mouth of a River*. 1658. Leipzig, Museum der bildenden Künste

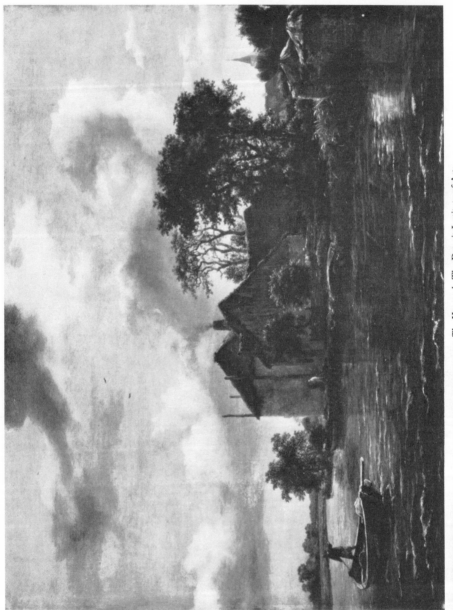

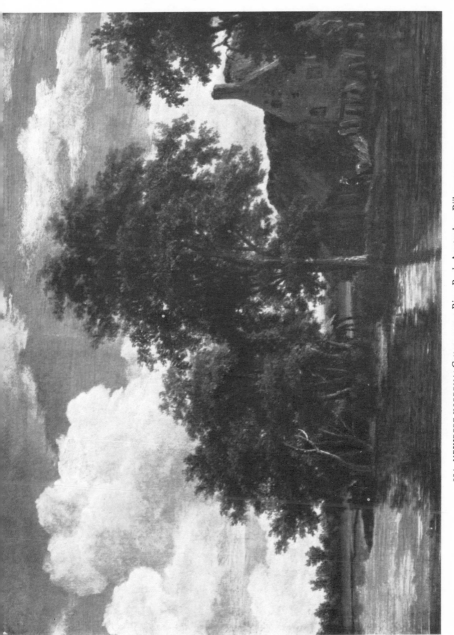

114. MEINDERT HOBBEMA: *Cottage near a River Bank*. Amsterdam, Rijksmuseum

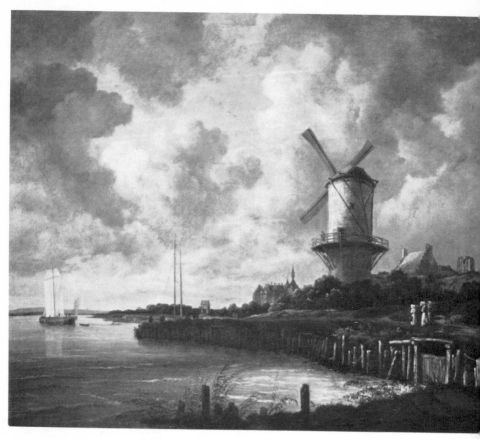

115. JACOB VAN RUISDAEL: *The Mill at Wijk bij Duurstede*. Amsterdam, Rijksmuseum

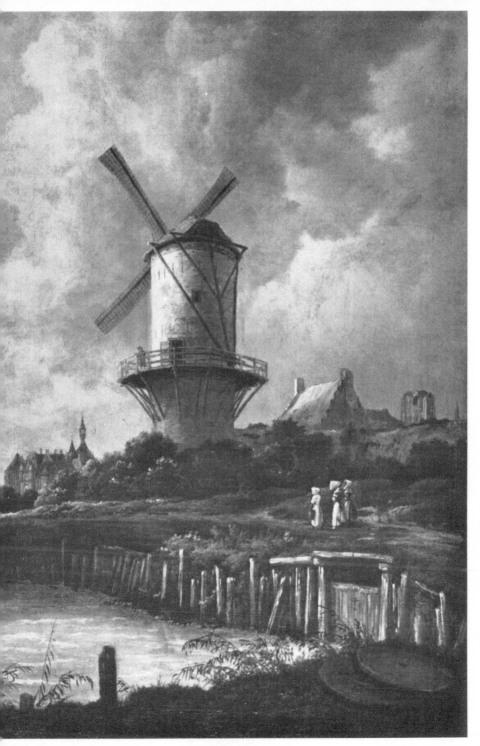

115a. Detail of 115.

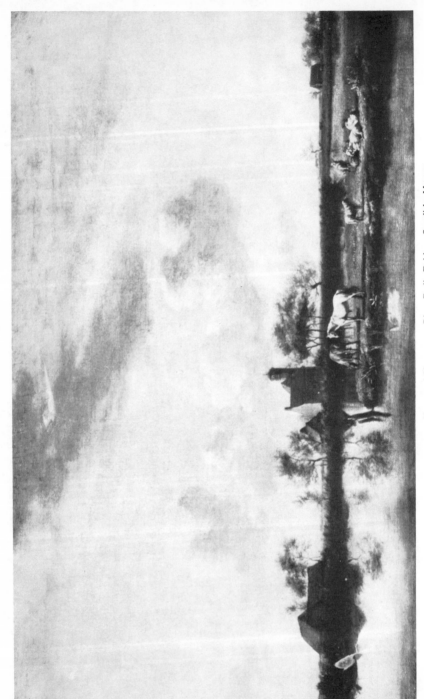

116. ADRIAEN VAN DE VELDE: *Horses and Sheep near a River*. Berlin-Dahlem, Staatliche Museen

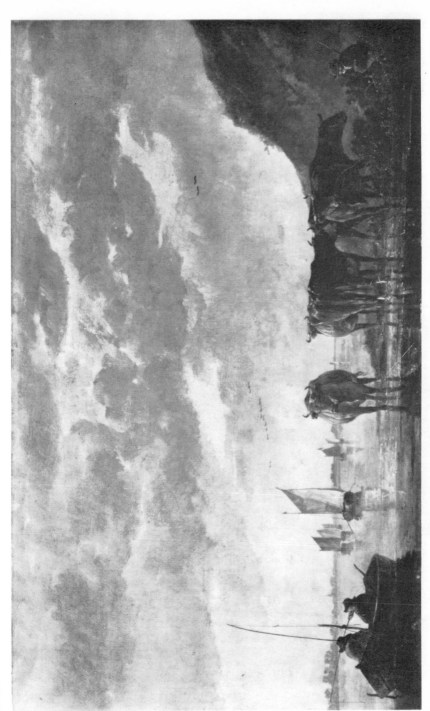

117. AELBERT CUYP: *Herdsman with Five Cows by a River*, London, National Gallery

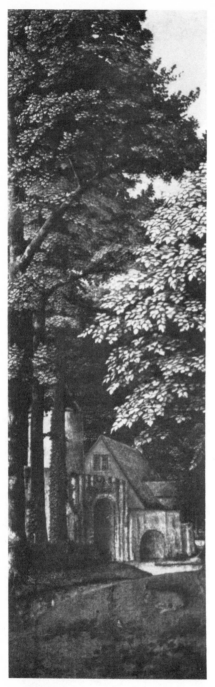
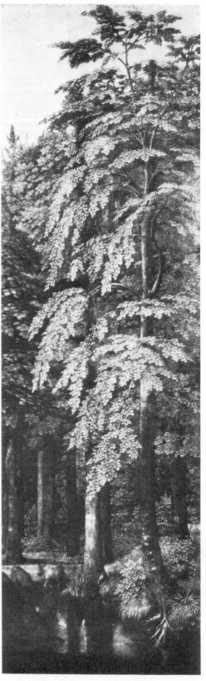

118. GERARD DAVID: *Altar Wings with Trees*. The Hague, Mauritshuis (on loan from the Rijksmuseum)

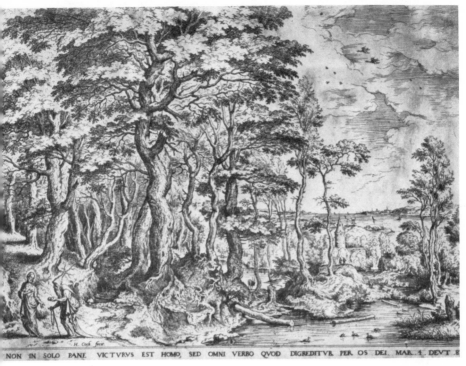

NON IN SOLO PANE VICTVRVS EST HOMO, SED OMNI VERBO QVOD DIGREDITVR PER OS DEI MAR. 4 DEVT 8

119. HIERONYMUS COCK: *The Temptation of Christ*. Etching

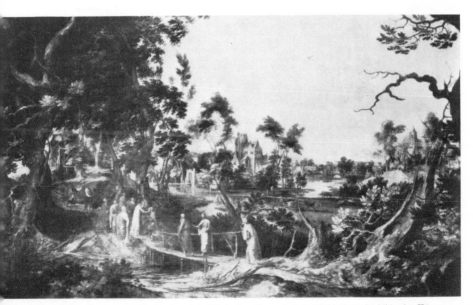

120. GILLIS D'HONDECOETER: *The Healing of the Blind*. 1615. Formerly Leipzig, Museum der bildenden Künste

121. PAOLO FIAMMINGO: *Diana and Nymphs*. Berlin-Dahlem, Staatliche Museen

122. GILLIS VAN CONINXLOO: *Forest*. 1598. Vaduz, Coll. Prince Liechtenstein

123. GILLIS D'HONDECOETER: *Entrance to a Forest*. 1609.
Coll. F. Lugt, Institut Néerlandais, Paris

124. ALEXANDER KEIRINCX: *Creek*. 1621. Braunschweig, Herzog Anton Ulrich Museum

125. GILLIS D'HONDECOETER: *The Bent Tree*. 1627. Enschede, Coll. L. A. Stroink

126. ALEXANDER KEIRINCX: *River Valley*. 1640. Braunschweig, Herzog Anton Ulrich Museum

127. ALEXANDER KEIRINCX: *Stag Hunt.* 1630. Antwerp, Musée des Beaux-Arts

128. ALEXANDER KEIRINCX: *The Temptation of Christ.* 1635. Munich, Bayerische Staatsgemäldesammlungen

129. HERMAN SAFTLEVEN: *Forest*. 1644. Etching

130. JACOB VAN GEEL: *Watermill*. 1637. Braunschweig, Herzog Anton Ulrich Museum

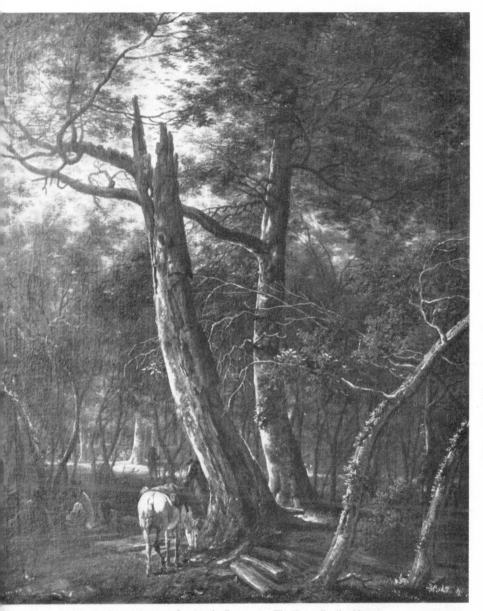

131. HERMAN SAFTLEVEN: *Interior of a Forest.* 1647. The Hague, Bredius Museum

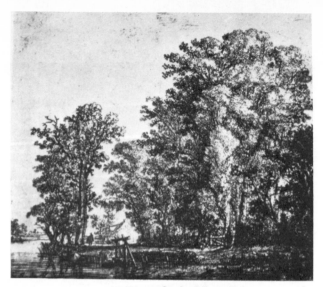

132. SIMON DE VLIEGER: *Canal and Forest*. Etching

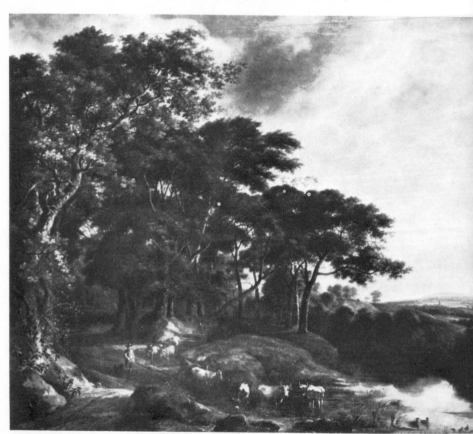

133. SIMON DE VLIEGER: *Entrance to a Forest*. Rotterdam, Museum Boymans-van Beuningen

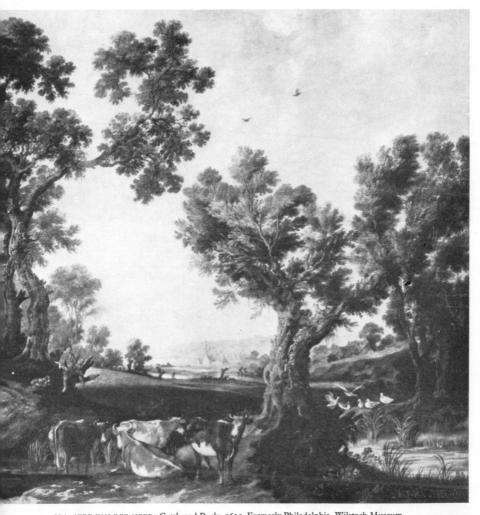

134. AERT VAN DER NEER: *Cattle and Ducks.* 1635. Formerly Philadelphia, Wilstach Museum

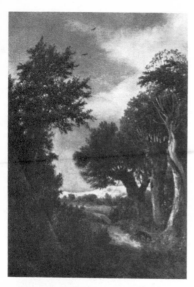

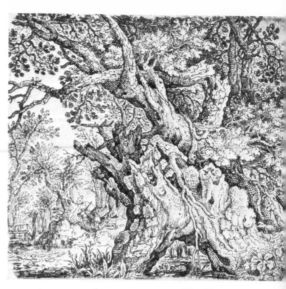

135. JACOB VAN RUISDAEL: *Willow Trees*.
Whereabouts unknown

136. ROELANDT SAVERY: *Giant Trees*

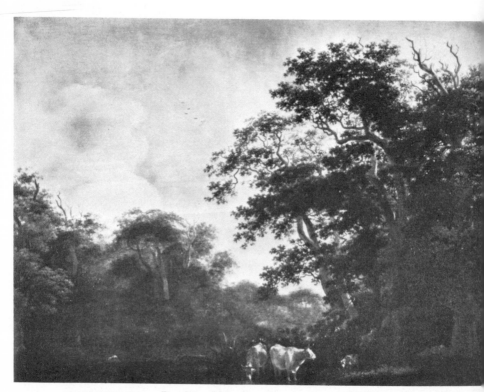

137. CORNELIS VROOM: *Forest View with Two Cows*. Rotterdam, Museum Boymans-van Beuningen

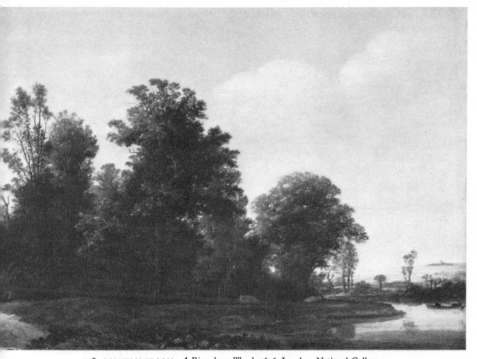

138. CORNELIS VROOM: *A River by a Wood.* 1626. London, National Gallery

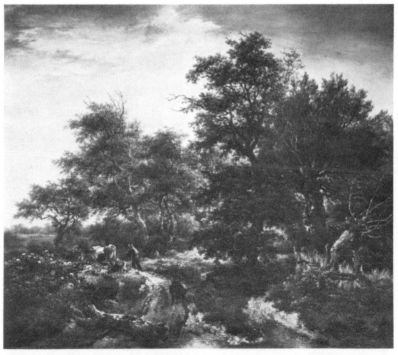

139. JACOB VAN RUISDAEL: *Forest Entrance.* 1653. Amsterdam, Rijksmuseum

141. JACOB VAN RUISDAEL: *Forest Entrance*. Vienna, Akademie der bildenden Künste

140. JACOB VAN RUISDAEL: *Plants*. 1646. Hartford, Conn., Wadsworth Atheneum

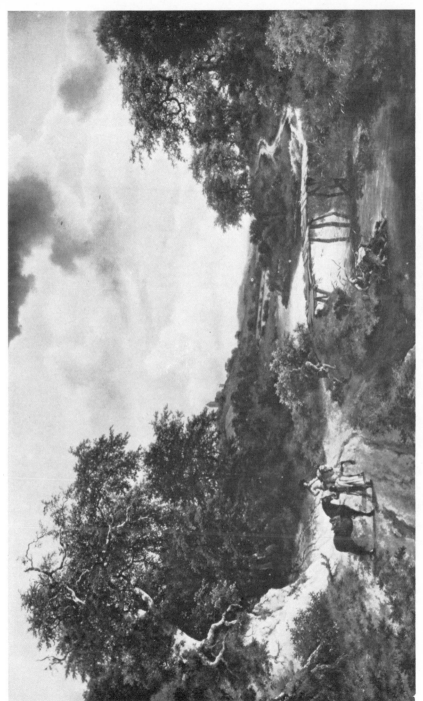

142. JACOB VAN RUISDAEL: *The Wooden Bridge*. 1652. New York, The Frick Collection

143. JACOB VAN RUISDAEL: *Pond in the Forest.* Fogg Art Museum, Harvard University, Cambridge, Mass.

144. JACOB VAN RUISDAEL: *Watermill*. 1661. Amsterdam, Rijksmuseum

146. JACOB VAN RUISDAEL: *A Pool Surrounded by Trees*. London, National Gallery

147. JACOB VAN RUISDAEL: *Pond near a Forest*. Hannover, Landesgalerie

148. JACOB VAN RUISDAEL: *Pond with Swans near a Forest*. 1678. Dublin, National Gallery of Ireland

149. MEINDERT HOBBEMA: *Watermill*. Cincinnati, Ohio, Art Museum

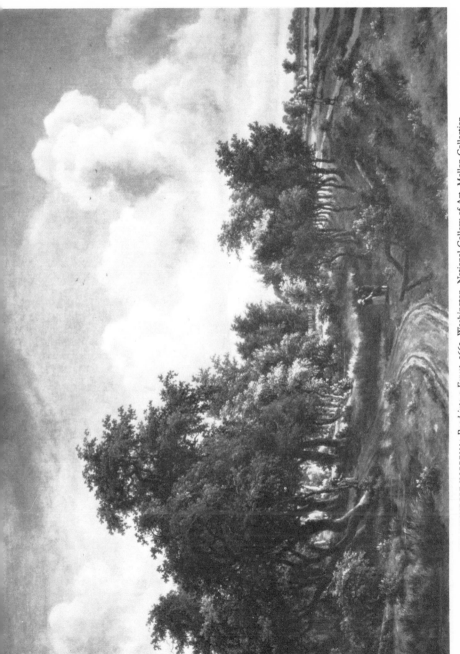

151. MEINDERT HOBBEMA: *Road into a Forest*. 1663. Washington, National Gallery of Art, Mellon Collection

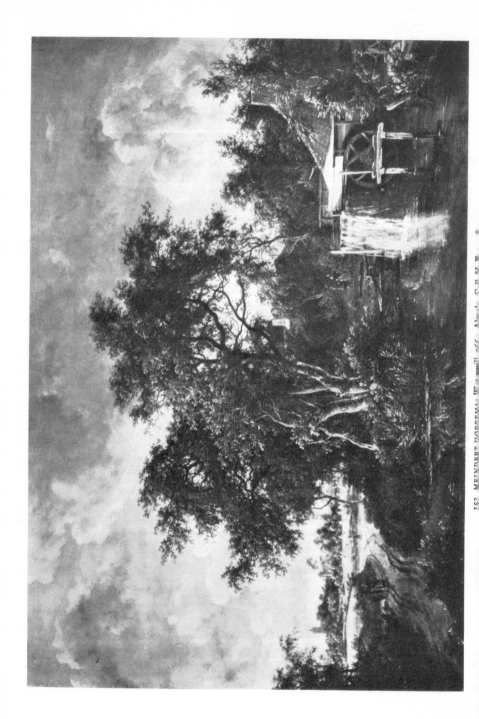

152. MEINDERT HOBBEMA, *Watermill* (60 Abol. Col. Mus.)

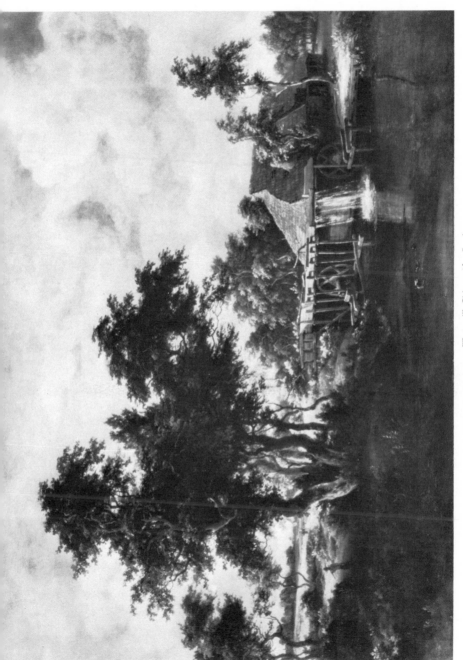

153. MEINDERT HOBBEMA: *Watermill.* Chicago, Art Institute

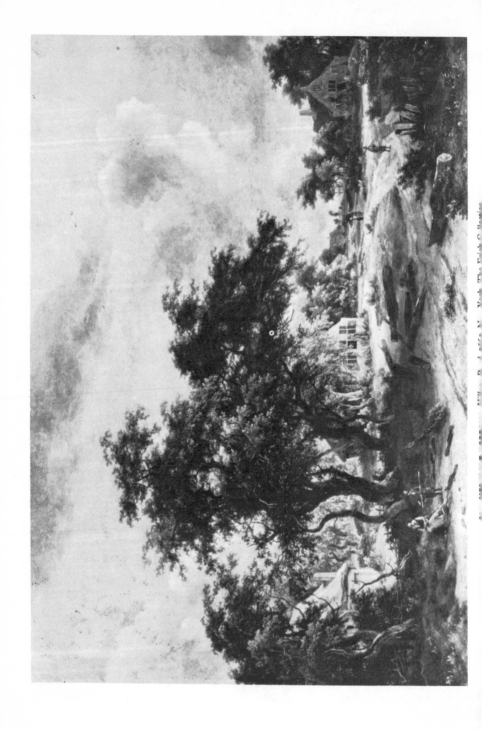

155. MEINDERT HOBBEMA: *Castle of Brederode*. 1671. London, National Gallery

156. MEINDERT HOBBEMA: *Forest Pond*. 1668. Oberlin, Ohio, Allen Memorial Art Museum, Oberlin College

157. PHILIPS KONINCK: *Entrance to a Forest*. San Francisco, California, M. H. De Young Memorial Museum

158. PAULUS POTTER: *Departure for the Hunt.* 1652. Berlin-Dahlem, Staatliche Museen

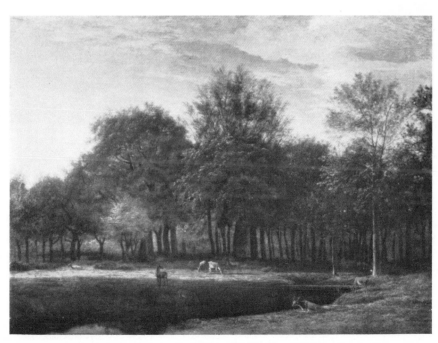

159. ADRIAEN VAN DE VELDE: *Forest Glade.* 1658. Frankfurt, Städelsches Kunstinstitut

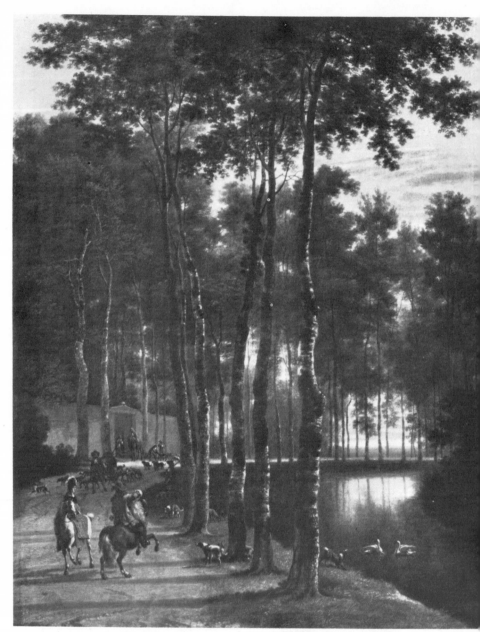

160. JAN HACKAERT: *The Alley*. Amsterdam, Rijksmuseum

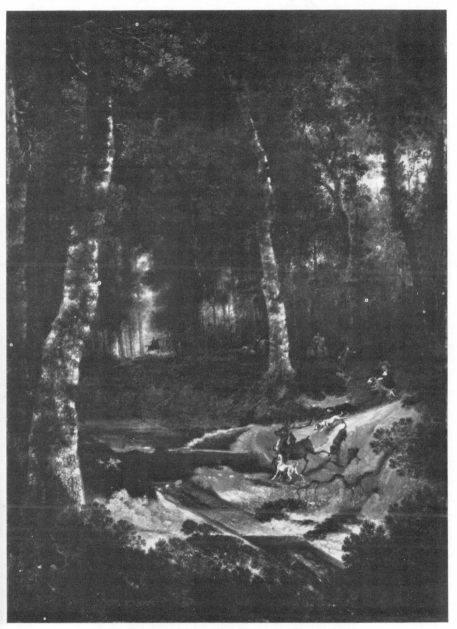

161. JAN HACKAERT: *Stag Hunt*. The Detroit Institute of Arts

162. HANS BOL: *The Skaters*. Etching

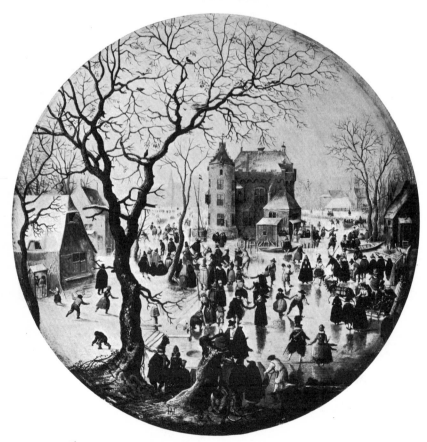

163. HENDRICK AVERCAMP: *Skaters near a Castle*. London, National Gallery

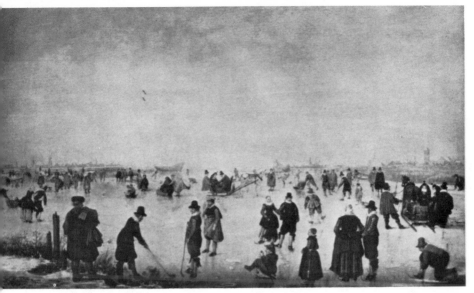

164. HENDRICK AVERCAMP: *On the Ice.* 1620. Whereabouts unknown

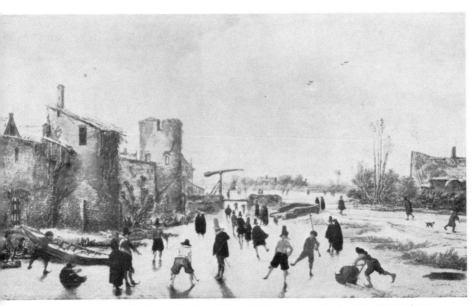

165. ESAJAS VAN DE VELDE: *Skating near the Town Wall.* 1618. Munich, Bayerische Staatsgemäldesammlungen

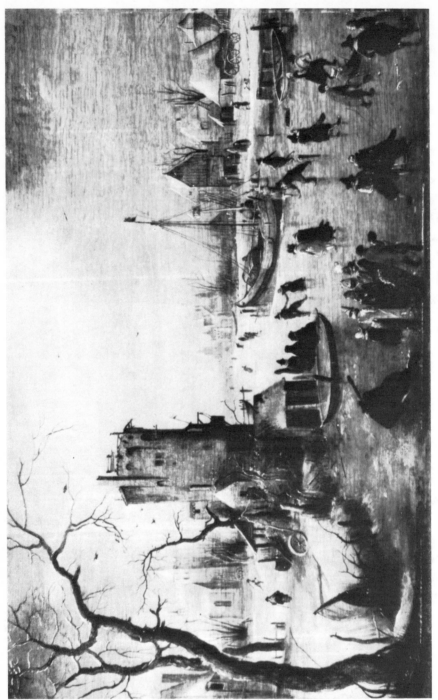

166. HENDRICK AVERCAMP: *Skating near a Town*. 1609. Whereabouts unknown

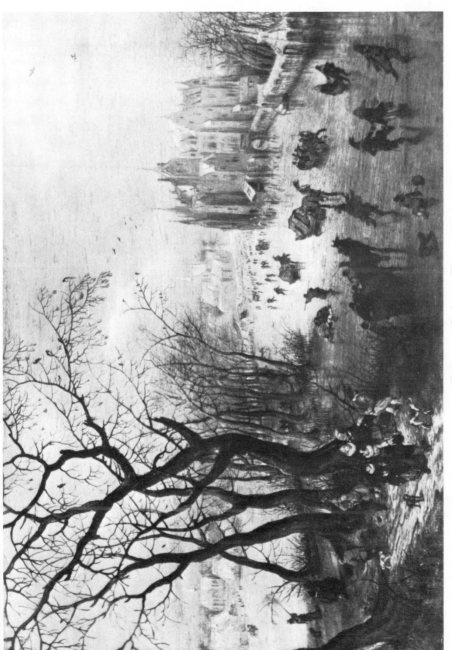

167. ADRIAEN VAN DE VENNE: *Skating near a Castle*. 1615. Worcester, Mass., Art Museum

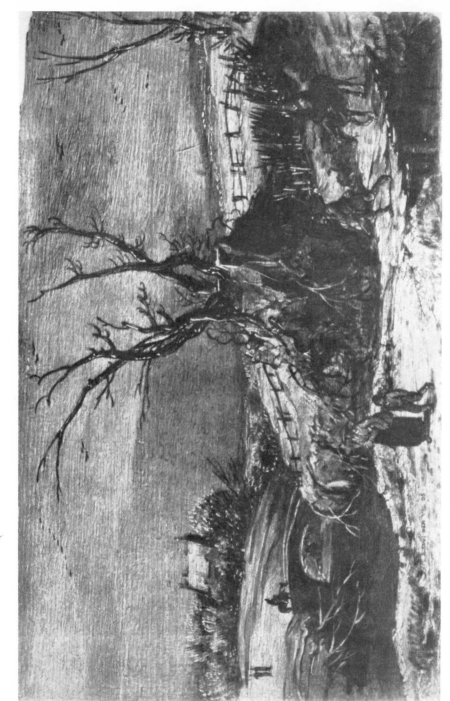

168. ESAJAS VAN DE VELDE: *The Flight into Egypt*. Whereabouts unknown

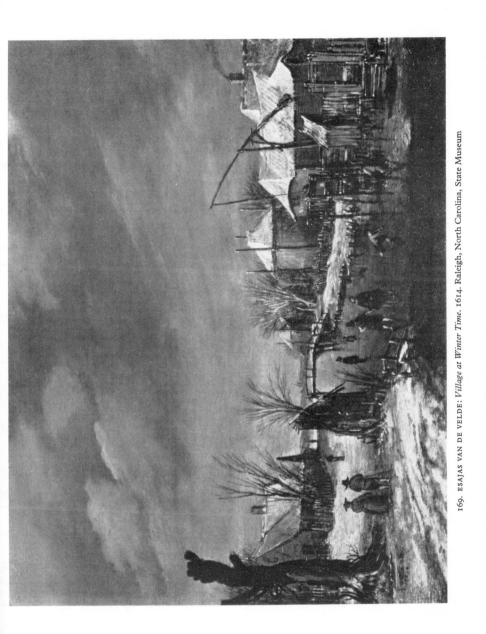

169. ESAJAS VAN DE VELDE: *Village at Winter Time*. 1614. Raleigh, North Carolina, State Museum

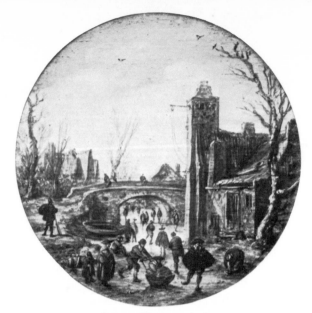

170. JAN VAN GOYEN: *Winter near the City Wall*. 1621.
Berlin-Dahlem, Staatliche Museen

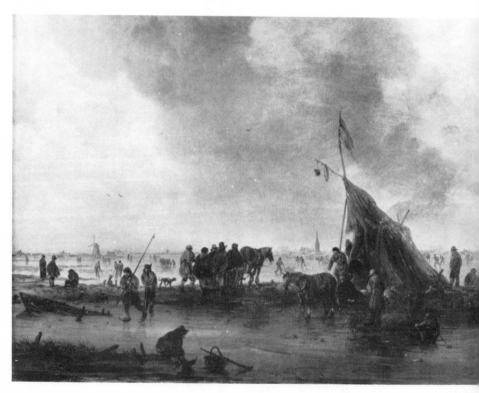

171. JAN VAN GOYEN: *A Scene on the Ice*. 1645. London, National Gallery

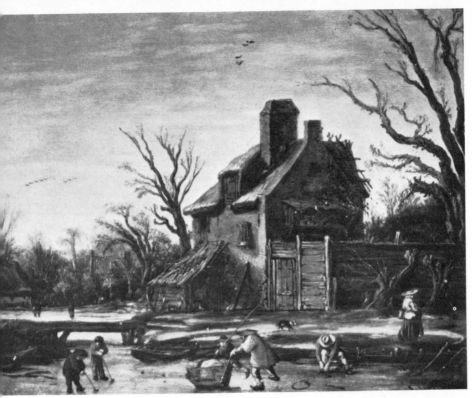

172. ESAJAS VAN DE VELDE: *On the Ice*. 1624. The Hague, Mauritshuis

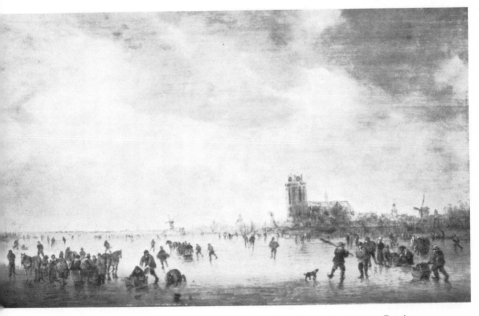

173. JAN VAN GOYEN: *On the Ice near Dordrecht*. 1644. Rotterdam, Museum Boymans-van Beuningen

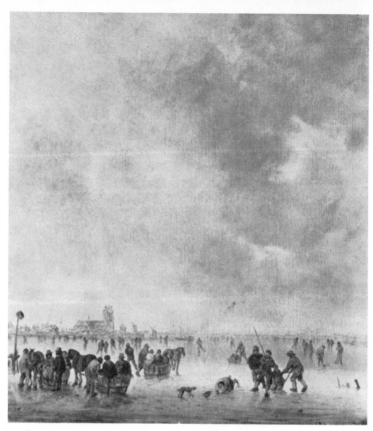

174. JAN VAN GOYEN: *On the Ice near Dordrecht.* 1643. St. Louis, Missouri, City Art Museum

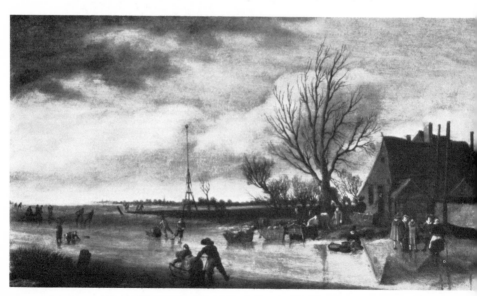

175. SALOMON VAN RUYSDAEL: *On the Ice.* 1627 (?). Whereabouts unknown

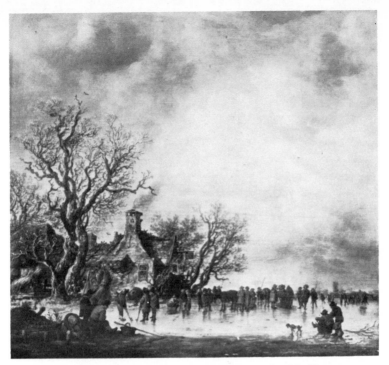

176. JAN VAN GOYEN: *On the Ice*. 1650. Berlin-Dahlem, Staatliche Museen

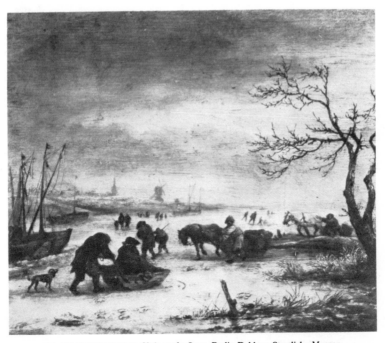

177. ISAAK VAN OSTADE: *Sleds on the Snow*. Berlin-Dahlem, Staatliche Museen

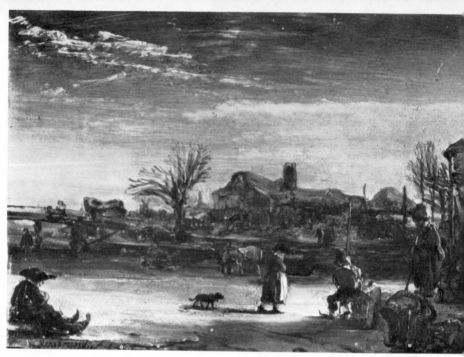

178. REMBRANDT: *Winter Day.* 1646. Kassel, Staatliche Gemäldegalerie

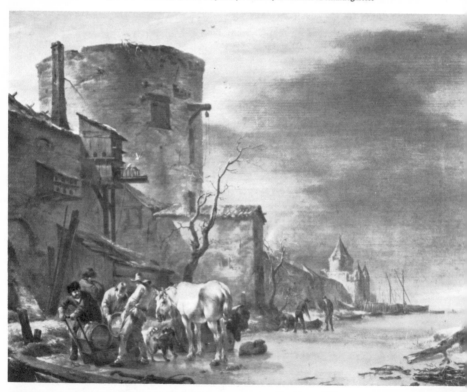

179. NICOLAES BERCHEM: *Ramparts at Winter Time.* 1647. Haarlem, Frans Hals Museum (on loan from Rijksmuseum)

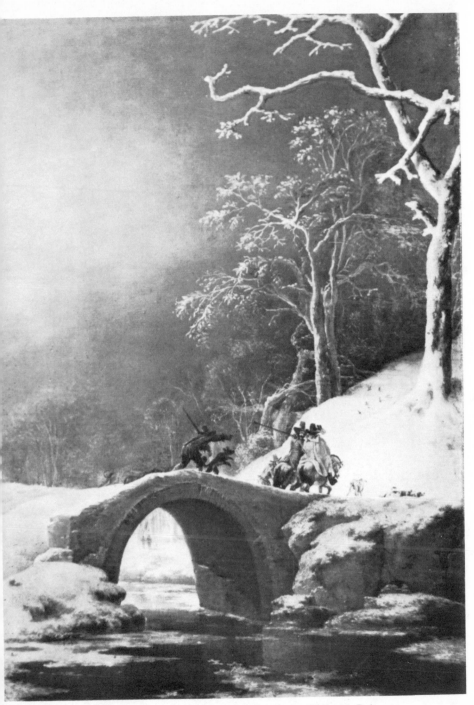

180. JAN ASSELIJN: *The Bridge*. Coll. F. Lugt, Institut Néerlandais, Paris

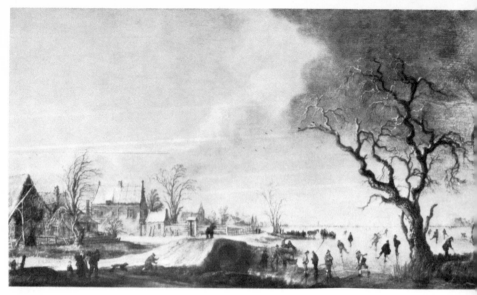

181. AERT VAN DER NEER: *On the Ice.* 1642. Hamburg, Private Collection

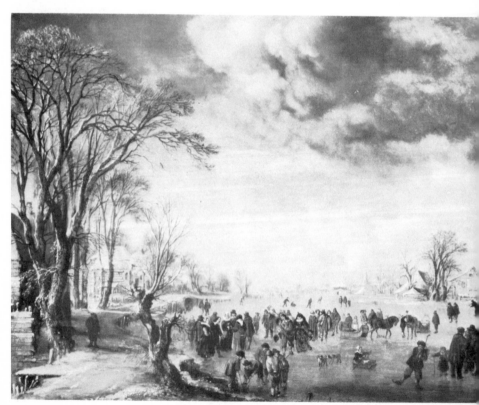

182. AERT VAN DER NEER: *Skating Scene.* 1645. Washington, Corcoran Gallery of Art, W. A. Clark Collection

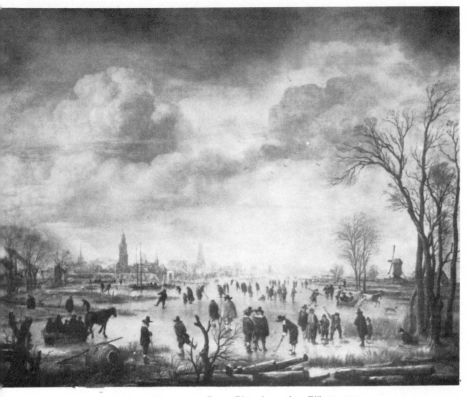

183. AERT VAN DER NEER: *Frozen River*. Amsterdam, Rijksmuseum

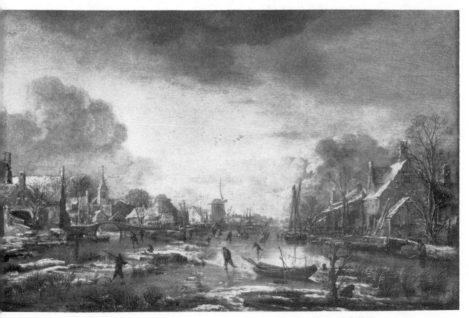

184. AERT VAN DER NEER: *Frozen River, Evening*. London, National Gallery

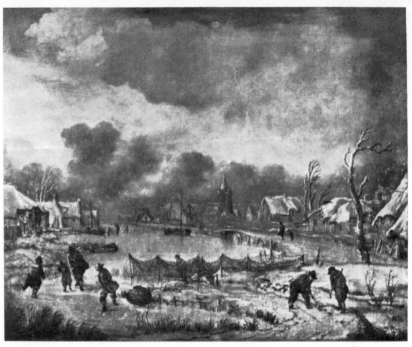

185. AERT VAN DER NEER: *Snowfall*. Vienna, Kunsthistorisches Museum

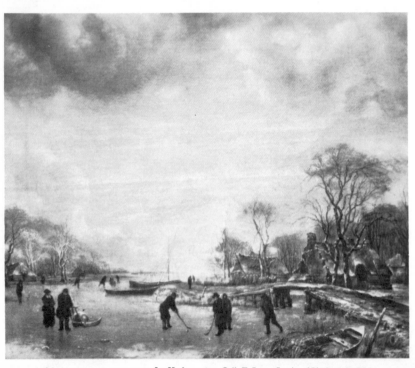

186. JAN VAN DE CAPPELLE: *Ice Hockey*. 1653. Coll. F. Lugt, Institut Néerlandais, Paris

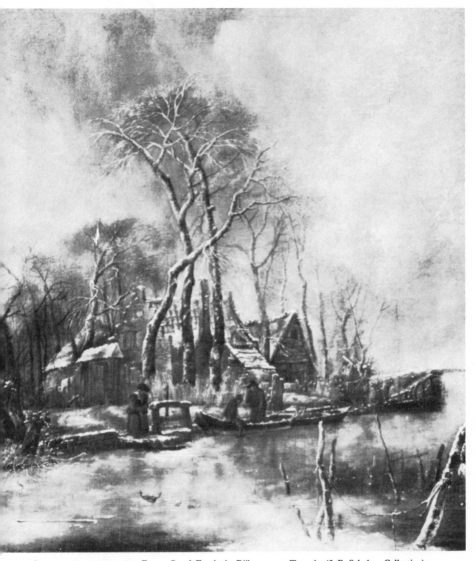

187. JAN VAN DE CAPPELLE: *Frozen Canal*. Enschede, Rijksmuseum Twenthe (J. B. Scholten Collection)

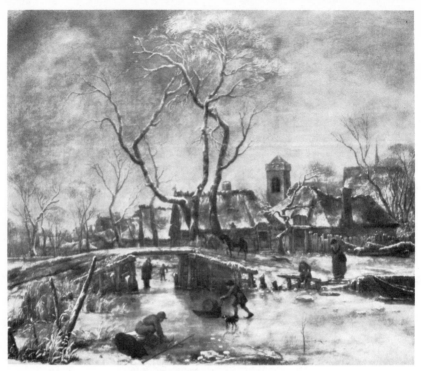

188. JAN VAN DE CAPPELLE: *Bridge across a Frozen Canal*. 1653. The Hague, Mauritshuis

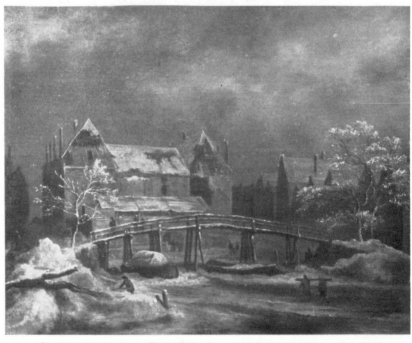

189. JACOB VAN RUISDAEL: *Wooden Bridge*. Formerly Coll. J. C. H. Heldring, Oosterbeek

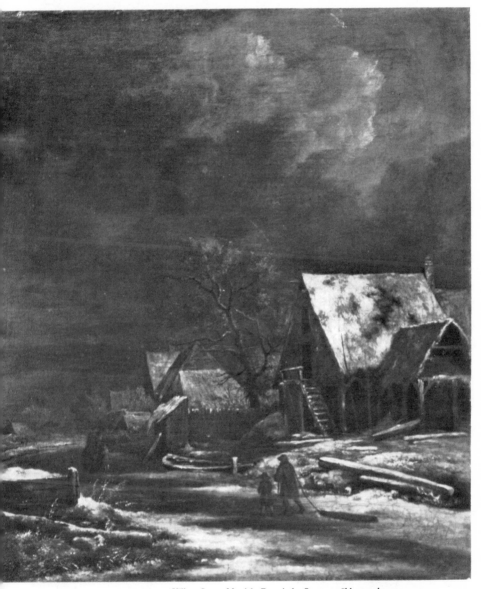

190. JACOB VAN RUISDAEL: *Village Street*. Munich, Bayerische Staatsgemäldesammlungen

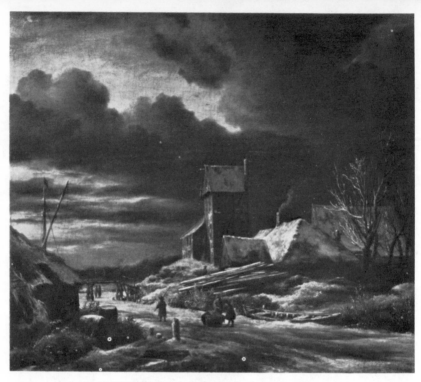

191. JACOB VAN RUISDAEL: *Snowy Evening*. Amsterdam, Rijksmuseum

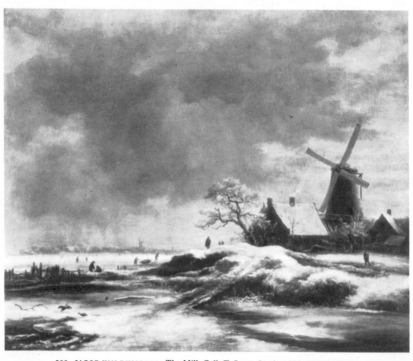

192. JACOB VAN RUISDAEL: *The Mill*. Coll. F. Lugt, Institut Néerlandais, Paris

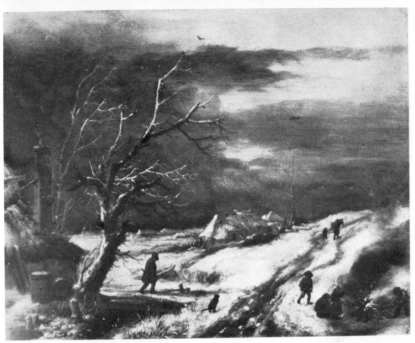

193. PHILIPS WOUWERMAN: *Snowy Day*. New York, Historical Society

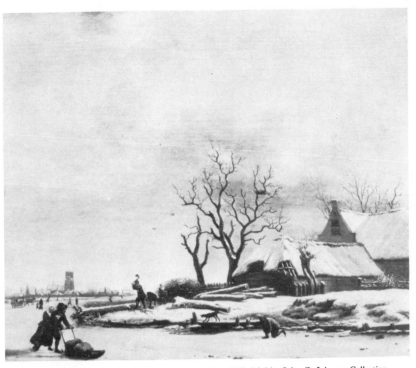

194. ADRIAEN VAN DE VELDE: *Farm at Winter Time*. Philadelphia, John G. Johnson Collection

196. JAN BEERSTRATEN: *View of Nieukoop*. Hamburg, Kunsthalle

197. HENDRICK GOLTZIUS: *The Whale*. 1598. Haarlem, Teyler's Stichting

198. JACQUES DE GHEYN: *The Beach*. 1602. Frankfurt, Städelsches Kunstinstitut

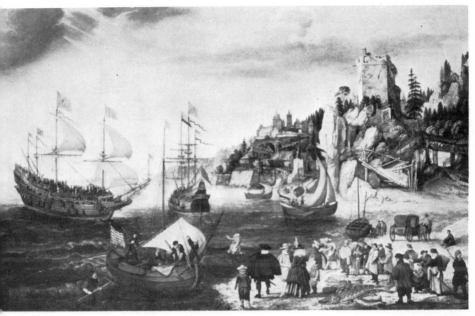

199. ADAM WILLAERTS: *The Embarkation of Frederick of the Palatinate.* 1613 (?). Amsterdam, Maritime Museum

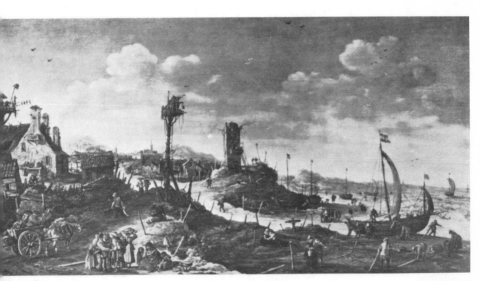

200. JAN VAN GOYEN: *Rocky Shore.* 1623. Whereabouts unknown

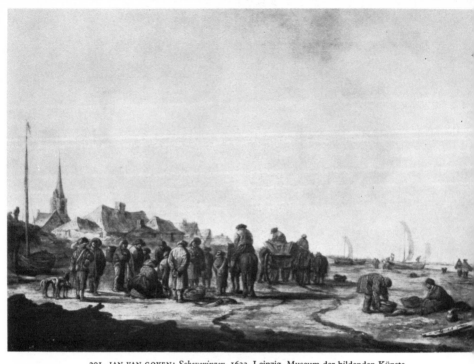

201. JAN VAN GOYEN: *Scheveningen*. 1632. Leipzig, Museum der bildenden Künste

202. SALOMON VAN RUYSDAEL: *Coast with Fishcarts*. 1635 (?). Whereabouts unknown

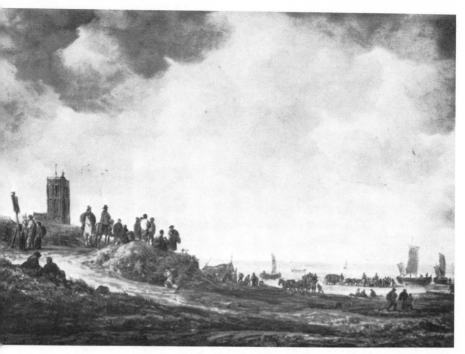

203. JAN VAN GOYEN: *Beach at Egmond aan Zee.* 1646. Paris, Louvre

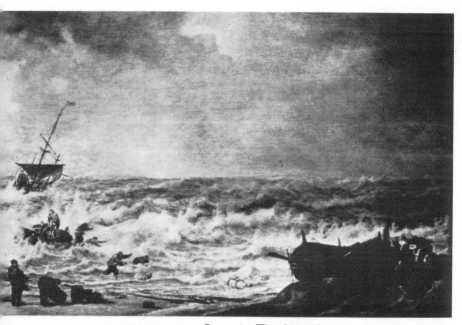

204. SIMON DE VLIEGER: *Rescue.* 1630. Whereabouts unknown

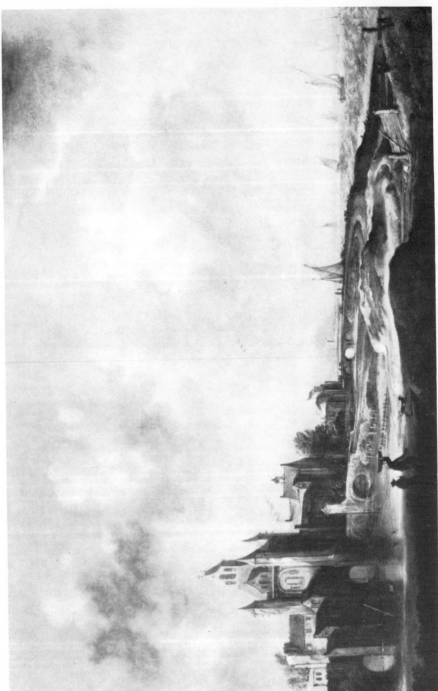

24. JAKOB PHILIPP DER NEFFE View of Thun 1761 Art Market

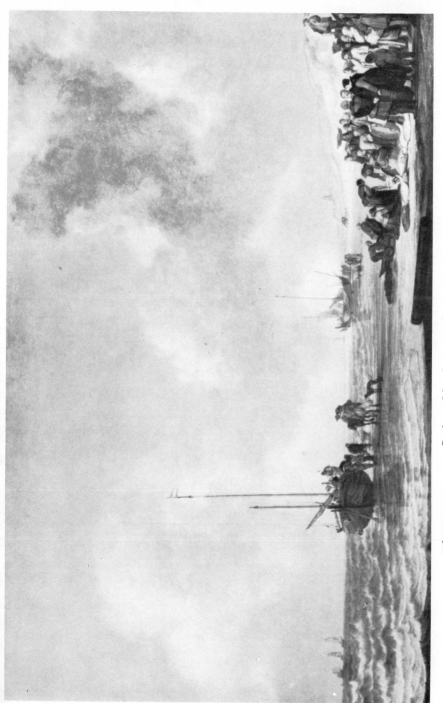

206. SIMON DE VLIEGER: *Beach near Scheveningen*. 1633. Greenwich, National Maritime Museum

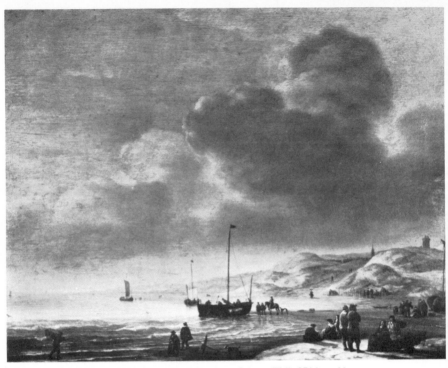

207. SIMON DE VLIEGER: *Scheveningen*. Cologne, Wallraf-Richartz-Museum

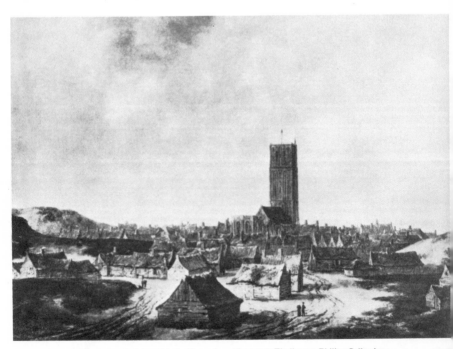

208. JACOB VAN RUISDAEL: *Egmond aan Zee*. 1646. Eindhoven, Philips Collection

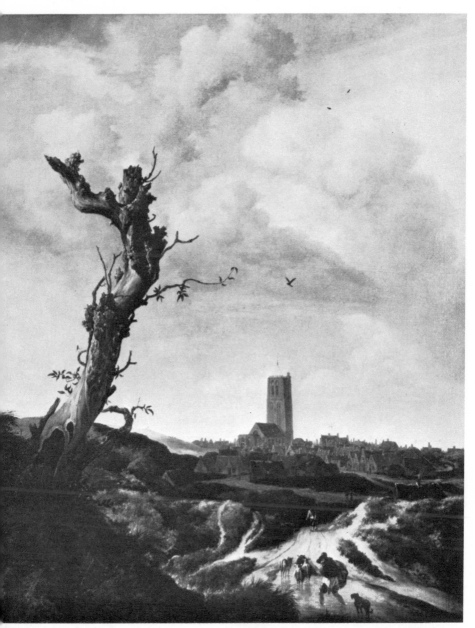

209. JACOB VAN RUISDAEL: *Egmond aan Zee*. 1648. Manchester, New Hampshire, Currier Gallery of Art

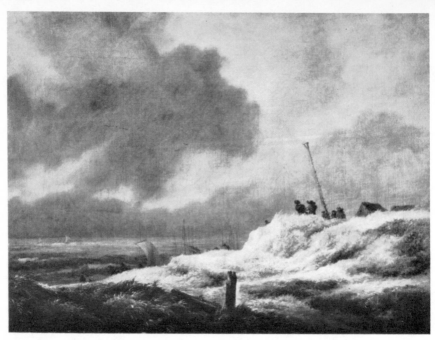

210. JACOB VAN RUISDAEL: *Dunes and Sea*. Zürich, Kunsthaus, Ruzicka-Stiftung

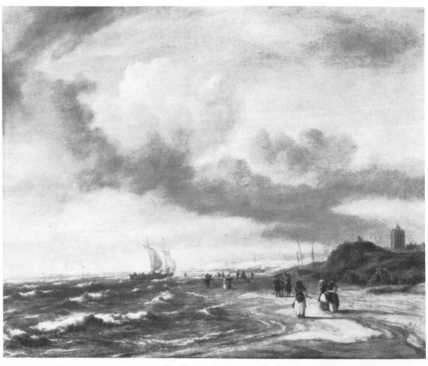

211. JACOB VAN RUISDAEL: *The Shore at Egmond aan Zee*. London, National Gallery

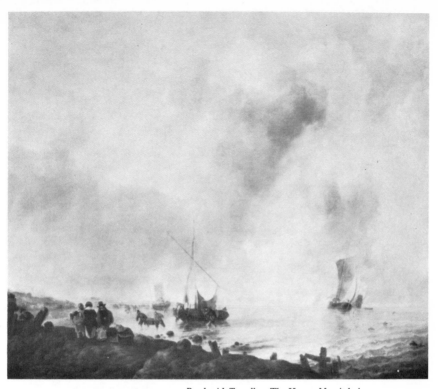

212. JAN VAN DE CAPPELLE: *Beach with Travellers.* The Hague, Mauritshuis

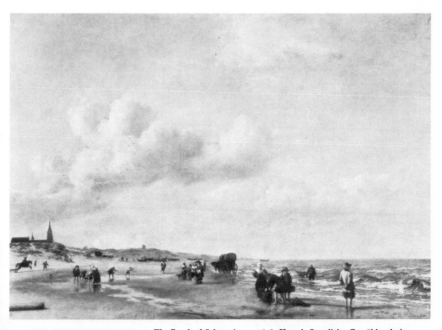

213. ADRIAEN VAN DE VELDE: *The Beach of Scheveningen.* 1658. Kassel, Staatliche Gemäldegalerie

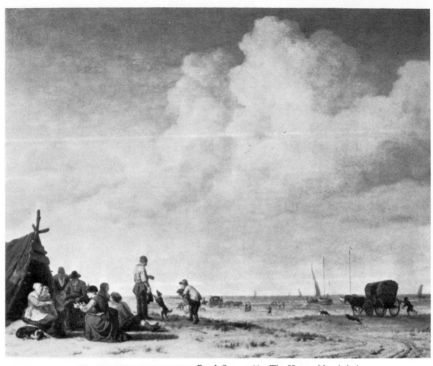

214. ADRIAEN VAN DE VELDE: *Beach Scene*. 1665. The Hague, Mauritshuis

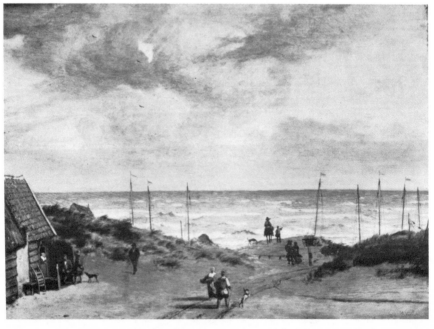

215. ADRIAEN VAN DE VELDE: *Beach near Zantvoort*. 1658 (?). Whereabouts unknown

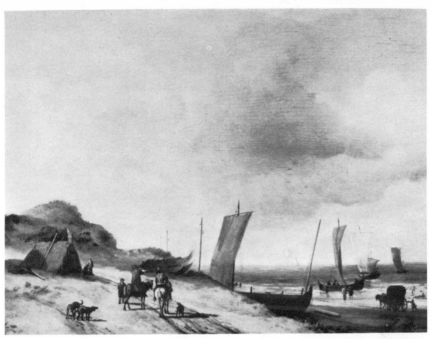

216. WILLEM VAN DE VELDE: *Horsemen on the Beach*. Indianapolis, Ind., Herron Museum of Art

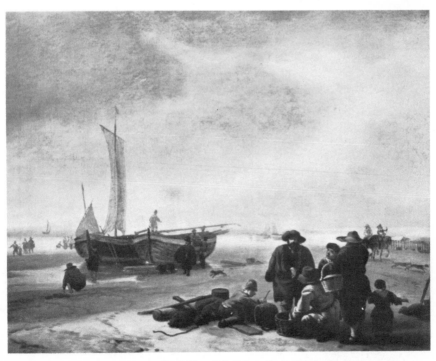

217. JACOB ESSELENS: *Beach Scene*. Coll. F. Lugt, Institut Néerlandais, Paris

218. JAN VAN GOYEN: *Sailing-boat*. Frankfurt, Städelsches Kunstinstitut

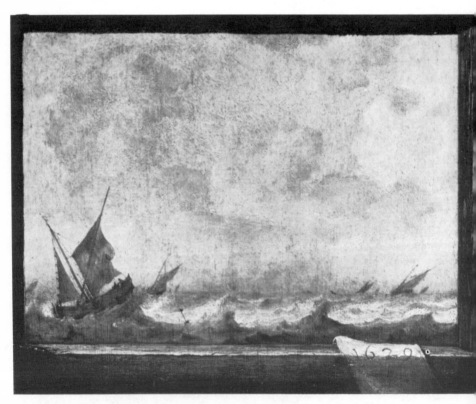

219. JAN PORCELLIS: *Stormy Sea*. 1629. Munich, Bayerische Staatsgemäldesammlungen

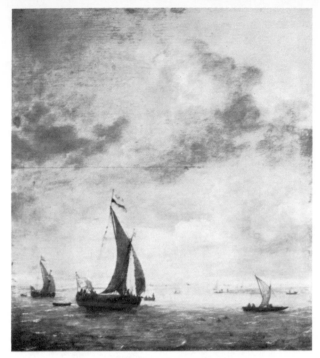

220. JAN PORCELLIS: *Sailing-boats*. Berlin-Dahlem, Staatliche Museen

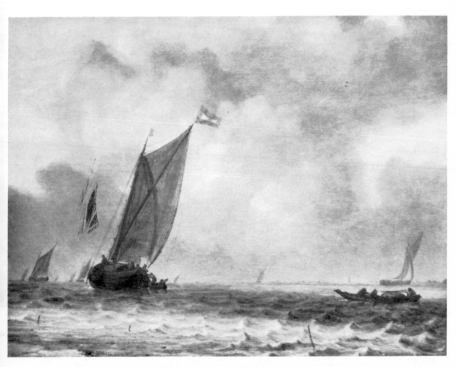

221. JAN PORCELLIS: *Sailing-boats and Rowing-boats*. 1629. Leiden, Lakenhal

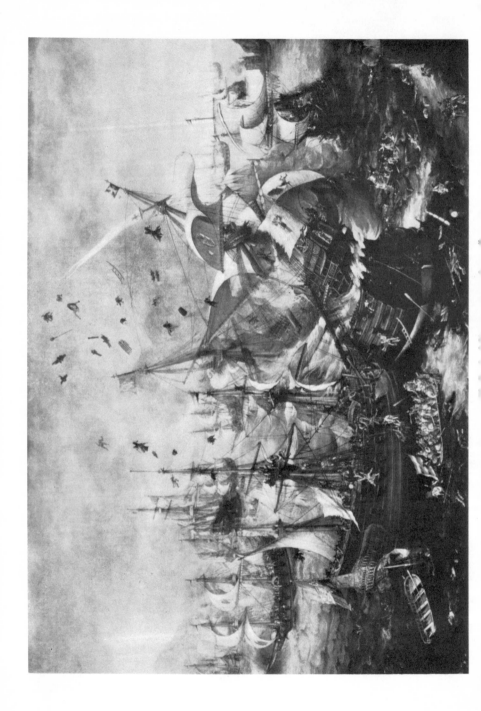

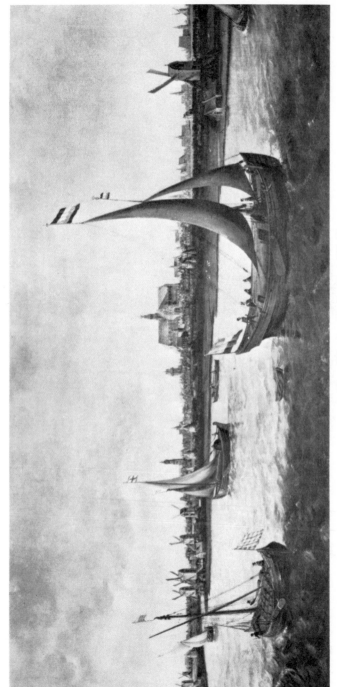

223. HENDRICK VROOM: *View of Haarlem*. Haarlem, Frans Hals Museum

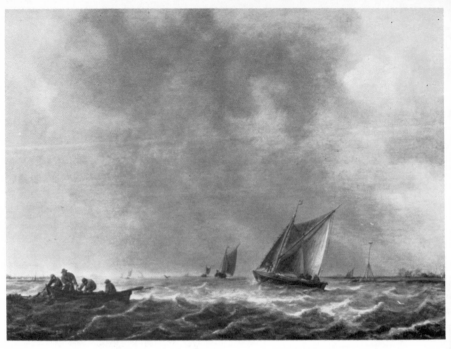

224. JAN VAN GOYEN: *Fresh Breeze*. 1636. Shoreham-by-Sea, Coll. A. A. E. Green

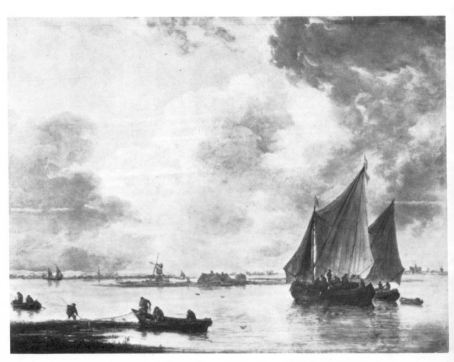

225. JAN VAN GOYEN: *Evening Calm*. 1656. Frankfurt, Städelsches Kunstinstitut

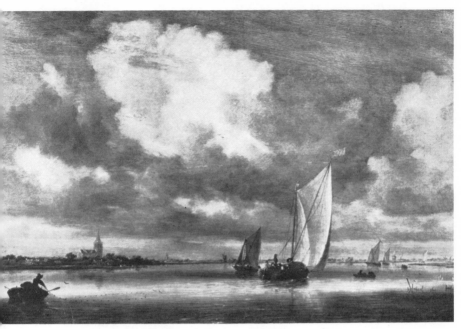

226. SALOMON VAN RUYSDAEL: *Laying the Net*. Frankfurt, Städelsches Kunstinstitut

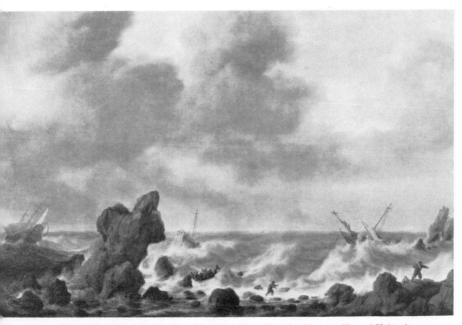

227. SIMON DE VLIEGER: *The Wreckers*. Cambridge, Mass., Fogg Art Museum, Harvard University

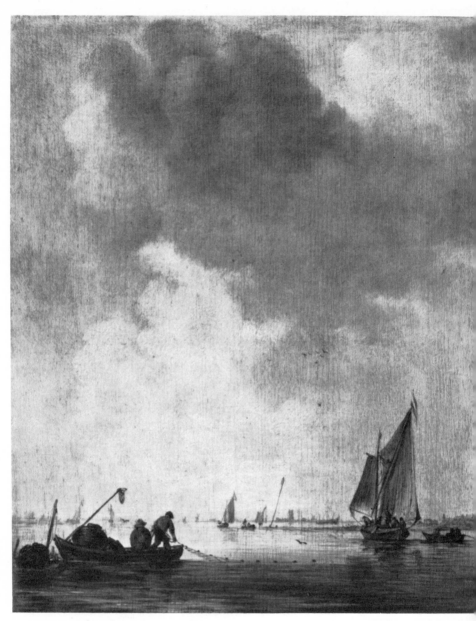

228. JAN VAN GOYEN: *Fishermen laying a Net.* 1638. London, National Gallery

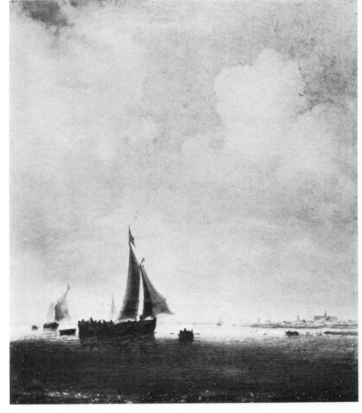

229. SALOMON VAN RUYSDAEL: *View of Alkmaar*. Lugano, Galleria Thyssen

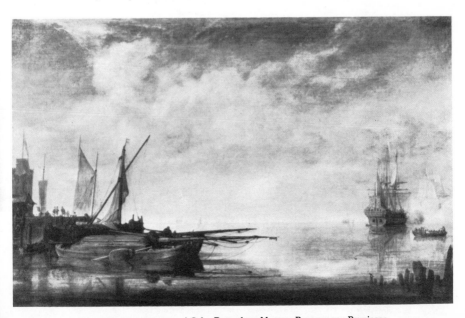

230. SIMON DE VLIEGER: *A Calm*. Rotterdam, Museum Boymans-van Beuningen

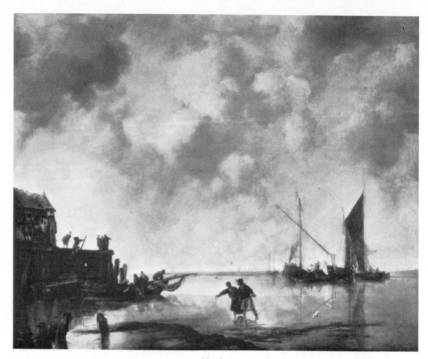

231. JAN VAN DE CAPPELLE: *The Calm.* 1651. Chicago, Art Institute

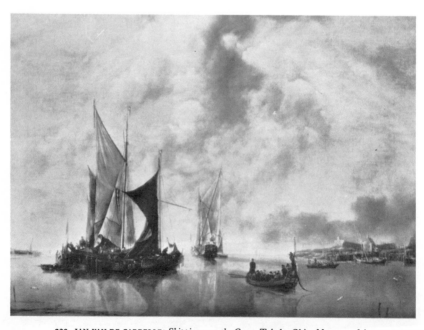

232. JAN VAN DE CAPPELLE: *Shipping near the Coast.* Toledo, Ohio, Museum of Art

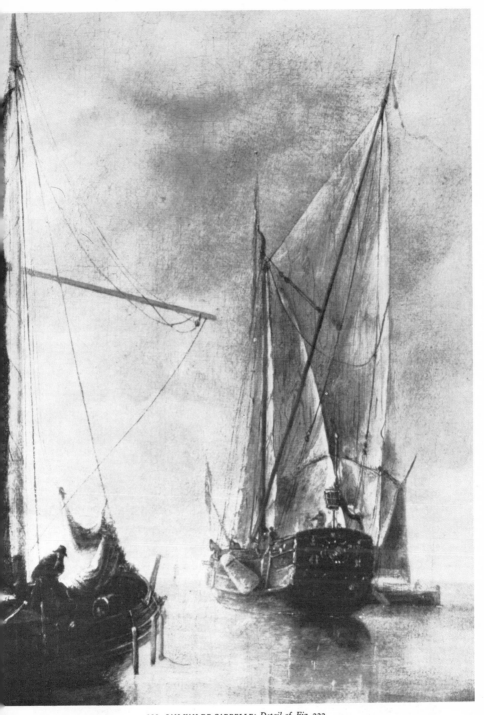

233. JAN VAN DE CAPPELLE: *Detail of Fig. 232.*

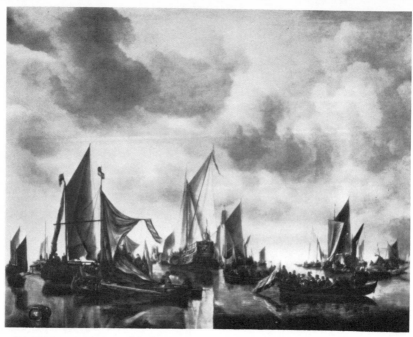

234. JAN VAN DE CAPPELLE: *Calm Sea with Sailing-boats*. Rotterdam, Museum Boymans-van Beuningen

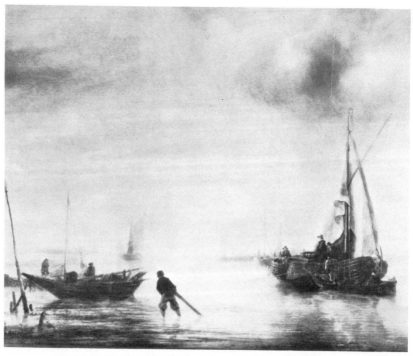

235. JAN VAN DE CAPPELLE: *Evening Calm*. Cologne, Wallraf-Richartz-Museum

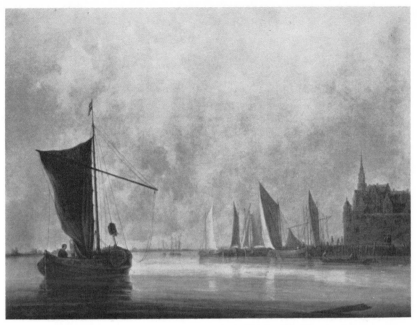

236. AELBERT CUYP: *River Scene near Dordrecht*. Toledo, Ohio, Museum of Art

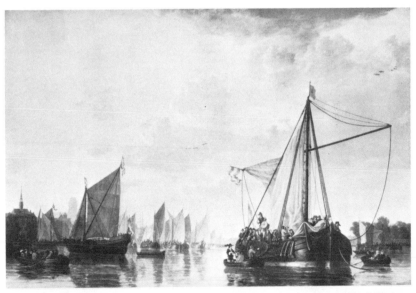

237. AELBERT CUYP: *Shipping near Dordrecht*. Washington, National Gallery of Art, Mellon Collection

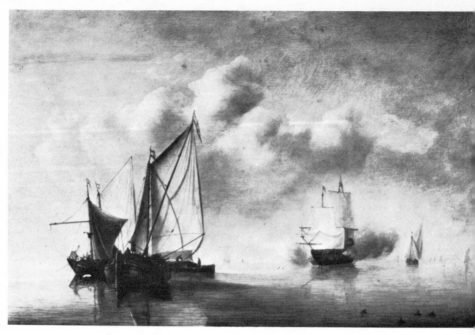

238. WILLEM VAN DE VELDE: *Calm*. 1653. Kassel, Staatliche Gemäldegalerie

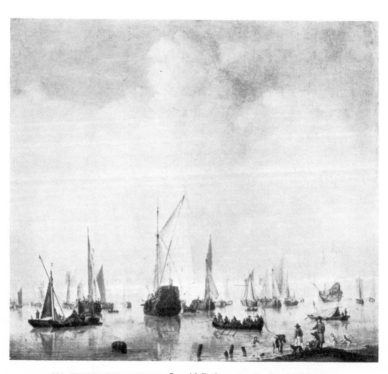

239. WILLEM VAN DE VELDE: *Sea with Bathers*. 1653. Leningrad, Hermitage

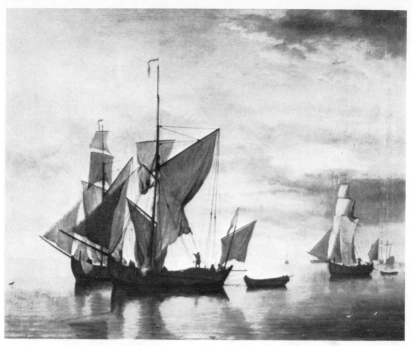

240. WILLEM VAN DE VELDE: *Evening*. Leipzig, Museum der bildenden Künste

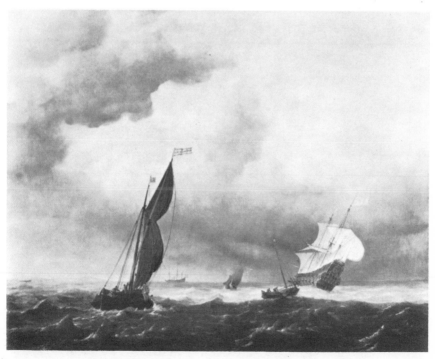

241. WILLEM VAN DE VELDE: *Strong Breeze*. 1658. London, National Gallery

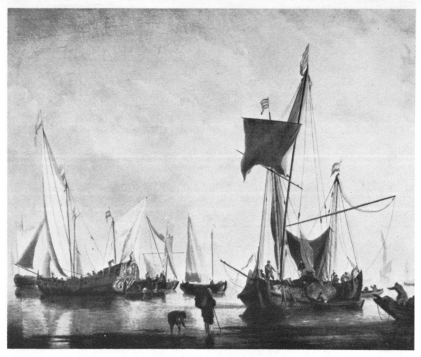

242. WILLEM VAN DE VELDE: *Vessels in a Calm*. 1674. Los Angeles, California, University of Southern California.
Elizabeth Holmes Fisher Coll.

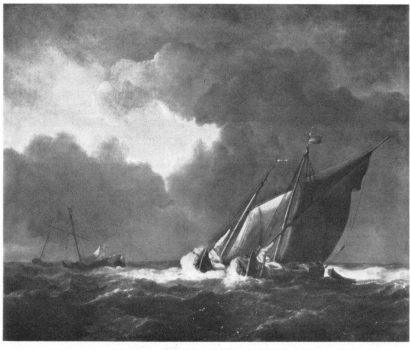

243. WILLEM VAN DE VELDE: *Rough Sea*. Philadelphia, John G. Johnson Collection

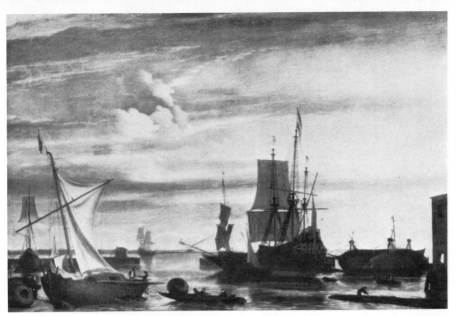

244. EMANUEL DE WITTE: *Harbour at Sunset*. Amsterdam, Rijksmuseum

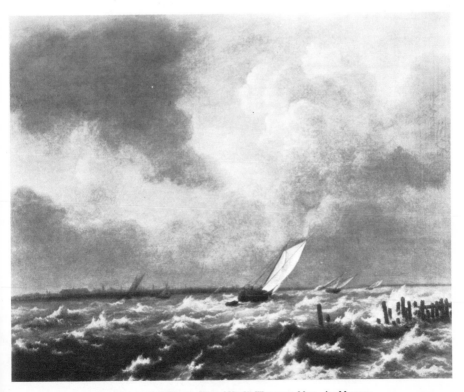

245. JACOB VAN RUISDAEL: *View of Het IJ*. Worcester, Mass., Art Museum

246. ALLAERT VAN EVERDINGEN: *Snowstorm at Sea*. Chantilly, Musée Condé

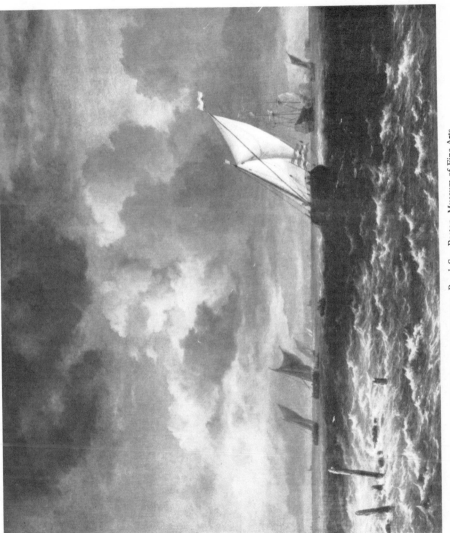

247. JACOB VAN RUISDAEL: *Rough Sea.* Boston, Museum of Fine Arts

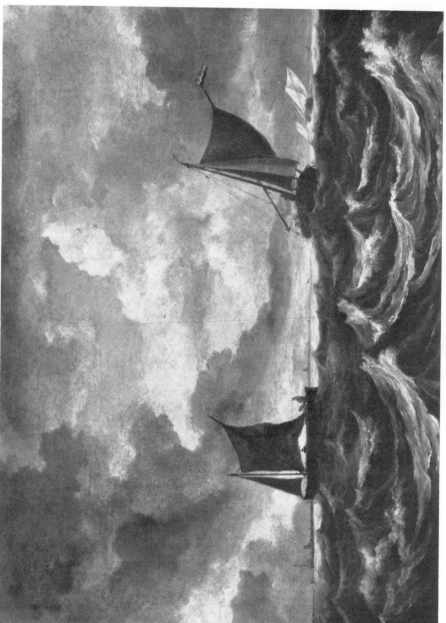

248. JACOB VAN RUISDAEL: *Stormy Sea*. Philadelphia, Museum of Art. Elkins Collection

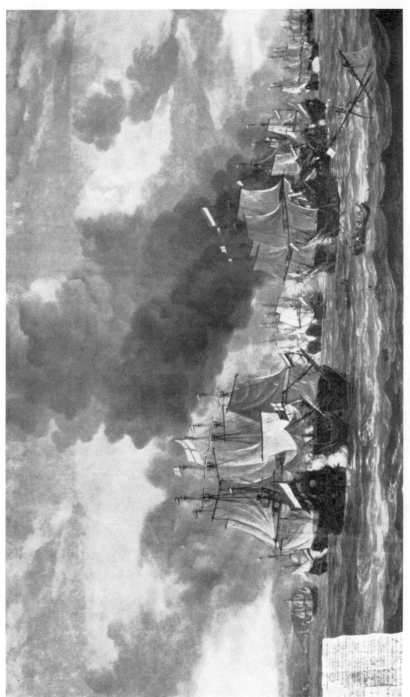

249. REINIER NOOMS (ZEEMAN): *The Battle of Leghorn.* Amsterdam, Rijksmuseum

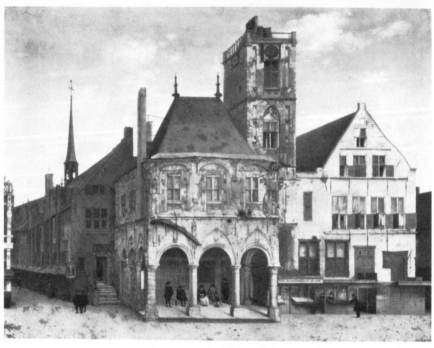

250. PIETER SAENREDAM: *The Old Townhall at Amsterdam.* 1657. Amsterdam, Rijksmuseum

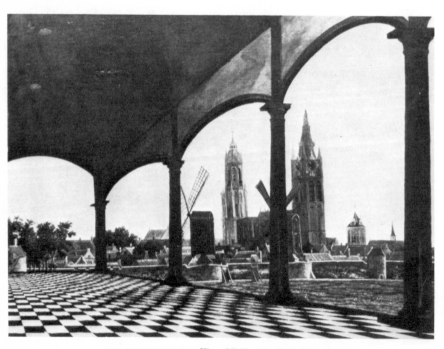

251. DANIEL VOSMAER: *View of Delft.* 1665. Delft, Museum

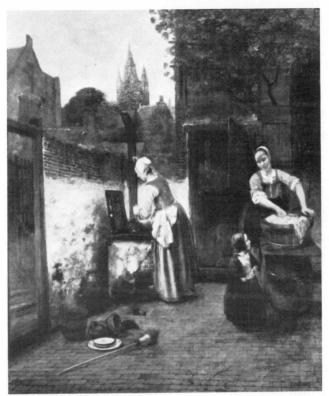

252. PIETER DE HOOCH: *Washing in the Courtyard.* Toledo, Ohio, Museum of Art

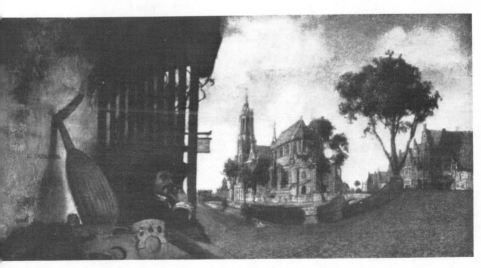

253. CAREL FABRITIUS: *The Instrument Dealer.* 1652. London, National Gallery

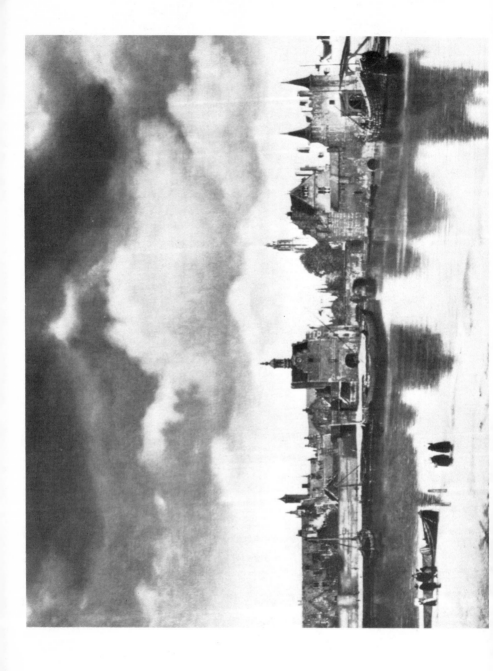

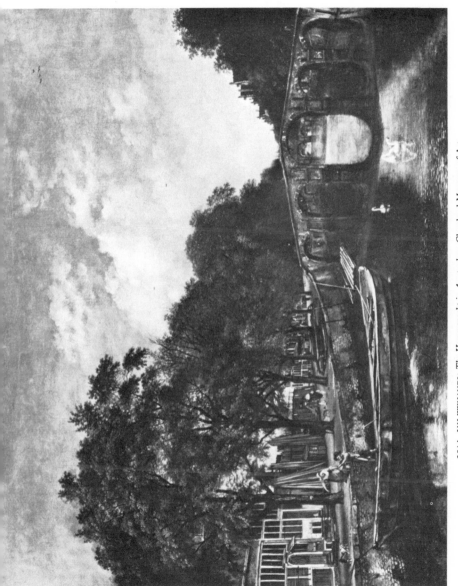

254A. JAN WYNANTS: *The Heerengracht in Amsterdam.* Cleveland Museum of Art

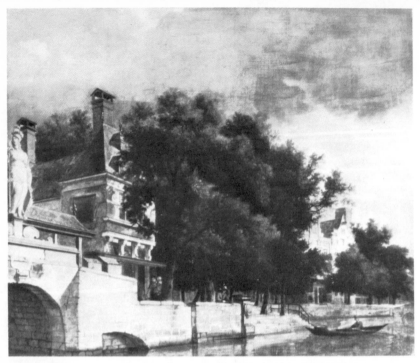

255. JAN VAN DER HEYDEN: *Gracht*. Karlsruhe, Staatliche Kunsthalle

256. JAN VAN DER HEYDEN: *The Garden of the Old Palace at Brussels*. New York, Coll. F. Markus

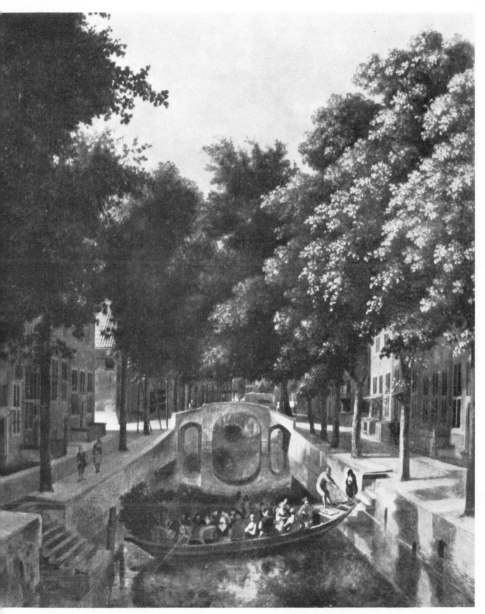

257. JOB BERCKHEYDE: *"Oude Gracht" in Haarlem*. 1666. The Hague, Mauritshuis

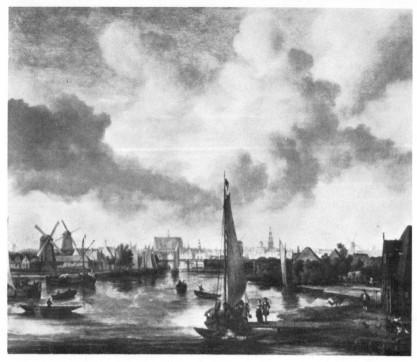

258. ALLAERT VAN EVERDINGEN: *View of Alkmaar*. Coll. F. Lugt, Institut Néerlandais, Paris

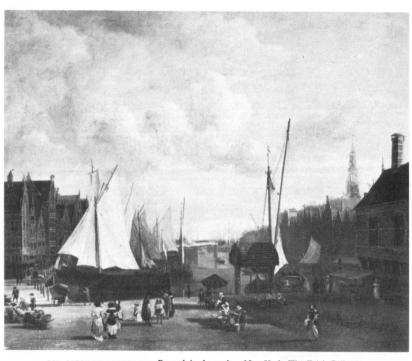

259. JACOB VAN RUISDAEL: *Damrak in Amsterdam*. New York, The Frick Collection

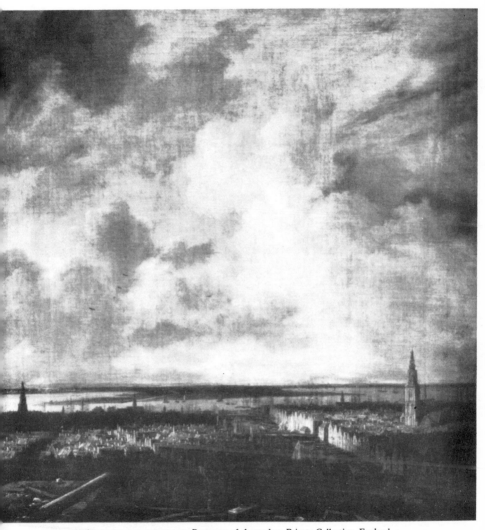

260. JACOB VAN RUISDAEL: *Panorama of Amsterdam*. Private Collection, England

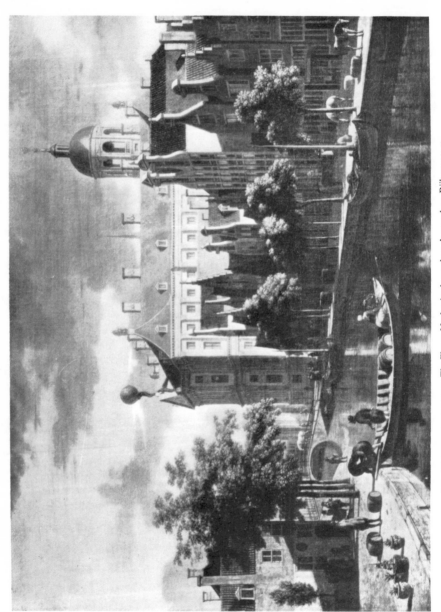

261. GERRIT BERCKHEYDE: *The Flower Market in Amsterdam.* Amsterdam, Rijksmuseum

262. MEINDERT HOBBEMA: *The Haarlem Lock in Amsterdam*. London, National Gallery

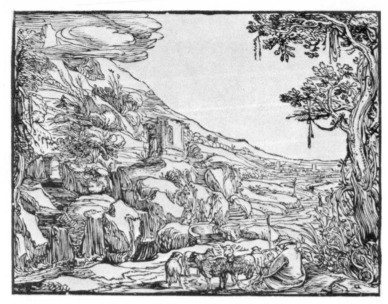

263. HENDRICK GOLTZIUS: *Arcadian Landscape*. New York, Metropolitan Museum of Art

264. KERSTIAEN DE KEUNINCK: *Diana and Actaeon*. Antwerp, Musée des Beaux-Arts

265. HERCULES SEGHERS: *River Valley*. Amsterdam, Rijksmuseum

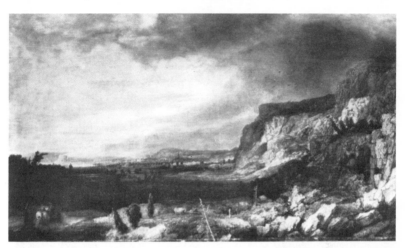

266. HERCULES SEGHERS: *Mountain Scene*. Florence, Uffizi

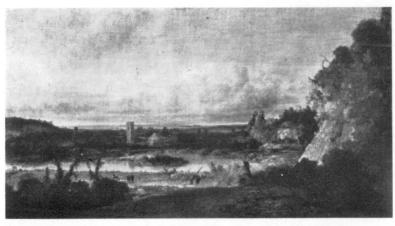

267. HERCULES SEGHERS: *The Valley*. Rotterdam, Museum Boymans-van Beuningen

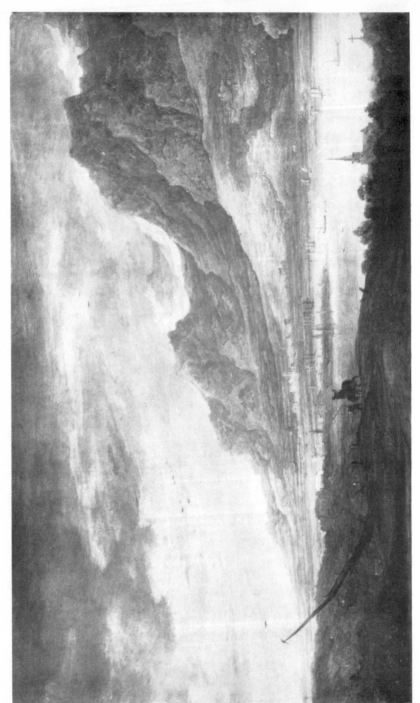

268. FRANS DE MOMPER: *River and Mountains*. Philadelphia, Coll. Henry P. McIlhenny

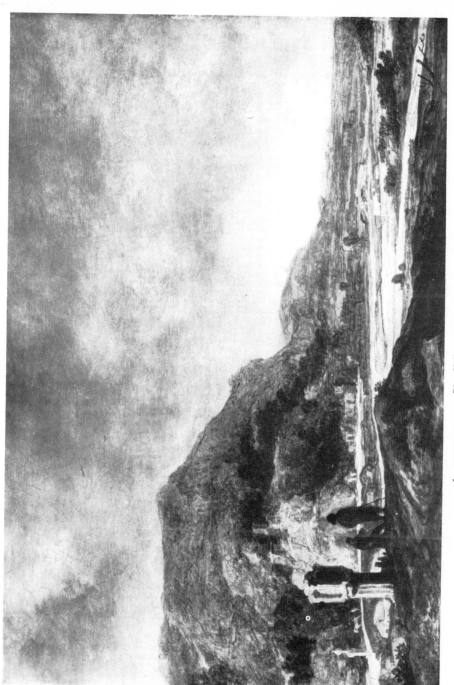

269. PIETER MOLIJN: *River Valley*. 1659. Berlin, Staatliche Museen

270. ESAJAS VAN DE VELDE: *Rocky Landscape*. Bonn, Rheinisches Landesmuseum

271. AERT VAN DER NEER: *Mountain Lake*. Coll. F. Lugt, Institut Néerlandais, Paris

272. AERT VAN DER NEER: *Mountain View*. Rotterdam, Stichting Willem van der Vorm

273. AERT DE GELDER: *Boaz and Ruth*. Formerly Berlin, Staatliche Museen (destroyed in 1945)

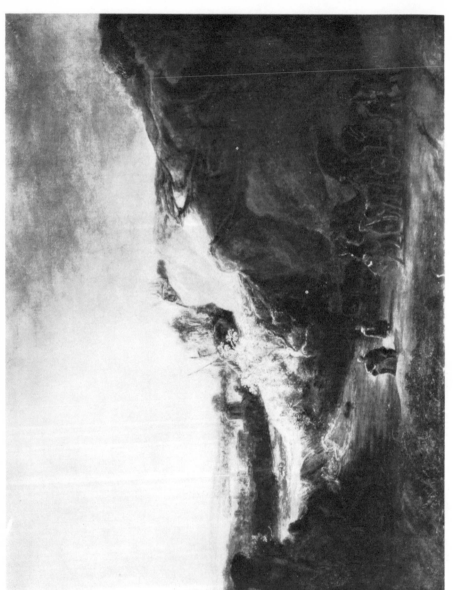

274. REMBRANDT: *The Baptism of the Eunuch.* 1636. Hannover, Landesgalerie

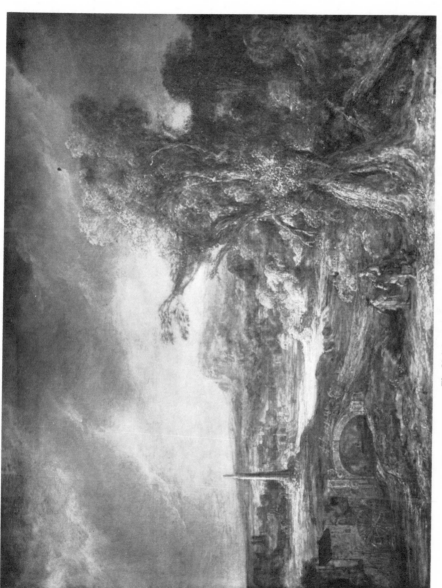

275. REMBRANDT: *The Obelisk*. 1638. Boston, Isabella Stewart Gardner museum

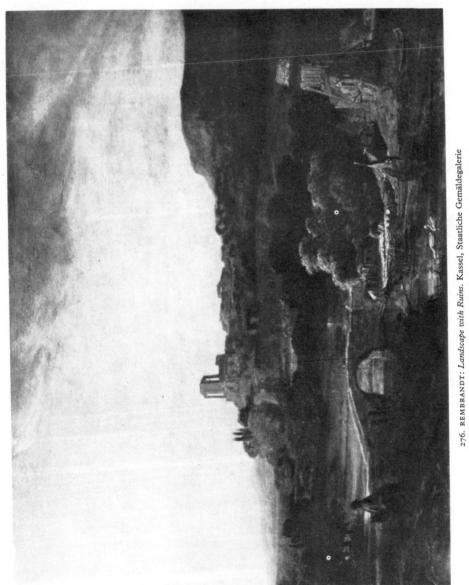

276. REMBRANDT: *Landscape with Ruins*. Kassel, Staatliche Gemäldegalerie

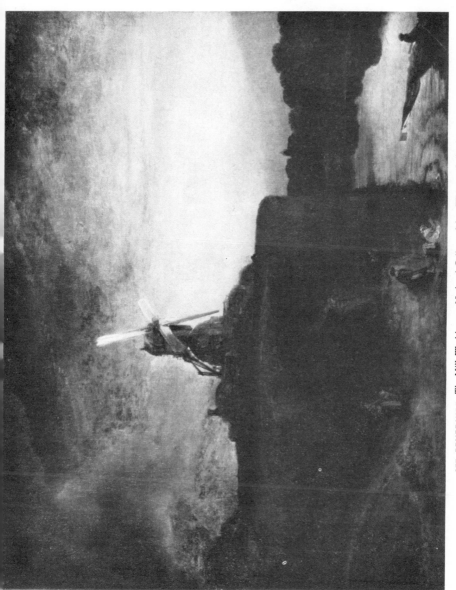

277. REMBRANDT: *The Mill*. Washington, National Gallery of Art, Widener Collection

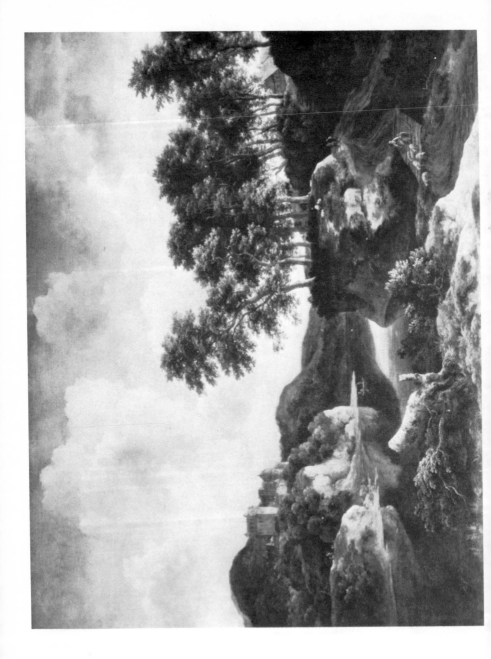

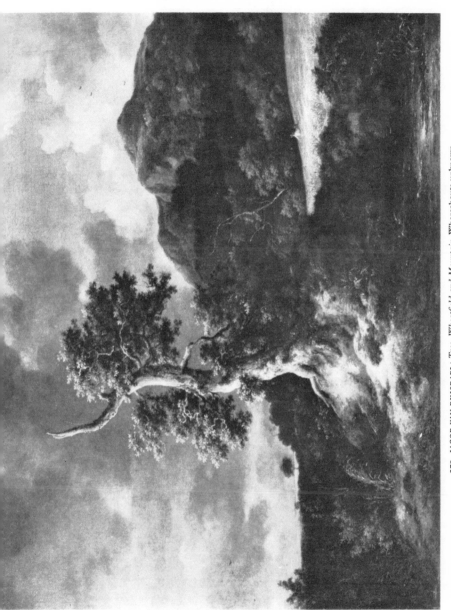

279. JACOB VAN RUISDAEL: *Tree, Wheatfield and Mountain.* Whereabouts unknown

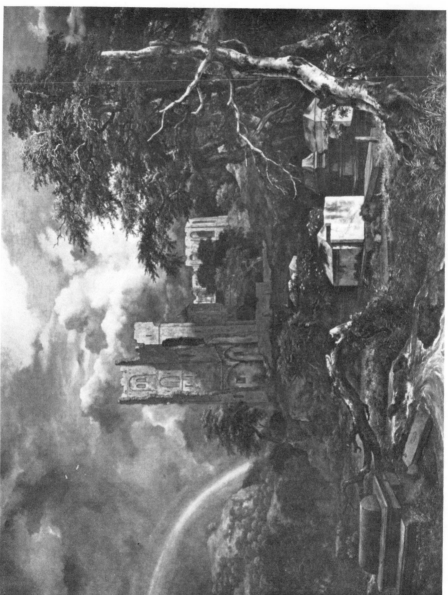

280. JACOB VAN RUISDAEL: *The Jewish Cemetery*. The Detroit Institute of Arts

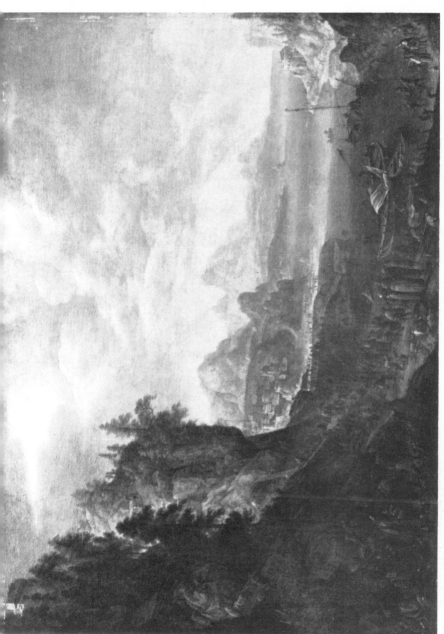

281. HERMAN SAFTLEVEN: *Christ Teaching on Lake Gennesaret.* 1667. London, National Gallery

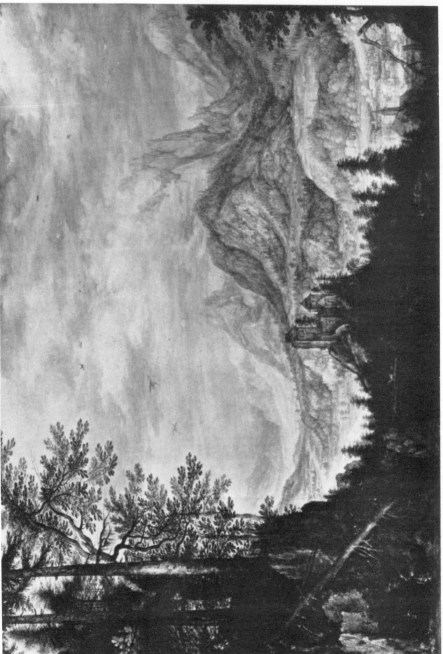

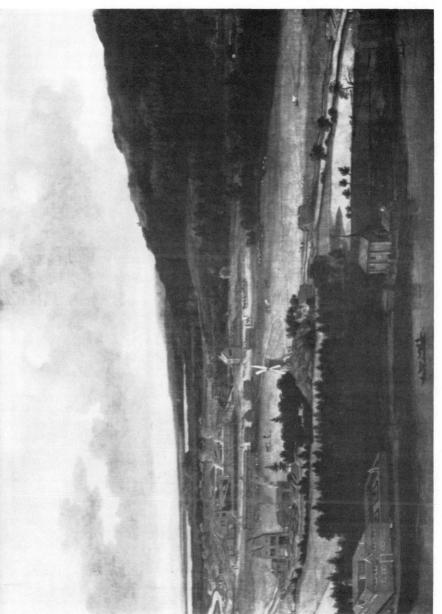

283. ALLAERT VAN EVERDINGEN: *View of Julitabroeck in Södermanland*. Amsterdam, Rijksmuseum

284. ALLAERT VAN EVERDINGEN: *Scandinavian View*. 1647. Braunschweig, Herzog Anton Ulrich Museum

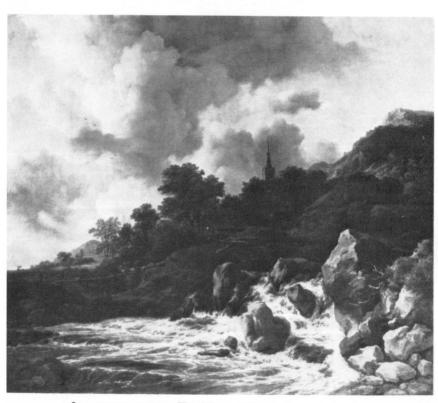

285. JACOB VAN RUISDAEL: *Waterfall near a Village*. London, National Gallery

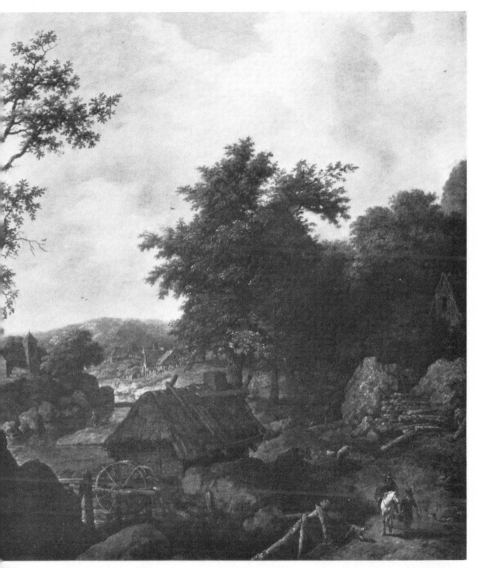

286. ALLAERT VAN EVERDINGEN: *Swedish Watermill*. 1655. Amsterdam, Rijksmuseum

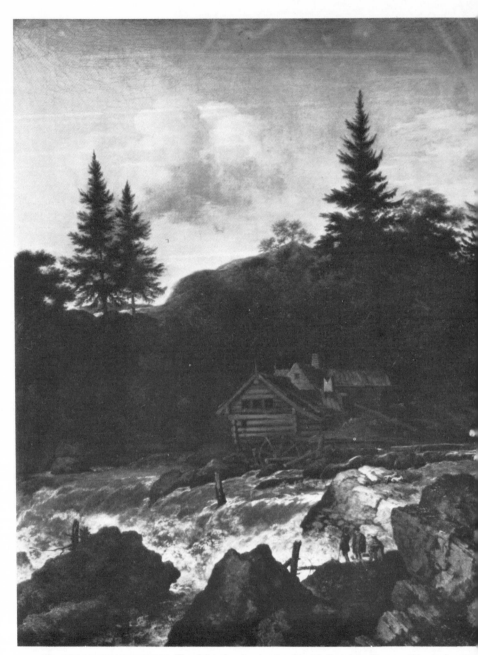

287. ALLAERT VAN EVERDINGEN: *Waterfall in Scandinavia.* 1650. Munich, Bayerische Staatsgemäldesammlungen

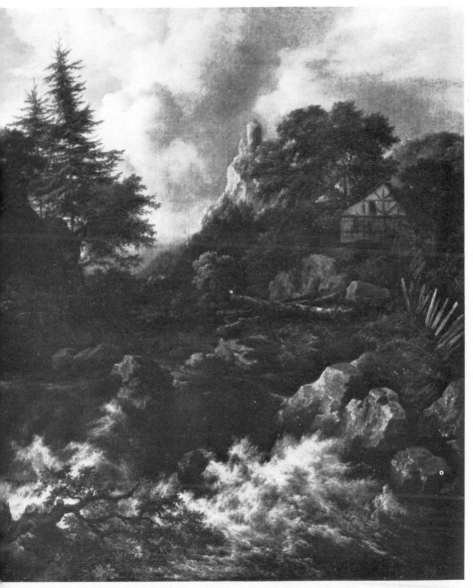

288. JACOB VAN RUISDAEL: *Waterfall with Castle*. Cambridge, Mass., Fogg Art Museum, Harvard University

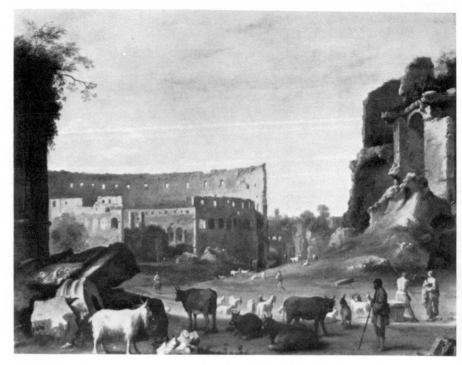

289. CORNELIS VAN POELENBURGH: *Roman Ruins*. Toledo, Ohio, Museum of Art

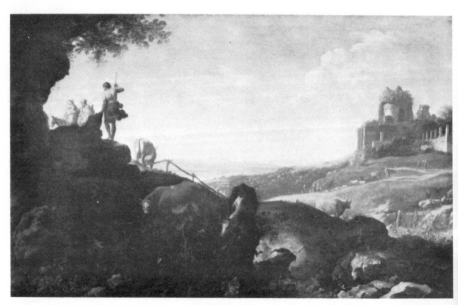

290. CORNELIS VAN POELENBURGH: *The Flight into Egypt*. 1625 or 1626. Utrecht, Centraal Museum

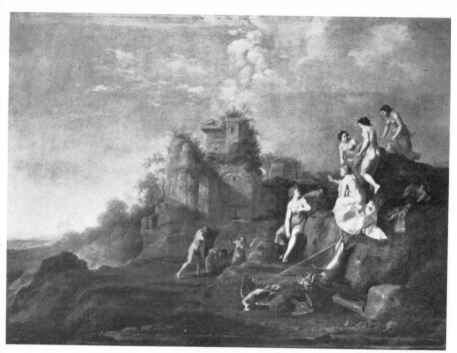

291. CORNELIS VAN POELENBURGH: *Diana and Nymphs*. 1659. Copenhagen, Statens Museum for Kunst

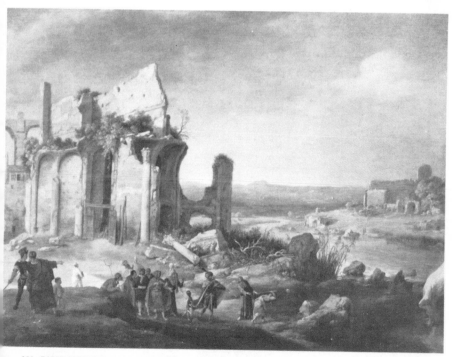

292. BARTHOLOMEUS BREENBERGH: *Moses and Aaron change Water into Blood*. 1631. Malibu, California. J. Paul Getty Museum

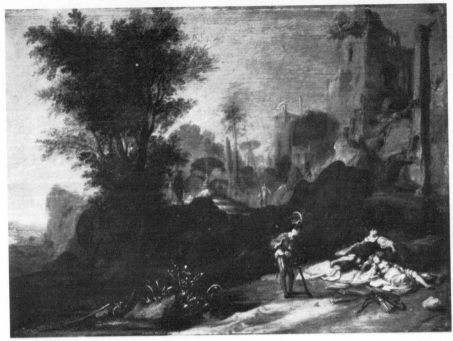

293. BARTHOLOMEUS BREENBERGH: *Cimon and Ifigenia*. 1640. Berlin-Dahlem, Staatliche Museen

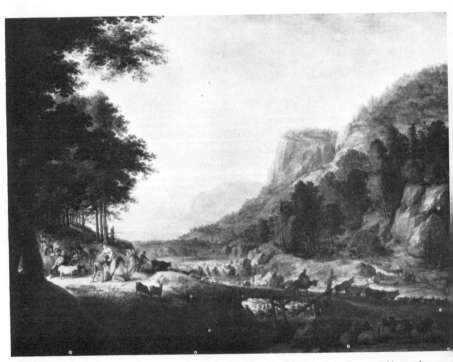

294. HERMAN SAFTLEVEN: *Rebekah and Abraham's Servant*. 1641. Munich, Bayerische Staatsgemäldesammlungen

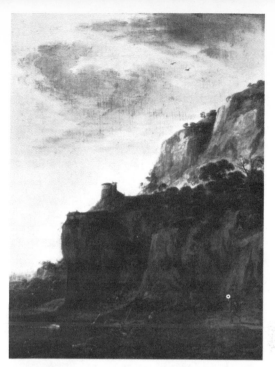

295. HERMAN SAFTLEVEN: *Mountainside.* 1643. Utrecht, Centraal Museum

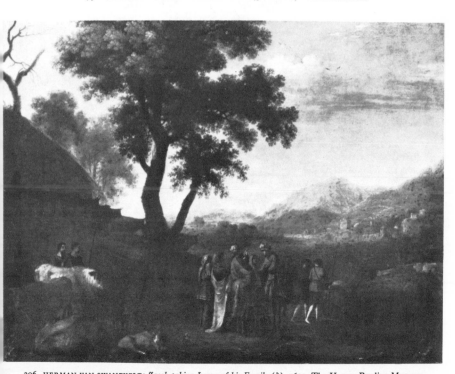

296. HERMAN VAN SWANEVELT: *Jacob taking Leave of his Family* (?). 1630. The Hague, Bredius Museum

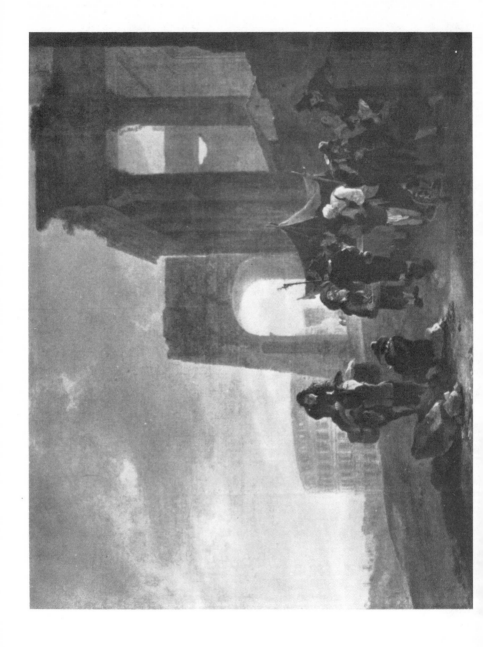

298. JAN ASSELIJN: *Roman Ruins*. Amsterdam, Rijksmuseum

88. Millet (?). Paris, Museum of Fine Arts.

300. JAN BOTH: *Peasants on a Campagna Road.* Indianapolis, Ind., Herron Museum of Art

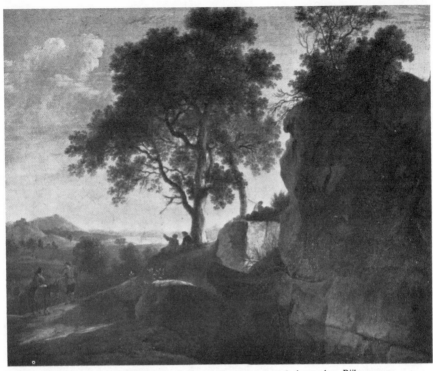

301. HERMAN VAN SWANEVELT: *Rocks and Trees*. 1643 or 1648. Amsterdam, Rijksmuseum

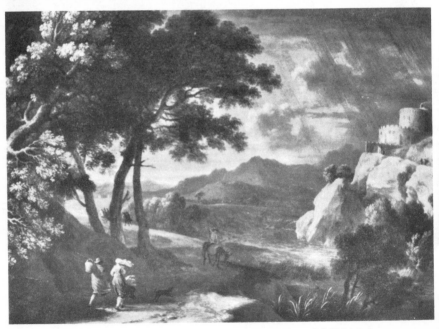

302. HERMAN VAN SWANEVELT: *The Storm*. 1646. Bad Harzburg, Coll. H. Lindenberg

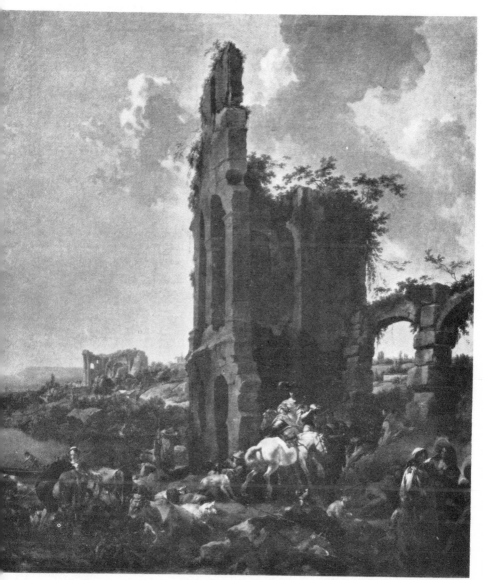

303. NICOLAES BERCHEM: *Ruins*. Munich, Bayerische Staatsgemäldesammlungen

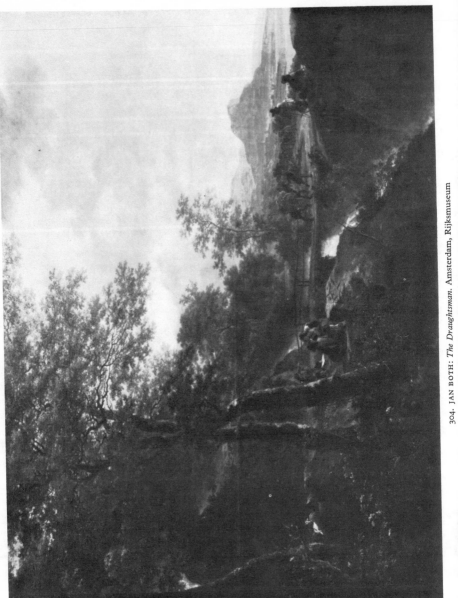

304. JAN BOTH: *The Draughtsman*. Amsterdam, Rijksmuseum

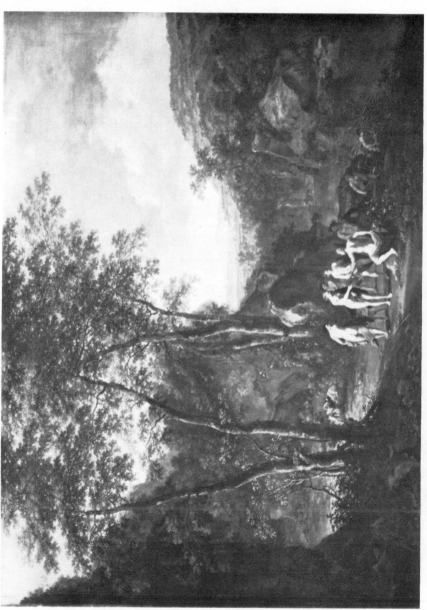

305. JAN BOTH and CORNELIS VAN POELENBURGH: *The Judgment of Paris*, London, National Gallery

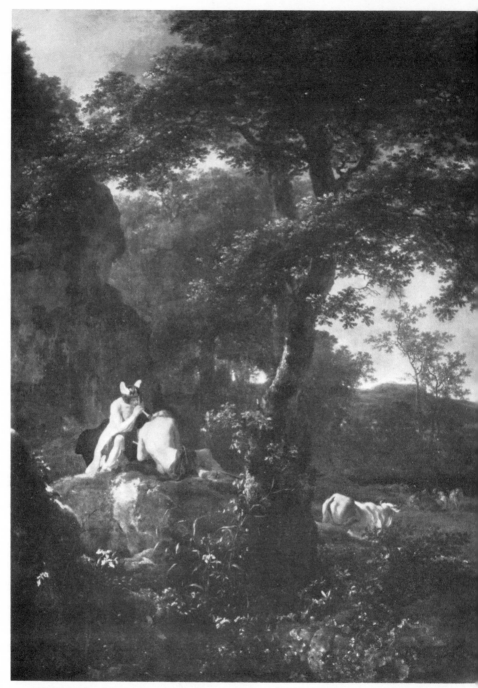

306. JAN BOTH and NICOLAES KNUPFER: *Mercury and Argus*. 1650. Munich, Bayerische Staatsgemäldesammlungen

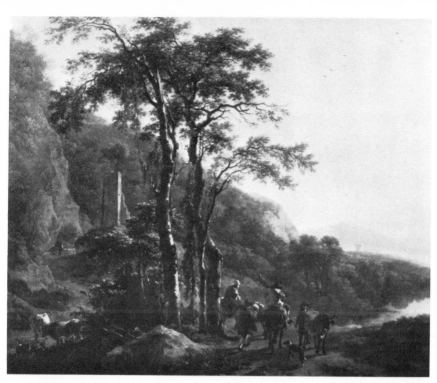

307. NICOLAES BERCHEM: *The Itinerant Musician*. 1657. Indianapolis, Ind., Private Collection

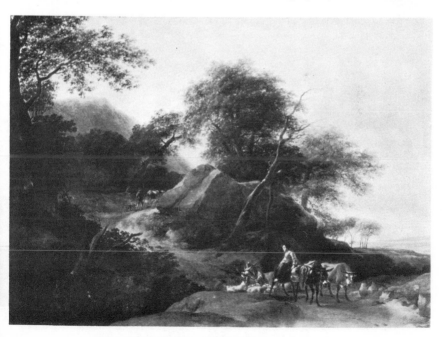

308. NICOLAES BERCHEM: *Oak Wood*. Hannover, Landesgalerie

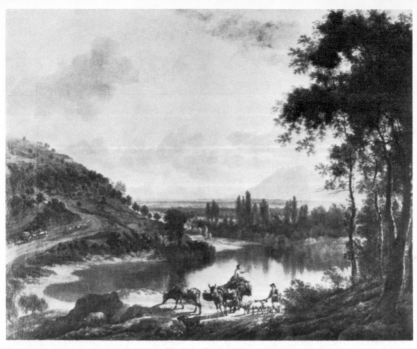

309. JAN HACKAERT: *The Lake*. Berlin-Dahlem, Staatliche Museen

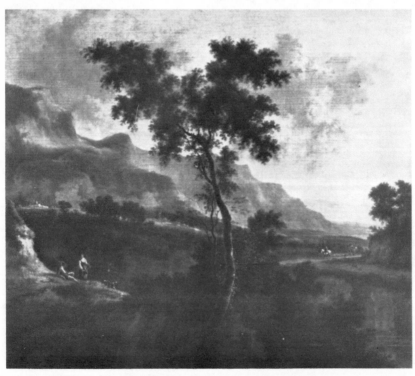

310. JAN HACKAERT: *Sunset*. Amsterdam, Rijksmuseum

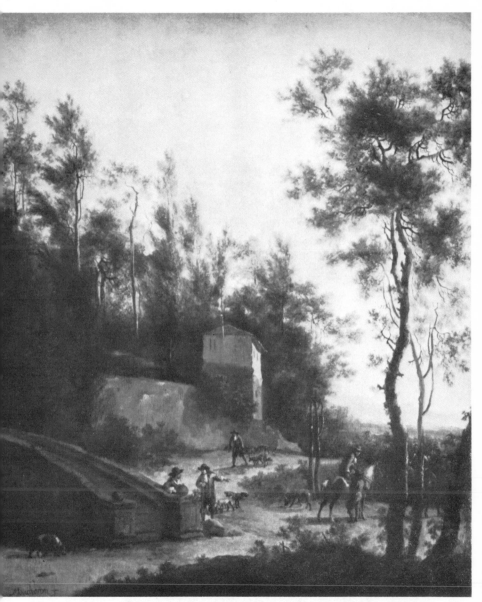

311. FREDERICK DE MOUCHERON: *A Park*. Amsterdam, Rijksmuseum

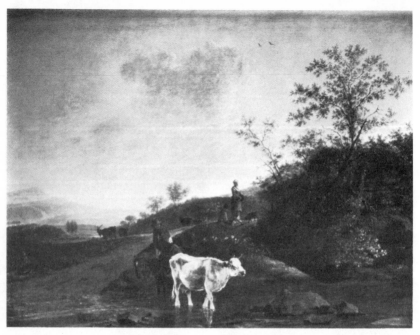

312. ADAM PIJNACKER: *The White Cow*. Munich, Bayerische Staatsgemäldesammlungen

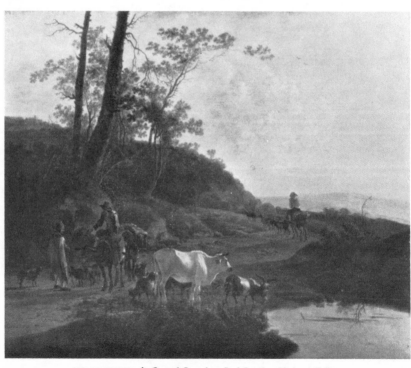

313. JAN BOTH: *An Ox and Goats by a Pool*. London, National Gallery

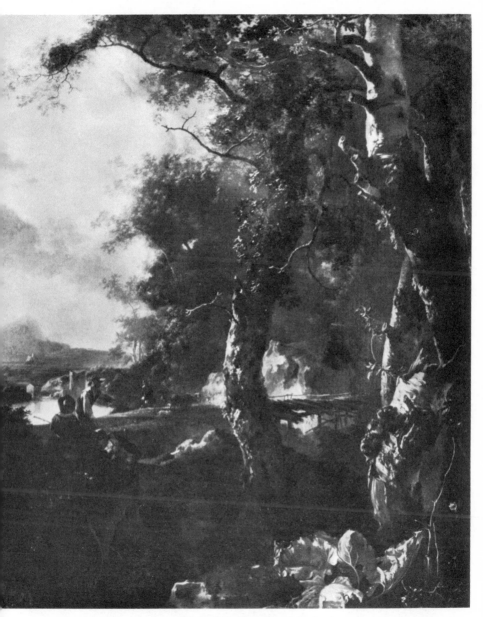

314. ADAM PIJNACKER: *Wooden Bridge*. Bonn, Rheinisches Landesmuseum

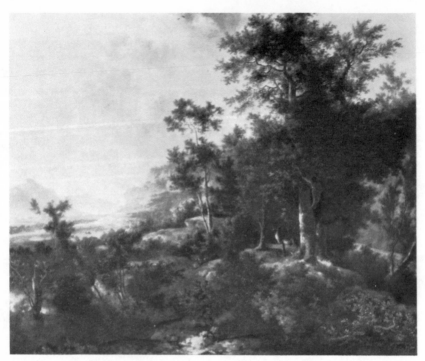

315. FREDERICK DE MOUCHERON: *Deer under Trees*. 1668. Whereabouts unknown

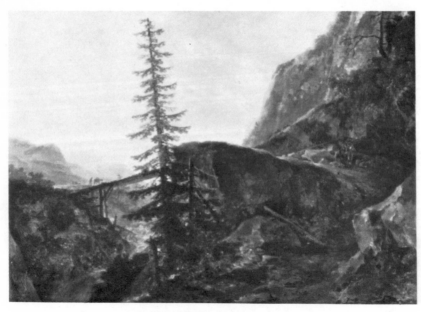

316. JAN BOTH: *Fir Tree and Wooden Bridge*. The Detroit Institute of Arts

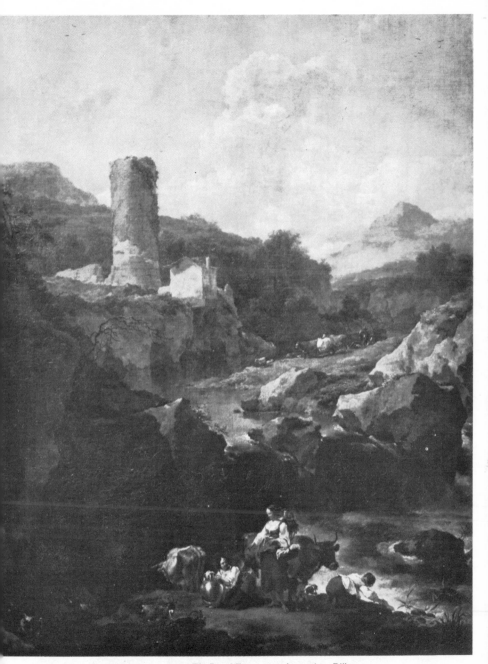

317. NICOLAES BERCHEM: *The Round Tower*. 1656. Amsterdam, Rijksmuseum

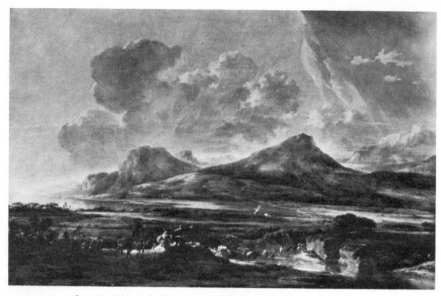

318. JAN ASSELIJN: *Southern Panorama*. Vienna, Akademie der bildenden Künste

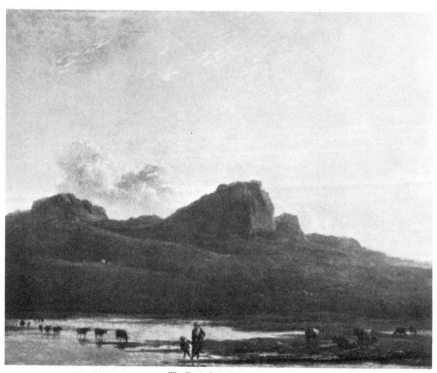

319. KAREL DUJARDIN: *The Ford*. Coll. F. Lugt, Institut Néerlandais, Paris

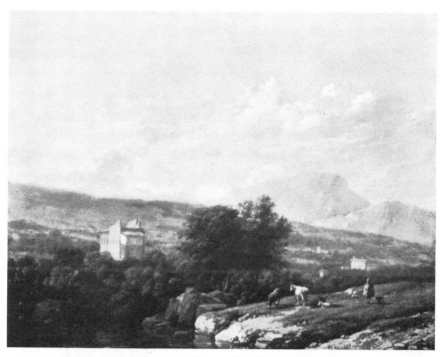

320. KAREL DUJARDIN: *« Le Diamant »*. Cambridge, Fitzwilliam Museum

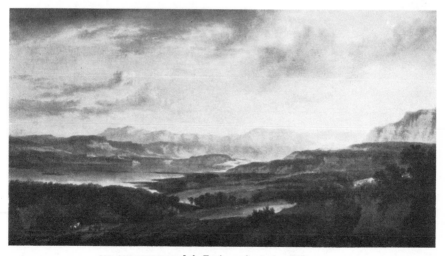

321. JAN HACKAERT: *Lake Trasimene*. Amsterdam, Rijksmuseum

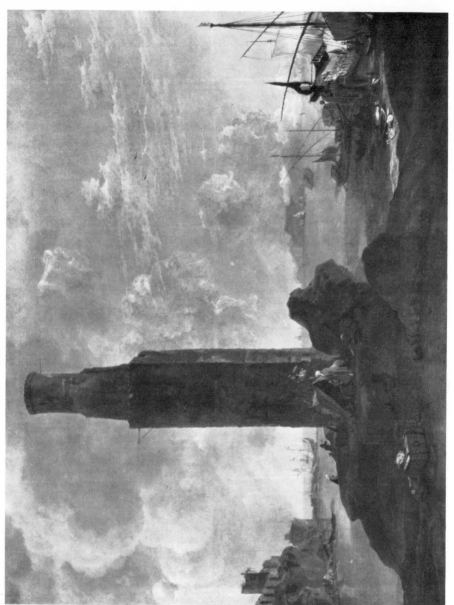

322. JAN ASSELIJN and J. B. WEENIX: *Harbour*. Vienna, Akademie der bildenden Künste

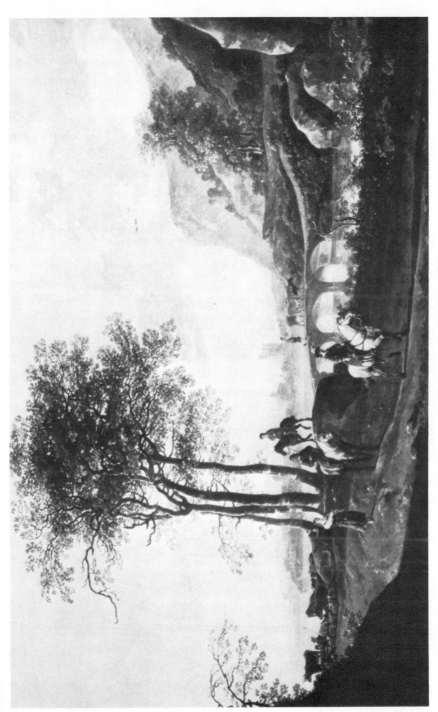

323. AELBERT CUYP: *Horsemen and Shepherds*. Private Collection

325. ADAM PIJNACKER: *Italian Coast*. Vienna, Akademie der bildenden Künste

324. JAN ASSELIJN: *Harbour Scene*. Amsterdam, Rijksmuseum

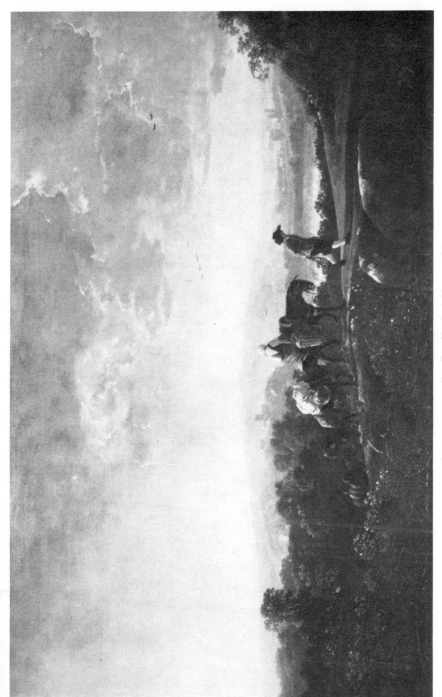

326. AELBERT CUYP: *Travellers*. Cleveland, Museum of Art

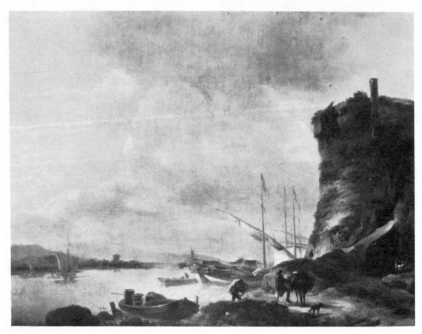

327. NICOLAES BERCHEM: *River Scene*. Leipzig, Museum der bildenden Künste

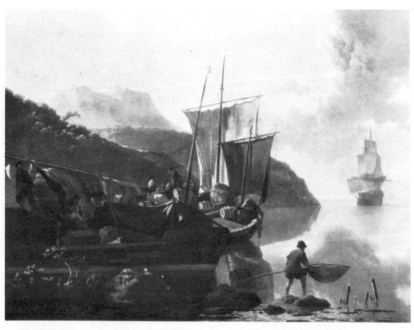

328. ADAM PIJNACKER: *Italian Harbour*. Hartford, Conn., Wadsworth Atheneum

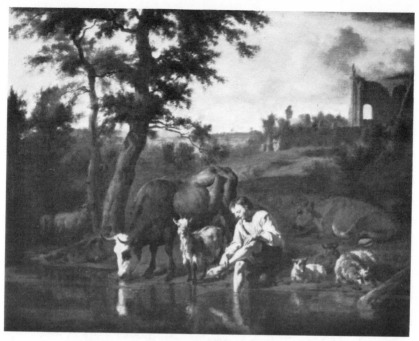

329. ADRIAEN VAN DE VELDE: *The Herdsman*. Pavia, Coll. G. B. Festari

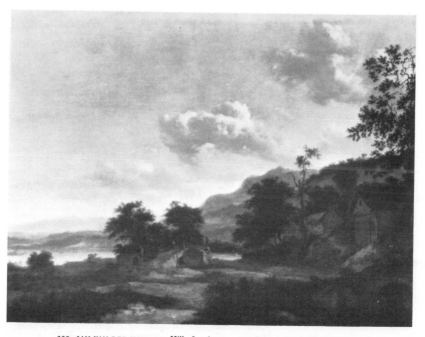

330. JAN VAN DER HEYDEN: *Hilly Landscape*. 1666. Private Collection, England

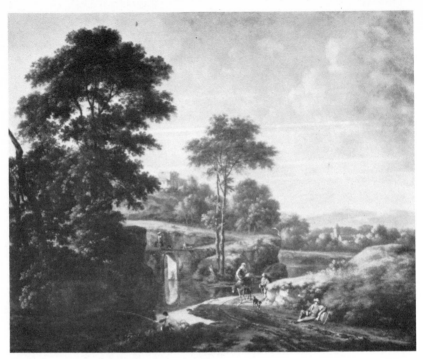

331. JAN WIJNANTS: *The Angler*. 1665. Whereabouts unknown

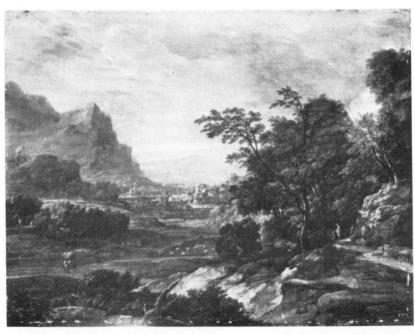

332. EGLON VAN DER NEER: *The Valley*. Munich, Bayerische Staatsgemäldesammlungen

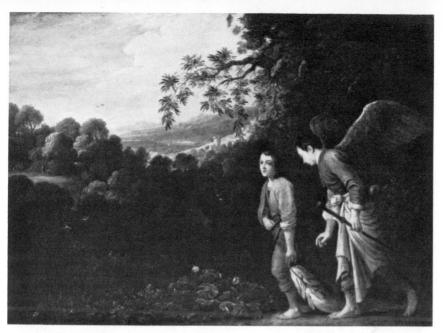

333. ADAM ELSHEIMER: *Tobias and the Angel*. London, National Gallery

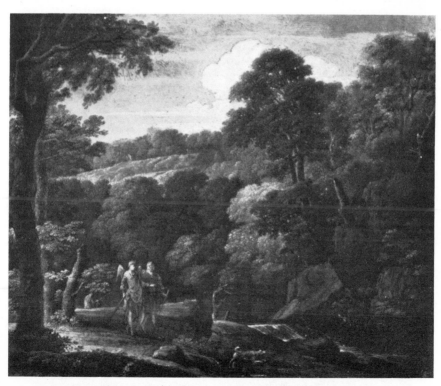

334. EGLON VAN DER NEER: *Tobias and the Angel*. Munich, Bayerische Staatsgemäldesammlungen

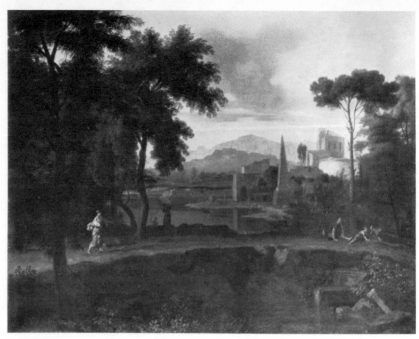

335. JOHANNES GLAUBER: *The Obelisk*. Braunschweig, Herzog Anton Ulrich Museum

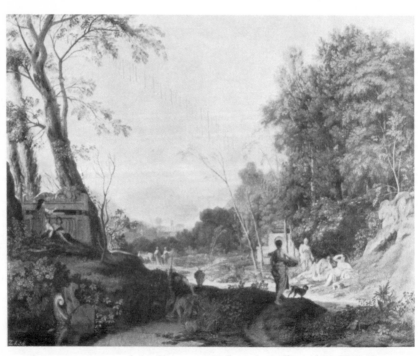

336. AELBERT MEYERING: *Ancient Monuments*. 1686. Braunschweig, Herzog Anton Ulrich Museum

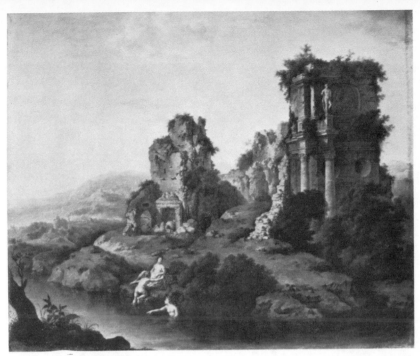

337. JAN GRIFFIER: *Ruins and Bathing Nymphs*. Cambridge, Fitzwilliam Museum

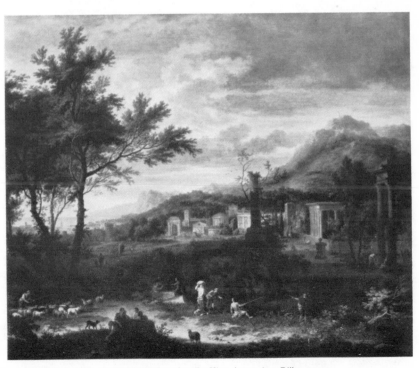

338. JAN VAN HUYSUM: *Arcadian View*. Amsterdam, Rijksmuseum

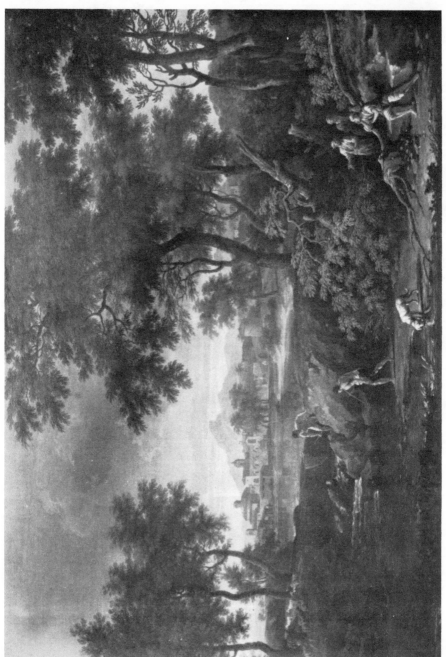

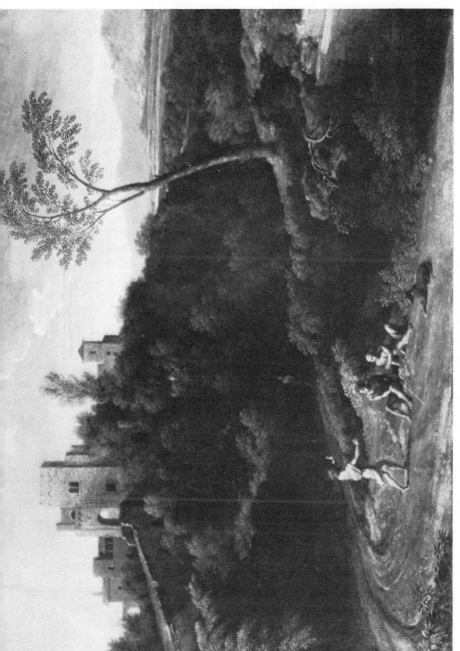

340. GASPARD DUGHET: *View of Aricia*. London, National Gallery

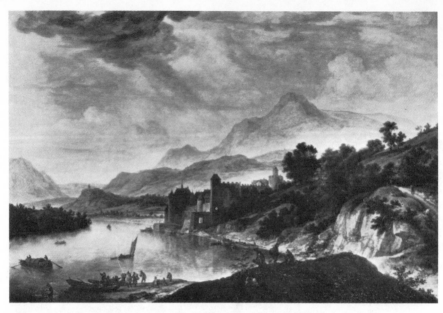

341. HERMAN SAFTLEVEN: *Rhenish Vista*. 1653. Mainz, Gemäldegalerie der Stadt

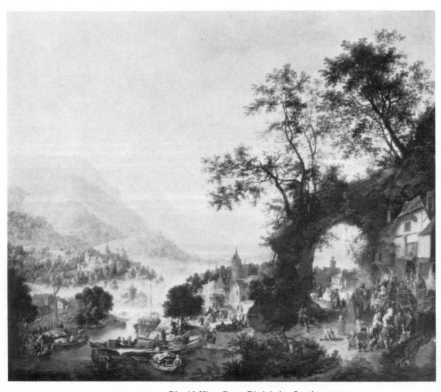

342. JAN GRIFFIER: *Rhenish Vista*. Bonn, Rheinisches Landesmuseum

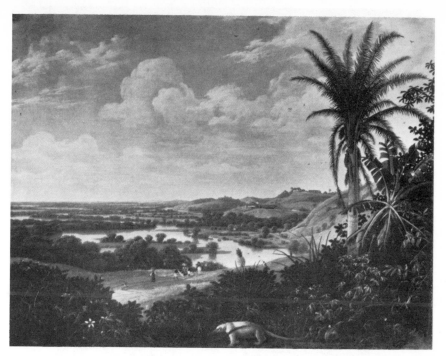

343. FRANS POST: *Brazilian View*. 1649. Munich, Bayerische Staatsgemäldesammlungen

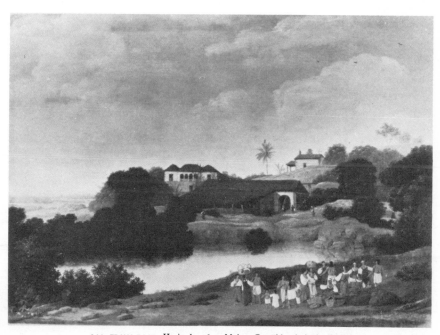

344. FRANS POST: *Hacienda*. 1652. Mainz, Gemäldegalerie der Stadt

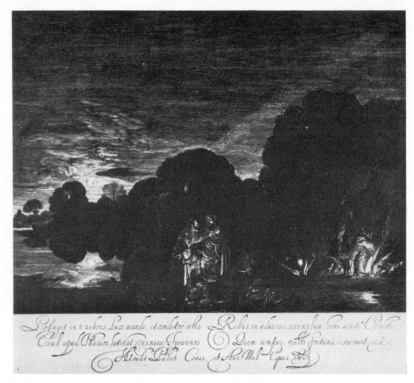

345. HENDRICK GOUDT after ADAM ELSHEIMER: *The Flight into Egypt*. 1613. Engraving

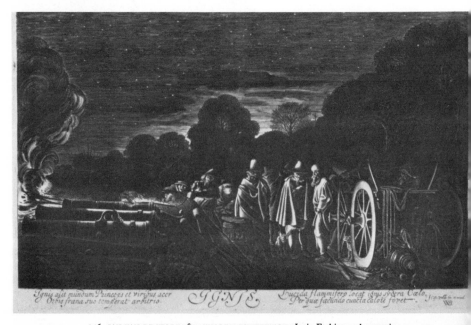

346. JAN VAN DE VELDE after WILLEM BUYTEWECH: *Ignis*. Etching and engraving

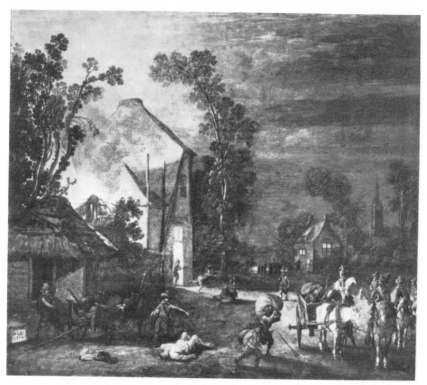

347. ESAJAS VAN DE VELDE: *Plundering of a Village.* 1620. Copenhagen, Statens Museum for Kunst

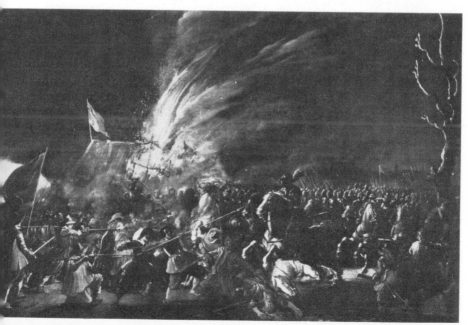

348. ESAJAS VAN DE VELDE: *Battle Scene.* 1623. Rotterdam, Museum Boymans-van Beuningen

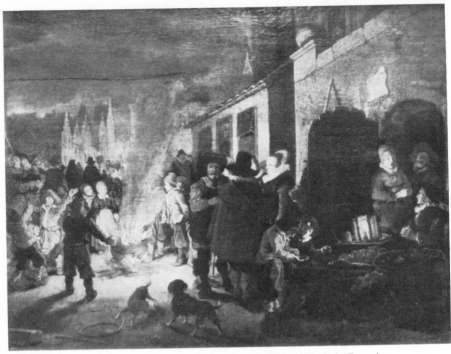

349. PIETER MOLIJN: *Nocturnal Street Scene*. 1625. Brussels, Musée des Beaux-Arts

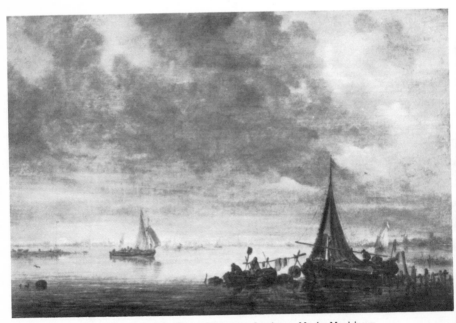

350. JAN VAN GOYEN: *Rising Moon*. 1643. Strasbourg, Musées Municipaux

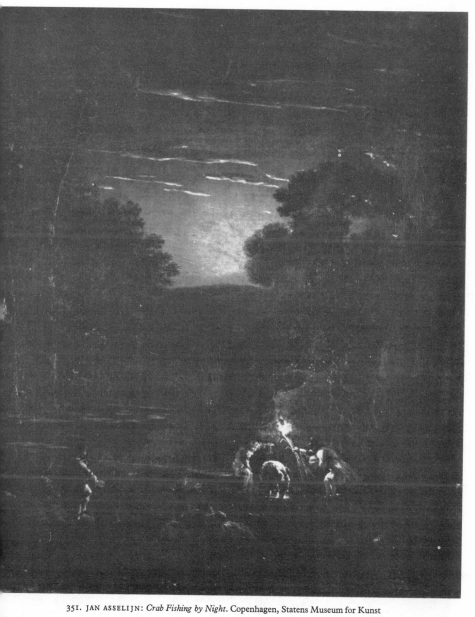

351. JAN ASSELIJN: *Crab Fishing by Night*. Copenhagen, Statens Museum for Kunst

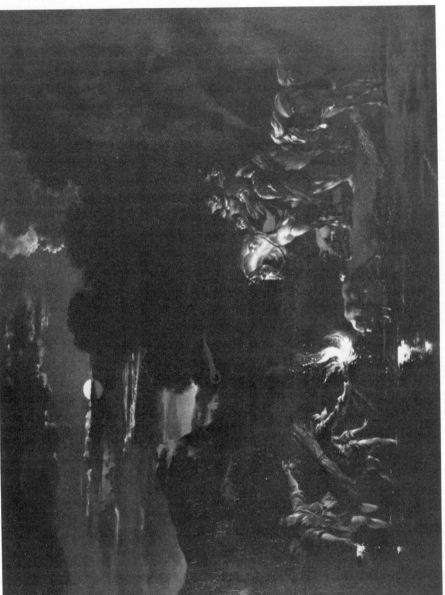

AERT VAN DER NEER: *Coast Fishing by Moonlight*, 1645. London, Coll. B. Cohen

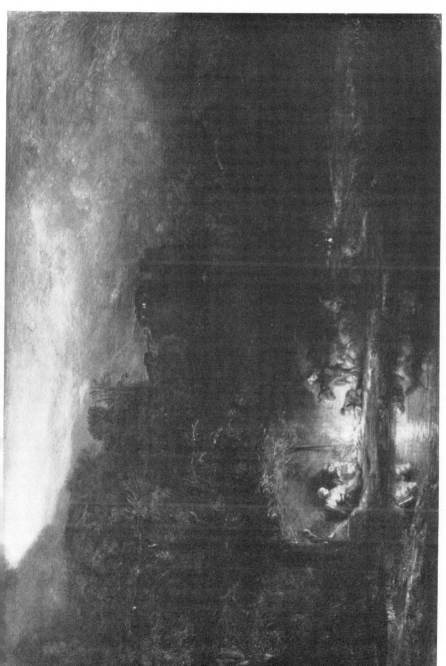

353. REMBRANDT: *The Rest on the Flight into Egypt.* 1647. Dublin, National Gallery of Ireland

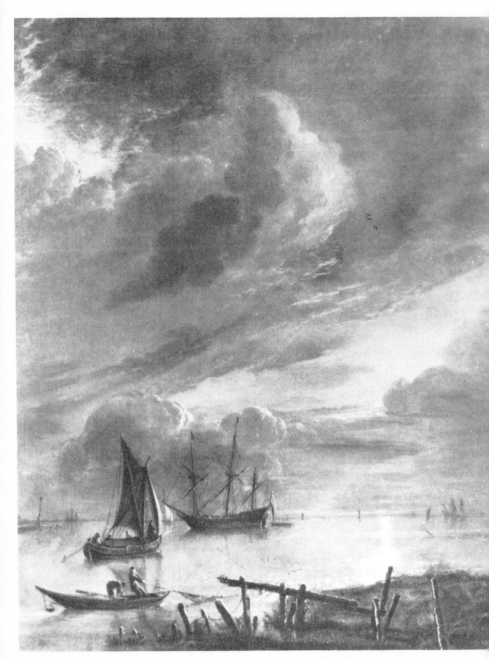

354. AERT VAN DER NEER: *Seascape*. 1646. Formerly Coll. N. Argenti, London

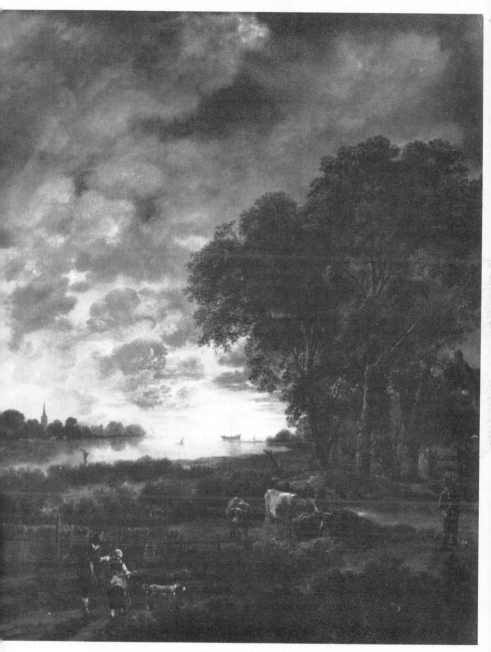

355. AERT VAN DER NEER: *River at Evening*. London, National Gallery

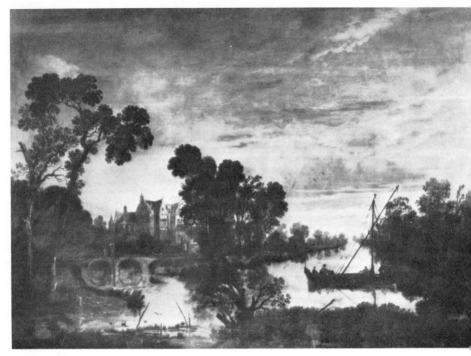

356. AERT VAN DER NEER: *Bridge and Castle*. 1643. Gotha, Museum

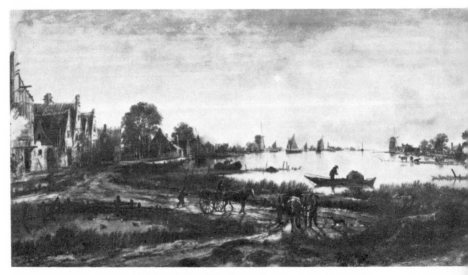

357. AERT VAN DER NEER: *Village and Canal*. Amsterdam, Rijksmuseum

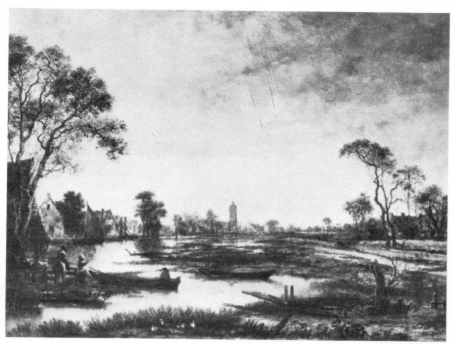

358. AERT VAN DER NEER: *Evening*. The Hague, Mauritshuis

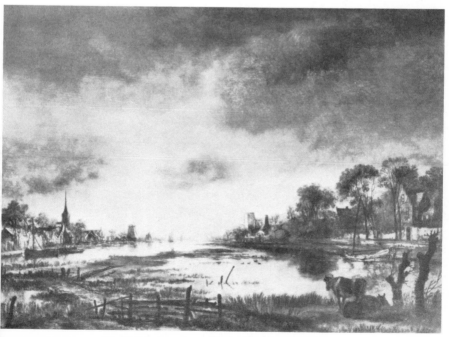

359. AERT VAN DER NEER: *Morning*. The Hague, Mauritshuis

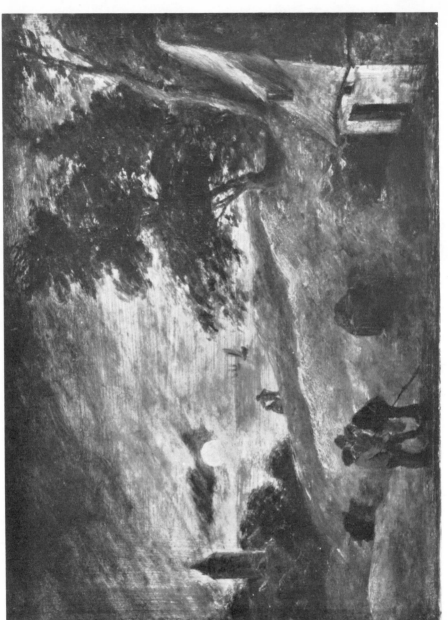

360. ADRIAEN BROUWER: *Dunes in Moonlight*. Berlin-Dahlem, Staatliche Museen

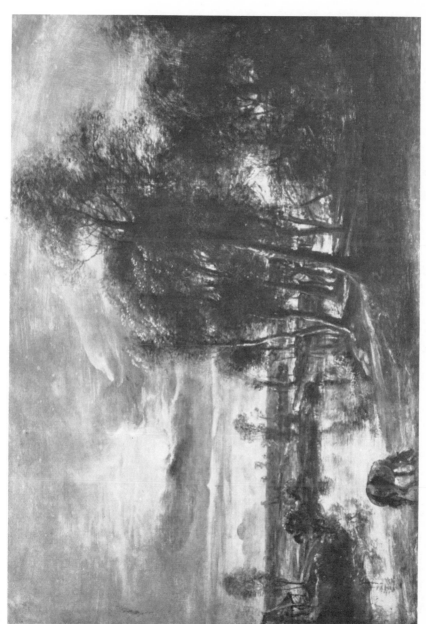

361. PIETER PAUL RUBENS: *Moonlight*. London, Coll. Count Antoine Seilern

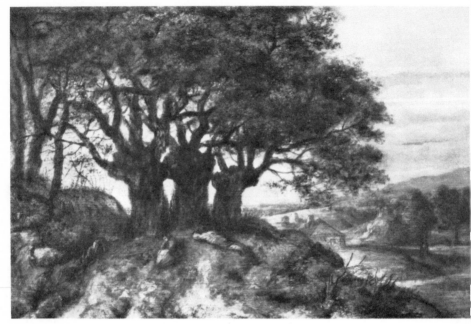

362. JAN LIEVENS: *Evening*. Coll. F. Lugt, Institut Néerlandais, Paris

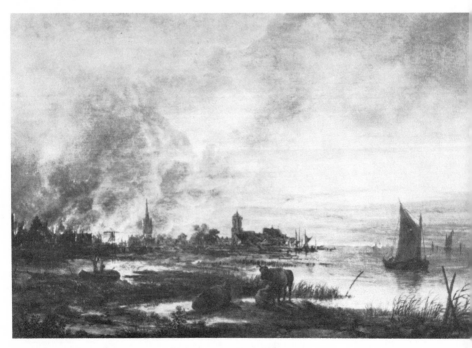

363. AERT VAN DER NEER: *Conflagration in a Town*. Brussels, Musées Royaux des Beaux-Arts

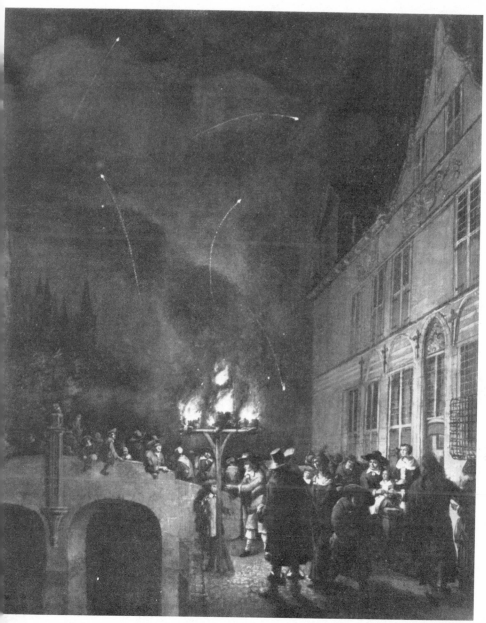

364. EGBERT VAN DER POEL: *Fireworks at Delft*. 1654. Bonn, Rheinisches Landesmuseum

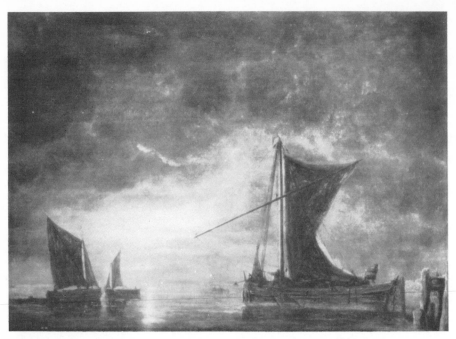

365. AELBERT CUYP: *Harbour by Moonlight*. Leningrad, Hermitage

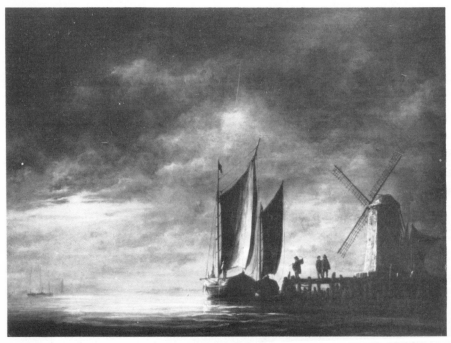

366. AELBERT CUYP: *Sailing-boats and Mill*. Cologne, Wallraf-Richartz-Museum

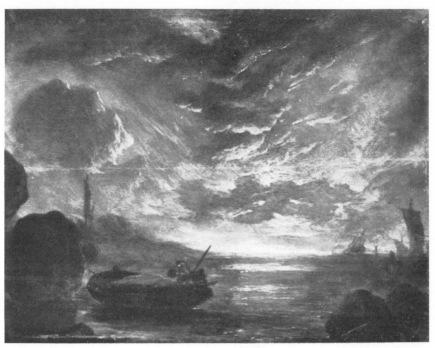

367. LIEVE VERSCHUIER: *Morning*. Rotterdam, Museum Boymans-van Beuningen

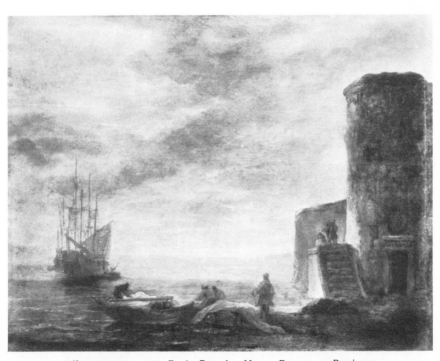

368. LIEVE VERSCHUIER: *Evening*. Rotterdam, Museum Boymans-van Beuningen

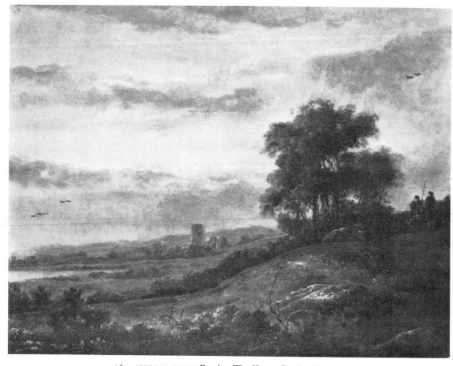

369. AELBERT CUYP: *Evening*. The Hague, Bredius Museum

LIST OF ILLUSTRATIONS

INDEX OF ARTISTS

LIST OF ILLUSTRATIONS

In the following list I have indicated whether a picture is painted on panel, canvas or some other material. Measurements are given in millimetres for drawings and in centimetres – reasonably, I believe, reduced to full and half centimetres – for paintings; height precedes width in all cases. Dates indicate those actually inscribed. I hope to be forgiven for changing some titles; this was done partly in order to avoid the repetitious designation: 'Landscape with . . .', partly because of the faultiness or lack of topographical indications in existing titles. I am afraid I cannot claim any clear principles in my use of English and non-English forms of names of cities; the desire to avoid ambiguities has been my guide in most cases. Sources of photographs are given to the best of my knowledge, permission to use them has been secured whenever possible.

1. Jan Wijnants: *Dunes*. 1667 (?). Panel, 38·5 × 36·5 cm. Kassel, Staatliche Gemäldegalerie. Photo Museum.

2. Joost de Volder: *Cottage and Trees*. Panel, 40 × 55·5 cm. The Hague, Dienst voor 's Rijks Verspreide Kunstvoorwerpen, on loan to the Rijksbureau voor Kunsthistorische Documentatie. Photo Rijksbureau.

3. Jacob van Ruisdael: *Waterfall*. Canvas, 115 × 147·5 cm. Toledo, Ohio, Museum of Art. Gift of A. J. Secor. Photo Museum.

4. Cornelis de Man: *Family Dinner*. Canvas, 59·5 × 73·5 cm. Malibu, California, J. Paul Getty Museum. Photo Museum.

5. Jan Vermeer van Delft: *A Young Woman Standing at a Virginal*. Canvas, 51·5 × 45 cm. London, National Gallery. Photo Museum.

6. Salomon van Ruysdael, *Winter near Utrecht*. Panel, 75·5 × 107 cm. Enschede, Collection Mrs. van Heek-van Hoorn.

7. Salomon van Ruysdael: *Pelkus-Poort*. Panel, 54 × 73·5 cm. The Hague, Dienst voor 's Rijks Verspreide Kunstvoorwerpen.

8. Gerrit C. Bleeker: *The Wooden Bridge*. Panel, 72 × 105 cm. Formerly Art Market, Holland. Photo Rijksbureau.

9. Seghers Forgery: *The Wooden Bridge* (left section of fig. 8). Panel, 37 × 45·5 cm. Formerly Art Market, Holland. Photo Rijksbureau.

10. Cornelis Cort (?): *Village*. Pen drawing, 129 × 397 mm. New York, Metropolitan Museum of Art, Rogers Fund. Photo Museum.

11. Pieter Bruegel: *Village*. 1560. Pen drawing, 143 × 190 mm. Berlin-Dahlem, Staatliche Museen, Kupferstichkabinett. Photo Museum.

12. Hendrick Goltzius: *The Ruins of Bredero Castle*. 1600. Pen and wash drawing, 175 × 279 mm. Amsterdam, Rijksprentenkabinet. Photo Museum.

13. Claes J. Visscher: *The Road to Leiden*. 1607. Pen drawing, 126 × 189 mm. Amsterdam, Rijksprentenkabinet. Photo Museum.

14. Esajas van de Velde: *Spaerwou*. Pen and wash drawing, 85 × 177 mm. Amsterdam, Rijksprentenkabinet. Photo Museum.

15. Esajas van de Velde: *Spaerwou*. Etching, Burchard 10. 83 × 175 mm.

16. Esajas van de Velde: *Summer*. Panel, 20·5 × 32 cm. Oberlin, Ohio, Allen Memorial Art Museum, Oberlin College. Photo Museum.

17. Esajas van de Velde: *Two Horsemen*. 1614. Panel, 25 × 32·5 cm. Enschede, Rijksmuseum Twenthe.

18. Esajas van de Velde: *Dunes and Hunter*. 1629. Panel, 18 × 22·5 cm. Amsterdam, Rijksmuseum. Photo Museum.

19. Jan van Goyen: *Village*. 1626. Panel, 32 × 59 cm. Leiden, Lakenhal. Photo Museum.

20. Jan van Goyen: *Village*. 1625. Panel, 78 × 124 cm. Bremen, Kunsthalle Photo Museum.

21. Abraham Bloemaert: *The Farm*. 1650. Canvas, 91 × 133 cm. Berlin-Dahlem, Staatliche Museen. Photo Museum.

22. Esajas van de Velde: *Country Road*. 1616. Pen drawing, 130 × 253 mm. Frankfurt, Städelsches Kunstinstitut. Photo Museum.

23. Pieter van Santvoort: *Sandy Road*. 1625. Panel, 30 × 37 cm. Berlin-Dahlem, Staatliche Museen. Photo Museum.

24. Pieter Molijn: *Sandy Road*. 1626. Panel, 26 × 36·5 cm. Braunschweig, Herzog Anton Ulrich Museum. Photo Museum.

25. Pieter Molijn: *Cottage*. 1629. Panel, 38·5 × 55 cm. New York, Metropolitan Museum of Art, Gift of H. G. Marquand. Photo Museum.

LIST OF ILLUSTRATIONS 487

INDEX OF ARTISTS

491